BayBank®

BayBank takes great pleasure in sponsoring *Winslow Homer* at the Museum of Fine Arts, Boston, and we welcome you. Through this showing, hundreds of thousands of visitors from Massachusetts and other states and countries will enjoy the extraordinary work of one of America's finest painters.

The Museum of Fine Arts is a local treasure, and we are delighted to support its efforts to expand further the cultural benefits it provides. As part of this event we will also share in a plan to heighten the appreciation of Homer's greatness through special educational programs for Boston-area schools.

Over the years BayBank has taken pride in the Museum of Fine Arts and the crucial role it plays in our community, our region, and in the world of art. In our role of sponsor, we hope our leadership will not only add to the recognition of this great Museum but also encourage additional continuing corporate partnerships.

On behalf of our directors, officers, and over six thousand staff members, we hope you enjoy this memorable exhibition.

Sincerely,

William M. Crozier, Jr.

William M. Crozier, Jr.
Chairman and President
BayBanks, Inc.

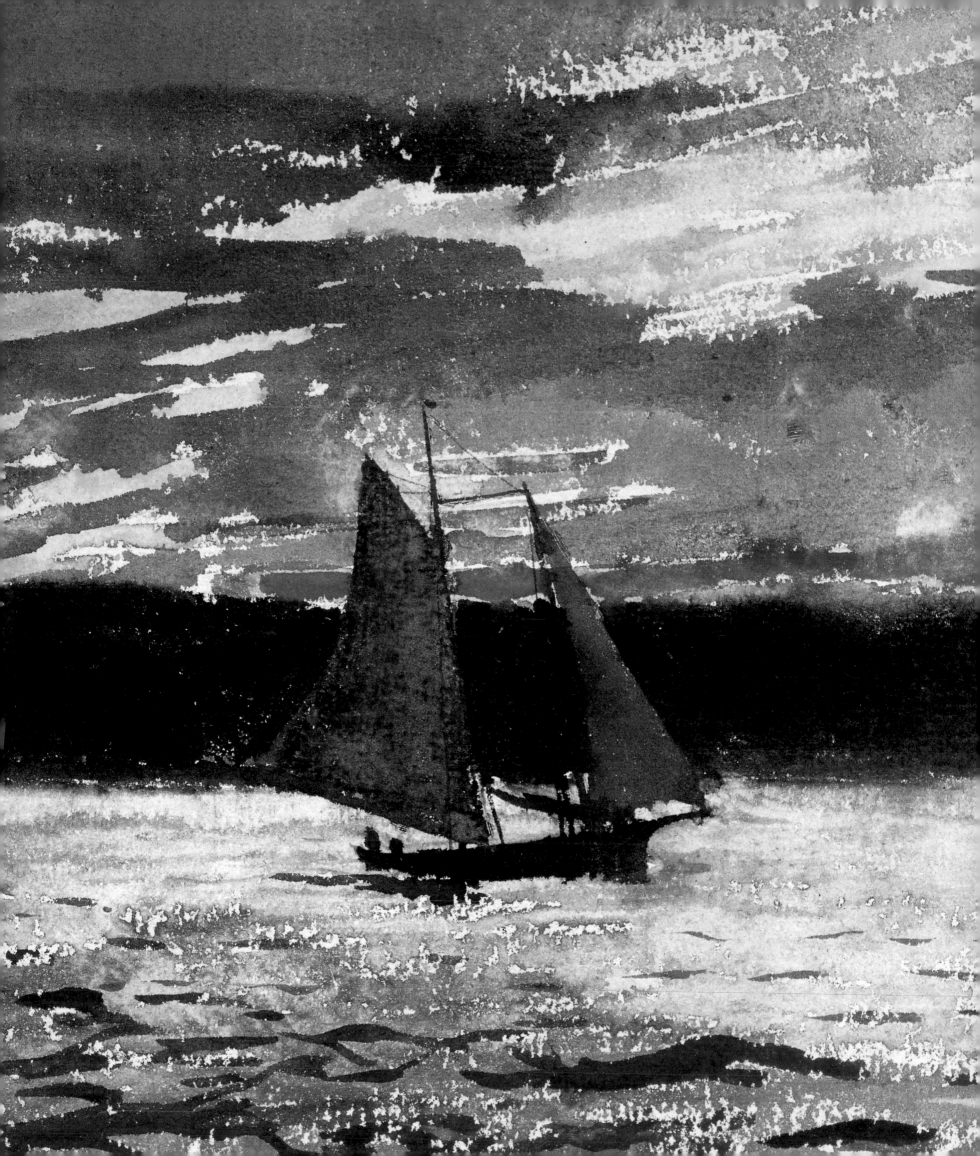

WINSLOW HOMER

Nicolai Cikovsky, Jr.
Franklin Kelly

WITH CONTRIBUTIONS BY
Judith Walsh and Charles Brock

National Gallery of Art, Washington
Yale University Press, New Haven and London

The presentation in Boston is sponsored by BayBank

The exhibition was organized by the National Gallery of Art, Washington

EXHIBITION DATES
National Gallery of Art, Washington
15 October 1995–28 January 1996

Museum of Fine Arts, Boston
21 February–26 May 1996

The Metropolitan Museum of Art, New York
20 June–22 September 1996

The catalogue is supported by a grant from
The Henry Luce Foundation

The book was produced by the Editors Office, National Gallery of Art
Editor-in-Chief, Frances P. Smyth
Editor, Susan Higman
Designer, Phyllis Hecht
Typeset in Janson by General Type, Washington, D.C.
Printed on 150 gsm Gardamatt Brillante
Printed and bound by Amilcare Pizzi, S.p.A., Milan, Italy
The clothbound edition is distributed by Yale University Press

LIBRARY OF CONGRESS CATALOGING-IN-PUBLICATION DATA
Cikovsky, Nicolai.
 Winslow Homer / Nicolai Cikovsky, Jr., Franklin Kelly with contributions by
Judith Walsh and Charles Brock.
 p. cm.
 "Exhibition dates, National Gallery of Art, Washington 15 October 1995–
28 January 1996, Museum of Fine Arts, Boston 21 February–26 May 1996,
Metropolitan Museum of Art, New York 20 June–22 September 1996"—T.p. verso.
 Includes bibliographical references and index.
 ISBN 0-89468-217-2 (paper); ISBN 0-300-06555-8 (cloth)
 1. Homer, Winslow, 1836–1910—Exhibitions. 2. Nationalism in art—Exhibitions.
I. Kelly, Franklin. II. National Gallery of Art (U.S.) III. Museum of Fine Arts, Boston.
IV. Metropolitan Museum of Art (New York, N.Y.) V. Title.
N6537.H58A4 1995 95-19025
759.13–dc20 CIP

cover: *Crossing the Pasture* (cat. 42); frontispiece: *Gloucester Sunset* (cat. 105); page 8: *Coconut Palms, Key West* (cat. 151)
details: page 16 (cat. 10); page 29 (cat. 8); page 38 (cat. 17); page 60 (cat. 18); page 94 (cat. 82); page 130 (cat. 65);
page 170 (cat. 132); page 246 (cat. 164); page 282 (fig. 201); page 300 (cat. 195); page 368 (cat. 231); page 378 (cat. 233)

Contents

Lenders to the Exhibition

Addison Gallery of American Art,
 Phillips Academy, Andover
Albright-Knox Art Gallery
Mr. Arthur G. Altschul
Amon Carter Museum
The Art Institute of Chicago
The Art Museum, Princeton University
The Baltimore Museum of Art
Bowdoin College Museum of Art, Brunswick
The Brooklyn Museum
Mr. John Spoor Broome
Mr. J. Carter Brown
The Butler Institute of American Art
Canajoharie Library and Art Gallery
The Carnegie Museum of Art
Mr. and Mrs. David T. Chase
Cincinnati Art Museum
Sterling and Francine Clark Art Institute
The Cleveland Museum of Art
Cooper-Hewitt, National Design Museum,
 Smithsonian Institution
The Corcoran Gallery of Art
Cummer Gallery of Art
The Currier Gallery of Art
Delaware Art Museum
The Detroit Institute of Arts
The Fine Arts Museums of San Francisco
Mrs. Daniel J. Fraad, Jr.
Mr. and Mrs. Hugh Halff, Jr.
Mr. R. Philip Hanes, Jr.
Mr. H. Rodes Hart
Harvard University Art Museums, Cambridge
Henry Art Gallery, University of Washington,
 Seattle
Hirshhorn Museum and Sculpture Garden,
 Smithsonian Institution
The Hyde Collection
Indianapolis Museum of Art
Mr. and Mrs. George M. Kaufman
Mr. and Mrs. William S. Kilroy
Los Angeles County Museum of Art
Mrs. Ivor Massey
Memorial Art Gallery of the University of
 Rochester
The Metropolitan Museum of Art

Mr. Carleton Mitchell
Musée d'Orsay
Museum of Fine Arts, Boston
Museum of Fine Arts, Springfield
National Gallery of Art
National Museum of American Art, Smithsonian
 Institution
The Nelson-Atkins Museum of Art
New Britain Museum of American Art
North Carolina Museum of Art
Museum of American Art of the Pennsylvania
 Academy of the Fine Arts
Philadelphia Museum of Art
Portland Museum of Art
The Regis Collection
Museum of Art, Rhode Island School of Design,
 Providence
San Antonio Museum of Art
Sheldon Memorial Art Gallery, University of
 Nebraska, Lincoln
Smith College Museum of Art, Northampton
Spencer Museum of Art, University of Kansas,
 Lawrence
Mr. and Mrs. A. Alfred Taubman
Terra Museum of American Art
Fundación Colección Thyssen-Bornemisza
Thyssen-Bornemisza Collection
Mr. and Mrs. Samuel H. Vickers
Wadsworth Atheneum
The Warner Collection of Gulf States Paper
 Corporation, Tuscaloosa, Alabama
Westmoreland Museum of Art
Mr. and Mrs. W. Bryant Williams
The Ruth Chandler Williamson Gallery Program
 at Scripps College, Claremont
Mr. and Mrs. Erving Wolf
Worcester Art Museum
Mrs. James B. Wyeth
Yale University Art Gallery, New Haven
several anonymous lenders

6

Foreword

As the steady stream of exhibitions and publications that followed his death eighty-five years ago clearly demonstrates, it is not possible to see too much of Winslow Homer, or to see too much in him. It is fitting that two of those exhibitions (one in 1958, the other in 1986) of America's greatest and most national painter were arranged by the National Gallery, as the present one, the grandest of them all, has been. It is also fitting that the exhibition will be seen in the capital of the nation whose life and finest values Homer's art enduringly expresses, as well as in the two places that nurtured and shaped his artistic being: Boston, where he was born and raised, and New York, where he was formed as an artist and achieved fame.

Since the last comprehensive Winslow Homer exhibition, organized by the late Lloyd Goodrich for the Whitney Museum of American Art almost twenty-five years ago, many scholars and curators have examined Homer and his art from almost every angle and available method in a succession of books, articles, exhibitions, and exhibition catalogues. We now know much, much more about Homer than we did twenty-five years ago, and if it is possible because of that to admire him more, we do. Clearly the time has come to take another large and serious look at this artist who holds such a towering position in our artistic heritage, and, as the great contemporary of Degas, Manet, and Whistler, in the art of the nineteenth century as a whole.

The challenging task of organizing an exhibition that would do justice to the scope and scale of Winslow Homer's achievement has been eagerly taken on and splendidly carried out by the Gallery's gifted curators of American art, Nicolai Cikovsky, Jr., and Franklin Kelly, as has the writing of this comprehensive catalogue. At the institutions sharing the exhibition, Philippe de Montebello, director of The Metropolitan Museum of Art, and Malcolm Rogers, director of the Museum of Fine Arts, Boston, have been models of helpful cooperation.

Exhibitions of the scale and importance of *Winslow Homer* are becoming increasingly difficult to mount without the assistance of corporate and foundation funding. We offer special thanks to GTE Corporation for so generously supporting the exhibition at the National Gallery of Art in Washington and The Metropolitan Museum of Art in New York. GTE Corporation has distinguished itself as one of the Gallery's most loyal corporate patrons. With *Winslow Homer*, GTE celebrates its ninth exhibition sponsorship, and we are deeply grateful to Charles R. Lee, chairman and chief executive officer, for his steadfast commitment to the Gallery's exhibition programs. The Metropolitan Museum of Art is proud and honored to welcome GTE Corporation to New York and is delighted that the *Winslow Homer* exhibition will inaugurate its association with this museum.

The Museum of Fine Arts, Boston, wishes to thank BayBank and its chairman, William Crozier, Jr., for generously supporting the presentation in Boston.

The three exhibiting institutions would also like to thank The Henry Luce Foundation, which has supported the catalogue and brochure for the exhibition. The Luce Foundation is the only major foundation whose arts program is devoted exclusively to American art, and its support has made possible the important scholarly and educational components for *Winslow Homer*. We are especially grateful to Henry Luce III, the foundation's chairman and chief executive officer, for his continued encouragement of the project.

Finally, we are deeply thankful to the many lenders, public and private, in this country and abroad, without whose trust and generosity neither this nor any exhibition like it would be possible.

Earl A. Powell III
Director, National Gallery of Art

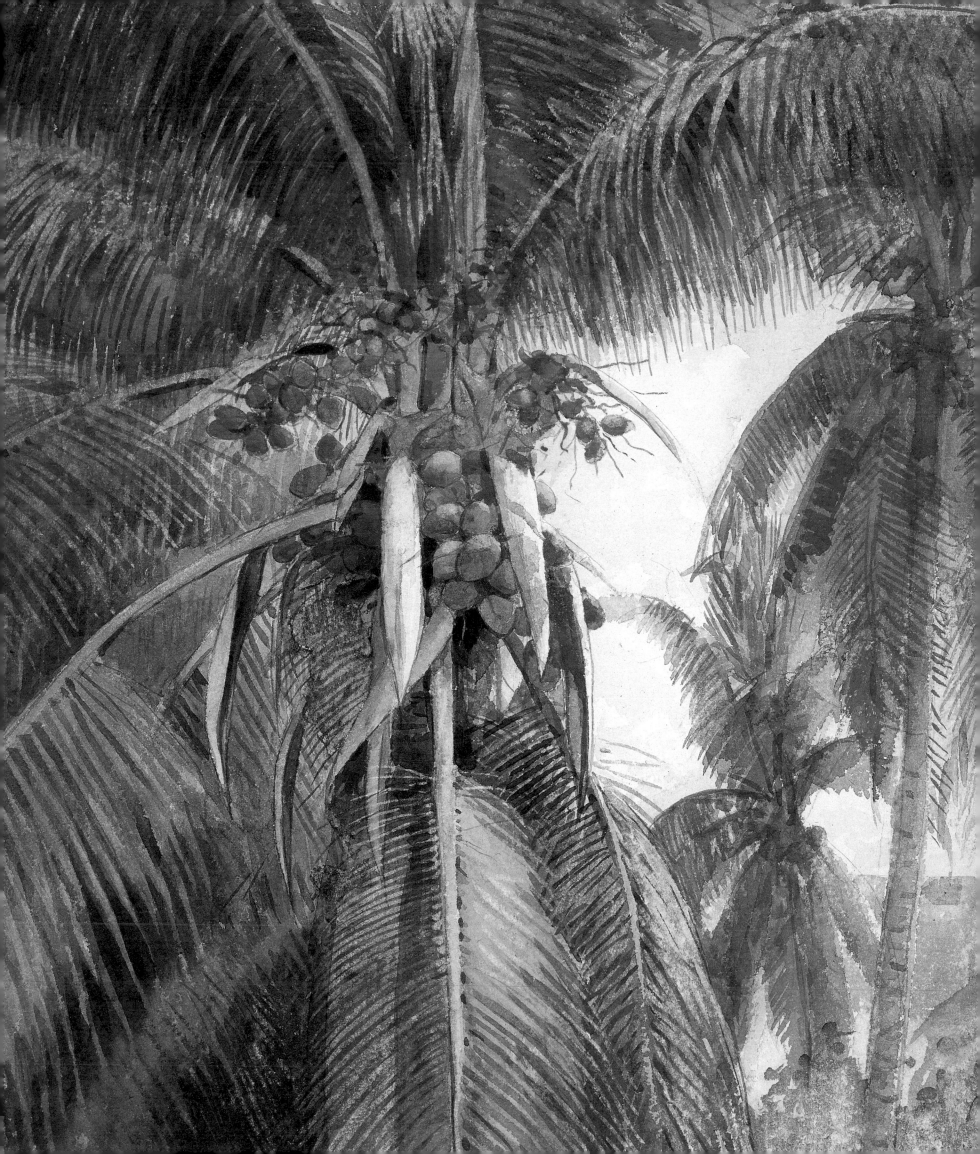

Acknowledgments

An exhibition of this magnitude of ambition and accomplishment does not happen without much help, great generosity, and huge sacrifices of time and energy. In the course of its arrangement many people have had many different and often difficult things asked of them, and their responses have been far kinder and more forthcoming than we had any right to expect. The acknowledgments that follow are but tokens of still greater gratitude.

We first thank those with whom we have worked most closely and consistently on the exhibition, namely our colleagues at the National Gallery of Art. J. Carter Brown and Earl A. Powell III, former director and director of the Gallery, respectively, provided enthusiastic support and encouragement, as did Roger Mandle and John Wilmerding, former deputy directors, and Alan Shestack, current deputy director. In the Department of American and British Paintings, Charles Brock, exhibitions assistant and a contributor to this catalogue, has kept the exhibition on track by handling vast amounts of correspondence, figuring the logistics of travel, conducting research, and performing many other absolutely essential tasks. Staff assistants Jennifer Friel and her successor Stephenie Schwartz handled countless administrative duties with grace and good cheer. Many interns, research assistants, volunteers, and students have also assisted us in important ways, in particular, Elizabeth Chew, Jennifer Harper, Daniel King Hart, Laurette McCarthy, and Jodi Mansbach. In the Department of Exhibitions, Dodge Thompson, its chief, and Ann Robertson, exhibitions officer, expertly handled the myriad details and delicacies that an exhibition of this size entails; Nancy Hoffmann, assistant to the treasurer, was responsible for the insurance arrangements; Susan Arensberg, head of the Department of Exhibition Programs, and Lynn Russell and Faya Causey, Department of Adult Programs in the Education Division, supervised the educational components of the exhibition with effortless skill; in the Editors Office, Frances Smyth, editor-in-chief, Susan Higman, editor, and Phyllis Hecht, designer, for whom no problem was unsolvable and no deadline too daunting, were brilliantly and unflappably efficient; Elizabeth Perry, formerly corporate relations officer, and Joseph Krakora, external affairs officer, were instrumental in securing funding and foundation support for the exhibition; Judith Walsh, senior paper conservator and specialist in Winslow Homer's watercolor technique, contributed importantly to the exhibition and catalogue; Catherine Metzger and Elizabeth Walmsley, associate painting conservators, provided information about Homer's painting techniques; Ira Bartfield, Barbara Bernard, and Sara Sanders-Buell in the Department of Imaging and Visual Services handled photography requests for objects in the exhibition; Neal Turtell and the staff of the Gallery's library, especially Thomas McGill, Ted Dalziel, Ruth Philbrick, and Wendy Cole, have been, as always, unfailingly helpful.

The actual assembling of the works for the exhibition and arranging of their display has been a herculean task to which many individuals have contributed energetically and efficiently. In the Registrar's Office, Sally Freitag, chief registrar, and Michelle Fondas, assistant registrar for exhibitions, deserve special praise. Senior Curator and Chairman of Design Gaillard Ravenel, Chief of Design Mark Leithauser, Lighting Designer and Head of Exhibition Production Gordon Anson, Head of Silkscreen Shop Barbara Keyes, Frame Conservator Stephan Wilcox, and Frame Project Coordinator Anne Kelley have with their staff worked tirelessly to present the exhibition elegantly and intelligibly.

It is always a pleasure to work with our colleagues at the Museum of Fine Arts, Boston, and The Metropolitan Museum of Art, New York, the two institutions where the exhibition will also be seen. In particular, we thank Theodore E. Stebbins, Jr., Carol Troyen, and Erica Hirschler in Boston; and John K. Howat, H. Barbara Weinberg, Carrie Rebora, and Kevin Avery in New York.

The demands of putting together a large exhibition tend to leave little time to reflect on the writing done for the catalogue and to recognize unsound arguments, illogical conclusions, and infelicitous language. We have thus been fortunate to have benefited from the careful reading of the catalogue manuscript by two scholars who have themselves contributed greatly to our understanding of Homer: Marc Simpson and Bruce Robertson. Simpson in his 1988 exhibition devoted to the Civil War paintings demonstrated an acute awareness of how the artist's images could be understood in depth and in detail through the means of a closely focused museum installation and catalogue. Our efforts here, though obviously on a larger scale, have been much guided by his example and by his advice on the catalogue. Robertson's 1990 exhibition on Homer's late paintings and their influence helped remind us of the wider context for Homer's art and understand some of his special genius by grasping how it affected others. To him we are also greatly indebted for general inspiration and for specific help on the catalogue.

There is a vast amount of primary material available on Homer, and our work simply could not have been done without the assistance of those who work in institutions that hold large collections of Homer's drawings, letters, and related objects. Elaine Dee and Marilyn F. Symmes of the Cooper-Hewitt, National Design Museum, Smithsonian Institution, New York, have been unfailingly generous in allowing us access to and providing information about that museum's unequaled collection of Homer drawings; Brad Nugent handled our many requests for photographs. Mattie Kelley at the Bowdoin College Museum of Art has, with seemingly unending patience and good humor, helped us with that institution's vast material, including original letters, scrapbooks, and photographs. And when one thinks of Bowdoin and Homer, Philip C. Beam's name also comes immediately to mind. We not only gained much from his knowledge of the Bowdoin material and of Homer, but were privileged to spend a delightful day with him touring Prout's Neck, seeing the places that Homer painted and the house and studio in which he worked. That one still has the opportunity to see Homer's studio is thanks to the efforts of his descendants, of whom we particularly thank Doris Homer and Lois Homer Graham. M. Knoedler and Company in New York, which served as Homer's primary dealer late in his career, also has rich holdings of letters and transcripts documenting the artist's relationship with the firm; Melissa DeMedeiros, Knoedler's librarian, kindly made that material available to us and answered many, many questions. Colonel Merl M. Moore shared with us his large file of copies of contemporary exhibition reviews of Homer's works, and was especially helpful with references from the Boston *Transcript*. We also made use of materials available through the Archives of American Art, the Boston Public Library, and the National Gallery's own holdings of transcripts of letters from Homer to his friends, family, and dealers.

Abigail Booth Gerdts, director of the "Lloyd Goodrich and Edith Havens Goodrich, Whitney Museum of American Art, Record of Works by Winslow Homer" at the Graduate Center of the City University of New York, kindly answered questions about specific details of provenance and dating of Homer's works on several occasions. More generally, her efforts in documenting Homer's career have already benefited many public and private owners of his works, thus making their task in providing us with information unquestionably easier. We are indeed grateful for her careful and conscientious stewardship of the Goodrich material.

No one, of course, can work on Homer without acknowledging the many scholars whose publications have played a fundamental role in shaping our image of him. The bibliography included in this catalogue makes clear the magnitude of important literature on Homer. In particular, we cite with pleasure the contributions of Henry Adams, Scott Atkinson, Linda Ayres, Philip C. Beam, Albert Boime, Sarah Burns, Mary Anne Calo, Rachel Carren, Margaret Conrads, Helen Cooper, David Park Curry, Karen C. C. Dalton, Linda Docherty, James Thomas Flexner, Albert Ten Eyck Gardner, Lloyd Goodrich, William Gerdts, Lucretia Giese, Eleanor Jones Harvey, Gordon Hendricks, Patricia Junker, Barbara Novak, Richard J. Powell, Paul Provost, Jules Prown, Michael Quick, Christopher Reed, Natalie Spassky, Roger Stein, David Tatham, John Wilmerding, Christopher Wilson, Bryan Wolf, and Peter Wood. The students in Franklin Kelly's 1992 seminar on Homer at the University of Maryland, College Park—Roberta W. Buchanan, Tracy Anne Caisse, Joan Feldman, Laurie Gillman, Leslie Clayton Howard, Cynthia Mills, Kathleen Mosier, Akela Reason, Lynn P. Russell, Linda Thrift, and Lee Vedder—also deserve special thanks.

During our extensive travels to examine works by Homer in public and private collections we were helped by many people, some old friends and colleagues, others new acquaintances. We thank all of those who helped us along the way; because this exhibition has been so long in the making, some of these individuals have inevitably moved on to other institutions. But it is a pleasure now to remember them where and when we encountered them in connection with Homer, and thus we extend special gratitude to the following: Jock Reynolds, Susan Faxon Olney, and Allison Kemmerer, Addison Gallery of American Art, Andover, Massachusetts; Douglas Schultz, Cheryl Brutvan, and Laura Catalano, Albright-Knox Art Gallery, Buffalo; Sarah Cash, Amon Carter Museum, Fort Worth; Lisa Carmichael, Ball State University, Muncie, Indiana; Sona Johnston and Jay Fisher, Baltimore Museum of Art; Frederick D. Hill and James Berry Hill, Berry-Hill Galleries, New York; Regina Rudser, Barbara Schapiro, Ann Havinga, and Sue Walsh Reed, Museum of Fine Arts, Boston; Linda S. Ferber and Barbara Gallatti, Brooklyn Museum; Louis A. Zona and Robert Kurtz, The Butler Institute of American Art, Youngstown, Ohio; Marie Moore and James Crawford, Canajoharie Library and Art Gallery, Canajoharie, New York; Ann Carleton; Louise Lippincott, Museum of Art, Carnegie Institute, Pittsburgh; Beverly Carter; Mrs. David Chase; Andrea Honore, Mark Pascal, and Judith A. Barter, Art Institute of Chicago; Jay Cantor and Debra Force, Christie's, New York; John Human Wilson and Kristen Spangenberg, Cincinnati Art Museum; Kay Koeninger and Mary Davis MacNaughton, The Ruth Chandler Williamson Gallery, Scripps College, Claremont, California; David S. Brooke, Michael Conforti, Steven Kern, Martha Asher, Thomas Fels, and Rafael Fernandez, Sterling and Francine Clark Art Institute, Williamstown, Massachusetts; Bruce Robertson and Michael Miller, Cleveland Museum of Art; Dana Hemingway, Warren Adelson, and Jerald Fessenden, Coe Kerr Gallery, New York; Thomas Colville; Jack Cowart, Linda Crocker Simmons, and Julie Soles, Corcoran Gallery of Art, Washington; Henry Adams and Robert W. Schlageter, Cummer Gallery of Art, Jacksonville, Florida; Inez McDermott, Darlene LaCroix, and Jolie Foucher, Currier Gallery of Art, Manchester, New Hampshire; Cecily Langdale, Davis and Langdale; Mary Holahan, Delaware Art Museum, Wilmington; Sam Sachs, Nancy Rivard Shaw, and Ellen Sharp, Detroit Institute of Arts; John Rexine, Everson Museum of Art, Syracuse, New York; Edith Murphy, William A. Farnsworth Library and Art Gallery, Rockland, Maine; Ivan Gaskell, Betsy Weyburn, Antien Knaap, and Miriam Stewart, Fogg Art Museum, Harvard University, Cambridge, Massachusetts; Steve Brooks, Frye Art Museum, Seattle; Edward Grombacher; Jonathan Warner and Charles Hillburn, Gulf States Paper Corporation, Tuscaloosa, Alabama; Mrs. Wellington Henderson; Stuart Feld and M. P. Naud, Hirschl and Adler Galleries, New York; Judith Zilczer, Frank Gettings, and Anne-Louise Marquis, Hirshhorn Museum and Sculpture Garden, Smithsonian Institution, Washington; Mrs. Thomas M. Hitchcock; Jennifer Saville, Honolulu Academy of Arts; Edward Nygren and Amy Meyers, Huntington Libraries and Art Galleries, San Marino, California; Angela Berg and Terry Wilson, Indianapolis Museum of Art; Marianne Kahan, International Business Machines; Phyllis Johnson; Vance Jordan, Jordan-Volpe Gallery, New York; Janet Farber, Joslyn Art Museum, Omaha, Nebraska; Lawrence Fleischman, Kennedy Galleries, New York; Mrs. Jonathan Leroy King; Mrs. Edward La Farge; Sheila La Farge; John and Colles Larkin; Ilene S. Fort, Los Angeles County Museum of Art; Mrs. George Lynch; Celia Brown, Malden Public Library, Malden, Massachusetts; James Maroney; Richard A. Manoogian and Joan Barnes, Masco Corporation, Detroit; Mr. and Mrs. Ivor Massey; Marnie Sandweiss, Mead Art Museum, Amherst College, Amherst, Massachusetts; Mark Ormond and Louis Grachos, Miami Center for the Fine Arts; Suzanne Dunaway, Mills College Art Gallery, Oakland, California; Elizabeth Broun, William Truettner, Mark Polombo, and Betsy Anderson, National Museum of American Art, Smithsonian Institution, Washington; Margaret Conrads, Nelson-Atkins Museum of Art, Kansas City, Missouri; Daniel Dubois, New Britain Museum of American Art, New Britain, Connecticut; John W. Coffey, North Carolina Museum of Art, Raleigh; Pam Perry, Norton Gallery and School of Art, West Palm Beach, Florida; Linda Bantel, Sylvia Yount, Robin Beckett, Susan James-Godziwki and Elisa Kane, Museum of American Art of the Pennsylvania Academy of the Fine Arts, Philadelphia; Meg Perlman; Gerald L. Peters, Gerald Peters Gallery, Santa Fe, New Mexico; Joseph J. Rishel, Darrell Sewell, Carter Foster, Mike Hammer, and John Ittmann, Philadelphia Museum of Art; Charles Moffett and Joe Holbach, Phillips Collection, Washington; Martha Severins and Jessica F. Nicoll, Portland Art

Museum, Portland, Maine; Allen Rosenbaum and Barbara Ross, Princeton Art Museum, Princeton University, Princeton, New Jersey; Doreen Bolger, Laura Urbanelli, Maureen O'Brien, Anne Slimmon, and Sarah Rehm Roberts, Museum of Art, Rhode Island School of Design; Marie Via, Memorial Art Gallery, University of Rochester, Rochester, New York; Rachel Lewandowski, San Antonio Museum of Art; Marc Simpson, Karen Breuer, and Robert Johnson, Fine Arts Museums of San Francisco; Mrs. R. Scott Schafler; Audrey Schwartz; William J. Harkins, Susan Sheehan Gallery, New York; Karen Merritt, Sheldon Memorial Art Gallery, Lincoln, Nebraska; Anne Seavers and Michael Goodison, Smith College Art Museum, Northampton, Massachusetts; Peter Rathbone and Dara Mitchell, Sotheby's, New York; Ira Spanierman and David Henry, Spanierman Gallery, New York; Ruth Cloudman and Chuck Pittinger, J. B. Speed Art Museum, Louisville, Kentucky; Stephan Goddard, Spencer Art Museum, University of Kansas, Lawrence; Mortimer Spiller; Martha Hoppin and Karen Papineau, Museum of Fine Arts, Springfield, Massachusetts; John Magnee, Ellen Battell Stoeckel Trust; Mary Ellen Perry, Strong Museum, Rochester, New York; Mr. and Mrs. Edward Swenson; D. Scott Atkinson and Jayne Johnson, Terra Museum of American Art, Chicago; Lucia Cassol and Emil Bosshard, Thyssen-Bornemisza Foundation, Lugano, Switzerland; Pat Whitesides, Toledo Museum of Art; C. J. Lambert, Tynemouth Volunteer Life Brigade, Tynemouth, England; Sam Vickers; Katherine Lee, Virginia Museum of Fine Arts, Richmond; Elizabeth Kornhauser and Cheryl Miller Horwitt, Wadsworth Atheneum, Hartford, Connecticut; David Meschutt, West Point Museum, West Point, New York; Brayton Wilbur, Jr.; Joseph Bayou, Wildenstein Gallery, New York; Vivian Patterson, Williams College Museum of Art, Williamstown, Massachusetts; Erving and Joyce Wolf; Susan Strickler, Annette Dixon, and David Atkin, Worcester Art Museum, Worcester, Massachusetts; Helen Cooper, Richard Field, and Lisa Hodermarsky, Yale University Art Gallery, New Haven, Connecticut; and Richard York and Eric Widing, Richard York Gallery, New York.

N. C. Jr. and F. K.

Introduction

This publication does two things that many recent exhibition publications in American art have tended not to do. First, it functions as a catalogue, not a book, which means simply that it is attentive to particular objects of art. Its organization and its rationale are inextricably linked to and shaped by the works that constitute the exhibition it accompanies. And second, it is monographic, not thematic, which means that it is attentive principally to its subject, Winslow Homer and his art. What it endeavors to say about Homer has in large measure been determined by considering him through what he created. Because what he created gathered into its wide embrace so much of nearly every issue and aspect of his times—historical, social, political, intellectual, and, of course, artistic—and revealed so much of his psychological and sexual natures in spite of the barriers he erected to hide and protect them, it is quite simply impossible to view his achievement, and him, in isolation or out of context.

This is the first comprehensive monographic exhibition of Winslow Homer in more than twenty years. The last such gathering, organized by Lloyd Goodrich for the Whitney Museum of American Art in 1973, stood at the end of a tradition of Homer scholarship—to which Goodrich himself was the chief contributor—which in largely synonymous terms regarded Homer as a purely American and purely realist artist, and found little reason to say much more about him. That view of Homer had been challenged a number of years earlier by Albert Ten Eyck Gardner, who pointed out the many French, English, and Japanese influences on Homer. But since Goodrich's exhibition the study of Homer has been even more thoroughly revised and reinvigorated, deepened and enlarged. John Wilmerding's monograph, published the year before it, represented the beginnings of that process. By also considering Homer's work in the larger context of American, European, and Japanese art, and, for the first time, its relationship to photography, he signaled a willingness to examine Homer in different and more subtle terms.

Gordon Hendricks' lengthy and profusely illustrated (but somewhat ramshackle) *The Life and Work of Winslow Homer* of 1979 in some ways continued the process of seeking a new and richer understanding of the artist, but in other ways proposed readings that were, at the very least, idiosyncratic. Hendricks did, however, make extensive use of primary sources—especially letters to and from Homer, and notices and reviews in contemporary newspapers and journals—and also documented more thoroughly Homer's movements than had previous scholars.

Since Hendricks' monograph Homer studies have tended more toward the analytical than the synthetic, with close scrutiny of individual works, objects in specific media, closely related subjects, and series of pictures. Employing a variety of methods, scholars have attempted to disinter precisely the kind of personal and cultural meanings that Homer himself always refused to discuss. A rich interpretative constellation has formed around Homer and his art, one so elastic that it allows a diversity of opinion perhaps unequaled in the study of any American painter. From David Park Curry's investigations of the croquet paintings, to Jules Prown's exploration of unintentional meanings in *The Life Line* and other works, to Albert Boime's examinations of "encoded" racism in *The Gulf Stream*, and many other valuable studies, Homer scholars have identified more precisely the internal and external, conscious and unconscious forces that shaped Homer's art.

At the same time, important documentary work, especially in museum catalogues, has also been accomplished. Exhibition catalogues devoted to specific aspects of Homer's output—such as *Winslow Homer Watercolors* by Helen Cooper, *Winslow Homer's Paintings of the Civil War* by Marc Simpson and others, and *Winslow Homer in the 1890s: Prout's Neck Observed* by Philip Beam and others, to name just three—have shed light on many key works with admirable clarity. Collection

catalogues from major repositories of Homer's art—notably The Metropolitan Museum of Art and the Sterling and Francine Clark Art Institute—have described in detail the history and physical state of individual works. The major project in this regard—the "Lloyd Goodrich and Edith Havens Goodrich, Whitney Museum of American Art, Record of Works by Winslow Homer," under the direction of Abigail Booth Gerdts at the Graduate Center of the City University of New York—will, when completed, provide scholars with a much-needed *catalogue raisonné*, bringing to fruition at long last the work to which Goodrich devoted much of his life. The appearance of this vast material will undoubtedly serve as a fresh catalyst for Homer studies.

The present exhibition and catalogue would not, and indeed could not, have taken shape without benefit of the work that has already been done. At the same time, by gathering works from his entire career and providing a full account of his life, they strive to do what has not been done since Goodrich's 1973 exhibition and Hendricks' 1979 monograph. That is, quite simply, to put Homer back together in a synthetic way and to reaffirm his primacy and centrality in all the questions we want to pose about him and his art, and in all the answers we might offer. We are under no illusions that this in any measure represents a definitive statement on Homer. If anything, it may prove most useful in pointing to new connections and possibilities in considering his art, even if we do not always manage to conclude precisely where they lead.

If the practical limitations of a museum exhibition and a published catalogue did not apply, a great many more works by Homer would have been selected for display and discussion, because over the course of five decades Homer created a truly extraordinary number of superb and compelling prints, drawings, watercolors, and paintings. Nevertheless, every important aspect of Homer's career is addressed: the Civil War paintings, which first attracted public attention; the works of the late 1860s and the 1870s, in which Homer assessed key issues of national life; the heroic, classically formed paintings of the 1880s; the Adirondack watercolors and oils; the colorful watercolors of the Tropics; the monumental Prout's Neck seascapes; and the tragic, almost visionary paintings of his final years. The majority of the works are oils and watercolors, the two mediums that Homer most often used for his exhibited works and through which he most fully expressed his artistic intentions. Still, his work as a draftsman and printmaker is not ignored, for such objects are included in several cases throughout where they particularly shed light on his creative process. Homer was never simply a "realist" artist who constructed his art on a framework received directly from the external world. On the contrary, his practice of recombining and exchanging figures and groups and settings across several mediums, and his lifelong fondness for revising (often through deletions and repainting) the actual appearance of his images in ways that revised their meanings as well, speak of an artist who consciously manipulated his subject matter for greater clarity and profundity. This point is so central to a complete understanding of Homer's art that a separate section in the exhibition has been devoted to examining his working methods. In the catalogue, drawings and other works related to or in some way associated with a specific painting are discussed with the work itself.

Homer once said of his picture *The Gulf Stream*: "Don't let the public poke its nose into my picture." Yet he said this as he sent it off to an exhibition where he knew that it would be, quite literally, on public display. Here we come to the heart of what is most challenging about understanding Homer and his art. Reticent almost to the point of secretiveness about the meanings of his creations, and protective of his privacy almost to the point of reclusiveness, Homer nevertheless did not stop showing himself to the public through his works. If this catalogue and exhibition manage to help explain why he did so and to aid in understanding why his beautiful and moving works are also so profoundly meaningful, then we will have been justified in poking our noses into his pictures after all.

N. C. Jr. and F. K.

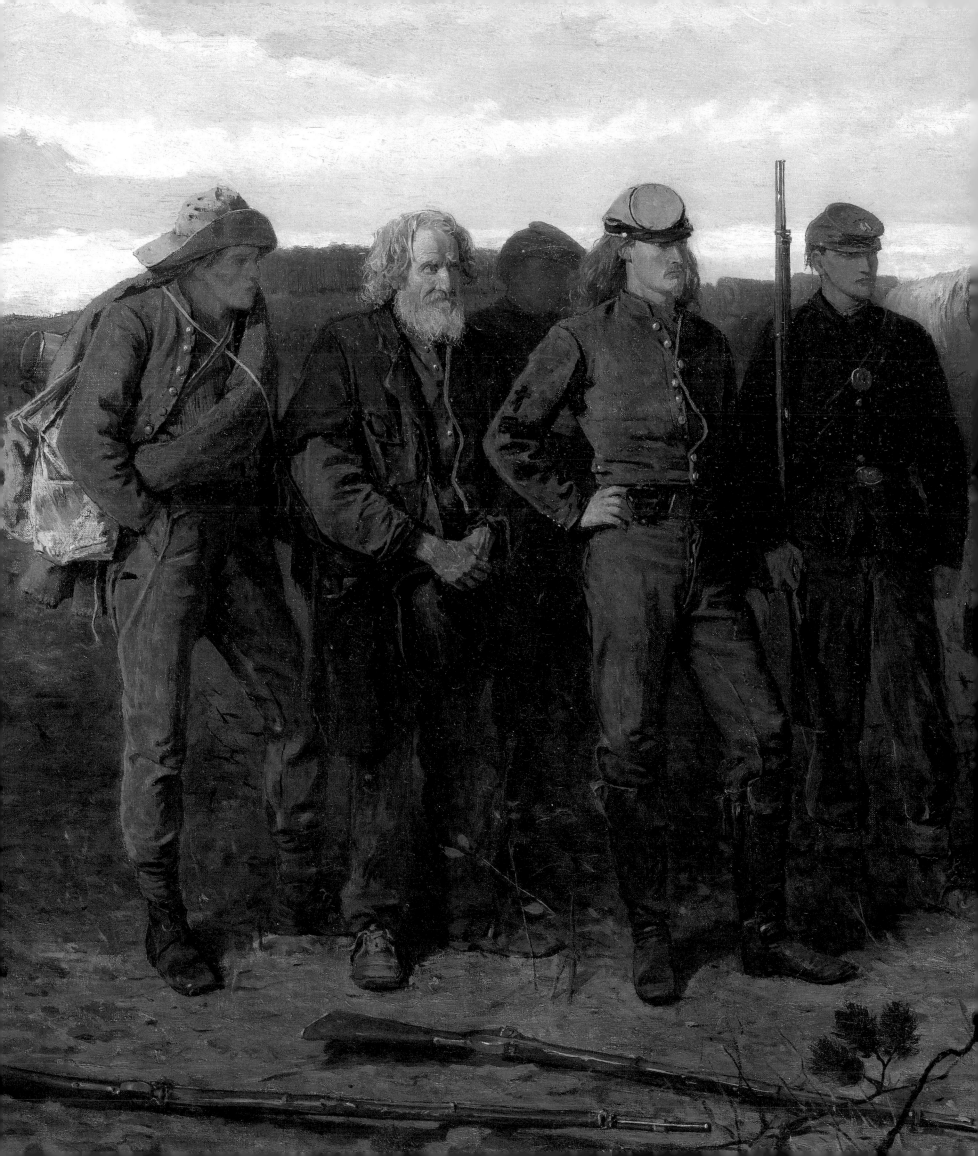

The School of War

Nicolai Cikovsky, Jr.

Winslow Homer was never properly taught to be an artist. He learned to become one, as nineteenth-century Americans often had to do, largely by inventing and improvising for himself. In the 1850s, when he was in his twenties, there were in his native city of Boston no art schools, few exhibitions, and only a small, undistinguished community of artists.[1] In view of the aridity of Boston's artistic culture, it is remarkable that Homer not only determined to become an artist but acted upon that determination to become—by any measure—the greatest America produced in the nineteenth century.

He did not, at the same time, lack advantages and opportunities. His artistic inclinations were nourished by his family, who set standards of professional achievement of which their son Winslow was not the only product; his older brother Charles—Harvard graduate, chemist, and successful businessman—was, in financial terms, even more successful. Their mother, Henrietta Benson Homer, a moderately accomplished painter in watercolor to whom Winslow was deeply attached, was an important influence on him, artistically and otherwise. Despite his fecklessness, his father, Charles Savage Homer, was equally instrumental in his son Winslow's achievement.[2] A business-man—an importer of hardware—he had an artistic streak expressed by a certain stylishness of dress and, in later life, eccentricity of behavior and appearance (fig. 1). He also encouraged his son's "leaning towards art"[3] by acquiring for him, on a business trip to England, such resources for artistic self-help as "a complete set of lithographs by Julian [sic]—representations of heads, ears, noses, eyes, faces, trees, houses, everything that a young draftsman might fancy trying his hand at—and also lithographs of animals by Victor Adam which the son hastened to make profitable use of"[4] (fig. 2). He also arranged for him one of the few opportunities for artistic education that Boston afforded, an apprenticeship with the commercial lithographer John H. Buf-ford (1810–1870), an acquaintance of his.[5]

Although well intended, Homer recollected his two years at Bufford's with deep and undisguised distaste. He described it later as "bondage" and "slavery,"[6] by which he meant working ten hours a day for five dollars a week, and the repression of creative independence and artistic identity that apprenticeship entailed. More than drudgery and exploitation, however, by bondage and slavery he surely meant something more dreadful still: the uninspired dreariness, hopelessness, and lifelong sameness of commercial work—its "treadmill existence," as he called it.[7] That prospect was more acutely appalling, because Homer had an alternative clearly in view: for, knowing that it represented both a different and a higher calling, he had "determined to be an artist."[8]

He declared the force of his determination and the degree of his ambition when, in a Boston picture gallery, he announced, "I am going to paint," and when asked the sort of thing he was going to paint, said confidently (and, it turned out, correctly), pointing to a picture by Edouard Frère (perhaps such as fig. 3), "Something like that, only a damn sight better."[9] Very early on he had an almost sensuous love of paint, at once tactile, ductile, and olfactory, and utterly different from the unappealing hardness and coldness of the lithographic stone (which must be why he hated it so): what he remembered best about a picture gallery, he said, was "the smell of paint; I used to love it in a picture-gallery."[10]

Exactly what Homer learned during his apprenticeship is unknown. The work he produced for Bufford—sheet-music covers and the like (fig. 4)—betrays no discernible signs of individuality or special artistic promise.[11] But in the illustrations he began contributing to magazines such as *Ballou's Pictorial* immediately after his apprenticeship ended in 1857, he appears as a maturely

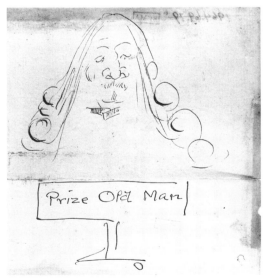

fig. 1. "Prize Old Man" (detail), 1897. Ink. Bowdoin College Museum of Art, Brunswick, Maine, 1964.69.79, Gift of the Homer Family

fig. 2. Bernard-Romain Julien. Lithograph for Léon Cogniet, *Cours de Desin*, Library of Congress

fig. 3. Edouard Frère. *The Cold Day*. Oil on panel. The Walters Art Gallery, Baltimore

accomplished draftsman, capable of producing work completely different in the currency of its subjects from the conventional subject matter (often imitated from earlier models) that he had made for Bufford, more ambitious in the challenging complexity of its compositions, and more perspicuously individual in style. Whether all of this had been pent up during his "bondage" under Bufford, or resulted from what he learned or had been taught by that experience, no matter how unpleasant, is impossible to determine.

When Homer left Bufford's in 1857, at any rate, he was sufficiently confident and accomplished to begin contributing regularly to *Ballou's Pictorial. Ballou's* was one of a number of illustrated magazines that began appearing in America about 1850, which included also *Gleason's Pictorial* (*Ballou's* predecessor in Boston), *Frank Leslie's Illustrated Newspaper,* and the greatest and hardiest of them all, to which Homer would soon be a major contributor, *Harper's Weekly* in New York. *Ballou's* recognized Homer's ability immediately. His first illustration, "Corner of Winter, Washington, and Summer Streets, Boston" (fig. 5), which appeared on the front page of the 13 June 1857 issue—like most of those that followed it at regular intervals for the next year or so—and, like all of Homer's work for *Ballou's,* was credited to him in the accompanying text, usually in the form, "our artist, Mr. Homer."

In 1857 Homer began contributing illustrations to *Harper's Weekly,* and in 1859 he moved to New York to be closer to the publishing houses, like Harper's, that for the next decade and a half would be his most reliable source of income. But with more art, more artists, and more artistic institutions (dealers, collectors, studios, and the National Academy of Design, which offered formal instruction and held annual exhibitions), New York's biggest attraction was that by the middle of the century it had become, without serious rival, America's most vital and stimulating artistic community—and simply, as another Bostonian, Charles Eliot Norton admitted, America's most vibrant city: "This is a wonderful city," Norton wrote his friend James Russell Lowell. "There is a special fitness in the first syllable of its name, for it is essentially New....A few years hence and Boston will be a place of the past, with a good history no doubt, but New York will be alive."[12] By the summer of 1860, when he had taken a studio in "a fortress of art," the New York University Building on Washington Square, Homer situated himself in one of the chief centers of that community.[13]

Homer's move to New York **did not,** in his mind, mark the end of his training and the commencement of his profession**al life. On the cont**rary, in New York he had access to disciplined

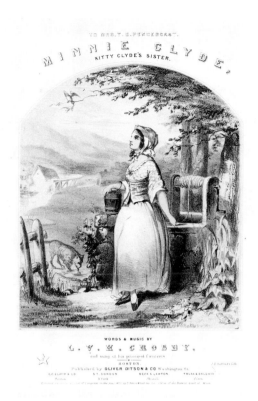

fig. 4. "Minnie Clyde, Kitty Clyde's Sister." Lithograph. The Metropolitan Museum of Art, Harris Brisbane Dick Fund, 1936 (36.51)

academic instruction that was not available in Boston, and his enrollment in the life class of the National Academy of Design in October 1859—a class described by its teacher as "well attended—the order perfect, the improvement good"[14]—shows that he took advantage of that resource soon after he arrived, and again in 1860 and 1863. And in New York, too, Homer learned to be a painter. Sometime early in 1861 he took a month of lessons from Frederick Rondel (a Boston artist whom he may already have known), "who, once a week, on Saturdays, taught him how to handle his brush, set his palette, &c." That summer, following the type of national artistic pedagogy frequently prescribed for American artists, "he bought a tin box containing brushes, colours, oils, and various equipments, and started out into the country to paint from Nature."[15] The orderly, graduated course of study that Homer had apparently embarked upon during his first year or so in New York was derailed by an event that would have the greatest impact on his formation: the Civil War.

The war's effect on him was not immediate. More than six months after it began in April 1861, following the bombardment of Fort Sumter, Homer was hoping to continue his artistic education at an even higher level. Because, as his mother said, "he so desires to go for improvement," in December 1861, she tried to raise money to send him to Europe, and several days later his father indicated the intensity of his son's desire when he wrote emphatically, "Win must go to Europe."[16] But that was not to be. Instead, the war became his school; more than any other experience, it was instrumental in determining what kind of artist Homer became. And when it was over, though Homer had the opportunity to study in Europe, he no longer had the interest or the need. The war called upon Homer's powers of innovation and interpretation in more ways and to a greater degree than more ordinary events and pedagogical procedures would have done. An event less unprecedented, less intensely and inescapably modern, could not have exerted the same challenging demands on his inventiveness and artistic intelligence; an event less historically momentous and nationally traumatic would not have as fully aroused his consciousness and convictions and made of him a moral and political being.

Homer first experienced the war directly in mid-October 1861, when *Harper's Weekly* sent him to the front as a "special artist" to "go with the skirmishers in the next battle," as he wrote his father (and where, his father thought, he had a good chance of being shot).[17] At the time, the Union Army under General McClellan was deployed in the defense of the capital, and the front did not extend much beyond Washington; Homer was in Arlington, Virginia, across the Potomac River.

fig. 5. Charles F. Damoreau, after Winslow Homer. "Corner of Winter, Washington, and Summer Streets, Boston." Wood engraving. In *Ballou's Pictorial*, 13 June 1857

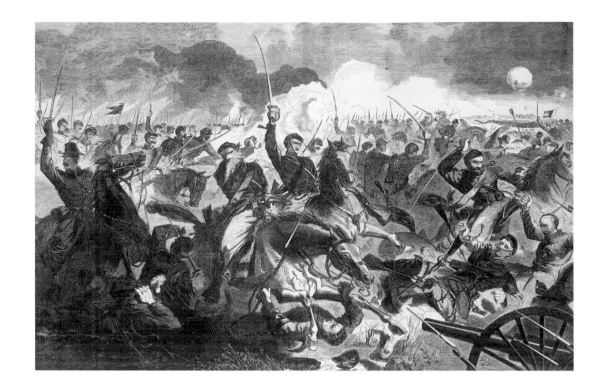

fig. 6. After Winslow Homer. "The War for the Union, 1862—A Cavalry Charge." Wood engraving. In *Harper's Weekly*, 5 July 1862

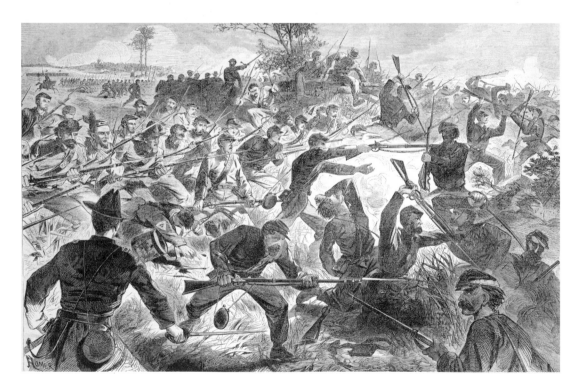

fig. 7. After Winslow Homer. "The War for the Union, 1862 A Bayonet Charge." Wood engraving. In *Harper's Weekly*, 12 July 1862

It was a largely uneventful time in the war, and Homer's first wood engraving, "A Night Reconnaissance," published in *Harper's Weekly* on 26 October 1861, depicts the sort of action he saw—and shows he was in very little danger. His next visit to the front, about six months later, lasted two months. Much or all of that visit was spent with Lieutenant Colonel Francis Channing Barlow of the 61st New York Volunteer Infantry, part of the 2d Corps of the Army of the Potomac at the siege of Yorktown, Virginia. Barlow reported on 18 April that Homer did the cooking and that they had a jolly time: "I have not laughed so much since I left home."[18] When Homer returned to New York, though, his mother gave a very different version of his time at the front: "He suffered much, was without food 3 days at a time & all in camp either died or were carried away with typhoid

fever—plug tobacco & coffee was the Staples....He came home so changed that his best friends did not know him."[19]

Homer's second visit to the front, not surprisingly, opened a floodgate of Civil War subjects. All of his *Harper's Weekly* illustrations for the next two years were war-related or war subjects, and many were based on sketches made at Yorktown. His most prolific year was 1862, with twelve illustrations, and it was pivotal in terms of Homer's understanding of the war, and of both his mode and medium of representing it.

His illustrations were made in a variety of ways. In some, Homer's sketches were translated more or less directly into engravings.[20] In others, his sketches, supplemented by other passages added specifically for the image either by Homer or the engraver, were used to create narratively (though not always stylistically) unified scenes.[21] In still others, Homer's sketches were in effect collaged together, by Homer or the engraver, into composite illustrations.[22] But in the case of two other illustrations that appeared in successive issues of *Harper's Weekly,* "The War for the Union, 1862—A Cavalry Charge" (5 July 1862) and "The War for the Union, 1862—A Bayonet Charge" (12 July 1862) (figs. 6–7), both images appeared to have been wholly invented; they were based not on Homer's sketches or even his own war experiences, but derived instead largely from conventions of military art that originated half a century earlier in the Napoleonic wars and were still alive at mid-century.[23] Finally, and uniquely, there was "The Army of the Potomac—A Sharpshooter on Picket Duty," which appeared in *Harper's Weekly* late in 1862 (15 November), bearing the epochal attribution, "From a Painting by W. Homer, Esq." (fig. 8). This is the first evidence of Homer as a painter, and this engraving is the first of many that would be based upon or directly related to his paintings. As if that were not momentous enough, it is the first evidence also, in both its subject and its form, of Homer's keen intelligence manifested in his suddenly clarified and deepened understanding of the essential modernity of the American Civil War. No pictorial precedent, Homer quickly perceived, could provide an adequate model for its depiction, just as he perceived with the same quickness the difference in its depiction between what was allowed in illustration, and what was allowed in painting. It accounts for the emphatic discontinuity between "Sharpshooter" and everything that preceded it in his work, particularly the two earlier "Army of the Potomac" illustrations. It is the difference between images conceived according to conventional rules of military art and ones that are not; between pictorial modes that are, on one hand, discursive (having the formality, copiousness, and digressiveness of discourse), and, on the other, diges-

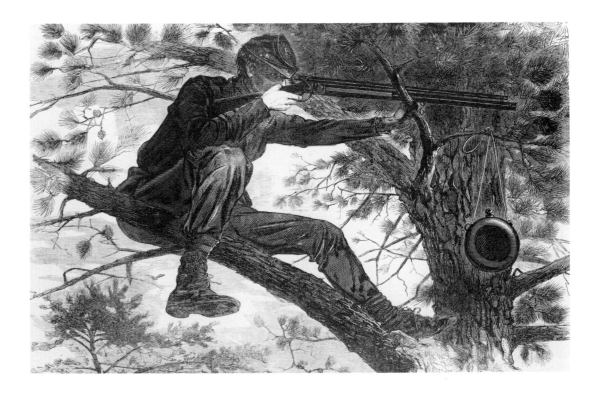

fig. 8. After Winslow Homer. "The Army of the Potomac—A Sharp-shooter on Picket Duty." Wood engraving. In *Harper's Weekly*, 15 November 1862

tive (condensed, summary, synoptic); and between a misunderstanding of the nature of modern warfare (which, at a time when the special nature of that war had not yet fully revealed itself, Homer shared with most Americans, even military ones), and total, almost epiphanically sudden, understanding.

The writer Nathaniel Hawthorne understood the war's special character after the epochal battle between the *Monitor* and *Merrimack* in March 1862. The contest between the two ironclad ships meant the end of naval warfare as it had been known for centuries: "…Old Ironsides and all, and Trafalgar and a thousand other fights became only a memory, never to be acted over again; and thus our brave countrymen come last in the long procession of heroic sailors…whose renown is our native inheritance." And he saw precisely what brought that heroic tradition to its abrupt end: "The Millennium is certainly approaching, because human strife is to be transferred from the heart and personality of man into cunning contrivances of machinery, which by and by will fight out our wars with only the clank and smash of iron.…Such is the tendency of modern improvement."[24] That is precisely what Homer perceived, as registered in the difference between the paraphernalia of heroism in "A Cavalry Charge" and "A Bayonet Charge," and the single figure of the modern sharpshooter that succeeded them just four months later, with its "machinery" of the rifled musket and telescopic sight, the range and accuracy of which made the strife of war unheroically heartless and mechanically impersonal (the writer who described the sharpshooter "California Joe" in 1862 as "one of the best shots and most efficient men in that most efficient and admirable corps, Berdan's Sharpshooters," did so in almost mechanical terms.)[25]

Homer's image of the sharpshooter is all the more forceful and meaningful because of the extraordinary visual and symbolic compactness of its form that makes the subject not an incident or episode of the war, but an emblem of what is essential in and special to it. This emblematic succinctness had appeared in none of Homer's other images of the Civil War, most of which had been assembled from his sketches, so it is as if the peculiar property of this image in the context of Homer's other illustrations was somehow peculiarly the property of the medium in which it alone among them had been conceived, namely, oil paint.

Throughout his life Homer understood the difference between the mediums of art, not in the sense of what was technically possible in each, but in the sense of what was expressively appropriate to them, what meanings each could best convey. Even at this early stage of his career, when his technical arsenal included printmaking and painting, and later when it included the mediums of watercolor and oil, Homer considered oil, on the whole, as the medium most suitable for expressing larger, summary, serious, and symbolic meanings, and less so for more narrative ones. That was not a hard and fast distinction, particularly in his early work. While some of the first paintings he exhibited had narrative subjects that they shared with his prints, others were distinctly more complexly layered and more compactly expressive in meaning.

In 1863, in his professional debut as a painter, Homer sent two paintings to the annual exhibition of the National Academy of Design: *The Last Goose at Yorktown*[26] and *Home, Sweet Home* (cat. 2). It was an auspicious beginning. Both paintings were sold and received abundantly favorable criticism. *Home, Sweet Home* was particularly admired. "[A] strong and assured piece of painting," said the *New York Commercial Advertiser*, which noted Homer's compositional skill and the painting's truth; the picture is "inspired by a fact of to-day, and bears evidence of thought." And, "The picture is a promise of a worthy art future."[27] The *Evening Post* was more lavish and unambiguous in its praise: "Winslow Homer is one of those few young artists who make a decided impression of their power with their very first contributions to the Academy," its critic wrote. "He at this moment wields a better pencil, models better, colors better, than many whom, were it not improper, we could mention as regular contributors to the Academy during the last six years.…The delicacy and strength of emotion which reign throughout [*Home, Sweet Home*] are not surpassed in the whole exhibition."[28] The critic for the *New York Leader* wrote, "Winslow Homer is a new name in the catalogue of the Academy pictures, but—if I may found a judgment from the works from his easel now in the exhibition—one that must do honor to any collection." Of *Home, Sweet Home* he wrote: "There is no clap-trap about it. Whatever of force is in the picture is not the result of trickery, and is not merely surface work, not admitting of examination, but painstaking labor directed by thought."[29] "There is no strained effect in it, no sentimentality," *Harper's Weekly* said, "but a hearty, homely actuality, broadly, freely, and simply worked out."[30]

Home, Sweet Home, the criticism suggests, was the greater of Homer's first two exhibited paintings—executed with more authority and more serious in its meaning. In the painting, two Union soldiers (infantrymen, as the precisely recorded insignia on their caps show) listen as the regimental band in the distance plays "Home, Sweet Home."[31] This happened frequently in the early years of the war as the two armies drilled, feinted, and battled as much with music as anything else. The Union General Nelson Miles, for example, described an occurrence in the valley of the Rappahannock when the two armies were within hailing distance:

Late in the afternoon our bands were accustomed to play the most spirited martial and national airs, as "Columbia," "America," "E Pluribus Unum," "The Star-spangled Banner," etc., to be answered along the Confederate lines by bands playing, with equal enthusiasm, "The Bonny Blue Flag," "Southern Rights," and "Dixie." These demonstrations frequently aroused the hostile sentiments of the two armies, yet the animosity disappeared when at the close some band would strike up that melody which comes nearest the hearts of all true men, "Home, Sweet Home," and every band within hearing would join in that sacred anthem with unbroken accord and enthusiasm.[32]

The painting's title both names the song to which the soldiers are listening and sympathetically evokes the "bitter moment of home-sickness and love-longing" that it inspires in them (with special poignancy in the seated soldier who, it seems, pauses to listen while writing a letter home). If it does so without the sentimentality with which the subject is dangerously fraught, that is because, as one critic put it, delicacy of emotion (sentiment) is balanced by strength—strength of technique and of form; strength of actuality; and, by something apparent in this, one of Homer's earliest paintings, that would ever after be perhaps the most important trait of Homer's creative posture, ironic distance. The title not only names the melody played, it refers also to the soldiers' "home," given in all the domestic details—the small pot on a smoky fire, the tin plate holding a single meager piece of hardtack—with which Homer, who was responsible for the domestic arrangements when in camp with Colonel Barlow, was personally and no doubt painfully familiar (he described himself as a "camp-follower").[33] In its hardship, loneliness, and comfortlessness, this "home" is ironically far, in every way, from "sweet."

Homer's paintings stood out in the Academy exhibition because of their comparatively greater quality—their technical strength and assurance; color, modeling, and drawing; truthfulness; and lack of sentimentality. But they stood out, too, because of the transparent novelty of their subject and form. Landscapes dominated the Academy exhibition as they had done for years, and although it was two full years into the war when the exhibition opened in April 1863, war subjects were still a rarity.[34] Homer's paintings struck a new and different note in two respects: in the comparative candor of their subjects, and, as figure paintings (as virtually all of Homer's early paintings would be), in their conspicuous departure from landscape to which most American artists had an unwavering allegiance. Even among military paintings in that year's exhibition they were distinguished by distinct and surely deliberate innovation. Another war subject in the exhibition, Victor Nehlig's six-foot *Cavalry Charge of Lieutenant Harry B. Hidden* (fig. 9), had "that conventionalized

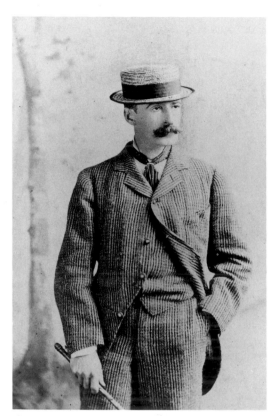

fig 10 Napoleon Sarony. *Portrait of Winslow Homer*, c. 1880. Photograph. Bowdoin College Museum of Art, Brunswick, Maine, 1964.69.179.4, Gift of the Homer Family

kind [of color] generally accepted by French battle painters…muddy and earthy," wrote the *Commercial Advertiser*; but "considered simply as a representation in black and white of a strong episode, [it] is far above anything that has been painted of the war, with the single exception," the writer added tellingly, "of a little work in the small gallery, by Mr. Homer, entitled 'Home, Sweet Home.'"[35]

A fierce independence marked Homer's character virtually from the beginning. It fueled his intense hatred of his apprenticeship, his ambition to paint "a damn sight better" than others, and what not a few of his contemporaries would come to regard as an almost perverse originality and impatience with convention that was from the first stamped on his style. Nothing revealed Homer's independence as clearly as his emergence in his first paintings as a fully formed and clearly marked artist. This was to some degree, perhaps, a matter of contrivance, of a consciously individual stylistic dress worn, so to speak, like his almost dandyish clothes (fig. 10). But it was necessitated more by the special conditions that the representation of the Civil War demanded of anyone who understood what they were and felt bound to conform to them. Homer saw that it was a mechanized war and adjusted his imagery accordingly. And he adjusted it, too, to fit its uniquely American— that is to say, its democratic—character.

It was a war fought by citizen soldiers, a war in which, Walt Whitman said, "the brunt of its labor of death was, to all essential purposes, volunteered";[36] a war fought not for territorial conquest but for the ideals of American democracy and the still new and untested federal Union. The Civil War made traditional martial pageantry—"long lines advancing and manoeuvering, led on by generals in cocked hats and by bands of music," as a contemporary described them—very quickly obsolete.[37] Hence the ordinary individual soldier, in conditions far from heroic and ceremonial, that figured repeatedly, and almost from the first, in Homer's paintings. In 1866, John Burroughs wrote of his friend Walt Whitman's poetry in terms that also apply to Homer's art: "[I]n obedience to the true democratic spirit, which is the spirit of the times, the attention of the poet is not drawn to the army as a unit…but to the private soldier, the man in the ranks, from the farm, the shop, the mill, the mine, still a citizen engaged in the sacred warfare of peace. Always and always the individual, this is the modern doctrine, as opposed to slavery and caste and the results of the feudal world."[38]

Two critics remarked on the thoughtfulness of *Home, Sweet Home*. Although they were probably referring to the care with which it had been painted and its sympathetic subject, this and other of Homer's Civil War paintings are thoughtful because of the discernible presence in them, as a crucial element of their content and quality and as another property of Homer's intellectual awareness, of such "doctrines" as democracy and modernity. Homer's Civil War paintings, as his critics noticed at once, were so much better than any others because they were painted with more skill, perception, and truth, and were invested with conviction that was to a great extent ideological and doctrinal. That is seen most clearly in two paintings made shortly after the end of the war. One, *The Veteran in a New Field* (cat. 8), was painted in the summer of 1865.[39] It depicts a recently disbanded soldier (so recently that his uniform jacket and canteen are thrown aside at the lower right) solemnly absorbed in a canonical event of peace, the harvest.[40] It is a remarkable painting in many ways, and, more than any of those that preceded it, is richly informative about Homer's artistic mentality and procedures. It represents an astonishing formal and expressive change in which, in just two years, Homer moved from the comparative loquaciousness of *Home, Sweet Home* to a terse, emblematic minimalism, a simplicity of statement that would be the pictorial goal for which ever after he always aimed, though he seldom reached it with such purity. And the method by which he often obtained that simplicity, one of refinement by a process of self-critical reductiveness, is first fully apparent in this painting as well. A critic who saw the painting when it was exhibited in the fall of 1865 complained (as many other critics would complain about Homer's style over the next decade or so) about its "slap-dash execution," particularly "in the cornfield and suggested trees," and also that the veteran forgot, "in his four or five years of campaigning, that it is with a cradle and not with a scythe alone, that he should attack standing grain."[41] As we see it today, the painting contains no trees. The critic did not imagine them, however; in an engraving made after the painting in 1867 (fig. 11), branches of a tree are clearly visible in the upper right. And as we see it today also, pigment that has become transparent over time reveals the cradled scythe that Homer deleted before the painting was exhibited. In two important ways, in other words, Homer changed his painting by removing things originally present in it, in one case soon after completing it in

1865, and in the other some time after 1867 but before his death about fifty years later (it hung in his studio in its present state at the time of his death). This process of reconsideration and emendation is characteristic of Homer's artistic method (or, to the extent that it was a consequence of his largely improvised training and his inability because of it to compose except, in effect, by trial and error, his lack of it). The usual formal result, as is radically the case in *The Veteran in a New Field*, is simplification. But the reductive dismantling of pictorial parts diminishes and even defeats the completeness and conclusiveness of narrative, which depends more or less directly upon visual incident and factual detail, as it is present, for example, in *Home, Sweet Home.* The usual result of that retreat from narrative explicitness is, in turn, a rich ambiguity or terse symbolism.

The Veteran in a New Field is the clearest example, certainly the earliest, of this revisionary process. It is the first painting in which Homer deliberately undid what he knew to be literally—or merely—true in favor of a larger meaning expressed by symbolic distillation. Homer knew just as well as his critic did that by the 1860s a cradled scythe would have been used to harvest a large field of grain; that, after all, is what he originally depicted. But he saw, or soon concluded, that the image of the harvesting veteran could express something very much greater if he did not insist on that fact of agricultural technology: by the single-bladed scythe he made the veteran into a symbol of Death the reaper. And, by invoking an image that reminds us that the veteran peacefully harvesting grain was not very long before, in a familiar metaphor of war, a harvester of men, Homer charges his painting with vibrancies of meaning that fact alone could not possibly convey.

The painting in its revised form resounds with other references as well. One is to the famous text from Isaiah 2:4: "they shall beat their swords into plowshares, and their spears into pruning hooks." Another is to the republican *exemplum*, particularly popular in republican America, of the legendary Cincinnatus who left his farm to assume the dictatorship of Rome and fight against its enemies, and, that accomplished, relinquished power and office to return to the occupations of peace and private life. Both were cited in the summer of 1865, when Homer was painting the *Veteran*, at a time when the issue of the peaceful disbandment of the large volunteer army was disturbingly unsettled: "Rome took her great man from the plow, and made him a dictator—we must now take our soldiers from the camp and make them farmers," *The New York Weekly Tribune* wrote. "We know that thousands upon thousands of our brave soldiers will return gladly to the pruning-hooks and plowshares."[42] Two years later, the text that accompanied the engraving of *The Veteran in a New Field* in *Frank Leslie's Illustrated Newspaper* drew the political lesson of disbandment: "One of the most conclusive evidences of the strength of a republican form of government is the way

fig. 11. After Winslow Homer. "The Veteran in a New Field." Wood engraving. In *Frank Leslie's Illustrated Newspaper*, 13 July 1867

in which our army has disbanded, each man seeking again the sphere of usefulness which he left only temporarily, to aid the government in its need." That "veterans returned to the old fields, or sought new ones, [is] one of the surest proofs of our political system."[43] Walt Whitman put it most eloquently: "The peaceful and harmonious disbanding of the armies in the summer of 1865," he wrote, was one of the "immortal proofs of democracy, unequall'd in all the history of the past."[44] In the summer of 1865, Homer painted the emblem of that great proof of democracy.

There is yet another level of meaning in this remarkable painting. Nothing touched Northern Americans as profoundly in the summer of 1865, when it was painted, as the assassination of Abraham Lincoln on 15 April; they were plunged into national mourning and moved to universal expressions of grief. Homer shared it: *The Veteran in a New Field* is his elegy on the death of Lincoln. By mimicking the reaper as Death, he invokes such biblical associations as Isaiah's "flesh is grass" (40:6) and Job's "[man] cometh forth like a flower and is cut down" (14:1–2). The latter was a passage that inspired images for, and was often used as an epigraph on, American funerary monuments, just as sheaves of wheat functioned as symbolic devices, and actual sheaves of wheat were placed on coffins before interment. Altogether, by its form and its inescapable biblical and funerary references, it is a moving lamentation on the death of Lincoln, cut down like mown grain by an assassin's bullet.

The Veteran in a New Field is a purposely symbolic painting. Homer changed the cradled to a single-bladed scythe for one reason only: not to make his painting more beautiful or more truthful (just the reverse), but to make it symbolic. In no earlier painting by Homer, indeed in no other painting by him at all, is it quite as certain that Homer made a symbol; and in no other, because of the transparency of the paint, can one see him making it. At almost the beginning of his career as a painter, therefore, Homer had the intention and the intelligence to speak in a pictorially symbolic language. Not every painting by him that followed *The Veteran* was as richly symbolic, or even symbolic at all; few, after all, were made in such momentous circumstances. But Homer's capacity, at the threshold of his career, to invent symbols and manipulate complicated symbolic meanings, and to engage with the events and culture of his time, signifies the operation of an acutely keen consciousness, and in its ideological and political dimensions, a developed conscience as well. Any account of his artistic mentality and practice must reckon with them, all the more as it has not been customary to regard Homer's intellectual and moral equipment as significant aspects of his artistic enterprise.

Prisoners from the Front (cat. 10), painted the year following *The Veteran in a New Field*, is yet another painting in which these properties are visibly at work.[45] To contemporary viewers, *Prisoners from the Front* was Homer's greatest work and the one that established his reputation; it became for at least a decade the benchmark of his achievement—a level of attainment that many critics believed he failed again to reach. No other Civil War painting assessed its causes and character as compactly, comprehensively, and compellingly, and with such analytical intelligence. It depicts a Union officer receiving a group of three Confederate prisoners. The Union officer is (now) General Francis Channing Barlow, whom Homer had visited at the front early in the war, and almost surely (though it is not documented) again in 1864, when he found subjects for this and such other paintings as *Skirmish in the Wilderness* and *Defiance: Inviting a Shot Before Petersburg* (cats. 4–5). One of Barlow's most celebrated accomplishments was the capture, by the 1st Division of the 2d Corps of the Army of the Potomac under his command, of a division of Confederate soldiers and two generals at the battle of Spotsylvania in 1864. Described as "perhaps the most brilliant single feat of the war," it made Barlow "one of the most conspicuous soldiers of the war—one of its most heroic and romantic figures."[46] That is the event to which *Prisoners from the Front* refers, although it does not precisely depict it. To the extent that it alludes to a celebrated event that occurred two years earlier, it is a history painting. But Homer's historical vision is not bound to a single event. It is larger, more epic, "A truly Homeric reminiscence of the war," one writer said.[47] As the critic for the *New York Evening Post* put it (he was Homer's friend, Eugene Benson, whose interpretation of the painting may have been clarified by Homer), the figures are "representative and at the same time local types of men," and he went on to explain what they represented and typified: "On one side the hard, firm-faced New England man, without bluster, and with the dignity of a life animated by principle, confronting the audacious, reckless, impudent young Virginian...; next to him the poor, bewildered old man,...scarcely able to realize the new order of things about to sweep

away the associations of his life; back of him the 'poor white,' stupid, stolid, helpless, yielding to the magnetism of superior natures and incapable of resisting authority."[48] It is precisely in these contrasts between dignity and audacity, principle and impudence, and in the irreconcilable difference, expressed by physical distance, between caste and culture that the meaning of the painting and its interpretive sweep lie. Homer's interpretation makes no pretense at impartiality—it is "frankly expressive of the elements in our Southern society that fomented and fed the rebellion against a beneficent and unaggressive Government," Benson wrote[49]—and *Prisoners* is in its way every bit as ideological, as much inhabited by political belief, as *The Veteran* had been: Barlow is as much a symbol of republican virtue as the nameless veteran, and the painting as much in its way a deliberately formed "proof" of democracy.

What Homer did in his earliest art he did not, despite his individuality, do entirely alone. He was intellectually stimulated and emotionally charged by an artistic climate in New York during the war years that was almost as passionate, partisan, and even political, as the climate of the war itself. "Our painters have worked in the midst of great events, and therefore subjected to the most tumultuous, shattering and ennobling experiences," a critic wrote in 1865,[50] and never before in America had artistic positions been as clearly drawn, as militantly held, or as acrimoniously debated as they were in New York in the 1860s: "Discussion is the necessity of our times," a critic wrote in 1866, and he described the contentiousness of its pitch and tone as a "battle."[51] Others used words such as "strife" and "stress" and "struggle" to describe the antagonism of this climate. And in 1866, indicating its range and force and inescapability, a critic wrote that "it is almost impossible to maintain a position of lofty neutrality."[52]

The city was divided into two hostile artistic camps. One, organized in 1863 as the Association for the Advancement of Truth in Art and composed of the American followers of John Ruskin and the English Pre-Raphaelite painters, insisted on truth to nature enacted stylistically (though they would insist that truth was not a matter merely of style) by rigorously detailed imitation. The association published its own organ, *The New Path*, the title an indication of its revisionary mission, in which it savagely attacked artistic falsity whenever it was found, which was often and almost everywhere. But the reach and volume of its voice was made all the greater because Clarence Cook, president of the association and editor of *The New Path*, was also the undisguisedly partisan art critic of one of New York's most important newspapers, the *Tribune*.[53] The other camp, less stridently militant and less highly organized, showed in the artists it included and the critics friendly to them and to their cause an artistic affiliation with modern French art, and on the whole practiced a broadly painted style that aimed for deeper and more allusive forms of truth.

However violently they disagreed, the two groups had one essential thing in common: each was alarmed by what they perceived to be the inertial complacency and anemic if not sclerotic condition of American art in the early 1860s, and each, with a sense of urgency made acute by the crisis of the Civil War, dedicated itself to a policy of artistic renovation and reform. By about 1860, landscape painting—its subjects codified, its style formularized, its institutional power (centered on the National Academy of Design) almost absolute—was deeply entrenched as the official form of American art. Nothing indicated that as clearly as the overwhelming numbers of landscapes, to the exclusion of nearly every other subject, in annual exhibitions of the Academy— "myriad of summer days,...cool green lanes that wind in and out; and groves of trees; so vivid and distinct do these stand out that one listens with uplifted ear, half expecting to hear the susurrus and murmur of the boughling pines, or the shivering of the maples that bend to the soft south wind," as *The Scientific American*, with a touch of sarcasm, described the preponderance of landscape subjects in the 1863 exhibition.[54]

For the American Pre-Raphaelites, themselves mostly landscape painters, the quarrel with official landscape was principally about what they considered to be its untruthful mannerisms and conventionality of style. But for the others it went deeper, to the fundamental inadequacy of landscape painting to address human values, particularly at a time when the unprecedented butchery of the war and emancipation at once threatened and redeemed those values, and in both cases made them of special concern. In the most penetrating examination of American art written during the war, *The Art-Idea*, published in 1864, James Jackson Jarves delivered one of the first challenges to landscape. "[I]t is the French school that mainly determines the character of our growing art," he wrote, and the chief evidence of it "is shown in the development of a taste for something beside

landscape." Because of their descriptive literalness of style, Jarves believed, American landscapes were especially "divested of human association. 'No admittance' for the spirit of man is written all over them." But thanks to what he termed the "incitement" of French art, "the dawn of a respectable school of *genre* and home painting is nigh at hand" as an alternative to its moral muteness.[55] While "Imperialism in France will not permit art to become the language of social and political hopes and aspirations," there was no reason, Jarves believed, "why the art of democratic America shall not," all the more so at a time when the war ("the present struggle of the powers of light against the powers of darkness") forced a "wider view of the duties of humanity…to the surface of men's conscience."[56] Jarves' was not a solitary voice. Others in the 1860s recognized that landscape was incapable of expressing the "duties of humanity." "Painting," a critic in the *New York World* wrote in 1865, "especially in America, has so tended of late years toward a pantheistic worship of inanimate things, that we are anxiously on the watch for the coming man who shall 'rehabilitate' human life."[57] Two years later, the *World*'s critic wrote, "As we live in the age, not of Wordsworth, but of Browning, we may properly give precedence to the painters of men and women over the painters of poultry and sweet peas, of mountains and of waves." The reformation of American art —"a new life and movement among our painters"—was, he said, "more likely to be found in the direction of humanity than in the direction of sands and shores and desert wildernesses."[58] "Is there nothing but landscape to be painted?" the critic for the *New York Tribune* asked with exasperation in 1869. "Does not social life offer subjects for the easel?"[59] And a writer in *The Independent* wrote, "[L]andscapes without figures can never be regarded as much higher than decorative art."[60]

Nor was Jarves alone in seeking genre and home painters capable of addressing in "a language of social and political hopes and aspirations"—though no one put that ideological requirement quite as plainly as he did—"human associations" and the "duties of humanity." Someone else who did was Benson (see Chronology 1866). Benson was an artist who exhibited regularly in the 1860s, but he was also, writing under the *nom de plume* of "Sordello" (taken from Browning to show, perhaps, that he was on the side of humanity, not of Wordsworth and landscape),[61] the art critic of the *New York Evening Post* and a prolific essayist.[62] In those capacities Benson was an important and insistent critical voice in New York in the 1860s. In writing approvingly of "the modern or democratic form of art [that depicts] the actual life of men and women in the nineteenth century,"[63] of "The gospel of modern art as it must be developed in America,…free from tradition, [and] based wholly on the common life of the democratic man, who develops his own being on a free soil, and in the midst of a vast country," and, perhaps borrowing the term from Jarves, of "the idea of producing purely American pictures from home subjects alone,"[64] Benson's critical views were clearly congruent with those of Jarves. Like him, he recognized that in American art in the 1860s, the issue of moment, unique to America, was its adjustment to democratic society. Like Jarves, Benson was an admirer of French art and, more aggressively than Jarves, took its side against the American Pre-Raphaelites, inspired by English art and art theory, in the artistic debate of the 1860s.[65]

What makes Benson especially significant is that he was Homer's friend, apparently a rather close one, in the 1860s.[66] That is particularly important because when it came to speaking about his ideas and ideals, of art or anything else, Homer was the most reticent of men. But if it was true, as it was said in 1866 (possibly by Benson himself), that "their thoughts…glided one into the other,"[67] then in Benson's thoughts, perhaps, one can get glimpses of Homer's.

If so, it is possible to think some things about Homer that it would be impossible to do with the same assurance otherwise. It is possible to think, for example, that he shared Benson's (and Jarves') preference for French art well before he went to France in 1866. And if Benson was correct in saying of *Veteran in a New Field* that its style was "an effective protest against a belittling and ignoble manner in art" and "a sign of that large, simple and expressive style which has made the names of Couture and Millet…so justly honored," we may know not only what sort of French art Homer preferred, but what he preferred in it, namely, its largeness of style—"the touch, the sweep, the dash of the brush," Benson said, without which "No man can be called a great painter."[68] But also by that preference aligning himself against the "belittling" manner of Pre-Raphaelitism, he took sides, as Benson did, in the artistic controversy of the 1860s.[69]

Benson preferred the older art of Thomas Couture and Jean-François Millet (as well as the still older art of Théodore Géricault and Eugène Delacroix) to that of such recent French artists

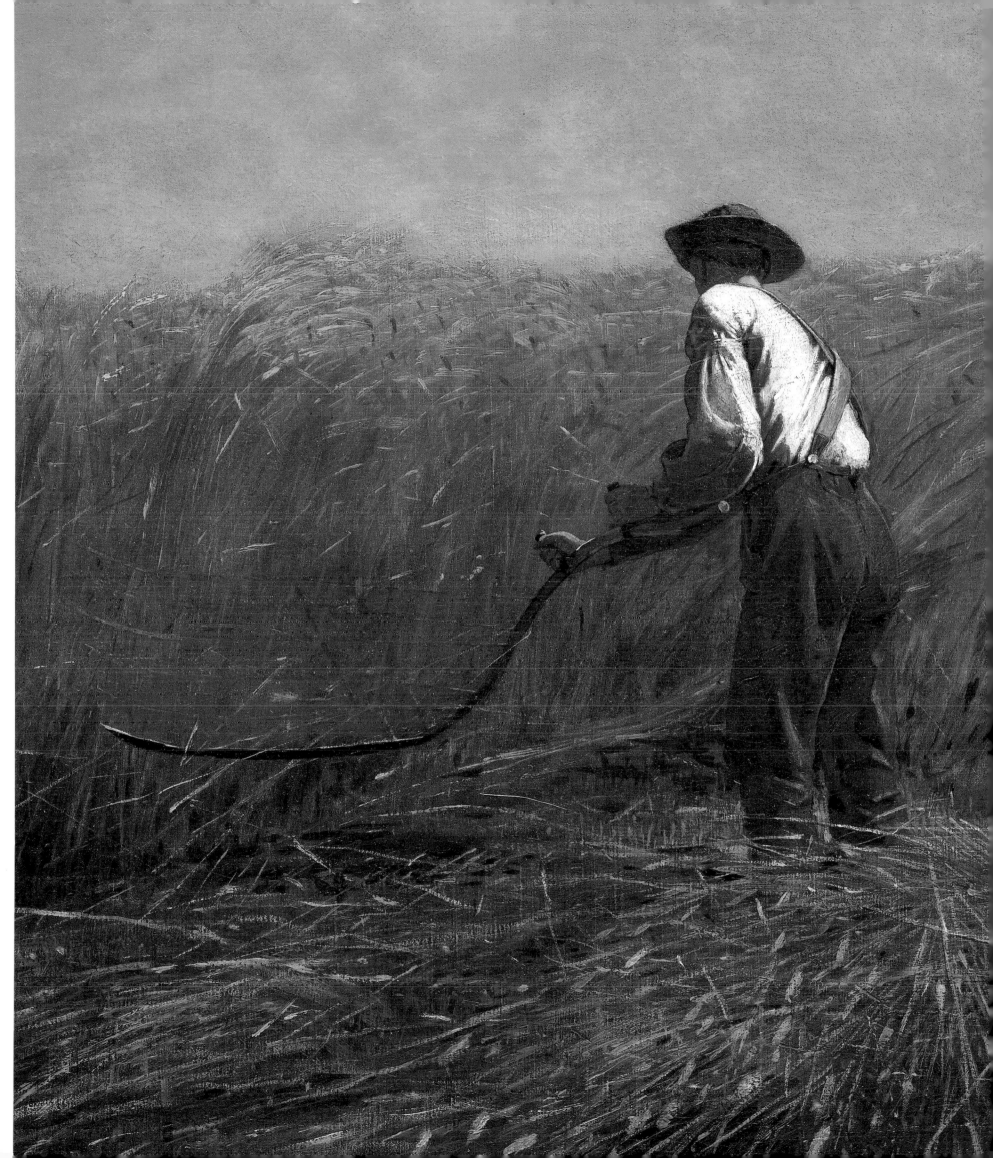

fig. 12. Heliog Boussod, after Jean-François Millet. *La Bruleuse d'Herbes*. Musée du Louvre, Paris

many others. As Benson said at the end of the decade, "we have nourished, if we have not satiated ourselves with…the unstinted importation of our best picture dealers…and, without crossing the ocean, have been able to see the elegant and correct and spirited work of men who are masters of the best methods of painting."[87] None of it, however, registered on Homer's art, even in the early stages of its development when, like any young artist and especially one, like Homer, who largely taught himself, he would have been most sensitive and susceptible to outside influence. Nothing in the character of his style or the nature of his subject matter requires one to suppose that the influence of other art or other artists affected either. This may result from an almost innate independence—toward the end of his life it was said of him, with his endorsement, that "He works… in utter independence of schools and masters"[88]—but however strongly Homer was temperamentally disposed to such stylistic independence, it could only have been fortified in the 1860s by the policies of artistic reform that Jarves and particularly Benson called for, policies that encouraged precisely such a position of independence in American artists.

The most severe test of that position was direct experience of European art and culture. For approximately the first decade of his artistic life it was not, though more by circumstance than desire, a test Homer had to face. But on the 5th of December 1866, Homer sailed for France. Two of his Civil War paintings, *Prisoners from the Front* and *The Bright Side* (cats. 10, 6), were among the paintings chosen to represent, as his two paintings were chosen deliberately to show, the newly restored, reaffirmed, and reconstituted United States in the 1867 Universal Exposition in Paris, and, almost as though he needed it as a pretext or an excuse, he made that the occasion for a long-deferred trip to Europe.

It was generally understood that he was going to France "for further study and improvement."[89] One critic was "sorry to hear it," because, as he explained, "although [his work] may well be improved in many respects by study and residence abroad, it is much more likely to be injured. Mr. Homer can trust himself further than most of our young painters, but the mere fact of his desiring to go to France and study shows that he will put himself under the influence of surroundings and teachings of which we have a great dread";[90] another said he "has gone to Paris, where, we are sure, he did not need to go."[91] And still another, putting a better face on it by hoping that he would continue to depict in Europe "national and distinctive costume" as he had done in America with "volunteers' uniforms and young ladies' dresses and hats, in Virginia camps and among New England hills," told by the nature of his hope how deeply, by the time Homer went abroad, he had become implicated in that aspect of the nationalist project of "home painting."[92]

Although people believed—perhaps because they were led to believe it by Homer, who may have believed it himself until he got there—that he was going to France to study, there is no indication that he did. Nor is there evidence, either, that he had any particular curiosity about current developments in French art. In 1867, he not only could have seen the art at the Universal Exposition, he surely would have seen it if only because his own work was represented in it. He also could have seen the special exhibitions that Gustave Courbet and Edouard Manet erected just outside the exposition grounds, as well as the Japanese art included in the exposition and visible elsewhere in Paris, and even something, perhaps, of the early impressionist paintings of Claude Monet and others.[93] It has seemed unthinkable to a number of scholars that Homer could be in France and not be profoundly influenced by that experience; Albert Ten Eyck Gardner, who argued the case for it most strenuously, thought it was improbable that Homer "would be able to spend such a long time in the center of the art world and yet remain completely blind to and completely unaffected by the exciting new currents of the day."[94] But it is not improbable at all. Homer, as usual, said nothing about what he saw or did in France. But another American artist, Homer's younger contemporary Thomas Eakins, who also went to Paris in 1866, who spent a great deal longer in France than Homer did, who studied there as Homer did not, and who spoke French as Homer also did not,[95] wrote detailed letters to his family in Philadelphia, in which he said nothing whatsoever about Courbet, Manet, impressionism, Japanese art, or any other "new currents of the day" that Gardner and those of like mind believed were irresistible to young American artists.[96] And when, in 1877, the much younger American artist, J. Alden Weir, actually went to an impressionist exhibition, he said "it was worse than the Chamber of Horrors" and left with a headache after fifteen minutes.[97]

In Homer's art, what is more, there is no apparent evidence of any lasting perturbation of influ-

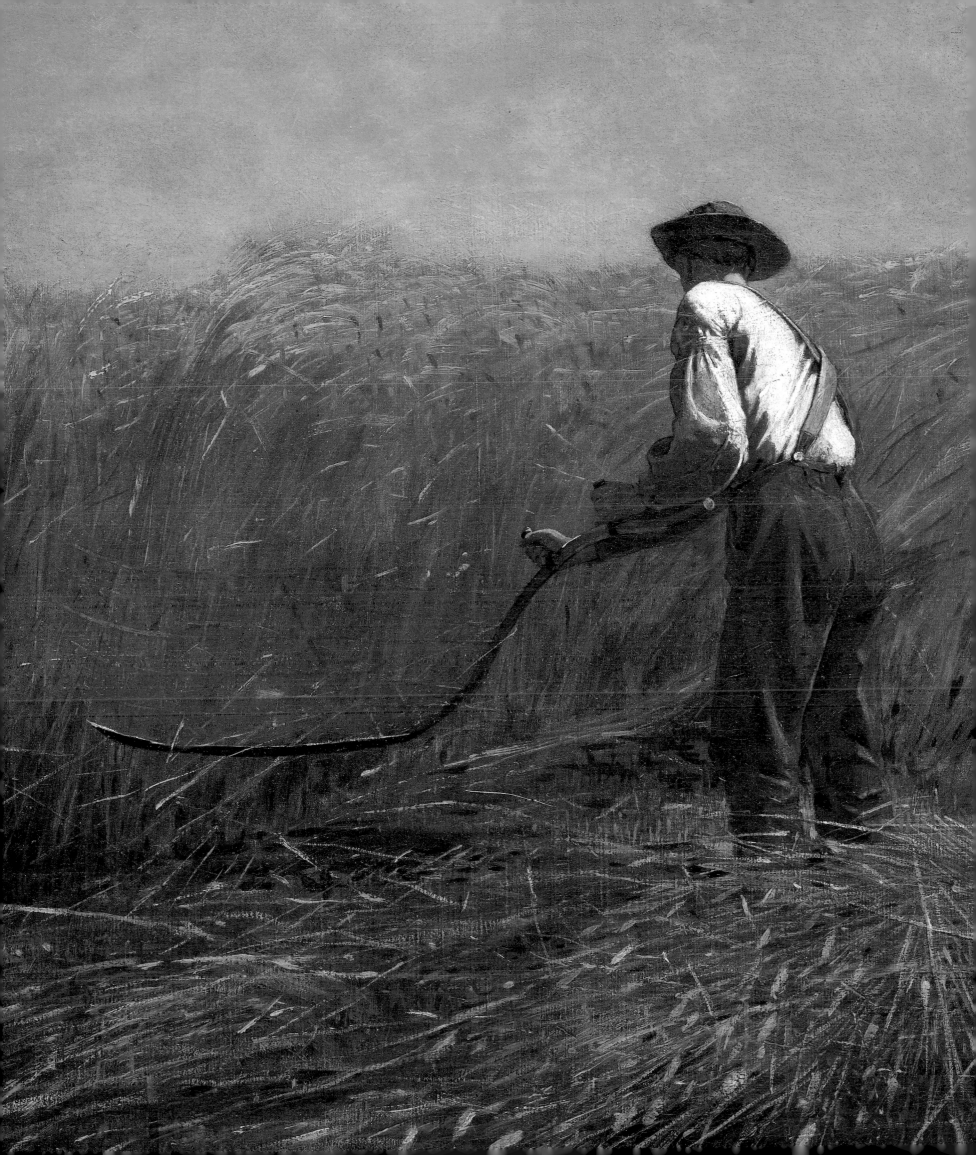

as Gérôme, Meissonier, or Baugniet, because of what he believed—and what he expressed often with affective and affecting rhetoric—was a deep and passionate commitment to the moral and political ideals of its time that newer French art conspicuously lacked. Delacroix, who dedicated his art "to the suffering of humanity," "was the artistic child of modern France, and he represented the passionate aspiration and the unformed spirit of his time. Like France itself, he dared to love ideas and hoped to realize ideals."[70] Benson wished that Thomas Couture might come to America because here he could express, as he could not in imperial France, "the great principles of republican liberty."[71] But the artists of the Second Empire—the likes of Gérôme, Meissonier, Cabanel, Baudry, and Hamon—"illustrate art detached from the moral,—the artistic emancipated from ideas of morality and ideas of democracy."[72]

Exactly what of this Homer might have shared or sympathized with is not known, but it is intensely interesting to suppose that moral and political questions such as these were, perhaps vehemently, aired in Homer's presence, and solicited and even compelled his consent. And pictures like *Veteran in a New Field* and *Prisoners from the Front*, painted just at the time he and Benson were closest, suggest by their clear concern for the "facts of his own epoch" (for which, Benson believed, Meissonier had no concern), and by the dimensions of political meaning and moral attitude they seem evidently and deliberately to contain, that some of it, to put it more passively than may be necessary, rubbed off on Homer.

Homer might also have been more than a passive participant in the program for American art that Benson outlined (but never more than that) in his critical writings. He did, in any event, exemplify for Benson the essential principles of that program: that American art should depict subjects from American life, and do so in a visibly American language of style. In *Prisoners from the Front*, Benson wrote, Homer enacted "the idea of producing purely American pictures from home subjects alone."[73] And as one of those American painters cited by Benson "who would rather stutter in a language of their own that admits of great development than impose upon themselves the fetters of what is acquired and foreign," he enacted for Benson the essential properties of a national style.[74]

Style was one of the most important issues in the artistic controversy of the 1860s, raised by it, indeed, to a level of conscious consideration and concern that it had not held before in America. Nothing separated the two artistic camps more decisively and divisively than the issue of stylistic allegiance, to English art on one side, and to French on the other. More important, however, was the subtle and sophisticated matter of what style in itself, considered separately from the subjects or objects it was employed to depict, could be understood to mean and to express. That was implicit, of course, in what allegiances of style signified with such divisive effect. For the Pre-Raphaelites, stylistic affiliation was not a matter of taste or of influence, and most definitely not a matter of habit or convention, but a deliberate, principled choice heavily weighted with moral responsibility.[75] For Benson, too, style could in itself be so articulate a "means of expression" that he thought and spoke of it as "language."[76] And, for Benson, one of the things the language of style could—indeed, more imperatively, should—contain and express, however stutteringly, as he said, was nationality.

Homer's style was virtually from the beginning of his career consistently the subject of critical scrutiny and of comments that concerned not only its technical merit but its expressive effectiveness. In 1863, one critic admired the "strength and boldness in execution" of *Home, Sweet Home*, and another said it was "broadly, freely, and simply worked out." Still another said the paintings he saw in Homer's studio were "strong and broad."[77] But by 1864, assuming the tone and attitude that the criticism of Homer's style would routinely take for more than a decade, a writer for *The Round Table*, rather than commending its breadth and strength, complained about the "roughness of execution" and "want of delicate painting" in the *Brierwood Pipe* in the annual Academy exhibition;[78] two years later a critic said of *Pitching Quoits* (cat. 7) in the Academy exhibition that Homer "lacks refinement of color and expression and is a little rude in his execution,"[79] and another, of *Veteran in a New Field*, that it is "a very insufficient and headlong piece of work."[80] Again and again Homer's style was criticized in this way, by those who otherwise—and it is important to stress this, because it indicates that their quarrel was with his style and not with other aspects of his work—generally admired and often lavishly praised Homer's paintings, as did the critics both of the *Veteran* and *Pitching Quoits*.[81]

It may well be that the roughness, rudeness, and incompleteness of Homer's style, particularly in his earliest paintings, was a matter of technical inadequacy, and the reflection in that respect of Homer's lack of rigorous training as a painter. Even so, there is little to show that he heeded his critics, or that greater experience made him more accomplished in their eyes: his paintings of the 1870s were for all intents and purposes as rough, rude, and incomplete as his first ones had been. It is possible that something else, therefore, something more positive than mere technical inadequacy, was actively and purposely at work in the formation of Homer's style. And his like-minded friend Benson may have indicated what it was. For it is possible, in view of their closeness, and in the larger view, too, of the agitation for discernible nationality of subject matter and style that was a central thrust of the artistic debate of the 1860s that Homer could not escape, and of the special awareness it gave to the expressive and ideological properties of style, that that awareness, that consciousness, more than technical incapacity, determined the character of Homer's style. When Benson spoke of American artists "stuttering in a language of their own" free from what was "foreign and acquired," Homer was one of the artists he had in mind, just as, by the same token, the roughness, rudeness, and incompleteness of Homer's style, a manner from which no amount of well-intended critical advice or outright censure could deflect him, was the deliberate enactment on his part of that national stylistic stuttering.

Someone else who conceived that possibility beyond any doubt was the poet Walt Whitman. Whitman deliberately fashioned a similarly rough and incomplete poetic language as a mode of national literary style. His own description of it—in, to locate it ideologically, *Democratic Vistas* (1871)—as a style not "correct, regular, familiar with precedents, made for matters of outside propriety, fine words, thoughts definitely told out," but a style rather that "tallies life and character, and seldomer tells a thing than suggests it," could serve as well as a description of Homer's (national and democratic) style. Like Whitman, Homer rejected artistic precedent, propriety, correctness, and fineness, and instead of objects and their compositional arrangements being "definitely told out" in his paintings, Homer purposely kept an openness and suggestiveness of form to "tally" the shifting, unresolved, and perhaps never resolvable configurations of American national life, or as Benson described it, "the hybrid and half-developed but virile civilization of our own land."[82] If it is somehow difficult to imagine Homer as a close reader of Whitman,[83] it is not unthinkable that he knew of his example and might have taken him at least as a model. And Benson—who knew of Whitman and what he represented, and who, in the late 1860s when the desirability of a national literature was, like national art, a subject of public discussion, was even associated directly with Whitman as one of those "persons who declare that they crave a literature that shall be truly American"—could have served as his interpreter.[84] Writers who "would face and report the myriad life of this most complicated age,...who aim to express life, who are most modern," Benson wrote in 1866, in language much like Whitman's and as applicable, too, to a description of Homer's artistic posture, "are flexible, varied, individual, independent...."[85]

The simplest prescription for obtaining a national style was what Jarves, borrowing a term from American nativist politics, called "art-knownothingism." "There is a set of men among us," he wrote, "who talk loftily of the independent, indigenous growth of American art; of its freedom of obligation to the rest of the world;...of the spoiling of those minds whose instincts prompt them to study art where it is best understood and most worthily followed," that is, in Europe.[86] Benson, who wrote that American artists should avoid "the fetters of what is acquired and foreign," was apparently of that set. And so, apparently, although he did not talk about it loftily or in any other way, was Homer. For what is remarkable about Homer's early art is how very little it resembles the work of any other artist, American or foreign.

That is not because he could not know the work of other artists. There was no shortage of art to be seen in New York; on the contrary, during Homer's formative years it was richer in that resource than it had ever been before. In addition to the work of American artists that could be seen in studios, galleries, and annual exhibitions of the National Academy of Design, there was in the 1860s an unprecedented amount of foreign art to be seen as well. At picture dealers, in auctions, exhibitions, and a number of private collections, and frequently discussed in the press, was the work, often very recent, of every important European artist of the time (as the time itself reckoned their importance): Bonheur, Bouguereau, Breton, Corot, Couture, Daubigny, Decamps, Delaroche, Detaille, Diaz, Dupré, Frère, Gérôme, Meissonier, Millet, Rousseau, Troyon, and

fig. 12. Heliog Boussod, after Jean-François Millet. *La Bruleuse d'Herbes*. Musée du Louvre, Paris

many others. As Benson said at the end of the decade, "we have nourished, if we have not satiated ourselves with...the unstinted importation of our best picture dealers...and, without crossing the ocean, have been able to see the elegant and correct and spirited work of men who are masters of the best methods of painting."[87] None of it, however, registered on Homer's art, even in the early stages of its development when, like any young artist and especially one, like Homer, who largely taught himself, he would have been most sensitive and susceptible to outside influence. Nothing in the character of his style or the nature of his subject matter requires one to suppose that the influence of other art or other artists affected either. This may result from an almost innate independence—toward the end of his life it was said of him, with his endorsement, that "He works... in utter independence of schools and masters"[88]—but however strongly Homer was temperamentally disposed to such stylistic independence, it could only have been fortified in the 1860s by the policies of artistic reform that Jarves and particularly Benson called for, policies that encouraged precisely such a position of independence in American artists.

The most severe test of that position was direct experience of European art and culture. For approximately the first decade of his artistic life it was not, though more by circumstance than desire, a test Homer had to face. But on the 5th of December 1866, Homer sailed for France. Two of his Civil War paintings, *Prisoners from the Front* and *The Bright Side* (cats. 10, 6), were among the paintings chosen to represent, as his two paintings were chosen deliberately to show, the newly restored, reaffirmed, and reconstituted United States in the 1867 Universal Exposition in Paris, and, almost as though he needed it as a pretext or an excuse, he made that the occasion for a long-deferred trip to Europe.

It was generally understood that he was going to France "for further study and improvement."[89] One critic was "sorry to hear it," because, as he explained, "although [his work] may well be improved in many respects by study and residence abroad, it is much more likely to be injured. Mr. Homer can trust himself further than most of our young painters, but the mere fact of his desiring to go to France and study shows that he will put himself under the influence of surroundings and teachings of which we have a great dread";[90] another said he "has gone to Paris, where, we are sure, he did not need to go."[91] And still another, putting a better face on it by hoping that he would continue to depict in Europe "national and distinctive costume" as he had done in America with "volunteers' uniforms and young ladies' dresses and hats, in Virginia camps and among New England hills," told by the nature of his hope how deeply, by the time Homer went abroad, he had become implicated in that aspect of the nationalist project of "home painting."[92]

Although people believed—perhaps because they were led to believe it by Homer, who may have believed it himself until he got there—that he was going to France to study, there is no indication that he did. Nor is there evidence, either, that he had any particular curiosity about current developments in French art. In 1867, he not only could have seen the art at the Universal Exposition, he surely would have seen it if only because his own work was represented in it. He also could have seen the special exhibitions that Gustave Courbet and Edouard Manet erected just outside the exposition grounds, as well as the Japanese art included in the exposition and visible elsewhere in Paris, and even something, perhaps, of the early impressionist paintings of Claude Monet and others.[93] It has seemed unthinkable to a number of scholars that Homer could be in France and not be profoundly influenced by that experience; Albert Ten Eyck Gardner, who argued the case for it most strenuously, thought it was improbable that Homer "would be able to spend such a long time in the center of the art world and yet remain completely blind to and completely unaffected by the exciting new currents of the day."[94] But it is not improbable at all. Homer, as usual, said nothing about what he saw or did in France. But another American artist, Homer's younger contemporary Thomas Eakins, who also went to Paris in 1866, who spent a great deal longer in France than Homer did, who studied there as Homer did not, and who spoke French as Homer also did not,[95] wrote detailed letters to his family in Philadelphia, in which he said nothing whatsoever about Courbet, Manet, impressionism, Japanese art, or any other "new currents of the day" that Gardner and those of like mind believed were irresistible to young American artists.[96] And when, in 1877, the much younger American artist, J. Alden Weir, actually went to an impressionist exhibition, he said "it was worse than the Chamber of Horrors" and left with a headache after fifteen minutes.[97]

In Homer's art, what is more, there is no apparent evidence of any lasting perturbation of influ-

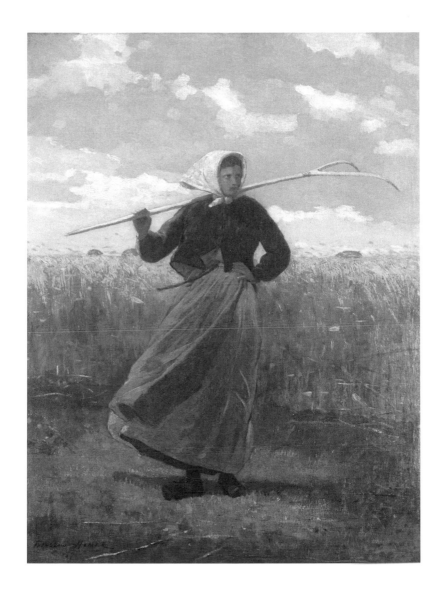

LEFT: fig. 13. *Girl with Pitchfork*, 1867. Oil on canvas.
The Phillips Collection, Washington, D.C.

RIGHT: fig. 14. *The Return of the Gleaner*, 1867. Oil on canvas.
Courtesy of the Strong Museum, Rochester, New York

ence—"lasting" because in the paintings he made in France, of which there are very few and all
of them small, one influence can easily be seen. It is not the influence of Courbet, Manet, impres-
sionism, or Japan, however, but of the kind of French art that Homer seems already to have
known and to have been affiliated with (at least by Benson) in America and which he surely would
have seen in France at the Universal Exposition, where it was heavily represented and highly hon-
ored (and where Benson admired it): the older art of the Barbizon school, "the profound and sim-
ple pictures of Francoise [sic] Millet,…the landscapes of Corot, Rousseau, Daubigney [sic], and
Dupres [sic]," as Benson wrote from Paris.[98] There is no mistaking the presence of the "profound
and simple" rural classicism of Jean-François Millet (fig. 12) in Homer's French paintings (fig. 13)
—but, perhaps more significantly, little trace of it in his later American ones.[99]

In 1869 Benson wrote a story called "Substance and Shadow," published in *Putnam's Magazine*,
that may contain a description of Homer in France. If it does, it describes an artist of such unwa-
vering certainty of conviction that he could easily remain undeflected by the temptations of influ-
ence. Benson subtitled his story "A Fantasy," but it is too flavored with reality to be an invention.
In it he described an American artist friend named Lawrence, who, like Homer, was visiting France
at the same time as Benson. The author visited Lawrence in the country, at a place that could
easily be the village of Cernay-la-Ville, in Picardy (a well-established artists' colony near Paris
almost as popular as Barbizon, though not as celebrated), where Homer lived and painted most
of his French pictures. Benson told how Lawrence was "hopeful about painting a certain peasant-
girl he had noticed raking hay," which was a subject Homer painted more than once (figs. 13–14).
Lawrence, who like Homer was a man of few words, "used his eyes, his feet, and his hands," Ben-

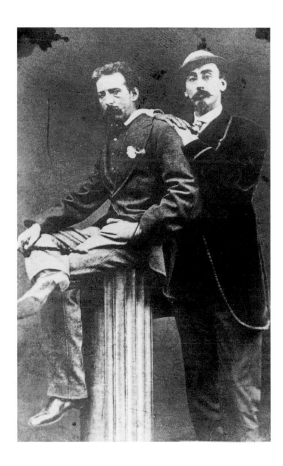

son wrote. "I respected him as I respected the Multiplication Table, in which there was no shadow of uncertainty or any possibility of caprice."[100]

One sign of French influence on Homer, it has been said, is the greater freshness and brilliance of light in paintings done after his trip to France than in those done before it (cats. 20, 27), a change that allegedly resulted from Homer's acquaintance in France with the impressionist practice of painting out-of-doors in natural light. Whether or not there is any such difference between his pre-European and post-European work may be a barely arguable point. What is not arguable is that Homer was painting out-of-doors well before he went to France, and, indeed, from virtually the beginning of his career as a painter: "If you wish to see him work you must go out upon the roof [of the University Building] and find him painting what he sees," the critic George Arnold reported in April 1865, and those of his early paintings set out-of-doors are, as the result of that practice, Arnold wrote, "warm with the glory of God's sunshine."[101]

The long and short of it is that we know almost nothing about what Homer did in France, either from what he himself said or from the unimpeachable evidence of his art. He painted very little in France (only nineteen paintings are known, all of them small, and some of them at least finished in America after his return).[102] And if French art influenced Homer, it was the influence of the Barbizon school, and chiefly of Millet, that he surely already knew before he went to France. He did visit the art colony of Cernay-la-Ville, but the subjects of the engravings he designed for *Harper's Weekly* in 1867 and 1868, to which may be added the *Gargoyles of Notre Dame* (private collection), trace a path through Paris that is more the conventional one of a tourist than of an alert and inquisitive artist: they depict the Grand Galerie of the Louvre, and dancing at the Mabile and the Casino, all standard tourist sites—and all illustrated a few years later in James D. McCabe's guidebook, *Paris by Sunlight and Gaslight*.[103] The photograph taken in Paris of Homer and his friend Albert Kelsey (fig. 15) is an almost ageless image of two American tourists abroad. And most telling of all, with the exception of a few French subjects that Homer completed and exhibited in America during the first several months after his return (probably because he did not have the time or the materials to paint American ones), he continued without divergence, and almost even with a vengeance, on the artistic course he had embarked upon before he left.

NOTES

1. The series of letters published in the *Boston Evening Transcript* in January, February, and March 1855 that debated questions of the education and proper subject of the American artist is, in its conventionality, symptomatic of the tenor of artistic life in Boston. It is notable also for being one of the few discussions of artistic matters in the city's leading newspaper.

2. See Beam 1947, 51–74.

3. Sheldon 1879, 26.

4. Bernard-Romain Julien (1802–1871), lithographs for Léon Cogniet's *Cours de Desin*, and Victor Adam (1801–1867), lithographic studies for animals. Both were published by about 1850. I am grateful to Judy Walsh for sharing this information, which she was the first to gather.

5. See David Tatham, *John Henry Bufford: American Lithographer* (Worcester, 1976). Tatham described Bufford's shop as "the barebones equivalent of a school of art" (p. 47).

6. Sheldon 1878, 226.

7. Sheldon 1878, 226.

8. Sheldon 1878, 226.

9. Goodrich 1944a, 6.

10. Sheldon 1878, 225.

11. *Pace* Wilmerding 1972, 28, who sees signs of development and individuality in Homer's lithographic work.

12. In 1864 James Jackson Jarves wrote, "Owing to the concentration of our most promising artists at New York, it has grown to be the representative of America in art, and indeed for the present so overshadows all others that we should be justified in speaking of American painting, in its present stage, as the New York school, in the same light that the school of Paris represents the art of France" (*The Art-Idea* [Boston and New York, 1864], 218). Norton to Lowell, quoted in Eric Homberger, *The Historical Atlas of New York City* (New York, 1994), 90.

13. "The already-venerable New-York University, a castellated edifice fronting on Washington Park, has become, by some strange chance, quite a fortress of art. A considerable force, with mahl-stick for spear, *palette* for shield, paint-tube for cartridge, and easel for scaling-ladder, must have taken the northern wing of the building by assault, in some unguarded hour" ("Studios of American Artists. Third Sketch," *The Home Journal*, 16 February 1856).

14. Thomas S. Cummings, *Historic Annals of the National Academy of Design* (New York, 1865), 276. The class usually began in October and lasted until March.

15. Sheldon 1878, 227. In 1855, Asher B. Durand advised aspiring American artists to "go first to Nature to learn to paint landscapes..." ("Letters on Landscape Painting," *The Crayon* 1 [3 January 1855], 2). About 1850, the landscape painters Sanford Gifford, Jasper Cropsey, and David Johnson all learned to paint by going directly to nature, as Durand would recommend.

16. Letters to Arthur Patch Homer, 17 December 1861 and 1 January 1862, quoted in Hendricks 1979, 45, 46.

17. Hendricks 1979, 43, 45, 46. Permission to pass "within the line of main guards one week" was granted on 15 October 1861. On 21 October he was with his family in Belmont, Massachusetts, for Thanksgiving. Sally Mills, "A Chronology of Homer's Early Career, 1859–1866," in Simpson et al. 1988, 18–19.

18. Letter to Edward Barlow, 18 April 1862, in Tatham 1979b, 87. Hendricks 1979 said Barlow was "a distant relative" of Homer's, but without providing any evidence of such a relationship.

19. Letter to Arthur Benson Homer, 7 June 1862, in Hendricks 1979, 50.

20. As in "The Union Cavalry and Artillery Starting in Pursuit of the Rebels Up the Yorktown Turnpike" and "Charge of the First Massachusetts Regiment on a Rebel Rifle Pit Near Yorktown," both published in *Harper's Weekly* (17 May 1862).

21. As in "Christmas Boxes in Camp—Christmas 1861," *Harper's Weekly* (4 January 1862) and "The Surgeon at Work at the Rear During an Engagement," *Harper's Weekly* (12 July 1862).

22. As in "News from the War," *Harper's Weekly* (14 June 1862) and "Our Women and the War," *Harper's Weekly* (6 September 1862).

23. "An Elaborate and Artistic Illustration of the Famous and Decisive Battle of Waterloo, Fought on the 18th of June, 1815," for example, appeared as a double-page illustration in *Gleason's Pictorial and Drawing Room Companion*, published in Boston, on 11 December 1852. Emanuel Leutze's painting *Washington Rallying the Troops at Monmouth*, 1853–1854 (University Art Museum, University of California at Berkeley), applies the Napoleonic mode to an American historical subject (and is very close in conception to Homer's "Cavalry Charge"). Victor Nehlig's *Cavalry Charge of Lieutenant Hidden*, c. 1862 (New-York Historical Society), applied it to a Civil War subject (fig. 9).

24. "Chiefly About War Matters. By a Peaceable Man," *Atlantic Monthly* 10 (July 1862), 59. Of the *Monitor*, Hawthorne wrote, "All the pomp and splendor of naval warfare are gone by. Henceforth there must come up a race of enginemen and smoke-blackened cannoneers...; and even heroism—so deadly a gripe [sic] is Science laying on our noble possibilities—will become a quality of very minor importance..." (pp. 57–58). The *Monitor*, he wrote, "could not be called a vessel at all; it was a machine..." (p. 58).

25. "California Joe," *Harper's Weekly* 6 (2 August 1862), 492.

26. See Simpson et al. 1988, 136.

27. "Proteus," "Thirty-Eighth Exhibition of the National Academy of Design. Third Article," *New York Commercial Advertiser*, 24 April 1863.

28. "The National Academy of Design. Its Thirty-Eighth Annual Exhibition. Fifth Article," *New York Evening Post*, 12 June 1863.

29. "Atticus," "Art Feuilleton," *New York Leader*, 9 May 1863.

30. "The Lounger. The National Academy of Design," *Harper's Weekly* 7 (2 May 1863), 274.

31. Nelson A. Miles, *Serving the Republic* (New York, 1911), 50. John R. Thompson's poem, "Music in Camp," is also set on the Rappahannock, and describes a similar event:

> The sad, slow stream, its noiseless flood
> Poured o'er the glistening pebbles;
> All silent now the Yankees stood,
> All silent stood the Rebels.
>
> No unresponsive soul had heard
> That plaintive note's appealing
> So deeply 'Home, Sweet Home' had stirred
> The hidden founts of feeling.

In *Bugle Echoes: A Collection of the Poetry of the Civil War, Northern and Southern*, ed. Francis Fisher Browne (New York, 1886).

32. *New York Evening Post*, 12 June 1863.

33. Letter to George G. Briggs, 19 February 1896 (Archives of American Art).

34. And as they still were a year later: "One of the most remarkable circumstances connected with the existing war is the very remote and trifling influence it seems to have exerted upon American art" ("Art. Painting and the War," *The Round Table* 2 [23 July 1864], 90).

35. *New York Commercial Advertiser,* 24 April 1863.

36. *Democratic Vistas* (1871), *The Portable Walt Whitman,* ed. Mark Van Doren (New York, 1977), 332.

37. *Meade's Headquarters 1863–1865. Letters of Colonel Theodore Lyman, from the Wilderness to Appomattox,* ed. George R. Agassiz (Boston, 1922), letter of 8 May 1863, 101.

38. "Walt Whitman and his 'Drum Taps,'" *The Galaxy* 2 (1 December 1866), 611.

39. See Wilson 1985b, 3–27, and Cikovsky, "A Harvest of Death," in Simpson et al. 1988, 82–101.

40. It was the subject of George Inness' *Peace and Plenty,* 1865 (Metropolitan Museum of Art), by which he celebrated the end of the war.

41. "Fine Arts. The Sixth Annual Exhibition of the Artists' Fund Society," *The Nation* 1 (23 November 1865), 663–664.

42. The *New York Weekly Tribune,* 30 September 1865.

43. *Frank Leslie's Illustrated Newspaper* 24 (13 July 1867), 268.

44. "National Uprising and Volunteering," in *Specimen Days* (1881), *Portable Walt Whitman,* 406.

45. For which see Cikovsky 1977, 155–172, and Lucretia Giese, "Prisoners from the Front: An American History Painting," in Simpson et al. 1988, 64–81.

46. "General F. C. Barlow," *Harper's Weekly* 8 (9 July 1864); "The Union Candidates. Gen. Barlow's Military Career," *The New York Times,* 23 September 1865.

47. "National Academy of Design. Forty-first Annual Exhibition," *The Independent* 18 (26 April 1866), 4.

48. *New York Evening Post,* 28 April 1866. At the beginning of the war, Nathaniel Hawthorne witnessed a similarly composed group of prisoners, and made a remarkably similar analysis of it: "There was only one figure in the least military among all these twenty prisoners of war,—a man with a dark, intelligent, moustached face, wearing a shabby cotton uniform, which he had contrived to arrange with a degree of soldierly smartness, though it had evidently borne the brunt of a very filthy campaign. He stood erect, and talked freely with those who addressed him....Almost to a man, [the other prisoners] were simple, bumpkin-like fellows, dressed in homespun clothes, with faces singularly vacant in meaning....They were peasants, and of a very low order;...It is my belief that not a single bumpkin of them all (the moustached soldier always excepted) had the remotest comprehension of what they had been fighting for..." ("Chiefly About War Matters," 54–55).

49. "Historical Art in the United States," *Appleton's Journal* 1 (10 April 1869), 46.

50. "Sordello" [Eugene Benson], "National Academy of Design. Fortieth Annual Exhibition," *New York Evening Post,* 3 May 1865. For more on Benson and Homer, see below.

51. "A First Look at the Academy," *The Round Table* 3 (21 April 1866), 249.

52. "Editor's Easy Chair," *Harper's Monthly Magazine* 32 (March 1866), 521.

53. See Linda S. Ferber and William H. Gerdts, *The New Path: Ruskin and the American Pre-Raphaelites* [exh. cat., The Brooklyn Museum] (Brooklyn, 1985); and Susan P.

Casteras, *English Pre-Raphaelitism and Its Reception in America in the Nineteenth Century* (Rutherford, N.J., 1990), chapter 7.

54. "The Annual Exhibition of the Academy of Design," *Scientific American* 8 (20 June 1863), 394.

55. *Art-Idea,* 217, 220, 231. Jarves' list of the "foibles" of American landscape painting included "slipshod work, repetition, impatient execution, and an undue self-estimate, arising from want of competitive comparison with better-instructed men" (p. 232). Writing in 1864, George Arnold believed that "The so-called 'genre' school of art has, within the last few years, really taken root in America," and in its number he included Eastman Johnson, William J. Hennessy, George C. Lambdin, Eugene Benson, and Homer ("The Fine Arts," *New York Leader,* 16 April 1864).

56. *Art-Idea,* 257.

57. "The National Academy of Design," *New York World,* 16 May 1865.

58. "National Academy of Design," *New York World,* 30 April 1867.

59. "Fine Arts. Third Winter Exhibition at the National Academy," *New York Tribune,* 20 November 1869.

60. *The Independent* 18 (26 April 1866), 4.

61. An American edition of Browning's *Sordello, Strafford, Christmas-eve and Easter-day* was published in Boston in 1864.

62. In addition to exhibition and literary reviews for the *New York Evening Post,* Benson was a frequent contributor to such publications as *The Galaxy, Putnam's Magazine, Appleton's Journal,* and *Atlantic Monthly.* For them, he wrote on the writers Swinburne, Hawthorne, Poe, Thoreau, Gautier; the critics Hamerton and Fromentin; the artists Millet, Gérôme, Vernet, Baugniet, Meissonier, Bouguereau, Rubens, Rembrandt, Steen, Mulready, Asher B. Durand, Eastman Johnson, and George Boughton; and on such topics as the Woman Question, Dress and Women, Paris and the Parisians, Historical Art in the United States, Pictures in the Private Galleries of New York, and even (for the *Evening Post*) on Charles Baudelaire on Hashish-Eating.

63. "Modern French Painting," *Atlantic Monthly* 22 (July 1868), 95.

64. "Modern French Painting," 91.

65. He did so out of taste and principle, but very likely too because he suffered from criticism in *The New Path:* his painting, *The Autumn Walk,* in the Artists' Fund Society Exhibition of 1863, it wrote, in a rather mild specimen of its critical tone, "is painted by a man who believes nothing in particular, and who therefore imitates coarsely and ignorantly the last thing that appears to take the public fancy....Mr. Benson's stock in trade as an artist consists in a weak vein of sentiment, and a still weaker way of expressing it" ("The Artists' Fund Society, Fourth Annual Exhibition," *The New Path* 1 [December 1863], 96–97). That would account for the bitterness of Benson's description of the American Pre-Raphaelites as "maggots that have crawled out of the literary body of John Ruskin" ("A New Art Critic," *Atlantic Monthly* 16 [September 1865], 325), and for his painting entitled *Coming Tears* that was a parody, "being as well painted as a parody need to be," on a picture called *Gone! Gone!* by one of the most important American Pre-Raphaelite artists in the 1860s, Thomas Charles Farrer ("Fine Arts. Peremptory Sale at Auction of Pictures—the Collections of Mr. Sheppard Gandy and of Mr. G. Talbot Olyphant," *New York Daily Tribune,* 24 March 1875. For Farrer and his painting, see exh. cat. Brooklyn, 1985, color pl. 6, cat. 8, and 154. Benson's parodic painting is unlocated).

66. Benson was Homer's somewhat younger contemporary. In the 1860s they both had studios in the University Building, they both studied at the life class at the National Academy of Design, and in 1866 they had a joint exhibition of their work (which Homer never did with anyone else) before going (separately) to France. In the *New York Evening Post*, it was said of this exhibition (perhaps by Benson, who was the paper's pseudonymous art critic) that "Each has learned through years of friendly intercourse something from the other....A something, you scarce know what, in their pictures show that they have painted side by side, and reveal to you that they are friends." As late as 1873, their paths by then having separated, Benson still wished Homer could see a recently completed picture of his, and he did not hesitate to think of asking Homer for help with a Boston picture dealer (Eugene Benson to John F. Weir, Rome, 20 March 1873. John F. Weir Papers, Archives of American Art).

67. "Interesting Exhibition," *New York Evening Post*, 16 November 1866.

68. "Jean Léon Gérôme," *The Galaxy* 1 (August 1866), 586. Another of Homer's friends in the 1860s, the painter and decorator John La Farge, whose allegiance was also French, traced the "foundation" of Homer's "independent talent" and "thoroughly American system of painting" to French influence. *The Higher Life in Art: A Series of Lectures on the Barbizon School of France Inaugurating the Scammon Course at the Art Institute of Chicago* (New York, 1908), 142.

69. "American and Foreign Art. Pictures at the Artists' Fund Exhibition," *New York Evening Post*, 23 November 1865.

70. "Modern French Painting," 89; "Jean Léon Gérôme," 581.

71. "Fine Arts," *New York Evening Post*, 7 October 1867.

72. "Modern French Painting," 89–90.

73. "Fine Arts," *New York Evening Post*, 17 May 1869.

74. "National Academy of Design," *New York Evening Post*, 12 May 1865.

75. They were described as "fanatics" "who protested the want of conscience and proclaimed the necessity of truth" (*The Round Table* 3 [21 April 1866], 249).

76. *New York Evening Post*, 12 May 1865.

77. *New York Leader*, 9 May 1863; *Harper's Weekly* 7 (2 May 1863), 274; "Proteus," "Art Intelligence. Artists' Studios," *New York Commercial Advertiser*, 11 November 1863.

78. "Art Exhibition of the National Academy of Design," *The Round Table* 1 (7 May 1863), 327.

79. "Proteus," "National Academy of Design. Fortieth Annual Exhibition," *New York Commercial Advertiser*, 22 May 1865.

80. *The Nation* 1 (23 November 1865), 663. In 1866, *The Nation*'s critic said three of Homer's pictures at Avery's gallery were all "very sketchy, rapidly painted in the 'broadest' manner, and we are sorry to see Mr. Homer's work always so slap-dash" ("Fine Arts. Pictures Elsewhere," *The Nation* 3 [15 November 1866], 395).

81. When the *Veteran* was in a sale in 1866, *The Nation*'s critic said it was an "admirable" painting and hoped it would bring the enormous amount of a thousand dollars ("Fine Arts. The Seventh Annual Exhibition of the Artists' Fund Society of New York. II.," *The Nation* 3 [22 November 1866], 416).

82. "Literature and the People," *The Galaxy* 3 (15 April 1867), 871.

83. It would not have been difficult to read him: editions of *Leaves of Grass* were published in 1860 and 1867; *Drum Taps* in 1865; and "Democracy" and "Personalism," parts of Whitman's most important work after *Leaves of Grass*,

Democratic Vistas, appeared in *The Galaxy* in 1867 and 1868—a periodical to which Homer contributed illustrations in 1868.

84. "Literature Truly American," *The Nation* 6 (2 January 1868), 7. For other discussions of national literature, see John DeForest, "The Great American Novel," *The Nation* 6 (9 January 1868), 27–29, and Thomas Wentworth Higginson, "Americanism in Literature [1870]," *Atlantic Essays* (Boston, 1871). For Benson on Whitman, see "Democratic Deities," *The Galaxy* 6 (November 1868), 663.

85. "About the Literary Spirit," *The Galaxy* 1 (15 July 1866), 492. Benson's examples, however, were European, not American: George Sand, Hugo, Carlyle, and Heine.

86. *Art-Idea*, 197.

87. "Pictures in the Private Galleries of New York. I. Galleries of Belmont and Blodgett," *Putnam's Magazine* 5 (May 1870), 534.

88. *Catalogue of the Private Art Collection of Thomas B. Clarke of New York*, part 1 (New York, 1899), 63. When asked for a statement about himself, it was the one Homer recommended.

89. "Fine Arts," *New York Herald*, 18 November 1866.

90. *The Nation* 3 (22 November 1866), 416.

91. "The National Academy of Design," *New York Tribune*, 9 May 1867.

92. "Fine Arts. Pictures on Exhibition," *The Nation* 4 (7 February 1867), 114.

93. A recent, thorough discussion of this episode is Adams 1990b, 61–89.

94. Gardner 1961, 90.

95. He needed the help of an English-French phrase book, A. Bolmar's *A Collection of Colloquial Phrases* (Philadelphia, 1865), which he must have acquired shortly before going abroad. See Tatham 1977, 97.

96. See Kathleen A. Foster and Cheryl Leibold, *Writing About Eakins. The Manuscripts in Charles Bregler's Thomas Eakins Collection* (Philadelphia, 1989), 189–210.

97. Letter to his parents, Paris, 15 April 1877, in Dorothy Weir Young, *The Life and Letters of J. Alden Weir* (New Haven, 1960), 123.

98. "Art at the Paris Exhibition," *New York Evening Post*, 5 November 1867. Benson, who visited Millet in his studio in Barbizon in November 1867, said on that occasion, "We had been interested in Millet for several years back, and his pictures at the great Exhibition...had much increased our enthusiastic appreciation of his remarkable genius" ("Francois [sic] Millet, the Peasant Painter. Visit to His Studio," *New York Evening Post*, 7 December 1867).

99. Unless a relationship to Millet's etching *Le départ pour le travail* (1863) helps to explain Homer's enigmatic *Answering the Horn* of 1876 (fig. 113, Muskegon Museum of Art).

100. "Substance and Shadow—A Fantasy," *Putnam's Magazine* 3 (February 1869), 172, 173.

101. "The Academy Exhibition," *New York Leader*, 30 April 1864.

102. See the "Checklist of the Paintings Homer Made in France, 1867. Compiled by Lloyd Goodrich," in Adams 1990b, 82–83. He "just completed a picture of French peasant life which he called 'The Lark,'" the *New York Evening Express* reported about two months after Homer returned from France (George Arnold, *New York Leader*, "Art Matters," 26 February 1868).

103. James D. McCabe, *Paris by Sunlight and Gaslight* (Philadelphia, 1869).

1

In addition to its title, the caption of the wood engraving *The Army of the Potomac—A Sharp-Shooter on Picket Duty,* published in *Harper's Weekly* on 15 November 1862, also read, *From a Painting by W. Homer Esq.* (fig. 8). After Homer's death, his friend Roswell Shurtleff recalled that it was "His very first picture in oils," and that he "sat with him many days while he worked on it" in his studio in the University Building.[1] The painting itself was not exhibited until January 1864 at the Atheneum Club in New York (when it was described as "a very characteristic picture"),[2] and the following month at a benefit exhibition for the Brooklyn and Long Island Fair (on that occasion described as "a striking, truthful picture, the most interesting, on the whole, that we have seen of this artist's very individual work").[3]

The two most elite units in the Union army at the beginning of the war were its regiments of sharpshooters and Zouaves, both with special uniforms and, in the case of sharpshooters, special privileges.[4] Homer depicted both sharpshooters and Zouaves, less for their eliteness than for their novelty and modernity (both were new to warfare), and because the most important of those units, Berdan's Sharpshooters and Duryea's and Hawkins' Zouaves, were from New York, where Homer's paintings were chiefly shown and seen.

Colonel Hiram Berdan organized two regiments of sharpshooters in the summer of 1861. A review of "the Berdan Rifle Regiments" in the October issue of *Leslie's* explained sharpshooting and its role in modern warfare: "It is only with the last few years that the rifle has been brought to play its part *en masse* in war; a rifle, twenty years ago, was like a Toledo blade—too expensive for common use—and it is only within the last eight years that mechanical science has manufactured thousands to the one formerly made....From the very commencement of the present war we have felt the want of that most necessary of all adjuncts to an invading army—sharpshooters—what the whiskers are to a cat, and the *antennae* to an insect, sharpshooters are to an advancing corps. They are at once life and safety to the advance, and death and danger to the foe. Like all great commercial nations, the United States found herself terribly deficient in this most necessary arm...."[5] Another pressing reason for raising units of sharpshooters was the high toll of Union officers lost to Confederate sharpshooters: "[O]ur loss of officers in late battles has been awfully disproportioned, and indeed entirely unprecedented; and it may be attributed wholly to the presence of sharpshooters, who, by the brilliant uniforms which our generals wore, were enabled to pick them off like so many partridges."[6] Sharpshooters were in action on both sides during the Peninsular Campaign

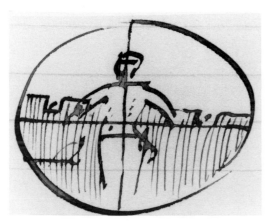

fig. 16. Letter from Winslow Homer to George G. Briggs, 19 February 1896. Archives of American Art

and the siege of Yorktown in 1862, though Union sharpshooters had the early advantage. It was there and then that Homer saw them in action.

With telescopic sights, like the one in Homer's painting, sharpshooters could hit targets more than a mile away, but even at closer range their victims were killed without a warning shot: "Some of those Yankee sharpshooters…had little telescopes on their rifles that would fetch a man up close until he seemed to be only about a 100 yards away from the muzzle," a Confederate lieutenant said. "I've seen them pick a man off who was a mile away. They could hit so far you couldn't hear the report of the gun. You wouldn't have any idea anybody was in sight of you, and all of a sudden, with everything as silent as the grave and not a sound of a gun, here would come…one of those 'forced' [rifled] balls and cut a hole clear through you."[7] The chief tactical value of sharpshooters was in pinning enemy infantry to its trenches and artillery crews to their emplacements. A Confederate major at Yorktown said "Federal sharpshooters were as audacious and deadly as I ever saw them. For the most part they were [like Homer's] concealed in the tops of tall pine trees and had down shots upon us, against which it was almost impossible to protect ourselves."[8] Despite their public celebrity and the admiration for their skill and daring, ordinary soldiers hated sharpshooters, looking upon them as cold-blooded, calculating, mechanical killers, as hunters stalking their prey. ("Your duties will be simple," Captain Drew of Vermont coldly promised future sharpshooters, "'watch and kill.'")[9] Homer shared that feeling. Many years after the war he wrote an old friend, "I looked through one of their [sharpshooters'] rifles once when they were in a peach orchard in front of Yorktown in April 1862.…the above impression [fig. 16] struck me as being as near murder as anything I could think of in connection with the army & I always had a horror of that branch of the service."[10]

NOTES

1. "Correspondence. Shurtleff Recalls Homer," *American Art News* 9 (29 October 1910), 4.

2. "Atheneum Club and Our Artists," *The Round Table* 1 (30 January 1864), 107.

3. "Artists' Reception for the Benefit of the Brooklyn and Long Island Fair," *New York Tribune*, 19 February 1864.

4. A circular issued by a Captain Drew of Vermont to raise five companies of sharpshooters promised, "You will have no digging, no working; no 'camp duty,' no standing guard, but will be kept to the front on picket duty or sent forward as scouts and skirmishers" ("Sharpshooters," *The Scientific American* 7 [22 November 1862], 330).

5. "Review of the Berdan Rifle Regiment," *Leslie's* 12 (5 October 1861), 325, 326.

6. "Sharpshooters," 330.

7. Quoted by Christopher Kent Wilson, "Marks of Honor and Death," in Simpson et al. 1988, 36 n. 51.

8. Quoted by Wilson in Simpson et al. 1988, 34 n. 40.

9. "Sharpshooters," 330.

10. Letter to George G. Briggs, 19 February 1896 (Archives of American Art).

2

Home, Sweet Home was shown at the annual exhibition of the National Academy of Design in 1863, marking Homer's professional debut. Critics, who had never seen anything by him, were able in this very early painting not only to take remarkable measure of his exceptional gifts, but of his artistic mentality and probity as well. "It is a little work of real feeling.… There is no strained effect in it, no sentimentality, but a hearty, homely actuality, broadly, freely, and simply worked out."[1] It "shows a strength and boldness in execution truly admirable. We hail it as a promise; we accept it as a worthy achievement.… There is no clap-trap about it. Whatever of force is in the picture is not the result of trickery, and is not merely surface work, not admitting of examination, but painstaking labor directed by thought."[2] "The delicacy and strength of emotion which reign throughout this little picture are not surpassed in the whole exhibition. Mr. Homer needs not our welcoming to the honorable rank which he took from the night of the private view."[3]

NOTES

1. "The Lounger. The National Academy of Design," *Harper's Weekly* 7 (2 May 1863), 274.

2. "Atticus," "Art Feuilleton," *The New York Leader*, 9 May 1863.

3. "National Academy of Design. Its Thirty-eighth Annual Exhibition. Fifth Article," *New York Evening Post*, 12 June 1863.

2. ***Home, Sweet Home,*** c. 1863
oil on canvas, 54.6 x 41.9 (21½ x 16½)
Private Collection
Provenance: Samuel P. Avery, possibly 1863 until 1867;
(Leeds Art Gallery, New York, 5 February 1867, no.
59); Mrs. Alex H. Shepherd; (Howard Young Galler-
ies, New York); (M. Knoedler & Co., New York);
George M. L. LaBranche, New York and New
Rochelle, by 1944; Mr. and Mrs. Nathan Shaye,
Detroit, by 1958 until 1984; (Sotheby's, New York,
30 May 1984, no. 19); (Hirschl & Adler Galleries,
New York, 1984).

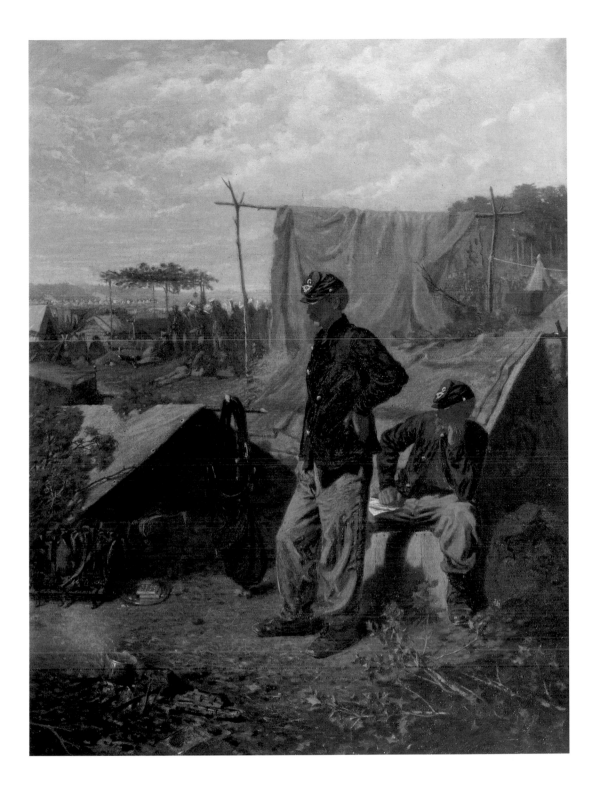

3

In 1855, during the Crimean War, General George B. McClellan, commander of the Army of the Potomac in 1862, was sent to Europe to collect information "on military subjects." Among the subjects he reported on were Zouaves:

The dress of the Zouaves is of the Arab pattern; the cap is a loose fez, or skull-cap, of scarlet felt, with a tassel; a turban is worn over this in full dress; a cloth vest and loose jacket, which leave the neck unencumbered by collar, stock, or cravat, cover the upper portion of the body, and allow the movement of the arms; the scarlet pants are of loose oriental pattern, and are tucked under garters.... The men say that this dress is the most convenient possible, and prefer it to any other.

The Zouaves…are selected from amongst the old campaigners for their fine physique and tried courage, and have certainly proved what their appearance would indicate—the most reckless, self-reliant, and complete infantry that Europe can produce. With his graceful dress, soldierly-bearing, and vigilant attitude, the Zouave at an outpost is the beau-ideal of a soldier.[1]

"The great European fame of the Zouaves commenced in the Crimean War," a writer said in 1861. "So far as the United States are concerned, the first great impulse given to this peculiarly attractive arrangement was the visit made last year by Colonel Ellsworth, of the Chicago Zouaves, to this city. The keen instinct of New York recognized their value, and at once set to work. The result has been the finest body of soldiers in the world; for it is an undoubted military fact that never before has the philosophy of physique been so admirably brought into play as during the last ten months."[2]

Today, when Zouave uniforms resemble nothing quite as much as the costumes of certain fraternal organizations, it is perhaps something of a surprise to learn that the "beau-ideal" upon which American Zouave units were modeled at the beginning of the Civil War was one of physical perfection, that their appearance signified toughness and fearless courage, and particularly that they actually liked their uniforms and considered them "convenient." But in the Civil War that is precisely what Zouaves were meant to signify; in *The Brier-Wood Pipe*, a poem by Charles Dawson Shanly, a New York Zouave says, "…I'm but a rough at best—bred up to the row / and the riot."[3]

He also said of his pipe: "…it's only a knot from the root of the brier-wood tree; / but it turns my heart to the northward," indicating, if Homer's Zouaves can be understood to share that sentiment, that the mood of *The Brierwood Pipe* is like that of *Home, Sweet Home*, painted the year before, and very possibly intended in its similarity to capitalize on that painting's great success. Like *Home, Sweet Home*, which it closely resembles in form (and which it probably resembled even more closely before he repainted it; see below, this entry), it too was probably based on Homer's experiences at the front during the Peninsular Campaign of 1862, and on drawings by which he preserved them (fig. 17).

If Homer hoped to trade on the success of *Home, Sweet Home*, he would, on the whole, have had reason to be pleased with the reception of *The Brierwood Pipe*. To be sure, one critic, after complimenting it for being "naturally composed" and for its "considerable truth of expression," also wrote that it "showed a sad falling off in the study and care that went to the execution of the last pictures, which we noticed"—but he

fig. 17. *Army Encampment*, 1862. Pencil. Cooper-Hewitt, National Design Museum, Smithsonian Institution, Gift of Charles Savage Homer, Jr. (1912–12–124). Art Resource, New York

was the Pre-Raphaelite, Clarence Cook, a fanatic about "study and care."[4] Others were astonished that a work by "a new beginner" was so accomplished and promising, and, trying to account for it, they described the two essential components of Homer's precocious artistic success. "Few if any of our young painters," one of them wrote, "have displayed in their first works so much that belongs to the *painter* as Mr. Homer. His pictures indicate a hand formed to use the brush."[5] The other traced his success to a different skill, one more acquired than innate: "…he did something that very few of our young artists do; learned to draw with the point before he attempted color. I hope not to be thought flippant if I say that too few of our students 'see the point.' They want to feel the gracious weight

of the palette upon their thumbs too early, and they bear animosity to the crayon."[6]

One of them particularly admired the sky of *The Brierwood Pipe*, "a sky," he said, "of much delicacy in execution and color, and which would do credit to our best landscapists."[7] The other described the method by which Homer obtained that admirable effect of luminosity: "Mr. Homer studies his figures from realities, in the sunshine. If you wish to see him work you must go out upon the roof [of his studio in the University Building], and find him painting what he sees,…real things, instinct with life and warm with the glory of God's sunshine."[8]

It is often thought and sometimes said that Homer first learned to paint out-of-doors from some experience of French impressionism dur-

ing his visit to France in 1866–1867.[9] It is clear, however, that he painted in "the glory of God's sunshine" well before that. Homer said later, "I prefer every time…a picture composed and painted out-doors,"[10] but that is an excessively and misleadingly impressionist characterization of a method far less disciplined, one that in practice was more pragmatic than principled—and in that respect, of course, more American than French. For it is perfectly clear that *The Brierwood Pipe* was not in its entirety composed and painted out-of-doors (as, at just about this time, Claude Monet insisted despite great and even insuperable difficulties on painting every part of such large and unwieldy canvases as *Women in the Garden* and the unfinished *Déjeuner sur l'herbe* [Musée d'Orsay, Paris] completely out-of-doors). Homer did not arrange a camp scene on the roof of his New York studio and rigorously paint from it. He posed and painted the costumed models and perhaps the sky out-doors, but the rest was confected in the studio from sketches (see below, cats. 10–16). It was there, too, that he reconsidered and significantly changed the painting by deleting certain details such as the leafless trees, which surely did not grow on his studio roof, that originally rose up behind the seated Zouaves.[11]

NOTES

1. "Those Terrible Zouaves," *The Scientific American* 1 (9 July 1859), 18.

2. "The Zouaves," *Frank Leslie's Illustrated Newspaper* 11 (11 May 1861), 406.

3. Frank Moore, *Anecdotes, Poetry, and Incidents of the War: North and South 1860-1865* (New York, 1866), 381.

4. "Fourth Artist's Reception," *New York Tribune*, 26 March 1864.

5. "Exhibition of the National Academy of Design. III," *The Round Table* 1 (7 May 1864), 326.

6. George Arnold, "The Academy Exhibition. Second Article," *The New York Leader*, 30 April 1864.

7. *The Round Table* 1 (7 May 1864), 326.

8. Arnold, "The Academy Exhibition."

9. See Adams 1990b, n. 13, for an excellent summary.

10. "Sketches and Studies—II. From the Portfolios of A. H. Thayer, William M. Chase, Winslow Homer, and Peter Moran," *The Art Journal* 6 (April 1880), 107.

11. See Simpson et al. 1988, fig. 8.1.

4. *Skirmish in the Wilderness,* 1864
oil on canvas, 45.7 x 66 (18 x 26)
The New Britain Museum of American Art, Harriet
Russell Stanley Fund
Provenance: William Parsons Winchester Dana, possibly from 1864; (Somerville Gallery, New York, 17 May 1870, no. 121); Union League Club, New York, 1870–1938; (Parke-Bernet Galleries, New York, 24 March 1938, no. 76); (F. Schnittzer, New York); (Vose Galleries, Boston, 1943).

fig. 18. *Studies of Soldiers Taking Aim,* 1862. Pencil. Cooper-Hewitt, National Design Museum, Smithsonian Institution, Gift of Charles Savage Homer, Jr. (1912–12–171). Art Resource, New York

RIGHT: fig. 19. *Studies of Soldiers in Action,* 1864. Charcoal and white chalk. Cooper-Hewitt, National Design Museum, Smithsonian Institution, Gift of Charles Savage Homer, Jr. (1912–12–108). Art Resource, New York

4

Skirmish in the Wilderness is as close as Homer ever came to the sort of conventional battle painting that depicted large bodies of soldiers deployed in orderly combat—"long lines advancing and manoeuvering, led on by generals in cocked hats," as a contemporary (who experienced the Battle of the Wilderness) described the type that still had currency in military art.[1] But the Battle of the Wilderness—"the strangest and most indescribable battle in history"[2]—did not fit it. Occurring in a densely tangled undergrowth that made maneuvering impossible, this "battle which no man saw"[3] thrust friend and foe together with deadly intimacy, jumbled the hierarchy of leaders and led, and muddled acts of individual heroism. It was fought in conditions so utterly foreign to conventional images of war and so repugnant to the customary tactical requirements of warfare that it illustrated, a participant wrote, "the tactics of savages rather than the science of modern war."[4] In other words, it suited Homer's revisionary mentality perfectly.

The Battle of the Wilderness of 5 and 6 May 1864 was Ulysses S. Grant's first battle as lieutenant general in command of all the Union armies, and the first move in his campaign on Richmond

that would end in Robert E. Lee's surrender at Appomattox Courthouse a little less than a year later. It exemplified Grant's fiercely stubborn determination ("I propose to fight it out on this line if it takes all summer," he wrote shortly after the battle in perhaps his most famous utterance),[5] but also his tolerance of frightful casualties as the price of victory. (The total casualties suffered by the more than 100,000 federal soldiers at the Battle of the Wilderness was 17,666, of which 2,246 were killed.)[6]

While there is no "hard evidence" to prove that Homer was a witness,[7] he said that *Skirmish in the Wilderness* "was painted from sketches made on the spot at the time of the battle,"[8] and the surviving sketches, by their abbreviation, suggest that they were executed quickly in tumultuous and even dangerous circumstances (figs. 18, 19). Also, Francis Channing Barlow (now Brigadier General) commanded the 1st Division, 2d Corps, Army of the Potomac, in the Battle of the Wilderness, and Homer may have been with him then as he had been earlier at the siege of Yorktown. The officer leading a column of soldiers at the right of the painting, carrying a long cavalry sword of the kind Barlow favored and wearing a cap with a red dot—perhaps the red cloverleaf insignia of the 2d Corps—may be Barlow. The greatest feat of the 1st Division under Barlow's command at the Battle of the Wilderness was the capture of a division of Confederate soldiers and two generals; it may be the event Homer memorialized ceremonially two years later in *Prisoners from the Front*, of which Barlow, at the right, with his long sword, is the principal figure (cat. 10).

NOTES

1. *Meade's Headquarters 1863–1865. Letters of Colonel Theodore Lyman, from the Wilderness to Appomattox*, ed. George R. Agassiz (Boston, 1922), letter of 8 May 1864, 101. Homer "does not choose for his motives, as a rule, the customary battle scenes, with long lines of troops advancing or retreating, clouds of gun-powder smoke, heroic officers waving their swords and calling upon their men to 'Come on!'—and all the rest of the stock material of the school of Versailles." Downes 1911, 42.

2. Quoted in Simpson et al. 1988, 175.

3. Simpson et al. 1988, 175.

4. Quoted in Simpson et al. 1988.

5. Simpson et al. 1988, 176.

6. Simpson et al. 1988, 178 n. 6

7. Of the sort Hendricks 1979, 54, required to be convinced that Homer was at the front in 1864.

8. Goodrich 1944a, 230.

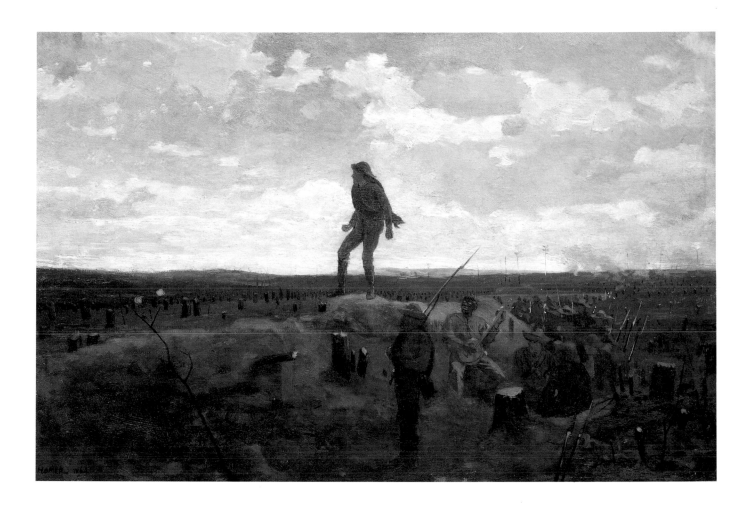

5. **Defiance: Inviting a Shot Before Petersburg,** 1864
oil on panel, 30.5 x 45.7 (12 x 18)
The Detroit Institute of Arts, Gift of Dexter M.
Ferry, Jr.
Provenance: Frederick S. Gibbs, New York, before 1899
until 1903; (American Art Galleries, New York, 25
February 1904, no. 157); Thomas R. Ball, 1904–1919;
(American Art Association, New York, 4 March 1919,
no. 96); (M. Knoedler & Co., 1919–1927); (American
Art Association, New York, 6 January 1927, no. 152);
Edward Ward McMahon, 1927–1929; (American Art
Association, New York, 24 January 1929, no. 79); Pas-
cal M. Gatterdam; (Macbeth Gallery, New York, 1931);
Whitney Museum of American Art, 1931–1950;
(M. Knoedler & Co., New York, 1951).

5

"One of the Union marksmen saw by means of
his telescopic rifle a man upon the ramparts of
Yorktown, who amused his companions by mak-
ing significant gestures towards the lines, and
performed queer flourishes with his fingers,
thumbs, and nose. The distance between them
was so great, that the buffoon supposed he was
safe; but the unerring ball pierced his heart, and
he fell inside the works."[1]

"It was almost certain death to show one's
head above the works, and yet a sort of dare-devil
fellow, belonging to one of the guns, mounted
the works, and catching his red cap from his
head, swung it defiantly at the enemy. Just then
a bullet struck him squarely in the forehead, and
he toppled over."[2]

These eyewitness accounts of the siege of
Yorktown indicate what Homer also must have
heard, and seen, at that time. They report, too,
on the certain outcome of the Confederate sol-
dier's rash act of defiance, which, the distant
flash and puff of rifle smoke indicate, was a split-
second away from coming about in Homer's

painting. Whether his was an act of foolish dar-
ing or buffoonery, or a result of the unbearable
psychological stress that many soldiers in the
trenches suffered from the relentless threat of
sharpshooters, is not clear.[3] The result, in any
case, was the same.

It is not clear either whether Homer was at
the front during the ten-month siege of Peters-
burg from June 1864 to April 1865, as he seems
to have been at the Battle of the Wilderness in
the spring of 1864 (cats. 4, 10) and at Yorktown
in 1862. There can be no doubt that the large
drawing of a war-devastated landscape—heavily
used, as its stains and folds indicate, and entirely
characteristic of Homer's sense of drawing as a
useful tool rather than an aesthetic object, though
it is extremely beautiful nonetheless—was taken
from nature, and no doubt either that it resem-
bles the landscape in *Defiance* very closely. There
is no certainty, however, that it was made at
Petersburg; that sort of landscape was all too
common, and Homer could as easily have seen
it at Yorktown.

NOTES

1. Quoted by Christopher Kent Wilson, "Marks of

Honor and Death," in Simpson et al. 1988, 36.

2. Quoted by Wilson in Simpson et al. 1988, 36, n. 50.

3. "[T]he pressure of the Federal sharpshooters became intolerable [and] one of our detachments broke down utterly from nervous tension and lack of rest," a Confederate officer said of the siege at Yorktown. Quoted by Wilson in Simpson et al. 1988, 36–37, n. 54.

6

The Bright Side was greeted with universal approval by critics—"it was altogether the best thing he has painted, and that is saying much," one wrote—and was crowned by the public "with smiling eye and silent applause."[1] They admired its bold and direct style and its truthful observation of nature, but above all its "vigorous emphasis of character,"[2] which most of them understood in racial terms. "It expresses…an accurate knowledge of African habits and peculiarities."[3]

"The African seems just beginning to assume a prominent place in our art, as he has for some time in our politics; and it is a natural consequence of the late war that the characteristics of the negro race in America should become a subject of study for the artist as well as the political philosopher," wrote a critic in 1867. "Still our artists have been slow in turning the new subjects offered to them to account; so that it has been a common remark that but few works of any value as illustrating the war have yet been produced, and only a small number of them relate to the part taken by negroes, and the phases of character developed in them by the circumstances amid which they have lately been thrown."[4] Considered socially and culturally, rather than individually, black subjects, thrust into the consciousness of the North by the Civil War and more forcefully still by Emanci-

pation, were indeed new to American artistic examination. Homer, surely understanding the subject as a "modern and national" one eminently entitled to a place in his project of "home painting," was in *The Bright Side* one of the first artists to give it serious attention.

"The peasant of France…is a careless and unambitious being, much like the negro of our Southern plantations." Setting aside carelessness and lack of ambition, the equation of the American Negro with the French peasant that Homer's friend Eugene Benson makes here is one that others also began to make in the 1860s. That he made it in an article on the French peasant painter Jean-François Millet is particularly interesting, because Homer's *The Bright Side*—though two critics compared it to another French artist, Gérôme—seems instead clearly to have been translated from Millet.[5] Not only does it resemble Adrien Lavieille's engraving after Millet's drawing *Noonday Rest* (fig. 20), thematically and—with haystacks as tents, cattle as mules, a hayrack as army wagons—almost categorically in every aspect of pose and composition, but more profoundly, it incorporates Millet's meaning into its own. "The peasant, on Millet's canvases," as Benson wrote and as Homer knew, "is often a figure as impressive, and sometimes as grand, as the figures and martyrs in the frescoes of the Italian painters."[6] And it is in terms of the nobility, dignity, and simplicity of character with which Millet endowed the peasant's life of endless toil that Homer understood and represented the "character" of the black teamsters in *The Bright Side* (just as in 1867 Edna Cheney saw in Millet's *Man with a Hoe* "the unpaid slave of our own country").[7]

If *The Bright Side* were hung beside *Prisoners from the Front* (cat. 10), Benson believed, "the two would make a comprehensive epitome of the lead-

fig. 20. Adrien Lavieille, after original drawings by Jean-François Millet. *Les Quatres Heures du Jour: Le Midi*, c. 1860. Engraving. The Metropolitan Museum of Art, Harris Brisbane Dick Fund, 1926 (26.84.2)

6. *The Bright Side,* 1865
oil on canvas, 33.7 x 44.5 (13¼ x 17½)
The Fine Arts Museums of San Francisco, Gift of Mr.
and Mrs. John D. Rockefeller 3d
Provenance: William H. Hamilton, from 1865; Thomas
B. Clarke, by 1886 until 1899; (American Art Associ-
ation, New York, 15 February 1899, no. 123); Samuel P.
Avery, Jr., 1899. William Augustus White, Brooklyn,
New York, by 1911 until 1917; (Macbeth Gallery, New
York, 1917–1918); Julia E. Peck, Port Huron, Michigan,
1918–1959; Mrs. Richard Andrae, Port Huron, Michi-
gan, 1959. (Du Mouchelle Art Galleries, Detroit,
Michigan, 1971); (Schweitzer Gallery, New York,
1971–1972); Mr. and Mrs. John D. Rockefeller 3d,
1972–1979.

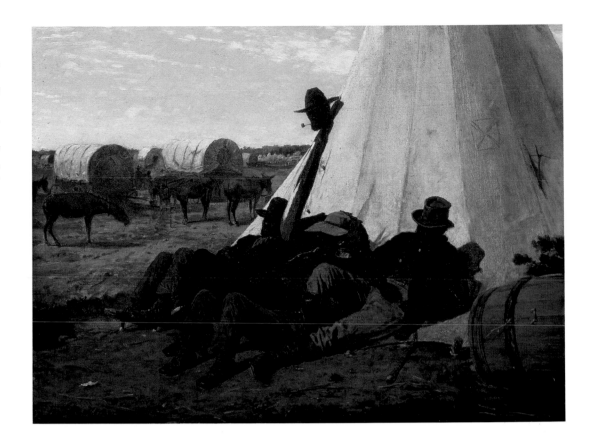

ing facts of our war."[8] Perhaps that is why Homer
sent them both to represent the United States
in the Exposition Universelle in Paris in 1867.

Homer painted a second and somewhat larger
and more complicated version of *The Bright Side*
in 1866 for the collector John H. Sherwood
(*Army Teamsters,* Virginia Museum of Art, Gift
of Paul Mellon).[9] He based the mules and wag-
ons on his own drawings.[10] A drawing study and
an oil sketch exist for the figure group,[11] which
was done from a model or models posed, per-
haps, on the roof of Homer's studio.[12] A wood
engraving was published in *Our Young Folks* in
July 1866.

NOTES

1. "National Academy of Design," *New York Tribune,* 3
July 1865.

2. "National Academy of Design. Fortieth Annual Exhi-

bition. Concluding Article," *New York Evening Post,* 31
May 1865.

3. "National Academy of Design. North Room," *New
York Times,* 29 May 1865.

4. "National Academy of Design. Forty-second Annual
Exhibition. Third Article. The Artist and the African,"
New York Evening Post, 2 May 1867.

5. I am indebted for this perceptive insight to Charles
Brock.

6. Eugene Benson, "The Peasant-Painter—Jean-Francois
Millet," *Appleton's Journal* 8 (12 October 1872), 404.

7. *The Radical* 2 (July 1867), 668.

8. Sordello, "National Academy of Design. Forty-first
Annual Exhibition. First Article," *New York Evening Post,*
28 April 1866.

9. Docherty 1993, 37, 40.

10. Simpson et al. 1988, figs. 13c, 13d, 13g, and 13.1.

11. Simpson et al. 1988, figs. 13a and 13b.

12. For his use of a model, see Aldrich 1866, 396–397.

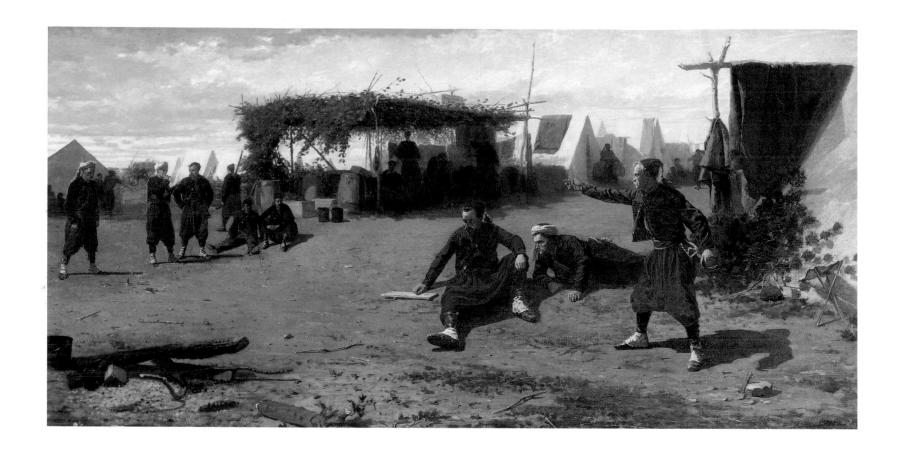

7. ***Pitching Quoits [Pitching Horseshoes, Quoit
Players],*** 1865
oil on canvas, 67.9 x 136.5 (26 ¾ x 53 ¾)
Harvard University Art Museums, Fogg Art Museum,
Gift of Mr. and Mrs. Frederic Haines Curtiss,
1940.298
Provenance: (Somerville Art Gallery, New York, 19
April 1866, no. 61, as *The Quoit Players*); Abijah Cur-
tiss, Yonkers-on-Hudson, New York, by 1870 or
1873; his son, Frederic H. Curtiss, Boston, by 1911.

7

Pitching Quoits, "a scene from the war" depicting
"a party of Zouaves," was "in progress" in Feb-
ruary 1865.[1] "Mr. Homer has…in progress…a
scene in a camp of Zouaves, where a group of
sunburned stalwart veterans are pitching quoits,
a favorite camp amusement," a visitor to his stu-
dio reported in March. "It is difficult to judge a
work so little advanced as this, but from what
can be seen of the foreground figures, it will be
full of action, life and power."[2]

Although "little advanced" in March, it was
complete by the time of the National Academy
of Design exhibition in May, where it was gen-
erally much admired for its strength of drawing
and color, its energy and action, and the improve-
ment that it marked in Homer's development.

Homer "has again given the Academy exhi-
bition some of the most vigorous and healthful
art work that finds place among hundreds of
paintings that would be better if they manifested
just a little of the life and energy of Homer's
effective picture of 'Quoit Players' in the large
gallery. Observe those figures! Are they not
hearty and positive in effect? I might tell you
that Homer lacks refinement of color and expres-
sion, and is a little rude in his execution; but
then I would assure you that he is no weak
draughtsman, but that he is true, and fails of

refinement only because of inexperience in the
management of pigments."[3]

"[A] company of red-breeched Zouaves, with
broad and bumpy heads and Henri-Quatre
beards, are playing at the ancient and respectable
game of quoits, but with horse-shoes instead of
the well-known rings. The action and drawing
are good, and the picture tells its little story
plainly and forcibly."[4]

"It is a camp scene, with a party of Zouaves
playing at quoits with horseshoes—army fash-
ion. The drawing of the figures, and the charac-
ter, varied and forcible, expressed in the faces,
are remarkably fine. The coloring…errs in the
right direction—that of strength—and seems
to call for study and experience only. Moreover,
the subject demands much of the flaming scarlet
and blue with which some departmental lunacy
has clothed a large portion of our heroes. And it
is a thankless task to search for errors in a work
so sincerely, so honestly and healthfully fancied.
You may go far, through many exhibition gal-
leries, without seeing a human figure so full of
real life and action as the Zouave in the fore-
ground who is just delivering his quoit; and Mr.
Homer cannot draw many such without finding
himself famous."[5]

"'Pitching Quoits'…is a large picture of
Zouaves, apparently of the Fifth New York Vol-
unteers [Duryea's Zouaves], some in the fore-

ground engaged in the standard amusement of which gives name to the picture, with horse-shoes for their missiles, others looking on, keeping tally of the game, smoking, and, in the background, cooking and lounging. The improvement in Homer's work is, from year to year, very noticeable. He promises to retain the position, which we think he has already won, of our first [best] painter of the human figure in action."[6]

Pitching Quoits is significantly larger and compositionally more intricate than any painting Homer had painted to that point in his still short career.[7] But all the while that he was painting small and (speaking only of their form) simply conceived paintings such as *Sharpshooter*, *Home, Sweet Home*, and *The Brierwood Pipe* that were so purposely different from conventional military art, he apparently harbored the ambition of making just that type of picture. The principal evidence for that ambition is a group of large chalk drawings that are, in their size and medium, in both those respects completely unlike Homer's other Civil War drawings. They differ from them in two other respects as well: figures in action, riding, shooting, and dying, which they depict, are not subjects that appear in Homer's other drawings; and none of them were used for any of Homer's Civil War paintings, as, of course, many of his other drawings were (cat. 10, for example).

Or rather, there is one painting for which such drawings were used, *Pitching Quoits*; two of them (figs. 21–22) appear in the distance at the left.[8] What their presence strongly suggests is that this many figured, elaborately composed picture, significantly larger than any Homer had previously painted, was an attempt — on the whole successful, though not, perhaps because of the comments it provoked on his lack of experience, one he would attempt again — to work in the mode of conventional, academic military art. A critic said of a figure in *The Bright Side* (cat. 6), shown in the same exhibition as *Pitching Quoits*, that it was "as true and full of expression as if Mr. Homer could paint like Gérôme."[9] Jean Léon Gérôme was one of the most celebrated French academic artists in the 1860s and greatly admired in America (Eugene Benson wrote about him and Thomas Eakins studied with him). If there is a resemblance between Homer and Gérôme, however, it resides less in the way he painted a single figure in *The Bright Side* — a painting in which the presence of another quite different French artist, Jean-François Millet, figures more largely — than in the way he conceived of pictorial management, spatial, compositional, and expressional, in *Pitching Quoits*. *The Death of Caesar* (fig. 23), one of Gérôme's most celebrated paintings (of which, as a measure of its celebrity, he painted more than one

fig. 23. Jean Léon Gérôme. *Death of Caesar*, 1859. Oil on canvas. The Walters Art Gallery, Baltimore.

fig. 24. *The Borghese Warrior*. Hellenistic sculpture. Alinari/Art Resource, New York

version) was exhibited in New York in the early 1860s,[10] and it is to its narrative and dramatic contrasts of large forms and small, near ones and far, and empty and filled space, that *Pitching Quoits* bears a very considerable emulative (but not imitative) relationship.[11]

The figure in the right foreground, "so full," one critic thought, "of real life and action," is another manifestation of Homer's suddenly enlarged and elevated artistic ambition. It is his first depiction of "the human figure in action." And it is at the same time the first of his figures in which the practice, canonical in academic method and central to academic instruction (as it was in the National Academy of Design), of studying and imitating classical models is evident. For its resemblance to the famous *Borghese Warrior* (fig. 24) is too remarkably close to be unintended.

NOTES

1. "A Visit to the Studios. What the Artists are Doing," *New York Evening Post*, 16 February 1865.

2. George Arnold, "Art Matters," *New York Leader*, 11 March 1865.

3. "Proteus," "National Academy of Design. Fortieth Annual Exhibition," *New York Commercial Advertiser*, 22 May 1865.

4. "National Academy of Design, North Room," *New York Times*, 29 May 1865.

5. George Arnold, "Art Matters," *New York Leader*, 3 June 1865.

6. "Fine Arts. The Fortieth Annual Exhibition of the National Academy of Design," *The Nation* 1 (13 July 1865), 58.

7. See Sally Mills in Simpson et al. 1988, 209, and passim; and Cikovsky 1990c, 95–98.

8. The figure between them was based on an oil sketch; see Simpson et al. 1988, fig. 14.c.

9. *The Nation* 1 (13 July 1865), 59.

10. The sculptor Augustus Saint-Gaudens saw the 1859 version at Goupil's Gallery in New York early in the Civil War. Fanny Field Hering, *The Life and Works of Jean Léon Gérôme* (New York, 1892), introduction. Benson wrote that "'The Death of Caesar' is a superb and classic composition…" ("Jean Léon Gérôme," *The Galaxy* 1 [August 1866], 522).

11. Mills in Simpson et. al 1988, 210, fig. 14.1, has very acutely noticed the similarity of *Pitching Quoits* to Homer's own "Cricket Players on Boston Common," published in *Ballou's Pictorial*, 4 June 1859.

8. *The Veteran in a New Field*, 1865
oil on canvas, 61.3 x 96.8 cm (24⅛ x 38⅛)
The Metropolitan Museum of Art, Bequest of
Adelaide Milton de Groot (1876–1967), 1967
Provenance: (Henry H. Leeds & Miner, New York,
17 November 1866). The artist, until 1910; Adelaide
Milton de Groot, New York, by 1936 until 1967.

8

"The bodies of once living and brave men, slowly
moldering to dust in this sanctified soil [Gettys-
burg]," someone was moved to reflect in 1865,
at the same time that the governing symbolic
image of *The Veteran in a New Field* was taking
shape in Homer's mind, "form but a small, a
single sheaf from that great recent harvest reaped
by Death with the sickle of war."[1]

From that harvest of war Homer's veteran,
still mimicking Death as a reaper, has only
recently returned.

NOTES

1. J. T. Trowbridge, *The South: A Tour of its Battlefields and
Ruined Cities, A Journey Through the Desolated States, and
Talks with the People* (Hartford, 1866), 20. Trowbridge vis-
ited the south in the summer and winter of 1865.

9. *The Brush Harrow,* 1865
oil on canvas, 58.4 x 95.3 (23 x 37 ½)
Harvard University Art Museums, Fogg Art Museum,
Anonymous Gift, 1939.229
Provenance: William W. Goodrich; his son, H. W.
Goodrich; (M. Knoedler & Co., New York, 1921);
Horace D. Chapin, Boston; private collection, Boston.

9

The Brush Harrow is not usually included among Homer's Civil War paintings,[1] but it was exhibited at the National Academy of Design in 1866 as the companion to *Prisoners from the Front* (cat. 10). The more easy legibility of the latter painting generated a torrent of critical commentary that overwhelmed the tenderly subtle and poignant meanings of *The Brush Harrow.* Only a single critic bothered to notice it. But in writing that "The horse is used up, or was never meant to be used, although marked U.S.,"[2] he indicated that it belongs exactly to the group of postwar paintings that includes *Prisoners* and especially *The Veteran in a New Field* (cat. 8), with which *The Brush Harrow* is contemporary. For the horse is another kind of veteran just recently returned, like the reaper, to peaceful agrarian occupations. Nor is it too great or too difficult an imaginative leap to think, despite its comparatively greater modesty and reticence, that the army horse pulling a harrow to smooth the ground for planting, who once pulled instruments of warfare as the

veteran with the scythe cutting wheat had once not too distantly cut down men, performs, attended by representations of youthful innocence, a deeply symbolic act of national healing and erasure one, indeed, that is almost an *enactment* of Abraham Lincoln's summons, delivered in his second inaugural address only months before the war's end and made tragically imperative by his martyrdom that came soon after it, to, "with malice toward none; with charity for all,…bind up the nation's wounds." *The Brush Harrow* is perhaps the most tenderly sensitive and perceptive of all of Homer's paintings of the Civil War.

NOTES

1. It is neither in Grossman 1974 nor Simpson et al. 1988.

2. "National Academy of Design. Forty-first Annual Exhibition," *New York Leader,* 21 April 1866. That the initials U.S. branded on the horse are not now visible, even by technical examination does not mean that they were not once there; see below, "Something More than Meets the Eye," n. 15, in which technical examination could also not detect what was unquestionably present in the painting.

10–16

Prisoners from the Front was painted in Homer's studio in the University Building. In an "Art Feuilleton" in the *New York Commercial Advertiser* in February 1866, someone who saw the work in progress said Homer's studio "walls are crowded with drawings and sketches in oil of incidents and episodes of war…";[1] someone else, who visited the studio the next day, described "walls covered with drawings of soldiers and girls, and battles, and episodes of the camp and march."[2] Thomas Bailey Aldrich's inventory of the contents of Homer's studio (which, it is worth noting, like the others made no mention of photographs) listed "A crayon sketch of camp-life here and there on rough walls, a soldier's over-coat dangling from a wooden peg, and suggesting a military execution, and a rusty regulation musket in one corner."[3]

From this material Homer assembled *Prisoners from the Front*. The "regulation musket" lies in its foreground. He used a drawing of officer's boots for those of General Barlow, on the right (cat. 15). The head of the Union guard to Barlow's left he took from a drawing of six soldiers' heads (changing the number of the regiment from 28 to 61, for the 61st New York Volunteer Infantry, which Barlow commanded earlier in the war) (cat. 16). *Escort of a General* (cat. 11) was made in the late 1880s, but it was based upon an earlier drawing from which Homer took the figures in the background of *Prisoners*. The landscape resembles the drawing now called "Sketches for *Defiance*," but which would have served as well for *Prisoners*, and upon the verso of which, making the connection more direct, is a sketch of the head of General Barlow Homer used for the painting (cats. 14, 13). Below Barlow's head on that sheet is a schematic sketch of the insignia (which tantalizingly awaits identification) on the right sleeve of the Confederate officer. It appears also on the sleeve of a Confederate officer in Homer's frontispiece illustration to John Esten Cooke's novel *Surrey of Eagle's Nest* (cat. 12), a figure virtually the same as that in *Prisoners from the Front*, and like it derived, it seems clear, from a drawing that does not otherwise survive—virtually, but not in its present form exactly, for he wears a different hat.

Originally, however, as infrared reflectography shows, he wore a broad-brimmed hat like the one in the illustration (fig. 25). This is only one of several important changes revealed by

10. **Prisoners from the Front,** 1866
oil on canvas, 61 x 96.5 (24 x 38)
The Metropolitan Museum of Art, Gift of Mrs. Frank B. Porter, 1922
Provenance: Samuel P. Avery, New York, 1866; John Taylor Johnston, 1866–1876; (Robert Somerville, New York, 20 December 1876, no. 181); Robert Lenox Kennedy, New York, 1876–1887; his sister, Mary Lenox Kennedy, 1887–1917; her great-grandniece, Rachel Lenox Kennedy Porter, 1917–1922.

fig. 25

fig. 26

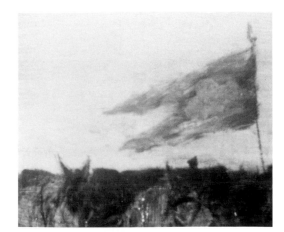

fig. 27

figs. 25–28. *Prisoners from the Front.*
Infrared reflectograms

infrared reflectographic examination: at first, Barlow's right hand was inserted in his coat front, as it is in Homer's drawing (fig. 26). Perhaps Homer found it too Napoleonic and removed it. And, in two changes that may be related to each other, the shape of the flag or guidon at the far right, now square, was originally forked (fig. 27); Barlow's head, because parts of it (nose, mouth, and chin, fig. 28) were painted over the background and uniform, seems to have been added after those passages had already been painted. This might confirm the story told by Barlow's son, which has never been taken very seriously, that someone other than Barlow posed for the figure (he said it was General Nelson A. Miles, who was with Barlow at the battle of Spotsylvania, and who Barlow appointed to a lieutenant-

fig. 28

11. *Escort of a General,* 1887
ink on paper, 22.9 x 38.1 (9 x 15)
The Carnegie Museum of Art, Pittsburgh, Andrew Carnegie Fund, 1906
Provenance: Century Company, New York.
Washington and New York only

12. **The Autumn Woods** (frontispiece for John Esten Cooke's *Surrey of Eagle's Nest*), 1866
12.1 x 8.9 (4¾ x 3½)
Portland Museum of Art, Portland, Maine, Gift of Peggy and Harold Osher
Provenance: Peggy and Harold Osher
Washington only

13. **Profile of a Man's Head** (General Francis Channing Barlow), 1864
black chalk on paper, 32.9 x 23.8 (12⅞ x 9⅜)
verso of cat. 14

14. **Studies of a Battlefield with Tree Stumps and Blasted Tree Trunks** (study for *Defiance*), 1864
pencil on paper, 23.8 x 32.9 (9⅜ x 12⅞)
recto of cat. 13
Cooper-Hewitt, National Design Museum, Smithsonian Institution, Gift of Charles Savage Homer, Jr.
Provenance: Estate of the artist; Charles S. Homer, Jr.; gift to the Cooper Union Museum for the Arts of Decoration, 1912.
Washington only

cat. 12

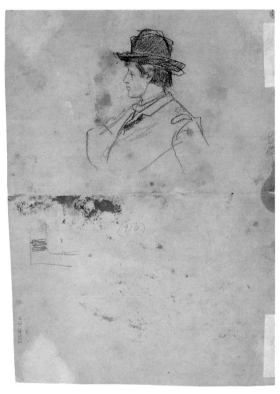

cat. 13 (verso)

cat. 14 (recto)

colonelcy of the 61st New York regiment, which he commanded, and to the command of which he succeeded).[4] In that light, it is suggestive that apart from Homer's drawings of Barlow's head and of his (or a) pair of boots, there are no other drawings for the figure. And in contrast to the large and sturdy body to which his head was attached (General Miles was described as "erect" and "strongly built"),[5] Barlow had "a slight, almost delicate form,"[6] "la figure d'un gamin de Paris," as a French officer described it;[7] the result of that attachment, consequently, is a slightly grotesque mismatch.

It appears, therefore, that *Prisoners from the Front* was nearing completion before Homer had settled on the identity of its principal figure: those who saw it in progress described it as an officer;[8] someone who saw it at the opening of the National Academy exhibition about two months later, however, recognized it easily as "an excellent portrait of General Barlow"[9] (see Chronology 1862). That he was preparing it for someone other than Barlow seems indicated by another important change in the painting that the addition of Barlow required. At first, the flag at the right was the forked-shaped headquarters

15. **Study of a Cavalry Officer's Boot** (for *Prisoners from the Front*), probably 1864
pencil on paper, 17.2 x 11.8 (6 ¼ x 4 ⅝)
Cooper-Hewitt, National Design Museum, Smithsonian Institution, Gift of Charles Savage Homer, Jr.
Provenance: Estate of the artist; Charles S. Homer, Jr.; gift to the Cooper Union Museum for the Arts of Decoration, 1912.
Washington and New York only

16. **Six Studies of Soldiers' Heads** (preliminary sketch for *Prisoners from the Front*), 1862
pencil on paper, 24.3 x 29 (9 ⁹⁄₁₆ x 11 ⁷⁄₁₆)
Cooper-Hewitt, National Design Museum, Smithsonian Institution, Gift of Charles Savage Homer, Jr.
Provenance: Estate of the artist; Charles S. Homer, Jr.; gift to the Cooper Union Museum for the Arts of Decoration, 1912.
Washington and New York only

flag of the 2d Army Corps; at some point Homer changed it to the rectangular white flag with red cloverleaf that was in 1864 the flag of the 1st Division of the 2d Corps—which Barlow commanded.

Why *Prisoners from the Front* did not include Barlow from the start is a mystery. He was not only a friend whom Homer had visited at the front at least once and probably more often than that, but was also "one of the most eminent" officers to survive the war.[10] Barlow had a record of valorous military service in which, particularly, "he distinguished himself at the Wilderness by leading his division in the grand charge which resulted in the capture of the rebel General Ed. Johnson's entire division"[11]—an incident of which Homer's painting can easily be considered a symbolic representation.

NOTES

1. "Art Feuilleton," *New York Commercial Advertiser,* 20 February 1866.

2. "About New York Painters. Works Now on their Easels," *New York Evening Post,* 21 February 1866.

3. Aldrich 1866, 574.

4. See Spassky 1985, 2: 443.

5. George E. Pond, "Major-General Nelson A. Miles," *McClure's Magazine* 5 (November 1895), 562.

6. *Life Sketches of the Government Officers and Members of the Legislature of the State of New York* (Albany, 1867), 23.

7. *Meade's Headquarters 1863–1865. Letters of Colonel Theodore Lyman, from the Wilderness to Appomattox,* ed. George R. Agassiz (Boston, 1922), letter of 7 July 1864, 186.

8. *New York Commercial Advertiser,* 20 February 1866; *New York Evening Post,* 21 February 1866.

9. "Fine Arts. Opening of the National Academy of Design," *New York Evening Post,* 17 April 1866.

10. "New Publications," *New York Herald* 1865.

11. "The New Men. Sketches of the Republican Candidates," *New York Herald,* 22 September 1865. Barlow was nominated by the Republican Party of New York for secretary of state.

17

A "'Camp near Yorktown' during a rainstorm, with soldiers grouped around a smoldering camp fire and the prominent figure of a donkey tied to a stake in the foreground" was first exhibited at the Century Association early in 1871.[1] Usually called *A Rainy Day in Camp,* after the title it bore in the 1872 Academy exhibition, the earlier title indicates that the painting was based on Homer's first real experiences of the war, when, in April and May 1862, he spent two months at the front during the siege of Yorktown. Some or all of that time he was in camp with Colonel Francis Channing Barlow, in command of the 61st New York Infantry in the 2d Army Corps. Describing himself later as a "camp follower," Homer was cook and scullion for himself and

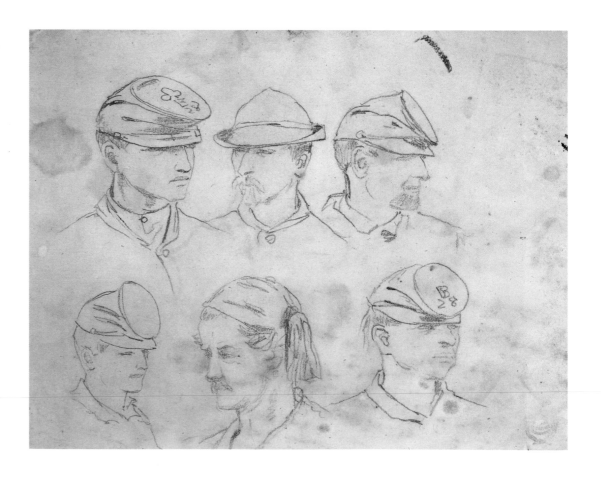

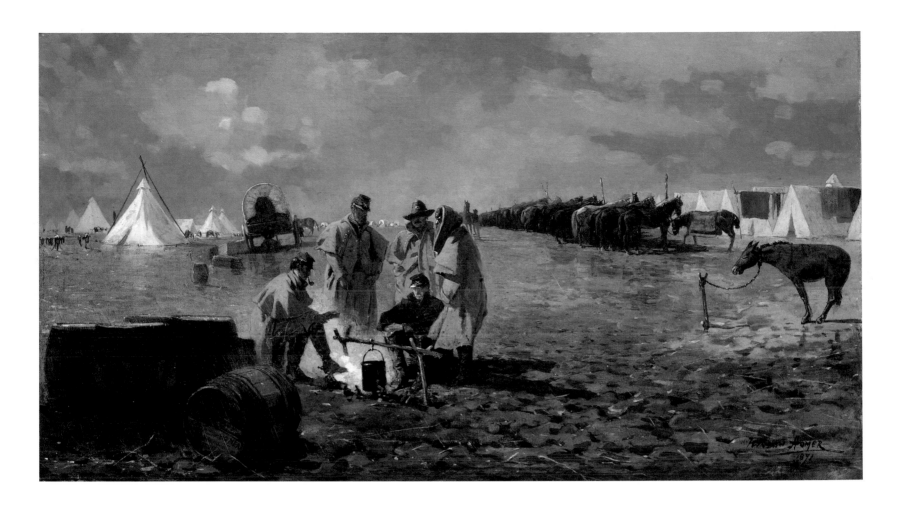

17. *A Rainy Day in Camp [Camp near Yorktown],* 1871
oil on canvas, 50.8 x 91.4 (20 x 36)
The Metropolitan Museum of Art, Gift of Mrs. William F. Milton, 1923
Provenance: William F. Milton, New York and Pittsburgh, 1871–1905; his wife, Mrs. William F. Milton, 1905–1923.

fig. 30. *Soldiers Around a Campfire*, 1862. Pencil and gray wash. Cooper-Hewitt, National Design Museum, Smithsonian Institution, Gift of Charles Savage Homer, Jr. (1912-12-115v). Art Resource, New York

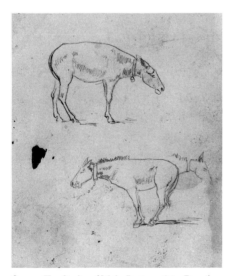

fig. 29. *Two Studies of Mules Resting*, 1862. Pencil. Collection of Lois Homer Graham

Barlow, and was, therefore, thoroughly familiar with the subject he depicted. According to his mother, he "suffered much" from disease, lack of food, and the miserable conditions of unrelenting and unrelieved cold and damp—the weather at Yorktown being so rainy that soldiers' letters home were datelined "Camp Muddy" and "Camp Misery"[2]—that, with his memory still uncomfortably fresh, he depicted in this painting.

The painting's most affecting detail is the piteously forlorn and bedraggled mule at the right, which, as one critic put it, "tells the whole story."[3] Later, Homer would almost routinely use the expressive tactic of investing animals with human feelings, usually his own. Earlier, in his 1870 *Harper's* wood engraving "Tenth Commandment," in a very direct case of ironic self-expressiveness, he identified with a fabled animal symbol of obstinacy and stupidity by placing his initials on an ass (fig. 180). Given this practice, the mule in *A Rainy Day in Camp*, especially in view of its almost caricatured expression and the fact that it was one of the last things added to the painting, is likely Homer's expressive surrogate.

In addition to what his keen memory supplied, Homer also used his Civil War sketches for the mule (fig. 29) and camp fire group (fig. 30).

NOTES

1. "Art at the Century Club," *New York Evening Post*, 6 February 1871. It was described also in "'The Century.' Its Art Gallery and the Exhibitors," *New York Evening Mail*, 6 February 1871.

2. Stephen W. Sears, *To the Gates of Richmond: The Peninsular Campaign* (New York, 1992), 49.

3. "The Realm of Art. Some Notes on the Academy Spring Exhibition, *New York Evening Telegram*, 20 April 1872.

Modern and National

Nicolai Cikovsky, Jr.

Soon after returning to America in December 1867, Homer resumed a practice, begun before he went to France, of painting in series. This practice, which would become a central part of his artistic method for the next decade and longer, involved the creation over a period of two or three years of a number of pictures (and sometimes related prints) on the same subject. Croquet was the subject of his first true series. Homer had made four croquet paintings in 1865 and 1866 (cats. 18–20 and fig. 31), before going to France, and after he returned added another painting to the series in 1867–1869 (fig. 32) and two engravings in 1869 (figs. 33–34). In their collective subject and in his method of treating it, Homer's series represent something that his friend Eugene Benson often talked about, something, indeed, that was the organizing principle of his artistic belief and his chief critical criterion, and something that lay similarly close to the core of Homer's artistic enterprise at the beginning of his career: modernity, that is, the responsibility of an artist to express the life of his own time.[1] Benson's fictional artist Lawrence (Homer) embodied the positivism of what Benson elsewhere called "the contemporary method in art,—in which," he said, "the observation is everything and the dream nothing."[2] And echoing both the substance and cadence of Baudelaire's famous definition of modernity, in "The Painter of Modern Life," as "the ephemeral, the fugitive, the contingent,"[3] Benson wrote that "the modern painter relies upon the occasional, the customary, and the characteristic."[4]

Seriality itself, as Homer practiced it, is essentially a modern method. It regards a subject not as knowable in any fixed and permanent way or, in its entirety, as a single configuration of form, and is therefore not liable to depiction by a single comprehensive, summary image. He understood that early in the Civil War, when he rejected the conventional battle picture that attempted to describe the war by just such comprehensive images; the closest his modernity allowed him to approach comprehensiveness was *Prisoners from the Front*—and that, in its array of discernibly separate types, was not very closely at all.

LEFT: fig. 31. *Croquet Player*, c. 1865. Oil on canvas. National Academy of Design, New York

RIGHT: fig. 32. *Croquet Match*, 1867–1869. Oil on millboard. Daniel J. Terra Collection, 32.1985. Photograph © 1995, Courtesy Terra Museum of American Art, Chicago

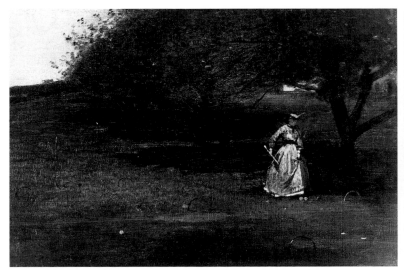

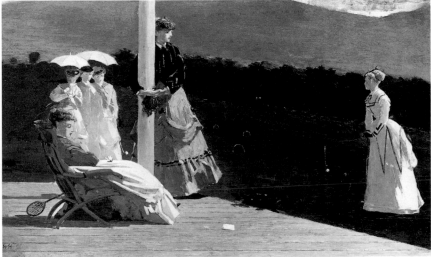

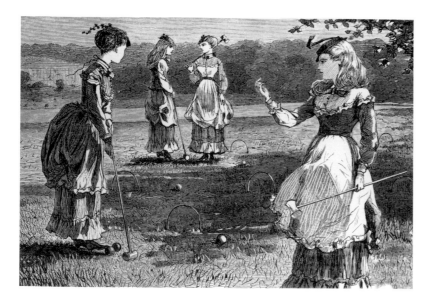

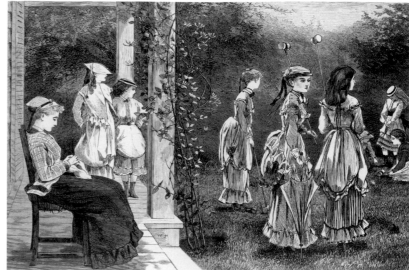

fig. 35. "Godey's Fashions for April 1866." In *Godey's Ladies Book*, April 1866

fig. 36. Edouard Manet. *La Musique aux Tuilleries*, 1862. Oil on canvas. Reproduced by courtesy of the Trustees, The National Gallery, London

A form of seriality had an important role in American art into the decade of the 1860s. It was the artistic device employed by the most influential artist in the first half of the nineteenth century, the landscape painter Thomas Cole, in such works as the five-part *Course of Empire* of 1836 and the even more famous *Voyage of Life*, of which he painted two versions in 1840 and 1842 (one of which was in the collection of John Taylor Johnston in New York, which also included Homer's *Prisoners from the Front*), and which was widely disseminated through engravings. As late as 1867, George Inness' three-part *Triumph of the Cross*, unmistakably indebted to Cole's example, was widely noticed when it was exhibited in New York that year. If Homer, too, was aware of that example (though not through Inness' series, which was shown while Homer was still in France), it was not one he chose to follow. His form of seriality, in another facet of its modernity, shows not a trace of the literary ambition that was central to Cole's; it also avoids the fixed narrative relationship between the parts of the series—Childhood, Youth, Manhood, and Old Age, in the *Voyage of Life*— that was wholly the point and purpose of Cole's serial ordering. There is none of it in Homer's croquet series, or in the series that followed, either in the chronological order in which they were painted, or in the arrangement of their parts.

The modernity of the croquet series lies not only in its narrative irresolution, but more overtly in its subject. Although the origins of croquet can be traced (somewhat murkily) to fourteenth-century France, the form in which it was known in America was imported from England in the 1860s, and by the middle of the decade, when Homer began depicting it, it had become suddenly and ubiquitously fashionable in America. American rule books were being published by the mid-1860s; an American croquet set had been patented by Milton Bradley in Springfield, Massachusetts, by 1866; croquet clubs, like the one in Newport, Rhode Island, had been founded by the same time;[5] and periodical literature was filled with articles on the rules and social rituals of croquet, complete with illustrations.[6] "Of all the epidemics that have swept over our land, the swiftest and most infectious is croquet," *The Nation* wrote in 1866, by which time it had already found its way into Homer's art.[7]

Two other issues of modernity were closely bound up with croquet: dress and sex. Women's dress is the most conspicuous part of Homer's croquet paintings. The women depicted (cats. 19–20) pose in the somewhat stiff and stilted manner of fashion plates (fig. 35).[8] If, as he seems to have done, Homer courted that resemblance (but surely did not copy it), it was to trade on the inseparable association between fashion and recentness. But modern dress was also an issue of modern art.[9] It was central to what has been called "the earliest true example of modern painting," Edouard Manet's *La Musique aux Tuilleries* of 1862 (fig. 36), and to all art like Homer's that aimed to depict, as Emile Zola put it in 1868, the "costumes and customs" of modern life.[10]

The most striking thing about Homer's post-Civil War paintings, like the croquet series, is the prominent role women have in them. That, too, is an explicit aspect of their modernity. Benson

fig. 37. "Women's Rights." Wood engraving. In *Harper's Bazar*, 19 December 1868

(who included an article on "The 'Woman Question'" among what might be called the inventory of modern subjects on which he wrote in the 1860s) was careful to say that the "modern or democratic form of art" depicted "the actual life of men *and women* [emphasis added] in the nineteenth century,"[11] and the most serious fault of Meissonier's art, he believed, and fatal to its modernity, was the absence from it of women.[12] But Homer's women are more pointedly modern, clearly to be understood as Modern Women: active, independent, and self-assured, the products, Benson said, of the age of emancipation. Matthias Pardon, in Henry James' *The Bostonians*, said the emancipation of women "is the great modern question." In a *Harper's Bazar* cartoon of 1868 (fig. 37), a "Young Lady" asks her father, much to the alarm of her unemancipated mother, "have you ever heard a lecture on Women's Rights?" (his reply: "Well, yes, I may say I have; and it has lasted for twenty years"); she is the distinctly modern type of woman who, without caricature or condescension and often in almost monumental form, populated Homer's paintings and prints beginning in the late 1860s.[13] She is the type of woman, too, that Whitman described in *Leaves of Grass:*

They know how to swim, row, wrestle, shoot, run...
They are ultimate in their own right—they are calm,
clear, well possess'd of themselves.[14]

They are the "robust equals" of men, who, in other serial paintings by Homer around 1870, ride to the summit of Mount Washington (cats. 22–23); swim at Manchester, Massachusetts (cat. 31); and, in a game at which they were the equals if not the betters of men, play croquet.[15]

Homer was utterly silent about almost every aspect of his artistic practice—about how he painted, and why he painted what he did. He did allow one thing to be known: he let George Arnold watch him paint on his studio roof and report about it in 1864, and it was surely Homer himself, in 1878, who told another critic, George W. Sheldon, that "many of his finished works," in contrast to "open-air sketches," were "painted out-doors in the sunlight, in the immediate presence of Nature."[16] Why he wanted it known that he painted out of doors, when, in fact, not all of his paintings or even all of their parts were painted in that way, is not clear. One reason may be that he knew it to be a modern method of painting. Modern in the sense that it was a novelty, a method not employed in making finished pictures before the 1860s, and unusual, as Sheldon suggested, well after that; and in the deeper sense that it was identified with the mission of modern painting: the French poet Mallarmé, writing about Manet in 1876, said "the open air... influences all modern artistic thought."[17]

fig. 38. *The Country School*, 1871. Oil on canvas. The Saint Louis Art Museum, Museum Purchase

At about the time Homer began the croquet series, another important subject, childhood, entered his art. It appeared hesitantly at first, in engravings and a few related paintings in the late 1860s, but by the early 1870s, particularly in the watercolors he began to paint in 1873, childhood had become his principal subject. After the Civil War there was something of a cult of childhood in America (it did not escape Benson; he wrote an article on "Childhood in Modern Literature" in 1869).[18] Homer's interest in the subject was an important reflection of it, although it was more fully the province of writers such as Louisa May Alcott, Thomas Bailey Aldrich, and, somewhat later, Charles Dudley Warner and Mark Twain. Perhaps its popularity stemmed from a shared sense of a lost past, or from a yearning for simplicity and innocence intensified by the moral and spiritual vacuum that followed the war;[19] or perhaps it reflected Homer's nostalgia, as he approached middle age, for his own childhood.[20] The one-room schoolhouse that he depicted, inside and out, in a series of paintings and engravings in the early 1870s (cats. 35–38; figs. 38–40), captures the longing for what was, by that time, an irrecoverable childhood. For when Homer painted them, such schools were becoming rapidly extinct, and what they stood for was in the process of preservation for future generations of Americans as the icon of the Little Red Schoolhouse: "many a boy, after years of absence from his native hills, look[ed] back to the little red schoolhouse at the forks of the road, and recall[ed] the days of his tutelage therein, with a degree of reverence," said a writer in 1873.[21]

For Homer and other American artists in the late 1860s, however, childhood was something more than an object of nostalgic longing. By the middle of the nineteenth century the condition of childhood became, as it would remain well into the twentieth century, a chief figuration of modernist inspiration and renewal. The American Pre-Raphaelite Clarence Cook wrote in 1863, "Childish simplicity and ignorance in matters of Art,…and perceptions naturally direct and true" were most pure in American art.[22] "Genius," Baudelaire wrote a little earlier, was "childhood recovered at will."[23] Following a long discussion of Homer's paintings in the 1870 Academy exhibition, a critic observed, "An artist is a being in whom the primitive man is not wholly dead" and "the child of nature lives in the artist," endowing him with the fresh, unpracticed touch of the child and its visual innocence—"the power," as another critic wrote of Homer two years later, "of looking at objects as if they had never been painted before."[24] And the boy who, in a kind of creative act, carves some letters in the schoolhouse wall in *School Time* (fig. 39), is Homer's child surrogate: the letters he carves are W. H., Homer's initials.[25]

There is another feature of Homer's early art in which it is possible to recognize a form of modernist practice. David Tatham has observed that "More than any other major American artist of his generation Winslow Homer…was a product of the Industrial Age." He meant that "a major influence in Homer's career was the mechanization of pictorial printing in the 1850s.…[It] deter-

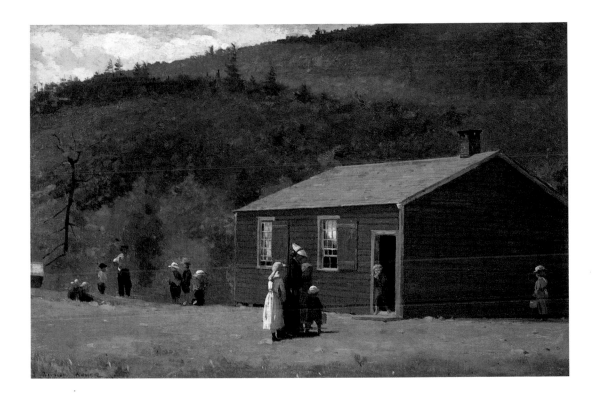

fig. 39. *School Time*, 1874. Oil on canvas. Collection of Mr. and Mrs. Paul Mellon, Upperville, Virginia

fig. 40. After Winslow Homer. "The Noon Recess." Wood engraving. In *Harper's Weekly*, 28 June 1873

mined his way of seeing and his way of recording what he saw. It gave him his first employment and it remained an essential element of his genius as a painter."[26] As the making of mechanically printed illustrations was among Homer's earliest artistic experiences, it may have affected Homer's vision and style as a graphic artist and painter, as Tatham believes. But there is another and larger sense, one more to do with the pictorial products of mechanized printing than with Homer's particular contribution to it, in which mechanized pictorial printing informed Homer's artistic practice. For Homer worked, borrowing the title of Walter Benjamin's seminal essay, in the first age of mechanical reproduction.[27] Beginning in the 1850s, steam presses and electrotyped wood engravings fostered an explosive proliferation of mechanically reproduced images, particularly in the popular illustrated weeklies—the American ones, such as *Harper's Weekly* and *Frank Leslie's Illustrated Newspaper*, to which Homer was an important contributor, and their English and French counterparts, *The Illustrated London News* and *L'Illustration*, which were also known in America (and to Homer). This new technology was followed not much later by chromolithography and photography as viable modes of pictorial distribution and dissemination. By the later 1860s the products of this image industry were so ubiquitously available that they became a mode of experience nearly equivalent to reality itself. Indeed, ranging in their imagery over the entire world, they were

broader, more varied, and in some respects more vivid than reality. It would take a half a century or so for "high art," with the appropriations of cubist collage in the first decade of the twentieth century, to acknowledge openly the artistic equivalency of this form of pictorial surrogate reality to reality itself. Yet a distinctive property of Homer's art, beginning sometime around 1870, is the correspondence between his subjects and subjects that appear concurrently in the domain of contemporary popular illustration. The correspondence is never so close to be considered an influence, but consists rather of the recurrent inclusion in Homer's high—or, in its aspiration, higher—art of subjects he and his audience knew as much through mechanically produced surrogate images as through their own immediate and private experience. Putting it simply, when Homer depicted croquet, depictions of croquet are found at the same time in the popular press (fig. 41); when he depicted Long Branch, Long Branch subjects are found there too (fig. 42); when his subject was schools, school subjects occur (fig. 43); and so on throughout the 1870s. This dialogue between high and low art is not confined to Homer's early work, nor to the subject matter it shared with popular imagery. His fishing and hunting watercolors of the 1890s are often matched in the popular lithographic prints of Currier & Ives (cat. 165 and fig. 44, and cat. 161 and fig. 184) and in chromolithographs such as those published by his friend Louis Prang (which reproduced some of Homer's works).[28] And Homer's last important painting, *Right and Left* (cat. 235), is, whatever else it might be or mean, a popular sporting image. In this connection, it is interesting that some of Homer's "high" paintings, exhibited in the formal settings of Academy exhibitions, were compared to types of popular art: in 1870, some were described as "omnibus panels and signboards," and in 1878 he was criticized for "a rawness of color that can only suggest the chromo."[29]

Mechanization touched Homer's artistic enterprise in another rather different way. By about 1870 Homer made his painted and particularly his printed images by a procedure that is remarkably akin to the distinctly American—indeed, like Homer himself, in origin specifically New

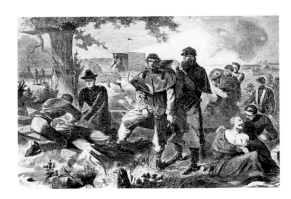

LEFT: fig. 47. John Filmer after Winslow Homer. "The Last Load." Wood engraving. In *Appleton's Journal*, 7 August 1869

CENTER: fig. 48. *Man with Scythe*, 1869? Pencil and white gouache. Cooper-Hewitt, National Design Museum, Smithsonian Institution, Gift of Charles Savage Homer, Jr. (1912-12-258) Art Resource, New York

RIGHT: fig. 49. After Winslow Homer. "Surgeon at Work at the Rear During an Engagement." Wood engraving. In *Harper's Weekly*, 12 July 1862

BELOW LEFT: fig. 50. After Winslow Homer. "George Blake's Letter." Wood engraving. In *The Galaxy*, January 1870, frontispiece

BELOW RIGHT: fig. 51. After Winslow Homer. "1860–1870." Wood engraving. In *Harper's Weekly*, 8 January 1870

England—method of mechanical industrial production. Called by its inventor, Eli Whitney, the Interchangeable System and known to Europeans as the "American system," it replaced the skilled artisan who made the entire product (gun, clock, lock, or shoe) with less experienced and less highly trained workers, or machines, that made only a particular part. Whitney described it as "a plan which is unknown in Europe & the great leading object of which is to substitute correct & effective operations of machinery for that skill of the artist [artisan] which is acquired only by long practice & experience, a species of skill not possessed in this country to any considerable extent."[30] What is suggestive in this is that Homer, who similarly lacked artistic skills "acquired only by long practice & experience," produced many of his early works by an improvised procedure more mechanical in its methods than conventionally artistic, and distinctively American, of assembling parts, often interchangeably, into larger pictorial wholes—a method less like pictorial composition than of mechanical compositing.

Examples of this interchangeability in Homer's work of the 1860s and early 1870s are many. It is found in his practice of using drawings, sometimes the same ones, in varying combinations in the production of his early prints and paintings. The state in which many of his early drawings survive, cut from larger sheets and clearly often handled, indicate their use in exactly that mechanically interchangeable way (figs. 45–46). A drawing might serve for a painting, and, with the addition of pieces that were not originally a part of it (and sometimes did not fit very precisely), for an engraving as well (cats. 24–26). Or for another engraving, he took one part from an unfinished painting, another from one of his French paintings, with the third part fashioned, it seems, for the

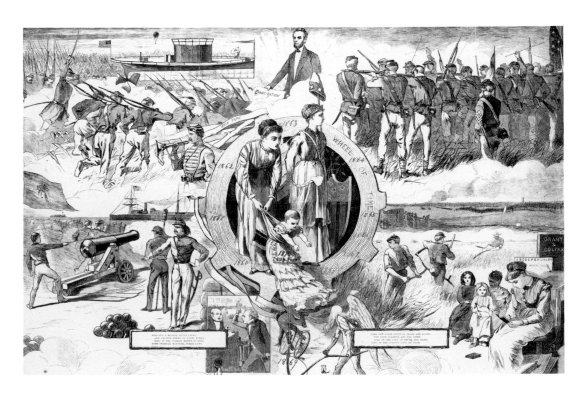

occasion (figs. 47, 48, 14). The clear stylistic discontinuity of many of his prints, because it reveals more than one hand at work in their making, is perhaps a truer—that is, less figurative—example of their manufacture (fig. 49, cat. 26). In January 1870, the figure in the illustration for "George Blake's Letter" was reinstalled with a different function in the engraving "1860–1870" (which was assembled from many other interchangeable parts as well, such as the figure of Father Time taken from *The Veteran in a New Field*) (figs. 50–51; cat. 8). An indication of how complicated the mechanism could be, and how prolonged its operation, is seen in the reuse of the central figure in the engraving "Thanksgiving-Day in the Army—After Dinner—The Wish-Bone," published in *Harper's Weekly* on 3 December 1864 (fig. 52)—in itself a refitted and, in terms of the changes in costume, reoutfitted version of *The Brierwood Pipe* exhibited earlier that same year, and, as its awkwardness suggests, a composite of different parts. Many years later, its arm reconfigured, it served for the upper part of the righthand soldier in *Officers at Camp Benton, Maryland* of 1881 (fig. 53), and shortly after that for the illustration entitled "Waiting for Breakfast. From a War-Time Sketch" (fig. 54, which used figures as well from three earlier paintings, *Sunday Morning in Virginia*, *The Carnival*, and *Upland Cotton* [cats. 81–82; and fig. 81]).

fig. 54. "Waiting for Breakfast." Wood engraving. In *Century Magazine*, 1887

NOTES

1. "His scene of negro women picking cotton is both fresh and modern as well as national in subject" ("Preparing the Pictures. The Artists' Varnishing Day," *New York Times*, 30 March 1879). "Against him the complaint cannot be urged that he does not choose modern and American subjects" (scrapbook, Bowdoin, review of the 1879 exhibition of the National Academy of Design).

2. "Modern French Painting," *Atlantic Monthly* 22 (July 1868), 90.

3. *The Painter of Modern Life and Other Essays*, ed. and trans. Jonathan Mayne (Greenwich, Connecticut, 1964), 13. Baudelaire's essay, written in 1859–1860, was first published in *Figaro* in November and December 1863.

4. "Pictures in the Private Galleries of New York. II. Gallery of John Taylor Johnston," *Putnam's Magazine* 6 (July 1870), 81.

5. Homer visited Newport in 1865 and again in 1866.

6. For an excellent discussion of this subject, see Curry 1984b.

7. "American Croquet," *The Nation* 3 (9 August 1866), 113.

8. American women's dresses, Benson wrote, "make our hotel parlors, hall, and streets, like living illustrations of Paris fashion-plates" ("Our Social Paradise," *Appleton's Journal* 3 [8 January 1870], 51). Baudelaire wrote about fashion plates at the beginning of "The Painter of Modern Life."

9. It was made an issue by lingering classicism that drew a sharp distinction between classical (historical) drapery and modern costume: "Costume varies according to place and time; it is often an affair of caprice or *fashion* [emphasis added]," as Charles Blanc explained in 1867, but "drapery…is eternal" (Charles Blanc, *The Grammar of Painting and Engraving* [1867], trans. Kate Newell Doggett [New York, 1874], 228). Homer's contemporary, James McNeill Whistler, played with the distinction as late as 1883, in his portrait of the critic Théodore Duret (supporter of such painters of modern life as Manet, Degas, and the impressionists): though he is clothed in thoroughly modern black evening dress, the pink dominoe draped over his left arm, while part of it also alludes to the classical drapery often deployed to mitigate the harshness of modern costume (as in, for example, the American sculptor William Rimmer's *Alexander Hamilton* of 1865, or Auguste Rodin's famous *Balzac*).

10. Françoise Cachin, *Manet* [exh. cat., Galeries nationales du Grand Palais; Metropolitan Museum of Art] (Paris, 1983), 126. Zola, quoted by Henri Loyrette, "Modern Life," in *Origins of Impressionism* [exh. cat., Galeries nationales du Grand Palais; Metropolitan Museum of Art] (New York, 1994), 269. One of Benson's subjects was "About Women and Dress," *Appleton's Journal* 1 (3 April 1869), 20–22. The famous scandal surrounding Manet's *Déjeuner sur l'herbe* (1863) was caused as much by the modern dress of the men as by the nakedness of the women.

11. "Modern French Painting," 95. Modern pictures are "a comment on the ideas, the tastes, the sentiments, the manners and customs, of the men and women of our epoch" ("Private Galleries," 81).

12. "Meissonier," *Appleton's Journal* 2 (11 September 1869), 119.

13. "Women's Rights," *Harper's Bazar* 1 (19 December 1868), 960.

14. "A Woman Waits for Me" (1856), *The Portable Walt Whitman*, 168. Among depictions of "The Girls of the Period" in *Harper's Bazar* in 1869 were those of swim-ming, rowing, fishing, and playing ball (2 [28 August 1869], 557); two months later Homer's "The Fishing Party" appeared in *Appleton's Journal* 2 (2 October 1869).

15. In a *Harper's Bazar* cartoon entitled "An Energetic Croquet Party Meet to Prepare Their Ground," a woman pulls a heavy roller while a frail man stands idly in the distance (*Harper's Bazar* 1 [18 July 1868], 608). Among the caricatured types of "Girls of the Period" in May 1869 is "The Croquet Girl." The accompanying poem reads: "No mortal man could e'er refuse / This maid her meed of adoration— / But humbly owns *La Belle Croqueteuse* / As good at *croquet* as flirtation" (2 [1 May 1869], 281). In the group of "The Graces of the Period" on the same page, the central "grace" plays croquet.

16. Sheldon 1878, 227.

17. Stéphane Mallarmé, "The Impressionists and Edouard Manet [1876]," in *The New Painting: Impressionism, 1874–1886* [exh. cat., Fine Arts Museums of San Francisco] (San Francisco, 1986), 32.

18. *Appleton's Journal* 1 (24 April 1869), 118–119.

19. "We are tired of the moral agitations of slavery and of the physical disorders of war; we wish for rest, we want comfort, and we are without enthusiasm…" (Eugene Benson, "To-day," *The Galaxy* 4 [November 1867], 815).

20. See Cooper 1986a, 25–27.

21. "The Little Red Schoolhouse," *Boston Evening Transcript*, 17 January 1873. "Every person from the country knows the powerful associations lingering around the old red school house….no spot in the whole world is so full of histories and memories" ("School-Children," *The Aldine* 5 [October 1872], 198). See also Fred E. H. Schroeder, "The Little Red School House," in *Icons of America* (Bowling Green, Ohio, 1978), 139–160.

22. "Introductory," *The New Path* 1 (May 1863), 1–2.

23. "The Painter of Modern Life," 8.

24. "The Annual Exhibition of the Academy," *Putnam's Magazine* 5 (June 1870), 703; "Fine Arts. Close of the Academy Exhibition. The Last Sunday," *New York Evening Post*, 6 July 1872. When the fastidious Henry James, in his famous review of the 1875 National Academy of Design exhibition, called Homer "almost barbarously simple," he was very possibly thinking of the same blend of the childish and the primitive ("On Some Pictures Lately Exhibited," *The Galaxy* 20 [July 1875], 93).

25. See Cikovsky 1986, 66–67.

26. Tatham 1992, 1.

27. "The Work of Art in the Age of Mechanical Reproduction," in *Illuminations* (New York, 1988).

28. See Katherine Morrison McClinton, *The Chromolithographs of Louis Prang* (New York, 1973).

29. "National Academy of Design," *New York World*, 24 April 1870; "Fine Arts. The National Academy Exhibition. Final Notice," *The Nation* 21 (30 May 1878), 363. If the *World's* critic unwittingly linked Homer with pop art, in the same breath he also linked him, just as unwittingly of course, to pop art's historical predecessor, abstract expressionism: "If there is any new revelation in art to be obtained by a man's shutting his eyes and rubbing all his pencils and pigments at once over a canvas in a conglomerate frenzy, Mr. Homer bids fair to revolutionize the pictorial business." Unfortunately, the paintings he referred to have not been identified or have not survived.

30. Quoted in Daniel J. Boorstin, *The Americans: The National Experience* (New York, 1965), 33.

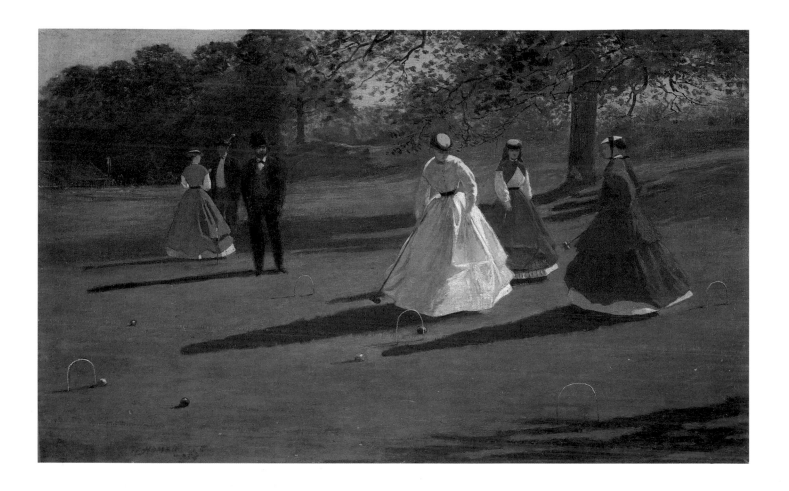

18. *Croquet Players*, 1865
oil on canvas, 40.6 x 66 (16 x 26)
Albright-Knox Art Gallery, Buffalo, New York,
Charles Clifton and James G. Forsyth Funds, 1941
Provenance: Clarence Stephens, Brooklyn and Pitts-
field, Massachusetts, by 1893 until 1920; his son, John
U. Stephens, 1920–1940; Robert W. Modaff, New
York, 1940; (M. Knoedler & Co., New York, 1940).

18–20

"This new game, played in the open air upon a
closely cut lawn, bids fair to become the most
fashionable as it is the most attractive and entic-
ing amusement of the day. The point wherein it
differs the most specially from other out-door
games is that it can be played with equal facility
by ladies and gentlemen, skill and ingenuity
being much more important to success than
mere physical strength."[1]

Croquet was part of a regimen of outdoor
exercise so often recommended about 1870 (see
below, *An Adirondack Lake*, cat. 57, and *Bridle
Path*, cat. 22) that it resembles a program for
national physical renewal and rebirth: "It is
delightful to know how the charms of out-of-
doors increase in favor with women...," a writer
for *Appleton's Journal* said in 1869. "It means the
walk, the mountain-ascent, the sail, the row, the
free scamper on sure-footed nags; it means
berrying, fishing, riding, romping, and merry-
making in fields and woods....It is important
that sometimes the sun should shine upon us,
the rains beat upon us, the winds get at us....
[C]roquet has, during the last few years, done

more than anything else to promote with young
ladies a liking for open-air games, and this is a
service in the cause of health and beauty that
deserves our unreserved approbation."[2]

When a "croquet study" (perhaps the Yale
version, cat. 19) was exhibited at Samuel P.
Avery's gallery in New York in 1866, a critic,
who thought he detected an error of drawing in
one of the figures, remarked, nevertheless, on
"how *well* the same figure is drawn, how power-
fully—how much the body is recognized inside
the preposterous and unmanageable dress!" He
made a special point, both as a matter of fashion
and as a subject of art, of the modernity of the
women's dress: "[A]s regards costume alone,
these pictures [he was also speaking of *Waverly
Oaks*, Thyssen-Bornemisza Collection] ought to
be taken care of, that our descendents may see
how the incredible female dress of the present
day actually did look, when worn by active young
women. And for the beauty of the pictures, it
could hardly have been supposed that the out-
door dress of fashionable young ladies could
have been made to 'look so well in a picture.'"[3]

19. *A Game of Croquet,* 1866
oil on canvas, 48.3 x 76.2 (19 x 30)
Yale University Art Gallery, Bequest of Stephen
Carlton Clark, B.A. 1903
Provenance: Stephen Carlton Clark.

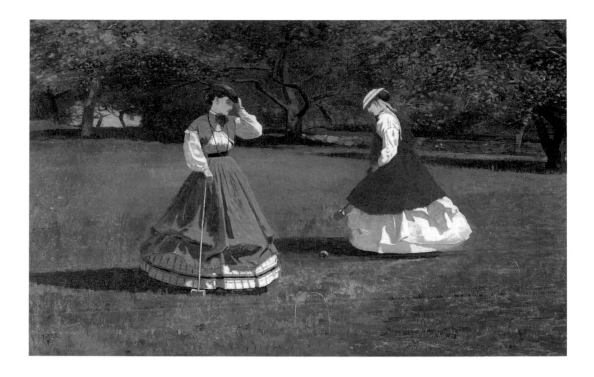

20. *Croquet Scene,* 1866
oil on canvas, 40.3 x 66.2 (15 ⅞ x 26 ¹/₁₆)
The Art Institute of Chicago, Friends of American
Art Collection, 1942.35
Provenance: William Sumner Appleton, Boston, 1871;
William Sumner Appleton, Jr., Boston, 1903; (C. D.
Childs Gallery, Boston, 1941); (M. Knoedler & Co.,
New York, after summer 1941).

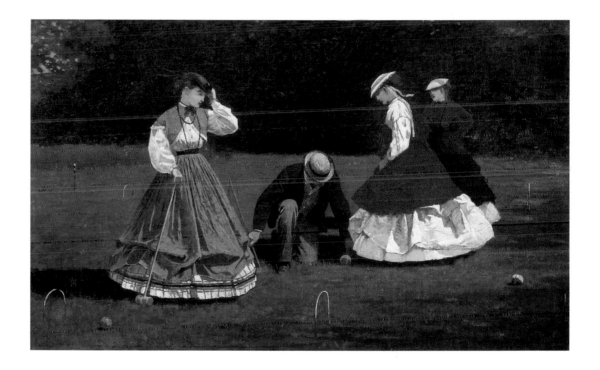

NOTES

1. "Amusements. Croquet," *The Round Table* 2 (2 July 1864), 42.

2. "Summer in the Country," *Appleton's Journal* 2 (10 May 1869), 465, illustration by Homer.

3. "Fine Arts. Pictures Elsewhere," *The Nation* 3 (15 November 1866), 395–396.

18

At some point, the figure of the man in the top hat at the left was painted out and replaced by an archery target. The outdoor sports of archery and croquet were frequently linked.

21–24

Homer's generation was the vanguard of fundamental change in American art. It was the generation (with critics like James Jackson Jarves and Eugene Benson to encourage and guide it) that challenged and eventually displaced landscape as the canonical subject of American art—the Great American Subject that had by about 1860 virtually expelled all others from the serious attention of American artists: "[I]t is hardly an exaggeration to say that rocks and stones, trees and waterfalls, have been presented to us for several years past by our artists and critics as the great moral exemplars of mankind," someone wrote in 1865. "We have heard and seen so much about the 'truth of trees,' the 'purity of pumpkin vines,' and the 'serenity of stones,' that the human in art has subsided to a secondary and insignificant position."[1]

Landscape had for years been the repository of American nationality. It was the emblem of national newness and innocence, the field of national enterprise, the historical reminder of "national infancy,"[2] and the setting of those temple-groves in which at least two generations of Americans approached the deity and learned, almost oracularly, of their national purpose and destiny. The ravaged and devastated landscape Homer depicted in such Civil War paintings as *Defiance* and *Prisoners from the Front* was a sad fact of war. But its devastation was the emblematic representation, as the Civil War was its historical one, of the damaged and crippled certainties (and pieties) of national belief that, as its principal and most perspicuous natural correlative, Americans had trustingly invested in their landscape.

There was a sense, too, that the war and its aftermath required a vehicle of artistic expression more humanistically articulate and capacious than landscape, in its very nature as Nature, was capable of being. "But composed of trees," as someone put its essential inadequacy a century earlier, there was a sense of the intellectual poverty and moral muteness of landscape art, and even of landscape itself—what Homer's witty contemporary Whistler meant, with complete seriousness, when, writing from the country, he spoke of "the blank condition of mind brought about by the continued contemplation of landscape"[3]—that made it inadequate to the expression of the values of a humanized and socialized (and simply more populated and urbanized) postwar America. One reason American artists responded so slowly to the war was that the form of art most of them cherished and practiced, landscape, could neither effectively nor affectively contain the physical and emotional feelings that war made most intense, and still

less (as Homer could do in *Defiance*, *Veteran in a New Field*, and *Prisoners from the Front*) their many shadings of conflict and complexity.

Landscape—Homer's landscape—in the years following the Civil War, the landscape he experienced and the one he depicted, unlike the unpopulated wilderness landscape that once had served as the idealized version of American nationality, was intensely populated and socialized, always filled (by their numbers, or, as in *Bridle Path, White Mountains*, by their size) with people, engaged almost always in some form of organized social behavior (games, sports, tourism). It was also a thoroughly democratized landscape, one accessible no longer only to privileged admission and private communion (fig. 57), but one that was, through "the levelling influence of railroads and carriage roads"[4] and other means of transportation (like bridle paths),[5] easily available to large numbers of visitors of wide social variety. Many people commented, not always approvingly, on the democratic social mixture of Long Branch, New Jersey, made possible largely by easy access by train and boat from Philadelphia and New York (cat. 27).[6] Accessibility, the very method of getting places, was itself Homer's subject, as in *Bridle Path*, "The Picnic Excursion" (*Appleton's Journal*, 14 August 1869), or "On the Road to Lake George" (*Appleton's Journal*, 24 July 1869) (fig. 55), and the *White Mountain Wagon* that he exhibited at the National Academy in 1870.

This, then—the cultural and sociological aspect and the intellectual climate (rife with ideological beliefs and theoretical explanations) of a distinctly new, if not as yet so distinctly formed America—was what Homer's postwar paintings did not merely reflect, but actively, positively, and with almost programmatic purpose described.

NOTES

1. "The National Academy of Design," *New York World*, 16 May 1865.

2. *The Literary World* 1 (15 May 1847), 348.

3. In Richard Dorment and Margaret F. MacDonald et al., *James McNeill Whistler* [exh. cat., Tate Gallery] (London, 1994), 172.

4. "Mount Washington," *New York Evening Post*, 15 September 1873.

5. "The triumphs of modern civilization—railroads, steamboats,…those marvellous inventions which have effected such a revolution in the world's intercourse…" ("The Age of Surface," *The Round Table* 7 [2 May 1868], 277).

6. "Boats…leave Pier 8, foot of Rector street, at 9:25 A.M. and 4 P.M., returning from Long Branch at 7:45 A.M. and 2:40 P.M. An increase of service will be made before the 1st of July, when four boats and trains will be run each way, leaving New York at 7, 9:40 A.M., 3:30 and 4:30 P.M., and Long Branch at 7:15, 8:15, and 11 A.M., and 2:45 and 4:15 A.M.…." ("Gossip from the Summer Resorts," *New York Evening Post*, 3 June 1874).

fig. 55. After Winslow Homer. "On the Road to Lake George." Wood engraving. In *Appleton's Journal*, 24 July 1869

21. *Artists Sketching in the White Mountains,* 1868
oil on panel, 24.1 x 40.3 (9 ½ x 15 ⅞)
Portland Museum of Art, Portland, Maine, Bequest
of Charles Shipman Payson, 1988.55.4
Provenance: John Fitch; his daughters, Elsie and Eliza-
beth Fitch, New York; (M. Knoedler & Co., New
York, by 1954); Mr. and Mrs. Charles Shipman
Payson, 1954.

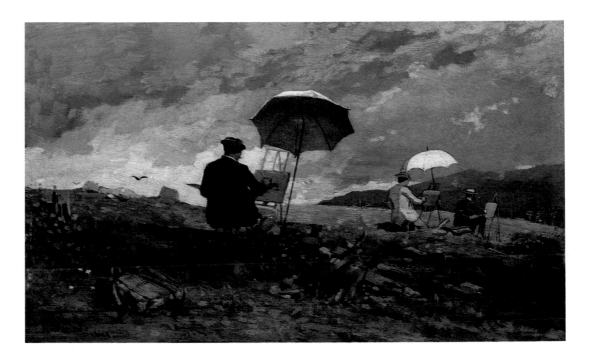

fig. 56. "Artist Sketching in the Mountains," 1869.
Wood engraving. In *Appleton's Journal,* 19 June 1869

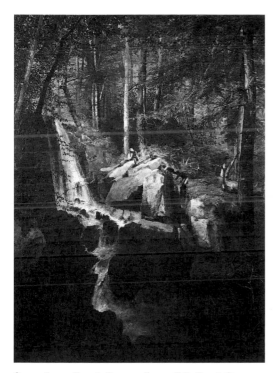

fig. 57. Jasper Francis Cropsey. *Janetta Falls, Passaic County,
New Jersey,* 1846. Oil on canvas. The Baltimore Museum of
Art, W. Clagget Emory Bequest Fund, in Memory of his
Parents, William H. Emory of A, and Martha B. Emory,
BMA 1958.14

21

Like most of Homer's White Mountain paint-
ings, the core of this one was derived from a
drawing (fig. 56). To it a figure was added at the
right, and, at the left, what may be attributes of
Homer—a knapsack in the foreground bearing
his name, and a bottle, which looks to be uncork-
ed, on a stump at the far left. Though with char-
acteristic deviousness he portrays himself from
behind, the central figure, with its porkpie hat
and moustache, closely resembles Homer (as in
a contemporary photograph, fig. 71).

If, as he seems clearly to have done, Homer,
like other artists and critics of his generation,
deliberately rejected landscape for figure and
genre painting, his image of landscape painters
at work in one of the sacred sites of American
landscape art, the White Mountains of New
Hampshire, may be understood as a satirical cri
tique of that enterprise. Homer's first years as an
artist, his first moments of artistic consciousness
at about the middle of the 1850s, coincided with
the consolidation of the American landscape
school—with Frederic Church's first great, iconi-
cally national landscape, *Niagara* of 1857 (Corco-
ran Gallery of Art), and with the first canonization
of its principles into a national theory of art in
Asher B. Durand's eight "Letters on Landscape
Painting," published in 1855 in America's first
national art journal, *The Crayon.* Even in Boston,
Homer knew about it. When he said "If a man
wants to be an artist, he should never look at
pictures," he was echoing one of the central prin-
ciples of American landscape theory; he surely

knew others. The cardinal tenet was that the
American artist should with religious devotion
study, and with faithfulness and humility depict,
"the virgin charms" of his native land (such as
"unshorn mountains") unpolluted by civiliza-
tion.[1] It is a principle figured in a painting like
Jasper Cropsey's *Janetta Falls* (fig. 57), in which
the artist is embedded in nature and engrossed
in its study. But in Homer's painting the three
artists seated one on top of the other on a heav-
ily shorn, stump-filled mountainside, polluting
themselves and nature by the bottle and its con-
tents, by showing how landscape paintings were
actually made and where, subversively mock and
call into question the sacred and solemn enter-
prise that Durand enjoined upon American
artists, and that landscape painters like Cropsey
piously obeyed.

NOTES

1. Asher B. Durand, "Letters on Landscape Painting.
Letter II.," *The Crayon* 1 (17 January 1855), 34–35.

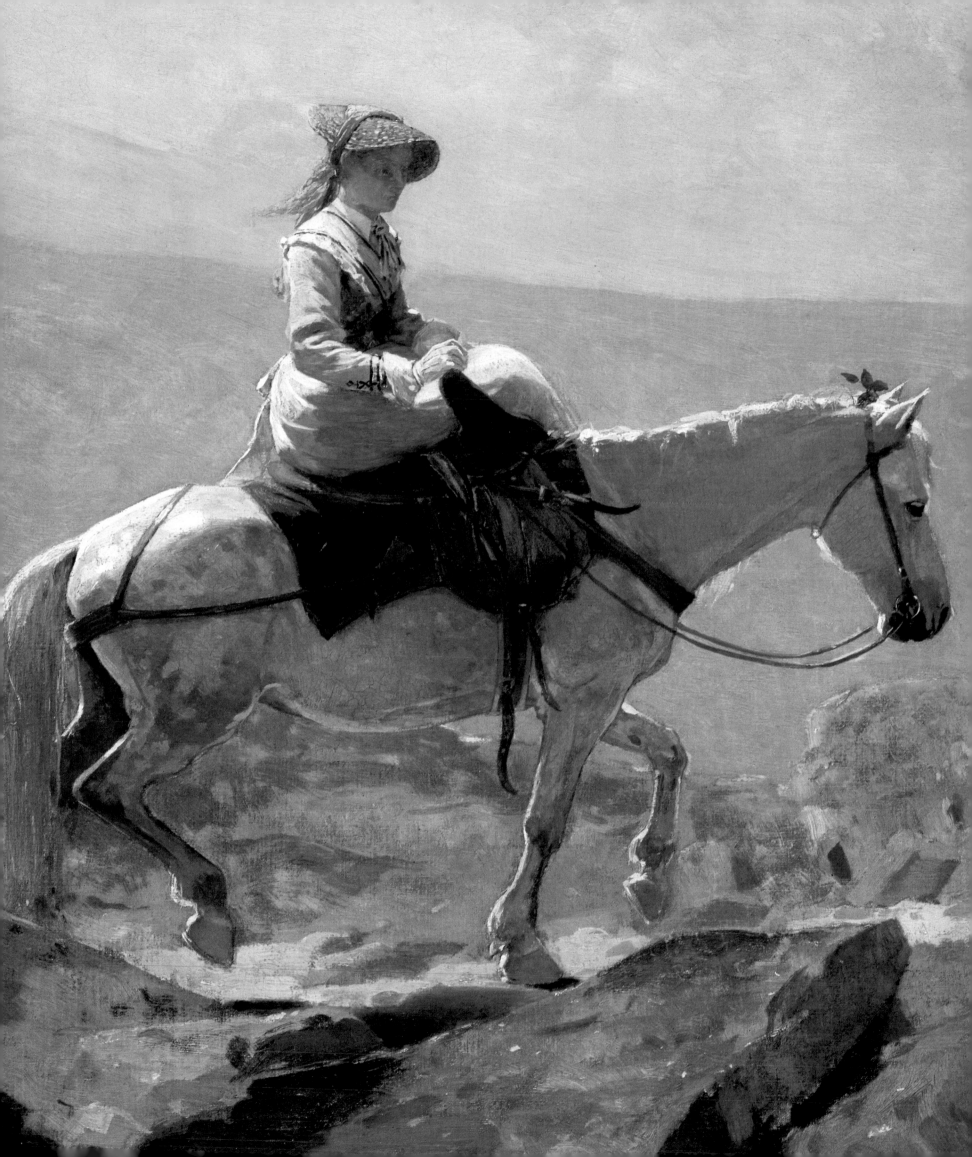

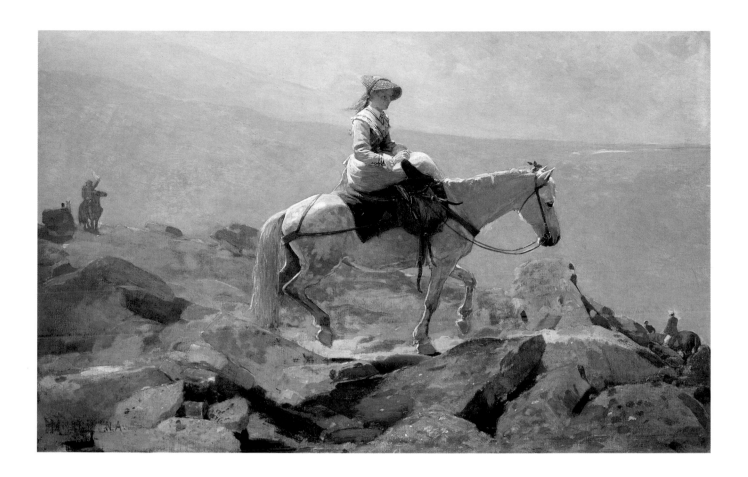

22. *Bridle Path, White Mountains,* 1868
oil on canvas, 61.3 x 96.5 (24⅛ x 38)
Sterling and Francine Clark Art Institute, Williams-
town, Massachusetts
Provenance: Martha Bennett Phelps; William George
Phelps, Binghamton, New York; by descent, Esther
Phelps Pumpelly, Oswego, New York. (Macbeth
Gallery, New York, 1937); (Milch Gallery, New York);
(Macbeth Gallery, New York); Whitney Museum of
Art, 1938; (M. Knoedler & Co., New York, 1950);
Robert Sterling Clark, 1 May 1950.

22

In 1873, when the ascent of Mount Washington
was "not so very much of an exploit," a writer in
the *New York Evening Post* looked back to the
time when "ladies only [were] allowed the privi-
lege of a horse," and when "The footpath from
the Glen or from Crawford's was…lively with
the voices of cheery pedestrians, who, it may be
remarked, were much more cheery during the
first mile or two than at any subsequent period
of the journey."[1]

Bridle Path, White Mountains touched a sensi-
tive critical nerve. One reviewer called it "a rather
eccentric picture" when he saw it at the Century
Association in November 1868.[2] Another, who
saw it at the Academy exhibition of 1870, admit-
ting that it had a "crude perverse originality,"
said nevertheless that there was "no excuse for
the exhibition of Mr. Homer's experiments in
originality; experiments"—putting his finger
squarely on the lack of finish that was a contin-
ual annoyance to Homer's critics—"which have
not yet attained the significance of pictures."[3]
Critics also found it curiously "incomprehensi-
ble." Perhaps that was because its rough, abbre-
viated modeling, its effect of atmosphere that
"conveys the impression of objects seen through
a hazy medium of some kind" and made "the

figure and the horse look like phantoms,"[4] and
the closeness of the horse and rider ("He thrusts
his scenes close up against the eye…")[5] gave it an
unexpected and aberrant appearance of flatness
that one critic compared to "omnibus panels and
sign-boards." Or perhaps it was not, or not only,
that his critics were unable visually to decipher
what Homer depicted as easily as they would have
liked, but were unable in the literary sense to
read it. "Modern art has become so dependent
upon literature," Eugene Benson wrote, that a
picture without it "may be said to be impotent"
and a "mere beginning"—which is, of course,
exactly what critics found the *Bridle Path* to be.

In all these respects, what the critics were
observing, whether they liked it or not, was the
development of Homer's style into a state of
almost idiosyncratic individuality. For Benson,
who knew and sympathized with Homer's inten-
tions—his insistent visual truth, his painterly
breadth and contempt for mindless finish, his
modernity (in these respects) of style and contem-
poraneity of subject, his artistic allegiance, his
nationality—the painting was completely clear:

It is so real, so natural, so effective, so full of light and
air; it is so individual; it is so simply, broadly, and vig-
orously drawn and painted; the action of the horse is
so good, the girl sits so well; she is so truly American,
so delicate and sunny, that, of course, you surrender

LEFT: fig. 58. *Sketch for "The Bridle Path, White Mountains."* Pencil. Cooper-Hewitt, National Design Museum, Smithsonian Institution, Gift of Charles Savage Homer, Jr. (1912–12–221). Art Resource, New York

RIGHT: fig. 59. *White Mare*, c. 1868. Oil on wood. The Cleveland Museum of Art, 1995, Bequest of Leonard C. Hanna, Jr., Fund, 58.33

yourself to the pleasure of her breezy, health-giving ride; you look at her with gusto; you see she is a little warm, perhaps too warm, from her ride up the mountain; but then she, like us, lets herself be refreshed with all the coolness and light about her, with the rising vapors that make a white, a dazzling veil between her and the shining, glittering valleys, all hidden by mist, and, as it were, under a river of light. There is something of contemporary nature, something that will never become stale; this is the picture of a man who has the seeing eye—an eye which will never suffer him to make pictures that look like "sick wallpaper," the elaborate expression of mental imbecility and mania for pre-Raphaelite art. Here is no faded, trite, flavorless figure, as if from English illustrated magazines; but an American girl out-of-doors, by an American artist with American characteristics—a picture by a man who goes direct to his object, sees its large and obvious relations, and works to express them, untroubled by the past and without thinking too curiously about the present. Mr. Homer is a positive, a real, a natural painter. His work is always good as far as it goes; and generally it falls below the standard of finish and detail which is within the reach of our most childish and mediocre painters, and which misleads many, and deceives painters with the thought that by going from particular to particular, of itself insures a fine result in art.[6]

This is one of the best early criticisms of Homer's art—better even in many ways, if less literate, than the famous assessment Henry James made of it several years later.[7]

Bridle Path, White Mountains is based on a beautiful pencil drawing inscribed "Mt. Washington / Aug. 1868" (fig. 58). It is a splendid example of Homer's characteristically painstaking attentiveness to technical detail, in this case the saddle, and to which, in this case, the horse and landscape are secondary and the rider seemingly an afterthought, added in the process of developing the drawing into the painting. Much the same hierarchy of interest is seen later in the equally beautiful drawing that, like this one, furnished the core element in *The Signal of Distress*, and to which figures were also added later (cat. 158). There is a painted study for the horse, without saddle or rider (fig. 59).

NOTES

1. "Mount Washington," *New York Evening Post*, 15 September 1873.

2. "Art Items," *New York World*, 21 November 1868.

3. "National Academy of Design," *New York World*, 24 April 1870.

4. "National Academy of Design. First Notice," *New York Evening Post*, 27 April 1870. It "conveys the impression of objects seen through a hazy medium of some kind." "Art Items," *New York World*, 21 November 1868.

5. "Fine Arts. The Landscapes at the Academy," *New York Tribune*, 30 April 1870.

6. "The Annual Exhibition of the Academy," *Putnam's Magazine* 5 (June 1870), 699, 702–703.

7. "On Some Pictures Lately Exhibited," *The Galaxy* 20 (1875), 90–91, 93–94.

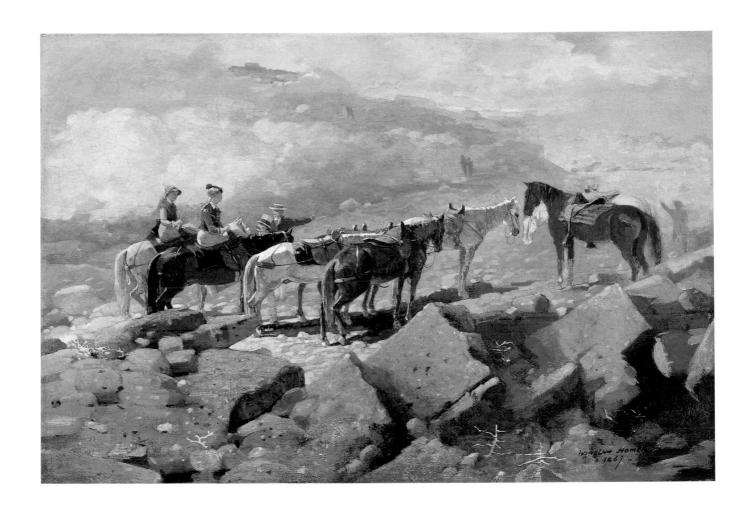

23. *Mount Washington,* 1869
oil on canvas, 41.3 x 61.8 (16 ¼ x 24 ⁵⁄₁₆)
The Art Institute of Chicago, Gift of Mrs. Richard E.
Danielson and Mrs. Chauncey McCormick, 1951.313
Provenance: Shadrack II. Pearce, Boston, Massachu-
setts, c. 1869; Mr. and Mrs. William II. S. Pearce,
Newton, Massachusetts, 1890; (Doll & Richards,
Boston, 1912); (Young's Art·Galleries, Chicago, 1912);
Mrs. Nathaniel French, 1912; Charles Deering,
Miami, 1923; Mrs. Richard E. Danielson and Mrs.
Chauncey McCormick, Chicago.

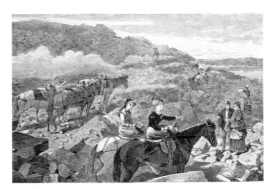

fig. 60. After Winslow Homer. "The Summit of Mount
Washington." Wood engraving. In *Harper's Weekly,* 10 July
1869

fig. 61. *Study for the Summit of
Mount Washington,* 1869.
Pencil. Cooper-Hewitt,
National Design Museum,
Smithsonian Institution, Gift
of Charles Savage Homer, Jr.
(1912–12–127). Art Resource,
New York

23

In contrast to the almost heroic monumentality
and isolation of the single figure in *Bridle Path,*
Mount Washington depicts a more typical congre-
gation of tourists at the mountain top.¹ That is
why, perhaps, Homer used it and not the other
for the engraving "The Summit of Mount
Washington," in *Harper's Weekly* on 10 July 1869
(fig. 60).

By the mechanically combinative method of
composition that Homer often employed in his
early art, *Mount Washington* was assembled from
a pencil drawing inscribed "Mt. Washington / Ho-
mer 1869" (fig. 61), into which he introduced—
or, putting it in a more fittingly mechanical way,
inserted—two additional horses and riders, one
of them lifted from the *Bridle Path,* at the left.

NOTES

1. "Art Gossip," *New York Evening Mail,* 4 May 1870.

24. *Mountain Climber Resting*, 1869
oil on canvas, 27.3 x 37.5 (10¾ x 14¼)
Private Collection, Washington, D.C.
Provenance: Chickering Piano Company, Boston,
1870. Mrs. George L. Nichols, probably before 1892;
(Anderson Galleries, New York, 6 January 1914, no.
45, as *Mountaineer Resting*); Robert M. Parker;
(Wildenstein & Co., New York, c. 1944); Mrs.
Hudleston H. Rogers, 3 October 1944; by descent,
until 1980; private collection, until 1994.

25. *Mountain Climber Resting*, 1868–1869
black and white chalk on paper, 19.6 x 35 (7⁹⁄₁₆ x 13¾)
Cooper-Hewitt, National Design Museum, Smith-
sonian Institution, Gift of Charles Savage Homer, Jr.
Provenance: Estate of the artist; Charles S. Homer, Jr.;
gift to the Cooper Union Museum for the Arts of
Decoration, 1912.

26. *"The Coolest Spot in New England—Summit of
Mount Washington,"* Harper's Bazar (23 July 1870)
wood engraving on newsprint, image: 35 x 23.3
(13¾ x 9⅛); sheet: 40 x 27.9 (15¾ x 11)
National Gallery of Art, Washington, Avalon Fund,
1986.31.208
Provenance: Emily W. Taft Collection; (David O'Neal).

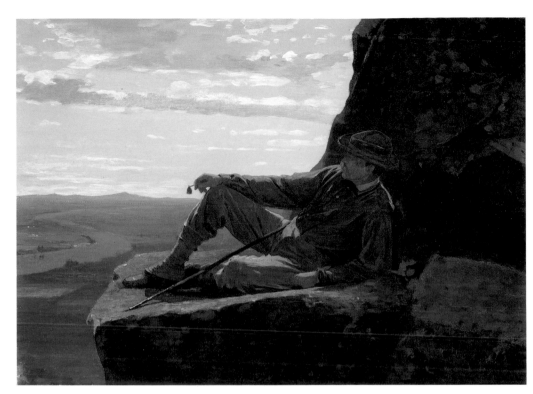

cat. 24

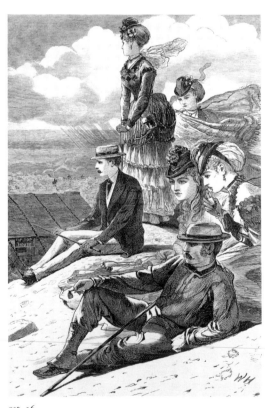

cat. 26

cat. 25

24

This painting was based, in every respect but its
size, on a chalk drawing (cat. 25). That drawing,
in turn, in a very conspicuous case of mechani-
cal pictorial assembly, was used with materials
from other sources for the wood engraving, "The
Coolest Spot in New England—Summit of
Mount Washington," published (for the vicari-
ous relief of overheated city dwellers) in *Harper's
Bazar* on 23 July 1870 (cat. 26). Homer signed
the block with his initials, but he surely did not
draw it in its entirety. The drawing of the moun-
tain climber was blackened on its back for trans-

fer, very possibly by Homer himself who used it
to draw the figure on the block. Given the clear
differences in style and the grotesque disparities
of scale between it and the other figures, it may
have been the only figure for which he himself
was directly responsible (though the women are
very Homer-like).[1]

NOTES

1. See, for example, those in "At the Spring: Saratoga,"
Hearth and Home (28 August 1869); "Tenth Command-
ment," *Harper's Weekly* (12 March 1870) (fig. 180); "On
the Bluff at Long Branch, at the Bathing Hour," *Harper's
Weekly* (6 August 1870) (fig. 64).

27. *Long Branch, New Jersey,* 1869
oil on canvas, 40.6 x 55.2 (16 x 21¼)
Museum of Fine Arts, Boston, The Hayden Collection, 41.631
Provenance: Robert Vonnoh, Philadelphia, before 1906;
Sherrill Babcock, New York.

27

The morning was bright and sunlit....

We strolled on toward the south, taking a yellow gravel path that led along the top of the cliff close to its edge.

On our left was an immense expanse of ocean, unbroken by islands, or by any land whatever. It came on in long, deliberate swells, and fell languidly but heavily upon the silvered beach....

Upon the cliff where we walked was a large number of rough plank pavilions, painted in various colors. These contained seats, facing the sea, that at that hour were filled with a strange multitude.

fig. 62. William Powell Frith, *Ramsgate Sands: "Life at the Seaside,"* 1854. Oil on canvas. The Royal Collection © 1995, Her Majesty Queen Elizabeth II

It was strange in that it defied classification among multitudes that gather at other watering-places under similar circumstances.

It was composed of nearly every ingredient that ever entered into the composition of a well-dressed mob, and it presented no character except absolute incongruousness.

It was only necessary to bring to mind any class of people to discover its representatives within a stone's-throw. It was easy to detect them by the quality of their cigars, the outline of their features, the comparative obtrusiveness of their attire, the freedom of their tongues, the latitude of their grammatical idioms, and the eccentricity of their positions. The air was full of loud laughter, and there was a flaming newness to all the hats and gowns that dazzled the eyes, and made one think of a modiste's pattern-plate come to life.[1]

Certainly there are not many places where Fashion can be found purer and less adulterated than at Long Branch, where one gets so little else.

...there must be a subtle, potent charm in a place which yearly attracts thousands of pleasure-seekers and is rapidly coming to rank first among the watering-places of the Union. Less brilliant, perhaps, than Saratoga, less select than Newport, it is probably gayer than either, and certainly quite as popular.[2]

...Its nearness to the metropolis [New York]...puts it under the peculiar disadvantages of a place accessible to the "rough-scuff" for a day's pleasuring....The atmosphere of the place is sensuous, crass, and earthy....Wealth there is in plenty, but it is the wealth of the

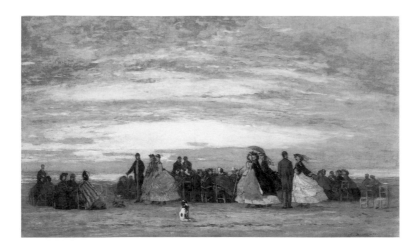

fig. 63. Eugène Boudin. *The Beach at Villerville*, 1864. Oil on canvas. National Gallery of Art, Washington, Chester Dale Collection

nouveaux riches, who have earned their money a good deal faster than they have learned how to spend it, and who have an idea that if their diamonds sparkle their talk may well be dull, and that the richness of their gowns will atone for the poverty of their mental furniture....[3]

Representatives of all classes are to be met, heavy merchants, railroad magnates, distinguished soldiers, editors, musicians, politicians and divines, and all are on an easy level of temporary equality.[4]

Long Branch is *sui generis;* and it is perhaps better in accord with the spirit of American institutions than any other of our watering-places. It is more republican...because within its bounds the extremes of our life meet more freely.[5]

Each civilized epoch seems to have left us the husks of its taste in which to sheathe our softest flesh. The sweetest bud of Republicanism, the most *piquante* daughter of New England, the most dazzling dame of New York, promenades under such compositie costumes, that we question whether she be infatuated with Chou Chou, Pompadour, or Eugénie.

Charming democrats we have in the women of the land. But how religiously they go out of it to seek their fashions! With what jealous reverence they shun the costume of the women of the [French] Revolution, and how carefully they refrain from inventing or adopting a national and simple dress which we can look at without being reminded of the license, and corruption, and folly of Continental life![6]

None of Homer's paintings of this period exemplifies quite as well as this one the "modern and democratic" character of his art. Although it has often been enlisted in the argument for impressionist influence upon him, the stress upon the undeniably vivid reality of the painting's natural light has tended to obscure the even stronger, and more intensely real, light of pictorial sociological description that Homer so brilliantly throws upon the subject.

fig. 64. After Winslow Homer. "On the Bluff at Long Branch, at the Bathing Hour." Engraving. In *Harper's Weekly,* 6 August 1870

Beach scenes, because they were such a distinctly modern phenomenon, lent themselves particularly well to the pictorial sociological analysis of modern life. The English painter William Powell Frith understood exactly that when he embarked on his *Ramsgate Sands* (1854; fig. 62): "Weary of [historical and literary] costume painting," he wrote in his autobiography, "I had determined to try my hand on modern life, with all its drawbacks of unpicturesque dress. The variety of character on Ramsgate Sands attracted me—all sorts of conditions of men and women were there."[7] And Eugène Boudin, the most dedicated portrayer of beach scenes (fig. 63), wrote in 1868 of "daring to include the things and people of our own times in my pictures, for having found a way of making acceptable men in overcoats and women in waterproofs...don't these bourgeois...have the right to be fixed on canvas, *to be brought to the light.*"[8]

Homer designed two Long Branch engravings: "On the Bluff at Long Branch, at the Bathing Hour," *Harper's Weekly* (6 August 1870) (fig. 64), illustrates from a different viewpoint and with graphic exaggeration the subject of his painting. "The Beach at Long Branch," *Appleton's Journal* (21 August 1869) (fig. 218), however, illustrates the other principal field of activity at Long Branch, the beach, and the activity that commonly took place there: "Many a heart has been lost in the surf here....The surf and flirtation make the main business of life at the Branch, with a slight advantage in favor of the latter."[9]

NOTES

1. "American Summer Resorts. VII. Long Branch," *Appleton's Journal* 12 (3 October 1874), 431.

2. "Long Branch," *The Round Table* 6 (6 July 1867), 8.

3. "Long Branch—The American Boulogne," *Every Saturday* [Boston] 3 (26 August 1871), 215.

4. "The Watering Places. Long Branch," *New York Evening Post,* 28 July 1868.

5. "Olive Logan," "Life at Long Branch," *Harper's Magazine* 53 (September 1876), 482.

6. Eugene Benson, "About Women and Dress," *Appleton's Journal* 1 (3 April 1869), 20.

7. *My Autobiography and Reminiscences* (London, 1887), 1: 243.

8. Quoted in John House, "Boudin's Modernity," in Vivien Hamilton, *Boudin at Trouville* [exh. cat., Glasgow Museums] (Glasgow, 1992), 20.

9. *Round Table* 6 (6 July 1867), 8.

28–29

At the winter exhibition of the National Academy of Design in 1869, Homer exhibited what one critic called "a Watering-place deformity" entitled *Low Tide*. "Conspicuous in the foreground are several pairs of boots painted to life," the *New York Tribune's* critic wrote. "The owners, not so much taller than the boots, are dabbling in the water a few rods off, apparently. There is no sense of distance to justify the smallness of the figures or the unwaterishness of the waves. Nothing but an evident honesty of intention—a purpose to paint just what the eye saw, neither more nor less—saves the painting from being slightly ludicrous."[1]

"We would pass this by without a word of comment were it not evidently a picture which by its size and show of color challenges criticism, even as the impress of an unclean hand upon a newly painted wall does," wrote a very critical reviewer in the *New York Mail*. "How an artist of acknowledged worth in a certain field of art, could permit this horror to leave his studio is simply incomprehensible to us." He then went on to describe it:

Here we have three grand horizontal layers of color—like rock strata. The upper is of brownish gray and dirty white with a suggestion of vermillion now and then—like the marble of Brachificari. This is the sky. The next lower level is of dark greenish blue, like some coal layers we have seen. On this there are dashes of flake white here and there which remind us of the story of how the artist succeeded in getting the foam on the mouth of a mad dog he was painting—by throwing his dirty sponge in indignation at the canvas. This second layer is the sea. The third is a belt of brown of many shades, and this is the beach; and to do it justice it looks like a beach, but it is the only division of the picture which taken apart has any evidence of design in it. The rest suggests unhappy accident on canvas only. On the wet sand, and on the dry sand, and further out toward those mysterious white places, are children bathing or about to bathe....But

among these figures is one to whose presence we object. It is of a young lady, with her back towards us and her hair in charming *negligé*, who stands close to where the water is supposed to be coming in and looks on. We don't object to her presence because her back is towards us, but because of her height—she is seven feet tall. Now, we don't believe that any young lady of her age of that height was down there.... On the strand are children's boots and things, and these and the strata make up a picture which covers some twelve square feet of canvas at the least.[2]

No painting of this description or of this size now survives, but there are at least two remnants of it. One is the Thyssen *Beach Scene* (cat. 28). It corresponds exactly to the critic's description of "children bathing or about to bathe" and the disproportionately tall young girl with her back to the viewer, "her hair in charming *negligé*." And, as the surviving head and shoulders of a bending child at the lower-right edge indicates (she is seen complete, though in reverse, in the center of fig. 66), it has obviously been cut from a larger canvas. The other surviving part is the Canajoharie *On the Beach* (cat. 29). To it, the Thyssen *Beach Scene* fits perfectly at the left, and allowing for cutting down at top, bottom, and sides, and allowing, too, for some approximation in the size the critic gave for the original *On the Beach at Long Branch*, joining cats. 28 and 29 together would produce a painting approaching a dimension of twelve feet square (fig. 67).[3]

On 6 August 1870, two companion engravings were published in the periodical *Every Saturday*. One, *High Tide* (fig. 65), was made with some slight changes after *Eagle Head, Manchester, Massachusetts* (cat. 31). The other, *Low Tide* (fig. 66), containing as it does figure groups from both cats. 28 and 29 as well as "children's boots and things," was apparently made after the dismembered *On the Beach at Long Branch*. The first owner of *High Tide-Eagle Head*, William F. Milton, after acquiring it "promptly" in 1870, wanted to acquire its "companion picture," *Low Tide*, which "showed bathers and a number of bare-legged children frisking on the beach." But

LEFT: fig. 65. After Winslow Homer. "High Tide." Wood engraving. In *Every Saturday: An Illustrated Journal of Choice Reading*, 6 August 1870

RIGHT: fig. 66. Kingdon after Winslow Homer. "Low Tide." Engraving. In *Every Saturday: An Illustrated Journal of Choice Reading*, 6 August 1870

28. **Beach Scene,** 1869
oil on canvas, 29.2 x 24.1 (11 ½ x 9 ½)
Thyssen-Bornemisza Collection
Provenance: Charles S. Homer, Jr.; Alan H. Morrill;
Allan Donald Morrill; Ophelia Reed Morrill; private
collection, Hampton, New Hampshire; (Vose Gal-
leries, Boston, 1979); private collection, Lincoln,
Nebraska; (Vose Galleries, Boston, 1984).

29. **On the Beach,** 1869
oil on canvas, 40.6 x 63.5 (16 x 25)
Canajoharie Library and Art Gallery
Provenance: Arthur P. Homer; (Macbeth Gallery, New
York, 1932).

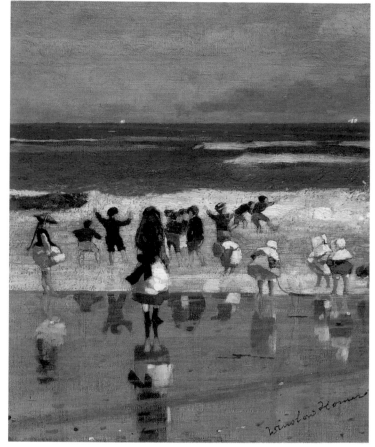

cat. 28

cat. 29

fig. 67. Possible reconstruction of *Low Tide*

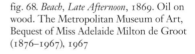

when he "went to Homer's studio a year or two later to buy *Low Tide*, he was told that the picture had been painted out and the canvas used over again for some new subject."[4] It does not matter that the painting was not painted out—though parts of it were, such as a figure at the right of cat. 28 whose legs remain reflected in the wet sand, and in cat. 29, a figure group in front of the breaking wave at the right of which a reflection also remains—but, as Homer may have been unwilling to admit to Mr. Milton, cut up; what does matter is that a few years after it was painted, or maybe sooner, it no longer existed in its original form.

Homer's original conception of the painting, and its shape, is preserved in the oil sketch now titled, descriptively, *The Beach, Late Afternoon* (fig. 68), datable to about 1869.[5]

Why Homer cut up the painting is not known. One reason for his doing so, however, may have been that it was not only criticized severely as a "horror" and a "deformity," but that he took literally the observation of the critic who, though he did not like it as a whole, said it was redeemed somewhat ("it would not be the work of Homer if it had not a lurking charm somewhere") by its parts being "charmingly-posed little pictures in themselves."

NOTES

1. "National Academy of Design. Winter Exhibition," *New York Tribune*, 4 December 1869.

2. "Fine Arts. The Winter Exhibition of the National Academy of Design," *New York Mail*, 6 November 1869.

3. Lloyd Goodrich (1973, 61) noted their relationship, though more as one of similarity than identity, when he reproduced them one above the other.

4. As reported by Mrs. Milton, in H[arry]. B. W[ehle], "Two More Early Paintings by Homer," *Bulletin of the Metropolitan Museum of Art* 18 (April 1923), 85.

5. When it was donated to the Carnegie Institute, Pittsburgh, by Mrs. Charles S. Homer, Jr. (Homer's sister-in-law), an oil sketch of a white horse, now separated from it and in the collection of The Cleveland Museum of Art (fig. 59), was on its back. Now dated 1872, it so clearly resembles the horse in *Bridle Path, White Mountains*, painted in 1868 (cat. 22) that *The Beach, Late Afternoon* must have been made at about the same time.

fig. 68. *Beach, Late Afternoon*, 1869. Oil on wood. The Metropolitan Museum of Art, Bequest of Miss Adelaide Milton de Groot (1876–1967), 1967

30. **By the Shore,** 1870s
oil on canvas, 24.1 x 25.4 (9 ½ x 10)
Private Collection, Courtesy of The Gerald Peters
Gallery, Santa Fe, New Mexico
Provenance: Edward Hooper, Boston; his daughter,
Mabel Hooper La Farge; her son, Thomas La Farge;
his wife, Marie La Farge.
Washington and New York only

30

Like the Thyssen *Beach Scene* (cat. 28), this painting too was cut down from a larger one, although on the grounds of style and scale it does not seem to have been the same one. It does seem related to the same creative moment, and in some way to the same or to a closely similar project. Like it, too, it is a "charmingly posed" little picture in itself.

Although Homer's surviving paintings of the late 1860s and 1870s are never very large and usually very simply composed, he apparently harbored an ambition at this time, though it was not consummated until the 1880s, to paint larger and conventionally more elaborate paintings than the ones he actually made or that remain intact. The large, spirited chalk drawings he made during the Civil War must have been created with a large and animated battle picture in mind, but of a kind he never made (figs. 21–22); that figures based on these drawings occur only in the largest and compositionally most complex of his Civil War paintings, *Pitching Quoits* of 1865 (cat. 7), is the token of that mostly unrealized ambition.[1] So, also, perhaps are these parts of an even more ambitiously large—and, it seems, at this point in Homer's artistic development ultimately too ambitiously large—bathing picture.

NOTES

1. On *Pitching Quoits*, see Simpson et al. 1988, 208–215. See also Cikovsky 1990c, 95–98.

31. **Eagle Head, Manchester, Massachusetts,** 1870
oil on canvas, 66 x 96.5 (26 x 38)
The Metropolitan Museum of Art, Gift of Mrs.
William F. Milton, 1923
Provenance: William F. Milton, New York and Pitts-
field, Massachusetts, by 1871 to 1905; his wife, Mrs.
William F. Milton, 1905 -1923.

fig. 69. Edouard Manet. *Olympia*, 1863.
Oil on canvas. Musée du Louvre, Paris

BELOW: fig. 70. Titian. *Sacred and Profane Love*,
c. 1514. Oil on canvas. Galleria Borghese, Rome

31

"Winslow Homer has been industrious and
courageous. His Beach Scenes attract and rivet
attention by their vivid presentation of things, as
they appear to the naked eye. There is no flinch-
ing from his realism, however the uninitiated
may flinch from it."[1]

Eagle Head, Manchester, Massachusetts (Eagle
Head is the landscape formation in the distance)
hung together with *Bridle Path, White Mountains*
in the 1870 National Academy of Design exhi-
bition, and, because of its somewhat *risqué* sub-
ject, pleased the critics even less than it did.

"There is a daring about the composition
and a vigor of treatment suggestive of power;
but to our mind it is power most sadly abused.
The subject is of questionable taste, to begin
with, and conceding to it the merits we have
named, there is nothing left but that which dis-
appoints us."[2]

"…Mr. Homer's 'Eagle Head, Manchester,
Mass.,' representing three females on a beach,
attired in the customary bathing dresses of a sea-
side watering-place, and appearing as ludicrous
as it is possible to make them. It is probably a
satire on the fashionable eccentricities of Grecian
beads and other modern dress addenda. But what
a pity to see such trifling subjects from a really
clever hand!"[3]

32. *On the Beach at Marshfield,* c. 1872
oil on canvas, 33.7 x 54.6 (13 ¼ x 21 ½)
Collection of Joyce and Erving Wolf
Provenance: Arthur B. Homer, 1911; Chester J. Robertson, 1951; Allen E. Robertson, 1958–1959; (Davis & Long Co., New York, 1980); private collection, 1980–1988; (Davis & Langdale Co., New York, 1988).
Washington and New York only

"…a very grotesque and downright representation of a couple of bathers, of the female persuasion, who have just issued from the waves. They are somewhat scantily clad, their lower limbs especially suggesting the time-honored joke about the *Bare-knees* (Bernese) costume…. [The figure] comfortably seated on the level beach…is a fair representation of 'the girl of the period.'"[4]

What these critics noticed but could not admire as a virtue or valid artistic purpose was the painting's assertive modernity, of which, as in Manet's *Olympia* of 1863 (fig. 69), its frank sexuality (its "questionable taste") was the most disturbing part. The critic who invoked *Prisoners from The Front* as the standard from which Homer had departed in *Eagle Head* was not prepared to see it as that painting's postwar counterpart and continuance, in the same form of the costume piece (in this case the "out-door dress of fashionable young ladies" instead of military uniforms) by which Homer analytically represented modern life.

The print after *Eagle Head*, "High Tide" (fig. 65), appeared in *Every Saturday* (published in Boston) on the same date, 6 August 1870, that "On the Bluff at Long Branch" (fig. 64) appeared in *Harper's Weekly* (published in New York). In view of the repeatedly unfavorable contrasts drawn between the vulgarity of Long Branch and the refinement of its New England counterpart, Newport, this is perhaps the contrast that Homer drew as well between the overdressed artificiality of the women at Long Branch and the more simple and natural (though not quite nude) women at a watering place in Massachusetts—the contrast between

overdressed vice and naked virtue that Titian made in his *Sacred and Profane Love* (fig. 70).

NOTES

1. "The Academy of Design. The Opening of the Season," *New York Tribune*, 15 April 1870.

2. "Art Gossip," *New York Evening Mail*, 4 May 1870.

3. "National Academy of Design," *New York Evening Post*, 27 April 1870.

4. "Porte-Plume," "More About Pictures and Painters," *The Citizen and Round Table* 6 (14 May 1870), 854–855.

32–34

The relationship between Homer's paintings and prints usually takes this form in two respects: first, the painting precedes the print (as can be seen in this case in the reversal by the printing process of the group of the two figures and the boat on the beach); and second, in making literal and literary in the print what is allowed to remain allusive and even ambiguous in the oil.

The painting preceded the print, so it must have been made before its publication in August 1872. The central figure in the print was based, in the arrangement of its upper part, though not in its dress, on a drawing (cat. 33). To this drawing Homer later added a quickly sketched female nude seen from behind, which may be related in some way to his bathing subjects, or may have had some deeper connection in his mind to the print for which the sheet that includes it was used.

Marshfield, Massachusetts, is located on the south shore of Boston. A photograph of Homer and his dog Jack is said to have been taken at Marshfield in 1869 (fig. 71).

33. ***Three Studies of Women,*** 1865–1868
pencil and charcoal on paper, 28.6 x 15.3 (11 ¼ x 6)
Addison Gallery of American Art, Phillips Academy,
Andover, Massachusetts
Provenance: Mary D. and Arthur L. Williston.
Washington and New York only

34. ***"On the Beach—Two Are Company, Three Are
None"***
wood engraving, *Harper's Weekly* (17 August 1872)
image: 23.3 x 35.2 (9 ⅛ x 13 ¹³⁄₁₆); sheet: 28.2 x 40.1
(11 ⅛ x 15 ¾)
National Gallery of Art, Washington, Avalon Fund,
1986.31.111
Provenance: Emily W. Taft Collection; (David O'Neal).
Washington and New York only

fig. 71. *Winslow Homer and his dog Jack, in Marshfield, Massachusetts, 1869.* Bowdoin
College Museum of Art, Brunswick, Maine, 1964.69.179.2, Gift of the Homer Family

cat. 33

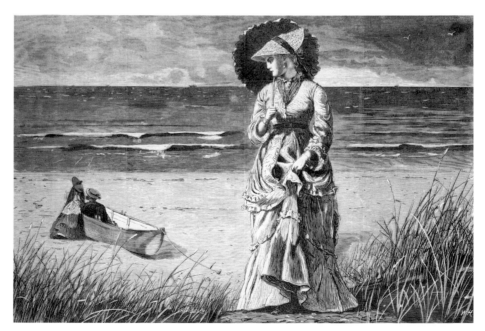

cat. 34

35–38

In the early 1870s Homer painted one of his most extensive serial projects. Its subject was the country school, which he published or exhibited in eight paintings and two engravings in the period 1871–1874. It was, like all of Homer's early subjects, a timely one. At this moment there was a good deal of nostalgia about early rural education: Edward Eggleston's *The Hoosier School-Master,* published in 1871, was set in the 1840s, and this was the time, when country schools were rapidly disappearing ("while there are yet a few left of the school-houses so abundant fifty years ago," a writer said in 1871, "they are the rare exceptions"),[1] that the Little Red Schoolhouse was canonized as a national icon. The critic of the *New York Evening Express* "welcomed" one of Homer's school paintings, *The Country School* (fig. 38), "as a picture thoroughly national" that showed "a thorough acquaintance with our life as a people…,"[2] for as everyone recognized, the American public school was canonically national. Even school buildings were "purely American; the unadulterated product of our peculiar civilization."[3] Homer, of course, was completely aware of the subject's meaning. In the 1878 Paris Exposition he represented the United States by two classes of subjects that were clearly national: depictions of blacks (*The Bright Side, Visit from the Old Mistress,* and *Sunday Morning in Virginia,* cats. 6, 80–81), and schools (*The Country School,* fig. 38, and *Snap the Whip,* cat. 37).

It was also, in a number of respects, a particularly modern subject. The woman teacher in *Country School* and *The Noon Recess* was a novelty about 1870, for the "capture of the common school" by woman teachers, as a writer pointed out in 1872, was "one of the most vital social changes wrought by our great civil war" as "large numbers of our schoolmasters went off to war and never came home." The result was that by about 1870, "our American common school [was] almost exclusively in the charge of women."[4] Earlier, when largely conducted by men, teaching "was disdainfully regarded as among the humblest and most unprofitable of callings," and "whenever a shiftless vagabond was found to be good for nothing else, he would resort to *school-keeping….*"[5] The modern woman teacher, however, particularly when she had a normal-school training (as she did increasingly after the middle of the century), brought to teaching a professional competence, dignity, and sense of vocation that was new to it.

By the time Homer painted his school subjects in the early 1870s, a modern, reformed educational policy had taken effect. Descended from the Enlightenment understanding of man-kind as morally neutral, not innately sinful, and more precisely from the educational philosophy of Jean Jacques Rousseau and the ideas and methods of his follower Johann Heinrich Pestalozzi, education was to be a matter so far as it was possible of unfettered natural development, not disciplined conformity, and a pleasurable activity in which children were treated with considerate kindness and allowed latitude for natural growth. All of Homer's school paintings reflect, or more actively exemplify, this modern educational practice—the schoolroom, with its stress on instruction rather than punishment (and on the special endowments of the woman teacher, who, "usually young, modest, timid, yet controls with a natural and acquired skill the throng of children by whom she is encircled");[6] *The Noon Recess,* with its enlightened, kindly discipline, that is as much punishment for the teacher as for her pupil; and *Snap the Whip,* with its free expression and explosively liberated natural energy that is a perfect emblem of everything modern pedagogy aspired to accomplish—and of the essential conception of childhood upon which it was founded.

NOTES

1. "The Old School-House and the New; or, Fifty Years Ago and To-Day," *American Educational Monthly* 8 (October 1871), 484.

2. "Art Matters. The Academy Exhibition. (Second Article), North Room," *New York Evening Express,* 18 April 1872.

3. "School-House Architecture—No. 2," *New-England Journal of Education* 3 (18 March 1876), 134.

4. "The Schoolmaster," *The Ohio Educational Monthly* 21 (August 1872), 261–262.

5. "The Old School-House," 476.

6. "The New School-Mistress," *Harper's Weekly* 17 (20 September 1873), 817.

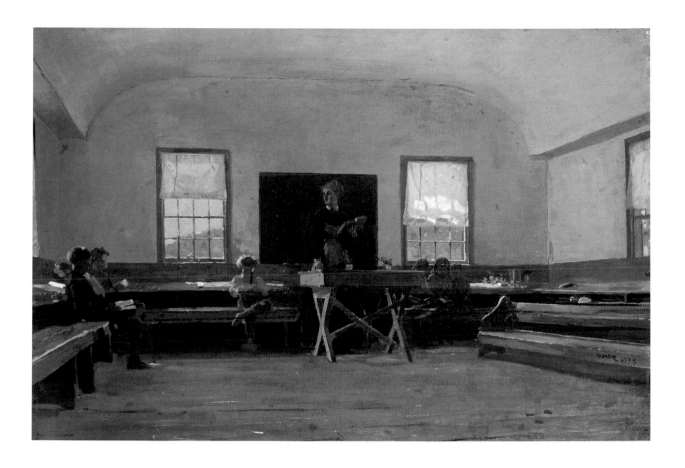

35. *Country School,* 1871–1872
oil on canvas, 30.2 x 45.1 (11 ⅞ x 17 ¾)
Addison Gallery of American Art, Phillips Academy,
Andover, Massachusetts
Provenance: Thomas B. Clarke, New York; United States
Printing and Lithographing Co., New York; (New-
house Gallery, New York and St. Louis); (William
Macbeth, New York); Thomas Cochran, New York,
17 March 1928.
Washington only

35

A smaller, somewhat abbreviated version of
The Country School that Homer exhibited at the
National Academy of Design in 1872, this paint-
ing shows the interior of the schoolhouse in *Snap
the Whip* (cats. 37, 38) and, through the win-
dows, the landscape of *The Noon Recess* (cat. 36).

Homer found its subject, as he did those of
the other paintings in the school series, begin-
ning in June 1871 during the "summer among
the Catskills," some part of which he spent in the
vicinity of Hurley, New York, near Kingston
(see cat. 56).[1] One writer was very specific about
the season, day, and hour Homer depicted: "It is
not the crowded winter school, but the compar-
atively empty room which marks late spring or
early summer in the rural districts. We are con-
vinced that it must be near the close of the term,
or about half-past eleven on Saturday forenoon,
when everybody is tired and longs to be out in
the sunny air, on the hill-sides of which we catch
a glimpse through the windows."[2]

NOTES

1. "Art Notes," *New York Evening Post,* 7 June 1871. When
The Country School was sold by its first owner, John H.
Sherwood, in 1879, it was called *A Country School-room in
the Catskills.*

2. "The Spring Exhibition," *The Christian Union* 5 (17
April 1872), 336.

36

The Noon Recess depicts the same schoolroom as
Country School (cat. 35), the same teacher, and the
same reading boy. The view out of the window
differs, with a group of actively playing boys, and
with a landscape that resembles *Snap the Whip*
(cat. 37).

When it was published in nearly identical
form in the 28 June 1873 issue of *Harper's Weekly,*
it included two details not apparent in the paint-
ed version (fig. 40). One is a map of the Western
Hemisphere on the wall behind the teacher.
Homer's contemporaries would have understood
it as well as the blackboard to be signs and sig-
nals of education reform. Earlier, when schools
were mostly "juvenile penitentiaries," not places
of serious study, instructional equipment like
blackboards, maps, and globes was virtually
unknown: "Of apparatus or appliances for aid-
ing in the work of instruction there were none,
except the well-seasoned hickory rod,"[1] some-
one recalled his district school about 1830. Far
from being merely incidental pieces of school
furniture, therefore, the map and blackboard
were in their time symbols—comparable in the
clarity of their very different meaning to the
hickory rod—of enlightened public education.[2]

In the *Harper's* engraving, the blackboard
contains legible numbers and the letters of the

36. *The Noon Recess,* 1873
oil on canvas, 23.5 x 35.9 (9¼ x 14⅛)
The Warner Collection of Gulf States Paper Corporation, Tuscaloosa, Alabama
Provenance: Nathan Clifford Brown, Portland, Maine; his sister, Mrs. Frank True, Portland, Maine; (Macbeth Gallery, New York); Stephen Carlton Clark, New York; Edwin D. Hewitt, New York; (M. Knoedler & Co., New York). Miss Lucy Aldrich, Providence, Rhode Island. (Firestone & Parsons, Boston). (Christie's, New York, 26 May 1993, no. 36).

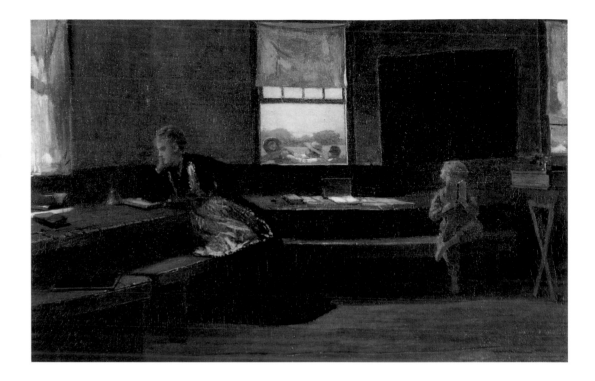

alphabet to H. On the blackboard, Homer, like a mischievous school child, inscribed his own initials (as he inscribed his name on the blackboard later in *Blackboard,* cat. 85, and as his surrogate inscribes or carves his initials on the schoolhouse wall in *School Time,* fig. 39).

NOTES

1. "The Old School-House and the New; or, Fifty Years Ago and To-Day," *American Educational Monthly* 8 (October 1871), 474, 479.

2. "Old School-House," 479.

37

"A few more days and [the artists] will all be gone [to the country] excepting possibly the genre painters, who will seize the time to capture the idle gamins of the street to pose for their canvas," a visitor to Homer's studio in June 1872 wrote. "This," he continued, providing a rare insight into Homer's painting method, "is what Winslow Homer proposes to do to procure models for the childish games he intends to play in oil. A group of boys are [sic] engaged in snapping the whip before an old red school house door."[1]

NOTES

1. "The Realm of Art. Gossip Among the Brushes, Mahlsticks and Easels," *New York Evening Telegram,* 8 June 1872.

38

Apart from its size and shape, this smaller version of *Snap the Whip* differs most noticeably from the other in its landscape setting. Originally, however, as infrared reflectography reveals (fig. 72), it had the same mountainous landscape background which at some point Homer, for a reason not known, went to the considerable trouble of painting out. The schoolhouse in both versions resembles that in *School Time* (fig. 39), but in this version the two boys who were up to something by the schoolhouse wall, whom Homer also painted out (fig. 73), resemble the single figure inscribing Homer's initials on the wall in *School Time* (fig. 39).

The double-page engraved version of cat. 37 in *Harper's Weekly* (20 September 1873), has made it one of Homer's classic images.

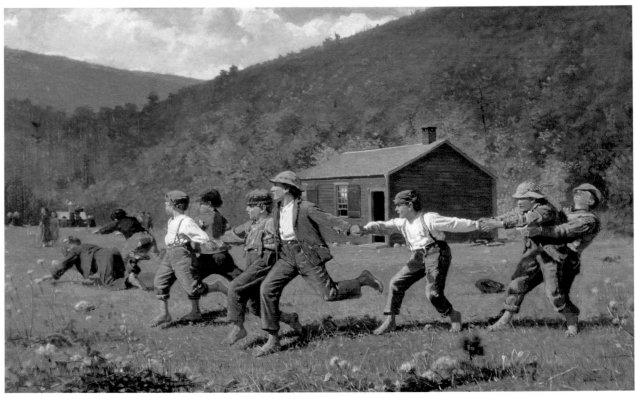

cat. 37

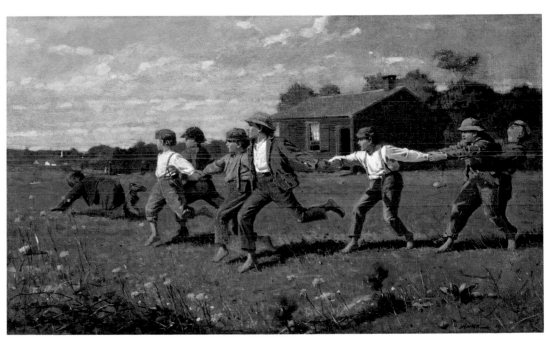

cat. 38

figs. 72–73. *Snap the Whip*. Infrared reflectograms

37. **Snap the Whip**, 1872
oil on canvas, 55.9 x 91.4 (22 x 36)
The Butler Institute of American Art, Youngstown, Ohio
Provenance: John H. Sherwood, until 1873; (George A. Leavitt & Co., New York, 17–18 December 1879). Parke Godwin, 1879; Richard H. Ewart, by 1911. (Macbeth Gallery, New York, 1918).

38. **Snap the Whip**, 1872
oil on canvas, 30.5 x 50.8 (12 x 20)
The Metropolitan Museum of Art, Gift of Christian A. Zabriskie, 1950.
Provenance: (Clarke's Art Room, New York, 28 January 1915, no. 26); Christian A. Zabriskie, New York, by 1950.

39. **The Morning Bell [The Mill, The Old Mill]**, 1871
oil on canvas, 61 x 97.2 (24 x 38¼)
Yale University Art Gallery, Bequest of Stephen
Carlton Clark, B.A. 1903
Provenance: Albert Warren Kelsey; Mrs. P.H. Wentworth; Stephen Carlton Clark.

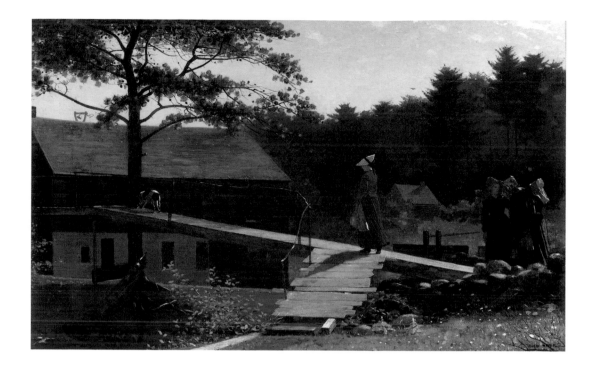

39

In 1944, Goodrich published this painting as *The Morning Bell* and dated it about 1866. Its title was appropriated from the one given when published in *Harper's Weekly* on 13 December 1873; its date was given from what Goodrich believed to be its stylistic similarity to the croquet paintings of the late 1860s. While some measure of confusion about its title and date has resisted change until the present day,[1] this is surely the painting exhibited first at the Century Association in 1871 as *Old Mill* and at the National Academy of Design in 1872 as *The Mill*.

When shown at the Century Association in 1871, it and *A Country School-House* (fig. 38) were called "companion studies." The critic who saw it in the National Academy of Design exhibition in 1872, in fact, thought, no doubt because of the bell on the roof, that it depicted "…an old school house, with a group of country girls, dinner buckets in hand going over the lone-ly wooden path leading to the upper story…."[2] He was not utterly mistaken, for the mill, like the school, was "one of the vital changes wrought" upon the social role of American women by the Civil War. The central figure in *The Mill* is in this respect interestingly similar to the teacher in *School Time* (fig. 39).

Another critic saw an Americanized Japanism in the painting: "If [Homer] has been struck by the harsh lines and mosaic effect of a Japanese design, he gives us an American mill-scene, so convincingly painted as to prove to us that we have precisely similar reliefs all around our own doors."[3]

NOTES

1. Goodrich 1944a, ill. 7. He illustrated it on the same page as *Croquet Scene*, 1866 (cat. 20), and dated it by what he believed was stylistic similarity. See Wolf 1992, n. 1, for a brief summation of the problem.

2. "The Realm of Art. Some Notes on the Academy Spring Exhibition," *New York Evening Telegram*, 20 April 1872.

3. "Fine Arts. Close of the National Academy Exhibition. The Last Sunday," *New York Evening Post*, 6 July 1872.

40. *The Country Store [A Rainy Day in the Country],* 1872
oil on wood, 30.2 x 46 (11⅞ x 18⅛)
Hirshhorn Museum and Sculpture Garden, Smithsonian Institution, Gift of Joseph H. Hirshhorn, 1966. *Provenance:* Samuel P. Avery, New York, until 1873; (Somerville Gallery, New York, 13–14 May 1873, no. 93, as *Rainy Day in the Country*). Noah Brooks, Castine, Maine, to 1904. Sargent Collection; Gilpin Collection, New York; William D. Swaney, New York, until 1964. (Parke-Bernet Galleries, New York, 23 April 1964, no. 43); Joseph H. Hirshhorn, New York, 23 April 1964–17 May 1966.

40

"'The Country Store' [is] an unmistakable transcript of village life, with a sly provincial humor in it," a critic explained. "One knows at once what those great, hulking fellows are talking about as they sit there with their bemired legs crossed, and smoke and expectorate. It is of the Squire's daughter and Larkin's blooded mare, and the coming circus—a conversation that will run presently into a fierce dispute as to whether some Bill or Jake had a side hold when he threw Jack."[1]

When it was in the collection of Samuel P. Avery in New York, *The Country Store* was titled *A Rainy Day in the Country.* "It is long since we have seen as good a picture by Mr. Winslow Homer as 'A Rainy Day in the Country…,'" a critic wrote in the *New York Tribune.* It was, he said, recognizing in it its serviceability as an almost utopian emblem of American nationality,

a happy transcript from American life, and sure to be a favorite and to do much good if once it could be well copied by chromo-lithography. It is the interior of a "country store," with three genuine American boys talking about the national store. A first-rate dog is stretched out all the chimney's length, and basks at the fire his hairy strength, and these four characters—

with the store itself well enough painted to make a Vermonter stranded in our Babel homesick—make up the picture. Apart from the clever painting, the popular value of the picture lies in its wholesome, happy portraiture of a wholesome, happy kind of life; a life that has no hardship that a man in later years will not look back upon as lost delights, and say that all other pleasures are not worth its pains; a life whose pleasures are simple, abundant, hearty, and generous in their nature; a life that breeds men and women, in short. When one reflects the many things the chromo-lithograph has inflicted on a sorrowing but unresisting world, 'tis a thousand pities it couldn't make some atonement by circulating a picture like this.'

If the critic was correct who said *The Country School* and *The Mill* were companion pictures, it is tempting to think that this painting, too, had a companion: it is nearly the same size as the smaller version of *Snap the Whip* (cat. 38), and may therefore explain why Homer painted (and also, perhaps, why he then repainted) it a second time.

NOTES

1. "Gossip in a Gallery. A Visit to the Academy of Design," *New York World,* 21 April 1872.

2. "Art and Music. Fine Arts," *New York Tribune,* 17 April 1873.

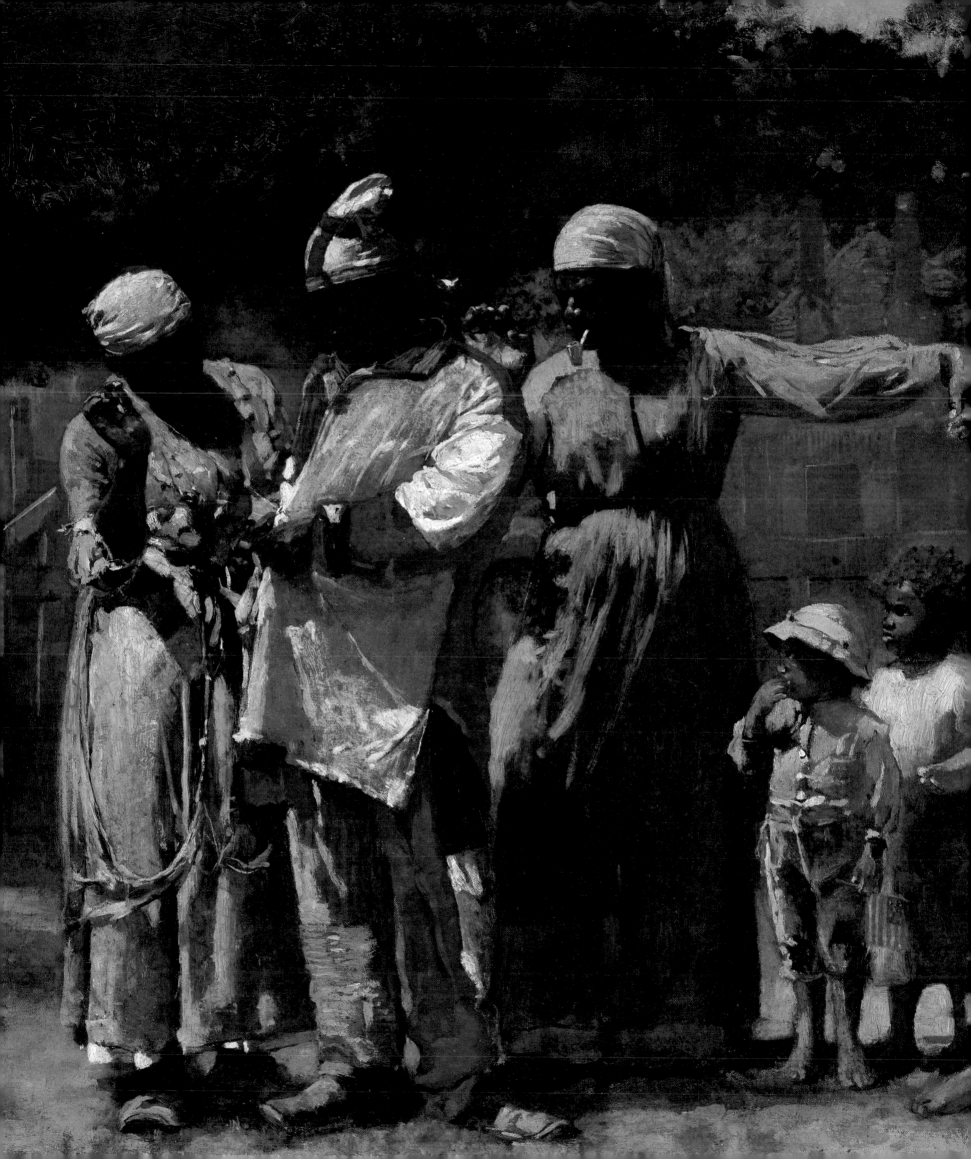

Reconstruction

Nicolai Cikovsky, Jr.

We have been at pains to place Homer in an ideological setting that helps to explain his artistic enterprise at the first stage of his career. It makes of it a purposive, ideologically informed and guided undertaking, launched in the charged climate of the Civil War and licensed by that climate as a valid and indeed inescapable matter of artistic concern. It makes it possible also to see that undertaking as a function of a social conscience and political consciousness that Homer's reserved and detached behavior and dandyish appearance (fig. 10) have disguised. To penetrate that reserve we have relied heavily on the words and ideas of Eugene Benson, who was articulate to a degree that Homer never was, and because of their closeness can be considered a spokesman for concerns that Homer shared with him. All of this helps to explain Homer's subject matter, style, and mentality in the 1860s, when each was undergoing formation. But it also bears upon the profound changes that, later, Homer wrought on both his art and his life.

Around 1870, critics were devoting increasing attention to Homer and also began with increasing clarity to understand the nature of his artistic enterprise. Although they continued to be severely critical of his style, as they would be for most of the decade, they were at the same time able to perceive Homer's artistic intentions. The same critic who considered his paintings in the 1870 Academy exhibition to be "incomprehensible...smears and splotches of paint," for instance, said in the next paragraph that they showed "a crude perverse originality, seeking to express itself in flakes and even in glacial bursts of pigment."[1] Another said Homer was "courageous," that his paintings showed "a defiance of conventionality," and that he was "a reformer, and a brave one," adding in reference to his style, however, that "like most reformers he is angular and awkward."[2] In 1872, a critic complained of "the ravellings and loose ends of execution" in Homer's style, but went on to describe it as "original" and "sharply redolent of the soil," in contrast to the style of "men who had come back from foreign schools."[3] Another, in the same year, also saw the congruence of style and (national) subject matter in Homer's paintings; regarding *The Country School* (fig. 38) — which still another critic called "a picture thoroughly national" that showed a "thorough acquaintance with our life as a people" — he wrote: "Mr. Homer's [national] subjects are such that elaborate finish would be out of place."[4] In 1880, Samuel G. W. Benjamin wrote, "The freshness, the crudity, and the solid worth of American civilization are well typified in the thoroughly native art of Mr. Homer."[5]

By the end of the 1870s Homer's artistic project and posture were so well understood that they could be recited effortlessly: his watercolor "style is bold, free and strong, the style of a lusty and independent American," wrote the critic for the *New York Evening Post*, with a hint of Whitman.[6] "He is wholly in sympathy with the rude and uncouth conditions of American life," a writer in the *Art Journal* said in 1877; "he likes the men, the women, the boys, and the girls, of the rustic by-ways of our land—and he likes them as they are, awkward in dress, spare in form, tanned and freckled by the sun...."[7] He "is wholly en rapport with American life," echoed *Appleton's Journal* two years later. "He cares nothing for schools of painting; he is utterly free from foreign influences...."[8] (A few years earlier, a Chicago critic said Homer was "a sort of American school of his own.")[9] In 1877, the *New York World* wrote about Homer in that year's Academy exhibition, "Looking back at his crudest days we are half inclined to think that even then what we mistook for crudity was partly—not altogether certainly—a youthful disregard of conventionality, rather unduly emphasized, a rather forcible as well as frank assertion of individuality," and on the same occasion, indeed on the same day, the critic of the *New York Evening Mail*, writing on "truly

fig. 74. T. W. Wood, *Sunday Morning*, 1877. Wood engraving. In *Illustrated Catalogue of the 52nd Annual Exhibition, National Academy of Design*

American" artists such as Homer, expressed the relation of individuality and nationality as a simple equation: "his manner…is largely individual, and hence American."[10]

About the middle of the decade, however, Homer gradually readjusted his artistic practice and premises; he also underwent a profound personal alteration that permanently changed the course and character of his life. In June 1877, a visitor to his studio said Homer was "just home" from a few weeks in the South, having returned with a number of sketches of "colored life on the plantations" and was at work on a "group dressed in carnival attire" (cat. 82).[11] In 1878, George W. Sheldon referred to Homer's "negro studies" as "recently brought from Virginia," and visitors to Homer's studio in February 1878 noted "a negro character study, 'Sunday Morning in Virginia'" (cat. 81) on his easel.[12] The question of when and how often Homer revisited the South after the Civil War is exceedingly complicated.[13] The only known reference to a southern trip was the one he made in 1877. The African-American subjects that appeared in Homer's art earlier in the 1870s did not necessarily derive, as *The Carnival* and *Sunday Morning in Virginia* quite evidently did, from a direct experience of postwar southern life;[14] whatever the merit of his other images of African-American life, which in several cases is very considerable, these are the most intelligent and affecting of those images. More than the others, and like all of Homer's national paintings, they touch on the most essential issues and conditions of the life of black (now) citizens of post-Civil War America with layers of ideology and political feeling.

The greatest longing of freed slaves was for what they had been systematically deprived of as the most serious threat to their enslavement: literacy ("The alphabet is an abolitionist," as *Harper's Weekly* put it).[15] A visitor to a village in Georgia in 1873 reported, "Ask any boy what he wants most. He answers, 'Larnin'.' Have asked this question in several other places as we have come along; the reply is the same, 'Larnin'.'"[16] One of the first efforts of Reconstruction, consequently, was to remedy that deprivation, and in the years following the Civil War black teachers and northern white ones—the latter often at serious risk—engaged themselves in the mission of education. With the same intelligence and sensitivity that had guided Homer to significant and timely national subjects for more than a decade, and with the same power to distill them into their most expressively affective and pictorially effective form, *Sunday Morning in Virginia* is by far the greatest image of the cruelest and most crippling intellectual legacy of slavery—illiteracy—and of its rectification. In *Sunday Morning in Virginia*, three black children listen and follow with utterly solemn attention as a teacher reads from the Bible she holds open before them, while at the right an older woman— a grandmother, perhaps, if this is to be understood as a family group—sits apart, rapt by the words she hears, but wrapped in an impenetrable cloak of illiteracy. The degree to which *Sunday Morning in Virginia* is charged with an intensity and clarity of conviction can be appreciated if compared to Thomas Waterman Wood's *Sunday Morning* (fig. 74). Exhibited in the 1877 Academy exhibition, Wood's picture was certainly known to Homer; its subject, a black boy reading to an older woman and the contrast between literacy and illiteracy that it figures, is obviously related to Homer's. But Homer's is so much deeper and more abundant in its meanings and so much more expressively forceful as a pictorial invention, so much less sentimental and story-telling, that Wood's painting cannot be considered a source to which Homer owed an essential debt but, if anything, a precedent to be criticized and corrected for its interpretive and formal inadequacy.

The painting now known as *The Carnival*, and said not too long ago to depict "the color and gaiety" of black life,[17] is probably the *Sketch—4th of July in Virginia* that Homer exhibited with other "studies of Virginia negro-life" at the Century Club in 1877,[18] and which represents, not the gaiety, but the essential tragedy of African-American life. In the painting, an older man is being dressed for Carnival as Harlequin, squarely in the tradition of the European *commedia dell'arte*. But the strips of cloth attached to his costume, like those on the clothing of the older boy at the right, derive from African ceremonial dress and more immediately from a character in the Jonkonnu festival. Once celebrated at Christmas time by blacks in Virginia and North Carolina (and still observed in the Caribbean), Jonkonnu (or John Canoe or John Cooner) was the occasion when costumed plantation slaves could leave the confines of their quarters and dance and sing at the master's house. Later, celebrations of Emancipation and the Fourth of July—represented by the American flags held by two boys at the right—were added to the festival. These cultural traditions, African, European, and American, meeting in Homer's astonishingly intelligent and perceptive painting, but pointedly never fusing, make of it a deeply moving and almost

emblematically tragic image of the uprootedness, dislocation, and disruption of African-American culture, and, by the figure of Harlequin—the sad clown and social outcast—of its alienation and marginality.[19]

The withdrawal of federal troops from the South in 1876 officially ended Reconstruction and soon returned much of its black population to a condition of virtual slavery. Painted after the end of Reconstruction, and representing in one case what it had accomplished and in the other what remained to be accomplished, the social and political meanings of *Sunday Morning in Virginia* and *The Carnival*, informed as they were with sympathies that were remnants of an earlier, more idealistic time, acquired in that regressive historical moment a more partisan message than any of Homer's other "national" paintings. Many years later Homer referred to his African-American subjects, privately and to someone who owned two of them, as his "darkey pictures."[20] Although he could paint such deeply intelligent and sympathetic images, Homer was, in matters of race, still very much a man of his time. It may also be that Homer spoke of them in that dismissive and demeaning way to blunt or diminish what, in racist post-Reconstruction America, they all too clearly meant. They were the last such paintings that Homer would make.

In 1877, a critic wrote with gratification that Homer was one "of our native *genre* painters who resolutely confine himself to American subjects" and who also "resolutely refuse to imitate in their methods any of the fashionable foreign masters whose works are so much sought after by American collectors"; another, that "No reputation, however authoritative, ever seems to reflect a tint upon his canvas, and no influence, however powerful, is seen to alter the sweep of his brush by a hair's-breadth."[21] By 1877, however, there were signs that his commitment to artistic nativism was by no means as resolute nor his imperviousness to outside influence as complete as these critics believed.

In the summer of 1873, at Gloucester, Massachusetts, he began for the first time to paint watercolors seriously. It was a medium that he would use with unrivaled brilliance for the rest of his life, and of which he would become the greatest and most influential master in American art. If Homer's early watercolors lack the extraordinary fluency and confidence of his later ones—which defined with absolute authority the possibilities of the watercolor medium—they are never merely tentative; he had the same immediate, untutored command of watercolor that he showed ten years earlier when he began to paint in oil. It is often said that watercolor requires in its making and displays in its results an irrevocable rapidity and directness of touch. Homer certainly took advantage of that property of the medium: some of his late watercolors are definitive in that respect. But Homer was never technically prissy or pure. His early watercolors, sometimes almost simultaneously, can range from little more than colored drawings, to others more freely brushed, to ones that have the density and opacity of oil paint (cats. 95–96). He did not hesitate, either, to alter his watercolors (often beyond recovery) by scraping and overpainting, removing details and sometimes entire passages, and reshaping formats by overmatting.

In 1875, two years after embarking on watercolor painting and a year after he first successfully exhibited his watercolors, Homer ended his career as a commercial illustrator. He began as an illustrator and had relied on his illustrations, as he could not rely on his oil paintings, for his livelihood. Homer was by far the best illustrator of his time, the most acute observer and the best inventor and designer of images of the many artists who supplied the pictorial press. Despite the freedom he enjoyed as a freelance illustrator, particularly for *Harper's Weekly*, to choose his own subjects, there was in the very collaborative nature of illustration—the necessary relationship between artists, engravers, authors, editors, and publishers—a constraint that someone with Homer's independence could only find disagreeable. Illustration, also, did not suit either his ambition or sense of the ranking of art. The painter John F. Weir, who knew Homer in the 1870s when they were both tenants of the Tenth Street Studio Building, remembered that "he was then drawing for *Harper's Weekly*, and struggling to get out of it to take up *more important work* [emphasis added]."[22] What might have been a particularly trying instance of editorial control might have helped to hasten the end of Homer's career as an illustrator. Early in 1874 *Harper's Weekly* assigned Homer as a pictorial reporter to cover life in New York. Although he had lived in New York for fifteen years, he seldom depicted it, and never its low life. Subjects such as "Station-House Lodgers," "Watch-Tower, Corner of Spring and Varick Streets, New York," "The Chinese in New York— Scene in a Baxter Street Club-House" (fig. 75), and "New York Charities—St. Barnabas House,

fig. 75. After Winslow Homer. "The Chinese in New York— Scene in a Baxter Street Club-House." Wood engraving. In *Harper's Weekly*, 7 March 1874

304 Mulberry Street"—homeless men, fire spotting, an opium den, and a home for single women—surely did not conform to what people had come to want and expect from him.[23] And an assignment, as the text accompanying "The Chinese in New York" described it, that required "our artist," Homer, to sit for hours in an opium den "watching the devotees" or to search vainly for their wives, could only have been repugnant in every way.[24] For whatever reason, in any case, as soon as he could support himself by painting alone, as the reception of his watercolors gave him the prospect of doing—the first watercolors he showed in 1874 "were snatched up at once, and the public cried for more"[25]—Homer quit illustration forever.

At one time largely the medium for amateur painters (like Homer's mother), around 1870 watercolor began to attract the attention of professional artists, their critics, and their patrons in America. In February 1873, an exhibition of nearly six hundred European and American watercolors and drawings, sponsored by the American Society of Painters in Water Colors, was held at the National Academy of Design in New York. A few months later, during his summer at Gloucester, Homer began making watercolors in earnest. Despite his evident affinity for the medium, he clearly recognized that watercolors, which could be made more quickly and in greater numbers than oil paintings, and sold more cheaply, could be a dependable source of income (when, later in life, Homer is reported to have said, "You will see, in the future I will live by my watercolors," he may not have meant, as he has usually been taken to mean, that his future fame would rest principally on his watercolors, but only that they would provide his steadiest income).[26]

Homer "made a sudden and desperate plunge into water color painting," a critic wrote, playing on words, in 1874,[27] in some years, to continue the play, flooding the annual exhibitions of the Water Color Society with his work. He was criticized for the suggestive breadth of his watercolor style as he was for his oils. But it was more excusable and more palatable in a medium, like watercolor, that was perceived to be inherently informal and spontaneous: a critic said of his first Gloucester watercolors, that while they were "mere memorandum blots and exclamation points," they were nevertheless "so pleasant to look at, we are almost content not to ask Mr. Homer for a finished piece."[28]

Homer tended to make his watercolors, early and late, on painting campaigns, like his summer at Gloucester in 1873. As a result, they are linked more or less directly to specific times and places. In this respect they are significantly different from his oils, which, though parts of them might have been painted outdoors and all were based on actual experience, were derived more distantly and distillatively from the experience or event that inspired them. In the 1870s, especially, subjects first explored as watercolors were reused in oil paintings: *Breezing Up*, of 1876, for example, was derived with only slight changes from *Sailing the Catboat*, made three years earlier (cats. 76, 77); *Dad's Coming!*, of 1873, was also closely related to a watercolor (figs. 103, 104). Watercolor was not, however, merely a preparatory medium; most watercolors did not lead to oil paintings, and most oils had no counterpart in watercolors. And as he matured, the difference between his oils and watercolors became increasingly emphatic. As his oils became larger in size, graver in meaning, more universal in content, and more conceptual than descriptive, watercolor became in the same degree Homer's most immediate response to visual experience, at once more spontaneous and experimental, and assuming in purer and more concentrated form those acts of observation and impulse that the timelessness and formality of his oils could not accommodate.

Adding watercolors to his artistic resources, and dropping illustration from them, were not the only changes, nor the most serious, that Homer made in his art in the 1870s. By the middle of the decade, it seems to have become apparent to him, almost as a crisis of faith, that what he believed as an artist and what he had set out to do a decade earlier, were increasingly irrelevant. The ideas and ideals that the outcome of the Civil War had confirmed were not as clear or as seemingly durable a decade later. The scandals, corruption, rampant venality, and moral decay that so deeply degraded democracy in Gilded Age America and disfigured it almost beyond recognition, made everything Homer believed have no bearing, no effect, and no direction, and thus no longer bearable. This was compounded by artistic changes that made the enterprise of "home painting" that had, after the war, been a populous mainstream of American artistic endeavor with which Homer was intimately associated, suddenly a lonely one. "What we used complacently to call the American school," a critic wrote in 1877, "assumes a wall-flower place" among younger American artists, recently returned from years of study in Munich and Paris, who filled Academy exhibitions

with work that made no attempt to disguise the European origin of its subject matter and style.[29] Only "a few of our artists," Homer among them, "bravely persist in painting pictures illustrative of American subjects," another critic wrote in the same year.[30]

So Homer sought refuge, retreating from an America that had lost all resemblance to the one in which he had been formed and that he had devoted his art to interpreting. He took refuge in art, concerning himself more deeply and more openly with artistic form and convention than he had done, or had allowed himself to do, earlier. He expressed himself through different subjects, on a new plane of meaning, and in a new language of style. That was accompanied by a social and emotional withdrawal. Clear signs of it appeared in the later 1870s, climaxed by his retirement to Prout's Neck, Maine, in 1883, where he would live alone, solitary if not in solitude, for the remainder of his life.

By the middle of the 1870s explicit aestheticism and overt formalism become visible in Homer's art, manifested by subtleties of design and refinements of pictorial arrangement. Earlier, his paintings had been constructed in the simplest possible way. In *The Veteran in a New Field* and *Prisoners from the Front* (cats. 8, 10), and later in paintings of the mid-1870s like *Crossing the Pasture*, *A Temperance Meeting*, or *Boys in a Pasture* (cats. 42, 47, 45), main figures are consistently placed straightforwardly in the center of the painting, close to the picture plane, so completely without compositional contrivance that it seems dictated by a sort of pictorial policy. "In composition they were not remarkable—few of Mr. Homer's productions are noteworthy in that respect," said a critic of paintings such as these; "he does not seem to care greatly for it."[31] Apropos *A Temperance Meeting*, a Louisville critic recommended that Homer "study more art in composition," which "he neglects and seems utterly to despise."[32]

But just one year later, in *Milking Time* of 1875 (cat. 49), the principal effect and primary purpose is the painting's vastly more complex, sophisticated, and overtly decorative pictorial construction. "Another artist [than Homer]," *The Nation*'s critic said of Homer's daring formal invention, "would hardly think of making a motive out of the horizontal stripes of a fence, relieved against a ground of very slightly differing value, so as to make the group at the fence"—placed with distinct asymmetry new to Homer's compositions—"appear like a decoration wrought upon a barred ribbon."[33] A writer in the *New York World*, less charitably but better expressing the visual power of Homer's composition, said it had "the tender grace of a gridiron."[34] A Chicago critic most acutely perceived the essential formalism of Homer's intention in *Milking Time*. "Profound" and "thoughtful" artists, he said, who have "different objects in view besides pleasing the popular, uncultivated fancy," must "almost as a matter of course" turn "to technical problems" and even, as Homer seemed "mainly occupied" in doing, to making "ornamental" objects that are "apprehended by artists better than by laymen." *Milking Time*, he added, "seems to have been painted altogether for this."[35] The numerous changes Homer made in *Breezing Up* of 1876 (cat. 76, fig. 106) were chiefly refinements of design, which, because of their extensiveness, he took great pains to make.

At this time, too, Homer began undisguisedly to embrace stylistic—as opposed to ideological—influences. One of them, clearly at work in the compositional subtleties of *Breezing Up*, was Japanese art. In this painting, the main form of the boat is placed far to the left, close to the picture surface, and balanced, not as it would be in Western compositional conventions by an equally weighted and similarly placed object, but by empty space and a small, distant form at the right that is a virtual commonplace of Japanese art. A figure in *Promenade on the Beach* of 1880 (cat. 103)—one of the most beautiful of what might be called Homer's decorative paintings—holds, indeed almost displays, a Japanese fan, just as the painting as a whole observes, as *Breezing Up* did, the Japanese compositional principles of asymmetry and occult balance. Japanese influence is unabashedly stated in the large watercolor *Backgammon Game* of 1877 (cat. 87): in the floating of the figure group as a shape against an empty background and its asymmetrical placement; the fan; and even the form and position of the signature and date at the right, which wittily imitate Japanese usage.

Homer's Japanism did not go unnoticed. A critic said the flatness of *Over the Hills* in the 1876 Academy exhibition (perhaps the painting now called *Beaver Mountain* in the Newark Museum, and "highly characteristic of a large class of Mr. Homer's work") suggested that if Homer could represent it "on a Japanese box in two lacquers…his secret ideal would be satisfied."[36] Another said some of the watercolors Homer showed in 1877 were "abrupt eulogiums of Japanese fan-painting."[37]

It is as though, in the late 1870s, after years of being closed, the ideological gate that had barred

fig. 76. *Butterfly Girl*, 1878. Oil on board. New Britain Museum of American Art, Friends of William F. Brooks

influences was suddenly flung open. The influences Homer accepted in the late 1870s were not just ones from the East—which, by that time, he was scarcely alone and rather behind in accepting among Western artists. For the critic who, in 1877, said that Homer resolutely refused to imitate "fashionable foreign [that is, contemporary European] masters" was mistaken. That year, in addition to the abundantly visible presence of Japanese influence, there was the equally visible presence of "fashionable" foreign art. The stylishly dressed young women in *Autumn* (cat. 88) or *The Butterfly Girl* (fig. 76) resemble nothing so closely as the similarly fashionable women in the contemporary paintings of such artists, widely collected in America, as Toulemouch, Baugniet, Boldini, Tissot, and particularly Alfred Stevens. And if the painting now called *The Butterfly Girl*—on which Homer was working concurrently with *Autumn*—was actually the one Homer exhibited as *Summer*, then he followed those fashionable artists even further by imitating their fondness for painting allegories of the seasons, as for example, Tissot and Stevens did (figs. 119, 77). Homer, however, did not carry his series further than these two paintings.[38]

Other ingredients can be added to this stew of influences. The reporter who saw *Autumn* and *Butterfly Girl* [*Summer*] in Homer's studio in January 1878, surely in Homer's presence and who, it is likely for that reason, interpreted them with Homer's help, wrote of them in terms that bear the distinct flavor of aestheticism: "The pictures do not profess to tell any story, for which true art has no necessity, and the adjuncts [presumably those that allegorized them] are simply used to intensify the attitude and beauty of the figures...."[39] This was the time when America was feeling the full force of the Aesthetic Movement, hence, this stress on beauty rather than meaning ("story"). The splendid large watercolors that Homer painted in 1877 are interesting in this connection, for their original titles, *Blackboard*, *Book*, and *Lemon* (the last two now called, respectively, *The New Novel*, and *Woman Peeling a Lemon*), are suggestively similar to the one-word titles, such as *Apricots*, *Azaleas*, *Apples*, *Birds*, and *Sapphires* (fig. 78) that the English painter Albert Moore gave to many of his paintings beginning in the late 1860s, paintings which, in depicting single female figures, resemble Homer's watercolors.

LEFT: fig. 77. Alfred Stevens. *Fall*. Oil on canvas. Sterling and Francine Clark Art Institute, Williamstown, Massachusetts

RIGHT: fig. 78. Albert Moore. *Sapphires*, 1877. Oil on canvas. Birmingham Museums and Art Gallery

fig. 80. *Shepherdess*, 1878. Ceramic tile. Lyman Allyn Art Museum, New London, Connecticut, Gift of Robert MacIntyre, 1945.155

Aestheticism, of which Albert Moore's paintings are very much a part, achieved its greatest visible currency through the craze for decoration that it inspired.[40] The late 1870s was a "decorative age," an artist said, and "we should do something decorative, if we would not be behind the times."[41] *The New York Tribune* reported in the summer of 1878 that "Numbers of artists have added decoration to their regular work this past season," and among them, no neophyte "in the mysteries of design," was Winslow Homer.[42] In that very year he made two ambitious sets of decorated tiles for fireplaces (fig. 79), and was an active member of the Tile Club, at the meetings of which he made single or sets of decorated tiles (fig. 80). And his friend John La Farge, who was by the later 1870s deeply engaged in mural decoration and stained glass, said later that Homer consulted him about wall decoration and, to his surprise, glass projects, although nothing of that sort by Homer survives.[43]

Decoration touched Homer more widely still. For example, a critic remarked on the flatness of his paintings in the 1876 Academy exhibition (which included *Breezing Up*), describing their style as "bald as patchwork" and comparing them to stage flats.[44] And in 1879, a critic described his painting *Upland Cotton* (fig. 81) as "a superb piece of decoration" and "a remarkable penetration of Japanese thought into American expression"; despite its completely American subject, the figures are stacked in shallow space in an emphatically vertical format that does indeed strongly, and of course purposely, resemble the panel of a Japanese screen.[45]

Also in the late 1870s Homer painted a group of watercolors of shepherdesses that is more decorative, in the sense of being more purely and unapologetically pretty, than any subject he had painted before. They were made during the summer of 1878, part of which he spent at Houghton Farm, near Mountainville, New York, owned by his friend and patron Lawson Valentine, at which sheep husbandry was a major undertaking.[46] Many of the shepherdesses he depicted, therefore, were those he saw at Houghton Farm. But others—"Little Bopeeps" in "Arcadian ribbons" with "all the daintiness of the true and original porcelain," "more essentially and distinctively pastoral than anything that any American artist has yet attempted"[47]—clearly were not (compare cats. 97 and 99). They originated ultimately in the pastoral subjects of eighteenth-century rococo paintings and porcelain, but more proximately in decorated tiles, in which they were a staple subject

fig. 79. *Shepherd and Shepherdess*, 1878. Ceramic tiles. Arthur G. Altschul

fig. 81. *Upland Cotton*, 1879. Oil on canvas. Weil Brothers, Montgomery, Alabama

(fig. 82), and from which Homer derived the pastoral motifs of his own tile decorations (figs. 79–80).

These pastoral paintings are, of course, further evidence of Homer's receptiveness to influence. But because it is now so clearly the influence of older art, it is perhaps the most overt case of it. Homer's shepherdesses, by being so utterly—and to that extent deliberately—different in their derivation from the "modern and national" art for which Homer was best known and still celebrated,[48] announce, almost polemically, how completely Homer was prepared to reconstruct his art and the nativist policy that had once guided it.

Congenitally reserved and disposed to privacy, Homer during his early years was, nevertheless, social and even outgoing. He had a circle of artist friends in New York that included La Farge, Homer Martin, Roswell Shurtleff, Eastman Johnson, Alfred Howland, and, of course, Benson. He worked in the two main centers of artistic life in New York: the University Building, and later the Tenth Street Studio Building. He shared studios with his friend Alfred Howland in 1868,[49] and traveled on painting expeditions with Enoch Wood Perry in 1872 and 1875. He was a national academician, serving as a council member and on hanging committees; a member of the Century Club (often appearing at its receptions) and the Palette Club;[50] and regularly attended the Wednesday evening meetings of the Tile Club, in 1880 participating in a bibulous dinner in William Merritt Chase's "sumptuous atelier" in the Tenth Street Studio Building.[51] He frequently allowed newspaper reporters to visit his own studio and see work in progress, and on three occasions allowed the writer Sheldon to publish details of his biography and, as he almost never did, some observations on art and artists.[52] He visited such popular resorts as Saratoga, Long Branch, the White Mountains, the Adirondacks, and the North Shore of Massachusetts. And judging by the women who are recognizable—though with the exception of Helena de Kay (cat. 54) seldom nameable—in his work of the 1870s, he had a significant number of women friends, some of them, it must be supposed, close and perhaps intimate.

But at the end of the decade that began to change. He showed nothing in the 1878 Watercolor Society exhibition, as his critics noted; one, implying petulance, said he has "withdrawn into his tent" because he sold nothing from the exhibition the year before, though another said it was because "of harsh criticisms passed upon his work."[53] A bit later another asked in his review of that year's Academy exhibition, "What has come over this artist of late years that he sulks in his tent, and seems to take pleasure in painting as badly as he can?"[54] Some commented on his gruffness and rudeness: "he is *posé* in the extreme, and affects eccentricities of manner that border upon gross rudeness," said a writer in 1880, giving a foretaste of the image Homer acquired in years to come. "To visit him in his studio," as would also be true in the future, "is literally bearding a lion in his den; for Mr. Homer's strength as an artist is only equalled by his roughness when he does not happen to be just in the humor of being approached."[55] It was said in 1881 that he had "retired wholly within himself" into "grim and misanthropic seclusion."[56]

A clear indication of Homer's altered state of mind is that when he returned to Gloucester in the summer of 1880 he chose not to stay at the Atlantic House on shore, as he had done in 1873, but to board instead at the lighthouse on Ten Pound Island, in the middle of Gloucester harbor (see Chronology 1880). An even more striking indication of that alteration is the extraordinary series of watercolors that he painted that summer in seclusion. They are quite astonishing—the most revealing things he ever made (cats. 104–106). In intensity of hue and almost total dependence in form and expression on free, vigorous, uninhibited washes of pigment, they are his most purely colorful paintings. Homer may have been influenced in this respect, as Helen Cooper has suggested, by contemporary color theory; he owned a copy of Chevreul's classic text on color, which he called his "bible," and Ogden N. Rood's important *Modern Chromatics* was published a few months before he went to Gloucester in 1880.[57] It is possible, too, that he may have been encouraged to greater painterly freedom by J. Frank Currier's broadly painted "impressionist" watercolors—influenced by the Munich school, not French impressionism—that caused a huge stir in the 1879 Water Color Society exhibition (fig. 83), and with which several critics associated Homer's watercolors in the same exhibition, and later ones as well.[58] From this point of view, the 1880 Gloucester watercolors may have been Homer's attempt to capture through intensity of color and breadth of form, as he had never been concerned to do earlier, transient conditions of nature, such as the most famously transient of them all, sunsets. But as the most emotionally

fig. 82. Dutch, Harlingen? *Shepherds and Shepherdesses in Landscape*, 1680–1725. Ceramic tiles. Philadelphia Museum of Art, Gift of Mrs. Francis P. Garvan

charged and revealing images that Homer ever painted, their "morbid intensity" and "fervid, half-infernal poetry," as critics described it[59]—the disruptive tension and anxiety that inhabit them and shape their agitated and turbid visual appearance—surely expressed an emotionally excited state of mind more than a fugitive impression of nature. "How queer they are and how unexpected," Edward H. Hale wrote when he saw them in Boston in December. "Some of them seem to lack common sense."[60] Mariana Griswold Van Rensselaer reported someone as saying they were "artistic brutality," and she herself said they were almost "diabolical" in their power, with "glowering, inky tints" that she found "repellent."[61]

The cause of the emotional disturbance, almost pain, that these watercolors reveal is largely hidden by the very inwardness and social withdrawal it produced in Homer. But three things, all coming to a head in the late 1870s, may have contributed to it.

One was criticism that acquired a tone of impatience—"Mr. Homer was never more careless and capricious and trying," as *The Nation* said in 1877[62]—and implied that his artistic promise remained unfulfilled and his accomplishment was merely provisional, or that he trifled with his unquestionable gifts. To his particular annoyance, critics continued to hark back to *Prisoners from the Front* as the standard to which he should hold himself but seldom did. "I'm sick of hearing about that picture,"[63] he said, venting what was surely a far deeper and almost unendurable frustration at the fact that, after nearly two decades of professional practice, and in middle age, he was still so largely misunderstood: "For fifteen years the press has called me 'a promising young artist,'" he said in 1887, when he was fifty-one years old, "and I am tired of it."[64] Benjamin, who was one of those who admired Homer's "eccentric and altogether original compositions" and his "versatility and inventiveness in choice of subject," also saw (in 1880) "Impatience, irritability,... written upon all his works."[65]

In the late 1870s Homer also may have suffered a seriously damaging emotional crisis—a romantic disappointment the nature of which can only be guessed at, but which permanently affected his conduct, causing in particular the defensiveness, mistrustfulness, and reclusiveness that would be salient traits of his personality for the rest of his life. There are many stories of Homer's attraction to women; in early life, he said, he had a "weakness" for pretty girls,[66] and his paintings (mostly in watercolor) of the 1870s constitute a virtual gallery of women who, by the very fact of their recurrence, were clearly more closely connected with Homer than professional models would have been. In the 1870s, Homer was in his late forties, of a marriageable age, and,

with reasonable prospects of professional success, financially in a marriageable position; what his paintings of that decade may show, apart from everything else, are episodes of or attempts at courtship. When they ended is unknown; that they ended, badly and unhappily, is certain. If Homer, who felt "a little under the weather" in May of 1878, was more emotionally bereaved than physically indisposed, it might explain the disappearance from his art of the young woman who, in a variety of roles and costumes, had figured so prominently in watercolors of 1877 (cats. 83–86), just as it might explain the blend of sexual conflict and emotional weariness that certain of the watercolors of 1878 seem so insistently to express, or what in others of them, from this point of view, might be considered the escapist fantasies of his rococo "Bopeeps" (cats. 94, 98–99; figs. 79–80).

Or perhaps in the moral and ethical collapse of the Gilded Age, Homer was driven by disoriented purpose and ideological disillusionment to a state like that of Madeleine Lee in Henry Adams' novel *Democracy* of 1880: "I want to go to Egypt," she exclaimed. "Democracy has shaken my nerves to pieces. Oh, what rest it would be to live in the Great Pyramid and look out for ever at the polar star!"[67] In 1881, Homer left America for England, in flight from whatever it was that seemed to trouble him so deeply, and, like Adams' Madeleine Lee, in search of lost bearings and an Egyptian permanence and stability that would be a refuge from the intellectually, ideologically, artistically, and emotionally agitated condition of post-Civil War America.

When he returned in 1882, he was, a critic said, speaking of his art but applicable to everything else about him, "a very different Homer from the one we knew in days gone by."[68]

NOTES

1. "National Academy of Design," *New York World*, 24 April 1870.

2. "The Academy of Design. The Opening of the Season," *New York Tribune*, 15 April 1870. "Fine Arts. The Landscapes at the Academy," *New York Tribune*, 30 April 1870.

3. "Fine Arts. Close of the Academy Exhibition. The Last Sunday," *New York Evening Post*, 6 July 1872.

4. "Art Matters. The Academy Exhibition. (Second Article.), North Room," *New York Evening Express*, 18 April 1872. "The Realm of Art. Some Notes on the Academy Spring Exhibition," *New York Evening Telegram*, 20 April 1872.

5. Benjamin 1880, 117.

6. "American Art in Water-Colors. The Twelfth Annual Exhibition of the Water-Color Society at the National Academy of Design," *New York Evening Post*, 11 February 1879.

7. "The Academy Exhibition," *The Art Journal* 3 (1877), 159.

8. "Editor's Table," *Appleton's Journal* 6 (May 1879), 471.

9. "Art Matters," *Chicago Tribune*, 10 April 1875.

10. "The Academy Exhibition. IV," *New York World*, 23 April 1877. "Fine Arts. The Academy Exhibition. II.," *New York Evening Mail*, 23 April 1877.

11. "Studio Gossip. The Round of the Studios," *New York Tribune*, 9 June 1877.

12. "Fine Arts. Studio Jottings," *New York Herald*, 3 February 1878; "Art Notes," *New York Daily Graphic*, 8 February 1878; Sheldon 1878, 227.

13. See Quick 1978, 60–81; Calo 1980, 4–27; Wood and Dalton 1988, 61 passim.

14. See cats. 79–82 for a discussion of the earlier paintings and the problem of Homer's southern visits.

15. Wood and Dalton 1988, 79, n. 177.

16. Albert Webster, Jr., "A Jaunt in the South," *Appleton's Journal* 10 (6 September 1873), 298. "The desire to learn displayed by the negro was perhaps the most surprising feature that grew out of his new condition. It quickly pervaded both sexes and all ages. Mother and child, romping youth and hoary age, attacked the alphabet and the spelling-book together, and kept up the assault with astonishing zeal. The number that has learned to read and write with tolerable facility is quite large, and there are few who do not make some pretensions to be classed therein" ("The Negro," *New York Evening Post*, 4 March 1874).

17. Wilmerding 1972, 94, drawing on Goodrich, who said what attracted Homer was "negro color, not only in their bodies but in their clothes, garish but instinctively right" (Goodrich 1944a, 59).

18. "The Century Club," *New York Evening Post*, 2 June 1877.

19. See Curry 1990, 90–113, and Wood and Dalton 1988, 101–106. For clowns, see especially Francis Haskell, "The Sad Clown: Some Notes on a Nineteenth-century Myth," in *French Nineteenth-century Painting and Literature*, ed. Ulrich Finke (Manchester, 1972), 2–16.

20. Letter to Thomas B. Clarke, Scarboro, Maine, 23 April 1892 (Archives of American Art).

21. "Home Subjects for American Art," *Leslie's* 44 (4 August 1877), 366; *The Art Journal* 3 (1877), 159.

22. *The Recollections of John Ferguson Weir*, ed. Theodore Sizer (New York and New Haven, 1957), 46.

23. "When he paints our American country scenes of farmer life, puts over them an American sky and around them an American atmosphere, he is at his best" (*New York Evening Mail*, 23 April 1877).

24. "The Chinese in New York," *Harper's Weekly* 18 (7 March 1874), 222.

25. "Fine Arts. The Ninth Exhibition of the Water Color Society," *New York Evening Mail*, 7 February 1876.

26. Goodrich 1944a, 159.

27. "Art Notes," *New York Herald*, 15 February 1874.

28. "Fine Arts. The Water Color Exhibition," *New York Tribune*, 14 February 1874. A writer in *The Century* (perhaps its editor, Richard Watson Gilder) thought watercolors were in their inherent clarity, crispness, and crudity more suited than oils to American artists and their public:

> Water-colors lend themselves better to the artistic qualities of our painters than oils, and the public understand and like them better. There is a quality among the Americans of the eastern and middle states that is called, for want of a better term, Puritanism, and although this characterization does not really fit the case, it will be sufficiently understood. This Puritanism, then, makes us a little obtuse to, and a good deal afraid of, anything that looks mellow, languid, or luxurious; so that when a painter does exhibit signs of a strong feeling for color, we are apt to fight shy of him. Water-colors are crisp, clear, and, unless in the best hands, crude; but even crudeness is not so terrible to us as richness of color. It is like our fear and contempt for what is called "Frenchiness" of manners, and like that may be termed a provincialism—healthy, it may be, but still a provincialism. The narrower limits and greater simplicity of water-color drawing predispose Americans to excellence in that branch, just as the wider range and greater complexity of oil-painting cause many of those who venture into that field to produce compositions rank or turgid in color.

In the next breath he wrote of Homer's watercolors as best pointing that moral, with the qualification that his oils were not rank or turgid in color. ("Culture and Progress. The Art Season of 1878–9," *The Century* 18 [June 1879], 310.)

29. "Notes," *The Nation* 24 (5 April 1877), 209.

30. "Home Subjects for American Art," 366. "Winslow Homer and Eastman Johnson...deserve mention, because of conscientious endeavors in a right direction, because of efforts impelled by a desire to render picturesque, not only the natural features, but also the life of our country, by portraying its incidents and their surroundings. These artists prove to us better than many others, perhaps, that such scenes are capable of being rendered equally interesting with scenes from German, French, Italian or Spanish life..." (*New York Evening Post*, 23 April 1877).

31. Sheldon 1879, 25.

32. "The Exposition," *Louisville Courier Journal*, 9 September 1874.

33. "Fine Arts. Fiftieth Annual Exhibition of the Academy of Design. I," *The Nation* 20 (15 April 1875), 265.

34. "The National Academy of Design. Second Notice," *New York World*, 15 May 1875.

35. "Fine Arts. Review of the Paintings at the Exposition Building," *Chicago Tribune*, 12 September 1875.

36. "Fine Arts. The National Academy Exhibition, II.," *The Nation* 22 (20 April 1876), 268.

37. "Fine Arts. Eleventh Exhibition of the American Water-Color Society. I.," *The Nation* 26 (14 February 1878), 120.

38. A visitor to Homer's studio early in 1878 saw two "portrait studies" which he thought "excellent." "In one, a young lady stands under a canopy of autumn foliage and scatters the crisp leaves with one hand; in the other [painting], she has just caught a butterfly in her net and is looking up at the mate which hovers above" ("Gossip of Local Art Circles," *New York Daily Graphic*, 16 January 1878). That Homer toyed with the idea of a seasonal allegory is suggested by two other unfinished paintings of the same size and format, *Gathering Autumn Leaves* (Cooper Hewitt, National Design Museum, Smithsonian Institution), in which a roughly dressed boy replaces the fashionably dressed woman in *Autumn*, and *Woman in Autumn Woods* (Santa Barbara Museum of Art). See also George H. Boughton's *Winter*, in Samuel G. W. Benjamin, *Contemporary Art in Europe* (New York, 1877), repro. 15, and *Autumn*, in Sheldon 1882, repro. 3. A double-page reproduction of James Tissot's *Winter* appeared in *Harper's Bazar* 10 (22 December 1877), 808–809.

39. *Harper's Bazar* 10 (22 December), 808–809.

40. See *In Pursuit of Beauty: Americans and the Aesthetic Movement* [exh. cat., Metropolitan Museum of Art] (New York, 1986), in particular, Roger B. Stein, "Artifact as Ideology: The Aesthetic Movement in its American Cultural Context," 23–51.

41. "The Tile Club at Work," *Scribner's Monthly* 17 (January 1879), 401, in which there is a virtual inventory of decorative possibilities: making "brass fenders and andirons," pasting "paper jimcracks on old ginger jars," making "Eastlakey" furniture; painting frescoes, and designing textiles and wallpaper (401–402).

42. "Brush and Pencil. Notes from the Studios," *New York Tribune*, 22 June 1878.

43. Kobbé 1910. He was said also to have painted murals for the business offices of Harper and Brothers that depicted Castle Garden, the Harper building itself and the inside of the pressroom, and an allegorical "Genius of the Press," but a description of murals painted in the 1870s mentions none by Homer, and when his biographer William Howe Downes went to see them in 1911 they had disappeared (*More Than One Hundred Years of Publishing* [New York and London, 1923], n.p.; Downes 1911, 244).

44. *The Nation* 22 (20 April 1876), 268.

45. "The Academy Exhibition," *The Art Journal* 5 (1879), 158.

46. Manly Miles, *Description of Houghton Farm. Experiments with Indian Corn* (Cambridge, 1882), 3–4.

47. "The Water Color Exhibition," *New York Sun*, 16 February 1879; *The Century* 18 (June 1879), 310.

48. "We always think of Mr. Homer when we feel hopeful of the uprising of a national expression in art" ("Fine Arts. The National Academy Exhibition. Final Notice," *The Nation* 26 [30 May 1878], 362).

49. "Alfred Howland and Winslow Homer have taken a new studio together in the Mercantile Library Building, between Astor Place and Eighth Street" ("The Studios. What Our Artists are Doing," *New York Evening Post*, 18 February 1868). "Messrs. Winslow Homer and A. C. Howland have lately established themselves in Clinton Hall, where they occupy one of the pleasantest and best arranged studios in the city" ("Art Gossip," *Frank Leslie's Illustrated Newspaper* 26 [4 April 1868], 35).

50. Francis Gerry Fitzgerald, *The Clubs of New York* (New York, 1873), 284.

51. "The Tile Club Dinner," *New York World*, 25 January 1880. The menu, a good specimen of the wittiness of Tile Club proceedings, read:

> Oysters.
> Some sort of wine.
> Soup of some kind.
> Another kind of wine.
> A large fish with a Tiley sauce.
> Certain small fishes with a kind of spicy sauce.
> More wine.
> Mysterious small interpolations.
> Select part of an ox with choice fungi.
> Part of a sheep with small cabbages.
> Cold arrangement with smokables.
> Kind of a duck from Baltimore with things.
> And another sort of wine.
> Nice vegetables.
> Cold matters and small things.
> Other things.

In the evening another gathering was held at Napoleon Sarony's studio. It was "well filled" with guests "well known in art and literature." Cold beefsteak pies were provided, "and the evening was spent merrily with music and beer and corn-cob pipes, and with an occasional lapse into rational conversation."

52. Sheldon 1878, 225–227; 1879, 25–29; 1880, 106–109.

53. *The Nation* 26 (14 February 1878), 120; "The Water-Color Society," *New York Times*, 1 February 1879.

54. Clarence Cook, "Fine Arts. National Academy of Design. Fifty-third Annual Exhibition. V," *New York Tribune*, 11 May 1878.

55. "Exhibition of the Academy of Design," *The Art Amateur* 2 (May 1880), 112; "The Studio. Art Interchange Artists," *The Art Interchange* 5 (22 December 1880), 130.

56. "The American Water Color Society," *New York Sun*, 23 January 1881.

57. Cooper 1986a, 72–74.

58. "The Water-Color Exhibition," *Leslie's* 47 (22 February 1879), 439, which spoke of the "'Impressionist' infection" that Currier's "capricious—and ugly—blotches of color" exemplified most clearly. "The impressionists were represented…by Mr. J. Frank Currier, a student in Munich, Mr. Winslow Homer, Mr. A. H. Wyant, and to a certain extent by Mr. John La Farge and Mr. Charles H. Miller" ("The Water-Color Exhibition," *The Aldine* 9 [1878–1879], 270). In 1881, a critic said that besides one of Homer's Gloucester watercolors in the Water Color Society exhibition, an "impressionist study called 'Sunset,'…there were few examples of the impressionist school outside of Mr. Currier's half-dozen contributions…" ("Art Notes," *The Art Journal* [1881], 95). In 1880, a critic noted a general tendency to more transparency in watercolor: "What has not escaped notice…is the lessened use of body color.…Probably never before were so many best pictures in an Academy water-color exhibition free from the trickery, the miscellany, the mischievousness of opaque color" ("The Painters in Water Colors. General Preview of the Thirteenth Annual Exhibition of the American Water Color Society in the Galleries of the National Academy," *New York Evening Post*, 28 February 1880).

59. Letter to "Margaret" Roxbury, Massachusetts, 2 December 1880 (Archives of American Art).

60. Letter to "Margaret."

61. Mariana Griswold Van Rensselaer, "The Water-Color Exhibition, New York," *The American Architect and Build-*

ing News 9 (19 March 1881), 135.

62. "Fine Arts," *The Nation* 24 (15 February 1877), 108.

63. Goodrich 1944a, 51.

64. Stonehouse 1887, 12.

65. Benjamin 1880, 117.

66. Letter to his father, probably March 1862, in Hendricks 1979, 46.

67. *Democracy* (New York, 1961), 189.

68. *The American Architect and Building News* 13 (24 March 1883), 138.

41. **The Dinner Horn,** 1870
oil on canvas, 48.9 x 34.9 (19¼ x 13¾)
National Gallery of Art, Washington, Collection of
Mr. and Mrs. Paul Mellon, 1994.59.2
Provenance: Given by the artist to Charles Collins, New
York; Virginia Collins Cronester, by descent; (Nich-
olas Hubby, Boston); Richard Manoogian; (Vose Gal-
leries, Boston); Mr. and Mrs. Paul Mellon, 1985–1994.

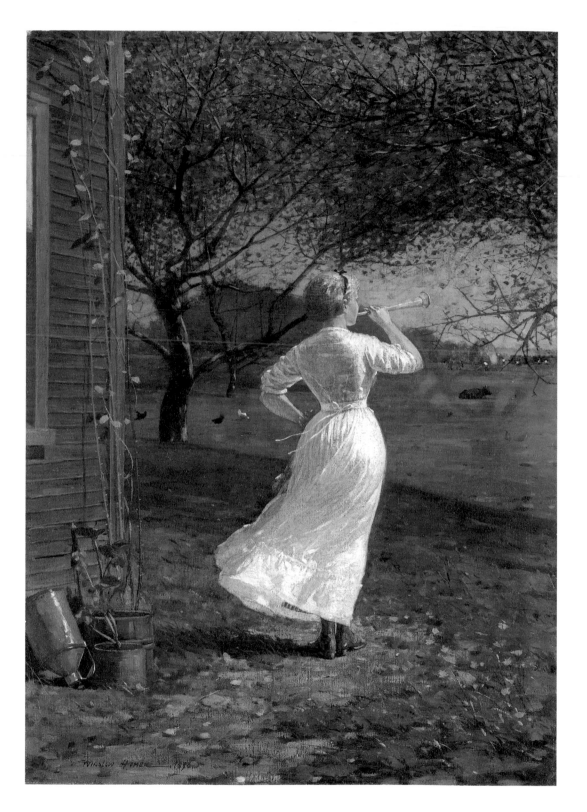

fig. 84. After Winslow Homer. "The Dinner Horn." Wood
engraving. In *Harper's Weekly,* 11 June 1870

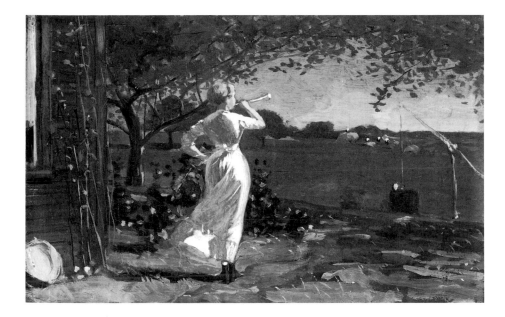 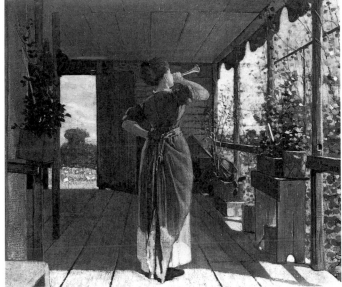

LEFT: fig. 85. *The Dinner Horn*, c. 1870–1873. Oil on panel. Gift of Julia Appleton Bird, Courtesy Museum of Fine Arts, Boston

RIGHT: fig. 86. *The Dinner Horn*, 1872. Oil on canvas. The Detroit Institute of Arts, Gift of Dexter M. Ferry, Jr.

41

This is the first of the farm (as distinct from harvest) subjects in which Homer took a consistent though far from undeviating interest throughout the decade of the 1870s.

He made a series of dinner-horn images in the early 1870s, of which this painting is the first and, with its breezy freshness, brilliant light, and delicately subtle coloration, arguably the most beautiful. It is closely related to the engraving "The Dinner Horn," published in *Harper's Weekly* on 11 June 1870 (fig. 84), and to an oil sketch in which Homer considered the subject in a horizontal format (fig. 85). A fourth version, finished in 1872,[1] depicts the woman in the same pose but in a darker dress and standing in a shaded porch (fig. 86).

She is, as she was described in the later version of the subject, a "farmer's daughter and maid of all work, just from the kitchen,... blowing the dinner horn"[2] (for the farm workers in the distant field), but her svelte figure, revealing dress, bit of petticoat, and touch of ankle make her the rural (though by no means rustic), inland counterpart of the bathing figures Homer also depicted at this time.

As pentimenti now show, Homer greatly altered the painting by removing a tree that originally stood in the right foreground, which would have made its effect not unlike that of the later *The Nooning* of about 1872 (cat. 43).

NOTES

1. As reported in "The Realm of Art. Gossip Among the Brushes, Mahlsticks and Easels," *New York Evening Telegram*, 8 June 1872.

2. "The Realm of Art."

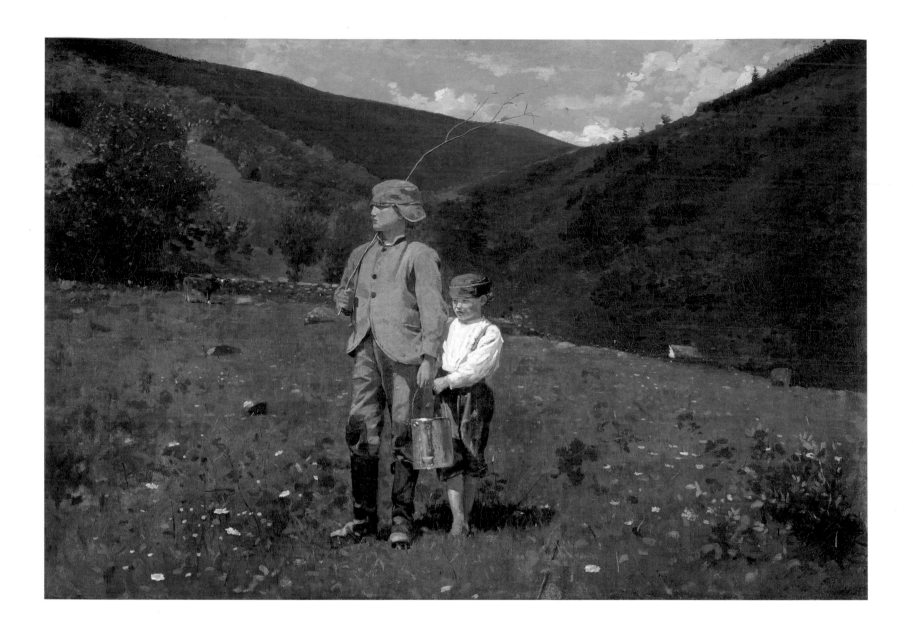

42. *Crossing the Pasture,* 1872
oil on canvas, 66.7 x 96.8 (26¼ x 38⅛)
Amon Carter Museum, Fort Worth
Provenance: Charles L. Homer, Quincy, Massachusetts;
(Macbeth Gallery, New York); William T. Hunter, Jr.,
Greenwich and Stamford, Connecticut, 31 May 1933;
his wife, Mrs. William T. Hunter, Jr., Stamford, Con-
necticut; her son, Andrew D. Hunter, Henryville,
Pennsylvania, 1970; (Davidson & Co., Inc.).

42

The mountainous landscape of *Crossing the Pas-
ture* resembles both that of *Snap the Whip* and the
one seen through the windows of *The Country
School,* and was probably seen at the same time,
during "the summer among the Catskills" that
Homer spent in 1871.[1] It was exhibited at both
the Century Association (as *Two Boys Going Fish-
ing*) and National Academy of Design (as *Crossing
the Pasture*) in 1872.

An advertisement for the Amon Carter
Museum, the painting's present owner, described
its subject in the following way: "With uneasy
expressions, the two farmboys anticipate some-
thing we cannot see, turning Homer's otherwise
idyllic landscape into a scene of subtle tension."
It is certainly true that the boys' expressions are
uneasy, but their uneasiness is caused not by
something unseen but something that can be

seen perfectly well: the bull in the distance, eye-
ing them with hostile wariness, which anyone at
all familiar with farm life would recognize as an
object of quite justifiable concern.

This is very likely, therefore, the painting
Homer exhibited at the Chicago Interstate
Exposition in 1875 as *The Bull Pasture.*

NOTES

1. "Art Notes," *New York Evening Post,* 7 June 1871. When
The Country Store (fig. 38) was sold by its first owner,
John H. Sherwood, in 1879, it was called *A Country
School-room in the Catskills.*

43–44

Strongly contrasted effects of light and dark that
Homer investigated in some of the dinner-horn
paintings and in *At the Window* (cat. 55), which
seemed to constitute one of his chief pictorial

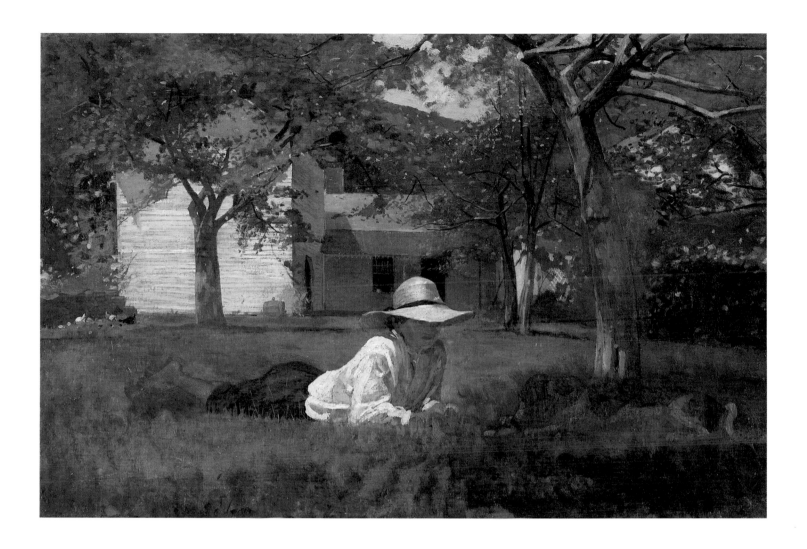

43. *The Nooning*, c. 1872
oil on canvas, 35.4 x 50.2 (13¹⁵⁄₁₆ x 19¾)
Wadsworth Atheneum, Hartford, Connecticut, The
Ella Gallup Sumner and Mary Catlin Sumner Col-
lection Fund
Provenance: Charles L. Homer, Quincy, Massachusetts;
(Macbeth Gallery, New York, 1932–1936); (Walker
Galleries, New York, 1936); Mrs. Thomas N. Metcalf,
Boston, 1937; (John Nicholson Gallery, New York,
1946).

44. *"The Nooning,"* published 1873
wood engraving on newsprint, image: 23.2 x 35 (9⅛ x
13¾); sheet: 28 x 41.2 (11¹⁄₁₆ x 16¼)
National Gallery of Art, Washington, Avalon Fund,
1986.31.116
Provenance: Emily W. Taft Collection; (David
O'Neal).

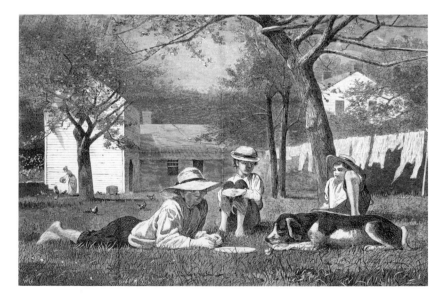

problems in the early 1870s, are present also in
the brightly lighted figure lying on a deeply
shaded lawn in this picture.

The engraving of "The Nooning" published
in *Harper's Weekly* on 16 August 1873 (cat. 44)
includes two additional boys and the figure of a
large dog in the right foreground. The dog, in

the same position, was originally present in the
painting, but Homer, perhaps to improve the
composition, and with the more important result
of disconnecting the narrative relationship,
painted it out.

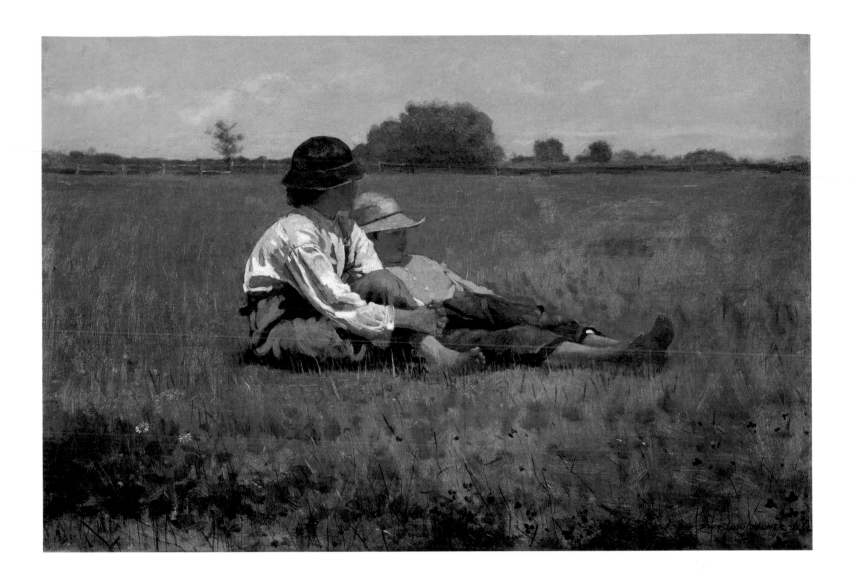

45. *Boys in a Pasture*, 1874
oil on canvas, 38.7 x 57.2 (15¼ x 22½)
Museum of Fine Arts, Boston, The Hayden Collection, 53.2552
Provenance: Mr. Tinker, Dublin, Ireland, after 1874; his granddaughter, Miss Tinker, Dublin; Patrick O'Connor, Dublin, before 1953.

45

This "…beautiful view of a pasture field, with two idle boys seated in the grass, painted in oil colors,"[1] which Homer exhibited at the Century Association in April 1875, has the quality of enigma that Homer often achieved by the deletion of narrative parts, as in *The Nooning* (cat. 43). In this case, technical examination revealed no evidence of change, but it seems possible, nevertheless, that there was at one time something in the upper-right distance that was the visual and narrative focus of the boys' attention,[2] as there is in the engraving contemporary with it, "Flirting on the Seashore and on the Meadow," published in *Harper's Weekly*, 19 September 1874 (fig. 87).[3] Jennie Brownscombe's "Mischief Brewing," published in *Harper's Bazar* on 11 November 1876, is one example among many, contemporary with *Boys in a Pasture*, of the sort of storytelling that Homer avoided in both the construction (or deconstruction) of his imagery and in his titles.

fig. 87. After Winslow Homer. "Flirting on the Seashore and on the Meadow." Wood engraving. In *Harper's Weekly*, 19 September 1874

NOTES

1. "Art at the Century," *New York Evening Post*, 5 April 1875.

2. See below, "Something More than Meets the Eye," n. 15.

3. The engraving was based on the oil *Enchanted* of 1874 (private collection).

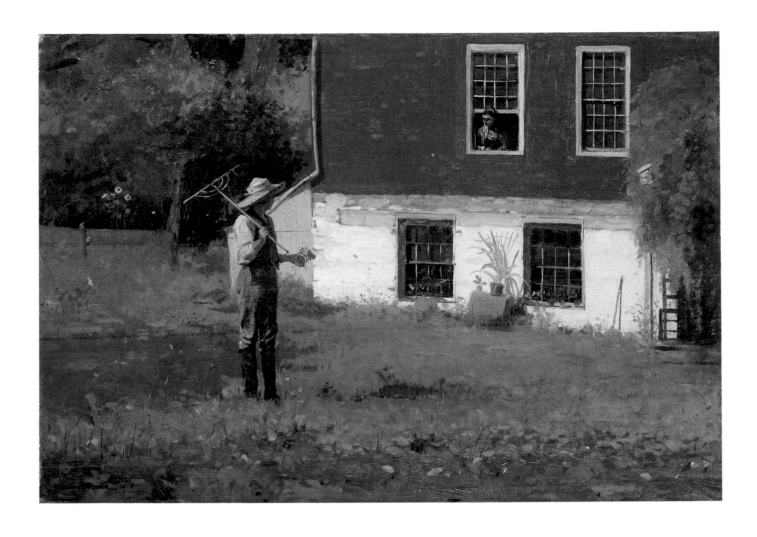

46. *The Rustics,* 1874
oil on canvas, 40.6 x 57.2 (16 x 22½)
Private Collection
Provenance: Mrs. Norman B. Woolworth.

46

In 1874, Homer painted a four-part series on the subject of rustic courtship, each part of which included the young farmer in straw hat and cow-hide boots who figures in both *A Temperance Meeting* and *The Rustics.* In one, the female figure is a milkmaid, in the other she is a housemaid; in one, she offers the farmer who passes her on a

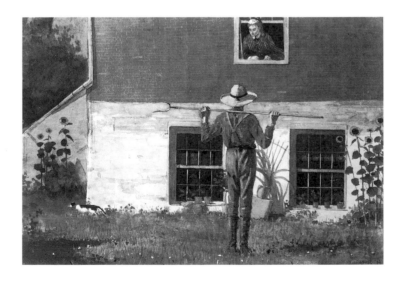

path a drink of milk, in the other it is the farmer who holds a bunch of flowers in his tentatively outstretched hand. *The Rustics* is closely related to the watercolor *Rustic Courtship* (fig. 88), and to a fourth painting titled *The Course of True Love* (unlocated) that, a description of it suggests, contained the same figures as in *A Temperance Meeting* ("...a New England farmer and a country-girl are sitting shaded by the tall grain....the woman, a true type of New England, is chewing, in country fashion, on a bit of straw she holds in her hand....Her lover, a manly-looking fellow, is twisted about, embarrassment peeping from every feature and even from the toes of his cow-hide boots").[1]

NOTES

1. "The Arts," *Appleton's Journal* 13 (8 May 1875), 599.

fig. 88. *Rustic Courtship,* 1874. Watercolor and gouache. Collection of Mr. and Mrs. Paul Mellon, Upperville, Virginia

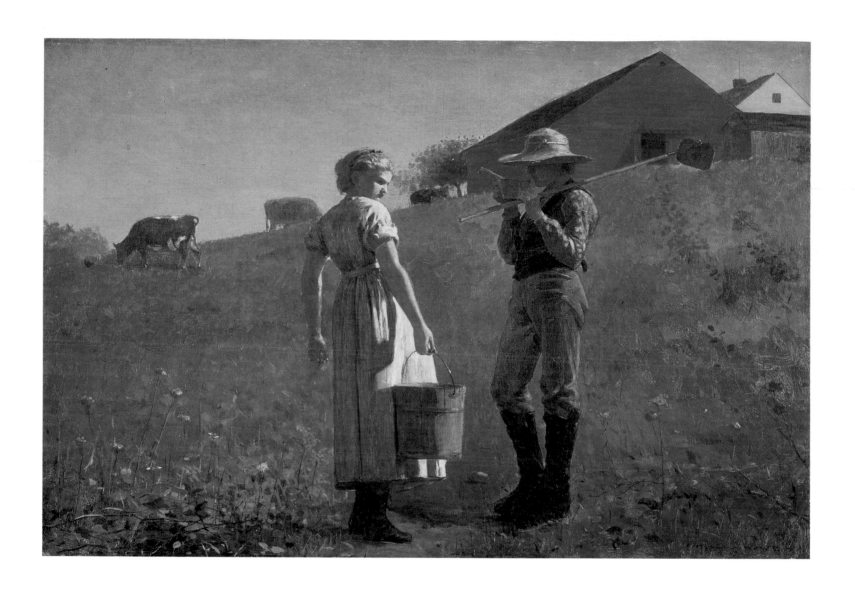

47. *A Temperance Meeting [Noon Time]*, 1874
oil on canvas, 52.7 x 76.5 (20¼ x 30⅛)
Philadelphia Museum of Art, John H. McFadden, Jr.
Fund
Provenance: Mrs. Theron Rockwell, Norfolk, Connecticut, by 1936; Mrs. Grace Ludlow, Connecticut;
(Wildenstein & Co., New York).

47

For many years called *A Gloucester Farm*, this is
the painting Homer wittily entitled *A Temperance Meeting*—except when he sent it to Louisville, Kentucky, for exhibition. Then, stripping
the title of the faintly wicked mention of temperance, but also of its wit, he called it *Noon Time*.[1]

NOTES

1. "Winslow Homer [is represented] by the 'The Temperance Meeting,' a milkmaid giving a shepherd lad a draught
of milk, good in drawing and strong in expression, and
one of the best works, we think, Mr. Homer has recently
produced" ("Fine Arts. American Art—The Palette Club
Exhibition, *New York Times*, 9 March 1874). "It is called
'Noon Time' (143).…The man is in the act of drinking,
while the woman stands holding a bucket of water in her
right hand and counterbalancing its weight by holding
out her bent, left arm in a perfectly awkward and natural
manner" ("The Exposition," *Louisville Courier Journal*,
9 September 1875).

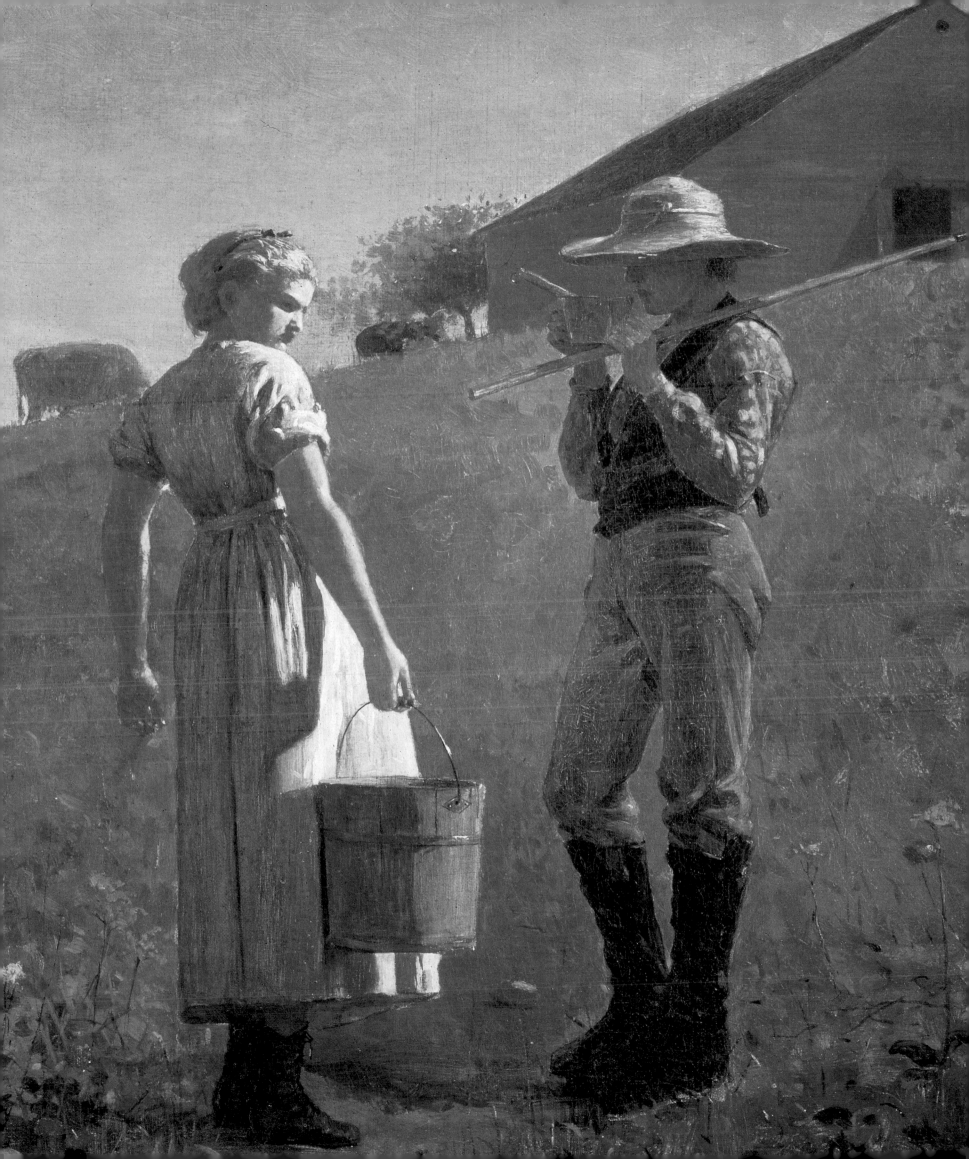

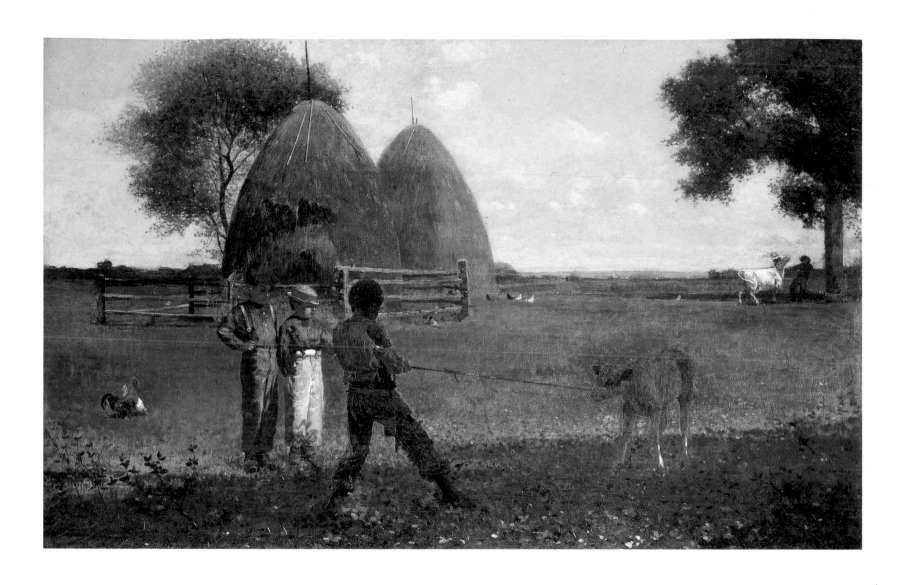

48. **Weaning the Calf,** 1875
oil on canvas, 61 x 96.5 (24 x 38)
North Carolina Museum of Art, Raleigh. Purchased
with funds from the state of North Carolina
Provenance: John H. Sherwood, New York; (George A.
Leavitt & Co., New York, 17 December 1879, no. 49);
Alfred R. Whitney, New York; his son, Maurice
Whitney, Albany, New York; (Macbeth Gallery, New
York, 1 March 1935); Stephen Carlton Clark, New
York, 1935; (Macbeth Gallery, New York); Mrs. Jacob
H. Rand, Summer 1946; (Babcock Galleries, New
York, 1948–1952); (John Levy Galleries, New York).

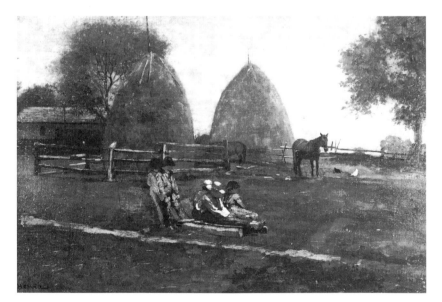

fig. 89. *Haystacks and Children*, 1874. Oil on canvas. Cooper-Hewitt, National Design Museum,
Smithsonian Institution (1918–20–3). Art Resource, New York

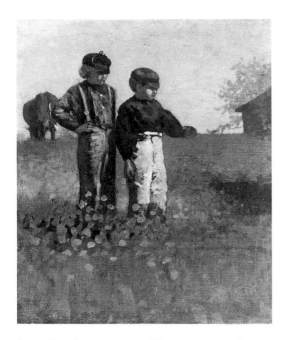

fig. 90. *Young Farmers*, c. 1874. Oil on canvas mounted on board. Courtesy of The Jordan-Volpe Gallery, Inc.

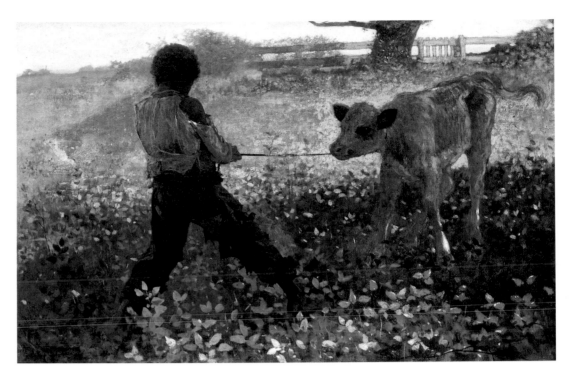

ABOVE RIGHT: fig. 91. *The Unruly Calf*, 1875. Oil on canvas. Courtesy of Sotheby's, New York

fig. 92. *Study for The Unruly Calf*, c. 1875. Pencil and Chinese white. The Brooklyn Museum, Museum Collection Fund 24.241

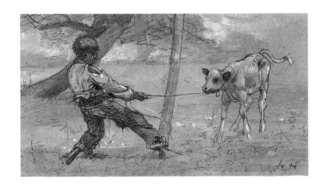

48

Although it is dated 1875, a visitor who saw *Weaning the Calf* in Homer's studio in early January 1876 reported that he "is putting the finishing touches to a farmyard scene of a very spirited character. There is a negro boy in the foreground tugging a cord, which is tied around the neck of an unruly calf, much to the amusement of two little [white] boys who stand near; and in the distance is the old cow, held by the sturdy farmer, but struggling to rejoin her calf. There are haystacks, fowls and other familiar objects shown in the landscape, the introduction of which will be appreciated by lovers of country life."[1]

At the time he was finishing *Weaning the Calf,* Homer was working on another painting of exactly the same size, *Breezing Up* (cat. 76). As he did in it, Homer assembled *Weaning the Calf* from a number of different sources: the background is based upon the oil sketch, *Haystacks and Children* of 1874 (fig. 89); the two onlooking boys upon another oil sketch, *Young Farmer Boys* of c. 1874 (fig. 90); and the black boy restraining the calf on the painting *The Unruly Calf* of 1875 (which was, in turn, based closely on a drawing, figs. 91–92). As he did in *Breezing Up,* Homer made several major changes to *Weaning the Calf,* such as significantly enlarging the size of the two white boys, and moving the position of the cow in the distance. And as he did with *Breezing Up,* perhaps regarding them as companion pictures (as he did, or as people thought he did, in several other cases, as in cats. 35 and 39, 80 and 81), he may have intended it for the 1876 Academy exhibition (where it did not go, replaced by *The Unruly Calf*).

NOTES

1. "Fine Arts," *New York Evening Post,* 5 January 1876. Recent published interpretations of the painting have dwelt with great ingenuity upon its symbolic references to Reconstruction, none of which, however, either this writer or Homer himself would likely have recognized (see Wood and Dalton 1989, 70, 72, and Docherty 1993, 32–48).

49. *Milking Time*, 1875
oil on canvas, 61 x 97.2 (24 x 38 ¼)
Delaware Art Museum, Gift of the Friends of Art and
other donors
Provenance: Charles F. W. Mielatz, New York; B. M.
Nelson, New York; Howard Kellog, Buffalo, New York;
Charles G. Lang, Glen Arm, Maryland; Mrs. Solton
Engel, New York; (M. Knoedler & Co., New York).

49–53

Once in a while Homer painted a picture his
critics found so trying—so "simply exasperat-
ing," as one of them said of *Milking Time*[1]—that
he might almost be thought, by "pushing his
individuality too far,"[2] to have done so purposely
to challenge them (as Whistler at just this time
and in just this way was doing so purposefully
in England). Some, of course, did not like to be
challenged: "The triple gray walls which cross
[*Milking Time*] give the whole composition the
'tender grace of a gridiron.'"[3] "It is impossible…
for his most ardent admirers to admit that he has
shown taste in the treatment of his subject. The
eye cannot but be offended by the straight lines
supposed to represent rails, occupying the most
important point in the composition."[4] Others,
however, saw more exactly what Homer was up
to. "[T]his year he puts forth several novelties of
effect that strike the eye like revelations. Another
artist, for instance, would hardly think of mak-
ing a motive out of the horizontal stripes of a
fence, relieved against a ground of very slightly

differing value, so as to make the group at the
fence appear like a decoration wrought upon a
barred ribbon. Yet that is the problem very effec-
tively wrought out in his milking-picture."[5]
Even Henry James, though he was not pleased
by it, understood its problematic artistic posture:
"Before Mr. Homer's little barefoot urchins and
little girls in calico sun-bonnets, straddling
beneath a cloudless sky upon the national rail
fence, the whole effort of the critic is instinc-
tively to contract himself, to double himself up,
as it were, so that he can creep into the problem
and examine it humbly and patiently, if a trifle
wonderingly." And he understood that the nature
of the problem Homer posed was essentially
formal and pictorial: "Mr. Homer's pictures…
imply no explanatory sonnets; the artist turns
his back squarely and frankly upon literature."[6]
A Chicago critic, however, saw most clearly the
essentially modernist attitude at work in this
and other of Homer's paintings: "The artist is
plainly striving at other objects than to make
pretty pictures—a fact inexplicable to persons
not particularly conversant with artist life," and

50. *In the Garden,* 1874
watercolor on paper, 23 x 17 (9 1/16 x 6 11/16)
Mr. Arthur G. Altschul
Provenance: Samuel P. Avery; (Clinton Hall Sale Rooms, 1876); probably J. H. Stedwell; Mr. and Mrs. Ambrose Topping, New York; Mabil Gardiner Adams; Lawrence Babcock; his wife, Nita Babcock; Arthur G. Altschul, 1965.

at values that "are apprehended by artists better than by laymen."[7] This is the case for art that is best understood for its own sake and by other artists that Whistler would argue in a few years in his suit against the critic John Ruskin.[8]

The female figure in *Milking Time* was one that Homer first considered, in the same costume but from a different point of view, in the splendid watercolor *In the Garden* of 1874 (cat. 50). She appeared as she would in *Milking Time* in an 1875 drawing (cat. 52), and in *A Milkmaid*, which has the aspect of having been made specifically for the painting (cat. 51). Later, he returned to the subject in a large watercolor, *The Milk Maid* of 1878 (cat. 53).

NOTES

1. "The National Academy of Design. Second Notice," *New York World*, 15 May 1875.

2. "Editor's Table," *Appleton's Journal* 14 (17 July 1875), 84.

3. "Editor's Table," 84.

4. "The Fine Arts," *New York Times*, 25 April 1875.

5. "Fine Arts. Fiftieth Annual Exhibition of the Academy of Design. I," *The Nation* 20 (15 April 1875), 265.

6. "On Some Pictures Lately Exhibited," *The Galaxy* 20 (July 1875), 90.

7. "Fine Arts. Review of the Paintings at the Exposition Building," *Chicago Tribune*, 12 September 1875.

8. For which see Linda Merrill, *A Pot of Paint: Aesthetics on Trial in Whistler v. Ruskin* (Washington and London, 1992).

cat. 51

cat. 52

51. *A Milkmaid*, 1874–1875
black chalk and gouache on paper, 37.5 x 18.1
(14¾ x 7⅛)
Addison Gallery of American Art, Phillips Academy,
Andover, Massachusetts, Gift of Mary D. and Arthur
L. Williston
Provenance: Mary D. and Arthur L. Williston
Washington and New York only

52. *Drawing of a Milkmaid from the Sketchbook of
Lars Sellstedt*, 1875
watercolor and pencil on paper, 12.7 x 17.8 (5 x 7)
Albright-Knox Art Gallery, Buffalo, New York, Gift
of Lars S. Potter, 1973
Provenance: Lars Sellstedt Potter, Buffalo.
Washington and New York only

53. *The Milk Maid*, 1878
watercolor over pencil on paper, 50.3 x 36
(19¾ x 14³⁄₁₆)
National Gallery of Art, Washington, Gift of Ruth
K. Henschel in memory of her husband, Charles R.
Henschel, 1975.92.11
Provenance: Grace Valentine, Darien, Connecticut.
Charles R. Henschel; his wife, Ruth K. Henschel.
Washington and New York only

cat. 53

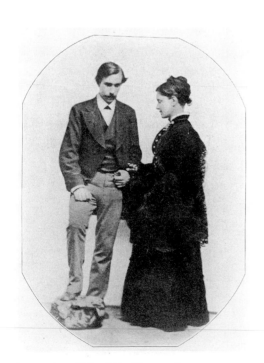

fig. 93. *Mr. and Mrs. Gilder.* Photograph. From *Letters of Richard Watson Gilder,* 1916.

54

Helena de Kay was the granddaughter of the Knickerbocker poet Joseph Rodman Drake (author of *The Culprit Fay*), a watercolor painter, and the younger sister of the critic Charles de Kay (who wrote, among many other things, important articles on the American artists George Inness in 1882 and Albert Pinkham Ryder in 1890). In 1874 she married Richard Watson Gilder (fig. 93), a poet and managing editor of *Scribner's Monthly* (and later editor of *The Century*). After their marriage, their house in Fifteenth Street in New York became a meeting place for artists and writers. Before her marriage, Helena de Kay had a relationship that seems to have been, at least on Homer's part, more intense than casual. If that relationship continued in some fashion after her marriage, it would have located Homer in one of New York's most cultivated literary and artistic circles.

By placing her in an Empire settee against a plain background, Homer virtually demands that his portrait of Helena de Kay be associated with Jacques-Louis David's famous portrait of the great beauty, Madame Récamier (fig. 94), which hung in the Louvre where Homer would have seen it. Also, no picture of a woman in a black dress seated in profile painted after 1871 can escape an association with Whistler's portrait of his mother (fig. 95). How Homer would have known it, however, is quite another matter, for it was not seen in America until about a decade after Homer painted Helena de Kay's portrait.

fig. 94. Jacques-Louis David. *Madame Récamier*, 1800. Oil on canvas. Musée du Louvre, Paris

But perhaps it was not Homer who knew it. Helena's brother Charles de Kay's novel *The Bohemian*, published in 1878, contains one of the earliest references to Whistler in America, and one, moreover, that showed a current knowledge of Whistler's art that most Americans at the time did not have, which suggests a precocious familiarity with Whistler among the de Kay-Gilder group.[1] From that group, too, there emerged in 1877 the most advanced artistic organization in America, the insurgent Society of American Artists, upon which Whistler exerted a strong if distant influence (he was described as its "demiurge" in 1879). And in 1879, the first serious article on Whistler to be published in America appeared in Gilder's *Scribner's Monthly.*[2]

Although Homer painted portraits from time to time—his paintings early and late contain

fig. 95. James McNeill Whistler. *Arrangement in Grey and Black: Portrait of the Painter's Mother*, 1871. Oil on canvas. Musée d'Orsay, Paris

recognizable and sometimes nameable people, like General Barlow in *Prisoners from the Front*, Orson Phelps and Monroe Holt in *The Two Guides*, and Michael Flynn in *Huntsman and Dogs* and *Hound and Hunter* (cats. 10, 59, 176, 179)— he was never in the usual meaning of the term a portrait painter. His few portraits are, like this one, more private than public. His one formal, commissioned portrait, *Officers at Camp Benton, Maryland* of 1881, painted from photographs, prints, and drawings twenty years after the event it purported to depict, is probably his least successful painting (fig. 53).

Helena de Kay's portrait is now inscribed with the date of her marriage to Richard Watson Gilder: "June 3rd 1874." It was painted earlier, however. Gilder, who met her in 1872, wrote that it was "painted ere mine eyes / Her ever holy face had looked upon." When the painting was exhibited at the Macbeth Gallery in New York in 1936, it was signed and dated "June 3 1871."[3] Perhaps a misreading, it is a more plausible date for the painting nevertheless. Homer took his studio in the Tenth Street Studio Building in 1871,[4] and the bare floors and walls in the painting suggest that that was where it was painted.

Offering to present the painting to her mother, Homer wrote Helena de Kay in December 1872, with unconvincing breeziness, "Why don't you limp into my studio on your way up or down and take it." Then he added, with a cheerfulness that is equally false and a pain he could not hide, "I am very jolly, no more long faces. It is not *all* wrong."[5] But something *was* wrong, and the return of her portrait (which she kept until her death) sadly marked the end of what can only have been a close and perhaps intimate relationship. Later, Richard Watson Gilder wrote a poem inspired by the painting that is charged with hints of his wife's not entirely unrequited earlier love:

This is her picture painted ere mine eyes
 Her ever holy face had looked upon.
 She sitteth in a silence of her own;
 Behind her, on the ground, a red rose lies;
Her thinking brow is bent, nor doth arise
 Her gaze from that shut book whose word
 unknown
 Her firm hands hide from her;—there all alone
 She sitteth in thought-trouble, maidenwise.
And now her lover waiting wondereth
 Whether the joy of joys is drawing near;
 Shall his brave fingers like a tender breath
That shut book open for her, wide and clear?
 From him who her sweet shadow worshippeth
 Now will she take the rose, and hold it dear?[6]

NOTES

1. "Look at Whistler, with his *nocturnes* in black, and *motifs* in blue, his peacock's feathers and frippery" (Charles de Kay, *The Bohemian: A Tragedy of Modern Life* [New York, 1878], 29).

2. William C. Brownell, "Whistler in Painting and Etching," *Scribner's Monthly* 18 (August 1879).

3. *An Introduction of Homer* [exh. cat., Macbeth Gallery] (New York, 1936), no. 71.

4. Annette Blaugrund, "The Tenth Street Studio Building: A Roster, 1857–1895," *American Art Journal* 14 (Spring 1982), 69.

5. Quoted in Hendricks 1979, 96.

6. "Love Grown Bold," in *The New Day, Lyrics and Other Poems* (New York, 1885).

55–56

"Winslow Homer contributed a strongly-painted and admirably-drawn interior, with the figure of a young lady seated at an open window. Flowering plants are growing upon the window-seat, and the landscape out of doors appears dressed in the foliage of early summer. The picture is particularly brilliant in the effect of light and shade."[1]

Homer made several paintings of this kind, all painted from the same model in the same dress at the same time (fig. 96), which serially investigated complicated pictorial problems of strongly contrasted light and dark, and interior and exterior space.[2]

That those effects were not of purely formal interest to Homer, or rather that what formal interest they possessed was art-historically stimulated, is suggested by their recurrent presence in seventeenth-century Dutch art. Dark interiors illuminated by brightly lighted windows are a virtual commonplace in Dutch paintings, particularly in those of such Little Masters as Gerard Dou (fig. 97, a painting in the Louvre that Homer might have seen). "Old Dutch and Flemish pictures are delightful," said a writer in *Appleton's Journal* in 1873, "interiors of houses,… partly in light, but mostly vague in sombre shadow.…"[3] The black dress and white shawl of the sitter, characteristic of Dutch seventeenth-century costume, makes its Dutchness all the greater, as does the turned slat-back great chair in which she sits. What may well have brought on this episode of Dutchness was Homer's visit to Hurley, New York, in the summer of 1872 where, it was reported in July, he was "sketching the quaint old Dutch interiors which abound in that neighborhood."[4] ("Hurley is a town of few inhabitants," it was said later, "and most of them are of Dutch descent.")[5] He depicted the exterior of one of the stone houses for which Hurley was famous in a splendid little oil, *Girl Reading on a Porch* of 1872 (fig. 98), which is as formally complex in its way as the interiors are.

fig. 96. *Reverie*, 1872. Oil on canvas. Private collection

cat. 55

fig. 97. Gerard Dou. *La lecture de la Bible*. Oil on canvas. Musée du Louvre, Paris

Dutchness is not confined to *At the Window* and the other paintings that resemble it. The exquisitely beautiful oil *Morning Glories* of 1873, which has seemed to some writers so Japanese in inspiration,[6] is more plausibly also Dutch in its derivation, being very much in the pattern of pictures by Dou and Gabriel Metsu (fig. 99, also in the Louvre), in which figures framed by openings in and around which objects are placed and plants grow are a common pictorial type.

NOTES

1. "Art at the Century," *New York Evening Post*, 3 February 1873.

2. As did, too, *The Country Store* of 1872 (cat. 40).

3. "Art, Music, and Drama," *Appleton's Journal* 10 (16 August 1873), 219.

4. *New York Evening Post*, July 1872.

5. "Gossip from the Summer Resorts," *New York Evening Post*, 18 June 1874.

6. Such as Gardner 1961.

fig. 98. *Girl Reading on a Porch*, 1872. Oil on panel. Private collection

BELOW: fig. 99. Gabriel Metsu. *L'Apothicaire*.
Oil on canvas. Musée du Louvre, Paris

cat. 56

55. *At the Window*, 1872
oil on canvas, 57.4 x 40 (22 ⅝ x 15 ¾)
The Art Museum, Princeton University, Gift of Mr.
and Mrs. Francis Bosak
Provenance: (M. Knoedler & Co., New York); (Babcock Galleries, New York); (Henry Antonville, New York); Michael J. Bosak, Sr., Scranton, Pennsylvania, 1924; his son, Francis Bosak, February 1937.

56. *Morning Glories*, 1873
oil on canvas, 49.8 x 33.7 (19 ⅝ x 13 ¼)
Private Collection
Provenance: (Maynard Walker Gallery, New York, 1953); Mr. and Mrs. Paul Mellon.

57. *An Adirondack Lake,* 1870
oil on canvas, 61.6 x 97.2 (24¼ x 38¼)
Henry Art Gallery, University of Washington, Horace
C. Henry Collection
Provenance: Mr. Scranton, Scranton, Pennsylvania; his
son, Walter Scranton, East Orange, New Jersey; (Mac-
beth Gallery, New York, 16 May 1911); Horace C.
Henry, 8 March 1912.
Washington and New York only

57

The Reverend William H. H. Murray's immensely influential travel book, *Adventures in the Wilderness; or, Camp-Life in the Adirondacks*, was published in the spring of 1869. Recommending the Adirondack wilderness as an alternative (and antidote) to the summer resort (like Long Branch), it produced a virtual stampede— a "rush" of tourists, called "Murray's fools"—to the Adirondacks in search of health and outdoor recreation, a part of that revitalizing regimen of exercise of which so many of Homer's postwar subjects partake.

Mr. Murray's book on the Adirondack Wilderness may almost be said to have created a new summer resort for American tourists....[His] enthusiasm for the Wilderness proved immediately and generally contagious; the press and the public seemed for the first time to have learned of the Adirondack region in its true character, as a vast play-ground for all tired Americans, and as a limitless hospital with the most potent medicaments of air, water and forest for the reinvigoration of nearly all classes of individuals.[1]

An Adirondack Lake, painted the year following the publication of Murray's book, is, therefore, with croquet, Long Branch, and White Mountain subjects, another of Homer's immediately current depictions of modern American manners and mores.

No picture in the gallery attracted more attention than that contributed by Mr. Winslow Homer; nor was there one which better merited complimentary notice. It is a scene on one of the Adirondack's lesser lakes, with the figure of an old guide who has just left his "dug out" canoe by the margin of the pond and is stepping landwards along a fallen pine. The sparkling daylight is powerfully suggested in this painting; the figure of the guide is admirably drawn and posed and there is charming realism in the treatment of the marshmallows of the foreground.[2]

The year after Homer painted *An Adirondack Lake*, a writer in *Appleton's Journal* described the figure of the guide who was central in his painting, and the figure, too, who was not only indispensable to nearly everyone's Adirondack experience ("...the most important of all considerations to one about to visit the wilderness," Murray wrote),[3] but the almost mythic personification of the place: "...my guide was a hunter, and the son of a hunter; 'born and raised in the woods,' to quote his own words, and had never set foot in a city. He had the noiseless step of an Indian, and was a man of marvelously few words."[4]

That this guide was a hunter, or conducted hunts, can be deduced by the "jack" lamp resting in the stern of his boat that was used to hunt deer at night. The process was described by someone who regarded it as a particularly base way of hunting: "In the bow is the jack, a lantern especially manufactured for this purpose....The party consists of the guide, who manages the boat, and the butcher, who sits in the bow back of the lantern. They move silently about not far from the bank until the deer are heard, when the cap is taken off the lantern, and a strong streak of light thrown on the water. Now the guide swings the bow around until the deer are discovered standing, probably in the shallow water, and then keeping the light in their eyes, which either dazzles or fascinates them so they do not attempt to escape; the boat, unseen, but quietly and swiftly, draws near, sometimes getting within fifty feet. The butcher, completely in the dark, waits until within range so short that the chances of missing his victim are few; then he fires.... And this is sport!"[5]

NOTES

1. "In the Adirondacks," *Every Saturday* 1 (3 September 1870), 563.

2. "Art Gossip. The April Exhibition at the Century Club," *New York Evening Mail*, 3 April 1871.

3. "Guides," in Murray, *Adventures*, 32.

4. James Grant Wilson, "Two Weeks in the Wilderness," *Appleton's Journal* 6 (9 September 1871), 293.

5. Caspar W. Whitney, "The Butchery of Adirondack Deer," *Harper's Weekly* 36 (16 January 1892), 58. Murray, however, regarded jack-shooting at night to be "the most exciting of all sport..." ("Jack-shooting in a Foggy Night," in *Adventures*, 175).

cat. 58

ber 1870) and again (twice) in 1874,[1] when he
found the subject for *Waiting for a Bite* in all of
its forms (and probably for *The Two Guides* as
well [cat. 59]).

NOTES

1. See Tatham 1988, 26.

59

In 1878, Homer did not exhibit in the annual
Water Color Society exhibition, where his pres-
ence was greatly missed, and staked everything
on the six oils he sent to the Academy. The Acad-
emy treated him shabbily, and his works were
either abused or neglected by the critics. Five of
his submissions were hung in a corridor—"an
unusual place for an academician to occupy"[1]—
and the critic Clarence Cook, in the *New York
Tribune*, said none of his six pictures "will add to
his reputation.... The subjects of some of these
are mean; those of all of them are uninteresting;
and the execution is as vapid as the theme."[2] *The
Two Guides*, the best of them and one now admired
as one of Homer's greatest paintings, was barely
noticed: it "is a spirited composition," one critic
wrote, and another, at greater length but with
no greater insight, said "it is interesting to note...
how different an impression the North Woods
make upon Mr. Homer from that which they
leave upon most of our artists who go a-sketch-
ing there. From no one else has a report of their

58

The engraving "Waiting for a Bite" was pub-
lished in *Harper's Weekly* in August 1874. The
watercolor that it closely follows, usually given
the same title, is probably the one entitled *Why
Don't the Suckers Bite?* in the 1875 Water Color
Society exhibition (fig. 100). The painting, dated
1874, which contains only two figures on the
dead uprooted tree in a desolate, cut-over land-
scape (based on an 1874 watercolor, fig. 101), is a
sterner and more disturbing image of modern,
"civilized" nature.

 Waiting for a Bite is located in the Adiron-
dacks, which Homer probably first visited in
1870 (and depicted in "Trapping in the Adiron-
dacks," published in *Every Saturday* in Decem-

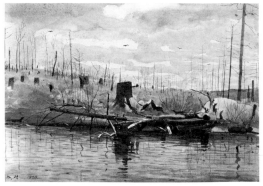

fig. 101. *Landscape*, 1874. Watercolor. Courtesy M. Knoedler
& Co.

58. *Waiting for a Bite*, 1874
oil on canvas, 30.5 x 50.8 (12 x 20)
Cummer Gallery of Art, Jacksonville, Florida
Provenance: (George A. Leavitt & Co., New York); Jon
S. Clapp; Zeb Mayhew; Mrs. Ellie Newton Sperry,
Fort Lauderdale, Florida; her daughter, Mrs. W. C.
Bristol; Francis M. Weld, 1936.

59. *The Two Guides*, 1875
oil on canvas, 61.6 x 97.2 (24¼ x 38¼)
Sterling and Francine Clark Art Institute,
Williamstown, Massachusetts
Provenance: (Reichard & Co., New York, March 1890);
Thomas B. Clarke, New York, by October 1891;
(American Art Association, New York, 17 February
1899, no. 360): Chauncey J. Blair, Chicago; (Scott &
Fowles, New York, 1916); Robert Sterling Clark, 3
November 1916.

breeziness, their freshness and their openness
anything like this of Mr. Homer's hitherto
come."[3]

For a reason that is not clear Homer seems
at this time to have irritated the critical and
institutional establishments of New York, and
they him. That would explain the insultingly
poor hanging of his Academy paintings; the bit-
ter remark that he "has not cared to trouble him-
self to put in an appearance" as an exhibitor in
the Water Color exhibition; and Cook's peevish
rhetorical question, "What has come over this
artist of late years that he sulks in his tent, and
seems to take pleasure in painting as badly as he
can?" It would account, too, on the other hand,
for Homer's choosing not to exhibit watercolors,
and for the rather thrown-together group of
paintings that he sent to the Academy, which
included works disparately varied in subject and
distinctly earlier in date, such as *The Two Guides*,
probably painted in 1875 (its date is indistinct),
and *Shall I Tell Your Fortune?* (private collection)
and *The Watermelon Boys* (fig. 176), both painted
in 1876.

It is strange, nevertheless, that a painting of
the extraordinary quality and not negligible size
of *The Two Guides* could go so largely unnoticed
and unappreciated.

The Two Guides depicts Orson Phelps, one of
the most famous Adirondack guides, and the
younger Monroe Holt, both of Keene Valley,
New York, which Homer visited in 1870 and
again in 1874.[4]

NOTES

1. "The National Academy of Design. II," *New York Sun*,
14 April 1878.

2. C[larence]. C[ook]., "Fine Arts. National Academy of
Design. Fifty-third Annual Exhibition. V," *New York Tri-
bune*, 11 May 1878.

3. "The Academy Exhibition. III," *New York World*, 18
May 1878.

4. Tatham 1988, 22–34.

cat. 59

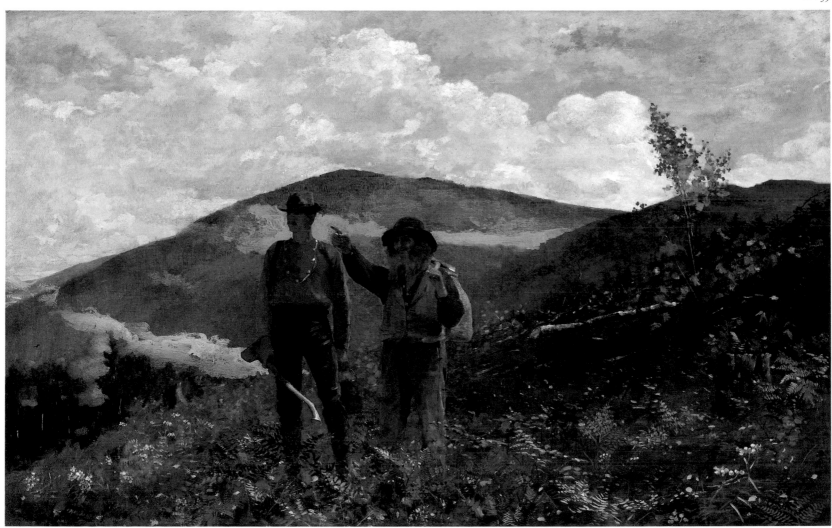

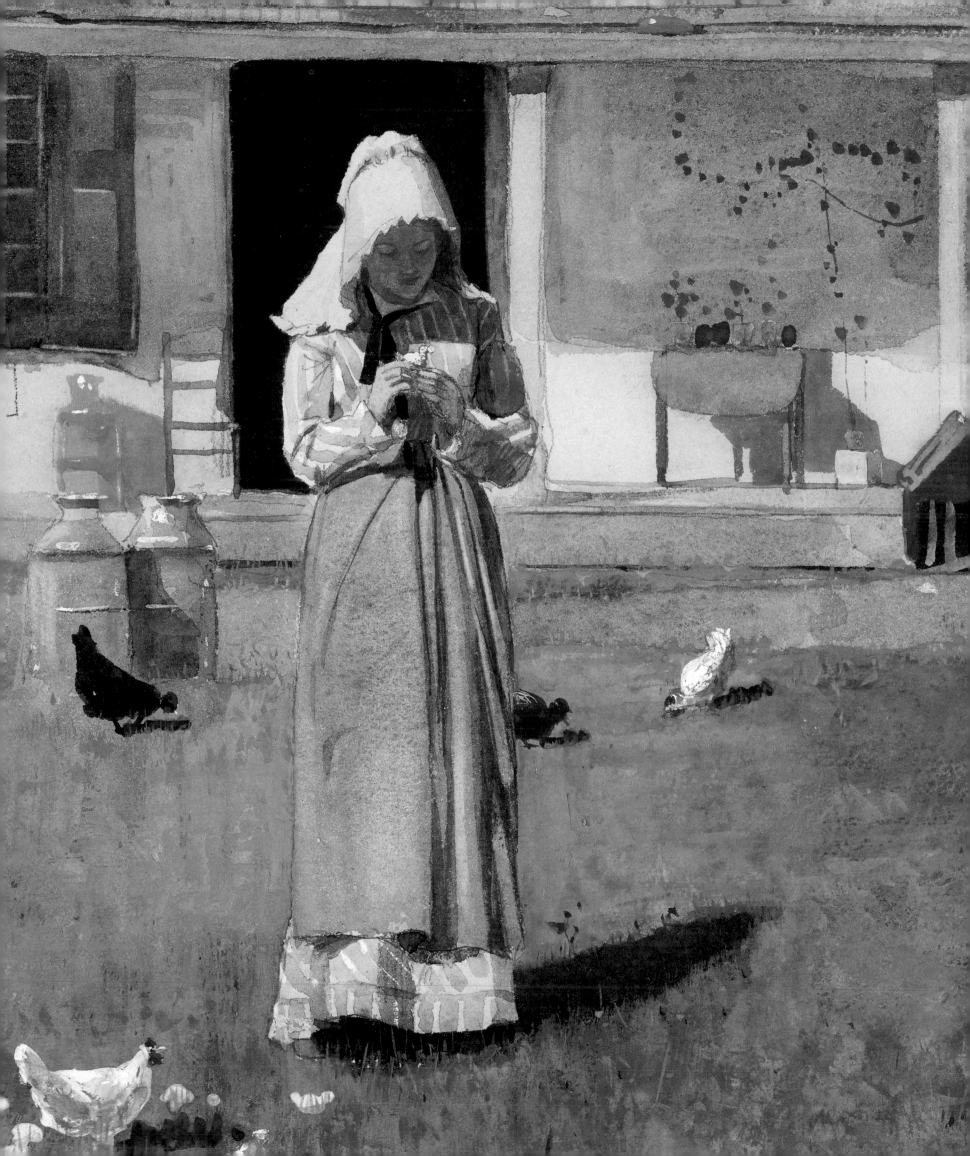

60–78

In "a sudden and desperate plunge into water color painting"[1] Homer sent twenty-seven watercolors to the Eighth Water Color Society exhibition in 1875. That exhibition included many of his finest early watercolors and provided an occasion for review of Homer's achievements in that medium, of which his critics, despite the usual reservations about finish, on the whole took favorable and accurate measure.

Mr. Winslow Homer, who rarely carries his works beyond the finish of sketches, sent several subjects broad enough in treatment, being mere indications of objects and effects, to please his most enthusiastic admirer....Mr. Homer's style is wonderfully vigorous and original; with a few dashes of the brush, he suggests a picture, but a mere suggestion only, and it is a mistaken eccentricity which prevents its finish.[2]

All...are representations of rustic life and character, and have a snap and sparkle to them that is altogether interesting and attractive. There is a peculiar swing and freshness in Mr. Homer's water-color painting that is wonderfully breezy and redolent of a strong and vigorous individuality.[3]

Mr. Homer is represented by a variety of quaint and brilliant sketches, none of which can be called "pictures," yet they are artistic works in every respect.[4]

[An] American painter, whose pictures please without a break, are the sparkling, broad sketches by Winslow Homer. Whether they represent Adirondack guides; "Lazy Days," when, with boat upturned on the beach, old fishermen and young ones spin yarns, squatted among the rock and peering out to sea; "Sick Chickens" [cat. 65], "Baskets of Clams" [cat. 60], or what not, they are bold and free, and alive with spirit.[5]

Mr. Winslow Homer, with rapid ease and photographic breadth, plants his flattened figures against a great variety of landscapes and coast-reaches. He contributes very copiously, and it is hard to say which of his sketches is the best when none are bad. Perhaps that of two smug and innocent fisher-boys, conveying a basket of clams, and just unconsciously swerving from the path at sight of a strange fish lying on the sand [cat. 60], is as characteristic as any. The pleasure with which we recognize truth-evidence in every study of Mr. Homer's is, however, marred by a really poignant feeling of regret. Seven or eight years ago this artist seemed to be prepared to paint pictures, and not mere effects; at present his highest exercise is to lay silhouettes of pasteboard on a ground of pasteboard differently tinted, and with these admirably-cut jumping-jacks to go through the various evolutions of life as given "in the flat."[6]

These twenty odd sketches of his are the slightest things Mr. Homer has yet sent to any exhibition, and while they give a comfortable notion of his industry,

and of both his acuteness of observation and his quickness in noting down what he sees—they are disappointing in not showing us anything that does justice to the known talent of the man. Indeed, we do not like to think how long it is since Mr. Homer showed us a finished picture—the record of art a few years back shows us only sketches, wood-cuts, and scraps like these that for the most part hardly deserve the name of sketches. We need not say how clever they are—how American, how loyally true to the awkwardness and innocence of country childhood, to all, in short, that makes country children seem like calves and sheep a little Darwinized....[He has] a delightful power of showing people really doing the things they pretend to be doing (look at the boys carrying the pail of water between 'em [cat. 60], at the boys reaching up to rob a bank-swallow's nest [cat. 63], at the "Darn the sucker, why don't they bite!" [fig. 100]—at any of these sketches that shows the human body in action); with all these advantages on his side, we say, Mr. Homer has never painted more than one important picture, the "Prisoners from the Front" [cat. 10], and is only known by a cloud of sketches like those in the present exhibition. What is the reason that all this force, this cleverness, this ability to see, almost never concentrates itself, or gets beyond the limits of a sketch, and a sketch of the slightest kind.[7]

It is impossible for Mr. Homer to finish anything, but notwithstanding this apparent fault his works have a value for force which is not excelled by any of his contemporaries....[8]

NOTES

1. "Art Notes," *New York Herald*, 15 February 1875.

2. "American Society of Painters in Water-Colours," *The Art Journal* 1 (1875), 92.

3. "Art Matters. The Water-Color Exhibition," *New York Evening Express*, 6 February 1875.

4. "The Water-Color Exhibition," *New York Evening Post*, 10 February 1875.

5. "The Arts. The Water-color Exhibition," *Appleton's Journal* 13 (13 February 1875), 216.

6. "Fine Arts. The Water-Color Society's Exhibition,—II," *The Nation* 20 (18 February 1875), 119.

7. "Fine Arts. The American Society of Painters in Water-Colors—Eighth Annual Exhibition," *New York Tribune*, 22 February 1875.

8. "Fine Arts. Exhibition of Water Color Drawings to be Opened this Evening," *Brooklyn Eagle*, 8 March 1875.

60. *A Basket of Clams,* 1873
watercolor on paper, 29.2 x 24.8 (11 ½ x 9 ¾)
Mr. Arthur G. Altschul
Provenance: Andrew E. Douglass; his grandson, Ronald
Eliot Curtis; his wife, Madeleine C. Curtis, c. 1960;
her daughter, Caroline Curtis Rounds, Cannondale,
Connecticut, c. 1965.

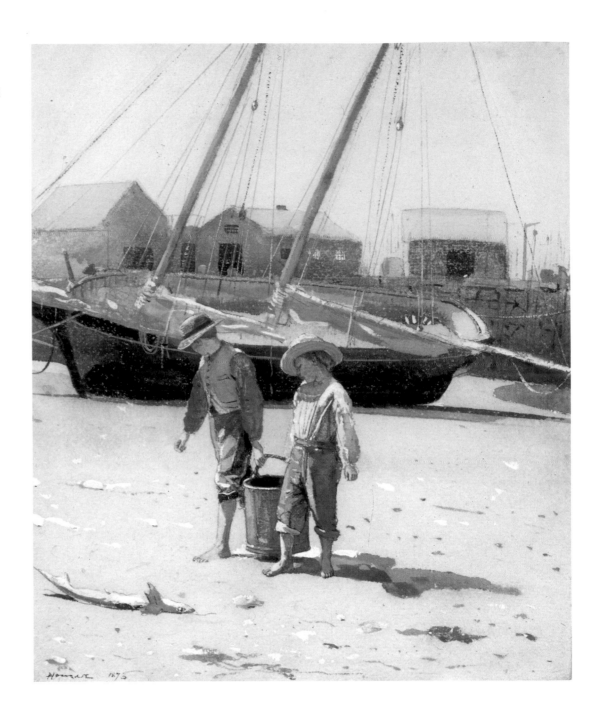

fig. 102. William H. Redding after Winslow Homer.
"Sea-side Sketches—A Clam-bake." Wood engraving. In
Harper's Weekly, 23 August 1873

60–62

The images in Homer's earliest watercolors
often went through a number of relocations and
transformations. The two boys in *A Basket of
Clams,* for instance, were combined with the
figure group in another 1873 watercolor, *The
Clambake* (The Cleveland Museum of Art), to
form the engraving "Sea-Side Sketches—A
Clam-Bake," published in *Harper's Weekly,* 23
August 1873(fig. 102). *Seven Boys in a Dory* (cat.
61) was used for the engraving "Gloucester
Harbor," *Harper's Weekly,* 27 September 1873 (fig.
108), and for the oil *Three Boys in a Dory* (private
collection).[1] *Three Boys in a Dory with Lobster Pots*

of 1875 (cat. 62), in turn, was based both on the
1873 watercolor *Seven Boys in a Dory* and the oil
Three Boys in a Dory.

NOTES

1. Christie's, New York, 28 May 1992, no. 132 (repro.).

61. **Seven Boys in a Dory,** 1873
watercolor on paper, 24.1 x 34.3 (9½ x 13½)
Mrs. James Wyeth
Provenance: (M. Knoedler & Co., New York); Mr.
Woolworth; his son, Fred Woolworth; (Coe Kerr
Gallery, New York).
Washington and New York only

62. **Three Boys in a Dory with Lobster Pots,** 1875
watercolor on paper, 34.5 x 52.1 (13⁹⁄₁₆ x 20½)
The Nelson-Atkins Museum of Art, Kansas City,
Missouri, Purchase Nelson Trust, 4455/1
Provenance: Albert Kelsey, Jr., Philadelphia; (M. Knoed-
ler & Co., New York, 1944).

cat. 61

cat. 62

63. **How Many Eggs?,** 1873
watercolor on paper, 31.8 x 24.1 (12½ x 9½)
Mr. and Mrs. W. Bryant Williams
Provenance: (Grand Central Art Galleries, New York);
James M. Cowan, Chicago; his niece, Lucy Cowan
Williams, 1930–1986; her son, W. Bryant Williams.
Washington and New York only

64. **Fresh Eggs,** 1874
watercolor, gouache, and pencil on paper, 23.7 x 19.3 (9 ⁵⁄₁₆ x 7 ⅝)
National Gallery of Art, Washington, Collection of Mr. and Mrs. Paul Mellon,
1994.59.26
Provenance: probably Samuel P. Avery, New York; (probably sold, Clinton Hall Sale
Rooms, New York, 1876); (Robert Keene Bookshop and Gallery, Southhampton,
New York, 1964); Arthur G. Altschul, New York, 1965; gift to the Whitney Muse-
um of American Art, 1967; (Christie's, New York, 31 May 1985, no. 60); Mr. and
Mrs. Paul Mellon, 1985–1994.
Boston and New York only

65. *The Sick Chicken*, 1874
watercolor, gouache, and pencil on paper, 24.7 x 19.7
(9¾ x 7¾)
National Gallery of Art, Washington, Collection of
Mr. and Mrs. Paul Mellon, 1994.59.21
Provenance: Lawson Valentine; his daughter, Almira
Houghton Pulsifer; her son, Harold Trowbridge Pul-
sifer; his wife, Susan Nichols Pulsifer; her nieces; Mr.
and Mrs. Paul Mellon, 1989–1994.
Washington and Boston only

65

At the Century Association in January 1875,
"In a little corner by themselves, Mr. Winslow
Homer exhibits a number of the best water-color
and charcoal sketches we have ever seen by him.
One of the most pleasing of these is of a country
girl surrounded by her poultry, and holding in
her hands a sick chicken. The girl is quite small,
and the fowls are so minute that each one of
them is delineated by a touch; but the touch is a
very precise one, and, in consequence of this cer-
tainty of hand and thought, specks of colour so
small that they would be entirely insignificant

in most pictures are in this artist's hand full of
freshness and force."[1]

Aesthetically and expressively, this is one of
Homer's most delicate and tender watercolors,
and one he quite literally valued highly; when it
was shown in the Water Color Society exhibition
later that year, where most of his contributions
were priced at between thirty and seventy-five
dollars, *Sick Chicken* was priced at one hundred
dollars.

NOTES

1. "The January Century Club Exhibition," *The Art
Journal* 1 (1875), 63.

66. ***Waiting for the Boats,*** 1873
watercolor and gouache over pencil on paper,
21.6 x 34.29 (8½ x 13½)
Private Collection
Provenance: Private collection, by descent.

fig. 103. *Dad's Coming!*, 1873. Oil on panel. Collection of
Mr. and Mrs. Paul Mellon, Upperville, Virginia

RIGHT: fig. 104. *Waiting for Dad*, 1873. Watercolor. Mills
College Art Gallery, Gift of Jane C. Tolman, 1912.2

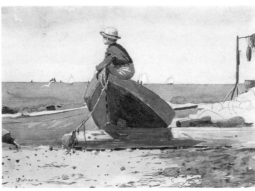

66–68

"The history of the Gloucester fisheries has
been written in tears....In a single year (1873)
thirty-one of her vessels sailed to return no
more, and 174 of her fishermen were laid in an
ocean grave."[1] In a single storm on 24 August
1873, exactly when Homer was at Gloucester,
128 men were lost.[2]

Waiting and watching were central to the
lives of the families and relations of Gloucester
fishermen, as they were to the families and rela-
tions of fishermen everywhere. For that reason
alone it is a central and recurrent theme in
Homer's Gloucester watercolors. But it was given
specially acute actuality by the exceptionally
large loss of life in the summer of 1873. Of its
tragic results—"...mourning throughout the
town....Wives weeping for their husbands, who
will never again bless them with their earthly
presence,...and little children ask[ing], in plain-
tive tones, 'Why does not my father come
home?'"[3]—Homer had what can only have been
painfully direct experience. He gave it its most
forceful expression, not in a watercolor (though
there is a watercolor related to it, fig. 104), but
in an oil, *Dad's Coming!* (fig. 103), perhaps the
earliest instance of the different dimensions of
meaning and conditions of form that he assigned
to paintings in oil and in watercolor. While it is
almost miniature in scale, it is monumentally
large in its quality of form and profundity of
meaning, and translates into classically timeless
and universal but also psychologically equivocal
terms the engraving "Here Comes Father's Ves-

fig. 105. Anonymous. "Here Comes Father's Vessel."
Engraving. In *The Fishermen's Memorial and Record Book*, 1873

cat. 67

67. *Watching the Harbor*, 1873
watercolor and gouache over pencil on paper,
21 x 33.7 (8¼ x 13¼)
Private Collection
Provenance: Private collection, by descent.

68. *Boy with Anchor*, 1873
watercolor on paper, 19.4 x 34.9 (7⅝ x 13¼)
The Cleveland Museum of Art, Norman O. Stone and
Ella A. Stone Memorial Fund
Provenance: John Hay. Mrs. C. E. Meder.
Washington and Boston only

cat. 68

sel," published in *The Fishermen's Memorial and
Record Book* in 1873 (fig. 105).[4]

NOTES

1. *The Fisheries of Gloucester from the First Catch by the English in 1623, to the Centennial Years, 1876* (Gloucester, 1876), 71–72.

2. His presence was noted in the *Gloucester Telegraph* and the *Cape Ann Advertiser* on 20 and 22 August, respectively. Atkinson 1990, 10.

3. Quoted in Atkinson 1990, 25.

4. For *Dad's Coming!*, see particularly Wilmerding 1986, 389–401.

68

The anchor, the traditional symbol of hope, upon which the watching boy sits and to which he almost clings, represents both by its meaning and by its size the principal content of the boy's thought and the condition of his feeling, in which expectation and anxiety are held in an uneasy balance.

69. ***Boy in a Boatyard [Boy with Barrels],*** 1873
watercolor, tempera, and pencil on paper mounted on
board, 18.7 x 34.9 (7 ⅜ x 13 ¾)
Portland Museum of Art, Portland, Maine, Bequest of
Charles Shipman Payson, 1988.55.5
Provenance: Mr. Beard, 1890s; Bessie Beard, by 1936;
(Macbeth Gallery, New York, 1936); Edmund Pren-
tiss, 1936; his son, Edmund Prentiss III; (Robert G.
Osborne, New York, by 1974); Mr. and Mrs. Charles
Shipman Payson, 1974.
New York only

70. ***In Charge of Baby,*** 1873
watercolor on paper, 21.6 x 34.3 (8 ½ x 13 ½)
Mr. and Mrs. A. Alfred Taubman
Provenance: Katharine May Wilkinson, New York, by
1944; (Wildenstein & Co., New York, 1953); (Sothe-
by's, New York, 25 May 1987, no. 5).

69–70

Homer's concern for *pictorial* architecture—for
formal and spatial structure in contrast to the
depiction of actual architectural objects (as in
the schoolhouse paintings of just a year or two
earlier)—first appears clearly and with highly
developed subtlety in paintings of 1873, as in the
Detroit version of *The Dinner Horn* (fig. 86), and
particularly in such Gloucester watercolors as
these. The visually exciting, and manifestly con-
trived, complexities of parallelism and rhyming
shape of *Boy in a Boatyard*, and the almost cubist
play of geometric spatial volumes of *In Charge of
Baby*, are the first evidence of Homer's very con-
siderable, and heretofore never as fully revealed,
powers of formal pictorial thought.

71. **Shipbuilding at Gloucester,** 1871
oil on canvas, 34.3 x 50.2 (13½ x 19¾)
Smith College Museum of Art, Northampton, Massachusetts, Purchased 1950
Provenance: Martin Burke, New York; his son, John Burke, New York, after 1933; (M Knoedler & Co., New York, 1945); Joseph Katz, Baltimore, 1945; (Victor Spark, New York).
Washington and New York only

71

Because its date clearly reads 1871, two years before Homer painted at Gloucester, and because the ships of the Gloucester fishing fleet were built not at Gloucester itself, but at nearby Essex, on the Essex River north of Gloucester (perhaps the "river town, but a short distance from the open sea" described below, cat. 75), the location of this painting seems misnamed. It was probably given its title from the *Harper's Weekly* engraving, "Shipbuilding, Gloucester Harbor" (cat. 75), for which Homer later used it.

72. *The Boat Builders [Ship Building],* 1873
oil on panel, 15.2 x 26 (6 x 10¼)
Indianapolis Museum of Art, Martha Delzell Memorial Fund
Provenance: Alexander Humphreys; Mrs. R. E. Turnbull; (M. Knoedler & Co., New York); (Macbeth Gallery, New York); Edward Ward McMahon; (Hirschl & Adler Galleries, New York).

73. *The Boat Builders,* 1873
pencil on paper, 24.1 x 31 (9½ x 12³⁄₁₆)
Mr. J. Carter Brown
Provenance: Private collection.

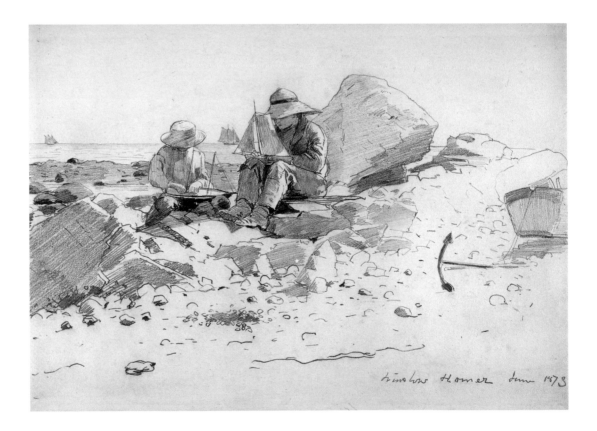

72

This "small cabinet picture entitled 'Ship Building'…showing two little boys seated among huge bowlders [sic] on the bay shore engaged in building miniature boats"[1] was shown at the Century Association in February 1874.

NOTES
1. "Art at the Century," *New York Evening Post,* 9 February 1874.

74. *Four Boys on a Beach,* c. 1873
pencil, watercolor, and gouache on paper, 14.1 x 34
(5 9/16 x 13 7/16)
National Gallery of Art, Washington, John Davis
Hatch Collection, Andrew W. Mellon Fund, 1979.19.1
Provenance: (Macbeth Gallery, New York, by 1936);
John Davis Hatch.
Washington and New York only

75. *"Shipbuilding, Gloucester Harbor,"* Harper's
Weekly (11 October 1873)
wood engraving on newsprint, image: 23.4 x 34.6
(9 3/16 x 13 9/16); sheet: 28 x 40.6 (11 1/16 x 16)
National Gallery of Art, Washington, Avalon Fund,
1986.31.119
Provenance: Emily W. Taft Collection; (David O'Neal).
Washington and New York only

75

A subject very like this one was described in
1870:

In a river town, but a short distance from the open
sea, there lies a ship-yard from which resound the blow
of the broad axe, and the stroke of the hammer.

This ship-yard was, years ago, like a fairy land to
the town's children. They gathered there in crowds
after school, some to gather chips for kindling, some
to build chip houses, some to watch and question the
workmen, and others to hollow out and rig miniature
vessels.[1]

After saying "The picture speaks for itself,"
the text that accompanied "Shipbuilding,
Gloucester Harbor" in *Harper's Weekly* went on
to speak for it: it is "interesting not only as a

work of art, but as a suggestion of the renewed
enterprise and activity which are beginning to
manifest themselves in American ship-yards. All
along our immense line of coast may be seen
indications which awaken the hope that Ameri-
ca will soon resume her former supremacy in
building ships."[2]

This is a particularly clear though unusually
complicated example of Homer's method of
assembling his prints from diverse sources — in
this case, from two oil paintings, a drawing, and
a watercolor.

NOTES
1. J. D. C., "Rob in Search of Fame," *The Youth's Companion*
[Boston] 43 (10 March 1870), 73.
2. "Ship-Building," *Harper's Weekly* 17 (11 October 1873),
902.

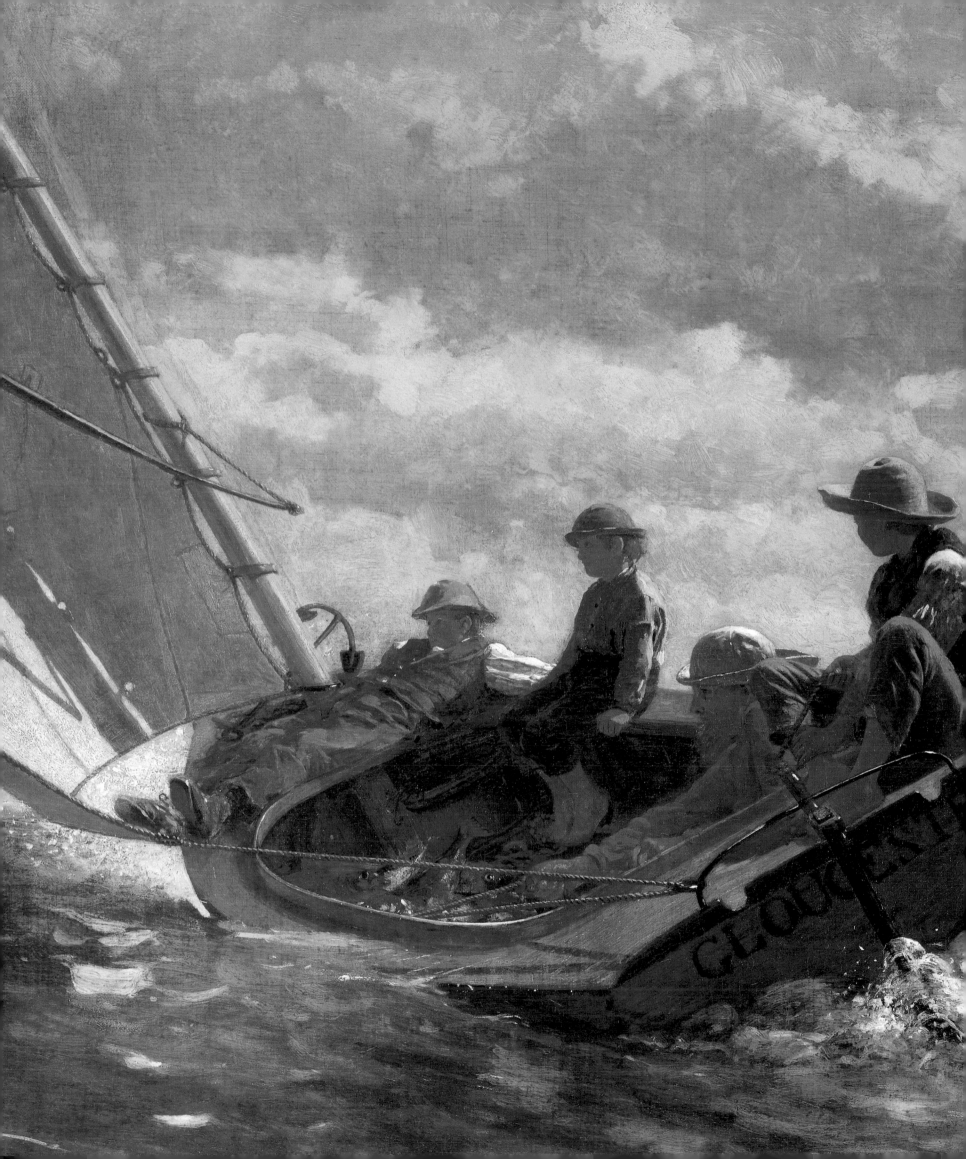

76

…Mr. Winslow Homer…has at last painted a picture, a marine subject, that will at once delight and surprise those who have feared we were never to have anything from his hand but sketches.…[1]

No eye that delights in salt water, and in the sight at least of a sail-boat bounding over it; and no eye that can take pleasure in seeing the human body painted with a master hand…but must admit that there is not a picture in this exhibition, nor can we remember when there has been a picture in any exhibition, that can be named along side of this.[2]

The drawing is simply superb, and the painting is free from those abominable lazinesses and hurryings which formerly disfigured some of his best productions.[3]

…Mr. Homer gives us this spring the most admirable sketch he has made since the period of his war-pictures. The exulting freedom with which his brush ripples over the canvas,…in which a fresh sea is cloven by the fisherman's boat, while his little boys drink in the health and breeze of the young day, is for Mr. Homer a revelation. He has never told a story so well, nor has his pithy economy of expression in telling a story ever become him more. The boatman's barefoot boy who sits upon the thwart, and whose bright eye evidently sees such enormous horizons as he looks through the curl of spray shaved up by the keel, is as clean-cut a piece of work as the best figure ever blocked out for a shipbuilder by the marine sculptor.[4]

…among the best things he has given the public since "Prisoners for the Front."[5]

Winslow Homer's "Fair Wind" is perhaps the best sea-piece he has ever contributed to an Academy exhibition. It is painted in his customary coarse and negligé style, but suggests with unmistakable force

fig. 106. *Breezing Up*. Infrared reflectogram mosaic. National Gallery of Art, Washington

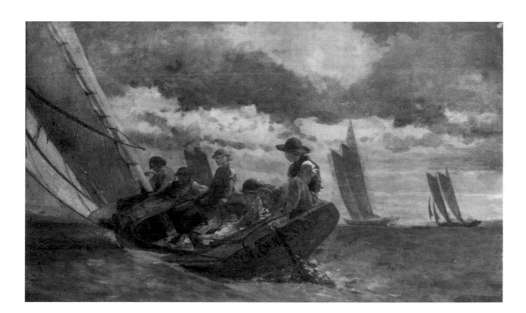

the life and motion of a breezy summer day off the coast. The fishing boat, bending to the wind, seems actually to cleave the waters. There is not truer or heartier work in the present exhibition.[6]

Breezing Up was the capstone of Homer's Gloucester paintings, his most popular painting since *Prisoners from the Front*, and so compellingly attractive that his critics, as they were seldom at this time willing to do, forgave the coarseness and abbreviation of style that, even here, they could not entirely pass by without comment.

Breezing Up is obviously closely related to a watercolor, *Sailing the Catboat* (cat. 77), most probably painted during his summer at Gloucester in 1873. A visitor to Homer's studio in January 1874 who reported that he "is working hard at boys and boats—elaborating and finishing the studies he made during the summer."[7] Two years later another visitor to his studio reported: "Mr. Homer is at present at work upon a marine picture showing a fishing boat going into port under the effect of a strong breeze."[8] It was first exhibited two months later.

The explanation for Homer's protracted effort is writ upon the painting itself, not quite for all to see with the naked eye, perhaps, but easily visible by infrared reflectographic examination. It reveals a palimpsest of alterations (fig. 106): a fourth boy, as fully finished as the other three, was seated on the bow; in the distance there were two other boats in full sail, both also highly finished; the tiller and rudder were in a different position, properly steering the boat to starboard, and when in that position the older man who holds the sheet held the tiller as well (as he does in the oil study, *The Flirt*, fig. 107).

It is plain that Homer's conception of the picture once had a form very different from the one it eventually took, and one very different, too, from that of the watercolor that it seems to follow so closely. He originally conceived of a harbor more crowded with other boats, one that resembled the wood engraving "Gloucester Harbor" (fig. 108)—from which, in fact, the placement and appearance of the two sailboats that he eventually deleted was taken.

What caused Homer so radically to change the painting after it had been largely completed in a different form is not certainly known. But two reasons at least are possible. One is that in the course of developing its composition he experienced an influence that by the force and attraction of its example compelled him to change it. That influence was Japanese art, and its effect was to transform the symmetrically balanced Western composition of "Gloucester Harbor" that Homer had been considering into the almost canonically Eastern one of *Breezing Up*. The other possibility is that Homer adjust-

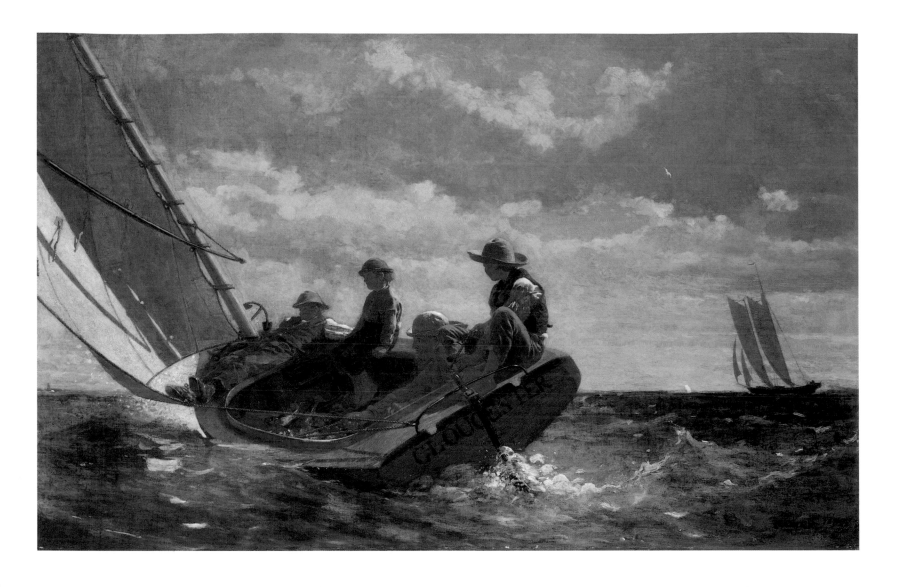

76. *Breezing Up [A Fair Wind]*, 1876
oil on canvas, 61.5 x 97 (24⅛ x 38⅛)
National Gallery of Art, Washington, Gift of the W.
L. and May T. Mellon Foundation, 1943.13.1
Provenance: Charles Stewart Smith, by 1878; his son,
Howard Caswell Smith, Oyster Bay, New York, 1909.
(Wildenstein & Co., New York, 1943).

fig. 107. *The Flirt*, 1874. Oil on canvas.
Collection of Mr. and Mrs. Paul
Mellon, Upperville, Virginia

ed details of the painting to remake or reinforce its meaning. The great event of 1876 was America's Centennial, celebrated by a large exposition held in Philadelphia. Marking the first hundred years of national existence, the Centennial was also an occasion to look into America's future as well as into its past. Americans "are animated by a new hopefulness," the "nation is only in its

childhood."[9] "We are young, strong, inventive, and quick-witted....When the Centennial is over, the whole nation will feel refreshed and encouraged."[10] These few specimens of the Centennial rhetoric of rejuvenation and hope suffice to show, particularly when it is echoed in the rhetoric of Homer's critics, how closely Homer's painting was its symbolic embodiment. That it was so more by calculation than by chance seems indicated by such changes Homer made to it as the replacement of the boy in the bow with an anchor, the symbol of hope (which, to indicate its public currency, Rhode Island adopted for its state seal in 1875), and the transfer of the direction of the boat from the older man to the young one in the stern, "whose bright eye sees such enormous horizons." Given Homer's proven weakness for puns, even its original title, *A Fair Wind*, may refer to the exposition—the *fair*—in Philadelphia that was the focal point of the Centennial celebration.

 Breezing Up was so popular, so readily understandable, so familiar, perhaps, because its cognates were widely distributed in contemporary

77. *Sailing the Catboat,* probably 1873
watercolor and gouache over pencil on paper,
19.1 x 34.9 (7 ½ x 13 ¾)
Private Collection
Provenance: Harold T. Pulsifer, by 1936. Private
collection, by descent.

fig. 108. After Winslow Homer. "Gloucester Harbor."
Wood engraving. In *Harper's Weekly,* 27 September 1873

popular imagery, such as J. C. Hook's frequently
reproduced "First Lesson in Navigation" (fig.
109), Sol Eytinge's "Blue Fishing" in *Harper's
Weekly* (10 August 1872), and Currier & Ives
prints such as *Blue Fishing* (fig. 110) and Mrs.
Palmer's *Trolling for Blue Fish* (Homer exhibited
a watercolor called *Blue Fishing* at the Century
Association in 1874).

NOTES

1. "Fine Arts. Fifty-first Annual Exhibition of the Nation-
al Academy of Design," *New York Tribune,* 28 March 1876.

2. "Fine Arts. National Academy of Design—Fifty-first
Annual Exhibition," *New York Tribune,* 1 April 1876.

fig. 110. Currier & Ives. *Blue Fishing.* Lithograph. From
Sporting Prints by N. Currier and Currier & Ives (New York
1930), 198

3. "The Fine Arts. Exhibition of the National Academy,"
New York Times, 8 April 1876.

4. "Fine Arts. The National Academy Exhibition, II.,"
The Nation 22 (20 April 1876), 268.

5. "Art Matters. A Hasty Glance at the Academy Exhibi-
tion," *New York Evening Express,* 20 April 1876.

6. "The National Academy of Design," *New York Sun,* 30
April 1876.

7. "Art," *New York Evening Mail,* 20 January 1874.

8. "Fine Arts," *New York Evening Post,* 5 January 1876.

9. "Topics of the Time. The Centennial," *Scribner's
Monthly* 11 (January 1876), 432.

10. "The Centennial and Its Effects," *New York Tribune,*
11 January 1876.

77

Undated, this must be one of the watercolors
Homer painted at Gloucester in the summer of
1873, upon which he based *Breezing Up.*

fig. 109. After James C. Hook. "The First Lesson in
Navigation." Wood engraving. In *Appleton's Journal,*
7 August 1869

78. *Calling the Pilot [Hailing the Schooner],* 1876
oil on canvas, 40.6 x 57.2 (16 x 22½)
Private Collection
Provenance: Francis Bartlett, Boston; his son-in-law,
Herbert M. Sears, Boston; H. H. Clowe, Indianapolis;
Pamela Woolworth, New York; (M. Knoedler & Co.,
New York, May 1961); Mr. and Mrs. Paul Mellon.

78

A "fisherman never attains to the highest excellence in his profession who has not been accustomed to a sea-faring life from early boyhood,"[1] and by the age of twelve or thirteen boys sailing on Gloucester fishing boats had not only learned how to fish and sail but also to navigate. "The fishermen of New England, as a class, are acknowledged to be excellent navigators," and "From their intimate knowledge of the coastline fishermen are recognized to be the best local pilots, and they are often called upon to act in that capacity by vessels unable to procure regular pilots."[2] It is in that capacity, though the painting's alternative title betrays some uncertainty about it, that the young fisherman, with his oilskin hat and bundle of clothes sufficient for a short voyage, is being hailed by the figure on the distant schooner.

The uncertainty about who or what is being called is not so much a narrative defect as, because it occurs in other of Homer's work, a narrative device with characteristically ambiguous consequences. In the engraving "'You Are Really Picturesque, My Love,'" published in *The Galaxy* in June 1868 (fig. 111), for example, one must suppose, without reading the story it illustrates, that the woman is speaking to the man, just as in "'Come!,'" published in *The Galaxy* in September 1869 (fig. 112), one also supposes, again without knowing the story, that the woman (who, like the pilot, is seen from behind) is speaking to the man. But in both cases it is just the opposite.[3] Similarly, the gestures and expressions in the painting *Answering the Horn [The Home Signal]* (fig. 113), painted about the same time as *Calling the Pilot,* were positively enigmatic: "Why he answers the horn by a motion of his arm, and why his face wears such a cross, almost sinister expression, and why the maiden seems desirous of getting behind him, and why she holds her fingers over her mouth—these things," a critic confessed, "we don't profess to understand."[4]

NOTES

1. George Brown Goode, *The Fisheries and Fishery Industries of the United States,* sect. III (Washington, 1887), 51.

2. Goode, *Fisheries,* 52.

3. See Tatham 1992, 80, 82.

4. "Fine Arts. The Academy Exhibition. II," *New York Evening Mail,* 23 April 1877.

ABOVE LEFT: fig. 111. After Winslow Homer. "You Are Really Picturesque My Love." Wood engraving. In *The Galaxy*, June 1868, opposite page 719

ABOVE RIGHT: fig. 112. After Winslow Homer. "Come." Wood engraving. In *The Galaxy*, September 1869, opposite page 293

fig. 113. *Answering the Horn*, 1876. Oil on canvas. Hackley Picture Fund, Muskegon Museum of Art, Muskegon, Michigan

79–82

A visit, or visits, to the South by Homer in 1875 and 1876 have been proposed to account for such African-American subjects as these (and others) that appear in Homer's art in those years.[1] They have become something of a fixture in Homer's chronology, although the only sure evidence of a visit by Homer to the South in the 1870s was the one reported in June 1877: "The fruits of one trip away from New-York are already visible in the studio of Mr. Winslow Homer who has been spending a few weeks in the South, and is just home. A number of sketches of colored life on the plantations have been brought back."[2] Several days earlier it was announced that Homer would exhibit "three studies of Virginia negro-life" at that month's exhibition of the Century Association.[3] One of them was *The Carnival* (cat. 82). Early the following year he was reported to be at work on another painting that his visit to the South produced: "Winslow Homer is at work upon a negro character study, entitled 'Sunday Morning In Virginia' [cat. 81], which bids fair to be one of his best pictures."[4]

Unlike these, few if any of his earlier African-American subjects were direct results of a southern trip. That is so of a group of watercolors— Helen Cooper calls it a "series"[5]—he painted in 1875. The black boy in *The Busy Bee* (fig. 114), *Taking a Sunflower to the Teacher*, and *Contraband* (fig. 115) was modeled by the same person who posed in Homer's studio and was located by him in generalized settings that were surely contrived.[6] That *A Visit from the Old Mistress* (cat. 80), painted in 1876, may have been similarly confected is suggested, in particular, by two things. One is its clear compositional similarity, almost to the point of congruence, to Homer's *Prisoners from the Front* of 1866.[7] The figures of the old mistress and General Barlow are similarly placed and are similarly erect and prepossessing, and in each case they confront a group of three figures that ranges similarly from proud defiance to retiring deference. Painted exactly ten years later, *A Visit from the Old Mistress* is, as though it were by its obviously repeated formal structure designed to be, the historical sequel to what was still, in 1876, Homer's most famous painting, *Prisoners from the Front*. Like it in form, it is like it also in content,

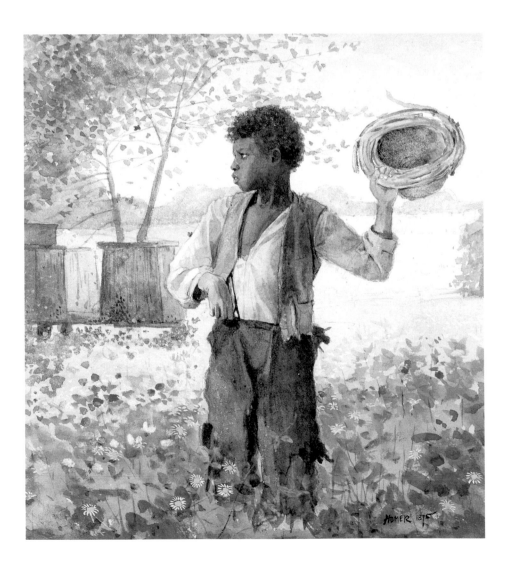

fig. 114. *The Busy Bee*, 1875. Watercolor. Berry-Hill Galleries, New York

fig. 115. *Contraband*, 1875. Watercolor. Canajoharie Library and Art Gallery, Canajoharie, New York

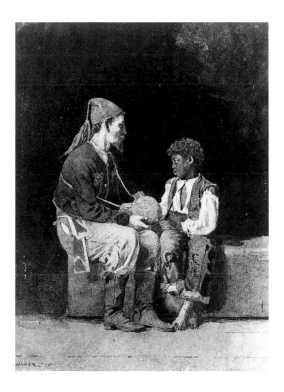

for in the same summary and analytical way both paintings, linked together almost as cause and effect, expound on the psychological and socio-logical consequences of the events they depict. *A Visit from the Old Mistress*, in other words, was not necessarily an artifact of something Homer actually experienced in the South in 1875 or 1876, but on the contrary was a response to one of his own paintings. That one of its parts, the figure at the far left, was based on one of Homer's own drawings (one he used again, as he did many of his Civil War drawings, in illustrations made in the 1880s [cat. 11, fig. 54]), also suggests artistic contrivance more than direct recent experience.

That is not so clearly the case in *The Cotton Pickers* of 1876. The field of cotton, the dress of the two figures, and the bag and basket they hold suggest by their apparent authenticity some firsthand experience of the subject. But at least two other large and important paintings of 1875 and 1876, both the same size as *The Cotton Pickers*—*Two Guides* and *Breezing Up* (cats. 59, 76)—did not, as *The Carnival* and *Sunday Morning in Virginia* seem clearly to have done, follow immediately from the experiences they depicted. *Breezing Up* was the delayed result of Homer's summer at Gloucester in 1873 and *Two Guides* of a visit to the Adirondacks no later than 1874 but perhaps as early as 1870. It is not inconceivable, therefore, that the *The Cotton Pickers* was likewise a deferred result of an earlier experience. What suggests it most of all, however, is the classical style in which *The Cotton Pickers* is cast and from which it receives a timelessly constructed mean-

ing that is very different from the more histori-cally and culturally precise—because more immediately known and directly felt—and intricately textured content of *The Carnival* and *Sunday Morning in Virginia*.

NOTES

1. "[H]e went to Petersburg, Virginia, in 1876, and there made a series of careful studies from life" (Downes 1911, 85). Cooper 1986a, chronology, speaks of "Visits to Vir-ginia" in 1875–1876; Quick 1978, 61.

2. "Studio Gossip. The Round of the Studios," *New York Tribune*, 9 June 1877.

3. "The Century Club," *New York Evening Post*, 2 June 1877.

4. "Art Notes," *New York Daily Graphic*, 8 February 1878.

5. Cooper 1986a, 34.

6. Hendricks 1979, 104, who had the same doubts. In 1875 also, a visitor to Homer's studio understood that the "very picturesque figure of a young fisher-boy" that he saw there was also posed: he "left his nets, for a 'good consideration,' to devote his time to the business of pos-ing for Mr. Homer" ("Arts," *Appleton's Journal* 14 [6 November 1875], 603).

7. Noted by Sidney Kaplan, "Notes on the Exhibition," *The Portrayal of the Negro in American Painting* [exh. cat., Bowdoin College Museum of Art] (Brunswick, 1964), unpaginated.

79

The Cotton Pickers was one of Homer's most seri-ously and sympathetically admired paintings, not only by Americans who saw it when it was briefly exhibited in New York, but by the "wealthy English cotton spinner" who acquired it in 1877 and took it to England.[1] "It was sent directly from his studio, with the paint still wet, to the Century Club for a Saturday night exhibition," F. Hopkinson Smith wrote later. "A stray Eng-lishman who was a guest bought it, and on the following Wednesday it was aboard a steamer for England." *The Cotton Pickers*, Smith wrote, "left something...in your mind. I saw it this one night, but I have never forgotten it." "The grey dawn of morning," he remembered, "dimly lighted up a field of cotton, the negro quarters on the hori-zon line. Dotted here and there, bending over the bolls, were groups of negroes, singly and in pairs, filling their bags. In the foreground walked two young negro girls, the foremost a dark mulat-to. It haunted me for days. The whole story of Southern slavery was written in every line of her patient, uncomplaining face."[2]

When it was shown in 1877 it was said that "Altogether the freshest piece of figure painting that Mr. Winslow Homer has put his name to is his latest work, the 'Cotton Pickers,' which pro-voked the admiration of the artists at the latest [March] reception of the Century Club, and will

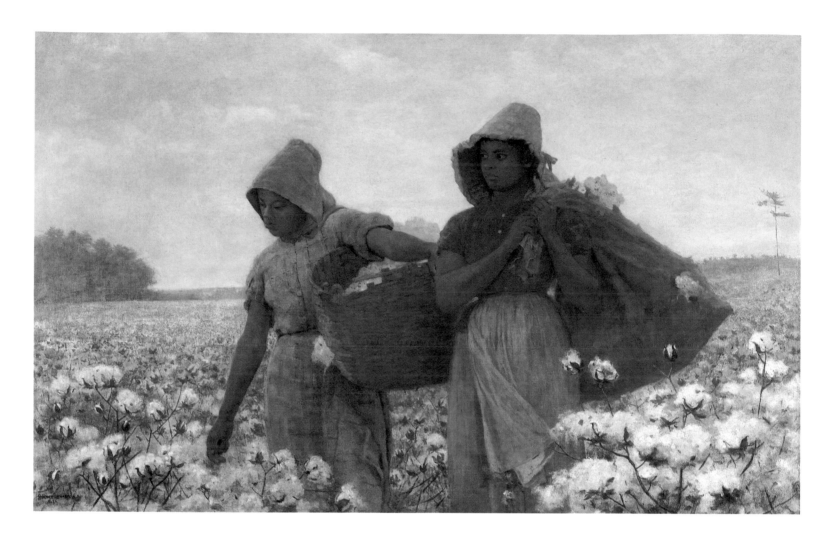

79. *The Cotton Pickers,* 1876
oil on canvas, 61 x 96.5 (24 x 38)
Los Angeles County Museum of Art, acquisition
made possible through Museum Trustees: Robert O.
Anderson, R. Stanton Avery, B. Gerald Cantor, Edward
W. Carter, Justin Dart, Charles E. Ducommun, Mrs.
F. Daniel Frost, Julian Ganz, Sr., Dr. Armand Ham-
mer, Harry Lenart, Dr. Franklin D. Murphy, Mrs.
Joan Palevsky, Richard E. Sherwood, Maynard J. Toll,
and Hall B. Wallis, M.77.68
Provenance: Private collection, London, 1877–1911;
Charles D. Guinn, Carthage, Missouri, 1911–1945;
(Wildenstein & Co., New York, 1947); James Cox
Brady II, New York, c. 1947–1971; Mrs. James Cox
Brady II, New Jersey, 1971–1977.

soon find good quarters and pleasant society in
a private gallery in London.... The story is one
not only worth telling, but one that can be told
better by the artist than by the historian. Its deep
meaning stares you in the face, as it should do
to be worth anything. The composition is sim-
ple, unpretentious, natural, and the technical
execution is brilliant and complete. The scene
was painted outdoors, and it looks outdoors.
Like most good things, also, the picture is finely
original and alluring, and when across the seas
will do honor to the land that made it."[3]

NOTES

1. Its English owner was described as "a wealthy English
cotton spinner" ("A Fine Winslow Homer," *American Art
News* 15 [9 December 1916], 1). See Quick, 1978.

2. *American Illustrators* (New York, 1894), 49–50.

3. "Winslow Homer's 'Cotton Pickers,'" *New York
Evening Post,* 30 March 1877.

80–81

"Mr. Homer shows an involuntary depth of
observation and philosophy, making his canvases
so many authentic documents," the critic of *The
Art Amateur* wrote of cats. 80 and 81 when they
were exhibited at the National Academy of
Design in 1880. They "...constitute him the
most valuable reporter of the tropical manners
implanted in our midst. The reason is, that he
observed these manners with the enthusiasm of
a historian and man of imagination."[1] Another
critic wrote that "Mr. Homer is one of the few
men who have been successful in painting the
negro character without exaggerating or carica-
turing it."[2]

NOTES

1. "Exhibition of the Academy of Design," *The Art Ama-
teur* 2 (May 1880), 112.

2. "Strix," "Our Feuilleton. The Academy Exhibition,"
New York Evening Express, 24 April 1880.

80. *A Visit from the Old Mistress,* 1876
oil on canvas, 45.7 x 61.2 (18 x 24⅛)
National Museum of American Art, Smithsonian
Institution, Gift of William T. Evans, 1909.7.28
Provenance: Thomas B. Clarke, 1892; (American Art
Association, New York, 16 February 1899, no. 230);
M. H. Lehman, New York; William T. Evans, until
1909.

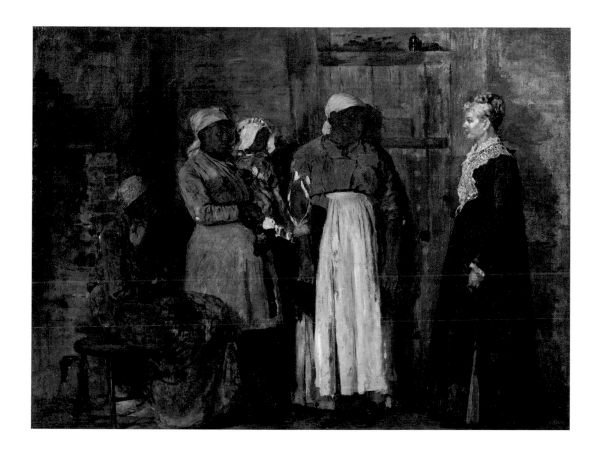

81. *Sunday Morning in Virginia,* 1877
oil on canvas, 45.7 x 61 (18 x 24)
Cincinnati Art Museum, John J. Emery Fund
Provenance: William T. Evans, by 1892 until 1900;
(Chickering Hall, New York, 2 February 1900);
J. C. Nicoll. (Ainslie Galleries, New York).

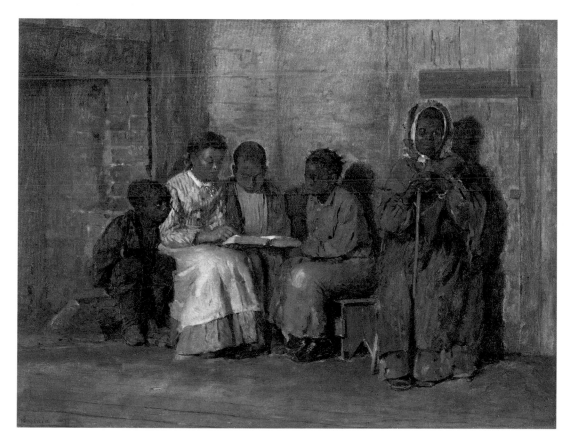

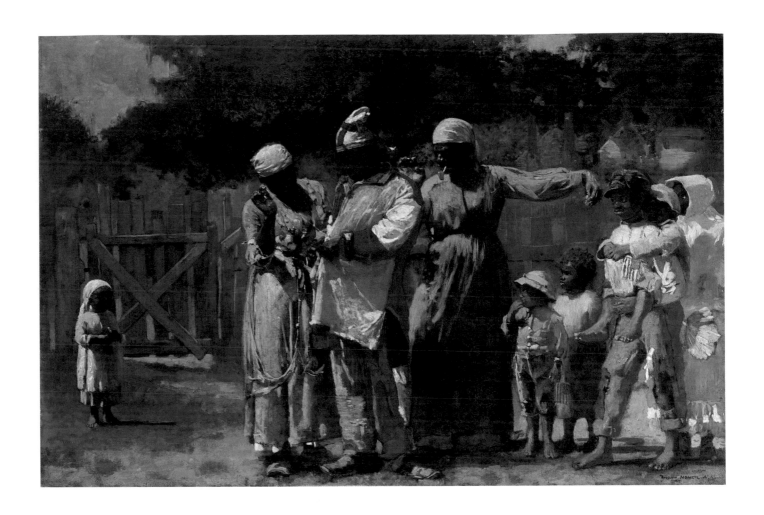

82. ***The Carnival [Dressing for the Carnival]***, 1877
oil on canvas, 50.8 x 76.2 (20 x 30)
The Metropolitan Museum of Art, Amelia B. Lazarus
Fund, 1922
Provenance: (Kurtz Gallery, New York, 9 April 1879, no.
106, as *Dressing for the Carnival*); the artist, by 1892;
Thomas B. Clarke, October 1892–1899; (American
Art Association, New York, 14 February 1899, no. 86,
as *The Carnival*); N. C. Matthews, Baltimore, 1899
until after 1911; (Kraushaar Galleries, New York, 1922).

fig. 116. After Winslow Homer. "The
Fourth of July in Tompkin's Square,
New York—'The Sogers Are
Coming!'" Wood engraving. In
Harper's Bazar, 11 July 1868

82

One of the "sketches" Homer brought back from
his southern trip in June 1877 was "a group,
representing a scene on the day, which in New-
York and in the vicinity of Tompkins-square
would be termed 'ragamuffins day.' The central
figures in the group are dressed in carnival
attire, giving a chance for the employment of
primary colors and lively effects."[1] (Homer's

engraving, "The Fourth of July in Tompkins
Square, New York—'The Sogers Are Coming!',"
published in *Harper's Weekly*, 11 July 1868 [fig.
116], explains the reference, and its appositeness
to a painting that also depicts the Fourth of
July.)

NOTES

1. "Studio Gossip," *New York Tribune*, 9 June 1877.

83. *Woman Peeling a Lemon [Lemon]* 1876
watercolor on paper, 47.9 x 30.5 (18⅞ x 12)
Sterling and Francine Clark Art Institute,
Williamstown, Massachusetts
Provenance: William Crowninshield Rogers, Boston;
his son, William B. Rogers, Sherborn, Massachusetts,
1888; his wife, Augusta K. Rogers, Dedham, Massa-
chusetts; (M. Knoedler & Co., New York); Robert
Sterling Clark, 1924.
Washington only

83–88

The paintings Homer sent to the 1877 Water
Color Society exhibition, one critic thought,
showed "a marked advance." From the tenor of
her criticism, it was an advance to a more marked
aestheticism—a direction in which the Water-
Color exhibition itself, with the "yellow-grey
hue of its walls, which gave delicacy and lightness
to the scene," had also moved.[1] Looking back to
this exhibition, a critic referred to Homer's con-
tribution as consisting of "some powerful effects
of the blotchy order, some abrupt eulogiums of
Japanese fan-painting, some cries of irreconcil-
able color, that excited the liveliest attention of
the public." He then explained Homer's absence
from the 1878 exhibition by saying, "none of
those who so readily celebrated the originality of
these striking works expressed their gratitude by
acquisition," and then indicated who they were
by saying Homer "has withdrawn into his tent
to ponder the bad faith of the champions of bric-

a-brac"—who, as everyone would easily have
understood, were devotees of the Aesthetic Move-
ment, and to whose taste, it is implied, Homer's
watercolors were purposely (but unsuccessfully)
designed to appeal.[2]

NOTES

1. S[usan]. N. C[arter]., "The Tenth New York Water-
Colour Exhibition," *The Art Journal* 3 (1877), 95.
2. "Fine Arts. Eleventh Exhibition of the American
Water-Color Society. I," *The Nation* 26 (14 February
1878), 120.

83

…in a picture which…we saw designated "Lemon,"
by Winslow Homer…[t]he background…was of a
pale, lemon-coloured shade, and the girl's dress ranged
all the way from the ruddy, yellowish hues of iron and
of burnt siena to the purest cadmium, and the artist
appeared to have delighted himself in exhausting his
palette with every tint he could afford to spread upon

84. *The New Novel [Book],* 1877
watercolor and gouache on paper, 24.1 x 51.9
(9½ x 20 ⁷⁄₁₆)
Museum of Fine Arts, Springfield, Massachusetts,
The Horace P. Wright Collection
Provenance: (Newhouse Galleries, Inc., New York).

the skirts of the girl in defining the broad lights and shade upon her well-marked and nicely-accented figure....Mr. Homer has combined not alone expressive action of the human form, but he has accomplished in it a scale of refined colour and tone which even his warmest admirers could hardly have anticipated from his brush.[1]

It would be a few years before yellow would be established as the canonical aesthetic color — the "greenery yallery Grosvenor Gallery," as Gilbert and Sullivan described one of the centers of aestheticism in *Patience* in 1881, and the "Whistlerian yellow"[2] that had become closely identified with that artist by the 1880s — but for Homer it seems already to have that significance.

NOTES

1. "Fine Arts. Eleventh Exhibition of the American Water-Color Society. I," *The Nation* 26 (14 February 1878), 120.
2. Quoted in Richard Dorment and Margaret F. Mac-Donald et al., *James McNeill Whistler* [exh. cat., Tate Gallery] (London, 1994), pls. 80a–80c, 175. Whistler's 1883 *Arrangement in Yellow and White* exhibition in New York had a yellow tiled mantelpiece, yellow furniture, yellow vases, yellow and white roses, yellow matting on the floor; a page dressed in yellow and white livery; an invitation with Whistler's yellow butterfly insignia. When Robert de Montesquiou lunched at Whistler's studio in the 1880s, Whistler prepared fried eggs that "represented, at that very moment," Montesquiou wrote, "the most seductive of 'arrangements' in white and yellow." Quoted in Edgar Munhall, *Whistler and Montesquiou* (Paris, 1995), 60.

84

"...'Book,' by Mr. Homer, represent[s] a young woman lying easily, and in a natural pose, reading from an open volume, with a rich and agree-

able palette of colour, composed of greens cool and warm, yellows of peculiar shades, composing textured material positive and charming, and this combination was keyed and emphasised by deep, dark blues and iron-colour."[1]

NOTES

1. S[usan]. N. C[arter]., "The Tenth New York Watercolour Exhibition," *The Art Journal* 3 (1887), 95.

85

As they resembled no known lessons in Euclidian geometry, what the marks on the blackboard represented, and what the instructor was teaching, long remained a puzzle. But one of the most influential educational innovations in America in the 1870s was the introduction of drawing as a required subject in public elementary education, and that is what *Blackboard* represents.

Drawing instruction was justified as valuable training in visual literacy, but its greatest value, as those who promoted it freely acknowledged, was its role in industrial education. It is no accident, therefore, that the heavily industrial and educationally advanced Commonwealth of Massachusetts led the way in industrial design training as the first state, by legislative act in 1870, to require the teaching of drawing in its public schools. The method of drawing instruction used in Massachusetts was developed by Walter Smith, appointed state director of art education in 1871. Smith's method, by virtue of being the first enacted but also because of his own energetic promulgation of its methods and principles, became the most influential system of drawing in the 1870s. It was based on two essential beliefs:

85. *Blackboard*, 1877
watercolor on paper, 50.2 x 32.4 (19 ¾ x 12 ¾)
National Gallery of Art, Washington, Gift (Partial
and Promised) of Jo Ann and Julian Ganz, Jr., in
Honor of the 50th Anniversary of the National
Gallery of Art, 1990.60.1
Provenance: William Townsend, Boston; Estate of
William Townsend, Boston; Rose Townsend, Boston;
Thomas H. Townsend, Boston; (Vose Galleries, Bos-
ton, 1977); Jo Ann and Julian Ganz, Jr., 1977.

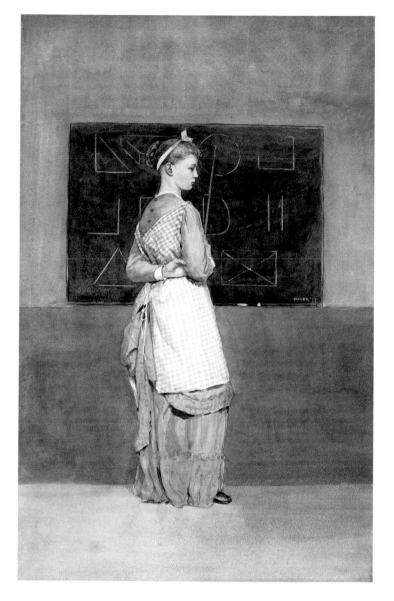

fig. 117. James McNeill Whistler. *Designs for wall decorations
for Aubrey House*, 1873–1874. Charcoal and gouache.
Hunterian Art Gallery, University of Glasgow, Birnie
Philip Bequest

that drawing instruction was a practical, not a
polite, accomplishment; and that to make it as
available as possible, it had to be capable of being
taught in public schools by regular teachers
without special gifts or artistic training. Smith's
method stressed principles of design, not what he
disdainfully called "pretty-work" and "picture-
making," and it began, not with complexities of
three-dimensional modeling and perspective,
but with "mere outline representation, based on
geometrical forms, and illustrating principles of
practical design." In what might almost be the
text for *Blackboard*, Smith described a drawing
lesson: "In the very earliest lessons to the young-
est children, drawings on the blackboard by the
teacher are the only examples used, the illustra-
tions being vertical, horizontal, and oblique lines
singly and in simple combinations, such as
angles, squares, triangles, and the division of
straight lines into equal or proportionate parts;
curved lines associated with straight lines on the

simplest geometrical arrangement."[1]

In its lower-right corner, where artists com-
monly sign their paintings, Homer signed the
blackboard as though, with a characteristic
blend of wit and seriousness, to claim the ele-
mentary markings as his own work.

The construction of the watercolor as a whole,
however, is so far from childish as to be one of
Homer's most aesthetically sophisticated designs,
so much so that its nearest cognates (though not
its sources) are found among the designs for
wall decorations that Whistler made for Aubrey
House in the early 1870s (fig. 117).[2]

NOTES

1. "Art Education and the Teaching of Drawing in Public
Schools," *The Massachusetts Teacher* 24 (November 1871),
389.

2. See Richard Dorment and Margaret F. MacDonald et
al., *James McNeill Whistler* [exh. cat., Tate Gallery] (Lon-
don, 1994), pls. 80a–80c.

86. ***Woman and Elephant,*** c. 1877
watercolor on paper, 29.9 x 22.2 (11¾ x 8¾)
Albright-Knox Art Gallery, Buffalo, New York, Gift
of Mrs. John W. Ames, 1959
Provenance: Augusta K. Rogers, Dedham, Massachu-
setts; (M. Knoedler & Co., New York); A. Conger
Goodyear, January 1923; Mrs. John W. Ames.

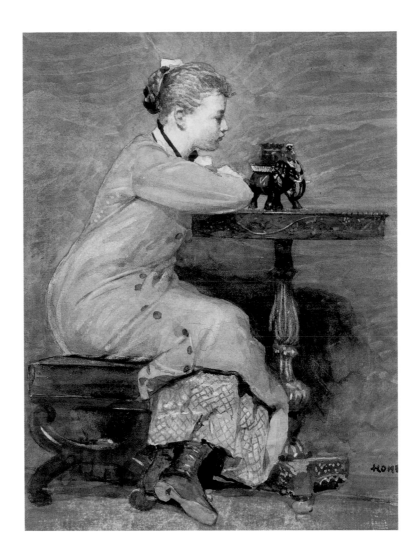

86

The rather odd subject of Homer's watercolor
is, because of its very peculiarity, suggestively
similar to a subject by Alfred Stevens of which
he painted several versions, *L'Inde à Paris,* which
shows a woman contemplating an Indian ivory
figure of an elephant (fig. 118). One version of
Stevens' painting was exhibited at the Exposition
Universelle in Paris in 1867, and, with seventeen
other of his paintings, earned Stevens a first-
class medal. Homer could have seen it there.[1]

It is, with *Backgammon Game,* another case of
Homer's orientalism in the late 1870s.

NOTES

1. See William A. Coles, *Alfred Stevens* [exh. cat., Univer-
sity of Michigan] (Ann Arbor, 1977), no. 13.

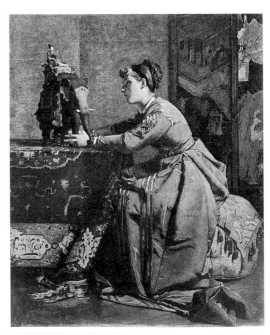

fig. 118. After Alfred Stevens. *L'Inde à Paris,* 1900. From
*Catalogue de Tableaux Modernes Pastels, Aquarelles, Dessin.
Galerie George Petit,* 11 June 1900, opposite plate 77

87. *Backgammon Game,* 1877
watercolor on paper, 56.5 x 67 (22¼ x 26⅜)
The Fine Arts Museums of San Francisco, Gift of Mr.
and Mrs. John D. Rockefeller 3d
Provenance: (Charles F. Libbie Gallery, Boston, 29 May
1878); William S. Eaton, Boston, possibly 1878 to
c. 1926; his son, Francis S. Eaton, Boston and Tucson,
by 1926 until 1943; (Macbeth Gallery, New York; and
Milch Gallery, New York, 1943–1946); Charles D.
Lang, Baltimore, 1946–1954; (Milch Gallery, New
York, 1954–1956); Mr. and Mrs. William J. Poplack,
Detroit, 1956–1959; (Hirschl & Adler Galleries,
New York, 1959–1960); John D. Rockefeller 3d and
Blanchette Hooker Rockefeller, New York,
1960–1993.
Washington only

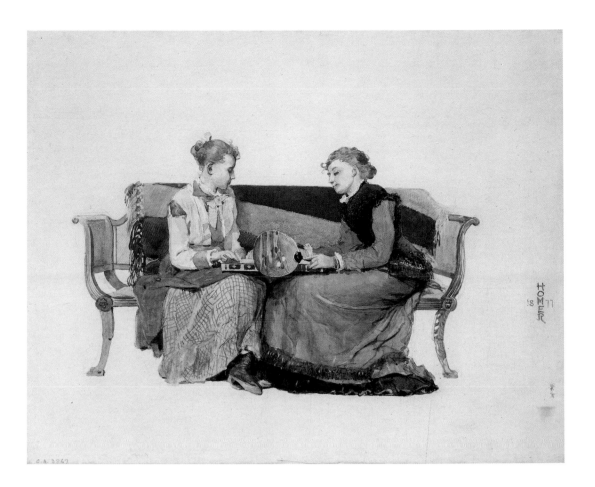

87

Winslow Homer has a quaint study, and one which
shows his strong personal characteristics in his "Back-
gammon".... Two young ladies seated upon a shawl-
covered sofa are deeply interested in a game of back-
gammon. The Sofa has no hind legs, and it is difficult
to understand how it is upheld with its load of youth
and beauty. Homer is eccentric in all his ideas, and
having seen the country milkmaids seat themselves at
their evening's work on a bench balanced on a single
leg, evidently deems four legs a superfluous number
for a sofa, and has adopted two instead.[1]

This splendid large watercolor is by far the
most explicit avowal of Homer's Japanism. The
figures silhouetted against a plain background
in flattened space, seated upon a sofa or settee
that disregards Western requirements of weight
and support; the painted fan; and even the sig-
nature in the form of a colophon, all declare
that affiliation.

NOTES

1. "Water Colors," *New York Commercial Advertiser,* 21
February 1877.

88. *Autumn,* 1877
oil on canvas, 97.1 x 58.9 (38 ¼ x 24 ³⁄₁₆)
National Gallery of Art, Washington, Collection of
Mr. and Mrs. Paul Mellon, 1985.64.22
Provenance: (Leavitt Art Rooms, New York, January
1878). (Doll & Richards, Boston, Massachusetts, June
1878); Stephen Westcott Nickerson, Providence,
Rhode Island. Charles T. Barney, New York. Edward
Runge, New York; (American Art Association, New
York, 9 January 1902); E. A. Rorke. M. J. Hegarty [or
Hogarty or Hagerty], White Plains, New York, c. 1911.
(M. Knoedler & Co., New York, 1936–1937). (Bab-
cock Galleries, New York, 1941); Philip G. Stevens,
New Haven, Connecticut, until at least 1944. H. B.
Yotnakparian. Polly M. Leavitt, Bangor, Maine.
Theodore Leavitt, until at least 1950. (Robert Carlen
Galleries, Philadelphia, 1951). Irving H. Vogel,
Philadelphia, 1951. (Wildenstein & Co., New York,
1954–1957). Mr. and Mrs. Nathan Shaye, Detroit,
1958 to at least May 1962. (Marlborough-Gerson
Gallery, Inc., New York); Mr. and Mrs. Paul Mellon,
1964–1985.

88

Mr. Homer has...two portrait studies, which are excellent. In one, a young lady stands under a canopy of brown autumn foliage and scatters the crisp leaves with one hand; in the other [painting], she has just caught a butterfly in her net and is looking up at the mate which hovers above.[1]

Mr. Winslow Homer's two full length figures entitled "Summer" [*Butterfly Girl*, fig. 76] and "Winter" [unlocated] are the most characteristic and noteworthy specimens he has exhibited since the appearance of his "Cotton Pickers" [cat. 79]. Unlike many of his productions, they introduce us to women of some physical beauty.[2]

Allegorical impersonations of the seasons, which date in an unbroken tradition from classical antiquity, experienced something of a revival in the 1870s among fashionable contemporary European artists such as Alfred Stevens, James Tissot, Giovanni Boldini, and others (figs. 77, 119). Homer's *Autumn* (and *Summer*) are squarely in that stylish mode. The reporter who saw them in Homer's studio, however, suggested that they belonged also to another strong current of contemporary taste and artistic belief: "The pictures do not profess to tell any story, for which art has no necessity, and the adjuncts are simply used to intensify the beauty of the figures, which possess a strong vitality and interest." Whether this aesthetic, art-for-art's-sake reading is the reporter's or Homer's is not clear, but that it was nurtured by the Aesthetic Movement, at this moment transatlantically in full flower, there can be no doubt. "Art," its high priest Whistler wrote at exactly this time, in his polemically titled "The Red Rag," "should be independent of all clap-trap—should stand alone, and appeal to the artistic sense of eye or ear...."[3]

fig. 119. James-Jacques-Joseph Tissot. *October*, 1877. Oil on canvas. Collection of the Montreal Museum of Fine Arts, Gift of Lord Strathcona and Family

NOTES

1. "Gossip of Local Art Circles," *New York Daily Graphic*, 16 January 1878.

2. "The Annual Sale of American Pictures. A Brilliant Display in the Leavitt Art Rooms," *New York Evening Post*, 25 January 1878.

3. "Mr. Whistler's Cheyne Walk," *The World*, 22 May 1878, in *The Gentle Art of Making Enemies* (London, 1890), 127.

89–102

When, at the beginning of Homer's professional life, his paintings were more admired than acquired, Lawson Valentine (1827–1891) became his most important patron. By about 1875 Valentine had what Homer himself described as "quite a gallery of my works," and though Homer added, "I can hardly expect you to desire more,"[1] he ultimately owned about forty (cats. 65, 92–94, 98–99). The Valentines had been friends of the Homers since the late 1850s, when both families had lived in Cambridge, Massachusetts. Their closeness continued in a different way when Charles Homer, Winslow's older brother, joined the firm of Valentine & Company, a manufacturer of varnishes, as chief chemist (and eventually board chairman).

In 1876, Lawson Valentine acquired a large farm in Mountainville, New York, near Newburgh and West Point, which, in honor of his wife, Lucy Heywood Houghton, he named Houghton Farm. Serving as a summer retreat for family and friends, it was also run as a serious experimental farm, staffed with botanists and chemists and stocked with Jersey cows, but also with "fancy" sheep and horses. Homer first visited Houghton Farm in the same year Valentine acquired it, and he may have returned a number of times afterward, but the summer he spent there in 1878 had the most significant artistic consequences.[2]

Early in May 1878 it was announced that Homer would "soon go into the country on a fishing excursion of a week or two,"[3] and no later than 5 July, it seems, he was at Houghton Farm.[4] He was there well into October (a Houghton Farm drawing is dated 15 October 1878) and maybe later still; not until 11 November 1878 was it announced that "Mr. Winslow Homer has returned from the country with a large collection of sketches and studies in water-colors...."[5]

When he showed some or all them early the following year at the Water Color Society exhibition—with rather casual unconcern, it seems, for it was "reported that he sent his portfolio to the hanging committee with a request for them to select two or three specimens, and that so pleased were they with the contents that they resolved to hang all"[6] — they received a mixed critical review. Some found them unacceptably cursory. They were "art stenography," said one,[7] and Mariana Griswold Van Rensselaer, who called them "eccentricities" which she found "inexplicable," said "Mr. Homer must have some idea of the indistinct crudeness of his own work both in outline and in color, or he would not carefully label his pictures *Girl*; *Sheep and Basket*; *Girl on a Garden Seat*; *Girl, Boat, and Boy*; *Girl with half a Rake* [*Girl with Hay Rake*, cat. 96]; and so on," as though without such labels their subjects would be unrecognizable.[8]

More than one critic associated Homer with the Munich-trained J. Frank Currier, whose

89. *The Flock of Sheep, Houghton Farm,* 1878
watercolor on paper, 21.9 x 28.4 (8⅝ x 11³⁄₁₆)
Hart Collection
Provenance: Lawson Valentine; his daughter, Almira Houghton Valentine Pulsifer; her son, Lawson Valentine Pulsifer; Natalie Pulsifer Byles; (Spencer Drummond Ltd.); (Davis & Long Co., New York); (Meredith Long & Co., Houston).

90. *Feeding Time,* 1878
watercolor on paper, 22.2 x 28.6 (8 ¾ x 11 ¼)
Sterling and Francine Clark Art Institute,
Williamstown, Massachusetts
Provenance: William C. Oberwalder, New York, 1926;
(M. Knoedler & Co., New York); Robert Sterling
Clark, 1926.
Washington only

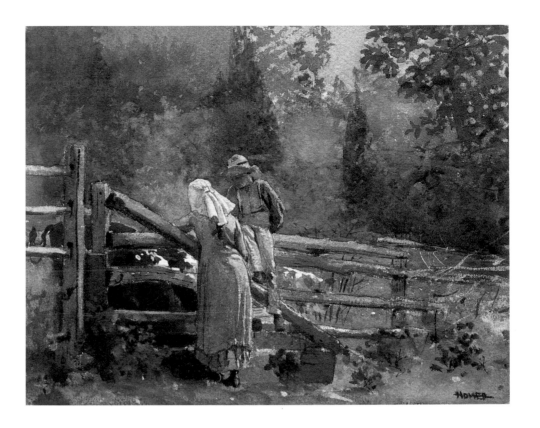

91. *Scene at Houghton Farm,* 1878
watercolor on paper, 18.4 x 28.6 (7 ¼ x 11 ¼)
Hirshhorn Museum and Sculpture Garden, Smith-
sonian Institution, Gift of Joseph H. Hirshhorn, 1966
Provenance: Joseph Montezinos, New York; Jon N.
Streep, New York, 1959; Joseph H. Hirshhorn, New
York, 1959–1966.

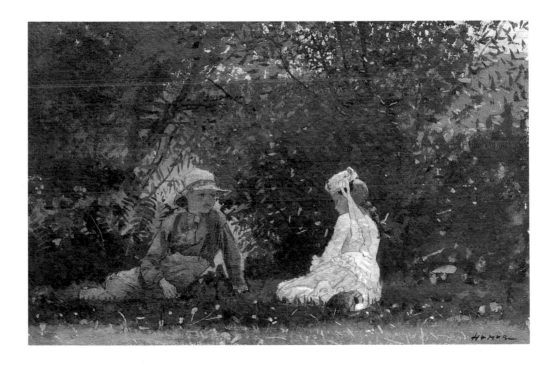

"impressionist" watercolors caused a great stir in the 1879 watercolor exhibition because of their extreme breadth and brevity. They disturbed the critic of the *Boston Transcript* almost to the point of derangement. They were, he said, "incomplete, worthless and false things bearing to real painting the same relation that a heap of building materials and scaffolding bears to the Parthenon" and could be hung upside down or sideways with the same effect; with the Paris Commune in mind, they were, he said, as frighteningly dangerous as communism, "and communism is to be dreaded in art as much as in government."[9]

Several New York critics located Homer in the "impressionist" camp, and those who did were not as frightened by that affiliation as their Boston colleague. Some, in fact, admired his

watercolors precisely for their breadth, simplicity, and informality of style. "[T]hey show no studied consciousness of serious endeavor, but, on the contrary, they have an air of happy naturalness and unpremeditated sincerity…," the critic of the *New York Sun* wrote.[10] "Their style is large and bold, free and strong, the style of a lusty and independent American…,"[11] said the *Evening Post*'s critic. Susan N. Carter found them particularly daring in color: "It is thought by some that Mr. Homer's colour is harsh, and, to those who care for melting golden or purple, there may be something not altogether attractive in it. But, running one's eye along the line of pictures in this exhibition, the impression received is of its being the result of a robust and healthy eye and taste," she wrote in *The Art Journal*, adding, "With a little of the flavour to the mental palate of the pickle or perhaps of olives, one may require time to relish it, but once liked it is heartily enjoyed."[12]

NOTES

1. Quoted in Linda Ayres, "Lawson Valentine, Houghton Farm, and Winslow Homer," in Ayres and Wilmerding 1990, 19. Most of what we now know about Homer, Houghton Farm, and the Valentine family is given in this careful essay.

2. Ayres in Ayres and Wilmerding 1990, 21–23.

3. "Art and Artists," *New York Evening Mail*, 7 May 1878.

4. Ayres in Ayres and Wilmerding 1990, 22.

5. "Art Notes," *New York Evening Post*, 11 November 1878.

6. "American Art in Water-Colors. The Twelfth Annual Exhibition of the Water-Color Society at the National Academy of Design," *New York Evening Post*, 11 February 1879.

7. "Fine Arts. The Growing School of American Water-Color Art," *The Nation* 28 (6 March 1879), 171.

8. Mariana G. Van Rensselaer, "Recent Pictures in New York," *The American Architect and Building News* 5 (22 March 1879), 93.

9. "Maurice Mauris," "Twelfth Exhibition of the New York Watercolor Society. II. Landscapes, *Boston Evening Transcript*, 13 March 1879.

10. "The Water Color Exhibition," *New York Sun*, 16 February 1879.

11. *New York Evening Post*, 11 February 1879.

12. S[usan]. N. C[arter]., "The Water-Colour Exhibition," *The Art Journal* 5 (1879), 94.

89–92

We have rarely seen anything more pure and gentle than the little American girl…half hidden away in the dark shade of the trees, with her sheep at her side. The picture, too, is delightful in *chiaro-oscuro*. But it takes an artist as well informed as Mr. Homer to dare to contrast such a dark, clear shadow with the brilliant dash of sunshine which isolates the little shepherdess from the spectator, and throws her woody retreat into a poetical remoteness.[1]

92. *Weary,* 1878
watercolor and pencil on paper, 24.1 x 31.1
(9½ x 12¼)
Terra Foundation for the Arts, Daniel J. Terra Collection
Provenance: Lawson Valentine, probably in 1878 or 1879; his daughter, Almira Houghton Valentine Pulsifer; her son, Lawson Valentine Pulsifer; his daughter, Alice Pulsifer Doyle; private collection, by descent; (Davis & Long Co., New York).

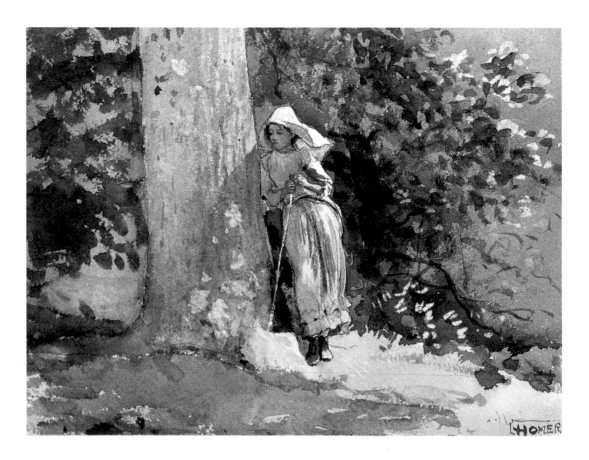

93. *The Green Hill [On the Hill]*, 1878
watercolor, gouache, and pencil on paper, 17.7 x 21.3
(6 ¹⁵/₁₆ x 8 ⅜)
National Gallery of Art, Washington, Collection of
Mr. and Mrs. Paul Mellon, 1994.59.24
Provenance: Lawson Valentine; his daughter, Almira
Houghton Valentine Pulsifer; her son, Harold Trow-
bridge Pulsifer; his wife, Susan Nichols Pulsifer; her
nieces; Mr. and Mrs. Paul Mellon, 1989–1994.
Washington and New York only

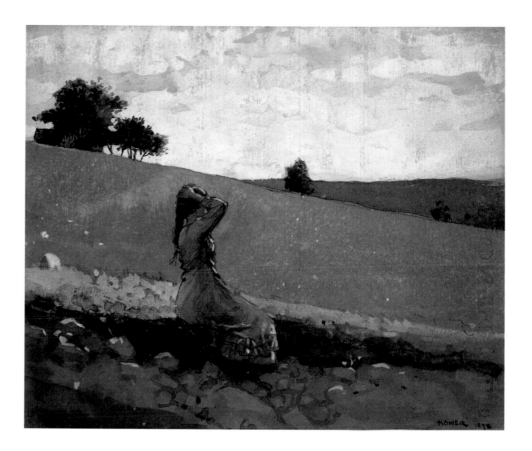

The boy and girl, usually together and some-
times alone, who, in a number of Houghton
Farm watercolors, are so withdrawn, so distantly
silent, and, it seems, so sad, suggest an emotion-
al depletion and social impairment that is not so
much their own—for they were surely modeling
for him—as Homer's.[2] When he painted them,
there are indications that Homer himself, for
reasons not (and probably never to be) exactly
known but caused largely by some profoundly
harmful emotional wound, displayed the same
emotional and social traits. From this point of
view, and considering too that he left New York
in the early summer of 1878 "feeling a little
under the weather" and kept his summer where-
abouts a secret, the four months or more that
he spent in the almost familial surroundings of
Houghton Farm have about them the character
of a therapeutically recuperative retreat.

NOTES

1. S[usan]. N. C[arter]., "The Water-Colour Exhibition,"
The Art Journal 5 (1879), 94.

2. "Homer's main subjects at the farm were, according to
the family, a young boy and girl named Babcock, children
of squatters…" (Linda Ayres, "Lawson Valentine,
Houghton Farm, and Winslow Homer," in Ayres and
Wilmerding 1990, 22).

93–94

It is rather surprising that an American artist should
come home to his studio…with a portfolio full of
"Little Bopeeps," as Mr. Homer has done. He found a
region, apparently, where there were shepherdesses
not only as real as sheep and crooks could make them,
but possessed of all the daintiness of the true and orig-
inal porcelain, distinctive in their own way as the
shepherdesses of Watteau were in theirs.…

To Mr. Homer belongs the distinction of having
discovered the American shepherdess and introduced
her to the public in studies that are more essentially
and distinctively pastoral than any American artist
has yet attempted.[1]

Shepherds and shepherdesses were staple sub-
jects for decorated tiles. Homer, who used them
for his own painted tiles in 1878 (figs. 79–80),
was obviously aware of that. He was prepared
by artistic tradition, therefore, to discover the
American shepherdess at Houghton Farm, at
which sheep husbandry was an important part of
its experimental mission.

By the end of the Civil War, sheep raising had
acquired political meaning: "[H]is coat is proving
more valuable to [New England farmers] than
cotton raised on soil tilled by bondman's sweat
and woman's blood," said a writer in the *New York
Weekly Tribune*, who looked forward to a northern
landscape studded with sheep that would "be to

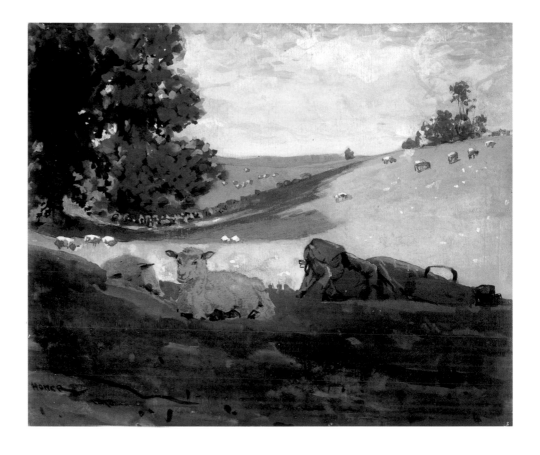

modern times what fair Arcadia was in ancient
days; and poets yet shall sing of shepherds watch-
ing their flocks by night."[2] That Homer's shep-
herdesses in "their Arcadian ribbons"[3] enacted
that image and partook of that political meaning
is suggested by the possibility that he regarded
them as pendants to his images of cotton pick-
ing in the South, one of which, *Upland Cotton*
(fig. 81), he exhibited at the National Academy of
Design only a month or so after exhibiting his
Houghton Farm watercolors at the same place.
When he showed some of the shepherdesses in
an exhibition and sale of his watercolors at the
Mathews Gallery in New York a year later, the
reviewer of the *New York Evening Post* read them
in strongly political terms: "Here are the Amer-
ican shepherdesses which only Mr. Homer
paints—self-possessed, serious, independent;
not French peasants who till the soil; not Swiss
slaves who watch cows, knitting stockings mean-
while with eyes downcast; not German *frauen,* ...
but free-born American women on free-soil
farms...."[4]

NOTES

1. "The Water Color Exhibition," *New York Sun,* 16 Feb-
ruary 1879.

2. "Interesting to Farmers, Sheep and Wool," *New York
Weekly Tribune,* 8 April 1865.

3. "Culture and Progress. The Art Season of 1878–9,"
The Century 18 (June 1879), 311.

4. "Fine Arts," *New York Evening Post,* 3 March 1880.

95–96

In 1878, "a wild Munich-American comet...
projected itself...into our peaceful water-color
system, with a train of astounding pictures." J.
Frank Currier's broadly and transparently painted
"impressionist" watercolors "made a sensation,
and the exhibition at which they appeared was
the most disputatious in the [Water Color]
society's history." By their fluidity of technique,
Currier's watercolors challenged the conven-
tional American use of opaque pigment. "They
were hung side by side with elaborate, brilliant,
and effective pictures, painted throughout in
solid body color, and while they were incoher-
ent, meaningless, and in some sense preposter-
ous exploits, at the same time they possessed a
quality of their own that commended them at
once. They were opposed to the dead, sunken
enamel of the former, pure, transparent color,
vitalized by the grain of the paper and full of
delicate and fortuitous gradations of tone," and
they revolutionized the painting of watercolor
in America: "Mr. Currier has had his effect; last
year's exhibition [1880] had more pure color in
it than all the preceding ones, and in the present
display the opaque method is in a hopeless
minority...."[1] Already in 1878 the critic
Clarence Cook wrote that "A pleasant feature of
the present water-color exhibition is the una-
nimity with which artists have abandoned body-

95. *Apple Picking [Two Girls in Sunbonnets],* 1878
watercolor and gouache on paper, 17.8 x 21.3 (7 x 8⅜)
Terra Foundation for the Arts, Daniel J. Terra
Collection
Provenance: George S. Robbins, Connecticut; his
daughter-in-law, Mrs. Edward C. Robbins, Haverford,
Pennsylvania, by descent; (Hirschl & Adler Galleries,
New York, January 1975); Margaret Lynch, Chestnut
Hill, Massachusetts; (Kennedy Galleries, Inc., New
York, 1981); Richard Manoogian; (Thomas Colville,
Inc., New Haven).

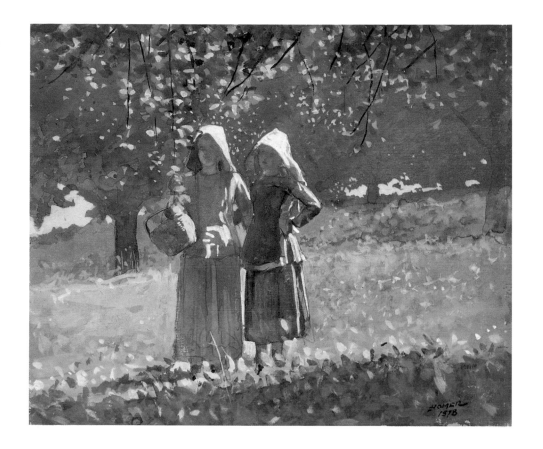

96. *Girl with Hay Rake,* 1878
watercolor on paper, 17.6 x 21.4 (6¹⁵⁄₁₆ x 8⁷⁄₁₆)
National Gallery of Art, Washington, Gift of Ruth
K. Henschel in memory of her husband, Charles R.
Henschel, 1975.92.17
Provenance: Charles R. Henschel; Ruth K. Henschel.
Washington and New York only

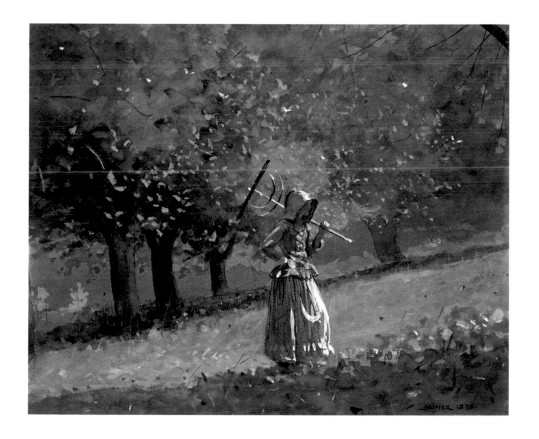

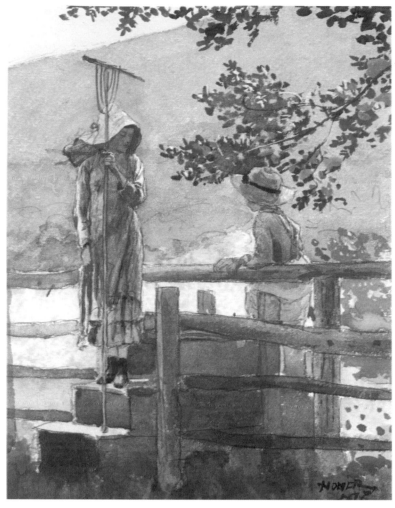

cat. 97

cat. 98

97. *Spring,* 1878
watercolor on paper, 28.3 x 21.9 (11 ⅛ x 8 ⅝)
Collection of Rita and Daniel Fraad
Provenance: Charles T. Barney, New York, c. 1878; his
son, Ashbel H. Barney, New York; his sister, Mrs. H. F.
Dimock, Washington, D.C.; her nephew, Ashbel H. Bar-
ney; (M. Knoedler & Co., New York); Ashbel H. Bar-
ney's cousin, Mrs. Barklie McKee Henry, New York,
c. 1940; (Hirschl & Adler Galleries, New York, 1966).

98. *On the Fence [On the Farm],* 1878
watercolor, gouache, and pencil on paper, 28.6 x 22.1
(11 ¼ x 8 ¹¹⁄₁₆)
National Gallery of Art, Washington, Collection of
Mr. and Mrs. Paul Mellon, 1994.59.22
Provenance: Lawson Valentine; his daughter, Almira
Houghton Valentine Pulsifer; her son, Harold Trow-
bridge Pulsifer; his wife, Susan Nichols Pulsifer; her
nieces; Mr. and Mrs. Paul Mellon, 1989–1994.
Washington and Boston only

color. A year or two ago, body-color was the
rule, and the best men…were making their
drawings look as much like oil…and as little
like water-color as they could contrive. This
year…they have all returned to pure water-
color…."[2]

Homer's Houghton Farm watercolors include
a number that are more transparently colored
and fluidly painted than those immediately pre-
ceding them had been. If that suggests that
Homer was influenced by or took sides in this
controversy over watercolor technique, works
such as *Apple Picking* and *Girl with Hay Rake,*
painted almost entirely in body color, show
that he refused to commit himself to the techni-
cal purity that Cook, for example, would have
enjoined upon the medium.

NOTES

1. "The American Water Color Society," *New York Sun,*
23 January 1881.

2. "The Water-Color Society," *New York Tribune,* 9 Feb-
ruary 1878.

97–99

It is attractive to think of the boys and girls
climbing fences that constitute a serial subset of
the Houghton Farm watercolors as being in their
natural gracefulness the rustic American coun-
terpart of the ballet dancers that Edgar Degas
made at approximately the same time (fig. 120).
It is interesting to know, therefore, that Degas'
Rehearsal of the Ballet (fig. 121) was exhibited at
the watercolor society exhibition in New York
earlier in the same year in which Homer painted
them.[1] Lent by Louisine Havemeyer, it was the
first Degas seen in America.

NOTES

1. Frances Weitzenhoffer, *The Havemeyers: Impressionism
Comes to America* (New York, 1986), 23, 26.

99. *On the Stile,* 1878
watercolor, gouache, and pencil on paper, 22 x 28.3
(8 ¹¹/₁₆ x 11 ⅛)
National Gallery of Art, Washington, Collection of
Mr. and Mrs. Paul Mellon, 1994.59.73
Provenance: Lawson Valentine; his daughter, Almira
Houghton Valentine Pulsifer; her son, Harold Trow-
bridge Pulsifer; his wife, Susan Nichols Pulsifer; her
nieces; Mr. and Mrs. Paul Mellon, 1989–1994.
Washington and New York only

fig. 120. Edgar Degas. *Dancers Practicing at the Bar*,
c. 1876–1877. Oil colors freely mixed with turpentine on
canvas. The Metropolitan Museum of Art, The H. O.
Havemeyer Collection, Bequest of Mrs. H. O. Havemeyer,
1929

fig. 121. Edgar Degas. *Rehearsal of the Ballet*, c. 1876. Pastel.
The Nelson-Atkins Museum of Art, Kansas City, Missouri,
The Kenneth A. and Helen F. Spencer Foundation
Acquisition Fund, F73–30

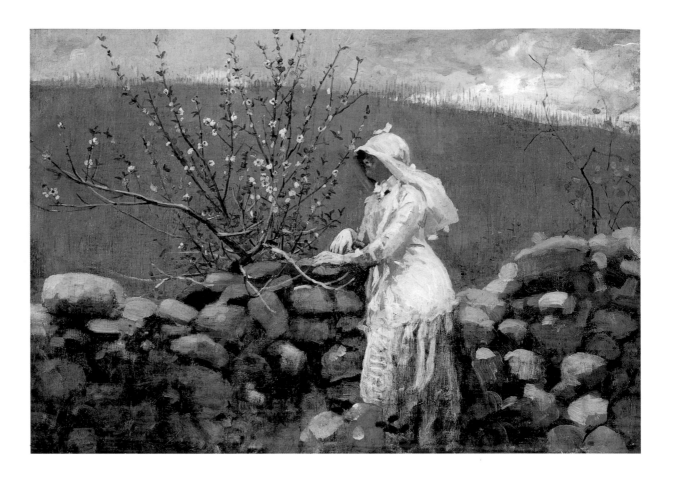

100. *Peach Blossoms,* 1879
oil on canvas, 40.6 x 57.2 (16 x 22½)
Mr. R. Philip Hanes, Jr.
Provenance: (probably Mathews Art Gallery, New
York, 1880); (James Gill, Springfield, Massachusetts,
1881); Mrs. James M. Thompson, Baltimore; (M.
Knoedler & Co., New York, 1924); James A. Dunbar,
New York; Mrs. James A. Dunbar, New York, until
1928; (M. Knoedler & Co., New York, May 1928–
May 1929); Albert Pierce, Chicago, May 1929;
(M. Knoedler & Co., New York, February 1950–
August 1961). David Workman, New York; (Kennedy
Galleries, Inc., New York).

100–102

"Mr. Homer has finished a picture of moderate
size called 'Peach Blossoms,'" a writer for the
New York Tribune reported in late January 1880.
"A gray stone fence runs across the front of the
canvas, upon which is sitting a maiden of sixteen
or so draped in white, and herself in the bloom
of the springtime of womanhood. A field beyond
and the gray sky assist to set her off to advantage.
Near by her, a peach tree in blossom shows its
snow-laden branches above the fence."[1]

"Mr. Homer's charming 'Peach Blossoms,' a
farmer's daughter in gray dress and blue bonnet
sitting on a stone wall near a blossoming peach
tree, is the principal attraction in the Mathews
Art Gallery in Cedar Street," the *New York Even-
ing Post* reported a few days later, adding, in the
diction of aestheticism, "Its answering harmo-
nies of color constitute one element of its artistic
and decorative worth."[2]

NOTES

1. "Brush and Pencil," *New York Tribune,* 26 January
1880.

2. "Art Sales," *New York Evening Post,* 2 February 1880.

101

Peach Blossoms is closely related to this watercolor
and to another oil, *Girl with Laurel* of 1879 (fig.
122).[1] It is also related in date, size, and very
probably location (though not motif) to *Houses
on a Hill,* in the foreground of which a similarly
dressed figure sits on the grass.

NOTES

1. The painting entitled *Peach Blossoms* in the Art Insti-
tute of Chicago is not considered authentic.

101. *Girl in a Garden,* 1878
watercolor on paper, 17.1 x 21.6 (6 ¾ x 8 ½)
The Ruth Chandler Williamson Gallery Program at
Scripps College
Provenance: (Copley Gallery, Frank W. Bayley, Boston);
Henry Sales, Boston, 1910. (American Art Association,
New York, 15 January 1920, no. 96); (Milch Gallery,
New York); Edward Clinton Young, c. 1928.
Washington and New York only

102. *Houses on a Hill,* 1879
oil on canvas, 40.3 x 57.5 (15 ⅞ x 22 ⅝)
Mr. and Mrs. Hugh Halff, Jr.
Provenance: Mrs. Charles S. Homer, West Townsend,
Massachusetts; (Macbeth Gallery, New York); Mr. and
Mrs. Bartlett Arkell, New York; Elizabeth Wilson,
Manchester, Vermont, and New York; (James Maro-
ney, Inc., New York); Steve Martin, Beverly Hills, Cal-
ifornia; (Christie's, New York, 31 May 1985, no. 85).

cat. 101

cat. 102

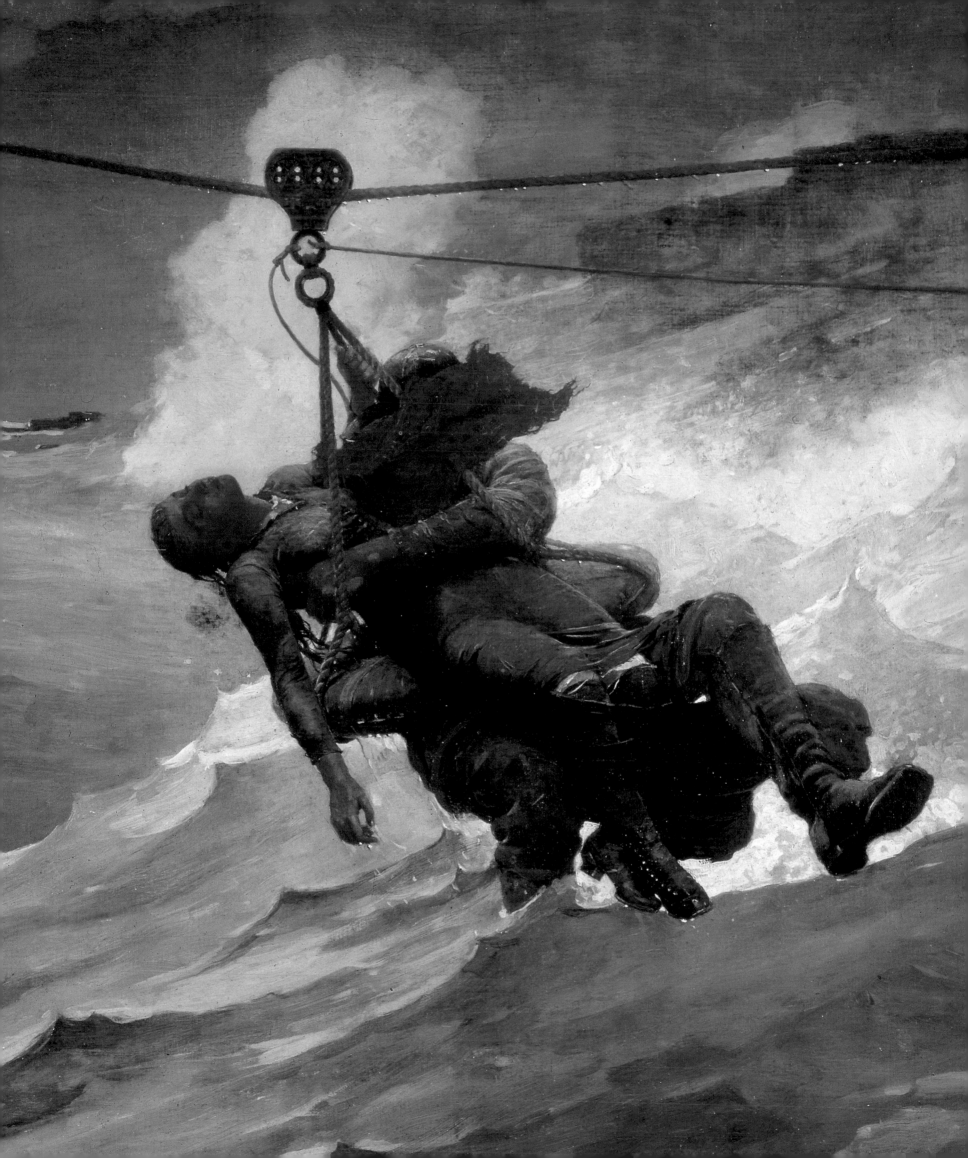

A Process of Change

Franklin Kelly

Change came to Homer's art when he was in his mid-forties. Around 1880 he began a process of reevaluation and redirection that would, by the mid-1880s, lead to a reshaping of both the style and the subjects of his artistic production. At the heart of this process were three acts of physical relocation. The first, the summer of 1880 spent living and working on an island in Gloucester harbor, and the second, a trip to England in 1881–1882, were temporary. The third, Homer's move in 1883 from New York to Prout's Neck, Maine, would be permanent.

It is not clear why Homer returned to Gloucester in 1880, or why he chose to isolate himself at the home of the lighthouse keeper on Ten Pound Island. Apparently there were some personal reasons for the move, for at this time reports of his unsociability, irritability, rudeness, and even reclusiveness began to appear with some regularity. But he must have had artistic motivations also, because there are already signs of change evident in the painting *Promenade on the Beach* (cat. 103), which was completed early in 1880.[1] With its brooding intensity and slightly eerie quality, this painting strikes a very different note than did his images of shepherdesses and farm girls of just a few months earlier (fig. 122); in many ways it recalls the similarly disquieting *Eagle Head, Manchester, Massachusetts* (cat. 31) of 1870. *Promenade on the Beach* is notable not only for its striking effects of stark light and shadow and boldly expressive handling of color, but also for its psychological intensity and enigmatic mood. The formal pairing of the two women and the distant, brightly lit schooner suggests a thematic linkage between them, but the way they turn their backs to it and gaze elsewhere creates a sense of disruption. The painting was odd enough to puzzle a potential buyer, who asked whether the girls were "somebody in particular," and whether they were looking at something specifically, and if so, what it was.[2] Homer's earlier paintings may have perplexed viewers at times, but in this work he seemed determined to make interpretation difficult. The women in *The Cotton Pickers* (cat. 79) embodied meanings that were legible to Homer's audience, but the significance of those in *Promenade*, who may equally hold meaning, simply cannot be so easily fathomed.

No oils resulted from Homer's summer in Gloucester, but he did create many watercolors. Though varying widely in subject and quality, all are notable for their high degree of formal and technical experimentation.[3] At their best, such as *Eastern Point Light, Gloucester Sunset*, and *Sunset Fires* (cats. 104–106), they are among the most impressive—and expressive—watercolors of Homer's career. Mariana Griswold Van Rensselaer was struck by these works, observing: "No one could have guessed he might attempt such things." As she continued, Homer

had boldly omitted everything that could not serve his purpose,—which was to show the demoniac splendor of stormy sunset skies and waters,—and then, unsatisfied by the brilliant hues of nature, had keyed them to deeper force, made them doubly powerful, the reds stronger and the blacks blacker,—insisting upon and emphasizing a theme which another artist would have thought already too pronounced and too emphatic for artistic use.[4]

However, other watercolors from this same moment (fig. 123) are marked by a rather staccato, broken handling of the brush, and are less successful. More than a few (fig. 124) are curiously unresolved and may well have been abandoned before completion. Some (fig. 125) are simply odd. Whatever the reason for Homer's decision to work in isolation in Gloucester in 1880, at least part of it was clearly concerned with rethinking and reformulating his watercolor style and technique.[5] The critic for *The Nation* recognized this when he saw a selection of Homer's Gloucester works at

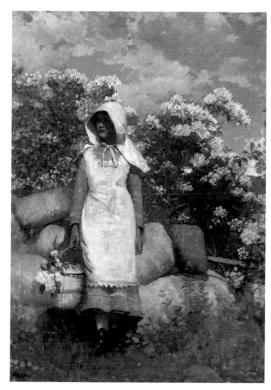

fig. 122. *Girl with Laurel*, 1879. Oil on canvas. Photograph © The Detroit Institute of Arts, 1995, Gift of Dexter M. Ferry Jr.

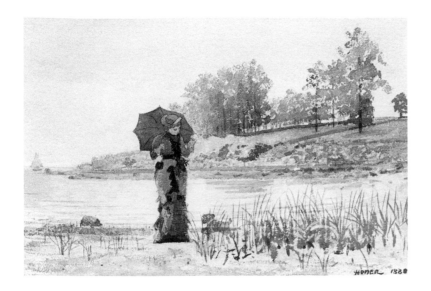

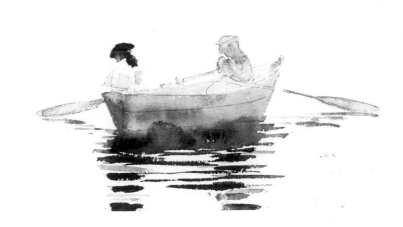

the Water Color Society Exhibition in January 1881. As he observed: "Mr. Winslow Homer goes as far as anyone has ever done in demonstrating the value of water-colors as a serious means of expressing dignified artistic impressions, and does it wholly in his own way...."[6] Sensing, or perhaps knowing, that Homer was planning some personal and artistic change, the writer concluded: "it is what he will do hereafter, rather than what he has hitherto done, that one thinks of in connection with Mr. Homer's work."

On 15 March 1881 Homer sailed from New York on the Cunard liner *Parthia*, bound for Liverpool.[7] While on board he painted at least two watercolors, *Marine* (cat. 156) and *Observations on Shipboard* (cat. 157). *Marine*, with its dark sky and broadly brushed passages, is similar in style and spirit to the watercolors of the previous summer, suggesting that he was continuing to investigate the implications of this new, more austerely dramatic handling.[8] Following his arrival in Liverpool in late March, Homer traveled to London. While there he painted at least one watercolor, *The Houses of Parliament* (cat. 107); doubtless visited exhibitions and museums; and possibly called on some of the American artists residing in London, such as his friend Edwin Austin Abbey.[9] Although we do not know precisely when he traveled north, he had definitely settled in the village of Cullercoats by August, for he sent a watercolor called *Cullercoats* to an exhibition in Newcastle which opened on the 26th of that month.[10]

Cullercoats (figs. 126–127), located on the shore of the North Sea, is a small village about two miles from the larger and better known city of Tynemouth. Tynemouth, in turn, is located a short way down the river Tyne from the still larger city of Newcastle, the famous coal port. By the time Homer came to Cullercoats in 1881, its economy had long been based on fishing, but it was also a popular summer bathing resort, particularly for workers taking day trips from Newcastle.[11] In 1881 its population numbered around 1,400, but it retained the character of a small village with a tightly knit community.[12] Situated on sandstone cliffs above a small bay bounded to the south by Tynemouth North Point and to the north by Brown's Point, Cullercoats boasted a secure harbor with a substantial curving breakwater. The town's structures consisted mainly of stone houses, shops, and fishermen's cottages, and its most distinctive architectural landmark was the Life Brigade House, with its clock tower and a porch protected by a distinctive sloped roof (fig. 127). Homer settled in "a little house surrounded by a high wall, with one gate, to which he had the key, so that he was safe from intrusion," and secured a studio that offered a fine view over the harbor and out to sea.[13] So far as we know, other than making a visit down the coast to Flamborough Head, at Scarborough (see fig. 163),[14] Homer remained in the Cullercoats/Tynemouth area until he was ready to leave for home. He sailed on 11 November 1882, on board the *Catalonia*, bound from Liverpool for New York.[15]

Virtually every writer who has had anything to say about Homer since 1882 has regarded the trip to England as a critical turning point in his career, one demarcating his early years, with

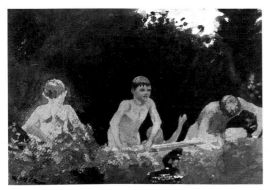

fig. 126. *View of Cullercoats,* 1896. Photographer unknown. Newcastle upon Tyne City Libraries and Arts

fig. 127. *Life Brigade House,* 1979. Photograph N. Cikovsky

all their promise, from his mature career, when he would bring to his art a new level of intensity and purpose. Speaking of his English watercolors and drawings in 1883, Van Rensselaer called them "*pictures* in the truest sense, and not mere studies or sketches, like most of his earlier aqua-relles."[16] For Downes, the works he produced in England "sounded a deeper, stronger, more seri-ous note than any that had preceded them."[17] Goodrich felt the same: "In all aspects of his art appeared a new maturity."[18] And we can find similar opinions expressed by Beam, Wilmerding, Hendricks, Cooper, and Cikovsky.[19] The English period has attracted close scrutiny in the form of articles by Wilmerding and Gerdts, an extended discussion of the effect the trip had on his watercolors by Cooper, an exhibition catalogue produced in Sunderland, England (just down the coast from Tynemouth), as well as other studies.[20] Minute details concerning Homer's stay have been ferreted out with great determination, and considerable speculation has been devoted to answering such questions as whom he may have met, what art he may have seen, and what influ-ences might have affected him. In fact, as much is known about this period in Homer's life as any other, and perhaps even more. Yet the fundamental questions of why he went to England at all, and what led him to the area around Tynemouth, have proved vexing from the first. And in these questions is another that comes to the very heart of Homer's artistic endeavor: did his art change *because* of his experiences in England, or had he determined to change his art before he went there, and instead merely sought out a place where he could effect those changes most efficiently and fully?

If we cannot know with certainty the personal reasons behind Homer's trip to England, we can at least reasonably speculate about the motivations that concerned his art. Some evidence is offered in the reminiscences of A. B. Adamson, who actually knew Homer while he was in Cullercoats.[21] Adamson once directly asked Homer his reasons for making the trip to England, and Homer replied that he was seeking "atmosphere and color." Homer further explained that he had come to feel there was too much similarity in the people and the towns of America, and that he was seeking something new. Apparently he found it: "Look at the fishergirls," Homer is reported to have said; "…there are none like them in my country in dress, feature, or form. Observe the petticoat that girl is wearing.…No American girl could be found wearing a garment of that colour or fashioned in that style."[22] As to why he settled in Cullercoats, Adamson offered this explanation: "It was by mere accident he had chosen the village of Cullercoats from among the many others in England that are better known to artists both English and American. On the voyage over he met a man, who, when Homer mentioned his object in crossing the Atlantic, told him to go to the village…where

he would find just the subjects for his brush that he was seeking...." It seems, then, that Homer knew precisely what he was looking for: the working women of England's fishing villages.

Certainly the works Homer created in Cullercoats confirm his interest in painting fisherwomen, as does Adamson's recollection: "Homer did not seem to care much about taking for his models the menfolk of the village, but chose rather to give an immortality to the faces and forms of the daughters of the men,...who were truly toilers of the deep." We need only look at watercolors such as *Mending the Nets* (cat. 124), monochromes such as *Blyth Sands* (cat. 129), or the oil *The Coming Away of the Gale* in its original state to see the truth of this (cat. 189, fig. 149), for these monumental women are, in every case, obviously and formidably the central subjects of the images. Women had always been important for Homer's art, but on only a very few occasions, such as *The Cotton Pickers* and *Autumn* (cats. 79, 88), had he portrayed them as such powerful presences.

Nevertheless, there is still the question of why Homer would want to paint fisherwomen at all and why he believed painting them would in some way further his artistic aims. The subject of women working on the shore was not, of course, unprecedented in art. It is, for instance, certainly possible that Homer knew and admired John Singer Sargent's *Oyster Gatherers of Cancale*, because a preparatory version of that painting (fig. 128) was shown in the Society of American Artists exhibition in New York in 1878.[23] Sargent's painting, especially in its low vantage point, expanse of sand with pools of reflecting water, and figures partially silhouetted against the sky, is suggestively similar to some of Homer's most ambitious Cullercoats watercolors, such as *Four Fisherwives* (cat. 123). Other works, including examples by the French artists François Feyen-Perrin, Jules Breton, and Jules Bastien-Lepage; Dutch artists of the Hague school, such as Jozef Israels; and the Englishmen James Clarke Hook and Stanhope Forbes, among others, have also been proposed as possible prototypes for Homer.[24] Likewise, Homer probably knew the strong-figured women in the art of Edward Burne-Jones, although they were not generally, to be sure, of the working class.[25] Still, perhaps in this instance Homer followed his own advice, namely, "If a man wants to be an artist, he must never look at pictures."[26] If so, other reasons must have led him to seek out and paint English women of the North Sea fishing villages.

Such women were, in fact, quite well known in Britain and elsewhere and had been often photographed by the time Homer arrived in Cullercoats (see figs. 129–136).[27] Some of these photographs were largely documentary in nature (figs. 129–133), but others, such as those by Frank Sutcliffe (figs. 134–136), who worked down the coast from Cullercoats in Whitby, were quite consciously artistic. We know that English artists made use of photographs of fishergirls, but whether or not Homer did is purely conjecture.[28] Whatever the case, such photographs offer compelling documentation of lives dominated by strenuous tasks associated with fishing: gathering bait, baiting hooks,

fig. 129. Flamborough: Molly Nettleton, Sarah Ann Mainprize, and unidentified figure, 1867. Photographer unknown. Master and Fellows of Trinity College, Cambridge

repairing nets, and hauling and cleaning fish. These labors, of course, were in addition to the many other domestic chores they were expected to perform: keeping house, preparing meals, raising children or siblings, and so forth. No time of the year offered any real respite, for the fishermen varied their catch as the seasons changed and were out at virtually every possible moment. In calm and storm, warm weather and bitter cold, the women were expected to provide support essential to the livelihoods of their husbands, brothers, and fathers. And those men, who put to sea in small flat-bottomed vessels called "cobles" (see fig. 136), were in constant peril, and the loss of loved ones through drowning was an all-too-frequent fact of life. Homer's Cullercoats women have often been called "heroic," and although he may have idealized them somewhat in his art, the stern facts of their lives clearly instilled in them great strength and courage

LEFT: fig. 135. Frank Meadow Sutcliffe. *Fishergirls,* c. 1880s. Photograph. The Sutcliffe Gallery, Whitby, England

RIGHT: fig. 136. Frank Meadow Sutcliffe. *A Coble at the Edge of Whitby Harbor,* c. 1880s. Photograph. The Sutcliffe Gallery, Whitby, England

Winslow Homer
1882

fig. 137. *Head of a Woman,* 1882. Pencil. Location unknown, photo courtesy of M. Knoedler & Co.

One way Homer may have learned of the fisherwomen of the North Sea coast was through popular literature, such as the English writer Charles Reade's novel *Christie Johnstone,* first published in 1853 and reprinted many times thereafter (including four editions in Boston between 1855 and 1868, and another in New York in 1878). Although Reade is no longer especially well known, his works were widely read in Homer's time. "After Dickens," observed a writer for the *New York Times,* "no English author of the day appeals so directly to all branches of the English-speaking race as Charles Reade."[29] This same writer praised Reade particularly for his "hatred of class injustice, of petty social spites and prejudices, of official wrongs and abuses, and his warm sympathy with all the fresh impulses and instincts of humanity." The *New York Observer* declared him "one of the most vigorous of modern writers of fiction" and found in all his works "a high moral aim."[30] The *Hartford Courant* was even more emphatic: "Here is something virile. Here is a man at least who knows something, and knows how to say it."[31] We know very little about Homer's taste in literature, but it is not hard to imagine that such qualities would easily have appealed to him.[32]

Christie Johnstone opens with the story of Lord Ipsden, a young nobleman. Ipsden, having been disappointed in love, is advised by his doctor to seek out the company of the lower classes, so that he may learn more about the world and humanity. Following this advice, Ipsden travels to the Scottish fishing village of Newhaven, on the Firth of Forth, where he makes the acquaintance of Christie Johnstone, a young fisherwoman. Over the course of its three hundred pages *Christie Johnstone* treats the reader to the countless narrative twists and turns typical of popular Victorian fiction, and details, among other events, a dramatic haul of herring, a ship in distress, and the drowning of a fisherman. In this context, however, it is the heroine of the book, Christie Johnstone, who is of particular interest.

Christie Johnstone, in fact, epitomized a highly romanticized view of the fisherwoman: physically attractive and strong, high principled, intelligent, passionate, and courageous (fig. 137). Some of these traits are made evident by Reade's prose describing Lord Ipsden's first encounter with her and another fisherwoman. After a detailed consideration of the specifics of their dress (taking, like Homer, particular notice of the petticoats), Reade offers this account of Johnstone's physical appearance: "fair, with a massive but shapely throat, as white as milk; glossy brown hair, the loose threads of which glittered like gold, and a blue eye, which being contrasted with dark eye-brows and lashes, took the luminous effect peculiar to that rare beauty."[33] However, Reade saved his most ecstatic language for a more general description of the two women:

Their short petticoats revealed a neat ancle [sic], and a leg with a noble swell; for Nature, when she is in earnest, builds beauty on the ideas of ancient sculptors and poets, not of modern poetasters, who with their

airy-like sylphs and their smoke-like verses, fight for want of flesh in woman and want of fact in poetry as parallel beauties.

These women had a grand corporeal traet [sic]; they had never known a corset! so they were straight as javelins; they could lift their hands above their heads!—actually! Their supple persons moved as Nature intended; every gesture was ease, grace, and freedom.

What with their own radiance, and the snowy cleanliness and brightness of their costume, they came like meteors....[34]

What is particularly interesting about Reade's prose is that he distinguishes the fisherwomen as uninhibited beauties who were quite different from the unnaturally thin (or corseted) fashionable women of the era. And Reade further sees women like Christie Johnstone as worthy of comparison with the great achievements of ancient artists, which for the nineteenth-century English-speaking world were epitomized by the British Museum's "Elgin Marbles," the famous group of sculptures from the Parthenon (figs. 138–139). Reade thus placed the North Sea fisherwoman squarely in the realm of art early in his narrative. That connection becomes even more specific when a young English painter named Charles Gatty is introduced into the story.

Gatty is something of a radical, for he decries the traditional practices of academic instruction and is a strong proponent of realism and painting out-of-doors.[35] As he says: "The world will not always put up with the humbugs of the brush, who, to imitate nature, turn their back on her. Paint an out o'door scene in doors! I swear by the sun it's a lie!"[36] Gatty meets Christie Johnstone and the two fall in love, and much of the novel revolves around their romance, which is of no relevance here. (Or, perhaps one should say that it *seems* of no relevance, because the fact that this is a romance between a young realist painter and a beautiful woman who was sometimes his model is highly suggestive of what is known of—and speculated about—Homer's personal life in the 1870s.) However, it is undeniably pertinent that for Gatty, Johnstone is the human equivalent of his artistic principles: a person of natural beauty, grace, and character, not the creation of insincere artifice. In short, Christie Johnstone, whose physique and grace evoked the great works of ancient art, and whose morality and intellectual honesty were unimpeachable, was a woman who could be a fitting subject for a high and profound art based on contemporary life.

That, it seems, was precisely what Homer was seeking—his "object in crossing the Atlantic."[37] For the moment he had exhausted the possibilities of painting the people of his own land, whom he now found too similar in appearance, and who now apparently no longer embodied for him the meanings he wished his art to convey. However he came to know of them, Homer was looking for fisherwomen like Christie Johnstone. As he said, "there are none like them in my country in dress, feature, or form." And even if we cannot say without qualification that Homer knew of Reade's heroine, at least one of his contemporaries, writing in 1882, immediately noticed her spirit animating the women in Homer's English watercolors: "There is a charming feminine

LEFT: fig. 138. "Persephone (?), Demeter, and Hebe (?)," Parthenon East Pediment. © British Museum

RIGHT: fig. 139. "The Three Fates," Parthenon East Pediment. © British Museum

grace in these sturdy Christie Johnstones, a grace not only of posture and bearing, but of look and expression."[38]

In seeking out this subject Homer was not exercising his independence, but consciously choosing to concern himself with matters of artistic form and content that were implicitly allied to tradition.[39] In virtually every way his earlier works had been deliberately his own, so much so that they struck reviewers as not only unmistakably his, but also as oddly unlike the work of any other artist or school. Now his wish was to make his art more like the highest achievements of European painting, and he knew that the foundations of such works were still firmly grounded in classical antiquity. Homer was not, of course, the only painter of the late nineteenth century to seek out equivalents in modern life for classical prototypes. But most artists of the day who used classicized figures were content to leave them in settings from the past (see, for example, fig. 140). One who was not was Homer's slightly younger American contemporary Thomas Eakins, who was greatly fond of ancient art, but disliked those who mindlessly imitated it. Eakins was particularly scornful of the academic routine of drawing from plaster casts of ancient originals, saying: "All this quite leaves the antique out of consideration, does it not?"[40] He continued:

The Greeks did not study the antique: the "Theseus" and "Illyssus," and the draped figures in the Parthenon pediment were modeled from life, undoubtedly. And nature is just as varied and just as beautiful in our day as she was in the time of Phidias. You doubt if any such men as that Myron statue in the hall exist now, even if they ever existed? Well, they must have existed once or Myron would have never made that, you may be sure. And they do now....And our business is distinctly to do something for ourselves, not to copy Phidias.[41]

Eakins, in fact, often depicted modern-day figures in ways that clearly emulated antique sculpture, as in *The Poleman in the Ma'sh* (c. 1881, National Gallery of Art), which recalls the antique *Doryphoros* (spear-bearer), and the figures in *The Swimming Hole* (fig. 141), so similar in arrangement to Greek pedimental sculpture.

Homer's adoption of classical forms and mood in his English works, although never so obvious, was still apparent to some of his contemporaries. Van Rensselaer recognized in them a greater gravity and seriousness which spoke of a mind now more closely attuned to traditions of high art. "Compare," she wrote, "the carelessly chosen attitudes, the angular outlines, the awkwardly truthful gestures of his New England figures, with the sculptural grace of these fisher-girls, and no contrast could be greater."[42] Speaking of *A Voice from the Cliffs* (fig. 142), she observed: "These outlines might almost be transferred to a relief in marble....They are statuesque figures, but they are living, moving, breathing beings, and not statues...."[43] These new works were, as Van Rensselaer concluded, "serious works of 'high art'...[with] an ideal tinge that lifts them above the cleverest transcriptions of mere prosaic fact."[44]

What was new in Homer's English art, besides its actual subject, were the changes he made in the formal qualities of design, lighting, color, and composition, and, most especially, in the role

LEFT: fig. 140. Albert Moore. *Dreamers*, 1882. Birmingham Museums and Art Gallery

RIGHT: fig. 141. Thomas Eakins. *The Swimming Hole*, 1885. Oil on canvas. Purchased by the Friends of Art, Fort Worth Art Association, 1925; acquired by the Amon Carter Museum, 1990, from the Modern Art Museum of Fort Worth through grants and donations from Amon G. Carter Foundation, the Sid W. Richardson Foundation, the Anne Burnett and Charles Tandy Foundation, Capital Cities/ABC Foundation, Fort Worth Star-Telegram, The R. D. and Joan Dale Hubbard Foundation and the people of Fort Worth

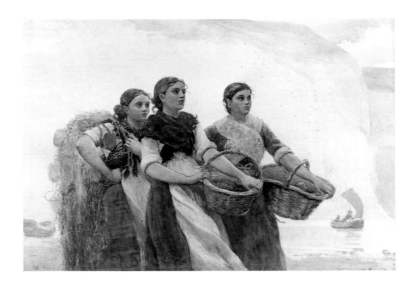

and prominence he gave to figures. Although many of his English watercolors are powerfully successful in their own right, he would not, in fact, make full use of the possibilities of this new style for several years. Still, to consider Homer's English works only in retrospective terms, to emphasize them primarily for the seeds they held for future development, is to pass too quickly over them. Indeed, there is danger in seeing the English trip too much in isolation, for it was part of a larger process of change in his art that began at least as early as the summer of 1880 and continued at least through the Prout's Neck oils of the mid-1880s, such as *The Herring Net* and *Undertow* (cats. 133, 136). During the 1870s critics had repeatedly faulted Homer's works for their lack of finish and crudeness, and he had at last determined to respond to those charges by reformulating his art. In Gloucester during the summer of 1880 he began to change the actual look of his work in watercolor, which became bolder and more coloristically expressive. In *Promenade on the Beach* of 1880 (cat. 103) he had already experimented with bringing those same changes to his oils. Having also determined to change his subject matter, Homer went to England, found new subjects, and then began working following his usual procedure.

By 1881 Homer's preference for working in series was well established. In the groups of works done in Gloucester in 1873, at Houghton Farm in 1878, and again in Gloucester in 1880, he investigated not just the possibilities of different subjects and themes, but also experimented with technique and composition. From 1873 onward, when he began working in watercolor seriously, Homer most often carried out such extended investigations in that medium, as would be the case in Cullercoats, where he would also create many drawings. The success Homer enjoyed with the twenty-three Houghton Farm watercolors shown at the American Water Color Society exhibition in 1879 and his profitable sale at auction of almost one hundred works the following year may well have convinced him to consider making his living through watercolors.[45] In light of that, his 1880 summer in Gloucester makes sense as part of a deliberate campaign on his part to reconsider his use of the medium, technically, stylistically, and thematically. And the goal of this concentrated effort was, at least in part, to elevate for him the status of watercolor, both personally and professionally.

Once in England Homer worked with great energy on revising his watercolor style. One obvious aspect of this concerned his actual handling of the watercolor medium. As Cooper has noted, even works from early in Homer's Cullercoats stay, such as *Watching the Tempest* (fig. 143), demonstrate how quickly his technique developed "beyond anything he had done in America."[46] Given the fact that English artists had a long tradition of excellence in watercolor, we might naturally assume that Homer's own progression was the result of careful study of other works in the medium, but that does not seem to have been the case. In fact, as Cooper further notes, in spite of the advances he made measured in personal terms, Homer's watercolor technique remained essentially conservative compared to the innovations of English artists of the 1870s and 1880s.

A more significant change that came to Homer's English watercolors (or at least to some of them) involved their actual size, so that they became, quite literally, more grand. But works such

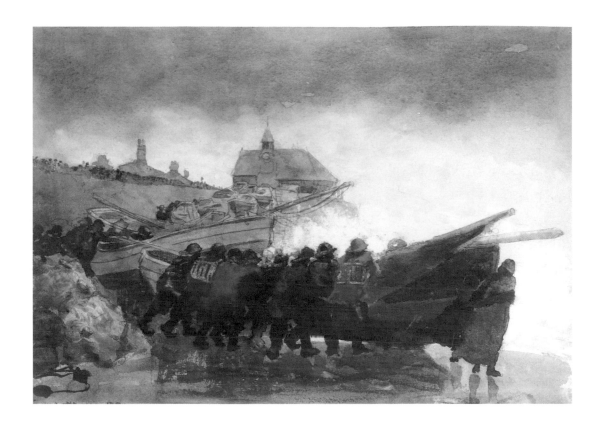

as *The Wreck of the Iron Crown, Mending the Nets, Four Fisherwives, Fisherwives,* and *Inside the Bar* (cats. 112, 124, 123, 127, 128) are not just physically larger; they also required a larger, more complex process of art involving preliminary studies and careful planning in the studio. These are not informal records of observed reality, but consciously organized compositions very much in the mold of what is known in England as an "exhibition watercolor" (see fig. 144).[47] Such works were deliberate attempts on the part of watercolor painters to rival the look and visual impact of oil paintings. That Homer experimented with moving his own watercolors into this larger arena is clear evidence of just how seriously he was reconsidering the place the medium could occupy in his professional output.

But if Homer's desire to elevate his art to a more serious plane was the key motivation for his trip to England, then any technical changes he made—whether in terms of actual handling, size of sheet, or whatever—ultimately were in the service of that larger goal. And certainly it is in the most ambitious works he created while in England, and immediately upon his return to America, that we can most clearly see how he set about achieving that goal. *The Wreck of the Iron Crown* might be considered one of those works, but it is something of an anomaly, having been inspired by an actual event that Homer witnessed. As such, it was not fully the result of conscious artistic planning in content and composition. But the fact that Homer made so many drawings while in Cullercoats investigating the same few subjects again and again (see, for example, cats. 118–121) clearly indicates that he was working with larger finished pictures in mind. But did such works actually result and, if so, what form did they take?

Homer's Cullercoats drawings fall into two basic categories. One type depicts men, usually in oilskins, rushing about on shore, launching boats, or urgently looking out to sea. The other shows women on shore engaged in such tasks as carrying fish baskets and mending nets; they, too, often look intently at the sea. What these two types have in common is, of course, the sea itself, which almost always provides the larger setting. And most often, the water is rough; sometimes we see great breaking waves, but even when we do not, the men's oilskins, or the billowing dresses of the women speak of the heavy weather common to the North Sea. There is a heightened sense of danger, as if some calamity—a drowning or a shipwreck—is imminent. When men and women appear in a single image, something such as a railing often divides space and keeps them apart, as if they are in separate, but closely related spheres of existence. In *A Dark Hour* (cat. 120) the men

fig. 144. Alfred William Hunt. *"Blue Lights" Tynemouth Pier—Lighting the Lamps at Sundown*, 1868. Watercolor and bodycolor. Yale Center for British Art, Paul Mellon Fund

LEFT: fig. 145. *Figures on a Rock*, 1882. Charcoal with white chalk. Seattle Art Museum, Purchased through the William Edris Bequest, the Richard E. Fuller Acquisition Fund and the Margaret E. Fuller Purchase Fund

RIGHT: fig. 146. *Hark! The Lark!*, 1882. Oil on canvas. Milwaukee Art Museum, Layton Art Collection

stand and stare out to sea, but the woman (with child in tow) is behind them, moving, and not looking at the water. Her face is buried in her sleeve; this may simply be to shield it from the wind, but it also suggests grief. The men, Homer seems to say, merely witness the tragedy of this dark hour as it occurs, but the woman feels and senses its full impact. The two sexes do not, at least in this moment, share the experience. In the rare instances when Homer does bring the two sexes into close proximity and shows them looking at the same thing, as in *Figures on a Rock* (fig. 145), he still manages to suggest their separateness. Here the net that connects the two unmistakably takes on the shape of a boat. The man stands at the "stern," as pilot and tillerman, but the woman is almost physically subsumed, seemingly transformed into a living figurehead. He, then, might represent the dangers of going to sea; she, all that is left behind on land. As figurehead she also functions as the spiritual personification of the boat, the vessel in which (if all goes well) the men will remain safe.

In his most ambitious Cullercoats watercolors, Homer almost always set up this emphatic juxtaposition between the realm of women (the shore) and that of men (the sea), charging them with suggestive symbolism. In *Four Fisherwives* (cat. 123) the women move determinedly about their own business while the men go, or prepare to go, to sea. In *Perils of the Sea* (cats. 117) men and women both see the face of peril, but from different vantage points. Even when the men are no longer

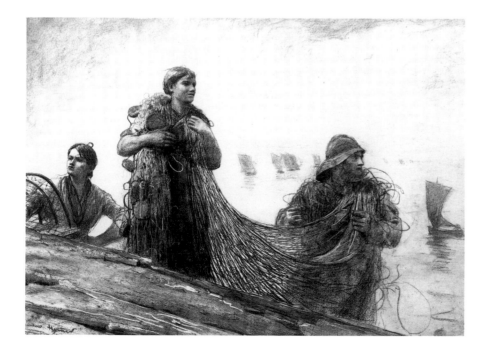

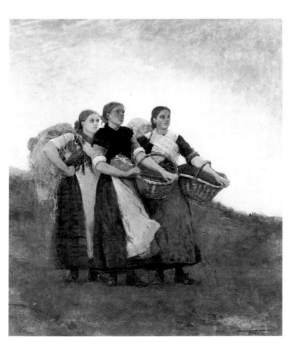

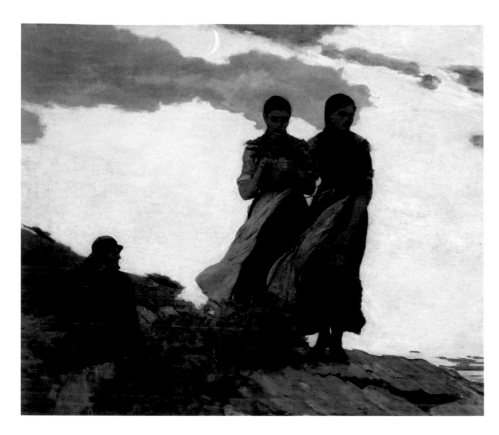

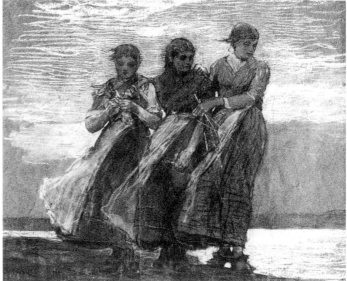

fig. 148. *Three Girls*, 1881–1882. Charcoal and white chalk. Private collection

LEFT: fig. 147. *Early Evening* (originally *Sailors Take Warning*), 1881–1907. Oil on canvas. Courtesy of the Freer Gallery of Art, Smithsonian Institution, Washington D.C., 08.14

physically on shore with the women, as in *Fisherwives* or *Inside the Bar* (cats. 127–128), their presence is still indicated by the boats. In the oil *Hark! The Lark!* (fig. 146), the nets and baskets remind us that these women, who have paused to listen to the song of a bird, are separated from their fishermen kin. And it is this same duality of men and women who are at once united through their shared inextricable links to, and dependence on, the sea, but separated by their inevitably different relationships to it, that lies at the heart of the two works that were unquestionably the culmination of Homer's English experience.

Those two works—*Sailors Take Warning (Sunset)* and *The Coming Away of the Gale* (see figs. 147, 149; and cat. 189)—were done in oil. As had so often been the case before, and would be again, Homer, after thoroughly investigating a subject in drawings and watercolors, returned to working in oil to make his final statement. No matter what the potential of bringing his watercolors to a more serious level, Homer instinctively knew that oil offered him the greatest possibilities for conveying the most serious and profound meanings. That had always been the case for him, but the Cullercoats experience served as a forcible reminder. At this moment when he was reconsidering and realigning his art in so many ways, he ended up reaffirming the primacy of the medium he had always used to greatest effect. Indeed, from this moment the separation between Homer's works in the two media became more complete. Never again would he attempt to make watercolors function like oils; in fact, his watercolors would increasingly become emphatically unlike his oils, with their own formal concerns and, most often, their own subjects.

Neither *Sailors Take Warning* nor *The Coming Away of the Gale* exists in its original state; each was repainted by Homer later, which suggests that he knew they were not at first fully resolved. There is evidence, however, of how they once looked. *Sailors Take Warning* was painted in 1881 and, as has recently been shown, was once larger, had a third figure of a woman at the far right, and a different sky.[48] Fortunately, a drawing of three women survives (fig. 148) showing the original grouping, and x-radiographs confirm that the right-hand figure in the painting matched that in the drawing. It is more difficult to know the original appearance of the sky, which Homer may have repainted first as early as 1893 and then again in 1907.[49] In any event, for this major English oil Homer clearly used the male/female juxtaposition as seen in other works. Here the man once

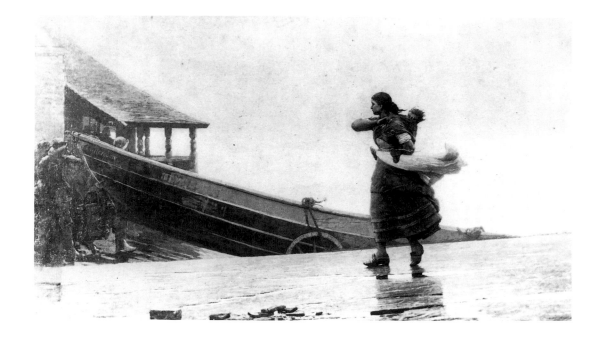

fig. 149. Photograph of *"The Coming Away of the Gale."* Bowdoin College Museum of Art, Brunswick, Maine, 1964.69.176.1, Gift of the Homer Family

fig. 150. *Winged Victory of Samothrace.* Musée du Louvre, Paris

again looks out to sea, but the women, gracefully intertwined in a way that recalls ancient sculptures of the Three Graces (Downes found in them "the plastic quality of a sculptural group"), turn their backs to the water.[50] The tension implied by their separateness augments the meaning suggested by the painting's title, *Sailors Take Warning*, as in the old weather rhyme, "Red sky at night, sailors' delight, Red sky at morning, sailors take warning." If this is evening, the red sky would promise good weather and fair sailing, so the "warning" must apply to the women, whose presence would tempt the man to turn his back on the sea and stay on land.[51]

The Coming Away of the Gale, which recalls the drawing *A Dark Hour*, was far more dramatic, showing a woman with a child on her back striding along a path by the Life Brigade House; in the background, a group of men in foul-weather gear stand near a boat. The tense postures of these men recall the figures in some of Homer's Cullercoats drawings and in the watercolor *Perils of the Sea*. Again, the implication is that the men are witnessing a marine tragedy, one that might well rob a woman and child like the ones in the foreground of husband, brother, son, or father. But the way this woman strides so powerfully into the wind suggests a physical and emotional strength to triumph over even this most devastating of losses.[52] She is like a modern version of an ancient "victory" figure, with a marked resemblance to the *Winged Victory of Samothrace* (fig. 150), which Homer must have seen at the Louvre in 1867.[53]

Homer chose not to exhibit *Sailors Take Warning* in public once back in New York, perhaps because he was in some way dissatisfied with it. He did, however, send *The Coming Away of the Gale* as his single contribution to the National Academy of Design's exhibition in the spring of 1883. That alone suggests that he thought highly of it, as did its price of $2,500, which was far more than he had previously obtained or even asked.[54] Critics had seen the signs of change in Homer's English watercolors when they were shown in New York in 1882, but few were prepared to accept the expressive power of the new oil. One writer felt it had "points of excellence that place the work far in advance of most of its companions in the exhibition," but another harped on its "bad qualities and mannerisms."[55] It was faulted for its "hard drawing and theatrical arrangement of the figures" and called "cold and ugly," "a picture that will not add to Mr. Homer's fame."[56]

We can only guess how Homer reacted to these criticisms of the work in which he so confidently expressed the newly revised nature of his art. Certainly he would have been, at the very least, disappointed. His decision ten years later to repaint the picture and show it again (this time with greater success) may have been as much an attempt to vindicate its qualities as it was any concession that the critics had been right. But in more immediate terms, it seems Homer began to think of the ways he could reformulate the narrative and aesthetic elements of *The Coming Away of the Gale* into a more successful statement.

In the summer of 1883 Homer renewed his acquaintance with the sea. This time it was the Atlantic at Prout's Neck, Maine, where his family had started visiting as early as 1875, and where he himself would live and work permanently, except for vacation trips, from 1883 onward. "This secluded country home on the coast of Maine" was, observed a writer for the *Boston Advertiser*, "a locality excellently adapted to the practice of his art."[57] Homer returned to working in watercolor, producing views of the surf breaking on the rocks (fig. 151) and of the starkly beautiful granite cliffs (fig. 152). He also painted *The Ship's Boat* (fig. 153), a large sheet that recalls his Cullercoats watercolors, although with their suggestion of maritime disaster now a reality. But his major efforts went into creating a new oil for the National Academy's 1884 exhibition.

That work, *The Life Line* (cat. 132), was said to have been inspired by an event Homer had witnessed in Atlantic City, New Jersey, in the summer of 1883.[58] Perhaps that was so, but certainly any sense of anecdotal reference to a specific event vanished as Homer composed the final image. Its real origins, in fact, lay in Cullercoats and, more precisely, in the consummate painting of that experience, *The Coming Away of the Gale*. On one level *The Life Line* "corrected" the perceived faults of the earlier oil, for it certainly has a more unified composition, greater dramatic emphasis, and less disjunction between the foreground figures and the background. But more importantly, in *The Life Line* Homer at last managed to bring his theme of men, women, and the perilous sea into sharper focus by reuniting the sexes physically. No longer do they occupy separate realms; now the man and woman share the same space, and experience the same dramatic and dangerous event. What Homer had been moving toward steadily had at last found form on canvas. In short, *The Life Line* was the first true masterpiece in his new style, the first fully successful result of the process of change that had consumed his artistic energies over the previous several years. To appreciate just how great this achievement was and to see clearly how much formal and emotive power Homer's art had gained, we need only compare *The Life Line* to *Breezing Up* (cat. 76) of less than a decade before. Whereas the earlier seascape, for all its beauty and expressive richness, retained some of the conventions of genre painting in its light-hearted subject and sense of pleasure, *The Life Line*, by virtue of its heroic intensity and force, compels the viewer to reckon with far deeper, far more profound, and ultimately far more difficult matters about life and death.[59] *The Coming Away of the Gale*, of the previous year, had been greeted by a chorus of complaint, but *The Life Line* met with resounding approval from the critics. Although Homer may by this point have had real doubts about the

fig. 152. *Maine Cliffs*, 1883. Watercolor over charcoal. Brooklyn Museum, 50.184, Bequest of Sidney B. Curtis in Memory of S. W. Curtis

fig. 153. *The Ship's Boat*, 1883. Watercolor. The New Britain Museum of American Art, Charles F. Smith Fund

discernment of art critics in general, he certainly recognized that he had reached a new plane in his art. The sale of *The Life Line* to the prominent New York collector Catherine Lorillard Wolfe for $2,500 soon after it went on view at the National Academy can only have reinforced that feeling.

Homer must have begun planning a sequel to *The Life Line* almost immediately. No doubt realizing he had achieved a statement on the theme of heroic rescue that would be hard to surpass, he wisely sought a new subject. An opportunity arrived when a vast school of herring came into the waters off Prout's Neck in 1884, attracting countless fishing boats. According to Beam, Homer took advantage of this fortuitous event by having himself rowed out so that he could make sketches of the fishermen working; these became the inspiration for *The Herring Net* (cat. 133) of the following year.[60]

However, before Homer completed that painting he was to reckon with a wholly new subject—the Tropics. What led him to this new subject was not his own choice, but a commercial arrangement of a type he had not accepted since giving up illustration in 1875: a commission from *Century Magazine* to illustrate an article on Nassau, the principal city and port of the Bahamas.

Before 1884 virtually every extended journey Homer had taken was primarily self-motivated and largely in the service of his art. He had gone to Europe at two critical junctures in his life: first in 1866 as a painter just beginning his profession, and again in 1881 in mid-career, when he had determined to seek new subjects and new inspiration. Even trips that were closer to home and of shorter duration—Gloucester in 1873 and 1880, Petersburg in 1877, Houghton Farm in 1878—served as occasions to concentrate on his work and investigate new subjects, new stylistic directions, and new thematic concerns. But the reasons Homer first visited the Tropics, and encountered some of his most felicitous subjects, were of an entirely different nature. So, too, would the art he produced on his tropical travels between 1884 and 1903 be fundamentally different from other works of the same years, whether painted in Prout's Neck or in the Adirondacks. By the mid-1880s Homer was working largely in oil and watercolor, although he continued to do some work in black and white. Oil was reserved for major paintings created in his Prout's Neck studio; watercolor became his preferred means of working while traveling. Thus, even though a few oil paintings relate to Homer's experience of the Tropics, most notably *The Gulf Stream* and *Searchlight* (cats. 231–232), all of his works that actually addressed the distinctive look of the tropical world are watercolors.

Although the Bahamas were beginning to attract tourists from North America, they were by no means a major mecca for travelers.[61] At the time Homer visited, there were said to be only about one hundred and fifty visitors at the height of the season, with the highest yearly total only about eight hundred.[62] In addition to scenery, the Bahamas offered a pleasant climate. "The idea of midsummer weather in midwinter warms the heart of the Northern visitor with a glow of cheerful anticipation."[63] The promise of warm weather was particularly attractive to those suffering from illnesses exacerbated by the cold winters of the Northeast, and Nassau early on developed a reputation as an attractive destination for invalids and a "place in which to seek complete repose for brain and nerves."[64]

With the explosive expansion of railroad lines and steamship routes, places that once required days or weeks of often arduous and complicated travel could be reached comfortably and quickly. Of course, this greatly increased mobility (like greatly increased leisure time) had far-ranging consequences for Americans of the late nineteenth century, and touched on more than simply matters of tourism. But what should be kept in mind in considering Homer's tropical works is that he was a tourist traveler (albeit a working one) when he first encountered the Tropics in 1884–1885.[65] Although his subsequent trips were taken on his own initiative, they too are best understood within the context of tourism and the peculiar conditions of the artist encountering new and unfamiliar subjects and responding to them in his art. These trips offered Homer escape from the demands of the studio and the intensive labor his oil paintings required; painting watercolors while he traveled must have been, in that way, at least, somewhat liberating. In this respect Homer's tropical travels represent quite a different matter than his experiences in England in 1881–1882, where he went specifically seeking new subject matter and specifically prepared to grapple with it through an extended campaign of investigation.

Homer went to Nassau on board a steamship from New York in the company of his father.[66] During the two months he was on the island Homer executed more than thirty watercolors on a variety of subjects, including architecture (cat. 147), women carrying fruit-laden trays (cat. 149), sponge and coral fishing (cat. 150), fruit trees (cat. 146), and unusual features of the landscape (cat. 148). Unlike the panoramic Nassau paintings of Albert Bierstadt, who was regularly on the island with his consumptive wife in the 1880s, Homer's watercolors usually focused on a single subject—a house, a woman, oranges on a branch, a coral arch.[67] They are highly descriptive, with concentrated visual interests and easy legibility. These qualities were due, in large part, to their intended function in the *Century Magazine* article, where they would appear in black and white, greatly reduced. But the way they read as pared down transcripts of the essential appearance of places and things makes them wholly different in effect from the more consciously artistic English watercolors that immediately preceded them. This difference was obvious to critics who saw the

watercolors on view in New York late in 1885 and in Boston in 1886.[68] "They are not 'pictures,' but broadly and rapidly handled studies," observed a reviewer in *The Critic*.[69] "Doubtless there was little chance here for Mr. Homer to make those fascinating and sympathetic studies, full of grave and simple feeling, that mark his chiefest individuality," observed another critic, who concluded: "as sketches the work shown here is really wonderful, but it hardly takes the place of an exhibition of genuine pictures."[70] And putting the works squarely into the realm of tourism, the ever-perceptive Van Rensselaer characterized them as "his memoranda of travel."[71]

Still, if the critics were quick to note that Homer's first tropical watercolors lacked the sense of gravity and seriousness that so memorably distinguished his Cullercoats sheets, they were equally quick to notice that in them he had demonstrated an impressive new handling of the medium. Homer had now found "color and sunshine" and "a new-born power of rendering them," a "frankness and yet a harmony."[72] And surely the source of that new power lay in the fact that Homer painted these watercolors not as part of a larger systematic process intended to result in a finished work of high ambition, but as records of actual experience.[73] They were, in other words, transcriptions of the visual encounters with new things in a new land that energized Homer's creative instincts, "memoranda of travel," but also memoranda of excitement, interest, and pleasure.

To understand just how crucial Homer's experience of place was in shaping the art that resulted, one need only compare his Bahamian watercolors of 1885 to those he produced during a five-week side trip from Nassau to Cuba. It is not known why Homer went to Cuba, but he initially felt it might be "the richest field for an Artist that I have ever seen."[74] However, he also complained about the conditions and the heat, and admitted he would "be very glad to get home."[75] As Cooper has observed, the eighteen or so watercolors Homer executed in Cuba are among his weakest, with little of the vibrant light and saturated color that made the sheets from the Bahamas so notable. Perhaps he was disappointed in what he saw, or simply too inconvenienced and uncomfortable to appreciate it fully. Whatever the case, the unhappy experiences of the traveler resulted in unsuccessful works of art.

Homer returned to New York in April 1885 and then went on to Prout's Neck. During the summer and fall he worked on what would become a remarkable series of pictures charting the life of New England fishermen. Although he had watched and studied the North Sea fishermen at Cullercoats, his focus then was on the women; in only a very few works did he actually show fishing activities (for example, *Tynemouth Priory, England*, 1881, Art Institute of Chicago). Now, however, in a period of extraordinary productivity he created *The Herring Net*, *The Fog Warning*, and *Lost on the Grand Banks* (cats. 133–135), three closely related pictures that each considered a distinct aspect of fishing in the North Atlantic.

The Herring Net, the first of these works, derived from the studies of the fishing fleet he had made the previous summer. In it two fishermen peacefully work a gill net from a dory; in the hazy distance beyond are larger vessels. "The picture is of the simplest description as to motive," observed one critic, but it nevertheless showed "Winslow Homer's simply incomparable strength."[76] This same writer concluded: "His drawing is simply masterly, it recalls certain old Italian work, it is the very concentration of strength." Monumental in conception and in effect, with a pyramidal composition and a low point of view that perhaps bring to mind the timeless stability of High Renaissance figure groups, *The Herring Net* invests its subjects with a quiet nobility.[77] It shows us the fishermen engaged in their normal day-to-day activities, but manages to elevate them through its sense of gravity and purpose to the realm of the ideal.

The mood shifts in *The Fog Warning*, which first appeared under the (apparently erroneous) title *Halibut Fishing*. A fisherman pauses momentarily from rowing to take a bearing on the ship on the horizon behind him. Large fish lying in the boat's bottom show that he has successfully concluded the first part of his difficult task, but the outcome of his next—returning to the ship—is in doubt. Homer underscored the drama by insisting upon the title *The Fog Warning*, because it made the true nature of the ominous cloud in the distance more apparent. Many in his audience would have known perfectly well that this man was in an extremely dangerous situation. Life for the fisherman on the Grand Banks was aptly described as "subject to perils unknown to the fisherman of olden time":

His frail boat rides like a shell upon the surface of the sea...a moment of carelessness or inattention, or a

slight miscalculation, may cost him his life. And a greater foe than carelessness lies in wait for its prey. The stealthy fog enwraps him in its folds, blinds his vision, cuts off all marks to guide his course, and leaves him afloat in a measureless void.[78]

Homer left the fate of the fisherman in *The Fog Warning* unresolved, giving it a tension that heightens its drama considerably. However, in the concluding picture of the series, *Lost on the Grand Banks*, the mood is far more ominous. One critic found in it "a rude vigor and grim force that is almost a tonic in the midst of the namby-pambyism of the many of the other pictures [at the National Academy exhibition]," while another admired "its bold, uncompromising ruggedness and truth."[79] The danger that was imminent, but not inevitable, in *The Fog Warning* here becomes inescapable. "Instances are on record of many a wearisome trip, of days and nights without food or water, spent in weary labor at the oars," noted one contemporary source.[80] There is, of course, always the possibility that things will turn out well and that these men will "find succor from some chance vessel or by reaching a distant port," but we cannot truly know that. Indeed, there is equally the chance that these men will suffer "the hardships experienced, the hopes awakened and dispelled, and the torturing fate of the many 'lost in the fog,' of whose trying experiences nothing is ever known."[81]

In December of 1885, having completed these three great oils, Homer again journeyed southward. This time his destination was Florida, which would become his favorite retreat from the rigors of winter at Prout's Neck. Although tourists had found their way to the state earlier, the most intensive development of Florida as a tourist site began around 1881.[82] Until then most tourist travel was centered on the St. Johns River and the middle of the state, but the railroads and hotels built by men such as Henry M. Flagler and H. B. Plant began to direct many visitors to the east and west coasts. Unlike the trip to Nassau the previous winter, which originated in a commission, Homer's Florida visit was a vacation. While there he visited Jacksonville, Tampa, and Key West.

"Florida is a strange land," observed a writer in William Cullen Bryant's *Picturesque America* of 1874, "both in its traditions and its natural features."[83] Relatively few artists had ventured there by the mid-1880s and produced serious work. The peripatetic landscape and still-life painter Martin Johnson Heade settled in St. Augustine in 1883, and over the next twenty years produced many scenes of Florida marshes and still lifes of magnolias and other flowers. Homer's initial artistic response to the state was to concentrate primarily on tourist scenes, which form the subjects of the dozen or so watercolors he painted there in 1885–1886.[84] Trees festooned with Spanish moss, exotic birds, coconut palms, storm-blown trees, and other subjects were all virtually emblematic of Florida's peculiar and distinctive scenery.[85] Still, these Florida watercolors are often notable for their dramatically cropped compositions, as in the powerful *Coconut Palms, Key West* (cat. 151), and for their technical complexities, as in *In a Florida Jungle* (fig. 154). However, critics took little notice of the two Florida watercolors he would show at the American Watercolor Society exhibition in January 1887, with one reviewer dismissing them as "unimportant and not particularly attractive sketches."[86]

Homer had returned to Prout's Neck from Florida by March 1886 and once again began working in oils. Around the time he had conceived of *The Life Line* he had begun a second canvas that also had its origins in something he had reportedly seen at Atlantic City in 1883. According to Downes, while there Homer "made friends with the members of one of the life saving crews" and "had the good fortune to see a rescue from drowning."[87] In the 1880s considerable attention was focused on the gallant exploits of such life-saving crews. As a writer for *Harper's Weekly* observed in 1881: "There are but few who can fully understand the severe labor which attends all the rescues by the life-saving men."[88] Their most dramatic efforts concerned rescuing shipwreck victims—the subject Homer first turned to in *The Life Line*—but they were also regularly called on to save bathers in trouble. Why he returned to this subject in 1886 is not known, but having concluded his three pictures on the life of the fishermen he may simply have been looking for a fresh subject. The result was *Undertow*, arguably the most complex and ambitious figure painting of Homer's career.

Undertow cost Homer considerable effort. "Probably no one will ever know the amount of work which has entered into this picture," observed the critic for the *Boston Transcript*; "it is the result of a year's labor. In it as many obstacles have been overcome as usually are resisted by most painters in a lifetime."[89] And there is evidence of that labor and of obstacles overcome in the

fig. 154. *In a Florida Jungle*, 1886. Watercolor over graphite. Worcester Art Museum, Worcester, Massachusetts

many drawings for *Undertow* that have survived (cats. 137–142). As these drawings suggest, what concerned Homer most—and what gave him the most difficulty—was the arrangement of the four figures. And if we recall that the conception of this painting occurred in the time immediately after Homer's return from Cullercoats and the exhibition of *The Coming Away of the Gale*, it is not surprising to see that he solved the problem by looking once again to the antique. In their solidity and massiveness, and in their organization into a cohesive "almost frieze-like line," these figures surely descend from the Parthenon sculptures Homer had seen in the British Museum.[90] Indeed, among all of the oils of the mid-1880s, *Undertow* was most consistently singled out for its sculptural qualities. "*Undertow*," said *The Critic*, "is a picture in which four figures, thrown together by chance, are made to assume magnificent combinations of line, and to present an heroic sculpturesque effect which endows them with the quality of the antique."[91] Homer had by this point learned how to use the lessons of the past to give his paintings a seriousness and gravity that quite literally set them apart from the work of his contemporaries. There were more than five hundred paintings on view that year at the Academy, but for many critics *Undertow* deserved "the post of honor."[92] Perhaps the only painting to rival it for attention was Thomas Dewing's *The Days* (fig. 155), before which, according to one observer, "everybody pauses."[93] Dewing's "highly decorative, quaint" painting, with its ethereal figures, poetic subject, and "all-pervading gray greenness," seems virtually the exact opposite of Homer's weighty forms and powerful composition.[94] *The Days* might have proved for some that "the aesthetic craze was not all rubbish," but for Van Rensselaer, Homer had shown that "realism need not mean the death of *pictorial* idealism, truth need not mean ugliness, local themes need not mean the exclusion of grace and form, any more than the exclusion of charm of color."[95]

Eight Bells (cat. 144), the last of these great works of the mid-1880s, was completed late in 1886, but not shown publicly until its appearance at the National Academy in 1888. For it Homer did not choose to depict an exceptional moment, but rather one that was part of the daily routine of life at sea.[96] Two men dressed in foul-weather gear have come on deck (eight bells was sounded at the hours of four, eight, and twelve o'clock) to "shoot the sun" with a sextant and thus determine the ship's position. The heavy seas and cloudy but clearing sky suggest, as Beam has noted, that this may be the first moment after riding out a storm that they have been able to complete this task.[97]

The Life Line, The Herring Net, The Fog Warning, Lost on the Grand Banks, Undertow, and *Eight Bells* represent a remarkable artistic achievement for fewer than three years of work. More to the point, they fulfilled what one critic thought implicit in Homer's English works, namely, that he was "now evidently bent most upon expressing something, and treats his art (as the generality of our younger artists do not) as the mere medium for conveying something of social or human interest. Mr. Homer is both the historian and the poet of the sea and sea-coast life...."[98] Homer was now firmly in many people's minds "in a place by himself as the most original and one of the strongest of American painters."[99]

In 1886 the fifty-year old Homer was, he complained, tired of being called "a promising young artist."[100] He had reason to protest, for these paintings of the mid-1880s are among the most accomplished figural works created by any American painter working in the 1880s. But in one crucial way they proved a disappointment. Between the sale of *The Life Line* in 1884 and the 1889 sale of *Undertow,* only *Eight Bells* managed to find a buyer, and that was at a reduced price.[101] Left with this ample supply of critically admired, but seemingly unsalable pictures, Homer actually gave up painting oils until 1890. Through an intense self-generated and self-motivated process of change Homer had wholly reformulated the substance and meaning of his art. But for the moment, that process of change had resulted in works of art that were perhaps too serious in intention and meaning to be truly palatable to potential buyers. The implications of this rejection were surely not lost on him, and they might have led other artists to reconsider their direction. But the evidence from his work over the next two decades indicates that, if anything, Homer would redouble his efforts to make his art timeless and universal. The changes he had made were permanent, and they would, in turn, lead to even greater, and more richly consequential reconsiderations of what his art was for and about.

NOTES

1. Wilmerding 1972, 131, has noted a "change in feeling" and an "almost subconscious probing toward a new style" in this painting.

2. Letter to George Walter Vincent Smith, 3 March 1880 (copy, curatorial files, Museum of Fine Arts, Springfield, Massachusetts). The letter is quoted in the entry for cat. 103.

3. Cooper 1986a, 69: "The summer was one of artistic restlessness and experimentation."

4. "An American Artist in England," *The Century* 27 (November 1883), 15.

5. When a group of Homer's 1880 watercolors were shown in Boston in October of that year, the critic for the *Boston Advertiser* noted their experimental quality, but concluded by saying: "It is by no means to be inferred that Mr. Homer intends to devote himself to water-color, but is merely digressing a little" ("The Fine Arts," *Boston Advertiser*, 21 October 1880).

6. 3 February 1881; see Hendricks 1979, 144, and Cooper 1986a, 78.

7. Hendricks 1979, 148, based on the passenger list printed in the *New York Times*, 17 March 1881.

8. Beam 1983, 21–22, noting the stern power of the ocean and sky in *Marine* especially, has suggested that these two watercolors must have been painted after Homer had worked during the summer and fall of 1881 in Cullercoats. Following Goodrich (1944a, 76), he proposes that Homer made a trip home to America in the winter of 1881, and that the watercolors were done at sea. However, as Hendricks (1979, 159–164) pointed out, several letters from Homer to the dealer J. Eastman Chase (Archives of American Art) clearly establish that Homer remained in Cullercoats during the winter of 1881–1882. William H. Miller, a steamship historian (letter, 11 October 1982, to Philip C. Beam; cited in Beam 1983, 44), has confirmed that both works unquestionably depict the *Parthia*, and as Homer sailed on a different liner when he returned to New York in 1882, *Marine* and *Observations on Shipboard* can only have been done on the voyage over.

9. Cooper 1986a, 80.

10. Knipe, Boon, et al. 1988, 31.

11. Cooper 1986a, 85.

12. Cooper 1986a, 85; Knipe, Boon, et al. 1988, 11.

13. Downes 1911, 99. John Boon, "An American Artist in Cullercoats," in Knipe, Boon, et al. 1988, 13, implies that this dwelling, known as "Stone House," was demolished around 1950.

14. Lois Homer Graham, according to Tony Knipe, in Knipe, Boon, et al. 1988, 7, has reasonably suggested that Homer went to Scarborough because he wished to see the place that had given the name to Scarboro, Maine, where Prout's Neck is located.

15. Hendricks 1979, 164, based on the *New York Times*, 11 November 1882.

16. "An American Artist in England," 17.

17. Downes 1911, 99.

18. Goodrich 1944a, 78.

19. Gardner 1961, 28–29, however, was so intent on establishing the primacy of Homer's 1867 trip to Paris that he downplayed the importance of the English sojourn: "his stay near Tynemouth when he was forty-five marked some significant turning point in his personal [i.e., not artistic] life...."

20. Daniel Strong, a graduate student at Princeton University, is currently researching a doctoral dissertation on Homer's English trip.

21. See his "The Homer that I Knew," in Knipe, Boon, et al. 1988, 15–21.

22. "The Homer that I Knew," 17.

23. Cikovsky 1990c, 109–113.

24. Gerdts 1977, 29–35; Cooper 1986a, 82–83; Kenneth McConkey, "...a dapper medium-sized man with a watercolour sketching block...," in Knipe, Boon, et al. 1988, 29–73.

25. Wilmerding 1972, 132–133.

26. Quoted in Downes 1911, 11, and Goodrich 1944a, 35.

27. See Michael Hiley's discussion of "Fisher girls of the Yorkshire Coast," in his *Victorian Working Women: Portraits from Life* (London, 1979), 103–110.

28. Wilmerding 1975b, 67, has pointed to the similarities between Homer's and Sutcliffe's images and has also proposed the influence of the cartoonist and illustrator George du Maurier. Arthur Munby (1828–1910), an Englishman who collected photographs of working women, recorded the following in his diary during an 1864 visit to the fishing village of Filey (near Scarborough): "I found a civil photographer near the station, and had a talk with him. He often takes photos, he says, of Filey fishergirls, for artists, and sends them to London, even to *Florence*, to an English artist there. The girls will come readily, if you give them a copy of the portrait" (quoted in Hiley, *Victorian Working Women*, 103).

29. Quoted in "Charles Reade's Works," an advertisement in *Harper's Franklin Square Library*, 18 September 1885. The advertisement includes among the "Harper's Popular Editions" (published by Harper and Brothers, New York) a volume with *Peg Woffington, Christie Johnstone*, and other stories.

30. Quoted in "Charles Reade's Works."

31. Quoted in "Charles Reade's Works."

32. Homer did own works of popular fiction from the 1870s, 1880s, and 1890s; see Tatham 1977, 92–98.

33. Charles Reade, *Christie Johnstone* (London, 1882), 25.

34. Reade, *Christie Johnstone*, 25–26.

35. Gatty's pronouncements about art are clearly derived from the theories of the Pre-Raphaelite Brotherhood of painters, which was formed in 1848.

36. Reade, *Christie Johnstone*, 61–62.

37. "The Homer that I Knew," 16.

38. "The Fine Arts," *Daily Evening Transcript* (Boston), 9 February 1882. Perhaps written by Downes, who also mentions Christie Johnstone on page 106 of his 1911 biography of Homer.

39. Wilmerding 1972, 133–134; Cikovsky 1990a, 75.

40. Quoted in Lloyd Goodrich, *Thomas Eakins*, 2 vols., (Cambridge, Mass., Washington, and London, 1982), 1: 173.

41. Goodrich, *Eakins*, 1: 173–174.

42. "An American Artist in England," 17.

43. "An American Artist in England," 17–18.

44. "An American Artist in England," 19. Some years later, after seeing the memorial exhibition of Homer's works held in 1911, Frank Jewett Mather would ask: "The English works have a peculiar flavor. How account for that admirable monochrome of a lugger, lent by Mr. Drake, in which sit peasant girls with the classic pose of goddesses?" See *Estimates in Art* (New York, 1931), 193.

45. Cooper 1986a, 62, 66.

46. Cooper 1986a, 101.

47. See Jane Bayard, *Works of Splendor and Imagination: The Exhibition Watercolor, 1770–1870* [exh. cat., Yale Center for British Art] (New Haven, Conn., 1981).

48. Mead 1993, 104–107. Homer wrote on the stretcher of the painting in 1907: "Painted in 1881, Winslow Homer. Cut down from large picture. Put in present shape, Dec. 1907. W. Homer." He also had written to his brother Charles on 30 November that he had reworked the picture: "*Only* this picture will not be new to you as it is the two girls & old pilot that have been hanging in my studio for so long. Only I have made a new thing representing early evening…." Homer's words suggest that he may have painted out the third figure at an earlier date and that his 1907 alterations were to the sky and to the actual size of the canvas. The top of the picture is visible above Homer's easel in the well-known picture of him working on *The Gulf Stream* (see Chronology 1899).

49. The painting was apparently not shown by Homer until February 1893 at Gustav Reichard's gallery in New York. A letter from Homer to Reichard of 27 January 1893 indicates the size of the painting was originally 33½ x 50 inches; see Sherman 1936, 84. In 1893 it also appeared in the World's Columbian Exposition in Chicago as *Sailors Take Warning (Sunset)*.

50. Downes 1911, 229.

51. I am grateful to Marc Simpson for helping me clarify my thoughts on *Sailors Take Warning*. The painting remained unsold in Homer's studio for many years and, according to Beam (1966, 243–244), he liked to "amuse visitors" by "touching the right corner of the ancient fisherman's eye with a stick of chalk, and instead of looking out to sea the old salt would have the appearance of leering at the two girls." Homer's whimsical alteration makes it clear how well he understood the central role that the direction of the man's gaze played in the painting's meaning.

52. The woman's pose was lampooned in a cartoon in *Life* 1 (26 April 1883), 196, entitled "This is the best our artist could do with the Academy Exhibition to inspire him." The drawing shows a wall of paintings at the National Academy annual exhibition, with each painting caricatured. Tiny roller skates were added to the woman in Homer's picture, which was then given the title "Phantom Skates."

53. Cikovsky 1990c, 113.

54. Hendricks 1979, 169.

55. "Fifty-Eighth Academy," *The Art Interchange* 10 (12 April 1883), 94; "Fine Arts. Fifty-Eighth Annual Exhibition of the National Academy of Design," *The Nation* 36 (19 April 1883), 348–349.

56. Hendricks 1979, 169, quoting from reviews in *The New York News, The Sun*, and *The New York Times*.

57. "The Fine Arts. Winslow Homer's Watercolors," *Boston Advertiser*, 1 December 1883, 1.

58. Downes 1911, 121.

59. Cikovsky 1990a, 87.

60. Beam 1966, 66–68. It has often been said (e.g., Hendricks 1979, 177) that Homer actually sailed with a herring fleet to the Grand Banks, but documentation for this trip is lacking; Beam's account seems more plausible.

61. Cooper 1986a, 130, suggests that *Century Magazine* may have been inspired to plan its article because of a series of popular reports on the islands published in the *New York Times* in 1884. She further notes that travel guides extolling the beauties of the islands were published in London and New York throughout the 1870s and 1880s.

62. William C. Church, "A Midwinter Resort," *The Century Magazine* 33 (February 1887), 500. Church's article was the one for which Homer's illustrations were commissioned. Nine of his watercolors were reproduced with the text.

63. "A Midwinter Resort," 500.

64. "A Midwinter Resort," 501.

65. Homer may well have purchased a current tourist guide once on the island, for among the books he is known to have owned is *An Almanack for 1884 with a Guide to the Bahamas* (Nassau, 1883); see Tatham 1977, 97. For background on tourist travel, see Eric J. Leed, *The Mind of the Traveler: From Gilgamesh to Global Tourism* (New York, 1991).

66. Thorough documentation of this and Homer's subsequent trips to the Tropics is found in Cooper 1986a.

67. The choice of these subjects may, of course, have been Homer's, but one wonders whether Church, the writer of the *Century* article, was with him on the island and perhaps also involved in the selection.

68. Cooper 1986a, 146.

69. "Art Notes," *The Critic* 4 (19 December 1885), 298.

70. "Winslow Homer at Doll & Richards," *Boston Daily Evening Transcript*, 25 February 1886.

71. M[ariana] G[riswold] Van Rensselaer, "Pictures of the Season in New York," *The American Architect and Building News*, 20 February 1886, 89.

72. "Pictures of the Season," 89.

73. Cikovsky 1990a, 97.

74. Undated letter to Charles S. Homer, Jr. (Bowdoin).

75. Undated letter to Charles S. Homer, Jr. (Bowdoin).

76. *Boston Daily Evening Transcript*, 25 February 1886.

77. Cikovsky 1990a, 87.

78. *The Fisheries of Gloucester, from the First Catch by the English in 1623, to the Centennial Year, 1876* (Gloucester, 1876), 58.

79. "Art Notes," *The Art Review* 1 (December 1886), 12; *The Critic*, 24 July 1886, 47.

80. *Fisheries of Gloucester*, 58.

81. *Fisheries of Gloucester*, 58.

82. *Florida: A Guide to the Southernmost State* (New York, 1939), 59–60.

83. T. B. Thorpe, "St. John's and Ocklawaha Rivers, Florida," in William Cullen Bryant, ed., *Picturesque America; or, The Land We Live In*, 2 vols. (New York, 1874; reprint ed., Secaucus, New Jersey, 1974), 1: 17.

84. Cooper 1986a, 150, 153.

85. As Cooper notes (1986a, 153–154), popular guidebooks offered prose descriptions of virtually every subject Homer painted.

86. "Fine Arts. The Water-Color Exhibition," *The Nation* 44 (10 February 1887), 128; Cooper 1986a, 157.

87. Downes 1911, 120.

88. "The United States Life Saving Service," *Harper's Weekly* (16 April 1881), 252–253.

89. "American Pictures at Doll & Richards," *Boston Daily Evening Transcript*, 21 January 1887.

90. Van Rensselaer, "Pictures of the Season in New York—III," *The American Architect and Building News*, 23 April 1887, 195. See also Cikovsky 1990a, 84.

91. "The Fine Arts. Good Work at the Academy," *The Critic*, 9 April 1887, 183.

92. "Art Notes," *Boston Daily Evening Transcript*, 5 April 1887.

93. "At the Academy," *New York Commercial Advertiser*, 6 April 1887.

94. *New York Commercial Advertiser*, 6 April 1887; "The National Academy Exhibition," *Art Amateur* 16 (May 1887), 125.

95. "Pictures of the Season—III," 195; *New York Commercial Advertiser*, 6 April 1887.

96. See Carol Troyen's entry on the painting in *A New World: Masterpieces of American Painting, 1760–1910* [exh. cat., Museum of Fine Arts] (Boston, 1983), 333–334.

97. Beam 1966, 81–82.

98. "Art Notes," *Boston Daily Evening Transcript*, 6 December 1883.

99. *New York Evening Post*, 1888 (quoted in Cikovsky 1990a, 91).

100. Cikovsky 1990a, 87.

101. Goodrich 1944a, 100–101, notes that Thomas B. Clarke paid only $400 for the picture in 1887.

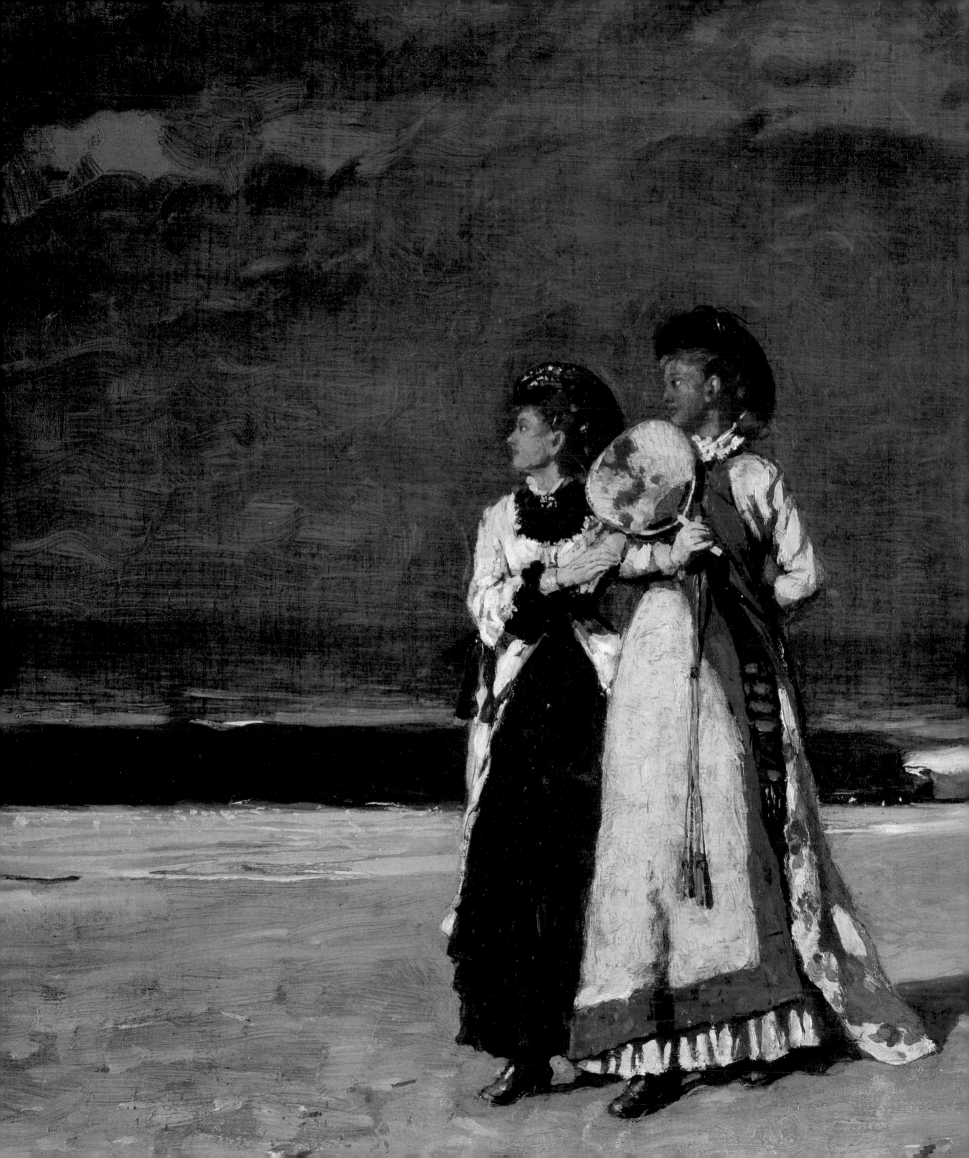

103. *Promenade on the Beach*, 1880
oil on canvas, 50.8 x 76.5 (20 x 30⅛)
Museum of Fine Arts, Springfield, Massachusetts,
Gift of the Misses Emily and Elizabeth Mills in
memory of their parents, Mr. and Mrs. Isaac Mills
Provenance: (possibly Matthews Art Gallery, New
York, 1880). (James C. Gill, Springfield, Massachu-
setts, 1880). George Walter Vincent Smith for Isaac
Mills.[1]

103

Promenade on the Beach, completed early in 1880, is among the most striking works of Homer's career. Although its stark lighting and slightly eerie mood are somewhat reminiscent of *Eagle Head, Manchester, Massachusetts* (cat. 31), the painting's closest stylistic parallels are to the most dramatic watercolors Homer would paint in Gloucester the following summer (see cats. 104–106). Like those works, *Promenade on the Beach* has saturated areas of black that almost read as voids in the pictorial space and effects of weather and atmosphere that seem at the very least portentous, if not, in fact, downright threatening.

The critic for the *Springfield Daily Republican*, who saw the picture when it was on view in that city in February 1880, was puzzled, but appreciative:

On the left of Mr. Shirlaw's large painting stands Winslow Homer's latest, one of his most peculiar motives, and like no one else in the world. It is a shore view in late afternoon, the skies nearly filled with violet clouds, through which patches of blue are seen, and rosy dots from the sinking sun vary their monotone. The sea is dully blue beneath, and fishing boats under full sail are scudding a little ways out, their sails gleaming strangely in the level sunlight. On the beach walk two women, both young, and looking out with such expressions in their faces as suggest romances. Mr. Homer probably painted this peculiar phase of nature first, but he has made a poem of it by introducing these figures. The painting of the whole is masterly; it is a Homer to be coveted.[2]

As this reviewer noticed, the inclusion of the elegantly dressed women (one of whom holds a Japanese fan), with faces that "suggest romances," gives the painting much of its particular flavor. One wonders, quite naturally, just who these women were and what it was that they were gazing at with such intensity. Indeed, the Springfield collector George Walter Vincent Smith apparently wrote to Homer asking precisely

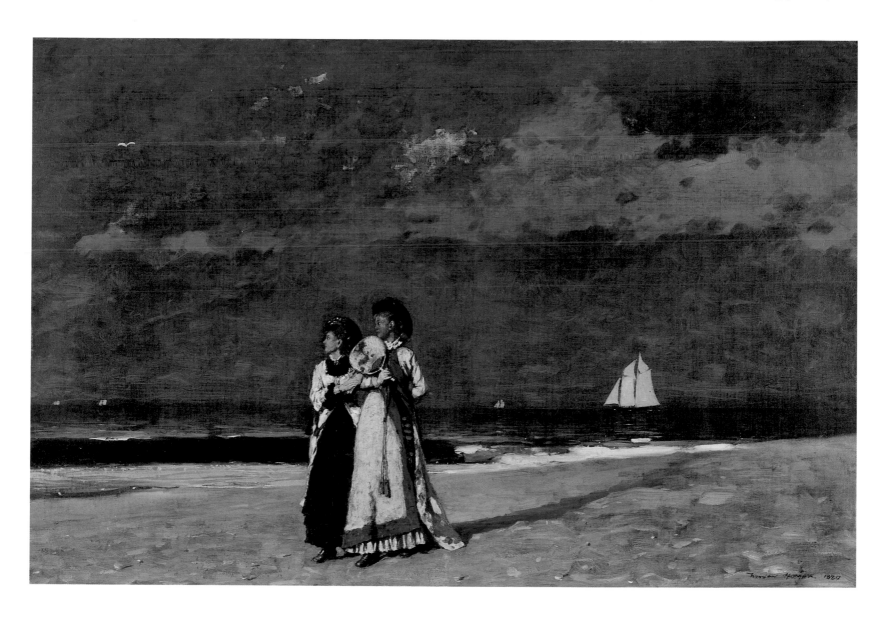

those questions, for the artist replied to him in a letter of 3 March 1880:

My picture represents the Eastern shore at sunset. The long line from the girls is a shadow from the sun. [Homer here drew a simple map of the Massachusetts coast and Cape Cod, showing the two figures and their shadow and the schooner. Further inland he noted the locations of Boston and Springfield, and the position of the sun, drawing a line from it straight to the figures. At the bottom he wrote "East" under Cape Cod and "West" under the sun.] The Girls are "somebody in particular" and I can vouch for their good moral character. They are looking at anything you wish to have them look at, but it must be something at sea & a very proper object for Girls to be interested in. The schooner is a Gloucester fisherman.

Hoping this will make everything clear.[3]

Homer's explanation of the painting does not really "make everything clear," for he pointedly avoided answering the questions that most concerned Smith, which had to do with the women and their motivations. Clearly, Homer knew that much of the effect of the picture depended on its enigmatic mood and its resistance to simple narrative interpretation, and he accordingly resisted Smith's request.

The pronounced decorative qualities of *Promenade on the Beach*, especially its tendency toward flattening of space and emphasis on simple patterns of color, have led to it being considered one of Homer's closest brushes with the Aesthetic Movement.[4] Indeed, around this same time Homer experimented with a similar subject (although with only one woman depicted) in a

ceramic tile (1880, Addison Gallery of American Art, Andover, Massachusetts). Whatever the case, the general origins of *Promenade* seem to date from nine years earlier, for a crayon and Chinese white drawing of 1871 (collection of Mrs. Thomas M. Hitchcock) first established the basic elements of the two finely dressed women (although differently posed) silhouetted against sea and sky with sailing vessels beyond.[5]

NOTES

1. According to Martha J. Hoppin, curator of American Art, Museum of Fine Arts, Springfield (letter of 13 August 1991), there is no evidence documenting the exact nature of the transaction between Smith and Mills.

2. "Mr. Gill's Exhibition," *Springfield Daily Republican*, 17 February 1880.

3. The letter is in the curatorial files of the Museum of Fine Arts, Springfield. The map is reproduced in Hendricks 1979, fig. 215, 139.

4. See, for example, Roger B. Stein's discussion of *Promenade on the Beach* in "Artifact as Ideology: The Aesthetic Movement in its American Cultural Context," in *In Pursuit of Beauty: Americans and the Aesthetic Movement* [exh. cat., Metropolitan Museum of Art] (New York, 1986), 41: "Rather, at this crucial 'aesthetic moment' in Homer's career…style as the abstract organizer of material from various cultures triumphs over the female subject, depersonalizing her and distancing the viewer, frustrating the search for some cultural meaning and resolving the experience of the picture only in aesthetic terms."

5. Reproduced in Goodrich and Gerdts 1986, 38. This drawing was the basis for an undated oil (private collection; see Hendricks 1979, fig. 201, 131); both are related to a set of fireplace tiles of 1878 (private collection). The watercolor *Startled* (1878, Philadelphia Museum of Art) is also related to this group of works.

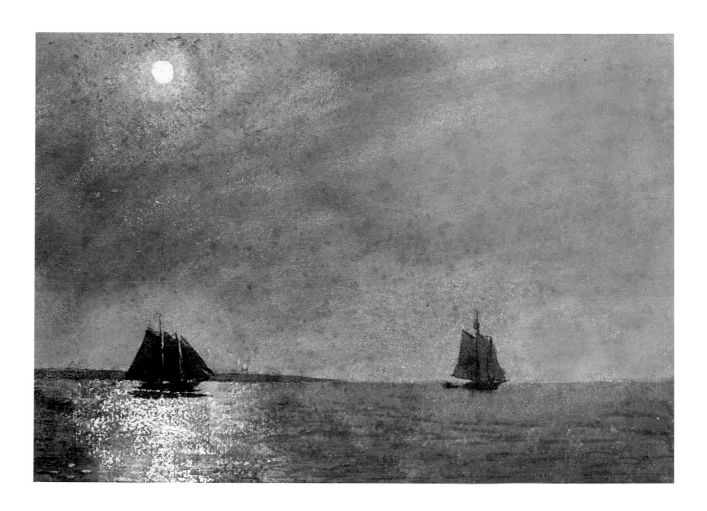

104. *Eastern Point Light,* 1880
watercolor on paper, 24.5 x 34 (9 ⅝ x 13 ⅛)
The Art Museum, Princeton University, Gift of Alastair B. Martin
Provenance: Charles S. Homer, Jr.; his wife, Mrs. Charles S. Homer, Jr.; her nephew, Charles L. Homer; (Hirschl & Adler Galleries, New York); Alastair B. Martin, March 1956.

104–106

In the summer of 1880 Homer returned to Gloucester, where he had first seriously taken up watercolor seven years earlier. His works from 1873 (see, for example, cats. 66–70) tended to focus on children and were, on the whole, among the most cheerful images of his entire career. That would not be the case in 1880. Secluding himself on Ten Pound Island in the middle of Gloucester harbor, Homer boarded in the home of the lighthouse keeper. According to one of his acquaintances, Homer "knew plenty of nice people, but he associated with two fishermen, and preferred their company."[1]

Why Homer chose to isolate himself in this way has been much speculated upon. There may have been professional reasons involved, for he seems to have found it more and more difficult to tolerate negative reviews of his work and was, according to one source, considering "relinquishing his studio...and continuing his work in private."[2] And personal reasons, perhaps a failed romance, may have been involved too, for there were reports that the formerly sociable Homer was becoming "grim and misanthropic."[3] But whatever the causes, Homer's work from the summer of 1880 speaks tellingly of personal and professional disruption. Whatever else he did or did not do during the summer of 1880, there is no doubt that Homer spent much of it working and experimenting, for he completed at least one hundred and twenty-five watercolors that are highly varied in style and technique.[4] Many are unresolved or unfinished, but some, such as these three examples, are among the most arrestingly expressive watercolors he ever painted.

When Homer's Gloucester watercolors went on view in Boston in December 1880, the critical response was mixed. The writer for the *Boston Sunday Herald*, although believing that "the artist seems to have water colors at his command to such a degree that he knows at just what point to leave his sketch," ended his review by quoting a spectator who had been heard "frankly to declare that he did not understand them."[5] The Bostonian Edward E. Hale observed in a letter to his sister: "Winslow Homer has some wildly impressionistic pictures at Doll's now....how queer they are and how unexpected, as startling as Japanese work, and some of them seem to lack common sense...."[6] But the most astonished reactions came in January 1881, when Homer sent a group of watercolors, including several

105. **Gloucester Sunset,** 1880
watercolor on paper, 24.1 x 34.3 (9 ½ x 13 ½)
Mr. and Mrs. George M. Kaufman
Provenance: Charles S. Homer, Jr.; his wife, Mrs.
Charles S. Homer, Jr., until 1928; (Macbeth Gallery,
New York, 1928); Mrs. H. S. Meeds, Jr., Wilmington,
Delaware; her daughter, Mrs. Pauline Wellford, 1968;
(Hirschl & Adler Galleries, New York, 1979).

Gloucester subjects to the American Water Color
Society in New York. The *New York Times* detect-
ed "a note of desperation in the bad drawing,
crude contrasts and ill-judged compositions in
some of his 23 pictures."[7] Of *Eastern Point Light*
one critic could only sputter: "Preposterous; a
child with an ink bottle could not have done
worse."[8]

As such comments indicate, many critics
were simply not prepared for the boldness of
Homer's 1880 Gloucester watercolors. A few
dismissed them as aberrations, but others, such
as Mariana Griswold Van Rensselaer, struggled
to understand these latest efforts by an artist
they greatly respected. As she said, "It is hard to
confess that one can take no pleasure in work
that one yet knows—and, indeed, *sees*—to be
powerful and original...."[9] She continued:

In spite of the fact that I gave intellectual assent, so to
speak, to the statement that Mr. Winslow Homer's
drawings were this year perhaps the strongest things
in the collection, they remained, as ever, repellant to
my eye, though not for want of much study and good
will. No effort could put me in sympathy with the
artist's outlook upon nature, though it was evident at
a glance that it was genuine and most decided. It was
artistic, too, in its own way, else it could never have
found expression in so consistent a form of artistic

speech. But the longer I looked the more it seemed to
me that Mr. Homer had travestied reality while
neglecting all ideal charm. I could not see with the
artist; I could not even see how the artist himself had
seen. Yet each picture clamored for attention, and
each left the same impression of intense conviction
on Mr. Homer's part. All were tremendously strong—
so strong, indeed, as I heard some one say, as to be
"artistic brutality." Perhaps the most striking thing in
the whole building was a large sunset sea-view [*Sunset
Fires*], with a black sail against a black sky streaked
with heavy crimson bars that was repeated in the
black and crimson water below. It was powerful, dia-
bolical, almost in its effect; I could imagine how Mr.
Homer might have seen something that to him looked
thus. But of some of the other drawings, notably of
one with a full moon shining over a black sea [*Eastern
Point Light*], I could not say so much.

For other critics there was, however, an
undeniable strength to the very qualities that so
troubled Van Rensselaer. *The Art Amateur* found
them "a set of pure impressions, many made by
imperfect light after sunset, and largely in the
nature of guesses, but invaluable for sincerity
and directness."[10] This same critic found in one
example (possibly *Gloucester Sunset*) virtue where
others saw only defect, particularly in its "quick-
ly moving water, sails, and fiery sky: the whole

106. *Sunset Fires,* 1880
watercolor on paper, 24.8 x 34.6 (9¾ x 13⅝)
Westmoreland Museum of Art, Greensburg, Pennsylvania, Gift of William A. Coulter Fund, 64.36
Provenance: (Macbeth Gallery, New York); private collection, Boston; (Gropper Gallery, West Somerville, Massachusetts); (Kennedy Galleries, New York); Dexter Davis, Englewood, New Jersey; (Hirschl & Adler Galleries, New York).

breadth of the running tide is interlaced and lashed with snaky lines of blackness alternating with strong color, conveying in marvelous degree the feeling of luminous moving water tortured with the whips of advancing night."

In 1883 Van Rensselaer, having seen Homer's English watercolors, and having been, as she admitted, "again surprised," reassessed the 1880 Gloucester works:

Two or three years ago, Mr. Homer must have astonished, I think, many who, knowing his work so well, thought they had gauged his power and understood its preferences and its range; for he then exhibited a series of water-colors conceived in an entirely novel vein. No one could have guessed that he might attempt such things. Yet the moment they were seen no one could doubt whose hand had been at work,—so strong were they, so entirely fresh and free and native.... They were chiefly stormy sunset views—glowing, broadly indicated, strongly marked memoranda, done with deep reds and blacks.... He had boldly omitted everything that could not serve his purpose,—which was to show the demoniac splendor of stormy sunset skies and waters,—and then, unsatisfied by the brilliant hues of nature, had keyed them to deeper force, made them doubly powerful, the reds stronger and the blacks blacker,—insisting upon and emphasizing a theme which another artist would have already

thought too pronounced and emphatic for artistic use. That he could do this and keep the balance of his work is a patent proof of his artistic power."

NOTES

1. Joseph E. Baker, quoted in Downes 1911, 18.

2. "Glimpses of Studios and Galleries," *Andrews' American Queen,* 20 March 1880.

3. "The American Water Color Society," *New York Sun,* 23 January 1881.

4. "Fine Arts," *New York Post,* 4 November 1880.

5. "Fine Arts," *Boston Sunday Herald,* 12 December 1880.

6. Letter to "Margaret," Roxbury, Massachusetts, 2 December 1880 (Archives of American Art).

7. "The Water Color Society," *New York Times,* 6 February 1881.

8. "Rough Notes on the Exhibition of the American Water Cooler [sic] Society for 1881," *Andrews' American Queen,* 12 February 1881, 110.

9. "The Water-Color Exhibition, New York," *The American Architect and Building News,* 19 March 1881, 135.

10. "Exhibition of the American Water-Color Society," *The Art Amateur* 4 (February 1881), 48.

11. "An American Artist in England," *The Century Magazine* 28 (November 1883), 15.

107. ***The Houses of Parliament,*** 1881
watercolor on paper, 32.4 x 50.2 (12 ¼ x 19 ¾)
Hirshhorn Museum and Sculpture Garden, Smith-
sonian Institution, Washington, Gift of Joseph H.
Hirshhorn, 1966
Provenance: Charles S. Homer, Jr.; his wife, Mrs.
Charles S. Homer, Jr.; Charles L. Homer; Mrs.
Arthur P. Homer, until 1956; (Babcock Galleries,
New York, 1956–1957); Joseph H. Hirshhorn,
1957–1966.
Boston and New York only

107

Homer arrived in Liverpool from the United
States in late March and, as far as we know, trav-
eled immediately on to London. Little is known
of what he may have done and seen while in the
city, although this watercolor at least tells us he
saw one of its most famous views, that across the
Thames over Westminster Bridge toward the
Houses of Parliament.[1] As Cooper has noted,
the technique is "subtle and refined," with affin-
ities to watercolors from the summer of 1880
such as *Eastern Point Light* (cat. 104).[2] This pic-
ture was among those shown early in 1882 at J.
Eastman Chase's gallery in Boston, where it was
noticed by a reviewer for the *New York Times:*

A curiously interesting water-color is a view of Lon-
don [sic] Bridge, the Thames at its widest, and the
Westminster building beyond. The moon, or else it is
the sun made vapor-like by a dense London fog, stands
about the towers. A boat with two rowers in the fore-
ground has been put in with the happiest effect; it
makes evident a rapid movement of the water. The
sepulchral gray of this water-color is not conducive to
its popularity, but it has all Mr. Homer's originality.[3]

Given the lack of knowledge about Homer's
activities in London, it can only be speculated
whether or not this watercolor might reflect the
influence of another artist. However, there is in
the choice of subject and, even more, in the
beautifully modulated blues and grays and over-
all tonal unity, more than a hint of the work of
James McNeill Whistler. That Homer might
have been curious about that famous American
expatriate, who was so strongly identified with
London and who was almost his exact contem-
porary (Whistler was two years older), hardly
seems unreasonable.

NOTES

1. On the general subject of artists in London, see Mal-
colm Warner, *The Image of London: Views by Travellers and
Emigrés, 1550–1920* [exh. cat., Barbican Art Gallery]
(London, 1987).

2. Cooper 1986a, 80–82.

3. "Art Notes," *New York Times,* 20 February 1882.

108–111

The days of the women who lived in North Sea fishing villages such as Cullercoats were filled with a variety of strenuous tasks. In addition to their domestic duties caring for fathers, children, and siblings, the women also gathered bait (usually mussels found in rocky areas near shore), repaired nets, provisioned fishing boats, helped haul and clean fish, and hawked the catch in the streets of their own town, or in villages and cities further inland. As one observer noted in 1864 after watching the women of Filey (near Scarborough): "They work harder than the men, ashore. Poor things! But then the men are almost always afloat, you see. They are big strong lasses, with hands and arms 'very large'...."[1]

During his time in Cullercoats Homer documented virtually every activity that occupied the time of the fisherwomen; he and his sketchbook must have become a familiar presence wherever the women went—along the breakwater, on the beach, on top of the cliffs, and in the streets and back alleys. In the watercolors he executed while in the village he always paid careful attention to details of their dress and to the specific nature of their activities. When a selection of these first English watercolors went on view in Boston in February 1882, reviewers responded positively to his portrayal of the women. "They deal with the humble life and vocation of the fisherwoman, a class whose picturesque costumes and sturdy characteristics afford an attractive theme," observed the *Boston Advertiser.*[2] "Mr. Homer seems to have observed the fish-wives of the little seaside town unusually closely," wrote the critic for the *Transcript*; "his women are women all over in the way they stand, sit, hold their hands, use their back and shoulders in carrying weights, such as baskets of fish and the like."[3]

Both *Summer Cloud* and *Fisherman's Family* received favorable attention from critics. In the former, observed a writer for the *Boston Herald*, "The feeling of a windy day is admirably described....The sky is dark with heavy clouds, but under the lee of a large boat on the sand two girls have found a safe retreat, where they are impervious to ordinary weather severity."[4] Of *Fisherman's Family* another critic observed: "Two fisher maidens sitting on the rocks and looking out to sea, with a storm showing in sky and water, have excellent sentiment; they are dramatic in their way."[5] But this same writer also faulted "the smoke of a distant steamer," which he felt had "too much edge and liquidity."

These works from Homer's first months at Cullercoats were painted with a certain informality, and this too was noticed by critics in America.

108. *Summer Cloud,* 1881
watercolor on paper, 34.3 x 49.5 (13½ x 19½)
Mr. and Mrs. A. Alfred Taubman
Provenance: granddaughter of the original owner, by descent; (Sotheby's, New York, 25 May 1988, no 74).
Washington and New York only

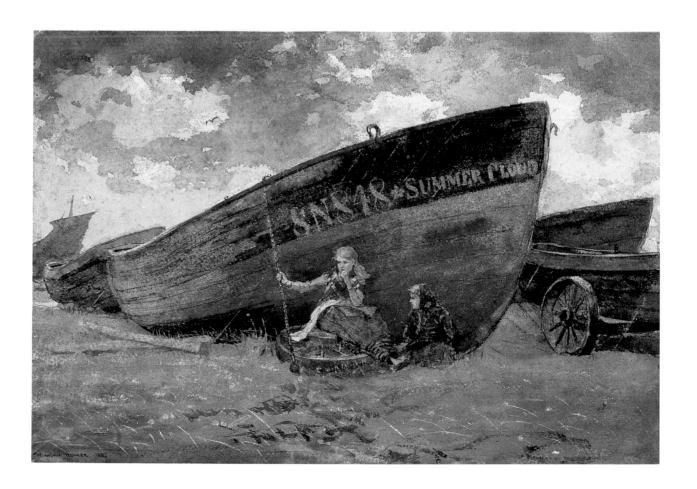

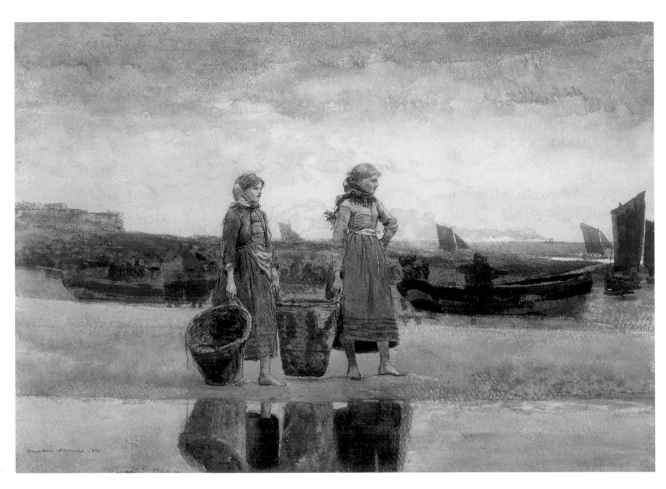

cat. 109

109. ***Two Girls at the Beach, Tynemouth***, 1881
watercolor on paper, 35.2 x 50.2 (13 ⅞ x 19 ¼)
Mrs. Ivor Massey
Provenance: (Doll & Richards, Boston); John S. Ames, North Easton, Massachusetts. (Wildenstein & Co., New York); private collection, 1972.

110. ***Beach Scene, Cullercoats***, 1881
watercolor on paper, 29.2 x 49.5 (11 ½ x 19 ½)
Sterling and Francine Clark Art Institute, Williams-town, Massachusetts
Provenance: (M. Knoedler & Co., New York); Robert Sterling Clark, 1924.
Washington only

111. ***Fisherman's Family [The Lookout]***, 1881
watercolor over pencil on paper, 34.3 x 49.2
(13 ½ x 19 ⅛)
Museum of Fine Arts, Boston, Bequest of John T. Spaulding
Provenance: Charles S. Homer, Jr.; (M. Knoedler & Co., New York); Thomas L. Bennett, New York, 1920; (M. Knoedler & Co., New York); John T. Spaulding.

"We do not believe," said one, "he has ever shown us any works so spontaneous in appearance and delightful in effect as these."[6] For another they showed an admirable "blending of vitality, vigor, and enthusiastic feeling," but were also slightly "too broad and general for the most thorough commendation...."[7] Indeed, although works such as these did not serve as actual studies for Homer—that purpose was served by the many black and white drawings (see, for example, cats. 118–121) he also did in Cullercoats—they are in comparison to larger and more consciously composed and artistically conceived watercolors, such as *Four Fisherwives* (cat. 123), undeniably more spontaneous, less idealized, and ultimately more accurately illustrative of the day-to-day lives of their subjects.

NOTES

1. Arthur Mundy, quoted in Michael Hiley, *Victorian Working Women: Portraits from Life* (London, 1979), 103.

2. "The Fine Arts; Winslow Homer's Water-Colors," *Boston Advertiser*, 4 February 1882.

3. "The Fine Arts," *Boston Daily Evening Transcript*, 9 February 1882.

4. "The Fine Arts," *Boston Herald*, 5 February 1882.

5. "Art Notes," *New York Times*, 2 February 1882.

6. *Boston Advertiser*, 4 February 1882.

7. *Boston Herald*, 5 February 1882.

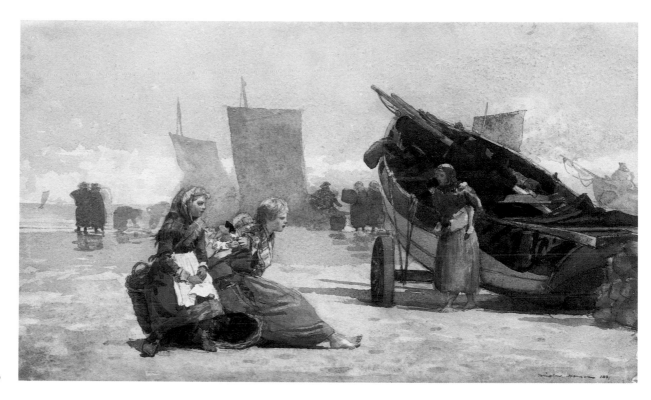

cat. 110

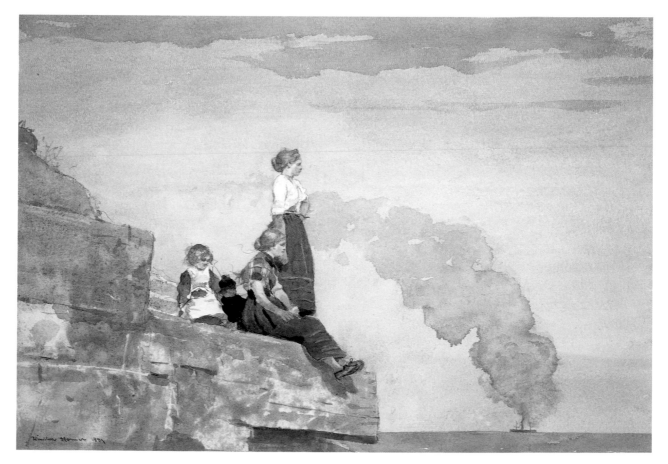

cat. 111

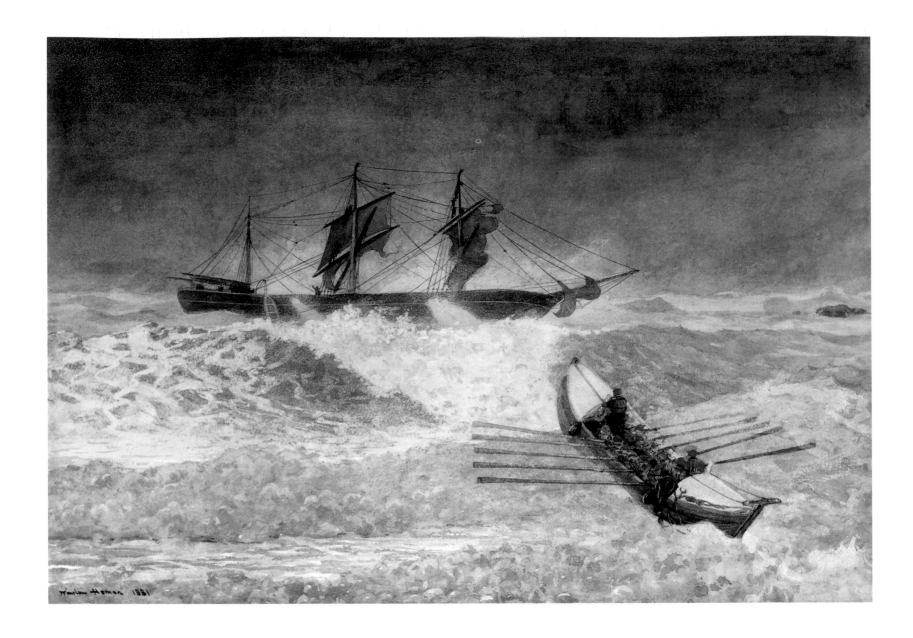

112. *Wreck of the Iron Crown*, 1881
watercolor on paper, 51.4 x 74.6 (20¼ x 29⅜)
Collection of Carleton Mitchell, on extended loan to
The Baltimore Museum of Art
Provenance: (J. Eastman Chase, Boston, 1882); Edward
W. Hooper, Boston; his daughter, Mabel Hooper La
Farge, probably by inheritance; (Ivan Podgowski);
Carleton Mitchell, 1944.

112–116

In the early morning hours of Friday, 21 October 1881, just a few months after Homer settled in Cullercoats, and following a week of heavy storms on the North Sea, the 1,000-ton barque *Iron Crown* was driven aground while trying to make harbor at Tynemouth. According to a contemporary newspaper account, the vessel drifted free and the crew managed to anchor her in deeper water.[1] A rocket with a line was fired by the Tynemouth Volunteer Life Brigade from one of the Tynemouth piers and a breeches buoy was connected, allowing the rescue of five crewmen. The most dramatic moments of the incident, however, occurred with the launch of the Tynemouth lifeboat, the *Charles Dibdin.*[2] According to contemporary accounts, it was "a scene of great excitement and perseverance," for the waves kept pushing the boat "broadside on the sand," and only after "25 to 30 men struggled there for

upwards of an hour" was the boat finally able to put to sea.[3] Fourteen additional crewmen and the captain's wife were rescued by the lifeboat, but around 11:00 A.M., when it was thought all were safe, another man, who had been presumed lost overboard, was spotted on the deck attempting to launch one of the *Iron Crown*'s boats. It was thus necessary to send the *Charles Dibdin* out again, and just as it was being launched, "…a little cab turned up with an old Cullercoats fisherman…[and] out stepped a dapper medium-sized man with a watercolour sketching block and sat down on the ways. He made a powerful drawing with some charcoal and some pastel."[4] This, of course, was Homer. Like others who came to see the spectacle, he must have heard news of the wreck in Cullercoats.[5]

If Homer's early career had prepared him well in one particular way, it was in the ability to record the salient details of an event in sketches made quickly on the spot. Among the four draw-

113. ***Fishermen in Oilskins, Cullercoats, England,***
1881
pencil on paper, 30.3 x 32 (11⅞ x 12⁹⁄₁₆)
Cooper-Hewitt, National Design Museum, Smithsonian Institution, Gift of Charles Savage Homer, Jr.
Provenance: Estate of the artist; Charles S. Homer, Jr.;
gift to the Cooper Union Museum for the Arts of
Decoration, 1912.
Washington and New York only

114. ***Men and Women Looking Out to Sea,***
Cullercoats, England, 1881
pencil on paper, 16.6 x 14.1 (6⅞ x 5⁹⁄₁₆)
Cooper-Hewitt, National Design Museum, Smithsonian Institution, Gift of Charles Savage Homer, Jr.
Provenance: Estate of the artist; Charles S. Homer, Jr.;
gift to the Cooper Union Museum for the Arts of
Decoration, 1912.
Washington and New York only

ings closely related to *Wreck of the Iron Crown,* cat. 115, with its inscription and date and rapid handling, seems most likely to have been made at the scene. It shows a view from a bluff high above the water, with figures standing beside a building (the Tynemouth Volunteer Life Brigade House) looking toward the lifeboat and the *Iron Crown.* This accords with Homer's account of the event in a letter sent to the Boston dealer J. East-

man Chase in February 1882: "I sent yesterday by mail a watercolor of a wreck—'The Iron Crown' which I saw at Tynemouth Oct. 28th. It was taken from a high bluff & that makes the horizon high."[6] Two other drawings (cats. 113-114), which focus on the figures by the wall, may have been done on the spot, but might also have been done from recollection. The careful study of the lifeboat cresting the waves (cat. 116), given its large size and comparatively unspontaneous handling, was almost certainly done in the studio in preparation for the final watercolor.

In the finished watercolor Homer chose to eliminate all traces of land and the watching figures, concentrating instead on the two vessels and the wild sea that separates them. The reason for the lifeboat's mission is made obvious by the tiny figure waving from the deck of the *Iron Crown* and by the unsuccessfully launched boat dangling uselessly from a davit near the stern. Homer thus chose to focus on the particular moment he had witnessed himself, and to remove all elements that were extraneous to the actual rescue. Of the drawings possibly done on site, then, only the right-hand third of cat. 115 was of direct use in composing the final image, and the relatively small size of the vessels there may have led Homer to make the larger study of the lifeboat (cat. 116). In that drawing he also worked out the slightly altered angle from which the boat is seen and drew the figures of the men in

115. *Study for "Wreck of the Iron Crown,"* 1881
charcoal on paper, 21.6 x 31.8 (8 ½ x 12 ½)
Collection of Carleton Mitchell, on extended loan to
The Baltimore Museum of Art
Provenance: (Doll & Richards, Boston); Edward W.
Hooper, Boston, 1884; his daughter, Mary Hooper
Warner, Boston; her sister, Mabel Hooper La Farge;
(Ivan Podgowski); Carleton Mitchell, 1944.

116. **The Life Boat** (study for *Wreck of the Iron
Crown*), 1881
charcoal, ink, gouache, and chalk on paper, 35.4 x
48.4 (13 ⁵/₁₆ x 19 ¹/₁₆)
Cooper-Hewitt, National Design Museum, Smith-
sonian Institution, Gift of Charles Savage Homer, Jr.
Provenance: Estate of the artist; Charles S. Homer, Jr.;
gift to the Cooper Union Museum for the Arts of
Decoration, 1912.
Washington and New York only

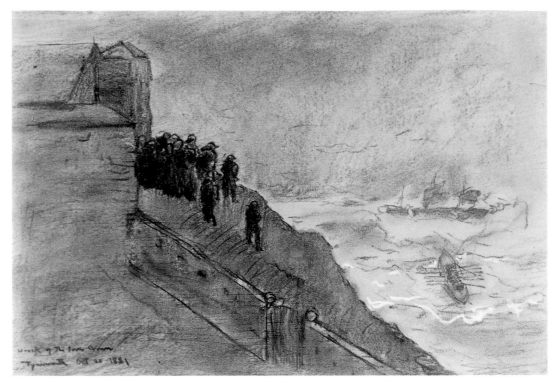

cat. 115

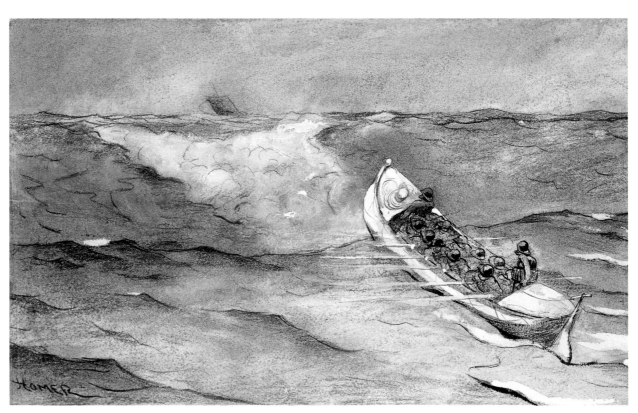

cat. 116

206

fig. 156. The *Iron Crown* wrecked off Tynemouth, England, October 1881. Courtesy Tynemouth Volunteer Life Brigade.

fig. 157. The Royal National Lifeboat Institution lifeboat *Charles Dibdin* going out to the *Iron Crown*, October 1881. Courtesy Tynemouth Volunteer Life Brigade

greater detail. For the *Iron Crown* itself it has been suggested that Homer consulted a contemporary photograph (fig. 156), which is certainly possible.[7] However, if one carefully studies the tiny form of the ship as it appears in cat. 115 in comparison to the watercolor, it is obvious that in every essential detail—the disposition of the sails, the lifeboat hanging from the davit, and even the vaguely suggested form of the waving crewman—the study, and not the photograph, served as Homer's guide.

As Cooper and others have noted, the large size, complex evolution from preparatory studies, and elaborate execution (in which Homer employed a variety of techniques, including masking, scraping, soaking, sponging, and multiple washes) of *Wreck of the Iron Crown* clearly identify it as an ambitious studio production.[8] It is, in fact, very much in the mold of English "exhibition" watercolors (see, for example, fig. 144), which were intended to rival oil paintings in visual impact. That Homer thought highly of his first effort of this type is confirmed by his decision to exhibit *Wreck of the Iron Crown* soon after its completion in the window of a Newcastle art dealer and then, in February 1882, to send it (priced at $250) to Chase in Boston. However, he also had reservations, being aware that his readjustment of elements he had actually seen for a more dramatically composed image may have in some way compromised the final result. In particular, he was concerned about the angle of the view and the relationship of the lifeboat (repositioned from the way it appeared in cat. 115) to the *Iron Crown*. As he wrote rather off-handedly to Chase: "If you like you may cut off the life boat."[9] He concluded that he was glad to have found a way to send watercolors to Chase (affordably, we may assume, because he used "book post"), but quickly qualified his words by adding, "should you wish any more."

We have no record of how critics responded to the watercolor, but in 1884 when one of the sketches (cat. 115) was shown with a group of other works in black and white, it was positively received:

Much, too, is suggested by the little and apparently careless (none of the studies are really careless) drawing of the "Wreck of the Iron Crown," off Tynemouth—dramatic and full of intense human interest. The compact group of men at the head of a flight of steps watch with breathless anxiety the course of the lifeboat as it flies to the aid of the sinking vessel which is dimly seen in the offing. As in most of these sketches, all is told in a few strokes of the crayon, with a directness and simplicity that is truly admirable.[10]

Although *Wreck of the Iron Crown* was not Homer's first essay on the theme of marine

disaster—he had already done, for example, the wood engraving "The Wreck of the 'Atlantic'—Cast up by the Sea" for *Harper's Weekly* in 1873, and the watercolor *A Wreck Near Gloucester of 1880* (Museum of Art, Carnegie Institute, Pittsburgh)—it was unquestionably the first in which he attempted to capture the drama of gale-tossed waves and intrepid human efforts to overcome the forces of the sea. In that way it stands squarely at the beginning of the sequence of works that led to the great marine epics of the 1880s such as *The Life Line* and *The Fog Warning* (cats. 132, 134) and ultimately to his final considerations of the theme's darkest implications in *The Signal of Distress* and *The Gulf Stream* (cats. 155, 231).

NOTES

1. Information about the *Iron Crown* kindly provided by C. J. Lambert, honorary assistant secretary, Tynemouth Volunteer Life Brigade, in a letter of 23 December 1994. For additional information, see Hendricks 1979, 151, with an extensive quotation from an article on the disaster in the *South Shields Daily Standard*. According to Lambert, the *Iron Crown* was "one of the strongest ships built at the time on the River Tyne…an iron built full rigged barque owned by Messrs. Shallcross and Higham of Liverpool."

2. See McConkey, "…a dapper medium-sized man with a watercolour sketching block…," in Knipe, Boon, et al. 1988, 32, where the spelling is incorrectly given as "Dibden." Hendricks 1979, 151, has it correctly as "Dibdin."

3. Hendricks 1979, 151, quoting the *South Shields Daily Standard*.

4. George Horton, "Artist with a Craze for Clocks," *Sunday Sun*, 5 March 1939; reprinted in Knipe, Boon, et al., 1988, 110. According to Lambert, the *Iron Crown* shifted position during the night, and she is clearly lying in different directions in the two views shown in figs. 156 and 157; Homer may have created a composite of the various events.

5. According to Lambert and the account cited in Hendricks 1979, 151, the ship completely broke up the following night. A collection of artifacts from the wreck are owned and displayed by the Tynemouth Volunteer Life Brigade in the Watch House. For a list of "Casualties at the Mouth of the Tyne" from 1865 through 1982, see *Tynemouth Volunteer Life Brigade*, undated pamphlet, 6–8.

6. Archives of American Art.

7. Knipe, Boon, et al. 1988, 8.

8. Cooper 1986a, 102.

9. Undated letter, February 1882 (Archives of American Art).

10. "The Fine Arts. Mr. Homer's Black and Whites," *Boston Advertiser*, 29 November 1884.

117. *Perils of the Sea,* 1881
watercolor on paper, 37.1 x 53.3 (14⅝ x 21)
Sterling and Francine Clark Art Institute,
Williamstown, Massachusetts
Provenance: Thomas B. Clarke, New York [acquired
from Homer prior to 1891]; (American Art Associa-
tion, New York, 16 February 1899, no. 269); Alexan-
der C. Humphreys, Hoboken, New Jersey; (American
Art Association, New York, 15 February 1917, no.
115); (M. Knoedler & Co., New York); O. H. Payne,
New York, 1917; Emma C. Larson; Francis M. Weld,
New York, 1927; (M. Knoedler & Co., New York);
Robert Sterling Clark, 1950.
Washington only

117–122

The harbor at Cullercoats was the center of daily
life for the men and women who made their
livelihoods from fishing the treacherous waters
of the North Sea, and it was also the center for
Homer's artistic endeavors. In many of the works
he executed in England the setting was in the
immediate vicinity of the harbor, with the Life
Brigade House (see fig. 127), breakwater, or broad
sandy beach often serving as easily identifiable
landmarks. There was considerable activity in
these places even on normal occasions, for it
was here that the fishing boats were loaded
and launched, and here that they returned and
unloaded the catch. But during times of bad
weather the area around the Life Brigade House,
which commanded an excellent view out to sea,
became the spot where virtually everyone gath-
ered to await anxiously the return of any boats
that were not already safely in the harbor.[1]

During the time Homer spent in Cullercoats,
which included the stormy fall and winter
months of 1881–1882, he must have witnessed
many such stressful occasions. Among his sur-

viving sketches are several quickly executed
examples (fig. 158) showing women and men in
the vicinity of the Life Brigade House looking
out to sea. From these, in turn, came a number
of more carefully considered drawings (cats. 118
–121) that suggest Homer was working with the
idea of creating an elaborate finished composi-
tion on the theme. Although these works vary in
the arrangement and disposition of the figures,
they all center on the motif of men and women
(sometimes with children) looking out to sea.
Sometimes, as in *The Last Boat In* and *Two
Women and a Child at a Rail,* the object of the
figures' gaze is actually shown, but equally often
it is not. These various studies culminated in two
closely related works: the watercolor *Perils of the
Sea* and the oil *The Coming Away of the Gale* (fig.
149 and cat. 189).

Perils of the Sea was vividly described in the
1891 catalogue of the collection of Thomas B.
Clarke, Homer's important early patron: "The
entire community of a coast settlement has
turned out to watch a wreck off shore. On a pier
in the foreground two women stand in attitudes
of intense and anguished attention. Below the

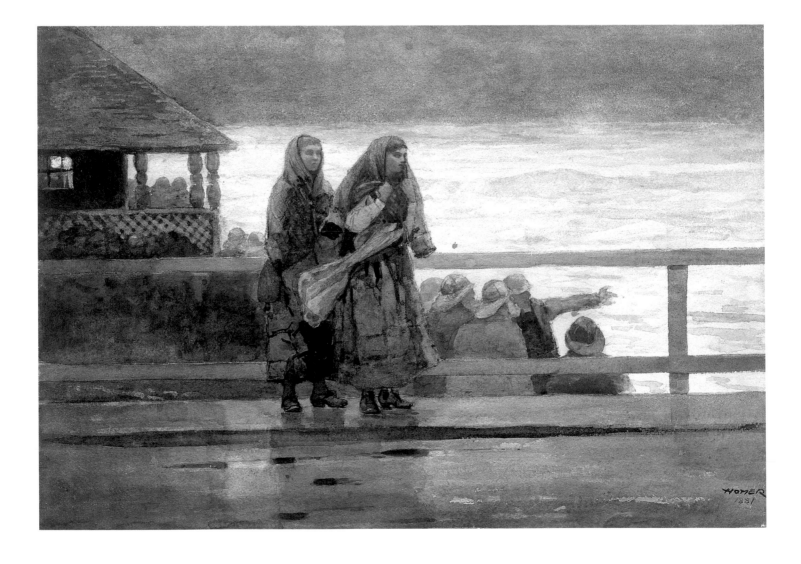

118. ***The Last Boat In,*** c. 1881
charcoal and chalk on paper, 21.4 x 31 (8 ⁷⁄₁₆ x 12 ³⁄₁₆)
Addison Gallery of American Art, Phillips Academy,
Andover, Massachusetts
Provenance: John Dorr, Boston; his daughters; (Doll &
Richards, Boston, 1933–1934); (Macbeth Gallery,
New York, 1934).
Washington and New York only

119. ***Two Women and a Child at a Rail, Overlooking
the Beach,*** 1881
charcoal on paper, 21.3 x 29.7 (8 ³⁄₈ x 11 ¹¹⁄₁₆)
Cooper-Hewitt, National Design Museum, Smith-
sonian Institution, Gift of Charles Savage Homer, Jr.
Provenance: Estate of the artist; Charles S. Homer, Jr.;
gift to Cooper Union Museum for the Arts of Deco-
ration, 1912.
Washington and New York only

cat. 118

fig. 158. *Women Watching the Launching of Dories, Cullercoats,
England,* 1881. Pen and brown ink. Cooper-Hewitt, National
Design Museum, Smithsonian Institution, Gift of Charles
Savage Homer, Jr. (1912–12–16). Art Resource, New York

cat. 119

pier, on the beach, many figures crowd, with all
eyes bent upon the raging of the wintry surf."[2]
 This description overdramatizes the situa-
tion by suggesting that a shipwreck is, in fact, a
certainty, whereas Homer left matters much
more in doubt and thus heightened the tension.
Certainly the possibility that a loved one or

friend will be lost in the storm was very strong,
given the extremely perilous nature of fishing
these waters from open boats. An English trav-
eler who visited the North Sea fishing villages
in 1865 noted that two of the three married
women he talked to on a single day had lost
their husbands to drowning.[3] And one of the

209

120. *A Dark Hour—Tynemouth*, c. 1881–1882
charcoal on paper, 21 x 30.5 (8 ¼ x 12)
Sheldon Memorial Art Gallery, University of
Nebraska-Lincoln, Gift of Olga N. Sheldon,
1973.U–3292
Provenance: Thomas Wigglesworth, Boston, 1884;
Mrs. Stephen Van R. Crosby, Manchester, Massachu-
setts; Norman B. Woolworth, New York; (M.
Knoedler & Co., New York); Mrs. Olga N. Sheldon,
Lexington, Nebraska, 1963–1973.
Washington and New York only

121. *House at a Railing with Beached Dories, Culler-
coats, England,* 1881
pen and ink on paper, 10.4 x 17.9 (4 ³/₁₆ x 7)
Cooper-Hewitt, National Design Museum, Smith-
sonian Institution, Gift of Charles Savage Homer, Jr.
Provenance: Estate of the artist; Charles S. Homer, Jr.;
gift to Cooper Union Museum for the Arts of Deco-
ration, 1912.
Washington only

most dramatic moments in Charles Reade's
Christie Johnstone, a novel about a fishing com-
munity very much like Cullercoats, occurs when
the people realize one of their town's boats is lost:
"After the first stupor, the people in the New
Town collected into knots, and lamented their
hazardous calling, and feared for the lives of
those that had just put to sea in this fatal gale
for the rescue…and the older ones failed not to
match this present sorrow with others within
their recollection."[4]

Still, if the subject Homer chose was one that
was not an uncommon event in Cullercoats, the
efforts he expended in creating his final images
of it suggest that he wished to move beyond mere
reportage. His intentions were clearly to portray
the ever present dangers of the North Sea fish-
ing communities in a way that would give them
a gravity and timelessness that transcended the
specifics of the time and place that inspired him.
That Homer felt he had done well in this regard
is made evident in his decision in 1888 to rework

122. *Perils of the Sea,* 1888
etching, 41 x 53 (16⅛ x 20⅞)
Sterling and Francine Clark Art Institute, Williams-
town, Massachusetts
Provenance: M. A. McDonald, New York; Robert Ster-
ling Clark, 1941.
Washington and New York only

Perils of the Sea (along with two other Cullercoats-
inspired works, *Mending the Nets,* cat. 124, and *A
Voice from the Cliffs,* see fig. 142) as an etching
(cat. 122). In the print Homer simplified the com-
position by removing the background railing; he
also enlarged the crowd of fishermen in the back-
ground and deleted the pointing gesture of one
of them.

NOTES

1. The Life Brigade House was built in 1879 on the site
of an open stone structure with wooden benches "where
villagers congregated to observe events at sea, shelter from
the wind, and gossip" (Knipe, Boon, et al. 1988, 103).

2. *Catalogue of the Thomas B. Clarke Collection of American
Pictures* [exh. cat., Pennsylvania Academy of the Fine Arts]
(Philadelphia, 1891), 61.

3. See Michael Hiley, *Victorian Working Women: Portraits
from Life* (London, 1979), 104.

4. Charles Reade, *Christie Johnstone* (London, 1882), 181.

123. *Four Fisherwives*, 1881
watercolor on paper, 45.7 x 72.4 (18 x 28¼)
The Ruth Chandler Williamson Gallery Program at
Scripps College
Provenance: (M. Knoedler & Co., New York); Timothy
S. Williams, Huntington, New York, 1916; his niece,
Mrs. A. Brooks Harlow, (Milch Gallery and Macbeth
Gallery, 1937); Edward Clinton Young, Scarsdale,
New York, 1937.

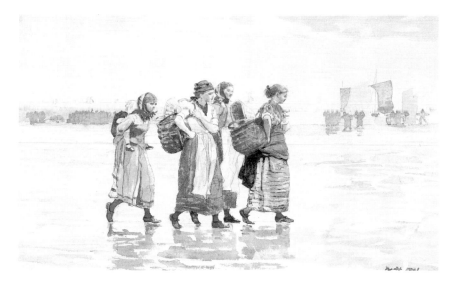

fig. 159. *Four Fisher Girls on the Beach at
Tynemouth, England*, 1881. Watercolor. Collection
of Mr. and Mrs. Paul Mellon, Upperville, Virginia

123–124

Among the watercolors Homer executed during his first year in Cullercoats were several sheets, including these two and *Wreck of the Iron Crown* (cat. 112), that were considerably larger than those he customarily used (see, for example, cats. 108–111). They were also the result of a larger artistic process, for Homer composed them in his studio by consulting his less formal watercolors and drawings as studies. His aim was to make water-

colors that achieved some of the aesthetic power of oil paintings in their large size, saturated colors, carefully arranged compositions, and modulated effects of light and shade. In these ways Homer was influenced not by American concepts of the possibilities of the medium, but by contemporary British artists and what were known as "exhibition watercolors."

When these two pictures were shown in America in 1882, critics immediately noticed the change they represented in Homer's use of water-

124. *Mending the Nets*, 1882
watercolor and gouache over pencil on paper,
69.5 x 48.9 (27⅜ x 19¼)
National Gallery of Art, Washington, Bequest of Julia
B. Engel, 1984.58.3
Provenance: Charles W. Gould, by 1911. (Milch Galleries, New York); Julia B. Engel.

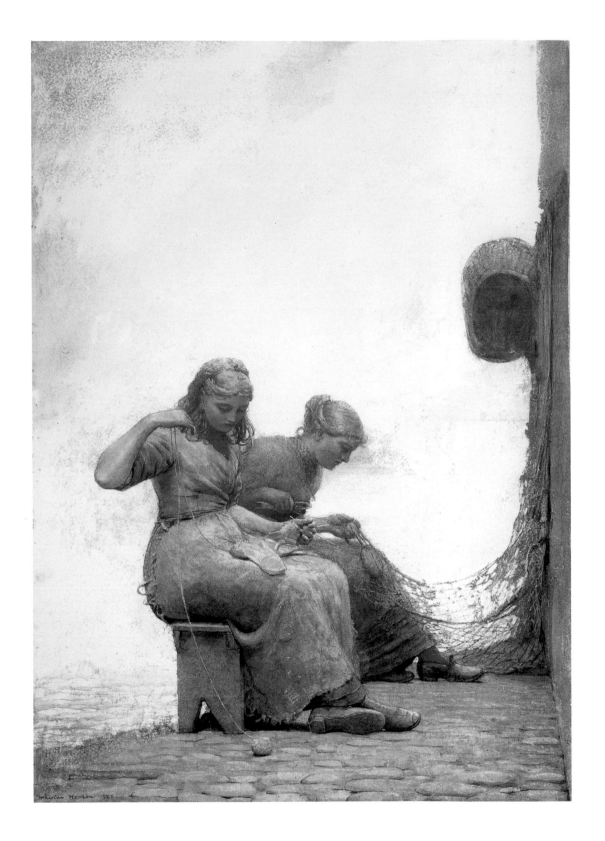

color. Mariana Griswold Van Rensselaer considered them "quite foreign" and "laboriously treated, highly and crudely yet conventionally colored, and neither individual nor attractive."[1] Another writer felt that "the leaden atmosphere of England has had a slightly depressing influence upon the artist," and that his coloring had now become "heavy and obscure."[2] Yet another observer, who noted that "the thoroughness of them approaches heaviness," was quite specific in identifying the influence behind these new watercolors: "They are English in method and style. One needs to read the signed name before believing that the maker of these British watercolors is the same who used to rouse the wrath or admiration of the critics by his quaint con-

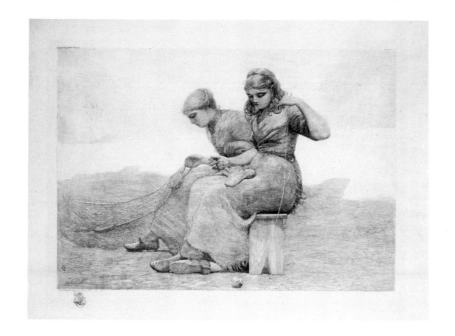

ceits, his bald oddities, his lovely transcripts of scenes that only he knew how to depict."[3] Others, however, were more charitable, sensing that there might be positive strengths in the artist's new style. *The Brooklyn Daily Eagle* noted that "Mr. Homer has recently got away to a great degree from a rather too impressionistic style he fell into a few seasons ago, and his paintings have improved very much in consequence."[4]

The figures in *Four Fisherwives* and *Mending the Nets* also suggest Homer's awareness of classical sculpture. The overlapping figures of the women in the former create a compact group in relatively shallow space, recalling relief sculptures such as the friezes of the Parthenon, examples of which were on view (the "Elgin Marbles") at the British Museum. The resemblance is even more striking in *Mending the Nets*, originally called *Far Away from Billingsgate*, which has been tellingly compared to an antique grave stele.[5] When that watercolor was first shown in 1882 the figures were "seated in a corner mending some fishnets [sic; one is knitting blue stockings] that hang from an opposite wall."[6] Homer subsequently revised the image on two occasions. For his 1888 etching *Mending the Tears* (fig. 160) he removed the walls and placed the women by the sea. Then, in 1891, when Homer again exhibited the watercolor, now titled *Mending the Nets*, he had scraped out the background entirely. Although this confused some observers ("It is hard to make out just what is meant by the background," wrote one), it served to silhouette the two figures starkly, emphasizing their strongly sculptural quality.[7] As one reviewer, who admired the knitting figure for its "combination of dignity and grace in the lines," correctly concluded: "The impression is conveyed that the group as

such, rather than the scene as a whole, has interested Mr. Homer...."[8] In 1893 Homer would make a precisely similar revision of an earlier work when he repainted *The Coming Away of the Gale* (see fig. 149) as *The Gale* (cat. 189), removing the detailed background and leaving only the monumental figure of the striding woman.

NOTES

1. "Water-colors in New York," *The American Architect and Building News* 11 (8 April 1882), 160.

2. "Fine Arts. The Water-Color Figure Painters," *New York Mail and Express*, 1 February 1882.

3. "Watercolor and Etching," *New York Times*, 28 January 1882.

4. "Water Colors," *Brooklyn Daily Eagle*, 16 March 1882. This writer was discussing "a broadly painted little example of Winslow Homer, entitled 'Fishing Fleet, Newcastle,'" which suggests it may have been the smaller version of the scene now in the collection of Mr. and Mrs. Paul Mellon (11 1/2 x 18 3/4 in.; see fig. 159). This smaller version was also apparently shown at Chase's Gallery in Boston in February; a reviewer for the *New York Times* ("Art Notes," 20 February 1882), in discussing that exhibition, called it "a light-colored first sketch of the view at the water-color exhibition (i.e., the American Water Color Society exhibition in New York) which shows four or five fisherwomen crossing the sands towards the boats."

5. See Cikovsky 1990a, 80–81, where the watercolor is compared to the *Grave Stele of the Hegeso* (c. 410–400 B.C., National Museum, Athens).

6. "Fine Arts," *New York Mail and Express*, 1 February 1882.

7. "Watercolors and Etchings at the Academy," unidentified newspaper clipping, Homer scrapbook, Bowdoin.

8. "Some Questions of Art. The Water-Color Exhibition," *New York Sun*, 15 February 1891.

125–128

125. _Returning Fishing Boats_, 1883
watercolor on paper, 40.3 x 62.9 (15⅞ x 24¼)
Harvard University Art Museums, Fogg Art Museum,
Anonymous Gift, 1939.233
Provenance: Horace D. Chapin.
Washington only

126. _An Afterglow_, 1883
watercolor over pencil on paper, 38.1 x 54.6
(15 x 21½)
Museum of Fine Arts, Boston, Bequest of William
P. Blake in memory of his mother, Mary M. J. Dehon
Blake
Provenance: (Doll & Richards, Boston); Thomas Wigg-
lesworth, Boston, December 1883; Henry S. Grew;
(Doll & Richards, Boston); William P. Blake, Boston,
February 1900.
Washington and New York only

127. _Fisherwives_, 1883
watercolor on paper, 45.7 x 74.9 (18 x 29½)
The Currier Gallery of Art, Manchester, New
Hampshire, Currier Funds, 1938.1
Provenance: Mr. and Mrs. Charles S. Homer; their
nephews, Arthur P. and Charles L. Homer, 1937;
(William Macbeth, New York).

Although Homer returned to New York from
Cullercoats in November 1882, his interest in
English subjects remained strong until at least
1884. Indeed, 1883 saw the creation of some of
his grandest watercolors and the major oil _The
Coming Away of the Gale_ (see fig. 149 and cat. 189).
In painting such works Homer could, of course,
turn to the many studies he had brought home
to refresh his memories of the look and feel of
life on the coast of the North Sea at Cullercoats.
But his intention was not merely to re-create
what he had already done in watercolors from
1881 to 1882 (see, for example, cats. 108–111,
123–124), but rather to reinterpret those famil-
iar subjects with a greater seriousness and a
heightened sense of artistic weight and power.
Works from 1883 such as these four are espe-
cially noticeable for their stronger and richer
colors, emphatic contrasts of light and dark, and
greater monumentality of form and gravity of
expression.

Many of those who saw works such as these
on view in New York and Boston in 1883 imme-
diately understood that Homer had introduced
a wholly new element into his art. "We have no
one but Mr. Homer who could do things so
powerful as these," observed the _New York World_;

"But Mr. Homer never did such things before."[1]
"First and foremost," wrote the critic for the
Boston Advertiser, "they have the quality of com-
position, a quality which is almost deliberately
ignored, very often even reviled and despised by
the artists of today."[2] And the writer for the
Boston Daily Evening Transcript concluded:

Mr. Homer has got beyond expending himself in mere
technique, though his technique is bold, original, and
powerful enough to form a merit and a study in itself.
He is now evidently bent upon expressing something,
and treats his art (as the generality of our younger

fig. 161. _Fishing off Scarborough_, 1882. Gouache and wash.
The Art Institute of Chicago, Mr. and Mrs. Martin A.
Ryerson Collection, 1933.1239

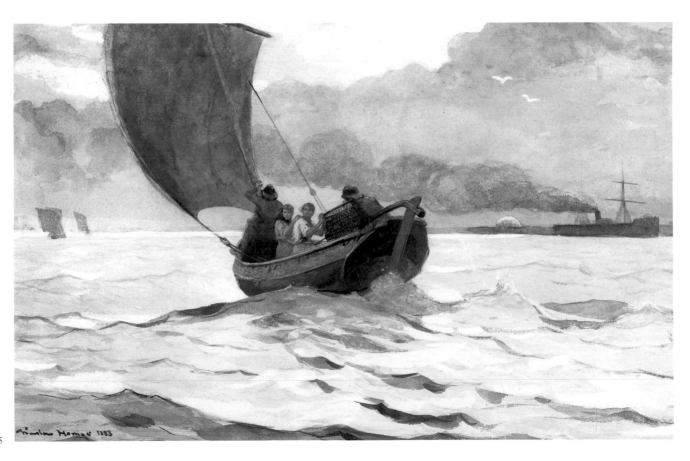

cat. 125

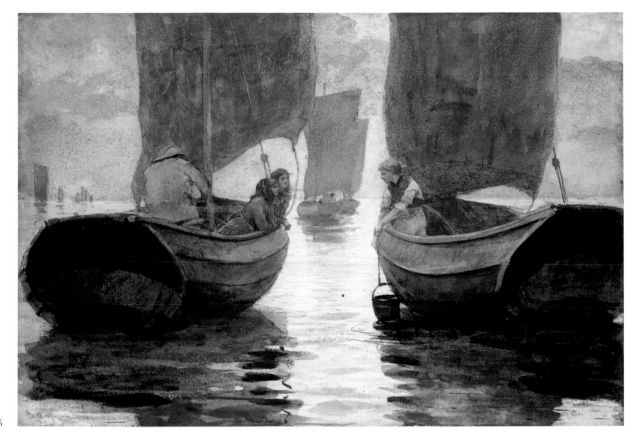

cat. 126

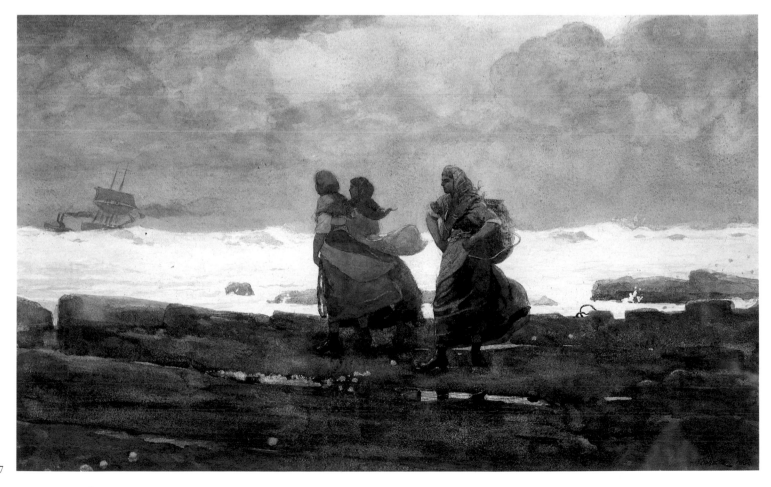

cat. 127

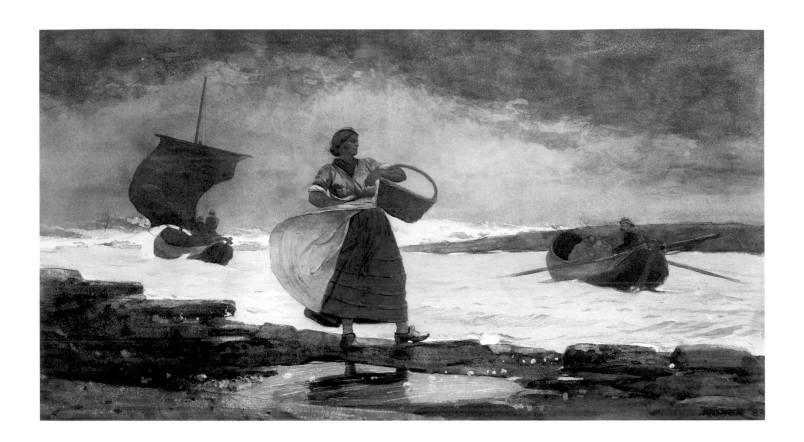

128. **Inside the Bar,** 1883
watercolor on paper, 39.1 x 72.4 (15 ⅜ x 28 ½)
The Metropolitan Museum of Art, Gift of Louise
Ryals Arkell, in memory of her husband, Bartlett
Arkell, 1954
Provenance: Bartlett Arkell.
New York only

fig. 162. *Windy Day, Cullercoats,* 1881. Chalk drawing with Chinese white. Portland Museum of Art, Portland, Maine, Bequest of Charles Shipman Payson, 1988.55.15

artists do not) as the mere medium for conveying something of social or human interest. Mr. Homer is both the historian and poet of the sea and sea-coast life....[3]

An Afterglow and *Returning Fishing Boats* feature the cobles that Homer had come to know well while in Cullercoats, but their mood is very different from earlier works that showed fishermen setting out to sea. *An Afterglow,* showing two cobles floating side by side on calm water, is memorable for the striking symmetry of its composition and its luminous color. One observer found in it "a richness and harmony of effect equal to what might have been produced with oils," while another praised it for capturing "one of the most admirable effects of light playing upon varied masses of color...that comes within the compass of watercolor or anything else."[4] *Returning Fishing Boats,* based on a drawing of 1882 (fig. 161), was also well received both for its "largeness and vigor of conception and expres-

sion" and for its "light and airiness…made still more apparent by the black smoke of a steamer in the distance."[5]

Fisherwives and *Inside the Bar* reprise the theme of women posed against the stormy ocean with vessels in the distance. Both are large and thoroughly worked like all of Homer's most ambitious studio watercolors of this period. *Inside the Bar* was the most extravagantly praised of all of the watercolors Homer showed in 1883 and, indeed, became something of a benchmark in his art. It was derived from a powerful 1881 drawing (fig. 162) and was called "the lion of watercolor exhibitions in New York."[6] Edward Strahan's comments were typical of the response to the watercolor when it first appeared:

It is a fisher's wife planted by a piece of angry water, watching for the eventful coming of the sail which carries her treasure; the storm wraps her coarse draperies about her with the closeness and crisp modelling of sculpture, and her attitude is a monument of fidelity or constancy. The spiteful foam of the inlet by which she stands is indicated with summary power, the landscape is altogether superb, the pose is a masterpiece, and the grand gravity of the picture shows how easily at need water-color can rise out of the reproach of frivolity.[7]

Observers were especially struck by the powerful figure of the woman, who seemed the very embodiment of resolute force. "This woman is not made of the stuff that is swept away," said *The American*; "She is transformed by the terrible beauty of the time and place; her stride is magnificent; she is part of the storm itself."[8] For *Harper's Weekly* this was someone that "the Greeks might have admired for commanding attitude, and Michael Angelo [sic] for the evidence that statuesqueness may have a soul."[9] As Van Rensselaer concluded: "the finest quality of all, one which he has never so revealed before, is a sort

of grandeur—of majesty in the landscape and the statuesque impression in the figure—that takes us into a high sphere of art."[10]

In these grand watercolors Homer had indeed reached a new phase in his art, one in which he asserted a greatly heightened awareness of the possibilities of design, composition, color, and light. But more than that, what most sets them apart is their tendency toward idealization, both of the men and women they depict and, although not so obviously, of nature itself. In them Homer had established an aesthetic stage upon which he could depict heroic figures engaged in dramatic action and, through them, convey serious and profound meaning. He had, as Van Rensselaer understood, set out to create works of "High Art," and from them would come *The Life Line* (cat. 132), Homer's pivotal oil of the following year, and the other great epics of the sea of the mid-1880s.

NOTES

1. [Mariana Griswold Van Rensselaer], "The Water-Color Exhibition," *New York World*, 27 January 1883.

2. "Pictures in New York. The Present Water-Color Exhibition," *Boston Advertiser*, 8 February 1883.

3. "Art Notes," *Boston Daily Evening Transcript*, 6 December 1883.

4. *Boston Daily Evening Transcript*, 6 December 1883.

5. "The Fine Arts. The Sixteenth Annual Water-Color Exhibition," *New York Evening Post*, 15 February 1883; *Boston Advertiser*, 8 February 1883.

6. "The Fine Arts. Mr. Homer's Black and Whites," *Boston Advertiser*, 29 November 1884.

7. "The Water-Color Society's Exhibition," *The Art Amateur* 8 (March 1883), 81.

8. "Sixteenth Annual Exhibition of the American Watercolor Society," *The American* 5 (17 February 1883), 299.

9. "The Water-Color Exhibition," *Harper's Weekly* 27 (3 February 1883), 71.

10. *New York World*, 27 January 1883.

129. ***Blyth Sands***, 1882
gouache and charcoal on paper, 43.2 x 65.1 (17 x 25⅝)
Amon Carter Museum, Fort Worth
Provenance: (Doll & Richards, Boston); J. Swett Cool-
idge, Boston; Mrs. George D. Howe, Boston; her
nephew, Philadelphia; Mr. and Mrs. William Follett,
Manchester, Massachusetts, about 1904; their son,
Enoch S. Follett, Manchester, Massachusetts, about
1956; (Hirschl & Adler Galleries, New York); Mr.
and Mrs. Dunbar W. Bostwick; (Christie's, New York,
3 December 1982, no. 57).

129–131

Homer was, of course, no stranger to working
in black and white, for his early career in illus-
tration had acquainted him well with both the
demands and possibilities of working without
color.[1] When he was in his sixties he was report-
ed to have told a friend: "I have never tried to
do anything but get the true relationship of val-
ues; that is, the values of dark and light and the
values of color."[2] Homer continued: "It is won-
derful how much depends upon the relationship
of black and white. Why, do you know, a black
and white, if properly balanced, suggests color.
The construction, the balancing of the parts is
everything."

Homer's use of drawings as part of his cre-
ative process varied considerably over the course
of his career, with his most consistent use of
them occurring in the 1860s, 1870s, and 1880s.[3]
From the 1890s onward he made far fewer, pre-
ferring to concentrate his efforts on watercolors
and oils. The kinds of drawings Homer made
also varied considerably. Many were quick, on-
the-spot sketches, some were studio studies exe-
cuted in preparation for watercolors or oils, and

fig. 163. *Flamborough Head, England*, 1882. Pencil drawing
with Chinese white. The Art Institute of Chicago, Mr. and
Mrs. Martin A. Ryerson Collection

some were finished works in their own right.
During his time in Cullercoats and in the months
immediately following his return to New York
Homer executed a number of examples of the
last-named type of drawings, and they stand
among his finest achievements in black and white.

Blyth Sands and *Flamborough Head* (fig. 163),
both dated 1882, were probably executed while
Homer was still in England. They are, in fact,

130. *A Little More Yarn,* 1884
charcoal and chalk on paper, 45.1 x 60 (17 ¾ x 23 ⅝)
The Fine Arts Museums of San Francisco, Gift of Mr.
and Mrs. John D. Rockefeller 3d
Provenance: (Doll & Richards, Boston, 1884); Robert
W. Hooper, Boston, from 1884; Louisa Chapin Hoop-
er Thoron, Boston, until 1977, by descent; (Hirschl
& Alder Galleries, New York, 1977–1978); John D.
Rockefeller 3d and Blanchette Hooker Rockefeller,
New York, 1978–1993.

very much in the spirit of the watercolors of
1881–1882 (see, for example, cats. 108–111,
123–124). *A Little More Yarn* and *Fisher Girls on
Shore, Tynemouth* of 1884 are, on the other hand,
decidedly more formal in mood and somewhat
more thoroughly worked. The differences be-
tween them and the earlier monochromes are
consonant with the change also evident in
Homer's English watercolors of 1883 (see cats. 125
–128). In the watercolors Homer sought to give
his subjects a greater sense of monumentality, and
that is true of the 1884 monochromes, in which
the figures of the women are seen from slightly
below, giving them an even grander and more
dominant relationship to their surroundings.

Homer thought well enough of his drawings
to show eighty of them in an exhibition at Doll
& Richards Gallery in Boston late in 1884.[4] The
majority of the works were English subjects, but
a number of more recent studies from Prout's
Neck were also included. Homer showed all
types of drawings, ranging from the on-the-spot
sketch for *Wreck of the Iron Crown* (cat. 112), to the
studio study *A Dark Hour* (cat. 120), to finished
works like *Blyth Sands.*[5] The exhibition received
good reviews in the Boston press, with an extend-
ed notice in the *Boston Advertiser* providing a par-

ticularly useful summary of Homer's intentions
and methods:

He has placed on the walls about 80 studies, executed
with a great variety of materials—charcoal, crayon, lead
pencil, chalk, India ink, and watercolor—on paper of
various tints. He desires it to be understood that these
are in no sense to be regarded as pictures, but as stud-
ies, which are of the nature of memoranda, and form
simply one of the steps in the process of making a
picture. Some of them, to be sure, are carried to a very
satisfactory degree of finish, but the majority are sim-
ple and broadly handled effects of masses and light and
shade, made for use. The employment of white chalk
for putting in the lights in charcoal studies on tinted
paper is remarkably effective. Many familiar figures are
to be seen in this collection, which have appeared in
watercolors made from them—the women knitting
stockings as they pace the English sea-shore; the men
of the life-saving service at their arduous, heroic work
in stormy times; the fishermen and other characters
with which Mr. Homer has made us acquainted in his
delightful pictures shown at the same place a year ago.[6]

The critic (probably William Howe Downes)
for the *Daily Evening Transcript* was equally
enthusiastic, declaring that Homer's work, in
contrast to the work of fashionable painters, was

131. *Fisher Girls on Shore, Tynemouth,* 1884
charcoal on paper, 58.4 x 44.1 (23 x 17⅜)
Wadsworth Atheneum, Hartford, Connecticut, Gift
of Mrs. James Lippincott Goodwin
Provenance: Mrs. James Lippincott Goodwin.

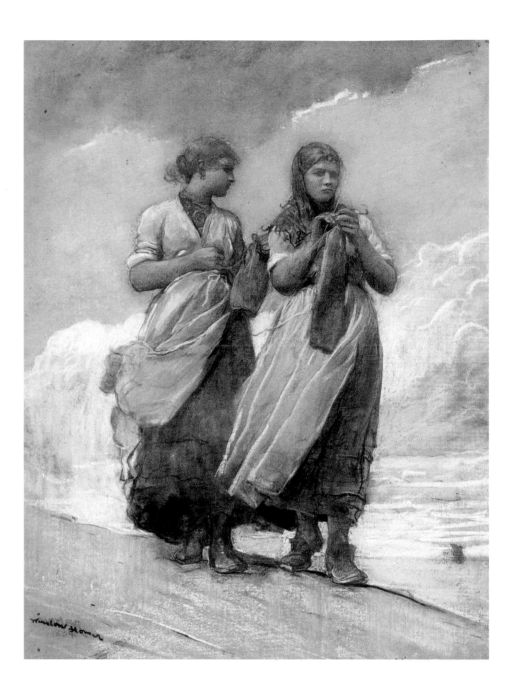

like "a bit of Bach or Beethoven, pure and true, in a dizzying whirl of Brahms and Berlioz, Saint Saëns and Rubinstein."[7] As he continued: "We have had enough of nude figures and red-coated soldiers, satin and sabots, paint and brush, affectation, falsity and vanity. What we need is earnestness...." Finding in Homer's black and white drawings "the Rembrandtesque power of light and shade," the critic praised Homer's ability to give "the entire effect and impression of color in a vague crayon sketch or sketchy monochrome." This writer must have had works such as *Fisher Girls on Shore, Tynemouth* in mind when he concluded: "This new power of Homer's, the consciousness of the existence of abstract beauty, is very strange and most welcome.... With the painting of ideas [has come] also the painting of

beauty, and the change is most grateful." For this viewer, at least, it was clear what Homer had been seeking for his art in going to England, and equally clear that he had achieved his goal.

NOTES

1. See Goodrich and Gerdts 1986.

2. Quoted in Goodrich and Gerdts 1986, 7.

3. Provost 1993, 35–46.

4. *Exhibition of Studies in Black and White by Winslow Homer* [exh. cat., Doll & Richards] (Boston, 1884).

5. These were, respectively, catalogue numbers 16, 10, and 39.

6. "The Fine Arts. Mr. Homer's Black and Whites," *Boston Advertiser,* 29 November 1884.

7. "Winslow Homer's Drawings," *Boston Daily Evening Transcript,* 4 December 1884.

132. *The Life Line,* 1884
oil on canvas, 73 x 113.4 (28 ¾ x 44⅝)
Philadelphia Museum of Art, George W. Elkins Collection
Provenance: Catherine Lorillard Wolfe; Thomas B. Clarke, by October 1896 until February 1899; (American Art Association, New York, 15 February 1899, no. 186); G. W. Elkins, Philadelphia.

132

For almost twenty years after its completion in 1866, Homer's *Prisoners from the Front* (cat. 10) remained his most famous and most admired work, so much so that he is reported to have said (although precisely when is not clear): "I am sick of hearing about that picture."[1] The exhibition of *The Life Line* in early 1884, however, changed matters completely, for it initiated a new standard of reckoning in Homer's art that would continue with his subsequent oils of the mid-1880s. As the critic for the *New York Herald* declared succinctly, *The Life Line* was "A Masterpiece…one of the pictures of the year."[2]

According to the account given by Downes and repeated by Goodrich, Homer had gone during the summer of 1883 to Atlantic City, New Jersey, where "a not uncommon scene…[was] the rescue of seamen and passengers from a shipwrecked vessel by the use of the breeches buoy."[3] He made friends with members of a life-saving crew there, and they explained and demonstrated the use of the apparatus.[4] There seems no

reason to doubt this account, but, in any event, by this time the breeches buoy and the exploits of those who employed them had become fairly well known. Here, for example, is an early account from an 1871 issue of *Harper's Weekly*, which concerns a steamer that has gone aground at night on "some rock-bound coast":

But assistance comes with breaking day. The cliffs are crowded with people ready to risk their own lives to save those of the helpless people on the steamer. A cask, to which a line is attached, is thrown overboard; it is cast ashore by the waves, and the line seized by skillful hands, is soon stretched from ship to shore. By means of this line a stout cable is drawn ashore, and a hardy seaman or life-boatman makes his way along it through the waves, dragging with him a second line, to which is attached a strong basket. This is slung to the cable by means of a block and tackle; and then, freighted with precious life, it is dragged ashore. Imagine to yourselves the supreme agony of that moment! It is a close wrestle with the elements. The sight of a basket swinging loosely from the fore-yard, and every now and then swept by the great green waves, might well deter them. Imagine mothers watching the tra-

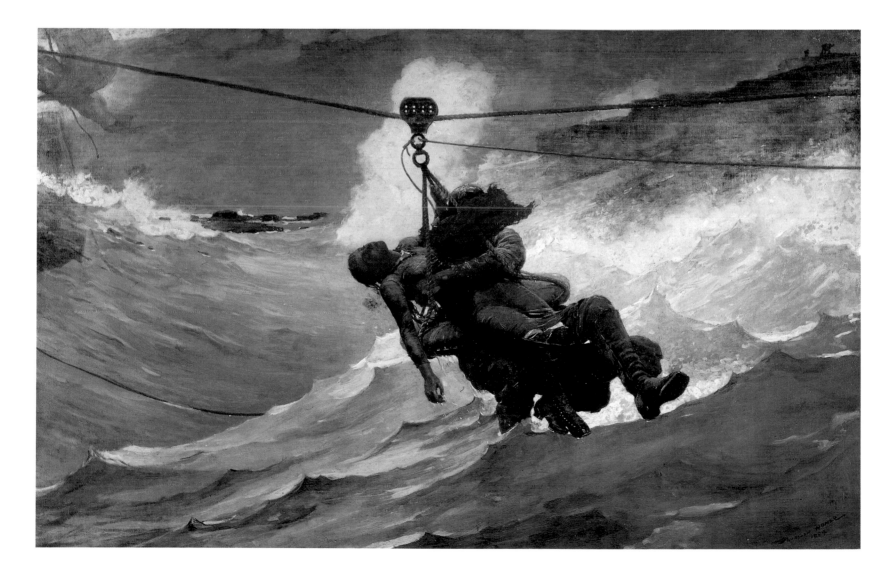

ject of their children, or husbands of their wives, and the long queues of expectants struggling, not for a good place in church or theatre, but for the chance of escape from a horrible death. Figure the agonizing deliberation of the process at best, and multiply the real time occupied by the frenzied impatience of those who know that the slightest freshening of the fickle wind is their death-warrant.[5]

As the article further noted, those who were saved in this manner, often arrived ashore "drenched with salt-water, chilled to insensibility, half drowned, yet still living."

Many appreciative accounts of *The Life Line* were published when it was shown at the National Academy, but that in the *New York Times* is particularly descriptive:

Mr. Winslow Homer by no means exhausted his quiver at the Water-colors, but reserved for the Academy a large-sized arrow. It is that part of a shipwreck in which the tragedy is taking a happy turn. The background is composed chiefly of two great gray rollers, between which a sailor and a young woman are passing, suspended to a life-rope, one end of which is supposed to reach the shore and the other to be fastened to a wreck whose spars are dimly descried in the left background. The heavy sailor, or rather coast guardsman, for he is dressed more like a fisherman than a sailor, sits in the apparatus which moves by means of a traveler under the rope. Of the two traction ropes, that toward shore is taut, so that we know that the rescue, unless something breaks, is merely a matter of time. But time is also precious. The coast guard is a well-drawn muscular figure with face hid-

den. His left hand holds the woman; his right is invisible, occupied with keeping himself in place. The hiding of his features concentrates the attention very cleverly on his comrade, who has fainted or is numb with fright. She has nothing on but her shoes, stockings, and dress, while the skirt of the latter has been so torn that her legs are more or less shown above the knees. Then, the drenching she has received makes her dress cling to bust and thighs, outlining her whole form most admirably. She is a buxom lassie, by no means ill-favored in figure and face. Her disordered hair, torn skirt, drenched dress, and set face call for sympathy; a redness of the skin, above her stockings hints at a cruel blow, and puts the climax on one's pity; at the same time, one cannot forget her beauty. Mr. Homer has sprung this figure on us unexpectedly. As usual, his is the charm of the unexpected.[6]

This review identifies the key elements at work in the dynamics of *The Life Line:* it tells a dramatic story, but also frames the drama in highly sensual, sexual terms. The critic, presumably a man, clearly could not keep from admiring the woman's form, but felt that "sympathy" and "pity" for her plight allowed him to do so without guilt. That he had this chance was apparently in itself somewhat unusual, for according to a contemporary source, the breeches buoy was "hardly suitable for women and children," who should be brought ashore by "a life-car," a covered boat drawn by ropes to and from the wreck.[7] Although safety was doubtless a primary reason for not using the breeches buoy for the rescue of women, the use of a covered boat suggests that matters of decorum were also at work. Indeed, the situation of the woman in Homer's painting not only leads to a revealing of her physical form ("her legs are more or less shown"; "the drenching she has received makes her dress cling to bust and thighs, outlining her whole form most admirably"), but also presents her as unconscious or semiconscious, and thus unable to exemplify her morality through her comportment. Rather, she seems virtually to have swooned in the arms of her savior ("It is one man and one woman, the one helpless, the other strong").[8] Indeed, were this entwined man and woman seen in some other context, they could easily be interpreted as lovers, which probably explains why the critic for the *Times* observed that Homer had "done the unusual thing of uniting cleverness of conception and good composition with a sensuousness...."[9] Seen in this light, *The Life Line* suggests provocative similarities to such works as Jean-François Millet's drawing *The Lovers* (fig. 164) or even Auguste Rodin's sculpture *The Kiss.*[10]

In an extended discussion of *The Life Line*, Jules Prown has emphasized the strongly sexual mood of the picture and proposed that it repre-

fig. 164. Jean-François Millet, *The Lovers*, 1850. Black crayon. Photograph © 1994, The Art Institute of Chicago, Charles Deering Collection, 1927.4434

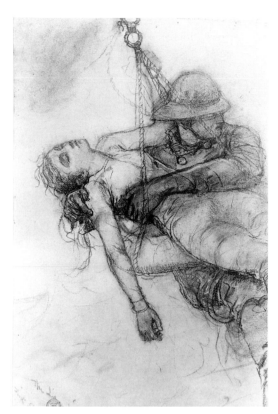

fig. 165. *Life Line*, 1882–1883. Black and white chalk on paper. Cooper Hewitt, National Design Museum, Smithsonian Institution, Gift of Charles Savage Homer, Jr. (1912-12-34). Art Resource, New York

sents the artist's own conscious and unconscious desires.[11] As he observes: "it is difficult to avoid the suspicion that if we were to unveil the face hidden by the red scarf, we would find Winslow Homer."[12] Prown was, of course, speaking metaphorically, but it is worth noting that *The Life Line* originally did show the face of the man. According to a newspaper account from the time the painting was on view at the National Academy, Homer, "finding that it scattered the interest, boldly threw over it the shawl of the fainting woman who lies in his arms, and braved the charge of shirking the work which he undid."[13] Thus, we may assume that the original appearance of the man was probably like that in the careful preparatory drawing (fig. 165) for the painting.

The Life Line was virtually an unqualified success for Homer. Although one or two reviews found more fault than merit in it—the critic for the *New York Evening Post* felt Homer was "giving himself up to the downward drift of art"—most praised it ecstatically.[14] It was widely considered the most popular work in the National Academy exhibition, a distinction that can only have been boosted by its sale to the New York collector Catherine Lorillard Wolfe for $2,500.

NOTES

1. Goodrich 1944a, 51.

2. "Fine Arts. Fifty-Ninth Annual Exhibition of the National Academy of Design. The First View," *New York Herald*, 5 April 1884.

3. Downes 1911, 120; Goodrich 1944a, 86.

4. Hendricks 1979, 151, says Homer first saw a breeches buoy during the rescue of the crew from the *Iron Crown* off Tynemouth in 1881. Although it is true the breeches buoy was used in the early stages of that rescue, Homer apparently arrived too late to see it and only witnessed the use of a lifeboat (see cats. 112–116).

5. "Saved from the Wreck," *Harper's Weekly*, 23 December 1871, 1211. Rockets that could be fired with a thin line over the stricken vessel provided an easier and safer means of attaching the cables. The article was accompanied by a two-page illustration of a man in a breeches buoy holding a swooning woman and child, which is suggestively similar to Homer's painting.

6. "The Spring Academy," *New York Times*, 5 April 1884. The reviewer continues with a brief discussion of the weakness of Homer's rendering of the water, but concludes: "Dull water or not dull water, Mr. Homer has marked a great triumph with this group."

7. J. H. Merryman, "The United States Life-Saving Service," *Scribner's Monthly* 19 (January 1880), 327. The pose of the man and woman in Homer's painting was lampooned in "Some Impressions," *Life*, 24 April 1884, 230, where a caricature of it is reproduced with the caption "Acrobatic Feet."

8. *New York Herald*, 5 April 1884.

9. *New York Herald*, 5 April 1884.

10. Prown 1987, 39–40, has noted the woman's pose is "as compositionally suggestive of postcoital exhaustion as that of the woman in [Henry] Fuseli's *The Nightmare*" (1781, Detroit Institute of Arts), and has also linked her position in the breeches buoy to the "tradition of sexual imagery of the swing—all that to-ing and fro-ing, that pleasurable rocking motion."

11. Prown 1987, 31–45.

12. Prown 1987, 38.

13. "Fine Art Notes," *New York Evening Telegram*, 21 April 1884.

14. "The National Academy of Design Exhibition. Fourth Notice," *New York Evening Post*, 21 April 1884.

133. *The Herring Net*, 1885
oil on canvas, 76.5 x 122.9 (30⅛ x 48⅛)
The Art Institute of Chicago, Mr. and Mrs. Martin
A. Ryerson Collection, 1937.1039
Provenance: Charles W. Gould, by 1908; (M. Knoedler
& Co., New York, October 1915); Mr. and Mrs. Mar-
tin A. Ryerson, Chicago, 1915–1937; Mrs. Martin A.
Ryerson.

133–135

These three pictures, completed during a
remarkably fertile year for Homer, constitute a
coherent series documenting the life and work
of the fishermen of the North Atlantic. Although
they were not initially exhibited together as a set,
they were all executed on canvases measuring
approximately 30 x 48 inches, are closely related
in style and coloring, survey the three principal
fish—herring, halibut, and cod—sought in New
England waters, and imply an informal narrative
progression. *The Herring Net* and *The Fog Warn-
ing* were shown together in Boston in 1886, and
critics at that time noted their close relationship
(the *Evening Transcript* declared *The Herring Net*
"incomparable—except with its mate").[1] And in
1893, when all three paintings were shown with
twelve other oils by Homer at the World's Colum-
bian Exposition in Chicago, it was obvious to
many observers that they were a trio. "Three of
the most interesting of them," wrote one critic
of Homer's works, "show New England fisher-
men in their dories on the Grand Banks."[2] Rec-
ognizing the sequence of events depicted, this

critic continued:

In one the boat lies across the foreground, while its
two occupants haul in their net, heavy with its shin-
ing freight....In another picture a fog is seen coming
up in the distance, and a fisherman in a dory is pull-
ing for dear life to get back to his schooner before he
is swallowed up in the fog. The third picture is called
"Lost in the Fog." The two men are peering over the
side of their dory, vainly trying to pierce the thick
mist, which completely hides from view their vessel.
There is no living artist in this country or abroad
who expresses the dramatic and often tragic phases of
the life of the sailor and fisherman with the force, the
truth and the skill of Winslow Homer.

As another observer concluded:

Each of these pictures is dramatically impressive in its
simple, forceful suggestion of the battle for life between
man and the sea. But when the three are seen togeth-
er the effect of each is greatly heightened, and we are
stirred as by some noble epic, beginning with a scene
of rough toil and ending with a premonition of tragedy.[3]

Judging from the sequence in which they
appeared in public exhibitions during 1885 and

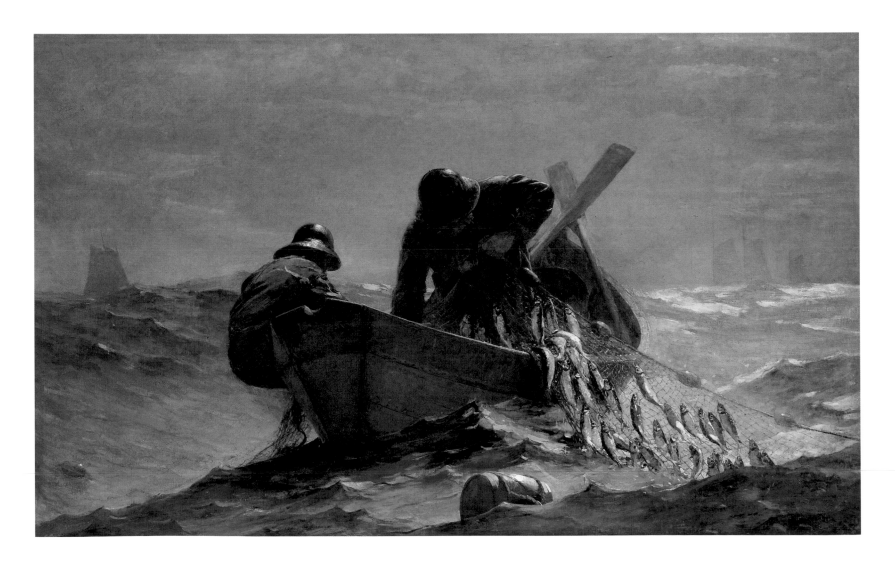

1886, Homer created the "noble epic" told by the three pictures in precisely the order it was read by the critics: *The Herring Net* first, followed by *The Fog Warning*, with *Lost on the Grand Banks* the conclusion. It has been said that all three originated in a trip during the summer of 1884 that Homer made with a fishing fleet to the Grand Banks.[4] As Beam pointed out in 1966, however, Homer, soon after settling in Prout's Neck in 1883, had made the acquaintance of the local fishermen and had begun observing (and, at times, sketching) their activities.[5] In the 1880s the local fishing fleet there was extremely active, as it had been since the early part of the seventeenth century. The area around Wood Island was, in fact, "one of the principal spawning grounds for the herring within the limits of the United States," and fishing for herring was "extensively prosecuted in this vicinity."[6] Roswell Googins, a Prout's Neck boy who knew Homer and who was interviewed by Beam, recalled that a huge school of herring had arrived off Prout's Neck in the summer of 1884 and that schooners from up and down the coast had come as a result. Googins rowed Homer out to the fleet, where the artist made sketches of the men and the boats.[7] A number of fine sketches done in charcoal and white chalk dated 1884 have survived, and were almost certainly the product of the experience recounted by Googins.[8] From these drawings, and in particular from one (fig. 166) that may have been worked up in the studio, came *The Herring Net*.

It was not Homer's first encounter with herring fishing, for the fish was pursued by the English fishermen he had come to know in Cullercoats in 1881–1882. At least one of his 1881 watercolors from England (*Tynemouth Priory,*

England, Art Institute of Chicago) shows a gill net being set (presumably for herring) from a Cullercoats coble. He may also have read about herring fishing in a variety of sources, such as an article entitled "After the Herring" that appeared in the English periodical the *Magazine of Art* during the very time he was in Cullercoats.[9] Or perhaps he knew the memorable account of a fabulous haul of herring in Charles Reade's novel *Christie Johnstone:*

the boys were struggling with a thing no stranger would have dreamed was a net. Imagine a white sheet, fifty feet long, varnished with red-hot silver. By dint of fresh hands they got half of her in, and then the meshes began to break; the men leaned over the gunwale, and put their arms round blocks and masses of fish, and so flung them on board; and the cod-fish and dog-fish snapped them almost out of the men's hands, like tigers.[10]

The fishermen in *The Herring Net* are not, to be sure, facing an exactly similar situation, but the size of their catch is made obvious by the many fish suspended in the net, their silver bodies flickering in the light and reflecting the blue sea water. For the few days the herring were running in full numbers in the waters around Wood Island, the activities of men and boats must have been quite frenzied, but Homer's painting seems instead calm and quiet. The atmosphere is serene; the anonymous fishermen concentrate intently on their work as their dory rides the swells; the sun breaks through the clouds for a moment, highlighting their forms and fixing them solidly in space. The pyramidal shape formed by the men, the boat, the rising diagonal of the net and the falling line of the wave at the lower left creates a powerful stability and monu-

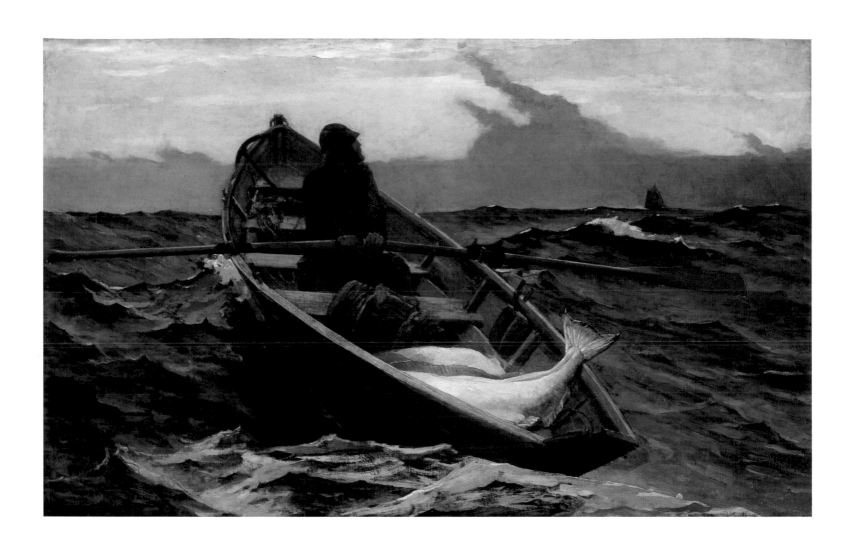

134. *The Fog Warning*, 1885
oil on canvas, 76.2 x 121.9 (30 x 48)
Museum of Fine Arts, Boston, Otis Norcross Fund,
94.72
Provenance: (Doll & Richards, Boston, 1886). Laura
Norcross and Grenville H. Norcross, 1893–1894.

mentality that suggests the timeless and the
ideal. Although the critic for the *New York Times*
complained that the picture was like "a strong,
raw Marsala [wine], so fresh and stirring, yet
faulty," others declared it "the picture of the
exhibition" when it debuted at the National
Academy in 1885.[11] "One overlooks the minor
discords," observed the critic for *The Independent*,
"as one sees how the artist has struck the true
keynote of the scene."[12] Or, as the *Boston Daily
Evening Transcript* tellingly noted: "it recalls cer-
tain old Italian work, it is the very concentration
of strength."[13] This critic may simply have meant
that the compositional order of *The Herring Net*
brought to mind High Renaissance painting
generally, but he may also have been thinking
specifically of something like Raphael's *The
Miraculous Draft of Fishes* (British Royal Collec-
tion, on loan to the Victoria and Albert Museum,
London). Indeed, it has recently been suggested
that the fact that Homer arranged the shipped
oars in *The Herring Net* in an "X" shape may
have been an allusion to the X-shaped cross upon
which Saint Andrew, the patron saint of fisher-
men, was crucified.[14]

Herring could be fished in coastal waters, but
pursuing halibut—the large fish that appear in
the stern of the dory in *The Fog Warning*—requir-
ed trips to the deep waters of the Grand Banks.
"There is no other food-fishery in the world in
which fish are sought at so great a depth," noted
a report from 1887.[15] Schooners carried small
fleets of dories to the Banks, where fishermen
(usually working in pairs) rowed out to set and
tend trawl lines.[16] This was strenuous work, and
the conditions of the Grand Banks, where heavy
seas and dense fogs were common, also made it
extremely dangerous. Those who fished for hal-
ibut were, according to contemporary reports,
"chosen men.…There is no branch of the fish-
eries which demands of the men employed in it
more skill, endurance, and courage.…"[17]
The Fog Warning shows a single fisherman
rowing a dory with two or more large halibut
weighing down the stern; the man has paused in
his rowing as the boat crests a wave, and he looks
off in the direction of a large sailing vessel on
the horizon. A dark bank of fog obscures the
lower portion of the sky, a "long and ominous
cloud," as it was called by one reviewer.[18] When

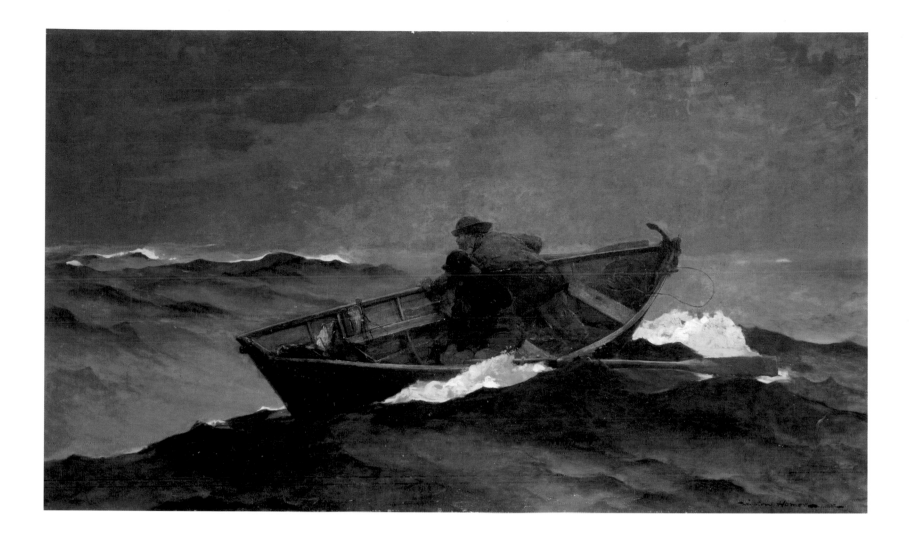

135. *Lost on the Grand Banks,* 1885
oil on canvas, 80 x 125.4 (31 ½ x 49 ⅛)
Mr. John Spoor Broome
Provenance: (M. Knoedler & Co., New York, June
1900); John Alden Spoor, Chicago; John Spoor
Broome, by descent.
Washington and New York only

it was initially shown, the painting was apparent-
ly called *Halibut Fishing* (or, *The Halibut Fisher*),
but Homer seems to have taken pains to correct
that. "Winslow Homer's picture," wrote the *Bos-
ton Evening Transcript*, "must be introduced anew,
as this name was not given by its original spon-
sor. The real name is 'The Fog Warning.'"[19] As
the latter title makes clear, the painting repre-
sents what was an all too common peril, namely
the "constant danger, at all seasons of the year,
of fishermen, while out in boats, losing sight of
the vessels."[20] Although the mother ship would
commence sounding a horn as soon as an
approaching fog was spotted, the widely scattered
fleet of dories could easily and rapidly become
enveloped in the mists before reaching safety.
The Fog Warning, a distilled image of that intense
moment when the fisherman must decide on a
new course to row if he has any chance of reach-
ing the ship, is one of Homer's most successful
epics of the sea. "It is not only powerfully dra-
matic in conception," wrote one critic who saw
the picture soon after it was finished in 1885,
"but carried out with a serious, almost grim
intensity that adds infinitely to its significance."[21]

That "grim intensity" becomes even more
pronounced in *Lost on the Grand Banks*, the con-
cluding picture of the series. Here two fisher-
men "are peering over the side of their boat,
vainly trying to pierce the drifting fog, which
does not seem to envelop them very closely, yet
hides their schooner as effectually as though it
were a tangible sable pelt."[22] The seriousness of
their situation is accentuated by the precarious
position of the dory, which seems perilously
close to being swamped by the wave that breaks
against its starboard side. The large cod in the
stern, the men in the middle, and the anchor at
the bow all seem to weight the boat unequally,
creating even greater imbalance. A rope blows
loosely at the bow, and the anchor, the tradi-
tional symbol of hope, seems as if it might fall
from the boat. Although during Homer's day
there were increasing calls for dories to be pro-
visioned with water, food, and a compass as a
"simple precaution against disaster and suffer-
ing," most of those lost in the fog could rely
only on their own wits and courage for survival:

Losing the position of their floating headquarters, the

229

schooner, they drift helplessly about, falling prey to hunger and thirst, until, perchance, they may reach land, or, exhausted and emaciated, be picked up by some passing vessel.... The terrible dangers incurred in setting and hauling the trawl-lines are beyond imagination. The fishermen cannot afford to take weather into account in venturing forth in their frail boats.... The chances are that the occupants of the little boat, though they fight never so bravely, fail to reach their vessel; and the benumbing effect of cold, the danger of being swamped, added to the pangs of hunger and thirst, render the ordeal one of the most terrible that man can be called upon to undergo. Too often are these brave fellows, notwithstanding their most desperate exertions, overwhelmed by the force of nature's elements, and borne down for ever to a billowy grave, their lonely fate witnessed only by the screaming gulls.[23]

Lost on the Grand Banks was well received when it appeared at the National Academy late in 1886. The critic for *The Art Review* admired the "utter simplicity of the composition, the fidelity to local coloring (and Mr. Homer's peculiar gamut of color never seemed more appropriate) and the spirited rendering of the wave-tossed boat and its anxious occupants," and concluded "Mr. Homer always has something to say."[24] *The Nation* considered *Lost on the Grand Banks* "the most remarkable work at the Academy.... On the whole this was something more than a good picture. It had the element of greatness which comes when true feeling is conjoined with accomplished workmanship and beautiful composition."[25]

The Life Line had been an immediate success when it debuted in 1884, but these next three pictures, although generally admired, went unsold for years after their creation. In spite of—or, more likely, because of—their striking aesthetic qualities and their strong and dramatic moods, they apparently went against the common standards of taste in mid-1880s America. They had, as a critic said of *Lost on the Grand Banks* hanging at the National Academy, "a rude vigor and grim force that is almost a tonic in the midst of the namby-pambyism of many of the other pictures."[26] Years later, when Homer said of his painting *The Gulf Stream* (cat. 231) that "no one would expect to find it in a private house," he may well have been thinking back to his experience with his first great epics of the sea, works that are still distinguished by their "rude vigor and grim force."[27]

NOTES

1. "Art Notes. Winslow Homer at Doll & Richards," *Boston Daily Evening Transcript*, 25 February 1886.

2. "Winslow Homer's Pictures at the World's Fair" (unidentified newspaper clipping, Bowdoin).

3. Unidentified newspaper clipping, scrapbook, Bowdoin. This reviewer also noted variety in Homer's treatment of the ocean in each picture: "it is a marvel and a delight to

see how, in these three works, where sky and sea are always chilly and gray, he has, nevertheless, painted three of the ocean's moods, each quite distinct from the other as regards both the color and movement of the water and the density and illumination of the air."

4. See Hendricks 1979, 177.

5. Beam 1966, 66–68.

6. George Brown Goode, *The Fisheries and Fishery Industries of the United States* (Washington, 1887), 1: 425; "The herring visit this region solely for the purpose of spawning. They arrive in small numbers about the 20th of September and gradually become more abundant until, a week later, the water is literally filled with them. The great bulk of the fish remain but a few days, after which they disappear."

7. Beam 1966, 66.

8. See Goodrich and Gerdts 1986, nos. 73–78.

9. Aaron Watson, "After the Herring," *Magazine of Art* 5 (1882), 405–411, 454–456 (cited in Gerdts 1977, 21).

10. Charles Reade, *Christie Johnstone* (London, 1882), 162–163.

11. "The Autumn Academy," *New York Times*, 22 November 1885; "The Academy Autumn Exhibition," *Frank Leslie's Illustrated Newspaper*, 5 December 1885.

12. "Fine Arts. The Autumn Academy Exhibition. Second Notice," *The Independent*, 10 December 1885.

13. *Boston Daily Evening Transcript*, 25 February 1886.

14. Zalesch 1993, 124. Zalesch concludes: "Homer's fishermen, whose hidden faces make them universal everymen, were being destroyed by modern, steam-powered trawling fleets. The fishermen, their way of life, and even their individualism, were being crucified by the new technologies which Homer detested."

15. Goode, *Fisheries*, 1: 5.

16. See the discussion in Provost 1990, 24.

17. Goode, *Fisheries*, 1: 6.

18. *Boston Daily Evening Transcript*, 25 February 1886.

19. "Art and Artists," *Boston Daily Evening Transcript*, 7 April 1886.

20. Goode, *Fisheries*, 1: 123.

21. Unidentified newspaper clipping discussing an exhibition at Reichard's Gallery in New York in December 1885 (Bowdoin).

22. Unidentified newspaper clipping, as in note 3, above.

23. "Fishing Perils on 'The Banks,'" *Frank Leslie's Illustrated Weekly*, 8 March 1884.

24. "Art Notes," *The Art Review* 1 (December 1886), 12.

25. "Fine Arts. Autumn Exhibitions and the 'Bayeux Tapestry,'" *The Independent*, 23 December 1886.

26. "Art Notes," *The Art Review* 1 (December 1886), 12.

27. Letter to the Chicago dealer M. O'Brien & Son, 20 March 1902 (quoted in Downes 1911, 149).

136–143

Undertow was among the most extravagantly admired of Homer's works of the 1880s, receiving critical praise recalling that which had greeted *The Life Line* (cat. 132) several years earlier. It was deemed "The star painting of the [National Academy] exhibition" by the *New York Herald;* a "masterpiece which is quite classic in its rugged strength and vigorous simplicity of treatment...."[1] For the *Evening Post* it had "a force about it, an air of truth, a fine sculpturesque quality of modeling, that puts it far beyond the ordinary.... by its virility, its truth, its sincerity of intention, [it] outranks every picture in the Academy exhibition."[2] And the *Tribune* concluded: "after Mr. Homer's intense epic one must wait a little or other paintings of the figure will seem tame."[3]

According to the account in Downes, while in Atlantic City during the summer of 1883 Homer "had the good fortune to see a rescue from drowning, which gave him the idea for another picture, 'Undertow,' which he began at once upon his return to his New York studio, but which he did not get ready to exhibit until

1887."[4] Downes further claimed that "much of the work on it had been done on the roof of the studio building" in New York, with Homer posing two young women "locked in each other's arms and dressed in bathing suits...drenched with water thrown over them, so that the effect of the sun on the wet clothing and the bare arms as well as the faces and hair should be entirely in accordance with the natural appearance of the group emerging from the surf."[5] Although it is not possible to say whether or not this actually occurred (Downes told a similar story about the genesis of *The Fog Warning*), if it did it would suggest that Homer's initial efforts concerned only the two central figures. The etching (cat. 143) then, rather than being an actual "study" for the final painting, might record Homer's initial conception for the canvas, which he put aside in 1883 to work on *The Life Line.*[6]

In any event, one of the drawings (cat. 139) associated with *Undertow* is dated 25 April 1886, indicating that the artist had by that time begun to rethink the composition.[7] Although there is no evidence to establish the exact order of the drawings (the current numbering of them is that

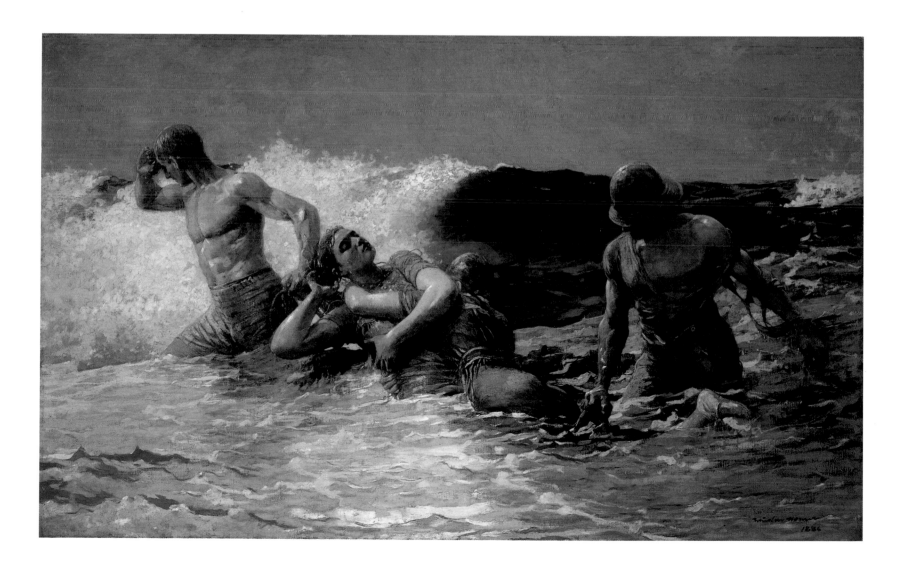

cat. 137

the drawings related to *Undertow* offer an especially revealing look at Homer's creative process. The artist himself knew they told an interesting story, for as he wrote to the owner of the painting in 1900: "I have hunted up these different studies of the subject of the painting—'Undertow' that I promised to give to you—I take pleasure in sending these things to you—they will amuse you much."[8]

Although some modern observers have judged *Undertow* to be less successful than *The Life Line* or *The Fog Warning*, by any balanced reckoning it must be considered one of the great achievements of his mature career, a work in which he set an extremely difficult formal challenge for himself and rose to master it.[9] Although the acerbic Clarence Cook found in it no redeeming qualities, many of Homer's contemporaries were deeply impressed by it.[10] Among the several lengthy discussions of the picture published in

cat. 138

cat. 139

fig. 167. *Studies for "Undertow" (Nos. 4 and 5)*, 1886. Pencil. Sterling and Francine Clark Art Institute, Williamstown, Massachusetts

of the owner), they show obvious difficulties in deciding the overall arrangement of the figures. In one (cat. 137), two standing figures support a slumped figure between them; although this grouping does not reappear in the series, it does represent the only drawing suggesting the appearance of the right-hand man in the final painting. All of the others investigate the relationship of the two women one to another and to the left-hand man; in one case (fig. 167), Homer experimented with the composition by overlaying two drawings. Yet another quick sketch close to the painting has four different left-hand edges drawn in and is also marked with an "X," as if Homer had rejected it. Whatever their actual sequence,

1887, the following account from the *Boston Evening Transcript*, which combines both a precise description of the subject and a sensitive assessment of the painting's aesthetic merits, is worth quoting in full:

Winslow Homer's unswerving self-reliance, knowledge and conscientiousness are already full known among the few; perhaps his strength is too keen and pure ever to be popular. Within the lines that bound his vision, pretty nearly all that is to be known he knows, and it can never be said that he in any way "plays to the gallery," shirks a particle of labor, or sacrifices in the least a point of principle for considerations of fame or finance. His work is frank, penetrating, outspoken;

137. *Study for "Undertow" (No. 1),* 1886
pencil on paper, 18.1 x 21.9 (7⅛ x 8⅝)
Sterling and Francine Clark Art Institute, Williamstown, Massachusetts
Provenance: Edward D. Adams, New York, 1900; (M. Knoedler & Co., New York, 1925); Robert Sterling Clark, 1925.

138. *Study for "Undertow" (No. 2),* 1886
pencil on paper, 12.7 x 19.8 (5 x 7 ¹³/₁₆)
Sterling and Francine Clark Art Institute, Williamstown, Massachusetts
Provenance: Edward D. Adams, New York, 1900; (M. Knoedler & Co., New York, 1925); Robert Sterling Clark, 1925.

139. *Study for "Undertow" (No. 3),* 1886
pencil on paper, 14.6 x 18.4 (5¾ x 7¼)
Sterling and Francine Clark Art Institute, Williamstown, Massachusetts
Provenance: Edward D. Adams, New York, 1900; (M. Knoedler & Co., New York, 1925); Robert Sterling Clark, 1925.

140. *Study for "Undertow" (No. 4),* 1886
pencil on paper, 14.6 x 22.5 (5¾ x 8⅞)
Sterling and Francine Clark Art Institute, Williamstown, Massachusetts
Provenance: Edward D. Adams, New York, 1900; (M. Knoedler & Co., New York, 1925); Robert Sterling Clark, 1925.

141. *Study for "Undertow" (No. 5),* 1886
pencil on paper, 13.5 x 9.1 (5 ⁵/₁₆ x 3⁹/₁₆)
Sterling and Francine Clark Art Institute, Williamstown, Massachusetts
Provenance: Edward D. Adams, New York, 1900; (M. Knoedler & Co., New York, 1925); Robert Sterling Clark, 1925.

142. *Study for "Undertow" (No. 6),* 1886
pencil on paper, 14.6 x 22.5 (5¾ x 8⅞)
Sterling and Francine Clark Art Institute, Williamstown, Massachusetts
Provenance: Edward D. Adams, New York, 1900; (M. Knoedler & Co., New York, 1925); Robert Sterling Clark, 1925.

cat. 140

cat. 141

utterly characteristic, his own; inevitable in fact, the only thing he *can* do. Probably no one will ever know the amount of work which has entered into this picture; it is the result of a year's labor. In it as many obstacles have been over come as usually are resisted by most painters in a lifetime. So far as knowledge goes, the picture is beyond question or criticism; yet at first we must declare the subject to be uninteresting in the extreme. A good criticism already made is that the picture would be sublime—without the figures. The subject is against it. The picture is called "The Undertow," and represents an incident that made a vivid impression on the mind of the painter some time ago. Two girls have been bathing, have been carried out to sea by the undertow, and are now being drawn to shore by two men who have rescued them after tremendous fighting, as is proved by their tattered clothing. The girls are unconscious, clasped together with rigid limbs; the two men, sailors evidently, have drawn them already into shallow water, close to shore, with a great green wave rising close behind them. The picture has the

cat. 142

233

143. **Study for "Undertow,"** c. 1886
etching, 24.6 x 33 (9 ¹¹⁄₁₆ x 13)
Sterling and Francine Clark Art Institute, Williamstown, Massachusetts
Provenance: The Homer family until 1968, by descent.

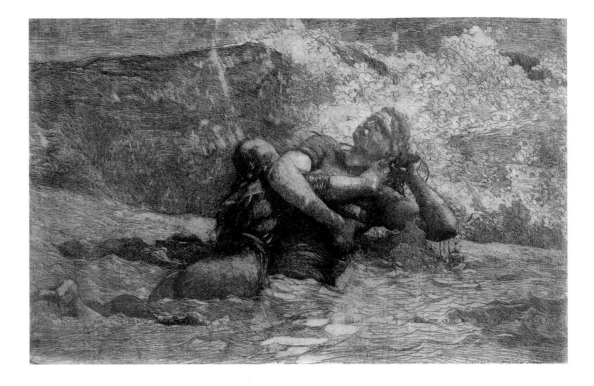

absolute truth of fact; so far as knowledge and painting go, criticism has nothing whatever to do. The painting of the sea in all its qualities, form and nature and color and movement, is simply entirely right and just. The rise of the water to the right, the thin edge of curling breaker, the glittering flashing foam, are all faultless. The same word applies to the figures; there can't be better modelling, because this is *exact*. The rigid arms of the unconscious girls, the heaving breasts of the rescuers, the play of light on their bodies, and so on, all through the picture. Again, in its broad effects one can find no fault. The air is wet and salt, a little chilly, but flashing with pale light; everything is salt and wet; one can feel the salt sea on the flesh. It is perfect realism, yet the tone is complete. The figures are placed *in* the water, not against it. This is Ruskin's veritable "uncompromising realism." Still, the picture is not interesting, or rather, its interest is professional, artistic. It is in no respect impressive or effective. We can see that the composition is unique and masterly; but our interest goes no further. The picture is a masterpiece; it lacks but a breath to make it monumental.[11]

NOTES

1. "The National Academy of Design," *New York Herald*, 8 April 1887.

2. "The Academy Exhibition. First Notice," *New York Evening Post*, 14 April 1887.

3. "The National Academy of Design," *New York Tribune*, 2 April 1887.

4. Downes 1911, 120–121.

5. Downes 1911, 142.

6. There is, however, no technical evidence to suggest that the figures of the two men were added later by, for instance, painting them over passages of water; my

thanks to Michael Heslip and Steven Kern of the Clark Art Institute for discussing *Undertow* with me.

7. See the discussion of the painting and the drawings in Conrads 1990, 78–83.

8. Letter to Edward D. Adams, 12 May 1900 (Clark Art Institute, Williamstown, Massachusetts).

9. Novak 1969, 185–187, argues that *Undertow* lacks a "resolution of two-dimensional design and three dimensional space…and thus is extremely instructive as an indication of Homer's constant dilemma. Here the plastic properties of the picture are in conflict with the element that in the 1880's assumed brief dominance in Homer's work: a narrative representation that at its worst could border on the illustrative."

10. See Clarence Cook, "The National Academy of Design: The 62nd Annual Exhibition," *The Studio* 2 (May 1887), 192 (cited in Conrads 1990, 80–81).

11. "Art Notes. American Pictures at Doll & Richards," *Boston Daily Evening Transcript*, 21 January 1887. The next sentence of this review—"From pure realism to pure poetry is the change from Winslow Homer to Francis Murphy"—suggests that poetic sentiment was what this critic felt *Undertow* lacked.

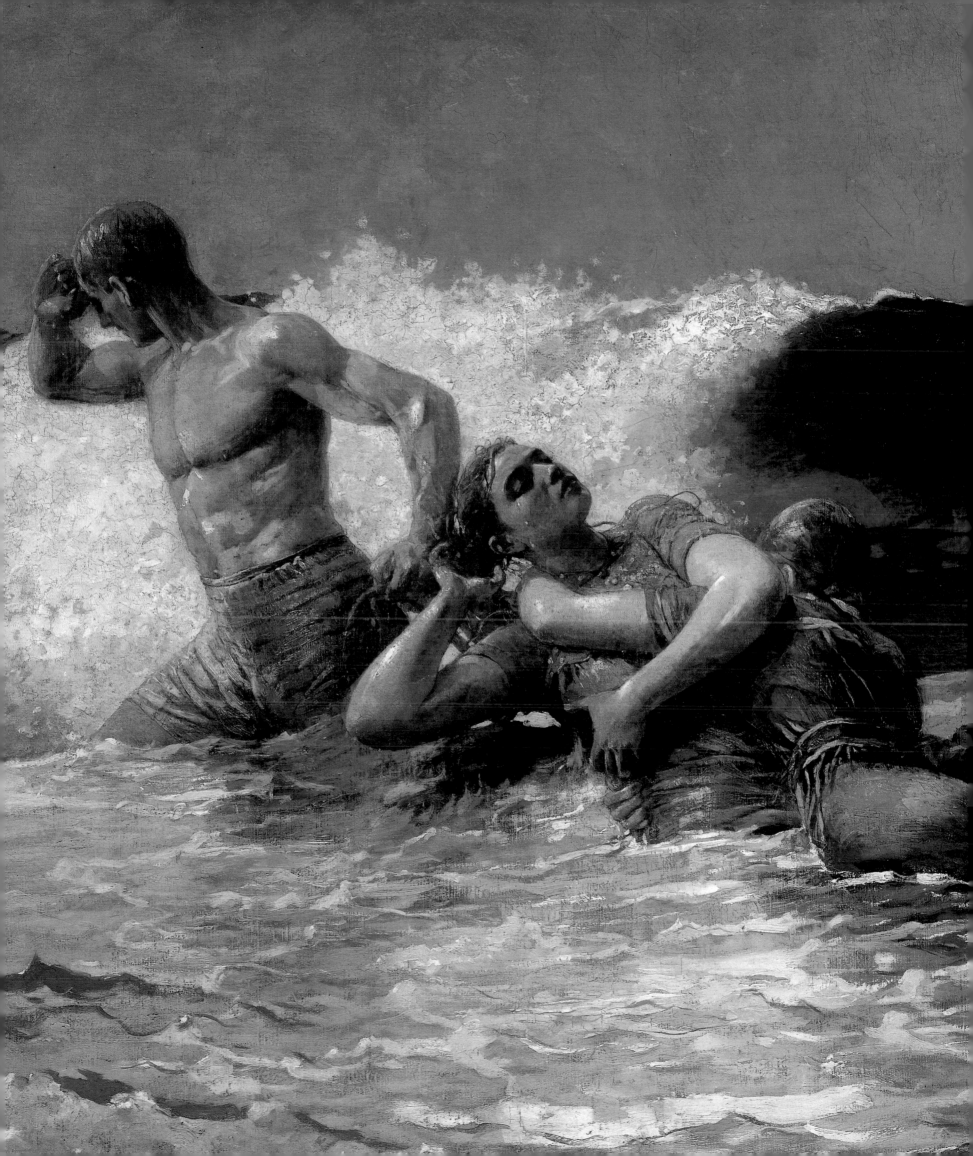

144

144. *Eight Bells,* 1886
oil on canvas, 64.1 x 76.5 (25¼ x 30⅛)
Addison Gallery of American Art, Phillips Academy,
Andover, Massachusetts, Gift of anonymous donor
Provenance: Thomas B. Clarke, by December 1887
until February 1899; (American Art Association, New
York, 17 February 1899, no. 370); (Herman Schaus,
1899); Edward T. Stotesbury, Philadelphia, 1899;
(Duveen, New York, by exchange); (John Levy Gal-
leries, New York). E. L. Lueder, New York; (William
Macbeth, Inc., New York); Thomas Cochran, 1930.
Washington only

Eight Bells, one of Homer's best-known paintings,
and the last of the series of great sea pictures that
had commenced with *The Life Line* three years
earlier, was completed in 1886, but not shown
until 1888. The title refers to the sounding of
"eight bells," done at the hours of four, eight,
and twelve A.M. and P.M.[1] By 1886 Homer had
traveled so many times at sea that he would have
had ample opportunity to witness sailors "shoot-
ing the sun" with sextants; his 1881 watercolor
Observations on Shipboard (cat. 157), made on his
voyage to England, shows precisely that activity.
According to Downes, however, *Eight Bells* came
about under somewhat unusual circumstances:

Arthur B. Homer, the younger brother, owned an old
plumb-stemmed sloop that he and his sons used to
knock about in at Prout's Neck. In the cabin were three
wooden panels, two of them rather wide, on the sides,
the third a short one set in the forward partition.
Winslow Homer, noticing these vacant spaces, sug-
gested that he would some day paint something to fill
the panels. In 1886 he started the promised series of
sketches. The two side panels were completed. One of
them represented a fleet of Gloucester fishing vessels;
the other two schooners at anchor with their sails up
against a sunset sky of lemon yellow, a very handsome

effect. For the shorter panel forward he began to make
a black-and-white oil study of a ship's officer in uniform
taking a noon observation, his back turned towards
the observer. His brother Arthur posed for this figure.
When it was almost done, Winslow Homer suddenly
stopped work on it, and, saying, "I am not going to
do anything more on this panel. You can have it if you
want it," he gathered up his brushes and rushed into
the studio. An idea for a picture had suddenly come
to him. This, as the reader may have guessed already,
is the genesis of that deep-sea classic, "Eight Bells."[2]

All of the panels mentioned by Downes are
extant; the first two are now in the Museum of
Fine Arts, Boston (figs. 168–169), and the third
is in the Portland Museum of Art (fig. 170).

When compared to either *Observations on
Shipboard* or *Taking an Observation, Eights Bells* is
remarkable for its considerably greater concentra-
tion of visual interest and increased monumen-
tality. The figures of the two sailors are more
dominant, and the details of the ship and its rig-
ging have been minimized. The man at the left
takes a reading from the sun with a sextant while
his companion focuses his attention downward
on the instrument in his hands (a "chronometer,"
according to Downes). Their purpose, of course,
is to fix the position of the vessel, and the unset-
tled condition of sea and sky suggests that bad

fig. 168. *Prout's Neck, Mackerel Fleet at Sunset,* 1884. Oil on
panel. Henry H. and Zoë Oliver Sherman Fund, Courtesy
Museum of Fine Arts, Boston

fig. 169. *Prout's Neck, Mackerel Fleet at Dawn,* 1884. Oil on
panel. Henry H. and Zoë Oliver Sherman Fund, Courtesy
Museum of Fine Arts, Boston

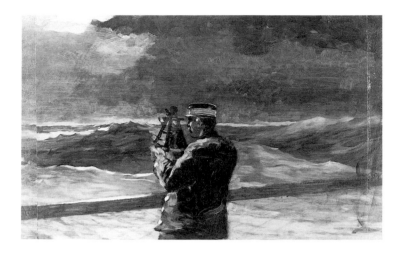

fig. 170. *Taking an Observation*, 1886.
Oil on panel. Portland Museum of
Art, Portland, Maine, Bequest of
Charles Shipman Payson, 1988.55.3

cat. 144

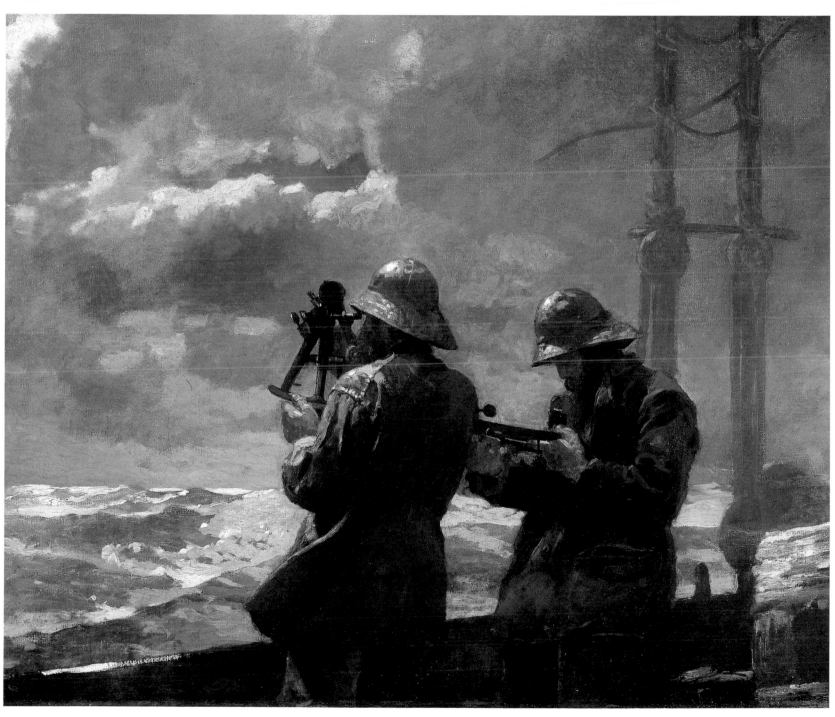

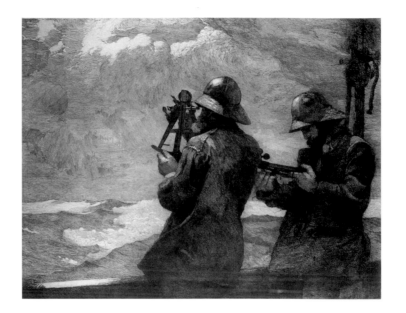

fig. 171. *Eight Bells*, 1887. Etching. National Gallery of Art, Washington, Gift of John W. Beatty, Jr.

weather may have recently prevented them from performing this essential navigational task. As he had done so memorably in *The Herring Net*, Homer chose to depict a moment that was not especially remarkable, but he distilled from it an heroic image. As Downes observed: "There is not the slightest occasion, nor is there the slightest endeavor, to make it appear any more interesting, dramatic, or heroic, than it really is; yet there is something about 'Eight Bells' that grips the mind and the memory, and will not let go."[3] Critics who saw the picture in 1888 also noted the way the painting seemed to transcend mere "realism." *The American* placed the picture among "the productions of men who are dead in earnest, who hate all bunting and shams, and who have taken off their coats in the service of truth and are not ashamed to be found in their shirt sleeves."[4] The critic for *The Art Review* made the comparison between Homer and the "followers of 'realism' and truth-to-nature devotees" even more directly:

In the hands of a "realist" his picture called "Eight Bells," showing a scene at sea of two sailors taking a noon observation with a quadrant at the rail of a vessel, might have been made a "stunning thing," meaning thereby a phenomenal development of hard hands and faces, oil-skin coats, and leather boots, but we are glad for our own sakes that Mr. Homer and not the "realist," painted the picture. For he has caught the color and motion of the greenish waves, white-capped and rolling, the strength of the dark clouds broken with a rift of sunlight, and the sturdy, manly character of the sailors at the rail. In short, he has seen and told in a strong painter's manner what there was of beauty and interest in the scene.[5]

Mariana Griswold Van Rensselaer, long an admirer of Homer, also spoke well of *Eight Bells*, citing in particular "the treatment of the water and the sky" and "the ruder vigor with which the figures are painted."[6] She was, however, even more drawn to the works of one of America's rising stars of the moment: "No pictures in the exhibition, I imagine, can have so attracted the eyes and inspired the praise of artists as Mr. Sargent's two studies of Venetian scenes—one an interior, the other a street perspective [*Street in Venice*, 1882, National Gallery of Art], both with figures in the foreground."

Homer made one of his finest etchings after *Eight Bells* (fig. 171). For the print he made minor adjustments and changes, principally by eliminating some details of the ship's rigging and reducing the amount of sky so that the figures are even more dominant. The painting itself was sold (reportedly for only $400) to Thomas B. Clarke by December 1887, apparently Homer's first sale of an oil since *The Life Line* (cat. 132) was purchased in 1884.[7]

NOTES

1. Carol Troyen, entry on *Eight Bells* in *A New World: Masterpieces of American Paintings, 1760–1910* [exh. cat., Museum of Fine Arts] (Boston, 1983), 333.

2. Downes 1911, 146.

3. Downes 1911, 147.

4. "Three New York Exhibitions," *The American*, 19 May 1888, 74.

5. "Spring Exhibitions of the 'Academy' and 'Society,'" *The Art Review* 3 (July–August 1888), 32.

6. "Fine Arts. The Academy Exhibition," *The Independent*, 26 April 1888, 519.

7. Goodrich 1944a, 100–101.

145. *A Garden in Nassau,* 1885
watercolor, gouache, and pencil on paper, 36.8 x 53.3
(14½ x 21)
Terra Foundation for the Arts, Daniel J. Terra
Collection
Provenance: John S. Ames, Boston; (Berry-Hill
Galleries, New York).
Washington and New York only

145–150

"There is not much danger of anybody losing his way in going to Nassau," observed a writer in 1884. "You take one of the Ward Line steamers from the foot of Wall Street on a Thursday afternoon, and on the following Sunday afternoon you eat your dinner in Nassau."[1] This is precisely what Homer, having received a commission from *Century Magazine* for illustrations for an article on Nassau, did with his father on 4 December 1884.[2] While in Nassau the Homers stayed at the Royal Victoria Hotel, "the largest and finest building in the Bahama Islands...."[3] During the two months he spent on the island Homer executed more than thirty watercolors of a variety of subjects, nine of which would be used in the *Century Magazine* article. Two of those watercolors—*Rest* (cat. 149; reproduced with the title "A Peddler") and *Glass Windows* (cat. 148; called "On Abaco Island")—are included here.

Homer's purpose was clearly to gather as many pictures representative of the scenery of the island and the lives of its citizens as possible, for his watercolors embrace a wide variety of subjects. However, he seems to have been particularly interested in the day-to-day activities of the black inhabitants.[4] There was a substantial African population on Nassau, because English planters had brought slaves to the island to work their plantations. Slavery was abolished in 1834, but the economic conditions of former slaves and their descendants remained extremely

difficult. Several of Homer's watercolors, such as *Rest* and *A Garden in Nassau,* hint at the lingering effects of slavery by showing black figures standing outside the coral limestone walls that typically surrounded white homes, suggesting that they were completely excluded from the world within.[5] In *Native Huts, Nassau* (cat. 147), Homer depicted a thatched house, a style of building that had been transplanted from Africa and that was, according to a contemporary account, "the most sensible house-covering for this climate."[6] Other works show the principal livelihoods of the inhabitants—gathering and selling fruit, sponges, and corals and shells. Only in a few instances, notably *Glass Windows, Bahamas,* which shows "one of the sights of the Bahamas," did Homer paint a subject that would have been common on tourist itineraries.[7]

When Homer showed his first tropical watercolors in New York and Boston in 1885–1886, most reviewers were struck by the new directions they seemed to indicate in his art, although they also agreed they "should not be considered as pictures, but they may be much enjoyed as sketches."[8] And certainly the informal composition and free handling of such watercolors as *Oranges on a Branch* (cat. 146) give it a sense of spontaneity and freshness that is markedly different from works of Homer's English series such as *Inside the Bar* (cat. 128). The critics also admired Homer's new handling of color and light, which showed "vividness and strength."[9] As a writer observed in the *Boston Evening Transcript:* "Native Cabin [probably cat. 147] is sim-

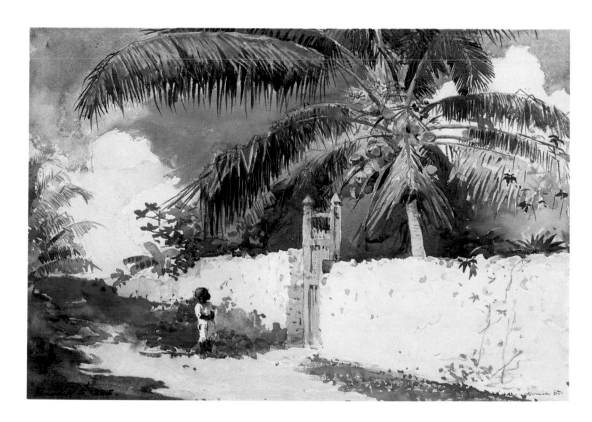

146. **Oranges on a Branch**, 1885
watercolor on paper, 36.8 x 52.7 (14½ x 20¾)
Collection Erving and Joyce Wolf
Provenance: Mrs. Charles S. Homer, Jr.; Mr. and Mrs.
Robert B. Honeyman, Jr.; (Hirschl & Adler Galleries,
New York); Stephen Richard Currier and Audrey
Currier.

147. **Native Huts, Nassau**, 1885
watercolor, pencil, and gouache on paper, 36.8 x 53.5
(14½ x 21 1/16)
National Gallery of Art, Washington, Collection of
Mr. and Mrs. Paul Mellon, 1994.59.20
Provenance: James Ellsworth, Chicago; his son,
Lincoln Ellsworth; (Kennedy Galleries, New York,
September 1866); Mr. and Mrs. Paul Mellon.

cat. 146

fig. 172. *Negro Cabin, Fox Hill, Nassau, Bahama Islands,* 1901.
Photographer unknown. Library of Congress, Prints and
Photographs Division, Detroit Publishing Company
Photograph Collection

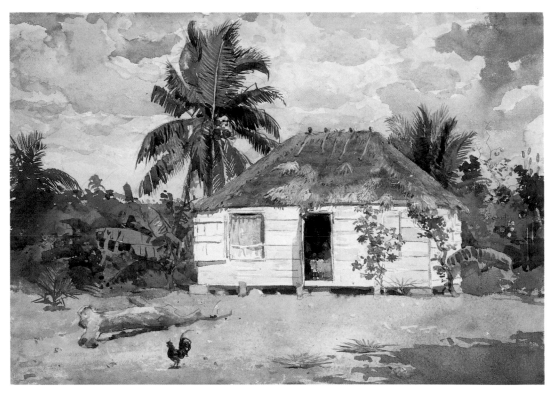

cat. 147

148. *Glass Windows, Bahamas,* 1885
watercolor with pencil underdrawing on paper,
35.4 x 51 (13⁵⁄₁₆ x 20¹⁄₁₆)
The Brooklyn Museum, Museum Collection Fund
and Special Subscription 11.545
Provenance: Executor of the artist's estate, Charles S.
Homer, Jr.
Washington only

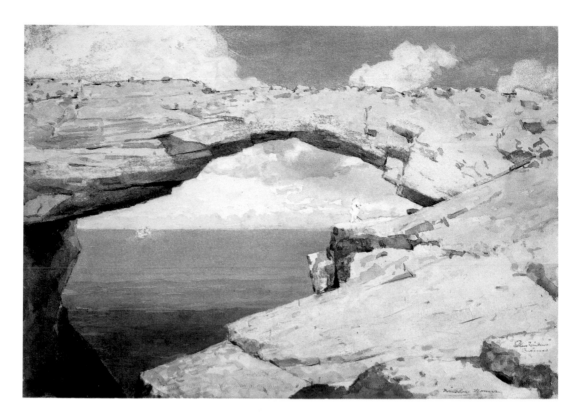

fig. 173. *Through "The Glass Windows."* Engraving.
From Drysdale, "In Sunny Lands," 1885

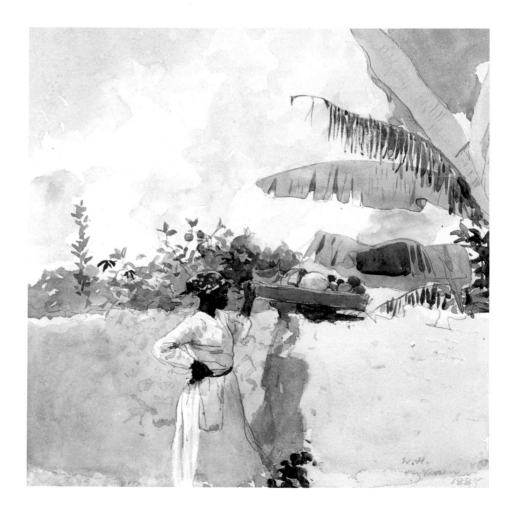

149. *Rest,* 1885
watercolor on paper, 35.6 x 35.6 (14 x 14)
Private Collection
Provenance: (Doll & Richards, Boston, 1886); Martin
Brimmer, Boston; Mrs. Martin Brimmer, Boston;
Mrs. W. Austin Wadsworth, Geneseo, New York;
William P. Wadsworth; (Hirschl & Adler Galleries,
New York).

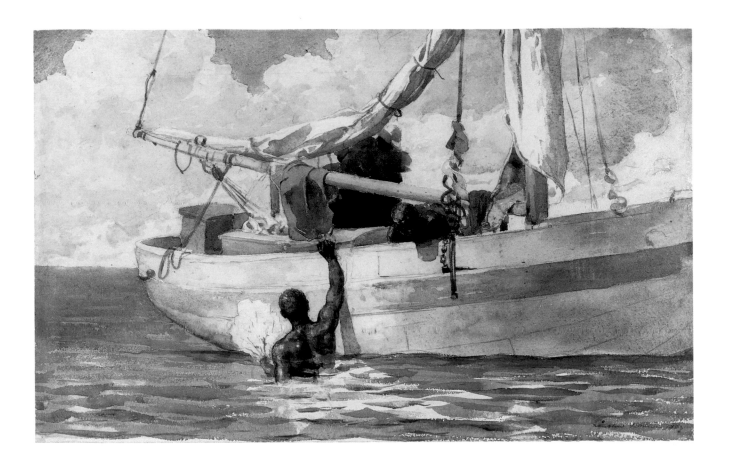

150. *The Coral Divers*, 1885
watercolor over pencil on paper, 33 x 52.7 (13 x 20¼)
Private collection
Provenance: Edward W. Hooper, Boston c. 1886; his
daughter, Mrs. Greely S. Curtis, before 1911.
Washington only

ply flashing with hot, scorching light; the sketch
is most uncompromising, the greens crisp and
living; the thing is full of movement."[10]

In February 1885 Homer left his father in
Nassau and took a five-week trip to Cuba, where
he also painted watercolors. The Cuban water-
colors tended to focus more on architecture than
had those from Nassau and are, in comparison,
less spontaneous and, in general, more labored.
He returned to Prout's Neck in April where,
according to a contemporary report, "he could
keep out of the way of the world, against which
he seems to have a grudge."[11] He returned to
working in oil, completing by the end of the
year his great trio of fishing pictures (see cats.
133–135). He had, however, apparently found his
time in the Tropics a pleasant respite from the
rigors of the Maine winter, for he would return
to tropical sites eight times during his life.

NOTES

1. William Drysdale, "In Sunny Lands: Out-Door Life
in Nassau and Cuba," *Harper's Franklin Square Library,* 18
September 1885, 1. This article first appeared as a series
of letters in the *New York Times* from 22 June to 23 Novem-
ber 1884; see Cooper 1986a, 148.

2. Cooper 1986a, 130. The article, by William C.
Church, "A Midwinter Resort," appeared in *The Century
Magazine* 33 (February 1887), 499–506.

3. "In Sunny Lands," 4.

4. Cooper 1986a, 133.

5. For a brief discussion of Homer's 1885 visit to Nassau
within the larger context of his depictions of blacks, see
Albert Boime, *The Art of Exclusion: Representing Blacks in
the Nineteenth Century* (Washington, 1990), 43–44.

6. "In Sunny Lands," 24.

7. "In Sunny Lands," 4, also includes an illustration of
"The Glass Windows." "A Midwinter Resort," 504, also
mentioned this site: "The ocean works it [i.e., the coral]
into fantastic forms, of which we have an illustration in
the famous Hole-in-the-wall on Abaco Island. This is an
opening in the calcareous rock, through which the set-
ting sun, blazing in its tropical majesty, at times produces
a picture leaving an impression never to be effaced."

8. Undated clipping, probably from *The Boston Advertiser*
(scrapbook, Bowdoin).

9. M[ariana]. G[riswold]. Van Rensselaer, "Pictures of
the Season in New York," *The American Architect and
Building News,* 20 February 1886, 89.

10. "Art Notes. Winslow Homer at Doll & Richards,"
Boston Daily Evening Transcript, 25 February 1886.

11. *Lewiston Journal,* quoted in "Art and Artists," *Boston
Daily Evening Transcript,* 11 May 1885.

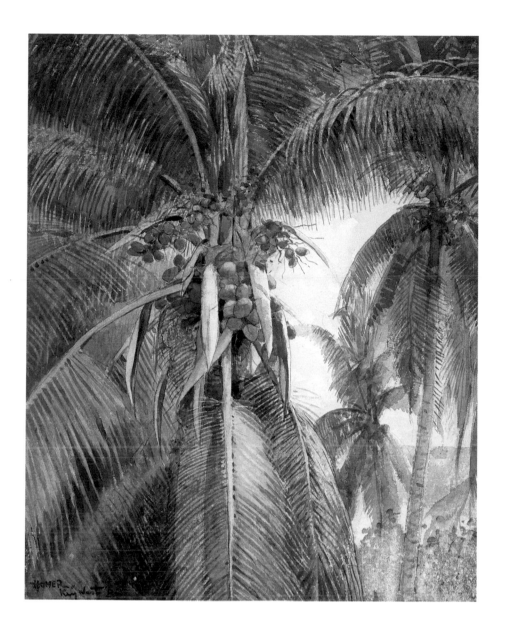

151–154

Homer made his second visit to the Tropics in December 1885 when he traveled to Florida, where he would remain through February 1886.[1] He probably first stayed in Tampa, where he executed several watercolors (for example, cat. 152) depicting Spanish moss draped from trees. Soon after he went to Key West, where he painted the close-up view *Coconut Palms, Key West* (cat. 151) and *Under a Palm Tree* (cat. 153).[2] All told, Homer is thought to have executed about a dozen watercolors while in Florida in 1885–1886.

As Cooper has noted, most of the subjects he chose—"coconut palms, alligators, exotic birds, live oaks, hurricane-swept palms, palmetto jungles thickly hung with Spanish moss, distant views of Key West, women under palms, and Indians in the swamps"—were all also common subjects for description in popular guidebooks

to the state.[3] However, if his subjects were not in themselves unusual, Homer's Florida watercolors were notable for the wide range of techniques he employed in them.[4] In January of 1887 Homer sent two of his Florida watercolors (one was *Thornhill Bar,* 1886, Museum of Fine Arts, Boston; the other, a Key West subject, is unidentified) to the American Watercolor Exhibition in New York, where they reaped generally negative reviews. As the critic for *The Nation* observed: "Mr. Homer, who has at other times overtopped his contemporaries at these exhibitions, this year only sends some unimportant and not particularly attractive sketches in Florida."[5]

Homer returned to Florida in February 1890, this time to the fishing community of Enterprise, on the St. Johns River. Although his primary activity was fishing, he also admired the scenery, telling his patron Thomas B. Clarke that Enterprise was "the most beautiful place in Flor-

152. *At Tampa,* 1886
watercolor on paper, 35.6 x 50.8 (14 x 20)
Canajoharie Library and Art Gallery
Provenance: Charles Homer; the Homer family, by
descent; (Macbeth Gallery, New York, 1941).

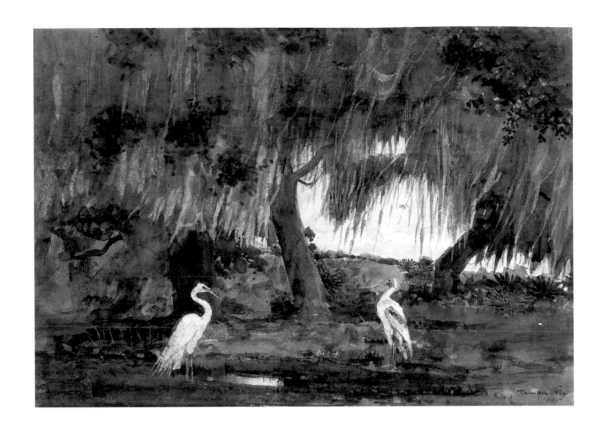

153. *Under a Palm Tree,* 1886
watercolor on paper, 38.3 x 30.9 (15 ⅟₁₆ x 12⅛)
National Gallery of Art, Washington, Gift of Ruth
K. Henschel in memory of her husband, Charles R.
Henschel, 1975.92.16
Provenance: Thomas B. Clarke; (American Art Associ-
ation, New York, 17 February 1899, no. 310). Franklin
Rockefeller, Cleveland, Ohio; Alice M. Rockefeller;
Charles R. Henschel; his wife, Ruth K. Henschel.
Washington and Boston only

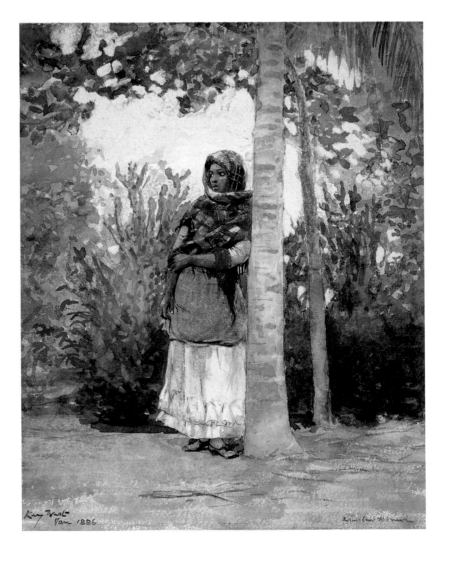

244

154. *St. Johns River, Florida,* 1890
watercolor on paper, 34.3 x 50.5 (13½ x 19⅞)
The Hyde Collection Trust
Provenance: Charles S. Homer, Jr.; Mrs. Charles S.
Homer, Jr.; Arthur P. and Charles L. Homer;
(William Macbeth, Inc., New York, 1938); Charlotte
Pruyn Hyde, 1938.

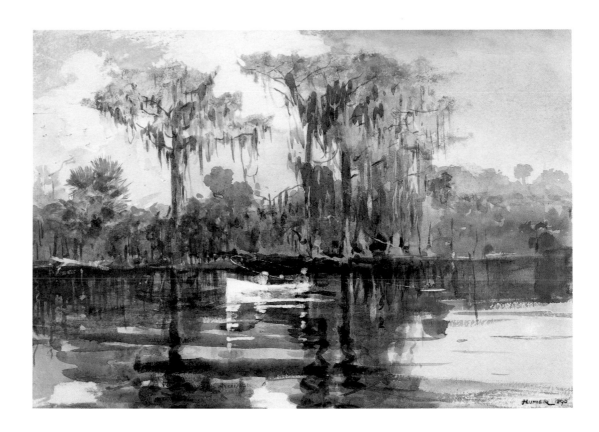

fig. 174. *Blue Spring, Florida,* 1890. Watercolor. National
Gallery of Art, Washington, Gift of Ruth K. Henschel in
memory of her husband Charles R. Henschel

ida."[6] Many of the approximately one dozen
watercolors he painted while there, such as *St.
Johns River, Florida* (cat. 154) show fishermen in
small boats. At their best, these watercolors are
notable for their fluid washes and delicate har-
monies of color. In other instances, as in *Blue
Spring, Florida* (fig. 174), which, though signed
and dated, was clearly left unfinished, and *Palm
Trees, Red* (1890, National Gallery of Art), which
the artist presumably cut down, Homer seems
to have encountered difficulties in resolving
technical and aesthetic problems.

Homer made four more trips to Florida, but
only during his visit in the winter of 1903–1904
did he create watercolors (see cats. 219–224).

NOTES

1. See Cooper 1986a, 151–152; as Cooper notes, neither
the exact dates nor precise itinerary of Homer's 1885–
1886 trip are known.

2. Downes 1911, 130, listed *Under a Palm Tree* with
Homer's works from Nassau in 1885; however, it is clear-
ly inscribed "Key West/Jan 1886" at the lower left.

3. Cooper 1986a, 153–154; "It is, in fact, relatively easy
to find prose equivalents for most of Homer's 1885–1886
Florida images."

4. Cooper 1986a, 156.

5. "Fine Arts. The Water-Color Exhibition," *The Nation*
44 (10 February 1887), 128.

6. Letter of 16 February 1890 (Archives of American Art;
quoted in Hendricks 1979, 201).

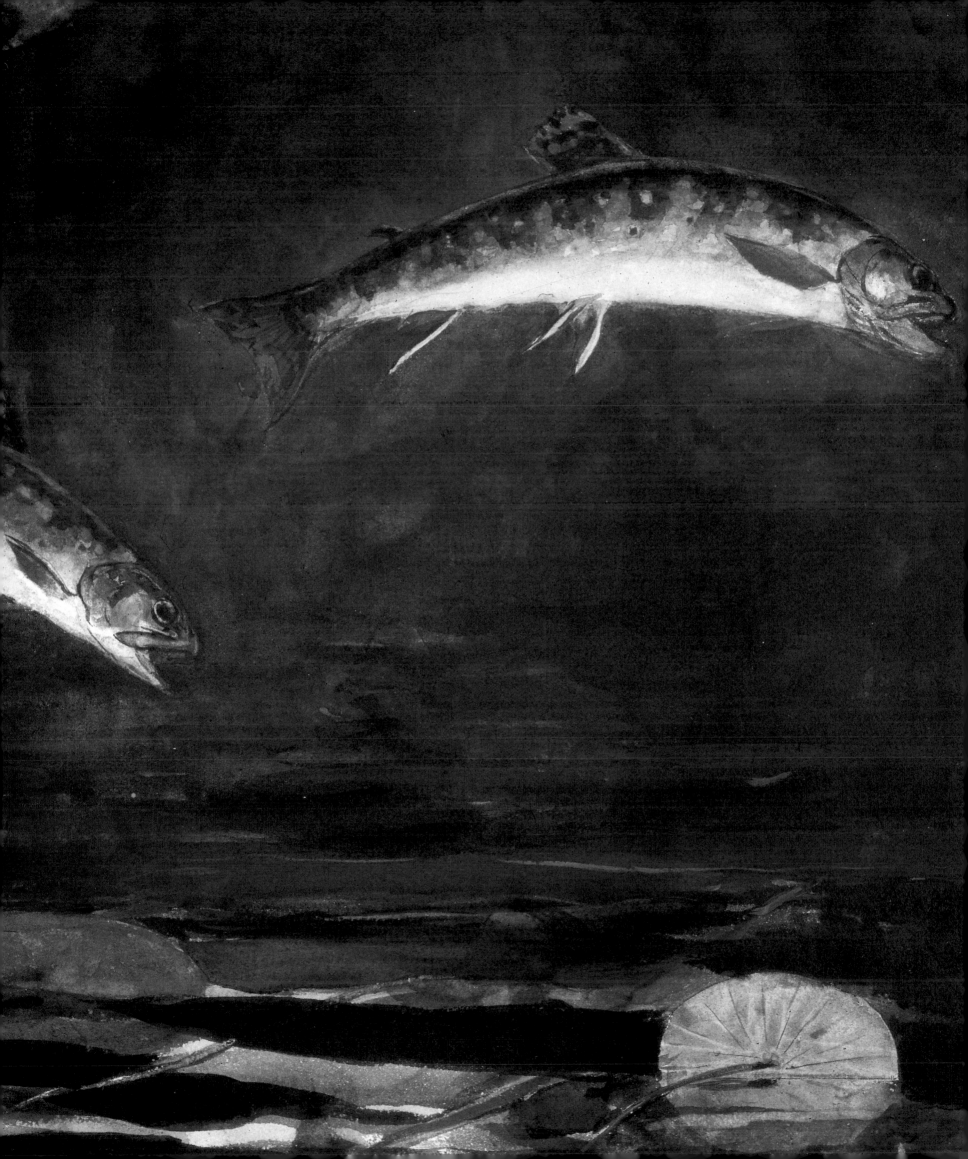

Something More than Meets the Eye

Nicolai Cikovsky, Jr.

By 1890—perhaps a little earlier, but no later—Homer's art entered a new stage. In that year, Homer painted the first of his Maine seascapes (cats. 186–187), which his contemporaries considered his greatest paintings (in another form of admiration, they were also his most widely imitated works).[1]

By this time, the pattern of Homer's life had become fixed. In 1883 he had settled at Prout's Neck, where he lived, mostly alone, for the rest of his life. In December 1884, he had made the first of many trips to the Tropics (Cuba, the Bahamas, Florida, Bermuda) and in 1889 began traveling to the North (the Adirondacks and Canada).

He had determined by about 1890 upon the mediums in which he would work, confining himself to watercolor and oil, and in each case with a degree of purity that he had not observed earlier. Watercolors were now reserved for the recording of fleeting effects and—because watercolor was more portable—the transient experiences of travel. Their technique, consisting of boldly applied transparent washes of pigment, liberal areas of reserved white paper, and only the slightest armature of drawing, approaches absolute purity. And they were painted very much for the marketplace, "something I can sell for what people will give"[2]—"goods," as Homer liked to call them, adopting (only partly as an affectation, for he was, after all, raised in a business family) the language of commerce, which he himself took an active role in merchandising. In 1903, he wrote Knoedler, his New York dealer, "As I shall go up [to Canada] for the spring fishing I will take my sketch block & will give you a full line of goods for the next season."[3] And for another New York dealer he went so far as to prepare the text of an advertisement "for publication in the Sporting papers" of his first exhibition of Adirondack watercolors: "To Flyfisherman & Sportsman / On exhibition Feby [sic] 6th to 12th / a small collection of Watercolors / taken in the North Woods, by / Winslow Homer N.A. and / treating exclusively of fish & fishing / Reichard & Co. / 225 Fifth Ave."[4]

Homer's oils, on the other hand, were consistently larger than his watercolors, and they were reserved for subjects of more serious, pondered, and universal meanings. (When he referred to his watercolors as "sketches," as he often did, it was not to indicate their preparatory or provisional character so much as, in the way the sketch had conventionally been understood, their station, that is, their lack of any claim or pretension to "higher" deliberated meanings.) In contrast to his watercolors, which more or less directly captured observed experience—in the latest of them (cats. 219–220) almost purely *optical* experience, conveyed as almost purely optical sensation—he painted his later oils in the studio over long periods of time and with much deliberation, so much so that by 1897, in contrast to an artist like A. T. Bricher who painted from nature, Homer was considered "a studio painter."[5] As "oily" as his watercolors were watery, the richly worked surfaces of his paintings assert the special and essential properties of their more tactile medium as his watercolors did their fluid one. ("[H]e sometimes loads the canvas with paint so that parts of the subject appear, in a bad light, to be modeled rather than painted," a critic observed in 1898.)[6] He involved himself in the marketing of his oil paintings (chiefly by peppering his dealers with advice on how to sell them), but, realizing how difficult they were to sell, and able at the same time to live by his watercolors, made fewer of them: "My work for the past two or three years has been mostly in water colors," he said in 1900. "I have…paid expenses in that way, while I have at times painted an oil picture."[7] He made his oil pictures for a different audience. In 1901 he suggested that Knoedler's try to sell *Maine Coast* (cat. 195) to "public institutions," and in 1902 proposed that his Chicago dealer, O'Brien & Son, offer *The Gulf Stream* to the Layton Gallery in Milwaukee

or to some other public gallery, because "no one would expect to find it in a private house."[8] In 1894, *Fox Hunt* (cat. 230), one of the largest and, in terms of the uningratiating grimness of its subject (but only in those terms), least private of Homer's oils, appropriately became the first to enter a public collection, the Pennsylvania Academy of the Fine Arts in Philadelphia. The public character of Homer's late oils about 1890 was recognized in another way, for his name, along with Edwin Austin Abbey, Frederick Bridgman, Kenyon Cox, Francis Millet, Howard Pyle, and others was included on a list of American artists proposed to execute murals for the main hall of McKim, Mead, and White's new Boston Public Library (for which, however, he was not chosen).[9]

And in 1890, too, Homer painted, and in 1891 exhibited, *The Signal of Distress* (cat. 155). It was probably intended to join the series of heroic paintings—*Coming Away of the Gale*, *The Life Line*, *The Herring Net*, *Fog Warning*, *Lost on the Grand Banks*, *Eight Bells*, and *Undertow*—that constituted his most serious artistic undertaking of the 1880s. Like *The Life Line* and *Undertow*, particularly (or the still earlier English watercolor, *Wreck of the Iron Crown*) (cats. 132, 136, 112), *The Signal of Distress*, in which a boat's crew rushes to man a lifeboat to assist a ship in distress, was another depiction of heroic rescue—or would have been had Homer left it in its original state. But he did not, and instead of being one of his heroic paintings, it became the first of his tragic ones.

In 1892, Homer drastically revised *The Signal of Distress*, as is evident in a comparison of the painting's present form to its first state as seen in an 1890 photograph (fig. 175). Of the many changes he made, such as the removal of the ship's railing and rigging, the one that most profoundly affected the painting's meaning was his alteration of the boat in the distance. Originally it was under full sail. After Homer's revisions it became an unpowered and uncontrollable derelict without sails or masts, bearing a tattering flag of distress, but otherwise showing no signs of life. By that change, an event of heroic rescue was transformed into one in which the mortal fate of the boat has been decided beyond the power of human agency, however heroic, to influence its outcome; one in which hope has given way to despairing hopelessness.[10]

Throughout his career Homer often rethought and revised paintings after finishing and exhibiting them. But there is no major painting, no painting of the ambition of *The Signal of Distress*, that he left as unresolved. And he dated it "1892–'6," less to certify its completion than, by recording how long he worked on it without resolution, its incompletion. His difficulties may have been formal or they may have been technical, but were rooted most of all, surely, in the failure, finally, to recast a painting conceived in a heroic mold successfully into one of tragic fatality. That would remain for another painting of a helplessly drifting boat to do: *The Gulf Stream* of 1899 (cat. 231).

In *The Signal of Distress* there are two things new to Homer's art, which appear in it for the first time about 1890: one is a sense of fatalism and futility, of uncontrollable destiny and human powerlessness; the other is an attitude of retrospection, of looking back at his own life, and, inseparable from that, of introspection, a looking inward. *The Signal of Distress* is Homer's first distinctly retrospective painting. It is the first in which he delved into his artistic past for its principal pictorial parts. The lifeboat in davits, the painting's main motif, is taken directly from a splendid drawing made on the *Parthia* on his trip to England in 1881 (cat. 158 and Chronology 1881). The figures rushing to answer the distress signal, not quite as directly, are from preparatory drawings for *The Wreck of the Iron Crown* (cats. 113–114), which suggest a thematic connection with that earlier subject and even a reconsideration or resumption of it. Homer often reused his earlier sketches. Yet the temporal distance between a painting and the experience which inspired it, in this case nearly a decade, had never been as great; never had that inspiration been as derivative and indirect, and never had it been so largely located in his past.[11]

What entered Homer's art in the 1880s and grew to a sense of tragedy in the 1890s was a consciousness—pervasive though never obsessive—of mortality: that of the fishermen and their families at Cullercoats (more so even, so far at least as Homer was concerned, than had the lives of soldiers during the Civil War), and that of his mother, whose death in 1884 touched him deeply and directly. Her death seems to have forced upon his consciousness or implanted in his unconscious a keen sense of his own mortality. On the eve of his sixtieth birthday, a number of years later, he reflected in a letter to his brother Charles: "I suppose I may have fourteen more (that was mother's age 73 years), and what is fourteen years when you look back."[12] (The subject of helplessly drifting boats that entered his art soon after his mother's death [figs. 229–230] may have been a symbolic response to it, and, if so, may help to explain the abandoned boat that emerged during the revisions of *The Signal of Distress* that preceded and ended on the year of his sixtieth birthday.)[13]

For someone who was described (in 1888) as "big, strong, clear-eyed, and simple of speech" (although he was in fact "a slender and smallish figure"),[14] and of whom it was said "of all the men in our art [he] does the greatest honor to the magnificent aphorism, 'The style is the man,'"[15] Homer's paintings, always strong, were seldom simple. For someone who could be gruff and abrupt to the point of rudeness, his paintings were seldom blunt and forthright, straightforward and aboveboard, but more often oblique and ambiguous.

One way in which he achieved obliqueness and ambiguity was by the disruption of narrative. In a particularly clear but by no means singular example, *Watermelon Boys* (1876) originally contained the irate figure of the melon patch owner who has caught the boys in their thievery, and whose appearance, or the expectation of it, accounts for the fear of the kneeling boy (fig. 177). But Homer later removed the figure of the farmer, leaving the boy's anxiety teasingly and suspensefully unaccounted for and the narrative outcome in doubt (fig. 176). In both *The Nooning* of c. 1872 (cat. 43) and *Boys in a Pasture* of 1874 (cat. 45), he similarly deleted the objects of the

LEFT: fig. 176. *Watermelon Boys*, 1876. Oil on canvas. Cooper-Hewitt, National Design Museum, Smithsonian Institution (1917–14–6). Art Resource, New York

RIGHT: fig. 177. After Winslow Homer. *Watermelon-Eaters*, 1876. Engraving. In Sheldon 1878, 225

fig. 178. *The Lookout—"All's Well,"* 1896. Oil on canvas. Courtesy Museum of Fine Arts, Boston, William Wilkins Warren Fund

boys' attention, with in each case, as a comparison to related wood engravings shows (cat. 44, fig. 90), consequences of ambiguity that were surely deliberate.[16]

Homer's obliqueness also took the form of the transference of his own feelings to surrogate figures, particularly, beginning about 1890, by the transposition of human conditions, like mortality, to animals. He would "repeatedly make the viewer confront a living creature that is about to die,"[17] as in the *Fox Hunt* of 1893, and in the almost visionary experience of his mortality enacted by the two ducks at the instant of their death in *Right and Left* (cat. 235), painted the year before his own.

The transposition of human feeling and meaning into something else is also, one suspects, the essential component of meaning and expression in his late seascapes, as it is, too, transferred to an Other, in *The Gulf Stream* of 1899.[18]

None of Homer's late paintings exemplifies quite as well as *The Gulf Stream* a refusal to yield meanings, whatever they might be, to conventionally satisfying narrative explanations or interpretive strategies. *The Gulf Stream* clearly baffled Homer's contemporaries, prompting his dealer, Knoedler, to intercede in their interest and ask for a description of its subject: "[I] regret very much that I have painted a picture that requires description," Homer replied. "You can tell these ladies that the unfortunate negro who is now dazed & parboiled will be rescued & returned to his friends and home & ever after live happily—."[19] By the heavy sarcasm of his response, however, Homer made it perfectly plain that he did not regret in the slightest the inexplicability or impenetrability of his painting, at least for those concerned only to know its story.

The obliqueness, evasiveness, and ambiguity of Homer's major oil paintings beginning in the 1890s may be no more than the extension into his art of the jealously protected privacy that encompassed every aspect of his later life. Yet these paintings are remarkably congruent with the property of suggestiveness that was the principal artistic condition and expressive device of fin-de-siècle symbolist poetry and painting. Like the symbolists, who sought in enigma and imagination a refuge from what they regarded as the discredited certainties of nineteenth-century realism, materialism, and science, Homer similarly sought refuge from the present. He sought it imaginatively in his own past, and, of course, he sought it physically in the remoteness of Prout's Neck, where he lived miles from the railroad and telegraph and without such conveniences as electricity, the automobile, and the telephone.[20] By the 1890s, symbolism was international and transatlantic in its reach, so that these congruences are, perhaps, not entirely coincidental.[21] In a discussion of Homer's *Lookout* of 1896 (fig. 178), the aroma of symbolism is unmistakable. "Mr. Homer has never felt obliged to ignore, in his devotion to paint, the poetic suggestiveness of a subject," a critic observed; Homer himself said *The Lookout* was "unexpected and strange" and not to be "understood by any but myself."[22] The critic continued, "There is here 'something more than meets the eye,' but the eye is none the less satisfied," and then added, "Our budding symbolists might take a hint from this."[23]

About 1890, Homer's preoccupation with mortality in nature, particularly as a figuration (or prefiguration) of his own death, became more insistent and its expression more intense. This happened in the watercolors he painted in the Adirondacks of upstate New York in 1889. Since his prodigiously productive time in England, Homer made watercolors hesitantly and fitfully. There are almost no successful Prout's Neck watercolors—"In water-colors one does not look for the grand style," a critic wrote in 1879, and the grand style, as Homer quickly came to recognize, was exactly what the life and landscape of Prout's Neck demanded[24]—and not many more fully successful early tropical ones, though some are splendid. But in the Adirondacks beginning in 1889, Homer reached a level of creative energy and expressive urgency comparable to, if not greater than, what he experienced earlier in England, and before that in his first summer at Gloucester.

Homer went to the Adirondacks to fish (he was a member of the North Woods Club, near Minerva), and fishing subjects make up a large part of his Adirondack watercolors. In them, fish leap for insects or for the bait; fishermen cast lines in the glassy stillness of early morning or evening calm; whipped arcs of fishing lines (sometimes incised through the pigment into the white paper with the point of a pen knife that, in the speed and deftness of its gesture, mimics the action it depicts); the water's dark surface is broken by cast flies, leaping fish, or landing insects (breaking the surface of the pigment and paper by scraping as the surface of the water itself is broken); rising fish are suspended in mid-air.

Homer painted a series of leaping fish. By their opulent color, exquisite design, and ability "skillfully to suggest motion," they avoided, one critic believed, "that curiously base quality which

nearly always characterizes 'sporting' pictures of all kinds."[25] But these were the same ones, "treating exclusively of fish & fishing" and painted in the heyday of sport fishing and outdoor recreation in America, to which Homer directed the particular attention of "Flyfisherman & Sportsman," just as he may have had that market in mind also for the deer-hunting watercolors he painted at the same time. These paintings of "a fishing & sporting character," as he later described some of his Canadian watercolors,[26] are rescued from being mere "sporting pictures" not only by their extraordinary artistic quality—as a group they are, perhaps, Homer's most unexceptionally beautiful watercolors—but by their expressive power. For, disguised by their "fishing & sporting character," they are some of the most compassionate, poignantly moving, and even indignant paintings he ever made.

Beginning in the 1870s, the Adirondacks teemed with those, like Homer, who fished and hunted for sport and recreation. But others profited from them in a different and more literal way. Deer were taken not only for sport, but were killed for meat and for trophies by commercial "pot" and "market" hunters. Many of Homer's most forceful watercolors depict, almost step by step, the brutal method of "hounding" deer to death by using dogs to drive them into water where they could easily be drowned or shot by hunters waiting in boats (cats. 168–172).[27] After the Civil War, the Adirondacks were depleted by commercial logging (cats. 181–185). A number of Homer's watercolors depict that profligacy and, by their deforested slopes and rotting trees and stumps, its legacy of destruction and depletion (cat. 177).

Homer also painted the human denizens of the Adirondacks—guides, hunters, trappers, woodsmen—often with heroic strength and dignity and in solemn moments of communion with the land in and from which they lived (cats. 163, 182). But, at the same time, he often depicted their uncaring cruelty to life and nature with an intensity of feeling that charged many of his Adirondack paintings, despite their great beauty, with indictments of their inhumane savagery. Dislodged by an aroused conscience from his posture of ironic distance, he was moved to make some of the most touching, angry, and overtly critical paintings of his life; on the back of *The Fallen Deer* (cat. 175), filled by outrage greater than his image alone could fully express, he wrote, "just shot. A miserable [illegible word] Pot hunter."[28]

Some commentators on the watercolors of leaping trout sensed beneath their immense artistic beauty the cruelty in the sport they depicted—the fish "leaping finely out of the water in pursuit of the glittering bait or because they are already cruelly hooked," as one of them wrote, deceived, as another said, by the "cruel hook" concealed by feathered lures.[29] Prompted by a reproduction of a Homer watercolor, one of them, in words whose meaning would have been plain to almost anyone by about 1890, invoked the process of natural selection and the struggle for survival that were central principles of Darwinian evolution: "He [the trout] is decidedly carnivorous, and following the order of nature, he is bold, strong, and aggressive."[30]

The Darwinian "order of nature"—in the medium, oil, in which he expressed his largest ideas and deepest feelings, and on a scale that, for Homer, approached monumentality—is what *Huntsman and Dogs* and *Hound and Hunter* are about. Like those in a number of his Adirondack paintings, the figure in both works is an actual person, Michael Francis "Farmer" Flynn (fig. 179).[31] But in these paintings he represents something greater than his own identity, something that connects him and the images he inhabits to an idea that touched, tinctured, and transformed virtually every aspect of the intellectual, cultural, and political life of the late nineteenth century. The bloody trophies that the hunter carries (skin and horns, the most saleable parts of the deer; in a related watercolor, *Guide Carrying a Deer* [cat. 177],[32] he carries an entire carcass), or the deer he drowns (or has already drowned or shot);[33] the whitened stumps of cut trees; the wildly baying dogs; the hunter's coarse and brutal features; and even Homer's name signed as though in blood on the tree stump at the right of *Huntsman and Dogs*, all combine to express a state of almost animal savagery and barbarism.

Other of Homer's late works can in certain ways be associated with the evolutionary theories of Charles Darwin. Some of the heroic oils of the 1880s, for instance, such as *The Herring Net*, *Fog Warning*, *Lost on the Grand Banks*, or *Eight Bells*, in which anonymous figures are engaged with a kind of instinctual intensity in a struggle the outcome of which is never quite certain, seem to exemplify the random, blind, uncaring processes of Darwinian evolution, or the seascapes of the 1890s and after in their ceaseless enactment of conflict and change. *Huntsman and Dogs* and *Hound*

fig. 179. *Portrait of Michael Francis "Farmer" Flynn* (right).
Photograph courtesy of Adirondack Museum

and Hunter, however, are more truly Darwinian. More directly, less metaphorically, they address the most deeply disturbing of Darwin's ideas, the descent of man from lower forms of animal life. Both paintings reflect the widespread fascination, nurtured by Darwin's theories of human development, with humanity's earlier stages and the supposed survivors of those stages—Hottentots, aborigines, American Indians—that were the link, it was believed, between civilized man and his animal ancestors. *Huntsman and Dogs*—the hunter, a critic said, "low and brutal in the extreme"[34]—and *Hound and Hunter* do not in this respect simply depict morally reprehensible ways of hunting deer in the Adirondacks. Suggesting by his savagery and somewhat simian appearance that the hunter is atavistically linked to a level of human development below that of civilized man—by placing him, that is, on an evolutionary scale—Homer casts upon these images the light of the greatest and most ramified issue of his time. (Among its ramifications was the "criminal anthropology" of Cesare Lombroso that became widely influential in the 1890s. Criminality, Lombroso claimed, was atavistic, a throwback to a savage state identifiable, he and his many followers believed, by such apish "stigmata" as long arms, large jaws, low and narrow foreheads, and darker skin. That these traits of appearance are visible in Homer's hunter would type him, according to Lombroso's theory, as a criminal.)[35]

Homer was by no means alone in his artistic Darwinism around 1890. Among other manifestations of it are the *Prehistoric Hunter* that DeWitt Lockwood exhibited at the National Academy of Design in 1891, the year Homer painted *Huntsman and Dogs;* George de Forest Brush's *Celtic Huntress,* painted in 1890; *The Stone Age in America,* by the Philadelphia sculptor John J. Boyle,

erected in Fairmont Park in the early 1890s;[36] and subjects of primitive Darwinian struggle that the French sculptor Emmanuel Frémiet made about 1890, such as *Orang-outang and a Savage of Borneo* and *Man of the Stone Age Struggling with a Bear*, both for the Musée d'Histoire Naturelle in Paris, and his earlier work, *Gorilla Carrying Off a Woman* (the last two were known in America and possibly, therefore, known to Homer at the time he painted *Huntsman and Dogs* and *Hound and Hunter:* they were illustrated by Theodore Child, in his article, "Living French Sculptors," published in the *New York Sun* in February 1891); and Frémiet's American student, Paul Wayland Bartlett, exhibited his *Bear Tamer* in the Paris Salon of 1887.

Homer's greatest Darwinian painting, arguably his greatest painting of any kind (and his largest), was not an Adirondack subject, though it was rooted in the Darwinian struggle that Homer seems first to have experienced as such in the Adirondacks. *Fox Hunt* was painted at Prout's Neck in the winter of 1893 (by the artifice, John W. Beatty reported, of placing the skin of a fox over a barrel put in the snow outside his studio to get the color and color relationship right).[37] Desperately searching for food—the meager sprig of red berries or wild rosebuds toward which it drags itself through the deep snow of a hard Maine winter—a fox, in an inversion of the natural order, is attacked by crows who have become predatory from hunger. That is the painting's subject, its story, what critics wrote about. But Homer's contemporaries were capable of reading beneath its nominal subject and equipped to see it, as Homer surely intended it to be seen, as something more— as an image of survival (not necessarily of the fittest) in its most primal form, of "nature, red in tooth and claw," in Tennyson's phrase that was often borrowed to describe the struggle of Darwinian evolution.[38]

But in addition to such meanings as these residing in the realm of shared culture and public discourse, Homer, with deep seriousness and an off-putting wit that was its disguise, indicated the presence of others in the privacy of his inner life. He did so, as he had done in a variety of ways throughout his career (most recently in *Huntsman and Dogs*), by using the location and sometimes the form of his signature as a means of often witty and playful, but never completely innocent self-revelation.[39] There is, for example, the early engraving, "Tenth Commandment," published in *Harper's Weekly* on 12 March 1870 (fig. 180). The text of the commandment is printed as its caption: "Thou shalt not covet thy neighbor's house, thou shalt not covet thy neighbor's wife [as she is in fact being coveted by a man not greatly unlike the young Homer in appearance], nor his servant, nor his maid, nor his ox, nor his ass, nor any thing that is his." Homer put (or more painfully branded?) his signature on the ass in the upper-left roundel. Earlier, in a Paris subject,

fig. 181. After Winslow Homer. "Art-Students and Copyists in the Louvre Gallery, Paris." Wood engraving. In *Harper's Weekly*, 11 January 1868

"The Morning Walk—The Young Ladies' School Promenading the Avenue" in *Harper's Weekly* of 28 March 1868, he placed his initials on an *affiche* advertising "Le roman d'un jeune homme pauvre / Comedie en cinq actes," while, in another French subject, "Art-Students and Copyists in the Louvre Gallery, Paris," *Harper's Weekly*, 11 January 1868, he put his initials in the upper-left corner of a still-unfinished copy which is, nevertheless, easily discernible as a painting of *Christ Bearing the Cross* (fig. 181). And in "The Beach at Long Branch," *Appleton's Journal*, 21 August 1869, in a clear reference to her inconstancy, a girl has inscribed Homer's initials in the sand with the tip of her parasol (fig. 218). Homer's signature in the lower left of the *Fox Hunt*, sinking like the fox into the deep snow and exactly mimicking its form and action (the serif of the "H" extends forward like the fox's left leg, and the long, thick tail of the "R" trails at the rear like the fox's) is another case, later and more exalted, of that kind of oblique self-disclosure. Thomas B. Hess, who interpreted the painting in Freudian terms (but did not notice the form of the signature), called the fox a self-portrait of Homer,[40] and in some real sense it must be (as artists' self-portraits typically do, it contains a brush; that is what a fox's tail, which Homer mimicked by his signature, is called). Perhaps it was the fox's fabled slyness that he identified with or took as the attribute of his own artistic cunning. Or, identifying with the fox as, in the words of a perceptive contemporary critic, a vagabond and outcast,[41] perhaps he took it as the emblem of persecution and neglect and his perceived sense of social and artistic alienation (this despite the critical praise that was routinely accorded him, the honors he received, and the financial security he enjoyed in his later years). Or perhaps, in the tradition of artists' self-portraits that often included skulls or other more forceful reminders of death and the transience of human life (as in, for example, Arnold Böcklin's *Self-Portrait with Death as a Fiddler* of 1872, fig. 182), the black crows represent in a similarly symbolic way, as they mean narratively, the ominous presence and tragic certainty of death.

NOTES

1. See Robertson 1990.

2. Letter to Charles S. Homer, Jr., September 1887 (quoted in Goodrich 1944a, 101).

3. Letter to M. Knoedler & Co., Scarboro, Maine, 30 March 1903 (M. Knoedler & Co.).

4. Letter to Reichard & Co., Scarboro, Maine, 19 January 1890 (William T. Evans papers, Archives of American Art). In 1905 he wrote Knoedler, "It would not be a bad idea for you to notify me if any of the watercolors sell— as I could replace them with a *higher class goods* if I had any encouragement to do so—So far in New York everything has been in favor of cheapening the article—like cigars—'two for five.'" Letter to M. Knoedler & Co., Scarboro, Maine, 14 April 1905 (M. Knoedler & Co.).

5. William S. Barrett in Jeffry R. Brown, *Alfred Thompson Bricher* [exh. cat., Indianapolis Museum of Art] (Indianapolis, 1973), 12.

6. "The Fine Arts. Paintings by Inness and Homer," *The Critic* 29 (9 March 1898), 201.

7. Letter to George G. Briggs, August 1900 (quoted in Goodrich 1944a, 163).

8. Letter to M. Knoedler & Co., Scarboro, Maine, 7 December 1901; Letter to O'Brien & Son, 20 March 1902 (quoted in Downes 1911, 149).

9. Augustus Saint-Gaudens to Charles McKim, in "Saint-Gaudens the Master. The Reminiscences of Homer Saint-Gaudens," *The Century* 78 (August 1909), 623. For a discussion of the decoration of the Boston Public Library (which does not mention Homer), see Walter Muir Whitehill, "The Making of an Architectural Masterpiece," *American Art Journal* 2 (Fall 1970), 13–35.

10. The British painter Clarkson Stanfield's *The Abandoned*, exhibited at the Royal Academy in 1856, "showed a broken hulk bobbing helplessly on its side in a rough sea, all trace of human life vanished." Later, Augustus Egg included a print of it in his triptych *Past and Present* "as a symbol of hopelessness" (Julian Treuherz, *Victorian Painting* [London, 1993], 70).

11. In the 1880s, to be sure, Homer reused his Civil War sketches to make illustrations for *The Century* magazine's series, "Battles and Leaders of the Civil War," but that is a different matter entirely.

12. Letter to Charles S. Homer, Jr., 21 February 1895 (Bowdoin). His estimate was eerily accurate; he died in 1910.

13. From this perspective, a toy boat with Homer's initials on its sail, floating safely in a water trough—in the engraving "Spring Blossoms" in *Harper's Weekly* (21 May 1870)—is a clear example of his identification with that image.

14. Harrison Morris, *Confessions in Art* (New York, 1930), 62. Homer's passport application gave his height as five feet seven inches.

15. "The Connoisseur. Among the Pictures," *Town Topics* 19 (2 February 1888), 12.

16. The dog in *The Nooning* has reappeared. Conservators have seen no evidence of deleted figures in either *Watermelon Boys* (see Wood and Dalton 1988, n. 190) or *Boys in a Pasture*. In the case of *Watermelon Boys (Farmer's Seed Melon)*, however, a contemporary description clearly indicates that the figure was originally there: "Winslow Homer sent an effective picture, entitled 'The Farmer's Seed Melon.' A party of roguish boys have invaded a melon patch and stolen one of the seed melons. The boys are stretched out on the grass in a neighboring meadow lot and feasting on their stolen fruit when the old farmer, who is supposed to own the melon patch, makes his appearance at the lane gate and brandishes a club at the juvenile marauders" ("Art. Brilliant Gathering of its Devotees. The Thirty-third Semi-Annual Reception of the Brooklyn Art Association," *Brooklyn Daily Eagle*, 5 December 1876).

17. Cooper 1986a, 155.

18. See Reed 1986, 74–75.

19. Letter to M. Knoedler & Co., Scarboro, Maine, 14 February 1902 (M. Knoedler & Co.).

20. John W. Beatty told how, in the course of visiting Homer at his New York hotel, he made a telephone call to another artist. When he finished, "Homer, with a quizzical expression, said, 'Would you mind telling me how you did that?'" (Goodrich 1944a, 218).

21. For symbolism and America, see Charles C. Eldredge, *American Imagination and Symbolist Painting* [exh. cat., Grey Art Gallery and Study Center, New York University] (New York, 1979), in which, however, there is no mention of the symbolist properties of Homer's late work. For symbolism generally, see Robert Goldwater, *Symbolism* (New York, 1979), and Michael Gibson, *Le Symbolisme* (Cologne, 1994). It is interesting that in Paris, more than any other place the birthplace of symbolism, Homer's *A Summer Night* (cat. 186) hangs compatibly with symbolist paintings in the Musée d'Orsay.

22. Letter to Thomas B. Clarke, 14 March 1897 (quoted in Downes 1911, 185).

23. "The Exhibition of the Society of American Artists," *The Art Amateur* 36 (May 1897), 108.

24. "The Water-Color Society. A Brilliant Show at the Twelfth Exhibition," *New York Times*, 1 February 1879.

25. "Art Notes," *The Art Interchange* 24 (1 March 1890), 66.

26. Such as cats. 202–207.

27. No subject was so widely debated, on moral and political grounds, as deer hunting in the Adirondacks. Hardly an issue of the weekly *Forest and Stream* in the late 1880s, for example, failed in some way to discuss it. Homer's friend the painter Roswell Shurtleff wrote a letter on "Deer in the Adirondacks" on 7 January 1886, 468.

28. See Jones 1988, 63 and passim; Stepanek 1977, 20, no. 79.

29. *The Art Interchange* 24 (1 March 1890), 66; "Trout on the Full Leap," *Harper's Weekly* 34 (12 April 1890), 279, illustrated by *A Perilous Leap*, "From the Painting in Water-Color by Winslow Homer" (cat. 166).

30. "Trout on the Full Leap," 279.

31. Tatham 1990b, 55–65. Tatham has done the most intensive work on Homer and the Adirondacks; see also, Tatham 1966, 73–90, and Tatham 1988, 20–34.

32. Tatham 1990b, 61.

33. Those who thought the deer was alive, Homer said, were wrong; if so, it was a mistake often made (see cat. 179).

34. Alfred Trumble, "Notes for the New Year," *The Collector* 3 (1 January 1892), 71.

35. See Stephen Jay Gould, "The Criminal as Nature's Mistake, or the Ape in Some of Us," in *Ever Since Darwin* (New York, 1977), 222–228.

36. "Statues...Good and Bad," *Philadelphia Inquirer*, 19 March 1893.

37. Goodrich 1944a, 221.

38. The term "survival of the fittest" was coined by the English philosopher Herbert Spencer, who was much admired and greatly influential in America. It became the chief slogan of Social Darwinism (for which Spencer was more responsible than Darwin), which, as a description of human social development used to justify unregulated competition, social inequality, and economic hardship in the era of high industrial capitalism, was the most popular and widespread application of evolutionary thought in late nineteenth-century America.

"Nature, red in tooth and claw" is from Alfred Lord Tennyson, *In Memoriam*, LV.

39. For some examples, including the *Fox Hunt*, see Cikovsky 1986, 59–61.

40. "Dapper, small, inquisitive, I see his self-portrait in the furry animal in the wonderful *Fox Hunt*" (Hess 1973, 72). The black crows, he believed, drawing upon Freud's interpretation of Leonardo's fantasy of the vulture in *Leonardo da Vinci: A Study in Psychosexuality*, represented "the nightmare of the flying penis."

41. [Alfred Trumble], "Facts, Ideas and Opinions," *The Collector* 4 (1 April 1893), 166.

155. *The Signal of Distress*, 1890 / 1892–1896
oil on canvas, 62 x 98 (24⁷⁄₁₆ x 38⁹⁄₁₆)
Fundación Colección Thyssen-Bornemisza, Madrid
Provenance: George G. Briggs, Grand Rapids, Michigan, c. 1896 until at least 1901. (J. W. Young, Chicago). Edward T. Stotesbury, Philadelphia, c. 1910. Ralph Cudney, Chicago, 1916; Cudney Estate; (Babcock Galleries, New York). Mr. and Mrs. Charles F. Williams, Cincinnati, Ohio, 1936 until at least 1944. (Wildenstein & Co., New York, 1955). Cornelius Vanderbilt Whitney, Lexington, Kentucky, and New York; Gertrude Whitney. (Sotheby Parke Bernet, Inc., New York, 17 October 1980, no. 148). (Kennedy Galleries, Inc., New York, 1980).

155–158

On 10 December 1890 Homer wrote his brother Charles, "I have got a fine picture called 'The Distress Signal' a scene in mid ocean. I expect to do well."[1]

It was first exhibited (as *The Signal of Distress*) at Reichard's Gallery in New York in January 1891. "It is a gray morning after a storm in mid-ocean, with gleams of fitful sunshine upon a troubled sea," wrote the critic of the *New York World*, who saw it there. "On the deck of a steamer," he went on, "evidently a large Atlantic liner which has stopped, an officer and sailors are rushing towards a boat into which two sailors have already tumbled and are preparing to let fall from the davits, evidently to go to the rescue of a far off ship under full sail which is standing towards them."[2] The *Evening Post*'s critic said it was "…a complete and satisfactory work…."[3]

If this description of the picture does not resemble its present appearance (there is no "ship under full sail," for instance) or its present state (it is patently not "complete"), that is because

Homer extensively repainted, and ultimately never finished it; the date he inscribed on the ship's deck in the lower-left corner, "1892–'6," documents a campaign of work that was terminated, not completed.

Homer based *The Signal of Distress* most immediately on experiences recollected and recorded on his trip to England in 1881 on the *Parthia* from New York (see Chronology 1881), which he depicted in two watercolors (cats. 156–157) and, despite its rigorous nautical precision about ropes and blocks, a very beautiful drawing (cat. 158) which served as the painting's central compositional object and dramatic fulcrum. But it is based, too, on events of dramatic rescue that Homer had observed at Cullercoats, the pictorial and expressive possibilities of which he had studied in a series of powerful drawings that were not at that time, however, carried any further (cats. 113–114). From this point of view, *The Signal of Distress* may be their much delayed outcome.

Or perhaps Homer delved more deeply than that into his own (art historical) past. For *Signal*

156. **Marine**, 1881
watercolor on paper, 24.1 x 34.9 (9½ x 13¾)
Bowdoin College Museum of Art, Brunswick, Maine,
Bequest of Augustus F. Moulton, Class of 1873, A.M.
1876, L.L.D. 1928
Provenance: A. F. Moulton, by 1907.
Washington and New York only

cat. 156

157. **Observations on Shipboard**, 1881
watercolor on paper, 23.5 x 29.2 (9¼ x 11½)
Private Collection, Courtesy of Spanierman Gallery,
New York
Provenance: Arthur P. Homer, c. 1909; Hugh Williams, 1928; (Macbeth Gallery, New York); Mrs.
Charles S. Homer, Jr., 1937; the Homer family, by
descent.
Washington and New York only

158. **Study for "The Signal of Distress,"** 1881
watercolor, pencil, and traces of black ink on paper,
35 x 29.4 (13¾ x 11⁹⁄₁₆)
Cooper-Hewitt, National Design Museum, Smithsonian Institution, Gift of Charles Savage Homer, Jr.
Provenance: Estate of the artist; Charles S. Homer, Jr.;
gift to the Cooper Union Museum for the Arts of
Decoration, 1912.
Washington and New York only

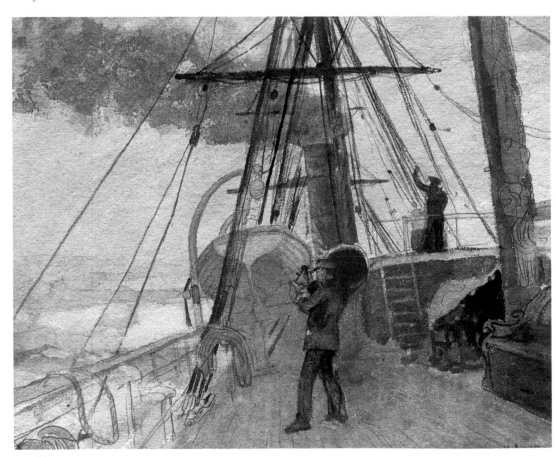

cat. 157

of Distress harks back to the engraving, "Homeward-Bound," published in *Harper's Weekly* in
December 1867 (fig. 183), which was based on
Homer's first transatlantic voyage. The resemblance resides largely in the subject they share,
but also more specifically in something that hap-

cat. 158

fig. 183. After Winslow Homer. "Homeward-Bound." Wood engraving. In *Harper's Weekly*, 21 December 1867

right, a figure (who is placed under Homer's initials carved into the boom and who rather resembles Homer himself, as in fig. 71) is, unlike all the others, seen from behind. With his binoculars he is focusing on something else, something that has also attracted the animated attention of some of the boat's crew in the distance, namely, a large fish leaping from the water. In *The Signal of Distress* this is exactly reversed, not only in the sense that an event located in the distance in one is in the foreground of the other, but in the more significant sense, because it so exactly mirrors a profound alteration in Homer's mental and emotional organization and humane orientation, that social manners have been replaced by human tragedy (or its clear potential) as the principal focus of attention.

The changes that Homer made in *The Signal of Distress*, to the extent at least that he carried them out, had two results (fig. 175). By removing the rigging and lowering the railing he appreciably reduced the painting's resemblance (which, he may have come to believe, distorted the understanding of *The Signal of Distress*) to his earlier and much admired *Eight Bells* (cat. 144), which one critic said could be described, before his changes, as its "pendant."[4] But by far the greater change, not in extent but in its consequences of meaning, was the conversion of the full-rigged ship in the painting's first version to a dismasted, apparently lifeless hulk flying a flag of distress. In its first state the painting was described in terms of energetic confidence and expectant hopefulness: "The figures are brisk in movement and express the determination of all hands to get to the rescue in the shortest possible time," one critic wrote,[5] and another that "One can almost…share the eagerness of the rushing rescuers."[6] In its altered form, expectant hope has no place or purpose, and so far from being perceivable as the pendant to the staunch heroic confidence of *Eight Bells*, *The Signal of Distress* is its opposite. It is now more properly the pendant to its great successor, *The Gulf Stream* (cat. 231).

NOTES

1. Letter to Charles S. Homer, Jr., 10 December 1890 (Bowdoin).

2. "In the Art World," *New York World*, 18 January 1891.

3. "Art Notes," *New York Evening Post*, 21 January 1891.

4. "The Winslow Homer Pictures," *The Art Amateur* 24 (February 1891), 65.

5. "Four Paintings by Homer," *New York Times*, 16 January 1891.

6. "In the Art World."

pens in both. "Homeward-Bound," like most of Homer's postwar art, is focused on sociological description, in this case on the various states of the human condition during an ocean crossing—seasickness, boredom, and flirtation—all compactly grouped in the foreground. But at the far

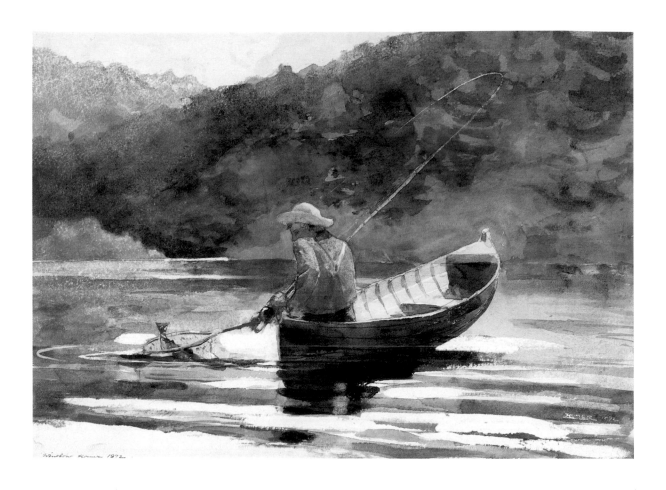

159. *Boy Fishing*, 1892
watercolor on paper, 37.2 x 71.1 (14⅝ x 28)
San Antonio Museum of Art
Provenance: (Coe Kerr Gallery).

159–163

Homer, an avid fisherman (though not so avid a hunter), joined the North Woods Club, at Minerva, New York, in 1888. He made his first visit as a member in the fall of 1889, when he produced nearly three dozen watercolors. He returned twice in 1891, when he painted only about ten watercolors, and twice again in 1892 — in both cases in early and late summer — when he painted more than thirty.[1] They are among the most formally and technically beautiful and powerful and explicitly expressive watercolors he ever made.

Writing in language that evoked their epic scale and scope, a correspondent for the *Boston Evening Transcript* said in 1892:

We have looked over a portfolio of his watercolor sketches of the Adirondacks, where he has lately been hunting, armed with a box of water colors and those big brushes which he wields with such bewildering skill, and we are more than ever impressed by his superb breadth and mastery. He gives a wonderfully vivid idea of the immense scale of things, the wildness, the grandeur, the rudeness, and almost oppressive solitude of the great Northern forest. Against this strange and stupendous background, as is his wont, he projects the virile and sinewy figures of the hardy out-door

type of fearless men — the hunters, guides and fishermen of the wilderness. We have seen his sailors braving the rage of the stormy sea, his soldiers facing the perils of battle and the manifold hardships of the march and the bivouac; and now we see his woodsmen, at their work — rough fellows, good shots, brawny and big of limb, the descendents of [James Fenimore Cooper's] Leatherstocking. He shows them as they paddle their canoes, swift, silent, over the deep dark lakes and through the boiling rapids; as they stalk the timid deer among the tangled brush and dead trees and the chaos of rocks on the lonely mountainside; as they play the agile trout in his beautiful black pool under the dense shadows of the huge pines overhead; as they glide back to camp in the twilight, the fire shining like a distant beacon from the shadowy shore; as they wake to look at the banks of morning mist rising from the lake and uncurtaining the splendid panorama of far blue mountains looming under a magnificent sky. It is like inhaling a breath of balsamic air from the big woods, full of stimulating and expansive life, to look at these robust and powerful sketches of the Adirondacks.[2]

NOTES
1. Tatham 1990b, 48.
2. "The Fine Arts," *Boston Daily Evening Transcript*, 23 December 1892.

160. *Sunrise, Fishing in the Adirondacks*, 1892
watercolor on paper, 34.3 x 52.2 (13½ x 20½)
The Fine Arts Museums of San Francisco, Mildred
Anna Williams Collection
Provenance: William F. Ewing, New York; Edgar William Garbisch, New York; (Hirschl & Adler Galleries, New York). Mr. and Mrs. Charles Henschel, by 1936.
New York only

159

"You may as well name it as anyone," Homer wrote the first owner of *Boy Fishing*, with a lack of concern about titles that he expressed elsewhere (cat. 183). "It's a boy fishing," he went on, "painted in the Adirondacks at a Club I belong to called 'the North Woods Club.'" [1]

NOTES

1. Letter to George G. Briggs, Scarboro, Maine, 16 April 1896 (Archives of American Art).

161

Having crossed a rapidly flowing stream in flight from the dogs that have driven it from the dark woods, a stag is killed at the moment of escape by a hunter on the distant shore. His presence is indicated by the puff of smoke of his "good shot." With the exception of his trout-fishing watercolors, this most resembles popular hunting imagery, such as the Currier & Ives color lithograph *The Death Shot* (fig. 184). [1]

NOTES

1. Cooper 1986a, 183–184. It is in the tradition, too, of hunted animals in the paintings of Sir Edwin Landseer, such as *The Hunted Stag* of 1833 (Tate Gallery, London).

161. *A Good Shot, Adirondacks,* 1892
watercolor on paper, 38.2 x 54.5 (15 x 21⁷⁄₁₆)
National Gallery of Art, Washington, Gift of Ruth K.
Henschel in memory of her husband, Charles R.
Henschel, 1975.92.5
Provenance: (Doll & Richards, Boston, 1894–1896);
the artist, 3 March 1896. (M. Knoedler & Co., New
York, 15 February 1908); J. R. Andrews, Bath, Maine;
(American Art Association, New York, 27 January
1916, no. 39); (M. Knoedler & Co., New York);
Charles R. Henschel; his wife, Ruth K. Henschel.
Boston and New York only

fig. 184. Currier & Ives. *The Death Shot.* Lithograph. Courtesy of the Library of Congress, Prints and Photographs Division, Currier & Ives Collection

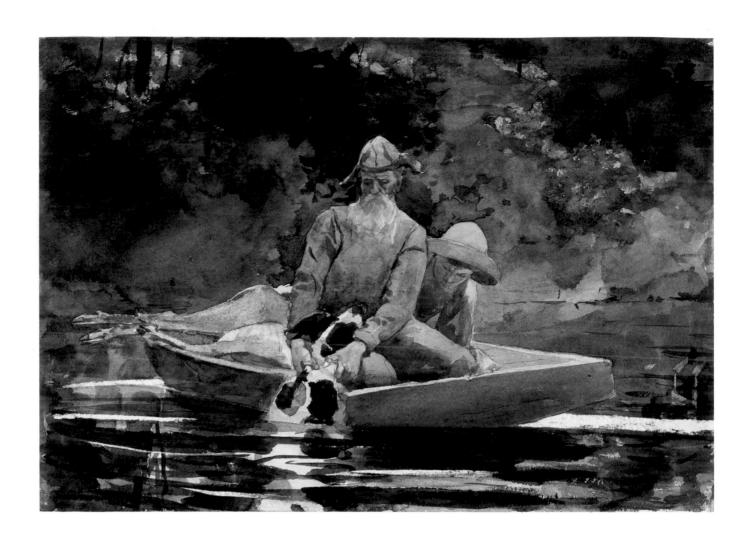

162. *After the Hunt,* 1892
watercolor on paper, 47.6 x 62.9 (18¾ x 24¾)
Los Angeles County Museum of Art, Paul Rodman
Mabury Collection, 39.12.11
Provenance: (Doll & Richards, Boston, 1900–1902);
George [Gustav] H. Buek, Brooklyn, 1902–1911;
(Moulton & Ricketts Galleries, Chicago and New
York); Paul Rodman Mabury, Los Angeles, 1916–1939.
Boston and New York only

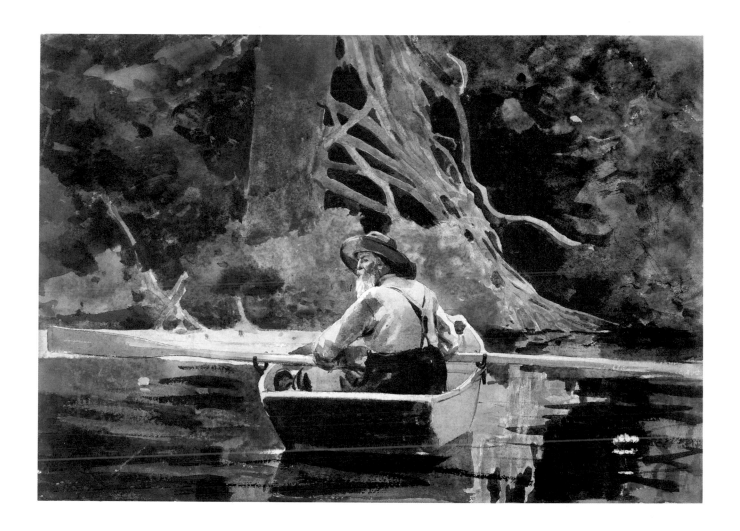

163 *The Adirondack Guide,* 1894
watercolor over pencil on paper, 38.4 x 54.6
(15⅛ x 21½)
Museum of Fine Arts, Boston, Bequest of Mrs. Alma
H. Wadleigh
Provenance: (Doll & Richards, Boston, March 1897);
George C. Wadleigh, Haverhill, Massachusetts, 1897;
his wife, Mrs. Alma H. Wadleigh.

163

The elderly bearded figure in several of Homer's
hunting watercolors also appears in images of
meditative contemplation. These figures corre-
spond to Charles Dudley Warner's description
of the celebrated guide Orson Phelps: "…in all
that country, he alone had noticed the sunsets,
and observed the delightful processes of the sea-
sons, taken pleasure in the woods for themselves,
and climbed the mountains solely for the sake of
the prospect."[1]

NOTES

1. Charles Dudley Warner, "The Adirondacks Verified.
V. A Character Study," *Atlantic Monthly* 4 (May 1878), 638.

265

164–167

"Mr. Homer's water-colors, in fact, are impressions," the critic of the *New York Evening Post* wrote in February 1890. "But Mr. Homer has not found it necessary to copy Manet or Monet, or Renoir or Degaz [sic]; he has means of his own, very simple means, artistic rather than scientific, and he uses them frankly. Truth is his first principle; to give the main facts with the least trouble the next. His results are delightful.... They do not give the movement of the fish so well as it is done in the best Japanese work, but Mr. Homer's aim is a more realistic and less decorative one than that of the Japanese artists."[1]

To convey the immediacy of Homer's leaping trout and other of his Adirondack watercolors, the *Evening Post*'s critic invoked both the "scientific" impressionism of Manet, Monet, Renoir, and Degas, and the Japanese print. But it is interesting that among this group of art and artists were ones who were by about 1890 particularly identified with, and in one case, Monet's, deeply engrossed in, the practice of *systematic* seriality—as in Degas' dancers and bathers; Japanese prints, such as Hokusai's well-known *Thirty-six Views of Mount Fuji* and Hiroshige's *Fifty-three Stations on the Tokaido;* and Monet's grainstack series that he began to paint in 1889, to be followed soon after by the series of poplars and Rouen Cathedral. Seriality, of course, had been a part of Homer's artistic method—and a

principal signifier of its modernity—for about a quarter-century. But in his fishing and hunting watercolors of the early 1890s, seriality appears in a form far more systematically organized than it had been earlier. What is more, Homer seems clearly to have regarded them as a series or suite, for when he exhibited them in February 1892, it was not at the Water Color Society, where they would have been dispersed among others and their serial character lost; instead, he showed them at Reichard's Gallery in New York, where, insisting that other works in the gallery "must not in any way be mixed with my show,"[2] they could be seen as a group (a reviewer in *The Critic* who saw them there called them a "series").[3] In similar fashion several years later, he showed twenty-seven of his Canadian watercolors at Knoedler's with the collective title "Water Colors of Life and Scenes in the Province of Quebec" that betokened their conception as a series or suite.

Homer's most distinct series comprised watercolors of leaping trout. And most impressive about that series, apart from its suggestion of motion, was its "rendering of color, texture and glint,"[4] which conspired to capture "a passing episode, a tiny rainbow, that comes and goes within a brief second of time," as the instantaneity of *Leaping Trout* (cat. 166) was beautifully described.[5]

"Several of the pictures in which fish are given the very first place...are wonderfully nat-

164. *Leaping Trout,* 1889
watercolor over pencil on paper, 35.2 x 50.5
(13⅞ x 19⅞)
Museum of Fine Arts, Boston, William Wilkins
Warren Fund
Provenance: Thomas B. Clarke; (American Art Association, New York, 17 February 1899, no. 330).

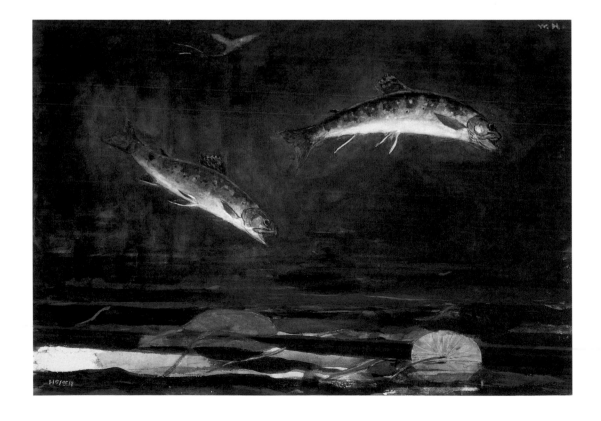

165. *Leaping Trout,* 1889
watercolor on paper, 34.9 x 50.2 (13¾ x 19¼)
The Cleveland Museum of Art, Anonymous Gift
Provenance: Ralph T. King, Jr., Cleveland, Ohio.
Private Collection until 1973.
Washington and New York only

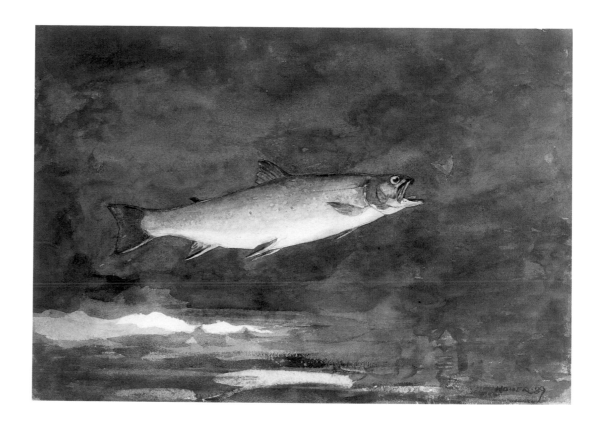

ural, but their color charm"—"the elusive scin-tillations of the gaudily scaled fishes," as this critic put it later—"almost surpasses the interest as studies of action."[6]

"The fish which he paints are the Adirondack trout.…Some studies illustrate the varied color-ing of trout according to age or the character of the water or the conditions of the lighting. There are troutlings with the bars still on their sides, leaping high in air. There is a trout jump-ing at the stretcher fly which is nearly…white in this light.…Another, drawn into the light by a fluttering red ibis, exhibits iridescent, purplish tones which are perfectly truthful."[7]

NOTES

1. "Art Notes," *New York Evening Post,* 19 February 1890.

2. Letter to Reichard & Co., Scarboro, Maine, 22 January 1890 (Archives of American Art, William T. Evans papers).

3. "Art Notes," *The Critic* 13 (22 February 1890).

4. "Art Notes," *The Art Interchange* 24 (1 March 1890), 66.

5. "Trout on the Full Leap," *Harper's Weekly* 34 (12 April 1890), 279.

6. "The Fine Arts," *New York Commercial Advertiser,* 15 February 1890.

7. "An Artist in the Adirondacks," *New York Tribune,* 26 February 1890.

164

"Two trout leaping together from the flat disks of the lily at the same dragonfly—and missing it—form a picture that sportsmen will delight in. They belong to the most brilliant variety of that game fish, and sweep through the air like tropical birds, with their brilliant spots and rud-dy fins fully displayed. The surface of the lake is wrought with a rare sense of color. Lily leaves overturned by the wind show their pink and white undersides, and one feels, rather than dis-tinctly sees, the background of sombre forest."[1]

NOTES

1. "Water Colors by Winslow Homer, N. A.," *New York Times,* 18 February 1890.

166. *Leaping Trout*, 1889
watercolor on paper, 35.7 x 51 (14¹/₁₆ x 20¹/₁₆)
Portland Museum of Art, Portland, Maine, Bequest
of Charles Shipman Payson, 1988.55.7
Provenance: Ralph King, Jr., Cleveland, Ohio; Mrs.
Charles R. Henschel, New York; (M. Knoedler & Co.,
New York); Mr. and Mrs. Charles Shipman Payson.
Boston only

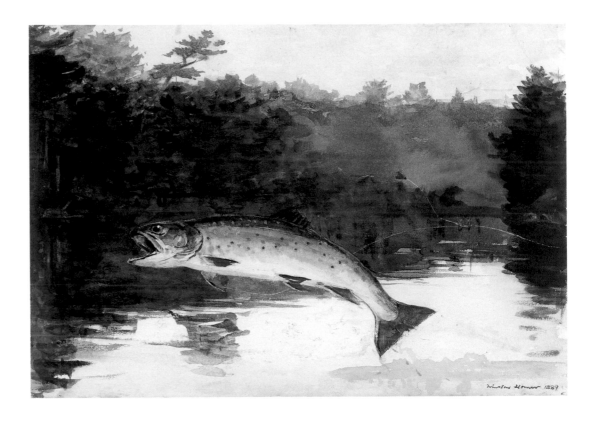

167. *Jumping Trout*, 1889
watercolor with pencil underdrawing on paper,
35.4 x 50.7 (13⁵/₁₆ x 20)
The Brooklyn Museum, in memory of Dick S.
Ramsay, 41.220
Provenance: Mr. and Mrs. Charles. S. Homer, Jr., until
at least 1915.
Washington only

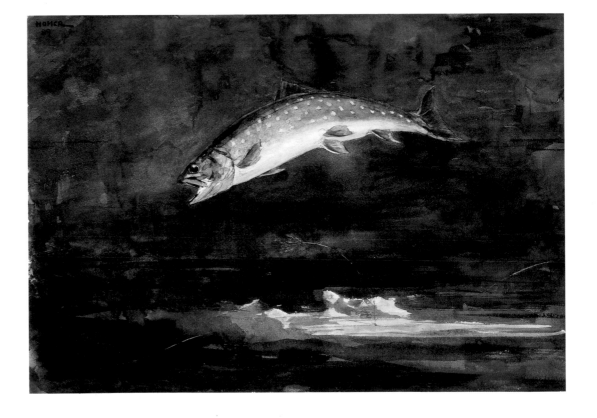

168–180

By a method called hounding, deer were hunted in the Adirondacks by driving them with dogs into lakes where by clubbing, shooting, or drowning they could easily be killed by hunters in boats. It is clearly shown in Arthur F. Tait's painting *Deer Driving on the Lakes* of 1857 (fig. 185), and, in serial form, in a number of Homer's most deeply moving Adirondack watercolors, in which the dogs forced the deer from the woods (cat. 168), a dog has driven a deer into the lake and is poised to leap in after it (cat. 169), the deer swims exhaustedly in the middle of the lake while the hunter watches from a boat in the distance (cat. 170), and dogs are gathered in the hunter's boat after the deer has been killed (cat. 172).

Hounding was widely regarded, and frequently indicted, as little more than uncivilized and unsportsmanlike butchery and murder. As someone who so regarded it wrote in 1873: "[I] am compelled to say that some of the Adirondack hunters would not be admitted into the society of hunters.... They butcher the deer... instead of shooting them in a fair way. Some still-hunting is done [the hunter tracking the deer and shooting it from a still position], but the principal part of the hunting here consists of driving the deer into the lakes and drowning them in the most abominable manner."

He then went on graphically to describe such a hunt:

The dogs were sent out with one of the hunters.... Suddenly one of the guides caught sight of a black spot on the surface of the pond...and no one but a hunter would have known that it was a deer.... The sportsman intercepted her flight, and then proceeded to belabor the poor animal's head with a paddle, and force her under the water.... By now the other two boats came up and joined the fray, and the murder was accomplished more artistically. One guide dashed in adroitly and seized the body of the doe...then it was easy for this sportsman to blow her brains out with his rifle. This, on my word, is the manner in which nine deer out of ten that are killed in the Adirondacks are murdered....[1]

"By all odds, the favorite and prevalent mode is hunting with dogs," Charles Dudley Warner wrote in 1878. "The hounds are sent into the forest to rouse the deer and drive him from his cover; they climb the mountains, striking the trails, and go baying and yelping on the track of the poor beast. The deer have their established runways,...and when they are disturbed in their retreat they are certain to attempt to escape by following one which invariably leads to some lake or stream. All that the hunter has to do is to... sit in a boat on the lake, and wait the coming of the pursued deer....[T]o shoot him from the boat, after he has plunged panting into the lake," Warner noted wryly, "requires the rare ability to hit a moving target the size of a deer's head a few rods distant.....To paddle up to the swimming deer and cut his throat is a sure means of getting venison, and has its charms for some. Even women and doctors of divinity have enjoyed this exquisite pleasure."[2]

"[T]he animal is driven into the water, where the men await it in a boat, ready to either hammer its brains out with a club, or blow them out

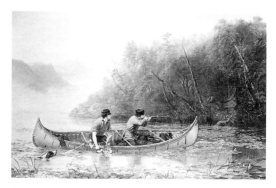

fig. 185. Arthur F. Tait, *Deer Driving on the Lakes*, 1857. Oil on canvas. Private Collection. Photo courtesy of Kennedy Galleries, Inc., New York

168. *On the Trail*, 1889
watercolor over pencil on paper, 32.1 x 50.5 (12⅝ x 19⅞)
National Gallery of Art, Washington, Gift of Ruth K. Henschel in memory of her husband, Charles R. Henschel, 1975.92.12
Provenance: Mrs. N. E. Pfizer; (M. Knoedler & Co., New York, May 1912); (Gustav Reichard & Co., New York). William T. Evans, New York, after 1900 until 1913; (American Art Association, New York, 31 March–2 April 1913, no. 96). Adolph Lewisohn; Sam Lewisohn. Charles R. Henschel; his wife, Ruth K. Henschel.
Boston and New York only

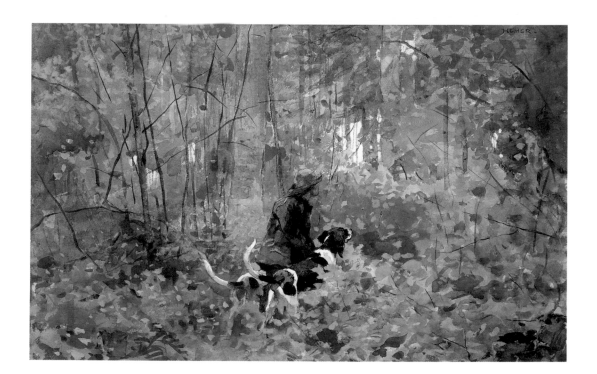

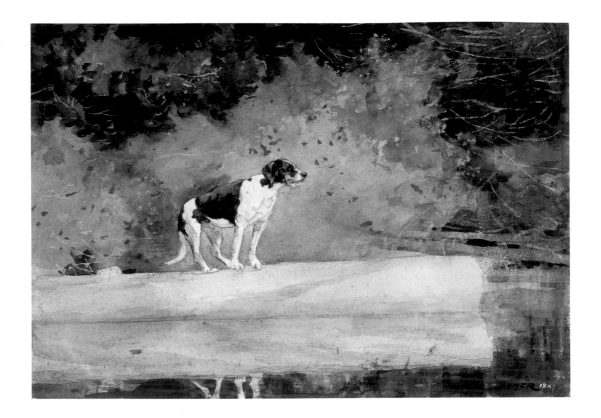

by placing their rifle against the head of the swim-
ming animal. This is sport—just about as much
as cutting the throats of pigs after a laborious
chase about the barn-yard."[3]

The feelings of moral revulsion that deer
hounding provoked and the public condemnation
of the practice—"animal murder," one writer
called it[4]—were feelings that Homer clearly
shared and a practice in the condemnation of
which he enlisted his watercolors.

NOTES

1. William C. Prime, *I Go A-Fishing* (London, 1873),
107–109, quoted in Jones 1988, 57–58.

2. "The Adirondacks Verified. IV. A-hunting of the
Deer," *Atlantic Monthly* 41 (April 1878), 524–525.

3. Caspar W. Whitney, "The Butchery of Adirondack
Deer," *Harper's Weekly* 36 (16 January 1892), 58.

4. Whitney, "Butchery," 58.

168

Mistakenly given the date of 1892,[1] this is clear-
ly the "charming picture of a hunter leading a
brace of hounds through autumn woods where
the diffused light and the sense of air are finely
expressed,"[2] which belonged to the group of
Adirondack watercolors Homer painted in 1889
and exhibited at the Reichard Gallery in 1890.

NOTES

1. Cooper 1986a, 175 and 253.

2. "An Artist in the Adirondacks," *New York Tribune*, 26
February 1890.

169

A "hound...leaps upon a log lying in the water,
and stands there, its feet close together to keep
its balance, hesitating before taking to the
water."[1]

NOTES

1. "An Artist in the Adirondacks," *New York Tribune*, 26
February 1890.

170

"One of the more 'important' hunting scenes,"
as the *New York Tribune*'s critic described this,
among the greatest of Homer's Adirondack
watercolors, "is an autumn scene, a lake where-in
a deer swims hard and fast before a boat," fleeing
from the barking dog on the shore. "The shores
and mountains...splendidly dressed in the red
and yellow robes of autumn, and [the]...vivid
blue tones in the water of the lake"[1] are the set-
ting of the drama being played out on the omi-
nously still waters of the lake, as the hunter in
the distance waits patiently as the exhausted deer,
with tragically certain futility, swims for safety.

The almost painful disjunction between
immense natural beauty and intense natural

170. *An October Day,* 1889
watercolor on paper, 35.2 x 50.2 (13⅞ x 19¾)
Sterling and Francine Clark Art Institute, Williams-
town, Massachusetts
Provenance: (Doll & Richards, Boston, 1890); J. Morri-
son-Fuller, Longwood, Massachusetts, 1890; Edward
Hooper, Boston; (Schneider-Gabriel Galleries, Chica-
go); (M. Knoedler & Co., New York); Robert Sterling
Clark, 1947.
Washington only

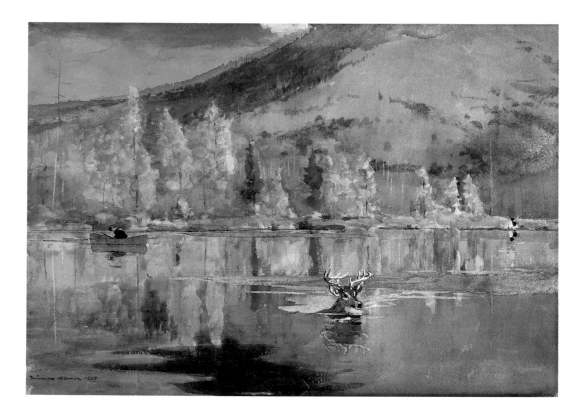

171. *The End of the Hunt,* 1892
watercolor on paper, 38.4 x 54.3 (15⅛ x 21⅜)
Bowdoin College Museum of Art, Brunswick, Maine,
Gift of Misses Harriet and Sophia Walker
Provenance: (Doll & Richards, Boston); Harriet S.
Walker, 1892.
Washington only

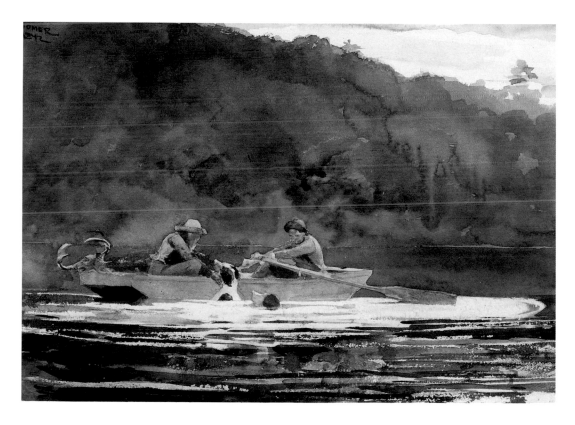

tragedy serves as a stringent Darwinian reminder
that nature's operations and human moral and
aesthetic values are things very separate and not
to be confounded with one another.

NOTES

1. "An Artist in the Adirondacks," *New York Tribune,* 26
February 1890.

172. *Dogs in a Boat,* 1889
watercolor on paper, 35.6 x 50.8 (14 x 20)
Museum of Art, Rhode Island School of Design, Gift
of Jesse Metcalf
Provenance: Probably purchased from the artist by
Jesse Metcalf.
Washington only

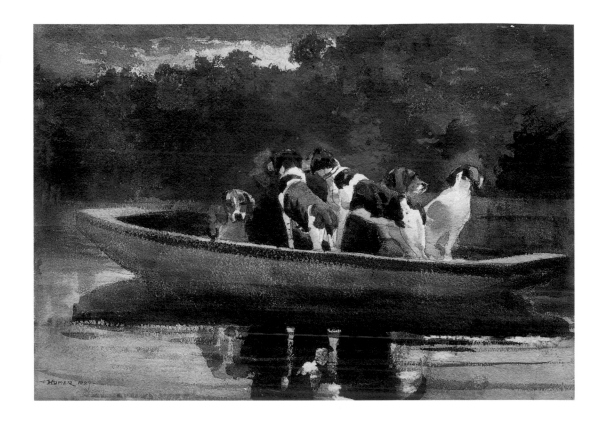

172

A "study of a pack of hounds in a scow, a quiet, comparatively low-toned, and very beautiful symphony" is the way the *Tribune*'s critic, in curiously Whistlerian terms, described this watercolor.[1] The hunt ended and the deer killed, the dogs have been rounded up in the hunter's "scow."

NOTES

1. "Water Colors by Winslow Homer, N. A.," *New York Tribune,* 18 February 1890.

173 – 175

These three watercolors, painted neither in the same year nor sequentially, constitute nevertheless, as though compelled to assume serial form by some urgency for documentary explicitness or by some internal expressive necessity, a deeply affecting and emotionally charged account of the moral wantonness of deer hunting in the Adirondacks.

173

"…a watercolor of a deer wading into the lily pads to feed has a good deal of fair work on the beast itself, while the surrounding water and forest are washed in with all Mr. Homer's rude skill."[1]

NOTES

1. "Water Colors by Winslow Homer, N. A.," *New York Tribune,* 18 February 1890.

175

On the back of this watercolor Homer wrote: "just shot," and, referring angrily to the hunters, often professional ones, who killed indiscriminately and without any regard for rules of sport, "A miserable [illegible] Pot hunter."[1]

NOTES

1. See Jones 1988, 55–65, for a sensitive discussion of this and its related watercolors; and Adams 1983, 113.

173. *Solitude,* 1889
watercolor on paper, 34.3 x 49.5 (13½ x 19½)
David and Rhoda Chase
Provenance: Mr. and Mrs. William Allen Putnam;
(Sotheby's, New York, 5 December 1985, no. 74).
Washington and New York only

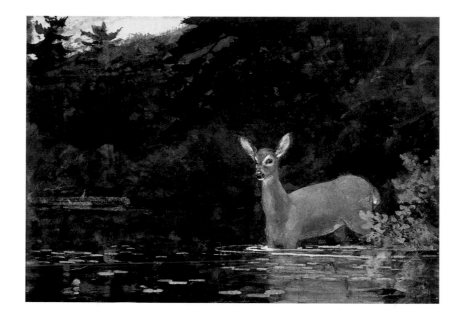

174. *Deer Drinking,* 1892
watercolor on paper, 35.7 x 51 (14¹⁄₁₆ x 20¹⁄₁₆)
Yale University Art Gallery, The Robert W. Carle,
B.A. 1897, Fund
Provenance: Courtland P. Dixon, New York.

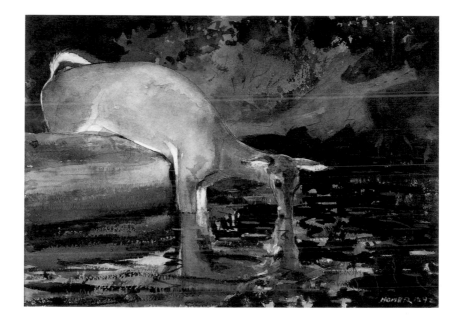

175. *The Fallen Deer,* 1892
watercolor over pencil on paper, 34.9 x 50.2
(13¾ x 19¾)
Museum of Fine Arts, Boston, Charles Henry
Hayden Fund
Provenance: William T. Evans, New York; (American
Art Association, New York, 31 March–2 April 1913,
no. 33); (Moulton & Ricketts, New York); (Frank K.
Bayley, Boston).

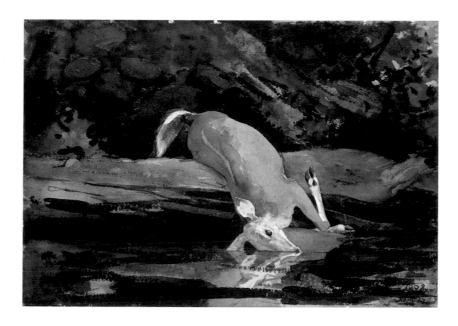

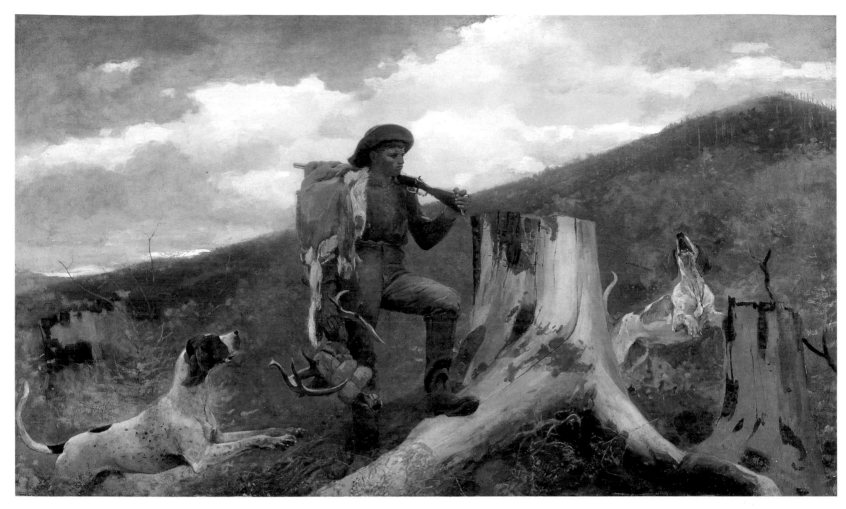

cat. 176

176. *Huntsman and Dogs*, 1891
oil on canvas, 71.1 x 121.9 (28 x 48)
Philadelphia Museum of Art, William L. Elkins
Collection
Provenance: Mr. Edward Hooper, Boston; his daughter,
Mrs. Bancel La Farge; (Reichard & Co., New York,
1893); William L. Elkins.

177. *Guide Carrying a Deer*, 1891
watercolor on paper, 35.6 x 51 (14 x 20¹/₁₆)
Portland Museum of Art, Portland, Maine, Bequest of
Charles Shipman Payson, 1988.55.10
Provenance: Charles S. Homer, Jr., by December 1891.
Charles F. Williams, Cincinnati, Ohio, by 1937; (M.
Knoedler & Co., New York, by 1955); Mr. and Mrs.
Charles Shipman Payson, 1955.
Boston only

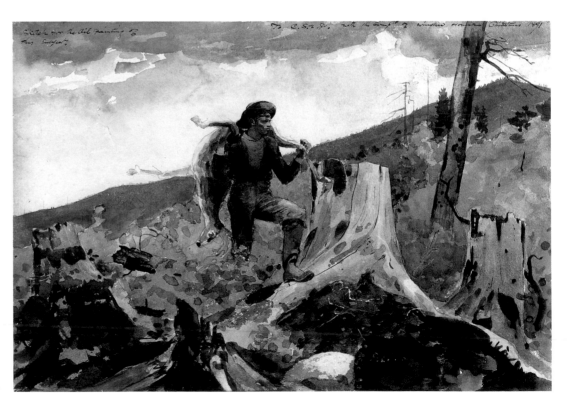

cat. 177

176–177

The Adirondack experience that Homer recounted in about seventy watercolors in the years around 1890 were epitomized in two large, impressive oil paintings that, because of their candor, were aesthetically and morally problematic for his contemporaries. Each painting was closely based on a watercolor "sketch," which, as though to place them *hors concours,* Homer did not sell but presented to his brother Charles.

176

Huntsman and Dogs "shows a large hillside or 'fell' in the Adirondacks during Autumn, with old, gray stumps of felled trees in the foreground, and a hunter, with two hounds, returning from a successful trip. The hunter carries the hide and horns of a stag, together with some of the deer's meat packed up. The hounds are in a state of excitement as they leap about their master. The latter is a typical woodsman, with coarse but good features, who looks as if he were performing merely the ordinary tasks of his life."[1]

The critic Alfred Trumble also interpreted the figure of the huntsman as typical, but far less benign: "The type of the huntsman, who carries the pelt of the deer over his shoulder, and its front and antlers in his hand, is low and brutal in the extreme," he wrote, using the "scientific" language of nineteenth-century physiognomy,

which read moral character in facial types, such as the low-browed, heavy-jawed, coarse features of the hunter that connoted moral baseness and brutality.[2] "He is just the sort of scoundrel, this fellow, who hounds deer to death up in the Adirondacks for the couple of dollars the hide and horns bring, and leaves the carcass to feed the carrion birds. The best thing in the picture is the true doggishness of the hounds," for, as he added in a Darwinian comment on the atavism of the hunter, "One doesn't expect hounds to have any instinct above slaughter." Trumble was not only repelled by the hunter; he was also put off by the painting—"a cold and unsympathetic work" and "a bit of cold, uncompromising realism"—though in saying that it "might have been created as an original for a Currier & Ives lithograph" or made "as the original for a newspaper illustration,"[3] he sensed that Homer, driven by urgencies of feeling and borne by currents of contemporary thought, was carried beyond the expressive decorum and pictorial protocols of "fine" or "high" art into less polite and polished but more direct modes of artistic speech.

NOTES

1. "Paintings by Winslow Homer," *New York Times,* 13 January 1892.

2. See Mary Cowling, *The Artist as Anthropologist: The Representation of Type and Character in Victorian Art* (Cambridge, 1989), chapters 1–4.

3. "Notes for the New Year," *The Collector* 3 (1 January 1892), 71.

178. ***Hunter in the Adirondacks,*** 1892
watercolor on paper, 35.2 x 57 (13⅞ x 22⁷⁄₁₆)
Harvard University Art Museums, Fogg Art Museum,
Anonymous Gift, 1939.230
Provenance: Chapin Collection; Osgood Collection.
New York only

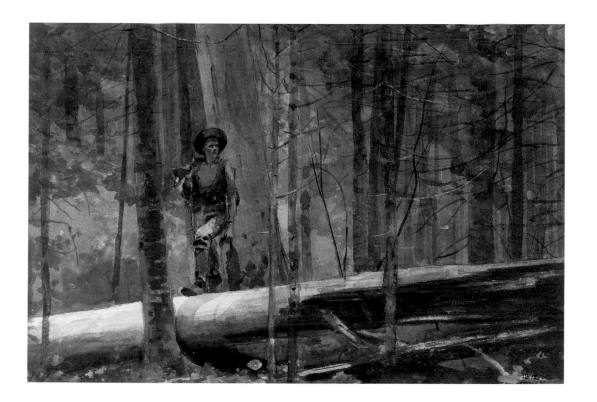

178

To point out that the "hunter" in this splendid watercolor holds what seems to be a beaver, or a small animal of the sort being held aloft in Homer's "Trapping in the Adirondacks," published in *Every Saturday* on 24 December 1870, and to suggest thereby that he is not a hunter but a trapper, is only to indicate that these roles were often combined in the same figure, who often took on the role of guide as well.

Homer's model was the hunter and guide Michael Flynn who appeared in a number of Adirondack paintings in the early 1890s, among them, in a very similar pose, *Huntsman and Dogs* (cat. 176). If the pose is similar, however, little else is: instead of the remains of a deer, the hunter carries, inconspicuously and almost furtively, a smaller animal; he stands in an uncut forest, not in a fell, and rests his foot upon an old, long-fallen log, not a recently cut stump—all of which suggests this is a carefully, indeed categorically, censored and sanitized alternative to *Huntsman and Dogs*.

179–180

Hound and Hunter is related closely to the watercolor (cat. 180) described in the inscription on its surface as the "original sketch for the painting." Homer referred to the painting in a letter to his brother Charles dated 15 October 1891 and written on the stationery of the Club House of the Adirondack Preserve Association: "I am working very hard & will without doubt finish the two oil paintings [the other, perhaps, *Huntsman and Dogs*, cat. 176] that I commenced Oct 2nd & great works they are. Your eye being fresh from European pictures, great care is required to make you proud of your brother." He added: "The original ideas of these pictures are in water-color & will not be put on the market, but will be presented to you with the one that I made expressly for you—."[1]

About a year later, on 25 October 1892, Homer wrote his dealer Thomas B. Clarke to say that he planned to show "my only new oil with ten or so watercolors (all Adirondacks)" in Boston that winter. He added a postscript that is an excellent specimen of the care and calculation with which he managed his artistic affairs: "I think I owe it to you to give you more particulars about this oil picture—I have had it on hand over two seasons & and now it promises to be very fine. It is a figure piece pure & simple—& a figure piece well carried out is not a common affair[.] It is called 'Hound & Hunter.' A man[,]

deer[,] & dog[,] on the water[.] My plan is to copyright it[,] have Harper publish it in the weekly to make it known[.] Have Klackner publish it as a print [etching] & then exhibit it for sale first in Boston (at $2000) with my watercolors."[2]

It was published neither in *Harper's Weekly* nor by Christian Klackner, who had published several of Homer's large etchings in the later 1880s (fig. 171, cat. 122). Neither was it exhibited first in Boston, but rather at the Union League Club in New York in December 1892, and not as *Hound and Hunter*, though this was the title Homer gave Clarke a month or so before, but as *In the Adirondacks*. It was described as "an incident of deer shooting. A country boy has shot a stag in the water, and, lying at full length in the stern of his boat, is trying to keep the creature's head above water until he can fasten the antlers with the boat's rope. He is angrily calling to his hound which swims up to the boat on the left, presumably ordering it off lest the dog should try to get into the light boat and upset it."[3]

It is not a pleasant subject, especially on the scale of a large oil painting, which is probably why he could not sell it until nearly the end of his life. It was particularly repellent to those who thought, as certain critics quite justifiably did when it was first shown, that the deer was being drowned by the hunter, as deer often were. Homer insisted that the deer was already dead and responded testily to such criticism: "The critics may think that that deer is alive but he is not—otherwise the boat & man would be knocked high & dry[.] I can shut the deer's eyes and put pennies on them if that will make it better understood." He then explained: "They will say that the head is the first to sink[.] That is so. This head has been under water & from the tail up has been carefully recovered in order to tie the head to the end of the boat[.] It is a simple thing to make a man out an Ass & fool by starting from a mistaken idea—So anyone thinks this deer alive is *wrong*."[4] Nevertheless, it was perhaps in response to such criticism that Homer slightly but significantly altered the picture by repainting the deer's head to make it more fully submerged and thus appear more lifeless than it had originally (and than it did in the watercolor, in which the deer clearly struggles desperately for life).

Homer himself thought very highly of *Hound and Hunter*. He told his brother Charles that it was a great work, one that was the equal of the European paintings he had just seen (and which suggests the standard, perhaps, upon which he was setting his sights). And at the very end of his life he said to Bryson Burroughs, who had spoken of his admiration for the painting, "I am

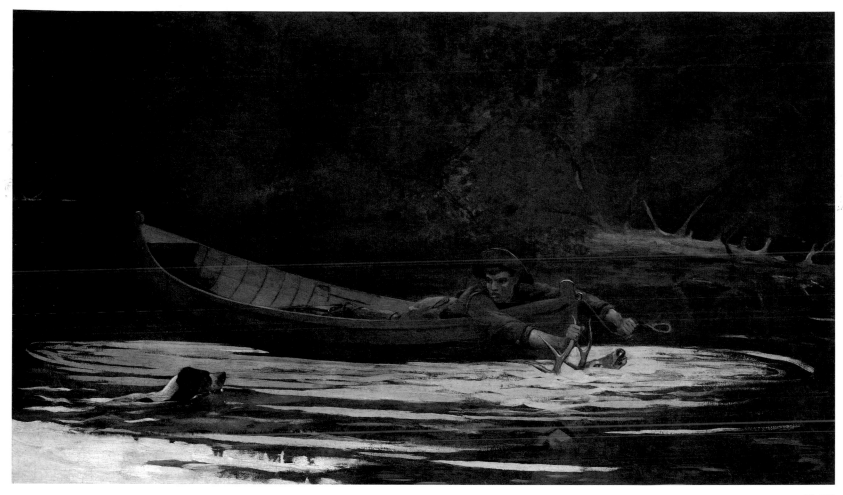

179. **Hound and Hunter,** 1892
oil on canvas, 71.8 x 122.3 (28¼ x 48¼)
National Gallery of Art, Washington, Gift of Stephen
Carlton Clark, 1947.11.1
Provenance: (M. Knoedler & Co., New York, 1900–
1902). Louis Ettlinger, New York, by 1908 until 1927;
his daughters, Mrs. Giles Whiting, New York, and
Mrs. Josephine McFadden, New York; Mrs. Whiting,
New York, and her nephew, Louis E. McFadden,
Peekskill, New York. (Wildenstein & Co., New York);
Stephen Carlton Clark, New York, 1946.

180. *Sketch for "Hound and Hunter,"* 1892
watercolor on paper, 35.4 x 50.7 (13⁸/₁₆ x 20)
National Gallery of Art, Washington, Gift of Ruth
K. Henschel in memory of her husband, Charles R.
Henschel, 1975.92.7
Provenance: Charles S. Homer, Jr. Charles R. Hen-
schel, 18 February 1937; his wife, Ruth K. Henschel.
Boston and New York only

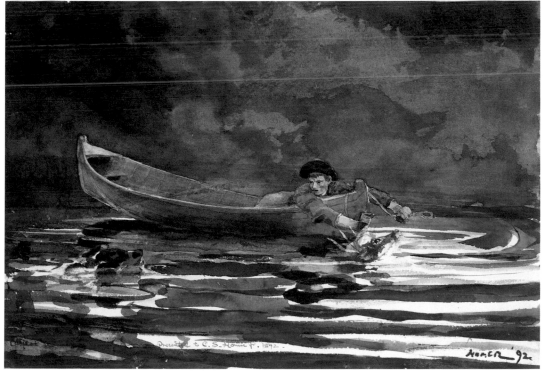

glad you like that picture; it's a good picture." Then, in an indication of the close and detailed observation that went into all of his paintings, he commented on a passage that he admired and had taken great pains to paint: "Did you notice the boy's hands—all sunburnt; the wrists somewhat sunburnt, but not as brown as his hands; and the bit of forearm where his sleeve is pulled back not sunburnt at all? I spent more than a week painting those hands."[5]

NOTES

1. Letter to Charles S. Homer, Jr., Minerva, New York, 15 October 1891 (Bowdoin). He gave it to his brother as promised, inscribing it, "Presented to C. S. Homer, Jr. 1892."

2. Archives of American Art; see Stepanek 1977, 23.

3. "Pictures Lent to the Union League," *New York Times,* 9 December 1892.

4. Archives of American Art; see Stepanek 1977, 23, no. 99.

5. Bryson Burroughs, "An Anecdote," *Bulletin of the Metropolitan Museum of Art* 28 (March 1933), 64.

181–185

"Nothing shocks Europeans more than the reckless use we are making of our forest patrimony, as if there were nobody to come after us," a writer in *Harper's Weekly* said in 1884 of the destruction of the Adirondack forest of New York state.

We are doing willfully, and in the face of historical and contemporaneous warnings, what the nations of Europe have done without such warnings, and are committing, at the increased rate of speed which saw-mills and other modern means of destruction permit, the ravages which they deplore and which they are trying to repair.... There is one point of view in which the destruction of the Adirondacks seems much more wanton that the ordinary waste of forests. Ordinarily the land is cleared that it may grow a crop more profitable or more immediately necessary than timber. But there is no pretense of this kind in New York. The land is cleared simply and solely for the value of the timber which stands upon it. The work is done, not by settlers, but by speculators, and when it is completed, its scene will be a rocky desert.... Our sketches from the devastated regions give almost ghastly evidence of the need that some effective steps should be taken to arrest the conversion of a wilderness into a desert.... It is the incidental destruction by fires and by the backwater of dams built to facilitate logging operations that most strongly proves the wantonness with which the work has been done....[1]

That Homer painted his logging subjects when "The public mind has been thoroughly aroused to the impending peril that threatens the Adirondack woods," and when the "intelligent public spirit" was agitating "against ruthless private greed,"[2] suggests that his mind and public spirit, too, had been aroused and that his art was an instrument of what assumed the form and intensity of almost political agitation.

NOTES

1. "The Adirondacks," *Harper's Weekly* 28 (6 December 1884), 805.

2. "The Threatened Adirondack Forests," *Harper's Weekly* 35 (13 June 1891), 438.

181. ***The Woodcutter,*** 1891
watercolor on paper, 34.9 x 50.5 (13¾ x 19⅞)
Private Collection
Provenance: (Doll & Richards, Boston); private collection, Boston; (Firestone & Parson, Boston).

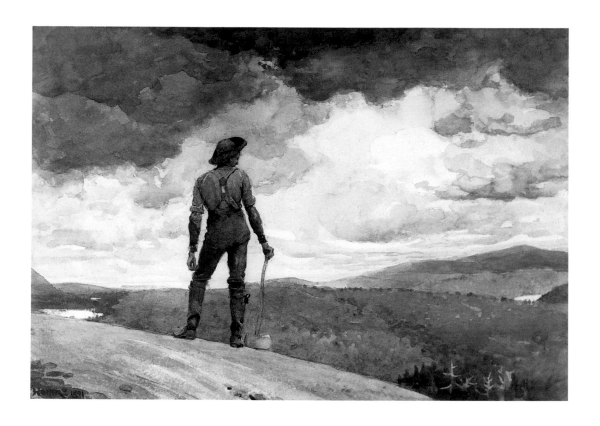

182. *Woodsman and Fallen Tree,* 1891
watercolor over pencil on paper, 35.6 x 50.8 (14 x 20)
Museum of Fine Arts, Boston, Bequest of William
Sturgis Bigelow
Provenance: (Doll & Richards, Boston); William Sturgis Bigelow, Boston, 1892.

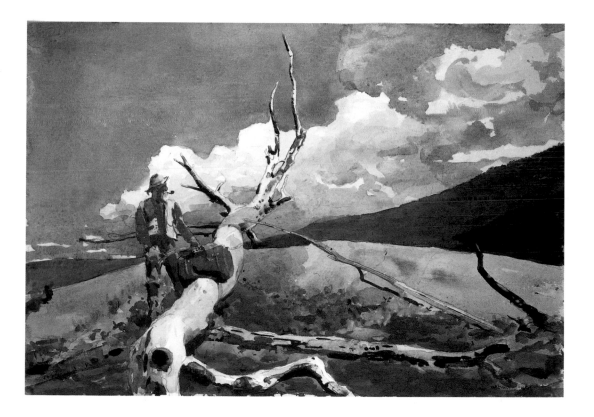

183. *Burnt Mountain,* 1892
watercolor over pencil on paper, 34.3 x 50
(13½ x 19 ¹¹⁄₁₆)
The Fine Arts Museums of San Francisco, Gift of Mr.
and Mrs. John D. Rockefeller 3d
Provenance: (M. Knoedler & Co., New York, by 1908);
J. R. Andrews, Bath, Maine, 1908–1916; (American
Art Association, New York, 27–28 January 1916, no.
108); (M. Knoedler & Co., New York, 1916–1917);
Charles R. and Ruth K. Henschel, New York, 1917–
1970; (M. Knoedler & Co., New York, 1970); John D.
Rockefeller 3d and Blanchette Hooker Rockefeller,
New York, 1970–1979.
Washington only

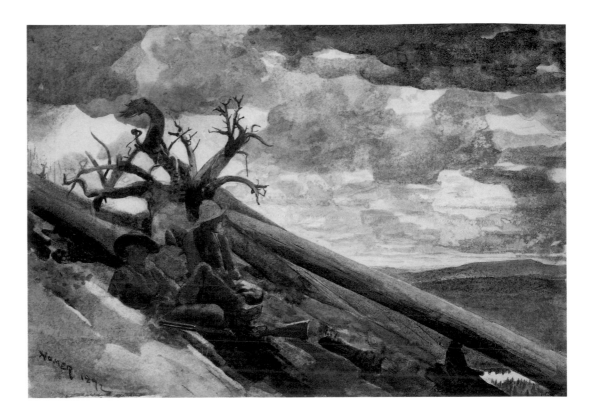

183

"The production of lumber is…the least impor-
tant function of the forest in its relation to man,"
Professor C. S. Sargent wrote in 1885 of the eco-
logical consequences of the destruction of the
Adirondacks. "Forests," he explained, "exert a
powerful influence upon the distribution of water
which falls upon the surface of the earth. They
check rapid evaporation, and regulate and con-
trol the flow of rivers.…Forests, when they exist
in mountainous regions about the sources of
streams, must be carefully guarded from destruc-
tion, or serious and permanent injury will be
inflicted upon all the territory watered by such
streams.…A wise and comprehensive public
policy would maintain, therefore, a forest growth
in all such regions,…because such a growth is
necessary for the public welfare in its influence
upon the flow of rivers.…There exists within
the State of New York, about the head-waters
of the Hudson…a region of this character.…
[Because of] excessive forest destruction…not
more than two-thirds, and in many cases not
one-half, as much water now flows during the
summer months from the streams issuing from
the Adirondack region as was seen in those
streams a quarter of a century ago."[1] The threat
this posed to water levels in the Erie Canal and
Hudson River, the commercial lifelines upon
which the economy of New York largely depend-
ed, was a serious one, and led to the establish-

ment of an Adirondack forest preserve, signed
into law by Governor Hill in May 1885.[2]

In his woodcutter, his forests devastated by
cutting and fire, and his loggers—logs were
floated down tributary streams from the Adi-
rondacks to the upper Hudson River, and from
there to the paper mills at Glens Falls—Homer
depicted, almost sequentially, each stage of the pro-
cess, as ruthless and heartless as the commercial
hunting of deer, of the commercial destruction
of the Adirondack woods and watershed.

Homer was never particularly concerned about
the titles of his paintings, as a letter to Knoedler's
about some of his late watercolors for which they
wished to have titles indicates. "[T]he titles of
my W-C-s I did not think of any consequence,"
Homer wrote. "The question," he said, "should
be are they good, or bad." He then added, "The
two fishermen are fishing for trout—call them
Thom—Dick—or Harry—The two log pic-
tures are on the Hudson river anywhere you
choose to place them—The trout is a trout—."[3]

NOTES

1. "Forest Destruction," *Harper's Weekly* 29 (24 January
1885), 58.

2. Roderick Nash, *Wilderness and the American Mind* (New
Haven and London, 1967), 118–119.

3. Letter to M. Knoedler & Co., 20 April 1901
(M. Knoedler & Co.); see also cat. 159.

184. *Hudson River,* 1892
watercolor over pencil on paper, 35.6 x 50.8 (14 x 20)
Museum of Fine Arts, Boston, Bequest of William
Sturgis Bigelow
Provenance: (Doll & Richards, Boston); William Sturgis Bigelow, Boston, 1892.
Washington and New York only

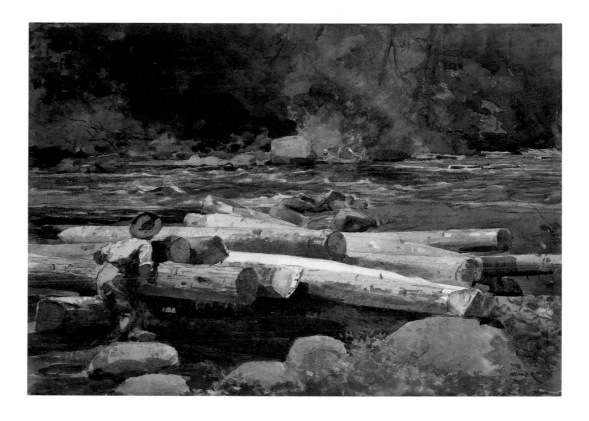

185. *Hudson River, Logging,* 1897
watercolor on paper, 35.6 x 52.4 (14 x 20⅝)
The Corcoran Gallery of Art, Washington, D.C.,
Museum Purchase
Provenance: (M. Knoedler & Co., New York).
New York only

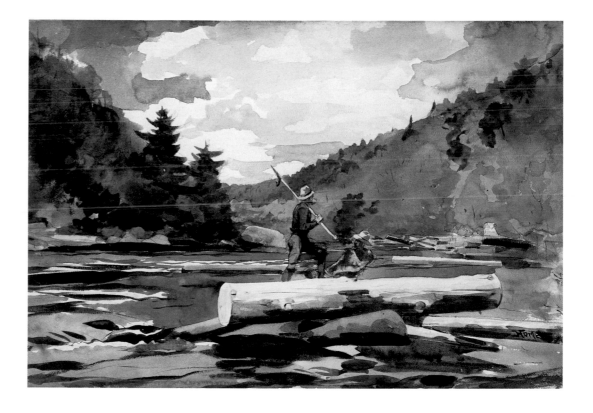

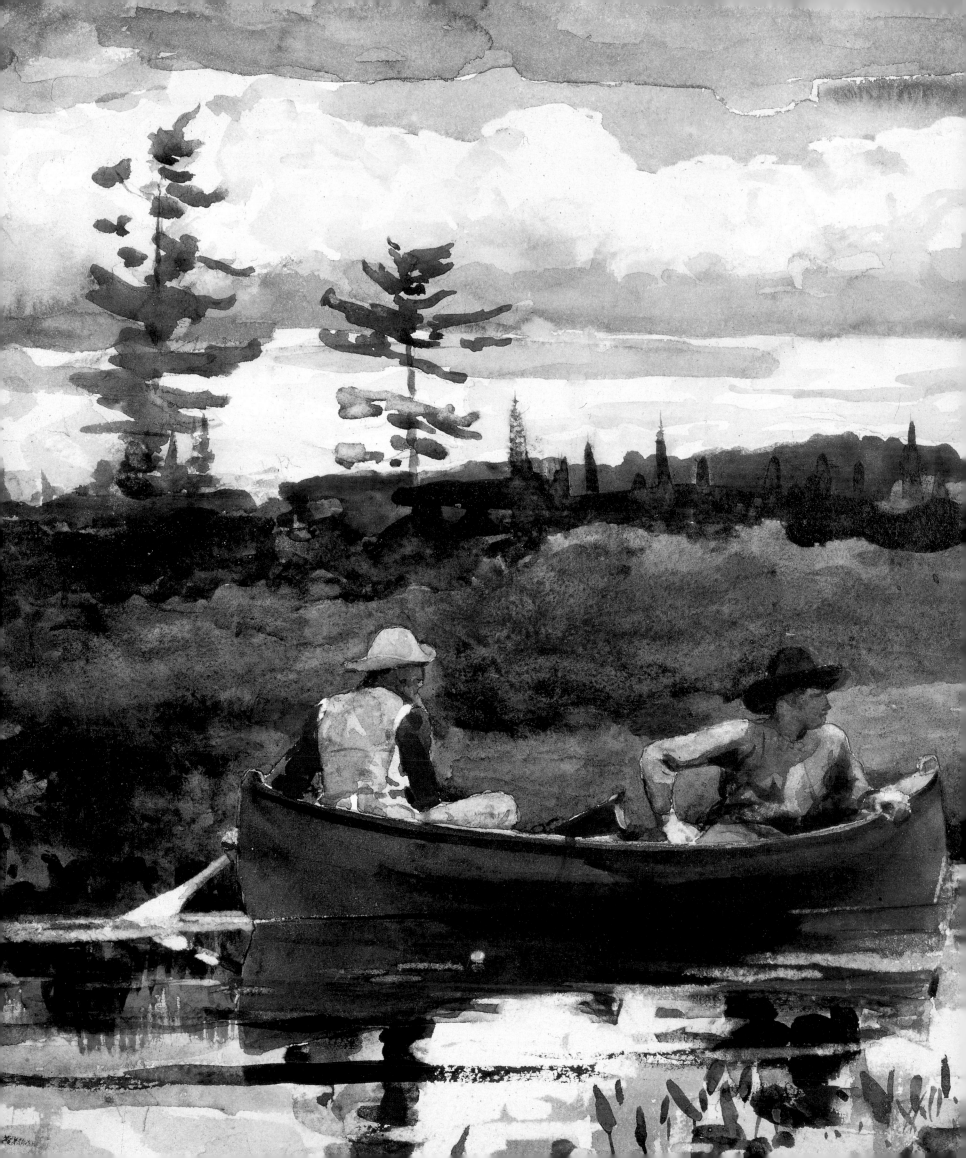

Innovation in Homer's Late Watercolors

Judith Walsh

In May of 1889, Winslow Homer left his home in Prout's Neck, Maine, and went to the North Woods Club, a sporting camp in the Adirondacks.[1] He returned to Maine in July, but revisited the camp in October and stayed another two months. During these two visits he made the first thirty-odd of his late watercolors, which are recognized as a benchmark in his career: they display an unprecedented facility in handling and show expressive qualities previously unknown in American watercolor.[2] After 1889 Homer continued to explore the potential of the medium and by 1905, when he made his last watercolor, Homer had used his singular vision and manner of painting to create a body of work that has not been matched.[3]

The changes in the application of paint as seen in the Adirondack works did not evolve over a period of experimentation and artistic struggle, as had Homer's earlier developments in watercolor.[4] Rather, they appear quite suddenly and are seen in the first group of watercolors from 1889. Complete integration of the new expressive techniques with his other manipulations of washes and paper can be seen in Homer's paintings by about 1892. Such an unusually rapid change suggests outside influence. One tradition of painting is very closely related to Homer's late watercolor painting in technique, subject, and decorative attitude: traditional Japanese painting in ink and watercolor on silk and paper.

Others have suggested that Homer used his experience of Japanese woodblock prints in compositions dating from the 1860s.[5] Beam and Cooper proposed Asian paintings as compositional sources for certain watercolors.[6] An encounter with the techniques used by Japanese watercolor painters is suggested here as the catalyst that allowed Homer to use his already great skill in a newly expressive way.

Leaping Trout (cat. 164), from 1889, is an example of Homer's breakthrough in technique and style. In the background, dark green, almost black, transparent washes that suggest the deep shadow of the northern forest were layered over bright blue and pink accents. The shimmering forms of the trout, illuminated from below by sunlight reflecting off the water, are held in sharp relief. Ripples in the water reflect bands of blue sky and white clouds. Lily pads and plant stems undulate with the current, revealing strands of olive green, magenta, pink, and purple in the foreground. These sensuous, abstract bits of color balance the darkness of the woods. The twigs and lily pads flow with the current, to form opposing diagonals to the trout and the moving water.

In this painting Homer consciously exploited the watercolor wash to create subtle variations in depth of color that evoke, rather than describe, the background landscape. The isolated patches of color in the forest are heavily veiled by darker washes, so that the eye first sees bright pink or blue, and then does not, in imitation of the way sunlight illuminates and then hides details as it passes through heavy foliage. Against this backdrop, Homer renders the fish, lily pads, and the foreground elements precisely. By varying the manner in which the parts of the watercolor are painted, he gives them different weight in the composition, and here has emphasized the simple fact of two trout leaping at (and missing) a cast fly.

Homer also made his late watercolors more formally legible than his earlier works by suppressing extraneous details. For example, a comparison between the 1885 watercolor *In a Florida Jungle* (fig. 154) and his 1889 *Dogs in a Boat* (cat. 172), shows the later work to be more focused. In the earlier subject, the spoonbill and alligator are small, static, and reworked, lost amid the detail of the jungle, in which leaf after leaf has been meticulously rewetted and blotted from the sheet (fig. 186). In the later work, the forest, which embraces the dogs, has been reduced to a unifying backdrop

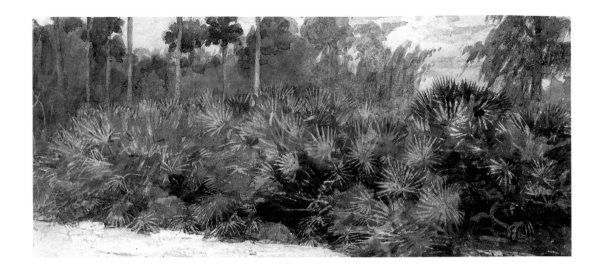

by a few daring, broad sweeps of color. The trees were washed in over a dry, heavily textured sheet. Small areas of the dry sheet held air in pockets, which resisted the wash; when the small bubbles burst, myriad tiny white dots of the paper, sparkling like light through the trees, appeared. Here, the painting technique does not distract the viewer from the expectantly waiting dogs.

From 1889 onward Homer experimented with the transparency, gloss, and weight of various pigments. Earlier he might have added texture or details over a dried wash with a small brush and darker paint, or rewet and scraped color to regain white highlights.[7] Beginning in 1889, however, Homer applied paint with a heavily loaded brush in sure broad strokes, which sometimes puddled and merged on the sheet, showing a preoccupation with painterly concerns. His conscious use of these techniques is seen in such details as the foliage along the bank of the lake in *The Rise* (fig. 187). A detailed photograph (fig. 188), taken in specular light to accentuate the reflection of light from glossy areas, reveals a section where slightly more glossy paint was dropped on the sheet behind the fisherman. The sheet was then, it seems, turned upside down, and the edges of the wet puddle were touched with the brush, releasing several drips of paint to flow toward the top of the sheet. Viewed in the proper orientation, when dry, the separate flows of paint look not so much like drips as rising mist. His use of paint gave Homer an expressive tool that expanded his already great descriptive ability. Combined with a dramatic sense of color developed in the Tropics, and his sweeping brushstrokes, Homer created sheet after sheet of startlingly beautiful watercolors.

When the first Adirondack watercolors were exhibited in New York in early 1890, only a few critics remarked upon the artist's technique. *The Art Interchange* reported that "the painter's command of his materials in this rendering of color, texture and glint, is only equaled by the artistic sense which enables him so skillfully to suggest motion."[8] The *New York Commercial Advertiser* said, "One never wearies of studying the delightful effects…secured with such simple materials. He has caught the movement of the waters, the elusive scintillation of the gaudily scaled fishes, and the constantly changing tints of the growth along the lakes and rivers. He has interpreted antipodal moods with equal sympathy."[9] Every observer or scholar who considered the Adirondack watercolors has echoed this delight in Homer's technical prowess. There is, in these works, an almost perfect exploitation of the transparency, fluidity, and apparent spontaneity of watercolor.

Not so very long before he made these watercolors, Mariana Griswold Van Rensselaer remarked: "He has worked out his technical manners for himself. The results show something of crudeness, of rugged angularity,—are unscholarly, perhaps, but extremely original.…[His technique is] not deft and rapid and graceful. We could never care for it in itself.…There is no denying the fact that Mr. Homer's work has sometimes been positively ugly."

Nevertheless, she found in his work: "beauty of form, of idea, of feeling and of strong expression only—very rarely beauty of color, and never…beauty of the suave and sensuous sort; and of decorative beauty we find not the slightest trace. But always…his work is vital *art*—…self-reliant …genuine…strong to a remarkable degree. For the sake of these qualities…we may a thousand

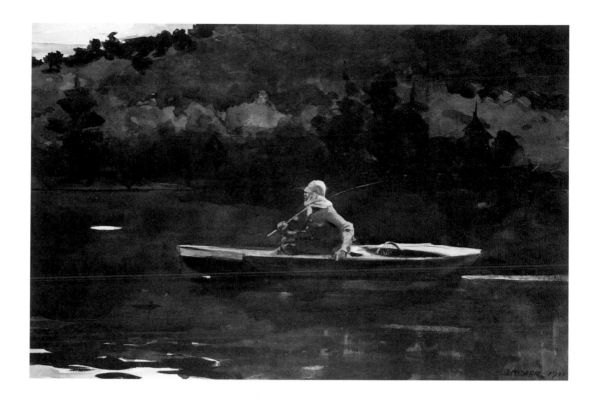

fig. 187. *The Rise*, 1900. Watercolor over pencil. National Gallery of Art, Washington, Gift of Ruth K. Henschel in memory of her husband Charles R. Henschel

fig. 188. Detail of fig. 187

times excuse all technical deficiencies we find...."[10] Beginning with the Adirondack watercolors, however, Homer no longer needed to be excused for technical deficiencies. On the contrary, the technical mastery of these watercolors reveals a sensuous beauty, in color and decoration, without any loss of vitality, genuineness, or strength. Homer deliberately constructed these images in ways that are so direct, so thoroughly appropriate to the subject and medium, that we recognize a consummate technician and a thoughtful artist. In the case of Homer, a frustratingly reticent man, this is the most direct communication we could have.

Homer's first watercolors date from the early 1870s, when the medium was becoming a means of serious artistic expression for American painters.[11] Executed in gouache (opaque watercolor), his early works owe much in technique to European gouache paintings then popular in New York.

Like oil painting, gouache can build the image from dark to light as the opaque medium tones and
highlights are able to cover the darks completely. By 1878 Homer was thinning gouache with water
to produce a more translucent paint, and he also began to experiment with transparent watercolor.
Although different technical resources are necessary for painting in gouache than in watercolor,
Homer used both water-based media in the summer of 1878, and made critically successful paint-
ings in each. He seems to have been weighing the merits of transparent painting against the control
and brilliant effects he could achieve with gouache.[12]

The Green Hill (cat. 93), a gouache from 1878, is on a pale green paper that provided a middle
tone for the pencil underdrawing.[13] Manufactured by the French firm of Canson-Montgolfier, this
sheet shows only a slight tooth, so the pencil could drag easily across the sheet in a firm line. The
forms were worked up by laying in blocks of color that covered most of the pencil drawing. When
that paint had dried, Homer added shadows and darks. Finally, highlights of small touches of Chi-
nese white were applied. *On the Fence* (cat. 98), in contrast, painted in transparent watercolor, is on
a heavier-weight, bright white paper. Manufactured by hand by the English firm J. Whatman, this
paper was among the first specifically engineered for an artistic purpose. It shows a medium tex-
ture with a slight twill. The paper's topography interrupted the line and energized the pencil
underdrawing that shows through the finished painting. In transparent watercolor, the white of
the unpainted paper is reserved to become the highlights, and the artist generally paints from light
to dark, applying the darkest notes last. Shadows are transparent, and the artist can make subtly
graded shadings over an already dried wash, as Homer has in the gray-blue shadow laid over the
boy's gold trousers. Because the paper is thick and heavily sized, water and pigment can be mixed
and manipulated by the artist without cockling and rippling of the sheet. Homer was able to rewet
and blot the band of yellow green at the bottom right to create a sunny patch, and at the bottom
left to suggest a rounded shady form. Even this slight manipulation of the paint was not possible
in gouache. After this summer, his watercolors are painted exclusively in transparent watercolor,
sometimes with opaque white touches.

In the summer of 1880 Homer made a spectacular series of night scenes of Gloucester harbor,
in which he first explored the expressive possibility of watercolor. In paintings like *Sailboat and
Fourth of July Fireworks* (fig. 189) he created the indistinct but recognizable forms of sailing ships
backlit by the setting sun or moon by selectively flowing pigment over already wetted areas of the

paper. Homer's use of water and paint in these paintings achieves a powerful effect of nighttime light over water, but he apparently could not find another image which the technique suited. His expressive manipulation of watercolor would have to wait almost a decade.

During his sojourn to England, from 1881 to 1882, Homer continued his technical development as a watercolorist. Individual sheets from the period show his interest in a variety of specific technical matters, some as basic as sheet size and texture, but, finally, Homer settled upon a method of painting that was an approximation of English exhibition watercolor practice of the time.[14] He relied on repeated washes of transparent color built up over pencil drawings, the bright white of the paper first toned down, then retrieved in a series of subtractive manipulations. From the pigment-washed foundation an artist could expose highlights, vary the texture, and correct the composition by rewetting and blotting, scraping and gouging out the wash and the paper as he needed. Homer used this subtractive method throughout the mid-1880s, as he produced critically praised watercolors that recorded his first visits to Prout's Neck, beginning in 1883; the Bahamas from 1884 to 1885; and Florida from 1885. The wet, loose skies and simple painterly effects in the foliage of these works recall his earlier attempts at expressive painting at Gloucester in 1880. By about 1887, perhaps in response to the glaring light of the Tropics, Homer began to use the emotive power of heightened color along with his already strong sense of design.

From 1886 to 1889, Homer took on two commercial projects. The first, his illustrations for *Century Magazine*'s Civil War history, were based on drawings he had made as a war correspondent.[15] These he reworked into bold compositions in brush and opaque black on watercolor paper, preparing them for photographic reproduction in the volumes of the commemorative history.[16] The second project was a series of etchings that he worked on at Prout's Neck with George W. Ritchie, a printer in New York, sending the plates back and forth for biting and proofing. Although Homer's etchings rely, as all etchings do, on tonal differences in the line for their legibility and success, his prints remain staunchly linear, exhibiting none of the washy, expressive biting of Whistler's prints from the same era.[17]

No source for Homer's new brilliance is found by looking at other watercolorists: none of Homer's contemporaries, either in Europe or at home, offers an example for his late work in the medium. Watercolor painters in the West had not found the expressive qualities of paint that Homer used in his Adirondack paintings. Painterly effects evoking deep ambiguous space or atmospheric perspective, a willingness to sacrifice unnecessary details to focus attention on the subject, and an emphasis on decorative beauty are among the distinguishing novelties of Homer's late watercolor style. Japanese painting could have suggested these and much more to a watercolor painter of Homer's ability.

With a limited range of opaque pigments, white, blue, green, yellow, and red, and the black *sumi* ink of calligraphy, Japanese painters developed schools of painting that prized bravura brushstrokes and intuitive manipulations of ink over the studied, intellectualized images of the established schools based upon ancient Chinese models. Rimpa and Shijo school painters, in particular,

fig. 190. Hashimoto Gaho. *Coming Home in the Rain*, late nineteenth century. Ink and light color. William Sturgis Bigelow Collection, Courtesy Museum of Fine Arts, Boston

fig. 191. Tawaraya Sotatsu. *Waterfowl*, early seventeenth century. Ink. William Sturgis Bigelow Collection, Courtesy Museum of Fine Arts, Boston

fig. 192. Maruyama Okyo. *Dragon*, 1777. Ink. William Sturgis Bigelow Collection, Courtesy Museum of Fine Arts, Boston

relied upon the power of expressive painting techniques to describe the very subjects Homer took up in 1889. They created decorative paintings of animals, landscapes, and flowers with broad flat sweeps of brushwork (fig. 190). By suppressing unnecessary details and carefully balancing their compositions, these painters presented dramatic moments as if stopped in time (figs. 191–192); their elegant designs appear to be spontaneous (fig. 193).

fig. 193. Suzuki Kiitsu. *Chrysanthemums*, nineteenth century. Ink, color, and gold on silk. Fenollosa-Weld Collection, Courtesy Museum of Fine Arts, Boston

fig. 195. Detail of fig. 194

Although Homer would have had to see Japanese paintings first hand (as reproductions and illustrations would not be sufficiently detailed to show the quality of washes),[18] he did not need to know anything specific about Japanese painting to learn from the works he saw. After so many years of practice in Western watercolor techniques, the ways Eastern painters created washes would have been intuitively obvious and understandable to him. Nor could the effects of ink washes be overlooked: Japanese standing screens are quite large, often five feet tall by eight feet wide (perhaps sixteen feet wide if placed as a pair), and display huge fields of broad wash or detailed areas of broken ink that are larger than Homer's entire watercolor sheet. The detail of the banana leaf in Shohaku's *Fowls under a Banana Tree* (figs. 194–195), for instance, pictures an area of the actual painting that is about three feet wide and two feet high. These extravagant washes of ink clearly display techniques that can hardly be seen in the smaller passages of Western watercolor painting.

In this technique, called *haboku* ("broken ink"), the hard edge or overall even application of an ink wash is "broken" by a competing flow of clear water or of another color wash. The flow can be introduced as drips off the brush (*taraishi-komi;* fig. 196) or by painting close to the existing wash and allowing the ink or water to meet and merge (fig. 197).[19] Literati painters would also "splash" ink on the sheet with apparent carelessness, or fling ink indiscriminately on the composition in bouts of drunken "ink play." These blots and blobs would then be refined into recognizable images of great subtlety.[20] The restraint with which Japanese painters controlled these self-activating washes is beguiling, as even a nonpainter is able to visualize the flowing motion that gave rise to any particular effect. Upon contemplation the viewer is struck by the dexterity required to achieve deliberately what appears to be accidental.

The insight gained from even a brief encounter with only a handful of ink paintings could explain the great leaps Homer made in 1889. The Japanese painting techniques of "broken ink" and broad washes of modulated color used to depict naturalistic landscape backgrounds are most easily identified in Homer's late watercolors, but his new variation in painting discrete areas of the

watercolor, simplification of compositions, focus on animals, stopped motion, and even his emphasis on decorative patterns seems attributable to an experience of Japanese paintings.

In Homer's time, despite the pervasive atmosphere of Japanism and the vogue for Japanist decoration, Japanese painting itself was largely unknown to even sophisticated collectors.[21] Beginning in 1886, though, the single best collection outside Japan was being amassed in Boston by private collectors for the eventual benefit of the Museum of Fine Arts. From 1887 to 1890, the vogue for Japanese painting accelerated in Boston, as scholars published on the paintings and the vast local collections became known. Japanese paintings of the Edo period were discussed as contemporary watercolors in the press, and as such would have been of great interest to Homer. His connections to collectors and the art scene in Boston would have allowed him access to a new cache of contemporary watercolors, in what was, after all, his home town.[22]

Traditional painting has always been closely held by the Japanese, except for a short period in the early 1880s. After the 1868 restoration of the Meiji emperor, renewed official contact with the West caused a wave of "Occidentalism" to sweep through Japanese society. Suddenly, traditional art was dismissed in the rush to be "modern." Ancient painting and sculpture, and the finest pottery became available for purchase.

Among the teachers and pilgrims who went to Japan in the early years of the Meiji era were a triumvirate of extraordinary Bostonians who took advantage of their contacts in Japan to gain access to the highest forms of Japanese fine art: Edward Sylvester Morse, Ernest Francisco Fenollosa, and William Sturgis Bigelow. Together with Japanese teachers and colleagues, the three helped establish the basic scholarship for a history of the fine arts of Japan, and formed collections that still rank among the finest in the world.

Fenollosa and Bigelow traveled throughout Japan together and, often buying in tandem, acquired two magnificent groups of paintings. They purchased more than three thousand screens and scrolls from the eighth to the nineteenth centuries between 1879 and 1884.[23] Bigelow, from a prominent Boston family with strong ties to the museum, had always anticipated that his collections would go to the Museum of Fine Arts. In 1885, he arranged to have Charles Weld, a Boston surgeon whose family had become wealthy in the China trade, buy Fenollosa's paintings with the promise that they would join Bigelow's at the Museum of Fine Arts. Although most of the documentation relating to the paintings is lost, it appears that Fenollosa delivered his paintings to Weld in Boston in 1886,[24] when he traveled across the United States and Europe on an imperial mission to study art education theories around the world.[25] Bigelow remained in Japan until 1890, but some of his collections were shipped to the museum as early as 1887.[26]

fig. 196. Detail of fig. 191

fig. 197. Detail of fig. 193

Another visitor to Japan, who may provide the link between Homer and Japanese painting, but who certainly provides documentation for the rarity of the paintings in the West at this time, was the painter John La Farge. One of the era's most educated and interested of Japanists, he had collected Japanese prints and objects since the 1850s. He had also been acquainted with Homer since at least the 1870s, when each had had studio space in the same building in New York.[27] As the guest of Bigelow and Fenollosa, La Farge traveled throughout Japan in 1886 in the company of Henry Adams.[28] In his letters from Japan, La Farge recorded his first reactions to Japanese paintings:

How shall I describe our ride through the enormous city? We were going far across it to call on Professor F—, the great authority on Japanese art, and to be delighted and instructed by him through some fragments of his collection....My mind is yet too confused with many impressions to tell you of what we saw that afternoon and evening, and what was said; all the more that the few beautiful paintings we looked at out of the great collection lifted me away from to-day into an indefinite great past. I dislike analogies but before these ancient religious paintings...I could not help the recall of what I had once felt at the first sight of old Italian art.[29]

Later he considered the paintings more calmly:

I enjoy in this...drawing which they call painting—the strange nearness I seem to be in to the feelings of the men who did the work. There is between us only the thin veil of consummate skill. The habit and methods resulting from it, of an old obedience to an unwritten law, common to all art, have asked for the directest way of marking an intention or an observation.[30]

La Farge bought prints, books, and several hanging scrolls on this trip.[31] By 1886, though, it was too late for visitors to buy great treasures of Japanese painting. In 1884, in large part due to Fenollosa's urging, the sale of important cultural property for export was terminated by law in Japan. The heyday of collecting Japanese paintings of great merit was over, having lasted less than ten years.[32] It is an accident of history that so much great Japanese painting happened to find its way to Boston in these years.

It is not known which of the paintings then in Boston Homer might have seen before he went to the North Woods Club in 1889, but the watercolors he made there suggest that he may have

fig. 198. *Mink Pond*, 1891. Watercolor. The Harvard University Art Museums, Fogg Art Museum, Bequest of Grenville L. Winthrop, 1943.304

fig. 199. *Old Settlers*, 1892. Watercolor. Bequest of Nathaniel T. Kidder, Courtesy Museum of Fine Arts, Boston

seen some. His two trips to the Adirondacks in 1889, by their timing, duration, and the work produced, suggest that they were an extended painting retreat. Homer left Prout's Neck in early May of 1889, and spent a total of five months at the club. His home on Prout's Neck would not have been isolated enough for concentrated work come summer: Homer's family, summer visitors, and other tourists would begin to bother him by June. Japanese painting may have also suggested subjects he knew he would find in the Adirondacks, as he had been there in the 1870s.[33] Homer had earlier taken extended trips to the centers of contemporary painting. He traveled to France from 1867 to 1868, where he apparently focused on oil painting, and in 1881 to 1882 he traveled to England, evidently to consolidate his ability in watercolor. In each case, Homer visited the center of the art he wished to study—Paris, London—then went to a more remote spot for a longer stay to work. Having seen Japanese painting in Boston, he went to a more remote spot, the Adirondacks, for concentrated practical application of what he had seen.[34]

In the winter of 1890, Homer could easily see all the Japanese paintings he might have wanted. In 1882, the trustees of the Museum of Fine Arts had discussed the need for more space. In 1886, fueled in large part by the promise of the Morse Collection of Japanese ceramics, and both the Weld-Fenollosa and Bigelow Collections of Japanese paintings, the trustees began a subscription campaign to pay for the expansion of their building. Late in 1889, the museum, then at Copley Square, was closed to the public for renovation. When it reopened in March of 1890, it showed the promised Japanese paintings and pottery. Fenollosa himself was hired to be the first curator of the Japanese collections. It is hard to imagine the spectacle of the new Japanese corridor at the museum where hundreds of Japanese screens and scrolls from all periods were on exhibit for more than two years. This ostentatious display, an early "blockbuster" exhibition of so many paintings at once from all historical periods and schools of Japanese painting, was probably unique. Perhaps deliberately, the connection between Japanese painting and American watercolors was demonstrated at the reopening of the Boston Museum. In a room contiguous to the Japanese corridor, one hundred and fifty-five American Watercolors were put on display. Dr. Hooper[35] lent one drawing and eleven watercolors by Winslow Homer for this inaugural exhibition in the new wing.[36]

Although there are no records of Homer having visited the Museum of Fine Arts—he never signed into the print room, became a member of the museum, donated to the building fund, or gave a work of art—we can assume he did go to the museum. He had traveled as far as Paris in 1867, and would go to the World's Columbian Exposition in Chicago in 1893, to see his work on display. He visited Boston often to see his father, get a haircut, or shop. (In fact, his grocer, S. S. Pierce, was next door to the museum in Copley Square at this time.)[37] A large exhibition of his watercolors, as well as those of his contemporaries, celebrating the expansion of the Museum of

Fine Arts would have been of keen interest to him. The display of the famed Fenollosa Collection of Japanese watercolor paintings could not have been ignored.

This was not the first public display of the Japanese paintings in Boston. The St. Botolph Club, a private club and a popular venue for contemporary art, including Homer's paintings, had displayed a small group of Weld's and Bigelow's paintings in February 1890 in anticipation of the museum reopening. The show was not reviewed by the art critic of the *Boston Evening Transcript*, but the "Listener," an ombudsman columnist for the paper, saw in these paintings a lesson for American watercolorists:

The Listener does not know what the critics will say about the Japanese water colors which the St. Botolph club is exhibiting to its friends at its gallery this week.... One is so much accustomed in exhibitions...to see a certain varnishy glitter all around, studded with compositions whose purpose strikes the eye at once, that these somber tinted pictures...seem to be an artistic chaos. Nevertheless, when examined most of the pictures turn out to be extremely simple.... The crowning feature of the artistic genius of the Japanese is their ability to enter into the spirit of the thing depicted.... [T]hey give the character, the essential quality, the perponderating [sic] motive of the animal, flower or plant that they are picturing.... Here...is a tiger, crawling along a rock, approaching prey. One would not say, at first glance, that the tiger was at all well painted, technically speaking.... But look...a moment longer. The face is ferocity, is greedy expectation itself. One would say a man could not paint such a face and head unless he had been brought up with tigers, and had seen them crawling upon him in just this way, and in just such a rocky, desolate place.... No menagerie beast this.... The savagely beautiful life and soul of him is in the painting....the lesson for young American artists...is the lesson of the value to art of the artist's abandonment in this subject.... [I]n such pictures, we have the evidences of a high grade of the truly poetic quality in art—the perfectly unconscious exercise of an undoubtably artistic genius.[38]

Part of the beauty we see in Homer's watercolors from the Adirondacks is his abandonment in his subjects, and his direct communication of his emotional response to the natural world.

By 1892, in his second group of Adirondack watercolors, Homer had gone beyond Japanese examples, incorporating the inherent possibilities of broken washes into his technique. Passing briefly through quotations of Japanese motifs and formats reminiscent of Edo-period decorative painting, as in such watercolors as *Mink Pond* (fig. 198) and *Old Settlers* (fig. 199), Homer soon perfected his late style. It was a synthesis of Eastern and Western watercolor techniques. His watercolors from 1892 onward show the use of Western methods, such as pencil underdrawing, and the subtractive methods of the English school of watercolor painting, particularly scraping, scratching, and blotting, as well as the Eastern methods of broken ink, and dripping and merging colors over already laid washes.

Two Adirondack paintings, *A Good Shot, Adirondacks* (cat. 161) of 1892, and *Casting Number 2* of 1894, were scrutinized for evidence of the artist's technique. While infrared light reflectography[39] shows detailed pencil underdrawing of the main figure at the center of each sheet, neither shows any underdrawing in the background foliage, and only the slightest indication of the horizon line is visible in *Casting Number 2*. Drawing with the brush placed the barking dogs at the right and the hunter at the left in *A Good Shot, Adirondacks* (fig. 200). These were then shaded with another dark pigment, and the puff of smoke from the rifle was scraped out. The elaborate washes of color with which the artist described the intricate play of light on the forest were laid in extemporaneously. In the case of *Casting Number 2*, the indication of the trees surrounding the pond suggests a virtuoso performance: it is only the gloss in the medium, concentrated at the drying edge of the wash, that outlines the towering fir trees in darkest green behind the fisherman. The rising mist is simply a thin layer of opaque yellow pigment scumbled over the dark greens. Over this, one long, gracefully curving line was scratched into the sheet in a long, sure motion—it represents the floating line and fly of the fisherman, the cast of the title.

A Good Shot, Adirondacks shows the artist's subtle exploitations of his materials. A pair of inch-wide, long glossy strokes start at the far left edge of the sheet, meeting at a sharp angle behind and just to the right of the deer. Like a gently cupping hand, these strokes pull the terrified figure of the falling deer toward the tiny figure of the hunter. Even if one knows the title of this painting, it is possible to overlook the hunter, obscured as he is by the puff of rifle smoke. These strong lines, which do no more than saturate the existing color with gloss, catch changes in lighting and insistently return the eye to the small figure of the hunter. Unfortunately, this subtlety in the paint

cannot be captured in photography; it can only be seen in changing reflected light. A viewer can
see the change in gloss while moving in front of the framed painting, or if the sheet is rocked when
held in two hands. These effects are so subtle, one must actively look for them, but these subtle
details of technique, consciously used by the artist to unify a composition, are unconsciously
accepted by the viewer. They are typical of Homer's ability in this medium.[40]

 The Blue Boat (fig. 201) is a singular example of Homer's amazing powers in watercolor. In almost
any aspect of the painting—the rendering of the background foliage, the reflection of light or the
canoe on the water, the treatment of the sky, the positioning of the fishermen's bodies, the use of
color, or the variations in brushwork—this Adirondack work is seen to be painted with a com-
mand of the materials that earlier work hardly suggests is possible. For example, in the simple line
of grasses along the river bank, transparent, glossy yellow-green bands of color wave over the sheet
in a gentle roll describing the topography of the area. Over these Homer has flooded a band of
very dilute, opaque, matte brown-red, probably the iron oxide pigment Indian red. The individ-
ual pigment particles of the red, being heavier than water, settled into the valleys among the high
spots in the paper's surface. Because the red pigment is both opaque and matte, even tiny deposits
cover and contrast with the underlying glossy, transparent green, giving the effect of the seed pods
on wild grasses with remarkable simplicity. Note also that the particular red chosen is the com-
plementary color of the green,[41] and the heaviest deposit of the dark red pigment is almost at the
dead center of the sheet, where the cloud of red supports the darker red of the old guide's shirt
reflected in the water below the boat. The dots of high-tone red on the guide's shoulders and
the abstract dot of bright green by the guide's face anchor and focus this painting, and the more
subdued red and green of the grasses seem to flow gracefully from this point. By 1892, Homer's
watercolors displayed an overwhelming and unprecedented sense of artistic and technical self-
confidence. They appear to be spontaneous.

 Technical quotations from Japanese painting can be seen in Homer's work until 1905. In 1894
and 1895, he did a series of black and white wash drawings on light gray or brown paper that pre-
cisely recall Shijo school painting on tea-stained silk. Homer had not used colored papers for water-
color for more than fifteen years when he painted *Two Men in a Canoe* of 1895 (cat. 204). Compare
Homer's receding black washes to a detail of Gaho's painting of *Coming Home in the Rain* (fig.
202): in each, only the drying line of the wash outlines the washed forms. Examples of Japanese

fig. 201. *The Blue Boat*, 1892. Watercolor. Bequest of William Sturgis Bigelow, Courtesy Museum of Fine Arts, Boston

monochromatic painting may have reawakened Homer's long interest in black and white images, which he had used intermittently throughout his career. Homer may have seen Shijo painting at the Museum of Fine Arts, or he may have seen Hashimoto Gaho himself in 1893 at the World's Columbian Exposition in Chicago, where the Japanese painter demonstrated *sumi*-ink painting to visitors.[42]

Homer's final watercolors, from the Tropics at the turn of the century, seem to be an idiosyncratic outgrowth of his "Shijo" painting. In these works, he adapted the monochromatic paintings by using the pigment Prussian blue in place of black wash. Prussian blue, like *sumi* ink, has a high tinting strength. It can be used in the thinnest, most transparent washes or in the darkest, opaque applications and still retain its hue. (Its brilliant color is also quite reminiscent of tropical water and light.)[43] Watercolors like *Key West, Hauling Anchor* (1904) (cat. 220) is painted mostly in Prussian blue, with a few daubs of black, ocher, and red to fill out the palette.

fig. 202. Detail of fig. 190

In 1911 the painter Kenyon Cox wrote a long appreciation of Homer's life work. As a fellow artist, Cox marveled at Homer's ability in watercolor, in which he "seizes instinctively on the nearest way" of representing the subject, not to be clever, but to set down the visual experience with immediacy. Cox concluded:

in the end, he painted better in watercolors—with more virtuosity of hand, more sense of the right use of the material, more decisive mastery of its proper resources—than almost any modern has been able to do....
One must go back to Rubens or Hals for a parallel, in oil painting, to Homer's prodigious skill in watercolor, and perhaps to the Venetians for anything so perfectly right in its technical manner. His felicity and rapidity of handling is a delight...not merely for its own sake but because it insures the greatest purity of the material....Therefore for the fastidious in technical matters Homer's sudden notations of things observed have an extraordinary charm which comes of perfect harmony between the end sought and the means employed....
The accuracy of his observation, the rapidity of his execution and the perfection of his technic increase together, and reach their highest value at the same moment. The one little square of paper becomes a true record of the appearance of nature, an amazing bit of sleight of hand, and a piece of perfect material beauty....[44]

The "perfect material beauty" Cox saw in Homer's late watercolors is not enough to have maintained these paintings so high in critics' estimations. Homer used his capability to create beauty in the service of his larger goal: to express his intense reactions to his observations of nature, and man's place in it. In his late watercolors, his color, handling, compositions, and choice of subject all come together to communicate directly and passionately to viewers. We can see, as La Farge saw in Japanese paintings, the feelings of the artist, through only a thin veil of consummate skill.

The author would like to thank Shelley Fletcher, head of paper conservation, and Ross Merrill, chief of conservation, at the National Gallery of Art for their support (and comfort) as she worked on this project. Most of the members of the scientific research department of the conservation division at the National Gallery have participated in this project at one point or another, but Barbara Berrie, conservation scientist, and Susannah Halpine, biochemist, deserve praise for identifying the pigments in Homer's watercolor box. Yoonjoo Strumfels, associate paper conservator, conducted studies on the fading of Homer's pigments. Thanks also are due to Dr. Elizabeth De Sabato Swinton, curator of Asian Art at the Worcester Art Museum, who has been a valued colleague and a resource on matters Japanese for many years. Helen Cooper, curator of American painting, Yale University Art Gallery, and Marjorie Cohn, curator of prints, Fogg Art Museum, made helpful comments on an earlier draft of the essay.

1. Tatham 1990a.

2. Lloyd Goodrich (1944a, 117) considered that "Homer's Adirondack phase was a new departure in American water-color painting. Up to this time most work in the medium had been in the old style of finished representation, even in the hands of progressive artists like Inness, Martin, La Farge and Eakins. Nothing like the freedom and brilliancy of these works had been seen before in this country."

3. This essay relies upon Helen Cooper's (1986a) excellent study of Homer's watercolors throughout.

4. Cooke 1961 and Walsh 1987.

5. Goodrich 1944a, 17; Wilmerding 1972, 172; Wilmerding 1980, 59; Gardener 1961, 89–119; Gardener 1958; Adams 1990, 61. I am grateful to Shelley Langdale, assistant curator at the Museum of Fine Arts, Boston, for sharing her unpublished research with me.

6. Beam 1966, 110; Cooper 1986a, 173.

7. Cooke 1961, 169–194; Walsh 1987, 44–65.

8. "Art Notes," *The Art Interchange*, 1 March 1890, 66.

9. "The Fine Arts," *New York Commercial Advertiser*, 15 February 1890.

10. Van Rensselaer 1883, 13–21.

11. Kathleen A. Foster, "Makers of the American Watercolor Movement: 1860–1890," Ph.D. diss., Yale University, 1982.

12. Gouache is the French term used to describe opaque watercolor paints. These rely upon an admixture of Chinese white (chalk) to brighten and opacify the colors made from the same pigments found in transparent water paints, which are referred to as "watercolors." Gouache was quite fashionable among French, Spanish, and Italian artists of the 1860s and 1870s for their costume studies and genre scenes, as it allowed the artists to impart a heightened light-reflecting brilliance to detailed work. English and German watercolor painters tended to use the more broadly applied washes of the transparent paints, though, since watercolor's suffusing luminosity reflected from bright white paper suited their idealized landscapes.

13. Unfortunately, the colored papers Homer used in the mid- to late 1870s for his gouache paintings have a tendency to darken when exposed to light. The mechanism by which the papers darken is not yet understood, although it seems to be connected to the method by which the French dyed and sized the pulp for the sheets. This painting was executed on a pale gray-green paper, the color of which can still be seen in the sky behind the thinnest wisps of clouds. Here, the alkalinity of the white protected the sheet from discoloration, preserving the original green.

The dark brown of the rocks in the foreground shows the color the gray-green sheet became upon exposure to light: this area should also be pale green, with blue shadows defining the rock wall. Likewise, the background color behind the seated figure and behind the translucent blue hills and yellow-green field should be green. In fact, the palette for this picture is exactly the same as *On the Fence*, but its coloration has been skewed by the uneven discoloration of the sheet.

14. Martin Hardie, *Water-Colour Painting in Britain*, ed. Dudley Snelgrove, 3 vols. (London and New York, 1966–1968). Technical information about individual painters is included in the entries for each painter, but general technical sections can be found in 1: 30–38, and 3: 212–214.

15. Tatham 1992, 120–128.

16. One of these illustrations resulted in a commissioned watercolor, *Two Scouts*, dated 1888, which was executed in the same technique he had formulated during his English period.

17. Whistler's watercolors, and his prints, were on display in New York in 1889, but I do not believe these are sufficient to have prodded Homer into his Adirondack work, even if he had studied them. (See Ruth E. Fine, "Notes and Notices: Whistler's Watercolors," in *Essays in Honor of Paul Mellon*, ed. John Wilmerding [Washington, D.C., 1986], 111–135.)

Whistler's work in watercolor might provide another fruitful avenue of research into the influence of Asian painting on Western artists, though. William Anderson gave his collection of Japanese paintings to the British Museum in 1882, and these may have shown Whistler a way to use watercolor that did not seem to bow to the theories of his nemesis, John Ruskin, who was the champion of Turner and the British school of watercolor. Whistler's watercolors appear to have taken the idea of emptiness in landscape from the ancient Japanese models based on Southern Sung Chinese painting, rather than the decorative, stopped-action motives of the Rimpa and Shijo schools Homer favored. Margaret F. MacDonald briefly describes the development of Whistler's watercolor technique, from 1881 to 1896, in an introductory essay to *Notes, Harmonies and Nocturnes. Small Works by James McNeill Whistler* [exh. cat., M. Knoedler & Co.] (New York, 1984), 17–19. (Thanks to Joyce Hill Stoner, University of Delaware, for this reference.)

18. Neither contemporary photographs nor reproductions of the paintings could show the subtleties of ink washes. In his published review of the chapter on Japanese painting in M. Gonse's *L'art Japonais* (Paris, 1883), Fenollosa cites this chapter as "the most original part of his work" since "no intelligible account of this special art has hitherto been published in European languages." Fenollosa criticized Gonse for relying on printed copies of Japanese painting, however. He wrote: "In the first place, the copies themselves…were not careful reproductions, but only rough notes to supplement memory; and in the second, Japanese wood-engravers, with all their cleverness, have never learned to reproduce the gradations in tint in good paintings, but have been satisfied with blotchy black masses which bear no resemblance to the originals. No wonder then that M. Gonse's reproductions of these engravings are quite worthless for a comparative study of styles" (Ernest F. Fenollosa, "Review of the Chapter on Painting in *L'Art Japonais*," *Japan Weekly Mail*, 12 July 1884 [reprint Cambridge, Mass., 1885], 7).

Samuel Bing's magazine *Artistic Japan: A Monthly Illustrated Journal of Arts and Industries*, available from 1889 in France and 1890 in English translation, was a step forward, with lavish colored wood engravings. These prints were the marvel of their time, but they do not reproduce the

effects of ink washes. Indeed, modern photography is hardly equal to the task.

19. Fritz Van Briessen, *The Way of the Brush, Painting Techniques of China and Japan* (Rutland, Vt., 1962).

20. Ancient Chinese philosophers discussed the ways in which ink could be used; they described six types of ink: dry, diluted, white, wet, concentrated, and black. These were paired in contrasting groups to better examine their attributes. Wang Yu, a Ching-period philosopher of painting, wrote, "In order to achieve a wondrous effect, one must play on the ink in such a way that where the brush stops 'something else' suddenly emerges" (Francoise Cheng, *Empty and Full, The Language of Chinese Painting*, trans. Michael H. Kohn [Boston, 1994], 83).

The notion of "ink play" has been discussed in the ink work of Japanese painters by Shen Fu, *Studies in Connoisseurship* (Princeton, N.J., 1971).

21. This is a remarkable fact that seems, at first, hard to believe. If one rereads the texts about collections in Western hands specifically looking for mentions of watercolor painting, it becomes conspicuous by its absence. For instance, Sheldon 1882 chronicles visits to the studios of three American artists: Colcman, Tiffany, and William Merrit Chase. He lists all their studio paraphernalia: Japanese objects, fabrics, embroideries, ceramics, armor, prints, pattern books, and some Western paintings, but no Japanese paintings. (Although standing screens do appear in the background of Chase's paintings, these are not necessarily painted; lacquer and printed screens were made for export, as were some lavish gold and opaque color screens of the Kano school.)

Most inventories of European and American collections formed in the nineteenth century mention "Japanese art" as a collective term to distinguish fine arts from crafts, but this is misleading, as it does not distinguish the woodblock prints from the watercolor paintings. The Edo-period artists who may be mentioned by name—Hokusai, Hiroshige, Utamaro, etc.—were all print designers in addition to being painters. In the context of the discussion of watercolor technique, the distinction becomes even more important. Although the woodblock prints were meticulously carved by craftsmen to preserve the character of the outlining brushstrokes in the original *sumi*-ink drawing, the play of colored ink in the paintings was never attempted in the printing of the woodblocks. Impressionist artists who took design, flatness, pattern, and the idea of the brushstroke from the prints could never have learned the expressive power of ink from these works.

Elisa Evett in "Japanese Pictorial Art: A Survey of Availability" discusses the availability of paintings in Europe in the critical era 1860–1900. Her overview is very instructive, in spite of the fact that she seems to imply that reproduction of the works is tantamount to availability of the works themselves, which, at least for the purposes of the discussion here cannot be accepted (in Stephen C. Foster, ed., *The Critical Reception of Japanese Art in Late Nineteenth Century Europe* [Studies in the Fine Arts, The Avant-Garde 36] [Ann Arbor, 1982] 1–21).

Fenollosa wrote of the problems faced by M. Louis Gonse in his study of Japanese art: "Again, it is hard to understand how M. Gonse, with all his diligence in research, could expect to find in Europe alone sufficient material on which to base a positive estimate. In painting, especially, he must have known that comparatively few representative specimens have ever left their country for the foreign market. One might as well think of studying old European painting by examining the specimens owned in America" (Fenollosa, "L'Art Japonais," 4).

In fact, as late as 1958, Peter Swann was able to write,

"Familiarity with Japanese art in the West generally begins and ends with colour prints.... The general art-loving public may also have seen a japanese ivory carving, a late (and generally bad) piece of export porcelain or a charming lacquer object. Little else has reached Europe" (*An Introduction to the Arts of Japan* [Oxford, 1958], introduction, i).

22. Sue Welsh Reed, "Watercolor, A Medium for Boston," in *Awash in Color: Homer, Sargent and the Great American Watercolor* [exh. cat., Museum of Fine Arts] (Boston, 1993), xvii–xxi.

23. Jan Fontein, "A Brief History of the Collections," in *Selected Masterpieces of Asian Art* [exh. cat., Museum of Fine Arts](Boston, 1992), 6–15.

24. Fenollosa apparently took all the documentation relating to his paintings when he left the Museum of Fine Arts in 1895, after what was then a scandalous divorce. These papers are now thought to be lost, as Fenollosa went first to New York, then later to Japan to continue his study and writing. One of his diaries/notebooks has recently been discovered in a Japanese collection, but it does not cover the period under discussion here. (Thanks to the registrar's office and the Japanese department at the Museum of Fine Arts, and Ellen Conant for this information.)

25. Fenollosa's experience of art education in the United States and Europe led him to establish a new system for Japanese schools that emphasized original work from the first, in contrast to the system prevalent in the West that emphasized drawing from plaster casts of classical sculptures. He believed that good design and the balancing of light and dark (notan) in a composition could be instilled in a student from the first. Arthur Wesley Dow, a printmaker and Fenollosa's assistant curator at Boston, eventually codified Fenollosa's ideas in his book, *Composition* (1895), which went through dozens of printings and became the standard text on art education in the United States at the turn of the century. Georgia O'Keeffe's reliance on the Dow-Fenollosa theory of "notan" may be the most notable legacy of this work.

26. Part of Bigelow's collection was apparently put on deposit in the Museum of Fine Arts in 1887. "20 boxes" from "1887" from his collection remained "unopened" in September of 1889, according to handwritten notes taken by William Howe Downes during an interview with Edward Robinson, the curator of classical art at the museum. In the article Downes wrote for the *Boston Evening Transcript*, he says that Bigelow's collection "can hardly be estimated yet, for there are about 20 packing-cases full in the basement, not yet opened, and more are on the way from Japan, whither Dr. Bigelow is expected to come in person in time to help in arranging this wonderful collection" (notes on the end sheet and reverse cover of the *Catalog of Museum of Fine Arts* [Summer 1889], from the library of the Boston Museum of Fine Arts, and "The New Wing. The new part of the art museum to be thrown open next January, and valuable acquisitions it will contain," *Boston Evening Transcript*, 28 September 1889, 8).

27. Downes 1911, 35–36, 83–84, 244.

28. Okakura Kakuzo, one of Fenollosa's students and an elegant and well-respected intellectual, was their translator for the journey. Best known in the West as the author of the perennially popular *Book of Tea* (1906), Kakuzo was a member of the Imperial Archeological Survey and succeeded Fenollosa as the second curator of Asian painting at the Museum of Fine Arts in Boston. He is credited with introducing "tea taste" or an appreciation of the studied simplicity and humility of the Zen aesthetic to the West.

29. John La Farge, *An Artist's Letters from Japan* (New York, 1903), 10–14.

30. *Letters from Japan*, 152.

31. In a letter published as an introduction to the second sale of his Oriental art, La Farge described his property. He wrote that he was not a collector of Japanese art so much as an accumulator of pieces that had some meaning for him in the long practice of his art. Some of the artifacts offered for sale were gotten as tools, and only a few were assembled in "the manner of a collector." For the sale in 1909, he took care to identify the time and place of purchase of many of the objects. (Unfortunately this inventory is incomplete.) Of the 664 lots offered in this sale, almost one hundred prints are identified as having come from his trip to Japan in 1886, but only five paintings: two by Toyokuni (an ambiguous designation, since at least three artists used the name, including Kunisada), and three by Hokkei (1780–1850), a pupil of Hokusai. The other two sales of his property, from 1908 and 1911, do not include even this incomplete information. All together, the three sales offered about 1,500 lots of Japanese prints, paintings, and a few decorative pieces.

Letter addressed to Major Turner, the president of Anderson Auction House, dated 1 March 1909, in sales catalogue 741, *Oriental Art Objects, The Property of John La Farge*, 24–27 March 1909, Anderson Auction Company, New York, unpaginated. *Catalogue of the Art Property and other objects belonging to the Estate of the Late John La Farge, N.A.*, March 1911, American Art Galleries Sales Catalogue, New York. *Valuable Artistic Property Collected by the Well-Known Connoisseur John La Farge, N.A.*, 13–14 February 1908, American Art Galleries Sales Catalogue, New York.

32. Henry Adams, in mourning over the suicide of his wife, Clover Hooper Adams (the sister of Homer's patron, Dr. Hooper), convinced La Farge to travel with him to Japan. Adams and his neighbor John Hay had hoped to furnish their new townhouses in Washington, D.C., with souvenirs of the trip. But Adams' letters to Hay repeatedly complain of the paucity of fine objects to be obtained in Japan:

> I have still to report that purchases for you are going on, but more and more slowly, for I believe we have burst up all the pawnbrokers' shops in Japan. Even the cholera has shaken out little that is worth getting. Bigelow and Fenollosa cling like misers to their miserable hoards. Not a Kakimono is to be found, though plenty are brought. Every day new bales of rubbish come up from Tokio or elsewhere; mounds of books; tons of bad bronze; holocausts of lacquer; I buy everything that is merely possible; and have got not a hundred dollars' worth of things I want for myself. (Letter to John Hay dated 22 August 1886, in *Henry Adams: Selected Letters*, ed. Ernest Samuels [Cambridge, Mass., 1992], 189–190.)

33. Tatham 1988, 21–35.

34. I am grateful to Bruce Robertson for pointing out this pattern.

35. Reed, "Watercolor," xix–xx.

36. Information garnered from the *Annual Report of the Board of Trustees*, Museum of Fine Arts, Boston, 1882–1891. Microfiche at the Archives of American Art.

37. The author is grateful to Sue Welsh Reed, associate curator of prints, drawings, and photographs at the Boston Museum of Fine Arts for this information. S. S. Pierce was very important to Homer: it is where he bought his rum, among his other staples.

38. "The Listener," *Boston Evening Transcript*, 24 February 1890.

39. Inspection of a work of art by infrared reflectography would reveal any carbon-based drawing media (such as graphite or charcoal) beneath infrared transparent pigments. IRR composite photo thanks to Carol Ann Eggert, paper conservation lab, National Gallery of Art.

40. The varnishing of oil paintings evens out variations in gloss, so when Homer revisited this composition for *Right and Left* (1909), he had to use another method to make the hunter more visible. In the painting he used a splash of bright orange-red to indicate the explosion from the hunter's rifle. See Wilmerding 1980, 61–62, for a discussion of the relationship between *A Good Shot, Adirondacks* and *Right and Left*.

41. Homer owned a copy of M. E. Chevreul, *The Principles of Harmony and Contrast of Colors and Their Applications to the Fine Arts* (1859). For a discussion of Homer and Chevreul, see Kristin Hoermann, "A Hand Formed to use the Brush," in Simpson et al. 1988, 105–107.

42. Thanks to Elizabeth De Sabato Swinton, curator of Asian Art, Worcester Art Museum, and Anne Rose Kitagawa, assistant curator, Japanese department at the Museum of Fine Arts, Boston, for information about Hashimoto Gaho at the Columbian Exposition.

43. Both Cooper 1986a and Cooke 1961 remarked on Homer's reliance on Prussian blue in these late tropical watercolors. Previously Homer most often had used the pigment indigo for skies and water, with some other blues (such as Prussian blue and cobalt blue) as accents. By 1886, Homer may have had another reason to abandon his earlier favorite. Indigo had been largely discredited by the *Report* of Russell and Abney, who tested common watercolor pigments for their permanence in watercolor painting in response to the English watercolor controversy of 1882. They declared Indigo to be untrustworthy upon exposure to light. (Russell and Abney, *Report* [London, 1886].)

44. Published privately in 1911 (Cox 1914a, 73–75).

Time and Narrative Erased

Franklin Kelly

fig. 203. After Winslow Homer. "Our Watering Places—The Empty Sleeve at Newport." Wood engraving. In *Harper's Weekly*, 26 August 1865

The sea was never far from Homer's life, and its appearance in his art was regular from the earliest years of his career. Its presence could be assertively obvious, as in *Breezing Up* (cat. 76); his Cullercoats works; or the heroic paintings of the mid-1880s, such as *The Fog Warning* (cat. 134). Or, it might be visible only in the far distance, as in "Our Watering Places—The Empty Sleeve at Newport" (fig. 203) or *The Dinner Horn* (cat. 41). But suddenly in 1890 the sea dramatically assumed a new role in Homer's art, bringing it aesthetically and thematically to the forefront.

Since settling in Prout's Neck in 1883 Homer had studied the sea continuously, recording its appearance under different conditions of light and weather in watercolors and drawings (fig. 204). He did not, however, make it the true protagonist of a major work in oil until his first pure marine painting, *Sunlight on the Coast* (fig. 205). Depicting the ebb of one wave from a rocky foreground ledge and the arrival of a second massive breaker that spans the center of the canvas, *Sunlight on the Coast* wonderfully expresses both the force and the beauty of the sea. Over the next nineteen years the sea would play a key role in virtually every oil he painted, and in some dozen of these it would emphatically be the principal subject. Works such as *Northeaster* (cat. 194), *West Point, Prout's Neck* (cat. 228), and *Early Morning after a Storm at Sea* (cat. 229) were among the best known of Homer's works for his contemporaries and remain among his most famous today. For many, these late seascapes express in undeniable terms the very essence of Homer's greatness. Yet even a century later they remain in some ways incompletely understood, even mysterious.[1] A painting like *Northeaster* may easily yield to a formal appreciation of its compositional dynamics and its richly brushed passages of pigment, and can also be readily admired for the way it captures the very look and feel (and even suggests the sound) of the sea. But such images can also forcefully repel attempts to probe more deeply into issues of meaning and content; indeed, two of the most basic questions asked of works of art—why were they created? what do they mean?—prove exceptionally difficult when applied to Homer's marines. What the paintings depict is obvious. How they fit into historical traditions and were received and understood by Homer's audience can be answered with at least some confidence. But unraveling his personal motives is a far more daunting challenge. Perhaps in this case definitive answers are simply not possible, as some have argued.[2] But it is possible, at the

fig. 204. *Prout's Neck, Rocky Shore*, 1883. Watercolor over pencil. Worcester Art Museum, Worcester, Massachusetts

very least, to make reasonable conjectures by looking beyond the ways in which late nineteenth-century American painting traditionally confined itself to narrative meaning and content.

A thorough investigation of Homer's intentions in his late marines involves three issues. First, there are the patterns that have shaped Western man's attitudes toward the sea. Second, there are the precedents in European and American seascapes that might shed light on Homer's marines, if only by contrast. And third, there is Homer's own attitude—both artistic and personal—toward the sea and the question of how his paintings of it express meanings of both a public and private nature.

Over the centuries the attitude of Western man toward the sea has shifted and metamorphosed countless times.[3] These changes were the result of complex and often conflicting events and circumstances that cannot be easily summarized; indeed the field of meanings embodied by the sea is impossibly vast, ranging from the cosmological (the book of Genesis identified water as the primordial matter of the universe) to individual associations. Not surprisingly, the sea has long been considered one of the most potent centers of archetypal metaphor at work in Western thought, embracing both negative and positive meanings.[4]

The sea's negative connotations have primarily revolved around its destructive potential. Its constant motion and the unending supply of debris cast up on its shores serve as constant reminders of its ability to overflow its boundaries and bring destruction to man's creations. As an agent of death the sea could take the life of a single unfortunate swimmer, or consume everyone aboard a crowded ship. Even beaches could carry negative associations as "no man's lands" where the sea fought with the earth, and where creatures from the deep could rise up and snatch an unwary victim from the land (as in the Rape of Europa).

Signs of changing attitudes to the sea are clearly discernible in the eighteenth century, when there was increasing appreciation of the sea's beauty, even if it was terrible and terrifying. A key component in this shift was the rise of the theory of the Sublime, which proposed a pleasure in contemplating even repellent aspects of nature. Edmund Burke, whose writings on the Sublime had the greatest influence on the visual arts, considered oceans of unsurpassed sublimity. "A level plain of vast extent on land, is certainly no mean idea," observed Burke, "but can it ever fill the mind with anything so great as the ocean itself?"[5]

During the later eighteenth and early nineteenth centuries, many factors, including new beliefs in the therapeutic benefits of sea air and salt-water bathing and increasing tourist travel, combined to give the ocean a wholly new identity in popular imagination (fig. 206). Although fear of the sea's destructive potential remained, it came to embody purity in contrast to the land, an unhealthy and degenerate place of moral, political, and social corruption. Such thinking, together with the

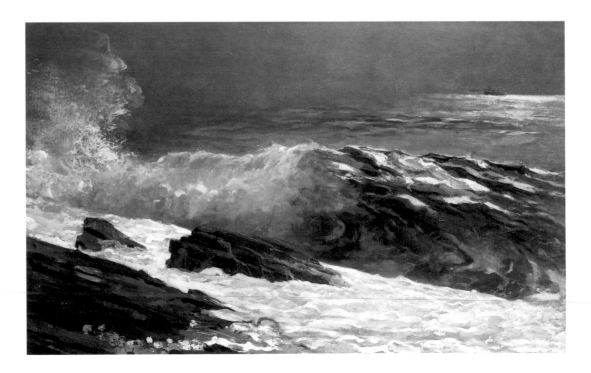

fig. 205. *Sunlight on the Coast*, 1890. Oil on canvas. The Toledo Museum of Art, Toledo, Ohio, Gift of Edward Drummond Libbey

identification of the sea as a place for redemption and voyages to knowledge, was most fully devel-
oped in the romantic era. In Byron's *Childe Harold*, for example, the sea is eternal, beyond the reach
of man and his history: "Man marks the earth with ruin—his control stops with the shore." For
Byron, the ocean was "Dark-heaving—boundless, endless, and sublime—The image of Eternity."[6]

By Homer's era advancements and achievements in oceanography and technology had largely
demystified the sea. Steam travel allowed easier passage across oceans, making them seem less like
dangerous wildernesses and more like permanent routes connecting rather than separating bodies
of land. Oceanography unlocked many secrets of the deep, and widespread chart making and weath-
er recording helped give some sense of order and predictability to the sea and its actions.[7] Yet even
though increased knowledge laid to rest old fears and misconceptions, the ocean in some ways
grew even more enigmatic and mysterious. In an era of rampant industrialization and rising prag-
matism, the ever-changing, restless sea could still function as a metaphor for the instability and
uncertainty of life itself. Indeed, Sigmund Freud in probing the unconscious paid special attention
to the images of water generally, and to the sea specifically. Recognizing its potency as an arche-
typal image in the human psyche, Freud identified "a sensation of *eternity*, a feeling as of some-
thing limitless, unbounded, something 'oceanic.'"[8] Herman Melville's Ishmael had already given
voice to this view of the sea when he spoke of it as "the image of the ungraspable phantom of
life;…the key to it all."[9]

During the nineteenth century marine subjects—pure seascapes, harbor scenes, ship portraits,
naval battles, shipwrecks—proliferated in both American and European painting.[10] But in the
context of Homer's late marines one particular subject—waves breaking on the shore—is most
obviously relevant. Although such pictures were by no means as numerous as some marine sub-
jects, they were particularly in vogue during the second half of the nineteenth century. Among
the many typical examples in American and European painting that could be cited are works by
James Hamilton, Martin Johnson Heade (fig. 207), William Trost Richards, Thomas Moran (fig.
208), James McNeill Whistler, Alexander Harrison (fig. 209), Jules Dupré, Claude Monet (fig. 210),
Berndt Adolf Lindholm (fig. 211), and William McTaggart (fig. 212). Homer was undoubtedly
aware of many such works, and thus would have known that there was nothing particularly novel
in his choice of subject. Nevertheless, even the most casual look at a Homer marine such as *North-
easter* is enough to suggest that his vision of the sea had little in common with virtually any other
painter of the era. Homer's sea and rocks are brought so close to the picture plane and made so
visually dominant that everything else is suppressed. His skies (except in a few cases such as *West
Point, Prout's Neck*, cat. 228) tend to be close in color to the sea, making it difficult to determine
where they begin and thus denying any readily identifiable area of visual escape. The composition-
al rhythms set in motion by diagonally placed rocks, billowing spray, and onrushing and receding
waves combine with the intensely tactile qualities of Homer's pigment to give these images a riv-
eting insistence that holds the viewer's attention so firmly as to suggest no possibility of release.

fig. 209. Alexander Harrison. *The Wave*, c. 1885. Oil on canvas. The Pennsylvania Academy of the Fine Arts, Philadelphia, Joseph E. Temple Fund

In fact, only in the extraordinary seascapes of Gustave Courbet (fig. 213) is there any counterpart in nineteenth-century painting to Homer's great marines. It is not known for certain what Homer thought of Courbet's art, nor even which particular examples he may have seen in this country or abroad. Nor is it known what he may have thought of being compared to the French artist, which is precisely what one reviewer did after seeing his first marines in 1891: "If it is necessary to compare him to some other, we should say that he comes nearer to Courbet than any other modern painter...."[11] Even so, the pertinent issue here does not concern stylistic or thematic influence, but whether Courbet's equally intense pictorial investigations of the sea shed any light on Homer's intentions and meanings.

Courbet visited Etretat in 1869 and began to produce canvases that focused on large waves at the moment they break and crash against the sand or rocks.[12] Courbet's contemporaries recognized that the powerful reductiveness and simplification of these pictures was without precedent in European painting, and that they were dramatically different from the seascapes of then-fashionable salon painters. As Emile Zola observed: "Do not expect a symbolic work in the manner of Cabanel or Baudry—some nude woman, with skin as pearly as a shell, who bathes in a sea of agate. Courbet has simply painted a wave...."[13] Zola's words also remind us that these works were radically unlike Courbet's more typical paintings, which generally included figures or animals. With only occasional exceptions, his seascapes are largely absent of living presences. And what particularly distinguishes them is the extraordinary richness of their surfaces, upon which Courbet built up thick passages of paint applied with palette knife and brush. His paint seems to swirl with the energy of its subject, so that it at once evokes the motion of the sea, and asserts his own physical activity in creating the canvas.

It is unclear precisely what drew Courbet to this subject and just what meaning he intended for his pictures. That he painted more than twenty-five of them in 1869 clearly indicates the intensity of his interest. On one level, these crashing waves offered an arena in which he could indulge his fondness for a strongly gestural handling of paint. In effect, they allowed him to paint in a way that gave full rein to the tactile pleasures of manipulating the material of his art. There is something of primal struggle in these pictures, something so assertively rough, even for a painter known

fig. 210. Claude Monet. *Rough Weather at Etretat*, 1883. Oil on canvas. National Gallery of Victoria, Felton Bequest, 1913

fig. 211. Berndt Adolf Lindholm. *View of the Cattegat*, 1890. Oil on canvas. The National Swedish Art Museums

fig. 212. William McTaggart. *The Storm*, 1890. Oil on canvas. National Gallery of Scotland

for his richly textured surfaces, that they become virtually self-referential. We sense that Courbet, through paint, was grappling with a subject that affected him viscerally and emotionally, so much so that he tried to understand it, and even to conquer it, through the means of art, his own greatest strength. Certainly the potency of the sea for Courbet and his determination to resist its force is evident in his words to Victor Hugo in 1864: "The sea! The sea!…in her fury which growls, she reminds me of the caged monster who can devour me."[14] Courbet's feminization of the sea was not, of course, unusual, and he had already made the point pictorially in his *Woman in the Waves* of 1868 (fig. 214). Thus, though Zola was literally correct that Courbet's seascapes eschewed salon-style symbolism actually equating waves and women, his seas nevertheless managed to express, even if only in personal terms, a powerful sense of sensual and sexual energy.

This is not the place to probe the motivations behind Courbet's seascapes. However, it is of interest to compare his engagement with the sea, which was, after all, based on temporary visits to the shore, with the similar experiences of Claude Monet when he journeyed to Belle-Ile-en-Mer in 1886. As Steven Z. Levine has shown, Monet went to Belle-Ile, a dramatically rocky island in the Atlantic off the coast of Brittany, as a traveler in search of sublime scenery.[15] Like Courbet at Etretat in 1869, Monet responded with a remarkable burst of creativity, painting more than thirty canvases. Monet wrote of his "passion for the sea," but, frustrated by his inability to capture its appearance on canvas, also denounced it as a "scamp," "minx," and a "she-devil."[16] By drawing on the traditional theory of the Sublime and on the writings of Arthur Schopenhauer and Freud,

fig. 213. Gustave Courbet. *The Wave*, 1869. Oil on canvas. National Gallery of Scotland

fig. 214. Gustave Courbet. *Woman in the Waves*, 1868. Oil on canvas. The Metropolitan Museum of Art, Bequest of Mrs. H.O. Havemeyer, 1929, The Havemeyer Collection

Levine proposes that Monet's Belle-Ile paintings may be read as images of an "oceanic sublime." The "oceanic sublime" can, in turn, be seen as a manifestation of sublimation, which Freud defined as a process through which seemingly irreconcilable conflicts in the human psyche between opposing drives such as love and hate are rechanneled in ways that are not self-destructive.[17] As Levine concludes, "we find the sea offering the opportunity for displacement and discharge of the desire to return from the tremors of life to the inviting tranquility of death."[18] We might add that Monet's seascapes (and Courbet's, to an even greater extent) suggest a release from pent-up sexual desire in the form of a frenzied physical confrontation with liquid pigment on canvas, as the artist's touch transforms the medium and brings into being a new image.

There may well be potential for applying such an approach to Homer's seascapes to uncover motivations and meanings. In this context, however, it is important to stress what was essentially different about his relationship with the subject. Whereas Courbet and Monet intentionally journeyed to the sea in search of subject matter, and then returned to their inland homes and studios, Homer purposely chose to live and work by the sea. When he made trips after 1883, they tended to be to escape that place, at least during its most severe season. And unlike the French artists, Homer's artistic engagement with the sea did not immediately result in pictures of it; on the contrary, he was seemingly unable to reckon with it in an oil painting for the first seven years of his residence at Prout's Neck. And once he did, the result was not a rapid production of canvases; instead, Homer painted at most a few a year, and sometimes none at all. Based on a restrictive view of what actually constitutes a "pure" seascape that says it must, among other things, have a large portion of the canvas given over to the sea and minimal or no human presence, fewer than one-half of the thirty to thirty-five major oils he created from 1890 until his death fully qualify. There is no obvious pattern in when they were created, although three years—1894 (*High Cliff, Coast of Maine*, cat. 191; *Weatherbeaten*, fig. 215; *Moonlight, Wood Island Light*, cat. 190), 1895 (*Cannon Rock*, cat. 193; *Northeaster*, cat. 194), and 1900 (*On a Lee Shore*, cat. 226; *West Point, Prout's Neck*, cat. 228; *Eastern Point, Prout's Neck*, cat. 227)—account for more than half the total and for some of the most extravagantly admired, then and now. And major works centered on humans or animals, such as *Huntsman and Dogs* (cat. 176), *The Gulf Stream* (cat. 231), *Kissing the Moon* (cat. 233), and *Right and Left* (cat. 235), occupied Homer's attention during the years when he did not paint the sea, thus interrupting any regular sequence of marines. However else his seascapes are categorized, it cannot be in precisely the same terms as those of Courbet or Monet. His paintings came at a slower pace, were not so literally a "series" (at least in the sense that Monet's Belle-Ile paintings were), and were arguably more deliberately thought out and executed as works for public display. The frenzied pace of production that characterized Courbet's and Monet's pictorial experience of the sea, and which had the hallmarks of intense personal struggle, was not a feature of Homer's process. His paintings of the sea, regardless of the private needs they may have addressed and fulfilled, functioned first and foremost as works of art to be shown and seen. What they might reveal about their creator is another matter entirely.

In fact, virtually all of Homer's pure marines were exhibited during the artist's lifetime, and several were shown on more than one occasion. This alone locates them squarely within the realm of his public persona, by and through which he represented himself as an artist to others. As such, the same critical judgments that apply to other exhibited works must be equally applicable, so that the seascapes can be located within an overarching view of Homer's work that makes them compatible, or at least not dissonant, with his other major subjects. Perhaps the most distinguishing factor in Homer's treatment of all his major subjects—the Civil War, fashionable games and resorts, the pastimes of children, the experience of African-Americans in the postbellum South, the men and women of the North Sea fishing communities, the life and work of Prout's Neck fishermen—is his deliberate and conscious attempt to express essential meanings about them that went beyond mere storytelling or the recounting of incidence. A work such as *Breezing Up* can be read as a story on its most basic level: a boat filled with boys and a man is under sail, it clearly got to where it is now by being sailed before the moment we see it, and it will continue to be sailed after it passes from the moment suspended by the artist. To be sure, it takes some imagination to set this story in motion, but not very much. In fact, this is narrative at its most obvious, wherein a tale is told that has an implied beginning, middle, and end. Yet time and time again, Homer made such seemingly straightforward narratives serve deeper and richer purposes. *Breezing Up* can be read (as it is

elsewhere in this catalogue) on several levels, most tellingly as a recasting of the venerable "voyage of life" theme, and thus a meditation on human mortality, and as symbolic of the present and future state of the American nation itself at the time of its Centennial.

Throughout his career Homer depended on narrative structures that would, just as they began to suggest a normal unfolding, deflect the viewer from obvious and easy interpretations. Thus, *Prisoners from the Front* (cat. 10) is about war, but does not show warfare; *The Coming Away of the Gale* (fig. 149 and cat. 189) is about the perils of the sea, but does not show marine tragedy; and *The Gulf Stream* is about the frailty of humanity and the uncertainty of life itself, but does not show death. In the case of the last-named painting we have Homer's well-known words confirming his intention to avoid any simplistic narrative: "You ask me for a full description of my picture of the 'Gulf Stream.' I regret very much that I have painted a picture that requires any description."[19] The "description" or "story" of the painting, then, is not the bearer of its true content, only the means of delivering it. As Homer concluded: "the unfortunate negro who now is so dazed and parboiled—will be rescued & returned to his friends and home & ever after live happily." Such pointed sarcasm makes it inescapably clear that Homer was telling us precisely what his painting was *not* about.

There are many instances of Homer reacting testily to such questions about his paintings. Sometimes, so far as we know, he ignored them, as in the case of a woman who wrote and asked what was "in that barrel" in *The Fog Warning* (cat. 134).[20] Other times he took pains to discourage what he felt were the wrong questions being asked, as in the case of *Hound and Hunter* (cat. 179). The proper question, Homer stressed, was not whether or not the deer was dead—it was, he said—but involved something larger, something, we are led to expect by the ominousness of the painting, more profoundly troubling. For Homer, this deflection of an expected narrative drama allowed a transformation of subjects that would not automatically be understood by viewers. *Hound and Hunter* offers no comfort by suggesting that its story can be compactly grasped and easily summarized, with a beginning, a middle, and an end that can each be understood and even predicted. This particular deer may die, but the motivations of its killer and of the society of which he is a part will not vanish in a single act. Deer hunting had been depicted in American art countless times before, even to the point of trivialization. That Homer managed to take the subject and wrest from it not just new meaning, but deeply serious meaning, is testament to his ability to manipulate narrative structure in a way that was unequaled by any other American painter of his day.

Two other paintings—*The Signal of Distress* and *Northeaster* (cats. 155, 194)—shed additional light on the role of narrative in Homer's art at the time he was painting pure seascapes. As is discussed elsewhere in this catalogue, *The Signal of Distress* originally included a large ship under full

fig. 215. *Weatherbeaten*, 1894. Oil on canvas. The Portland Museum of Art, Portland, Maine, Bequest of Charles Shipman Payson, 1988.55.1

sail in the distance, but Homer later replaced it with a dismasted ship flying a tattered flag. The possibility of an heroic rescue—a subject that would provide a more predictable narrative structure—was thus removed.[21] Homer's alterations to *Northeaster*, made five years after its completion in 1895, though less dramatic than those he made to *The Signal of Distress*, were equally telling. Most of the changes involved reworking the large burst of spray and the breaking wave at the center, but he also made a significant deletion. Originally, two men in sou'westers were on the rocks at the left, seemingly crouching in awe below the towering spray of the wave. By taking these men out, Homer removed a pronounced narrative element, for their presence established a human frame of reference. The changes to *Northeaster*, according to Homer, "made it much finer";[22] once again, he moved firmly but decisively away from the implications of ordinary narrative structure.

How might Homer's attitude toward narrative content help us understand the meanings of his seascapes? Do they, too, in some essential way begin with the underpinnings of narrative, but end up subverting its usual ways of working? If narrative is at the heart of these works, then it is necessary to identify the subject or subjects of the story. The seascapes can easily be divided into three main parts: land, sea, and sky. As already noted, the skies are only rarely of strong visual interest; it is the land and the sea around which the images revolve. And each of these two elements is shown at its most elementally forceful—massive breaking waves and hard, resistant rocks. At their most obvious Homer's marines tell what has recently been called a "simple" story, with a "plot of stormy water and obdurate rock."[23] Homer's contemporaries easily recognized in this plot the age-old theme of the sea warring with the land. In one undeniable sense that is what these paintings are about. Indeed, Lloyd Goodrich concluded in 1944 that "Homer had always been a storyteller. Dramatic action was what interested him; and this the sea supplied, to take the place of human action…the drama of the sea and its never-ending battle with the land."[24]

Was that, in fact, all that Homer's seascapes offered to his audience? Was their plot really so simple and so seemingly straightforward? By the late nineteenth century, there were many potential meanings and associations implicit in the subject of the shore, and viewers' responses to Homer's marines would have varied widely. In the absence of written accounts, however, it is impossible to recover these kinds of personal associations.[25] The sea as portrayed in Homer's paintings may have suggested, in Ishmael's words, "the key to it all," but what lay behind the door it unlocked for each individual is beyond knowing. But if we frame the question more specifically and ask, for example, what lessons about the physical nature of the world might have been implicit in Homer's seascapes, we are on firmer ground. As the geologist Nathaniel S. Shaler wrote in 1892:

…in most lands the order of nature is so quiet, and its processes so familiar, that the whole appears merely commonplace. It is otherwise, however, with those who dwell in the peculiar realm where the great reservoir of the waters comes in contact with the land: on the ocean's shore the processes of change are so marked, man's combat with them so continued, that all mariners, and even those who reside near the sea, acquire a far more vivid impression of the earth's activities.

All those who would find an easy way to a conception of the facts of geologic science should take up their inquiry on the coast-line: if they understand the processes which are there in operation—they are indeed easily understood—they will gain a clue to nearly all the great truths of geology.[26]

A text such as this does suggest a plausible explanation of Homer's seascapes, for it would grant them a seriousness fully consonant with his intentions in other major oils. In this way the interaction between sea and shore became emblematic of the immense yet intricate system of natural forces and conditions that form and define the world itself. The seascapes read as intense, distilled images of nature's operations. With good reason they have been called his "grandest Darwinian subject," the works that most fully express the "unceasing, unfeeling operations of natural processes of change through struggle."[27] In fact, if there was a single widely shared interpretation of the seascapes among the most perceptive of Homer's audience, this was likely it. Still, it may also be possible to look beyond even the far-reaching implications of this interpretation to a view that in some ways closely ties the seascapes to Homer's mature oils generally, but also suggests that they are in other ways different from anything else he ever painted.

This reading, inevitably, returns our attention to the matter of narrative. As we have seen, Homer's seascapes do, on one or more obvious levels, function within a narrative structure, no matter how loosely organized. Their narratives can be as simple as the story of the ocean's majestic

force revealed by its confrontations with the land, or as complicated as a meditation on the complex physical processes of the entire world. But if we ponder such ideas long, the very nature of the sea itself will ultimately erase all sense of narrative progression. In its endless rhythmic motions and impermanent moods is no sense of beginning, middle, or end, only unending instability.[28] Henry Ward Beecher, the popular mid-nineteenth-century preacher and writer, saw this clearly when he observed that the ocean was completely lacking in the kinds of associations that the sensitive traveler (or viewer of paintings) could readily find in "bends in a river, nooks in a mountain side, clefts in rocks, sequestered dells…that bring thronging back with them innumerable memories and renewed sensations of pleasure or sadness." As he continued: "The ocean can not produce such effects. Whatever may be the sources of its power, it does not depend upon association. The ocean has no permanent objects. The waves of yesterday are gone to-day; and the calm of to-day will be tumultuous to-morrow. The very effect of the sea, in part depends upon its exceeding changeableness. Upon what can we hang our associations?"[29]

Although Beecher conceded that the shore, and particularly its "surrounding rocks or sand-hills," might inspire associative thoughts, he concluded that "the sea forces life away from us. We stand upon its shore as if a new life were opening upon us, and we were in the act of forgetting the things that are behind, and reaching forth unto those which are before and beyond."[30] In this reckoning contemplating the sea ultimately washes away not only all sense of self ("Normally," observed Freud, "there is nothing we are more certain of than the feeling of our self, our own ego"),[31] but even the very notion of present time as something that the individual can know and experience. Time is, after all, a human construct, conceived out of the necessity to give order, structure, and predictability to the external world and our interactions with it. The sea, whether viewed as the remnants of pre-Creation chaos, seen objectively as fluid covering most of the earth's surface, or as something else, is utterly and wholly beyond human control through either physical or intellectual means.

Moreover, as Shaler knew, even the compelling narrative image of a ceaseless war between sea and shore was itself an intellectually dubious anthropomorphic reading: "although the contest between land and sea is the most ancient, far extended, and unbroken of all the many combats which make up the life of this sphere, neither side is ever victorious or is ever likely to prevail. It is indeed only in a metaphoric way that it can be called a battle at all, for the results of the inter-action are profitable to the interests of sea and land alike."[32] Thus, even this strategy to make the sea comprehensible by framing its interactions with the land as a narrative of epic struggle is in the end unsatisfactory. Time—mankind's way of dividing continual, seamless experience of external reality into something quantifiable—and narrative—the ordering of experiences and events into sequences of causes and effects—thus are denied a field in which to operate.

Yet, if it is true that time and narrative are ultimately erased in Homer's seascapes, is there not a danger of a *reductio ad absurdum* that would rob them of all meaning? Are they, as has been said, "Full of the import of meaning and change…[but] actually empty of it?"[33] Is it possible that they are, in fact, entirely nihilistic?[34] If so, then Homer's pure seascapes would stand counter to virtually everything else that his art represents so movingly and eloquently. The only plausible answer to this apparent conundrum is not only that they do have meanings (no matter how difficult they may be to verbalize), but that Homer consciously and deliberately intended for them to express precisely those meanings.

The year 1890 is significant for more than just the first appearance of pure seascape in Homer's oils; it also marked his return to painting after a four-year hiatus. Not since *Eight Bells* (cat. 144) of 1886, the last of his epic sea pieces of the 1880s, had he worked in oil. It is not known why he had stopped painting, though Goodrich suggests the lack of buyers for his oils (between the purchase of *The Life Line* in 1884 and the 1889 sale of *Undertow*, only *Eight Bells* sold, and that was for a very modest price) would obviously have discouraged him. And certainly in 1887–1889 he concentrated on watercolors, which he knew he could "sell for what people will give."[35] Nevertheless, Homer continued to think of possible subjects for oils, for there are at least two drawings from c. 1886 showing a ship's deck with a woman lashed to a mast that were probably made with a finished picture in mind.[36] That he did not execute such works suggests that, in addition to whatever practical reasons he may have had, he had intellectually and aesthetically exhausted the possibilities of the theme of men and women in struggle with the sea. Of the five oils he painted in 1890,

only *The Signal of Distress* (cat. 155) took up that theme again and, as we have seen, Homer had difficulties resolving its narrative structure.

Winter Coast (cat. 187) and *Sunlight on the Coast* (fig. 205) both examine the realm of the shore and the confrontation of sea and land. The former retains an element of narrative with its hunter, rifle in hand and dead goose slung over his shoulder. Though immensely powerful and beautiful in its own right, it also maintains a certain detachment from the sea, which lies just beyond the rocky cliffs and is only manifested in the billowing spray. *Sunlight on the Coast*, in contrast, forces our attention on the wave and the rocks; the distant steamer, even though picked out by the light, is but a minimal remnant of narrative content. What Homer had come to realize, after seven years of life on the coast, was that pure seascape's resistance to imposed narrative structure did not make it an unsuitable subject for art.[37] On the contrary, for an artist perpetually troubled by the potential for narrative to be misunderstood in his work, seascape offered a release from such constraints. This is not to say that Homer abandoned all interest in narrative; one need only look at *The Gulf Stream* (cat. 231) to see that was clearly not the case. But seascape did from this point onward come to occupy a special place in his art and to satisfy a fundamentally different set of conditions. No one would ask for a description or wonder what happens next in *Northeaster*, because the answers are there before him. The painting, and its meaning, become self-contained and self-referential. There is no before, no after, no sequence of events, no obvious questions, no certain answers, no time, no narrative. But what is left? Perhaps this is Ishmael's "ungraspable phantom of life" or Freud's "something limitless, unbounded, something 'oceanic'" made pictorially visible. Perhaps, as Downes and others concluded, it is the face of eternity.[38] To look at Homer's seascapes is not to see a mirror that reflects our own thoughts, but to glimpse the very essence of the forever unknowable.

Perhaps this will seem too strong a claim, for it proposes that Homer was, even if not in a way he could, or would, articulate in words, profoundly aware of and concerned by the most challenging and complex questions posed by human existence. Certainly he is not customarily viewed as having especially strong inclinations toward philosophical or metaphysical musings, so pervasive and persistent is his image as an "uncompromising realist." However, similarly profound content is widely acknowledged in "realist" sea fiction of the same period, such as Stephen Crane's masterful story "The Open Boat."[39] Reading comparable content in Homer's seascapes depends, finally, on considering the personal experiences of Homer as he painted the sea, and of ourselves, as we contemplate his creations.

If one reason Homer left New York and settled in Prout's Neck was to be near the sea, another of equal or greater importance was that he no longer wished to live in the midst of American civilization in its most fully developed form. Great cities like New York might represent the epitome of progress, but their very conditions could afflict inhabitants with nervousness and agitation.[40] In these terms, Prout's Neck offered Homer escape from the "unstable equilibrium" of modern urban life and a chance to regain personal happiness and equilibrium.[41] Whether or not he was literally a recluse or hermit during his last twenty years, there is no doubt that Homer greatly valued (and protected) his solitude and privacy. "This is the only life in which I am permitted to mind my own business," he wrote in December 1893; "I suppose I am the only man in New England who can do it. I am perfectly happy & contented."[42] In an era when American commercial enterprises were growing ever larger and more complex and employing more and more people, Homer could run his own professional "business" by himself, and keep the rest of his "business" to himself. He was (or liked to think he was) self-reliant and self-contained. Whatever the reasons that led him to seek out this life, there can be no doubt that Homer's existence at Prout's Neck was necessitated by some powerful emotional need.[43] Being at Prout's, and not being in the city, brought Homer contentment, and also allowed him as much or as little contact with his family as he wished. "The life I have chosen," he said on the eve of his fifty-ninth birthday, "gives me full hours of enjoyment for the balance of my life. The sun will not rise, or set, without my notice and my thanks."[44] Left to his own business—artistic and personal—Homer could contemplate those things that interested him most. And although time and again he would tell his dealers that he had given up painting— "At present and for some time past I see no reason why I should paint any pictures," he said in 1893—some motivation always made him pick up his brushes once more. Some aspect of that motivation must have originated in a need to seek answers about himself, his life, the place he lived, and

fig. 216. Everett Shinn. *5th Avenue and 34th Street*, 1905. Pastel. Courtesy M. Knoedler & Co. The painting on the easel may be Homer's *The Gulf Stream* (cat. 231)

the world he knew. As such, his late seascapes, in addition to the roles they filled as objects for public display, also recorded—perhaps more obviously than did any of his other subjects—his own subjective experiences.

There is undeniable evidence of this in the paintings themselves, particularly in their tendency toward suppression of illusionistic space and emphasis on richly expressive paint surfaces. Indeed, the closer one approaches these canvases, the less they actually suggest the appearance of rocks, sea, and sky, and the more they dissolve into abstract patterns of pigment. Remarkably, when *Winter Coast* and *Sunlight on the Coast* were first shown in 1891, ropes were positioned in the gallery to prohibit viewers from getting too close. "The range at which these pictures look their best is very great," observed a writer for the *New York Times;* "at a distance of thrice the width of the canvas their beauty is far from what it is when the observer stands ten picture breadths away." He concluded, one must keep "a respectful distance" and "examine them from the other side of the gallery."[45] Whether or not Homer actually stipulated this arrangement is not known (although that seems likely, because only these two of the four paintings on view—*Signal of Distress* and *A Summer Night*, cats. 155, 186, were the other two—were apparently affected), but there were other instances where he expressed concerns about viewers standing too close to his pictures. In 1904 he told Knoedler to show his pictures "one at a time in your show window," because that would "keep them away from critics." He concluded: "Your window [see fig. 216] is the only place where a Picture can be seen in a proper manner—That is at a point of view from which an artist paints his Picture—To look at & not smell of."[46] In 1907 he wrote to Knoedler about the painting *Early Evening* (see fig. 147): "It can be seen properly from the opposite side of 5th ave…as it is painted at the distance of 60 feet from the artist." At the bottom of the letter Homer included a sketch of a man standing very close to a framed oil painting with the caption "This man cannot see it."[47] The display of the two seascapes in 1891 confirms that it is not simply modern eyes well-accustomed to pure abstractions that see in these pictures two aesthetic identities. From a "respectful distance" they are legible as images of the ocean, but from a closer vantage point they insistently assert that they are pigment that Homer put on canvas. Homer, of course, knew this perfectly well. As he said in 1900 of the oil *Cannon Rock* (cat. 193): "I did not put it out or change it in any way as the breaking on the bar part of it looked so broken & so like decanters and crockery, & at the same time looked so fine at a proper distance."[48] He also told John W. Beatty that when he painted *A Summer Night* he had "hung it on that balcony [of his studio], and studied it from a distance…."[49] Indeed, among all of Homer's oils the late seascapes are the most expressive of artistic process and the most revealing of artistic personality. Nowhere else do we glimpse so strong and clear an image of Homer as a manipulator of paint, or feel so palpably his presence traced in the pathways marked by the brush. It is not too much to say that these paintings are, in this literally tangible way, about Homer himself.

Homer once said (speaking specifically of *The Gulf Stream*): "Don't let the public poke its nose into my picture."[50] He also, as is well known, told William Howe Downes, "it would probably kill me to have such [a] thing [i.e, a biography] appear....the most interesting part of my life is of no concern to the public...."[51] Still, no matter how deeply rooted were his fears, he kept painting, and kept showing the results to the public, and in that way made it inevitable that people would continue to poke their noses into the interesting parts of his life. That Homer did not want people to get too close to his seascapes is provocatively suggestive, for it reveals that he believed them capable of saying something crucially important about himself. Keeping a "proper distance" from the paintings may have had an aesthetic rationale, but it also served to push the viewers themselves— each of whom might want to know about him—away from the physical presence of the very objects with the greatest potential to tell them something. We suspect that Homer was most troubled not by the possibility that close inspection meant an inability to see ("This man cannot see it"), but that far too much might be glimpsed. And even ropes keeping viewers at a "respectful distance" could not ultimately prohibit at least some of them from wondering what these powerful paintings said about their famous and mysterious (by the 1890s Homer was, in the popular imagination, increasingly mysterious) creator. Still, the seascapes may seem to promise possibilities for understanding Homer, but they do not readily yield to probing. The subject of the sea itself, which we read from a distance, defeats efforts to find narrative meaning, and the dried swirls of pigment we see upon closer examination tell us the artist was once present, but do not obviously say who he was. They present a tantalizing offer of revelation, but obscure its unfolding. Coming from a man who disliked simplistic readings of the narrative structures of his paintings, fiercely guarded his privacy, and yet over and over "showed" himself to the outer world through his art, this can only have been a deliberate and conscious artistic strategy.

If this view is correct, it suggests the process of sublimation.[52] In the sea Homer found a subject through which he could reconcile the conflicts between his obsessive need for privacy as an individual and his need for public exposure and disclosure as an artist. It is telling that only the sea in its most unstable, agitated, and assertive states could serve this purpose for him. As John W. Beatty recalled: "when I knew him he was comparatively indifferent to the ordinary and peaceful aspects of the ocean....But when the lowering clouds gathered above the horizon, and tumul-

fig. 217. *Driftwood*, 1909. Oil on canvas. Henry H. and Zoë Oliver Sherman Fund and other funds, Courtesy Museum of Fine Arts, Boston

fig. 218. John Karst after Winslow Homer. "The Beach at Long Branch." Wood engraving. In *Appleton's Journal*, 21 August 1869

tuous waves ran along the rock-bound coast and up the shelving, precipitous rocks, his interest became intense."[53] Watching once as Homer "clambered over rocks…while the spray dashed far overhead," Beatty marveled: "This placid, self-contained little man was in a fever of excitement, and his delight in the thrilling and almost overpowering expression of the ocean, as it foamed and rioted, was truly inspiring."

The sea, then, in its "ordinary and peaceful" guises offered the usually "placid and self-contained" Homer a sympathetic environment and did not intrude upon him. It could serve as the ultimate refuge from so many of the things that disturbed the peace of his psyche. Living at Prout's Neck Homer escaped the turmoil of the city, its complications, its disappointments, and its potentially problematic human relationships. As he wrote to an acquaintance soon after settling at Prout's Neck in 1883: "If I had your gift of doing four things at once all equally well I could live in New York."[54] But he could not, so he simplified the business of his life and art radically. Perhaps in contemplating the sea day in and day out he could forget himself and, to use Emerson's words, "open his eyes to see things in a true light and in large relations."[55] But when the sea was disturbed, when its great breakers crashed with thundering impact upon the rocks just beyond the walls of his studio, he was overcome with a "fever of excitement" and virtually transformed, as Beatty witnessed, into someone else, someone who felt an urgent, and apparently irrepressible urge to counter the sea's force with his own. And whether Homer ultimately found this experience exhilarating or frightening, or both, the best way he knew to reckon with it was through the means of his art. In painting the sea Homer could suspend the workings of time and narrative, yet still speak with a meaningful voice that at once denied and asserted his own presence. In *Driftwood* (fig. 217) Homer shows a man struggling to secure a massive log that has been cast up by the sea, just as he struggled to take from it something he could make his own through art. But after painting *Driftwood* he smeared his palette and hung it on his studio wall, this time declaring with irreversible finality an end to his life as a painter.[56] Homer had already, it seems, predicted the outcome of his personal and artistic encounters with the sea some forty years earlier in the wood engraving "The Beach at Long Branch" (fig. 218). There, by the side of the sea and amid a crowd of fashionably dressed men and women, we find his initials scratched in the sand. A young woman, perhaps the one who has put these letters there, points at them with her parasol, while two others gaze at them with seeming indifference.[57] In this amusing, but deeply moving way, Homer told us of his presence and affirmed that the image was there only because of his creative actions. But he also told us that he and his art, like all else of this world, would eventually be washed away and subsumed by the sea of eternity.

NOTES

1. David Tatham, "Winslow Homer and the Sea," in Beam et al. 1990, 66–85, offers a balanced and measured assessment of Homer's marines and breaks some important new ground in interpreting them. Robertson 1990 has also written eloquently on the subject. My discussion here, although differently nuanced, is nevertheless much indebted to the fine work of these two scholars, specifically, as well as more generally to all of those who have tried to understand and explain the extraordinary complexity of Homer's seascapes. Roger Stein's (1990b) discussion of Homer's use of narrative has also been particularly helpful.

2. Robertson 1990, 8.

3. See Michael Osborn, "The Evolution of the Archetypal Sea in Rhetoric and Poetic," *The Quarterly Journal of Speech* 63 (December 1977), 347–363, and Alain Corbin, *The Lure of the Sea: The Discovery of the Seaside in the Western World, 1750–1840*, trans. Jocelyn Phelps (Berkeley and Los Angeles, 1994; first published 1988 as *La Territoire du vide*).

4. Osborn, "Evolution," 347.

5. *A Philosophical Enquiry into the Origin of Our Ideas of the Sublime and Beautiful* (1756; quoted in Corbin, *Lure of the Sea*, 127).

6. In these same years the sea also loomed large in scientific theories about the origins of the earth and the formation of its principal geological features. Among the adherents of catastrophism, who argued that the surface of the earth was formed by violent actions, were the "Neptunists" (as opposed to the "Vulcanists"), who favored flood waters as the agents of such dramatic change. Although the theories of Sir Charles Lyell in *Principles of Geology* (London, 1830–1833) would replace catastrophism with a geological model based on slow change over the eons, even he was profoundly impressed by the powerful erosive effects of the ocean and its potential to wreak vast havoc in even a short time; see also Corbin, *Lure of the Sea*, 119.

7. Margaret Deacon, *Scientists and the Sea, 1650–1900: A Study of Marine Science* (London and New York, 1971); Susan Schlee, *The Edge of an Unfamiliar World: A History of Oceanography* (New York, 1973).

8. *Civilization and its Discontents* (1929), in Robert Maynard Hutchins, ed., *Great Books of the Western World*, vol. 54, *The Major Works of Sigmund Freud* (Chicago, London, and Toronto, 1952), 767.

9. Herman Melville, *Moby-Dick; or, The Whale* (1851; reprint ed., New York, 1967), 14.

10. For overviews, see John Wilmerding, *A History of American Marine Painting* (Boston and Toronto, 1968; rev. ed., New York, 1988); Roger Stein, *Seascape and the American Imagination* [exh. cat., Whitney Museum of American Art] (New York, 1975); and, William Gaunt, *Marine Painting, a Historical Survey* (London, 1975).

11. "The Fine Arts; Four Paintings by Winslow Homer," *The Critic* 15 (24 January 1891), 47. Gardner 1961 mentions Courbet only twice and briefly (118, 232), in spite of his tendency to emphasize Homer's debts to French painting. Goodrich 1973, 41, observes that Courbet's seascapes offer the "closest counterparts" to Homer's marines, but considers the French painter's works "romantic and traditional" in comparison. Adams 1990b, 71–72, notes the likelihood that Homer saw Courbet's *La Curée* (c. 1856, Museum of Fine Arts, Boston) on exhibition in Boston in 1865. Robertson 1990, 50, stresses, although only in passing, Homer's affinities to Courbet and concludes that he must have studied his work closely.

12. See Robert Fernier, *La Vie et L'oeuvre de Gustave Courbet* (Lausanne and Paris, 1978), 2: 78–91, nos. 676–710.

13. "L'Ecole Française de Peinture à l'Exposition de 1878," in *Emile Zola, Salons*, ed. F. W. J. Hemmings and Robert J. Niess (Geneva and Paris, 1959), 201; quoted in Sarah Faunce and Linda Nochlin, *Courbet Reconsidered* [exh. cat., Brooklyn Museum] (Brooklyn, 1988), 188–189.

14. Quoted in Roger Bonniot, "Victor Hugo et Courbet," *Gazette des Beaux-Arts* 80 (October 1972), 242; quoted in exh. cat. Brooklyn 1988, 188.

15. Steven Z. Levine, "Seascapes of the Sublime: Vernet, Monet, and the Oceanic Feeling," *New Literary History* 16 (Winter 1985), 377–400.

16. Letter of 30 October 1886 (quoted in Levine, "Seascapes," 379).

17. Levine, "Seascapes," 396–397.

18. Levine, "Seascapes," 397–398.

19. Homer to Knoedler, 19 February 1902 (typescript, NGA).

20. Downes 1911, 238.

21. Cikovsky 1990a, 119 122.

22. Homer to Thomas B. Clarke, 31 December 1900 (Archives of American Art).

23. Robertson 1990, 30.

24. Goodrich 1944a, 135; see also Tatham, in Beam et al. 1990, 71. Robertson 1990, 27, has also stressed Homer's allegiance to storytelling: "'Meaning' in Homer's paintings normally resolves itself into a story, whether it is one contained within the painting or one seen in comparison with other works."

25. Robertson 1990, 7, has written: "Whatever the nature of the observer, Homer's paintings present themselves as a blank screen on which his audience can project its own meanings."

26. Nathaniel S. Shaler, "Sea and Land," *Scribner's Monthly* 11 (May 1892), 611.

27. Cikovsky 1990a, 112, 116.

28. On the significance of "instability" in late nineteenth- and early twentieth-century American culture, see Cecelia Tichi, *Shifting Gears: Technology, Literature, Culture in Modernist America* (Chapel Hill and London, 1987), 42–53.

29. Henry Ward Beecher, *Star Papers; or, Experiences of Art and Nature* (New York, 1857), 202.

30. *Star Papers*, 203–204.

31. *Civilization and its Discontents*, 767.

32. Shaler, "Sea and Land," 614.

33. Robertson 1990, 7: "Full of the import of meaning and change—crashing waves, lowering skies, strong winds—they are actually empty of it. We become conscious of this when reviewing the many interpretations of his paintings that either repeat endlessly what has always been said or contradict each other completely."

34. Although Robertson 1990, 42, points to the "incipient nihilism" of Homer's late seascapes, he reasonably concludes that they cannot be considered simply "a blank screen of waves."

35. Letter to Charles Homer, September 1887 (quoted in Goodrich 1944a, 101).

36. Goodrich 1944a, 102.

37. It is customarily said that Homer's 1880s watercolors of breaking waves at Prout's Neck (for example, figs. 151, 204) were ultimately unsuccessful (both to the artist and to modern eyes) because the lighter, less dense properties

of the medium simply could not properly evoke the weight and force of the subject. Perhaps that is so, but in terms of the argument presented here, whatever dissatisfaction he may have felt must also have been caused by his inability at that point to see the positive possibilities of a non-narrative subject.

The essentially nonnarrative nature of Homer's treatment of the sea would also help explain why the many breaking wave pictures by later painters who imitated his seascapes are not similarly invested with profound meaning. For such painters, looking at Homer's paintings of the sea resulted in a distancing from the subject that precluded the kind of direct and intense involvement at the heart of his endeavor. It is thus not surprising that only in the seascapes of painters such as George Bellows and Marsden Hartley, who deeply admired Homer but never openly imitated him, do we find anything approaching a comparable aesthetic and emotional power.

38. "With the enlargement of purpose has come a corresponding grandeur of style; they [i.e., the seascapes] realize, as no other marines with which I am acquainted, the majesty, isolation, immensity, ponderous movement and mystery of the ocean,

> boundless, endless, and sublime—
> The image of Eternity—the throne
> Of the Invisible.

(Downes 1911, 186; the quotation at the end is from Byron's *Childe Harold*). Tatham, in Beam et al. 1990, 76, also proposes that Homer "glimpsed eternity," though he reaches that conclusion by a somewhat different train of thought. Patricia Junker's essay "Expressions of Art and Life in *The Artist's Studio in an Afternoon Fog*," in Beam et al. 1990, 34–65, concludes by proposing that Homer's late oils express a vision of the world consonant with that expressed in George Chaplin Child's *Great Architect: Benedicite; Illustrations of the Goodness of God, as Manifested in His Works* (1867), a book that Homer owned in an 1871 edition. As she writes (62): "According to Child's theory, Prout's Neck would have revealed to the painter ample evidence of divine order and good will, even in its darkest, coldest, and most foreboding aspects. By extension, then, even Homer's most somber and brooding images of that landscape and sea likewise might carry a message of hope and salvation." Although Homer's ownership of Child's book should not be ignored, it cannot, of course, be assumed that he necessarily subscribed to the beliefs it expressed. In any event, the reading of his seascapes proposed here obviously points in a somewhat different direction.

39. Crane's story was first published in *Scribner's Magazine* in June 1897. On American sea fiction generally, see Thomas Philbrick, *James Fenimore Cooper and the Development of American Sea Fiction* (Cambridge, Mass., 1961) and Bert Bender, *Sea-Brothers: The Tradition of American Sea Fiction from Moby-Dick to the Present* (Philadelphia, 1988).

40. See Tichi, *Shifting Gears*, 51.

41. The phrase "unstable equilibrium" is from Robert Ezra Park, *The City* (1925); quoted in Tichi, *Shifting Gears*, 51. Tichi also notes that during the 1880s the American neurologist George Beard "blamed 'American nervousness' on the sensory demands made by urban, technological life."

42. Letter to Louis Prang (quoted in Goodrich 1944a, 113).

43. "Voluntary loneliness, isolation from others," according to Freud, "is the readiest safeguard against the unhappiness that may arise out of human relations" (*Civilization and its Discontents*, 772).

44. Quoted in Goodrich 1944a, 113.

45. *New York Times*, 16 January 1891. If one applied this formula, the "recommended" distance for *Sunlight on the Coast*, the larger of the two paintings, would have been forty feet! One wonders if this matter of keeping a "respectful distance," as the writer for the *Times* said, might explain the enigmatic inscription on *The Gulf Stream* (cat. 231), which reads: "At twelve feet you can see it." When that painting was first shown in Philadelphia in 1900, Homer wrote to Harrison S. Morris, the director of the Pennsylvania Academy of the Fine Arts: "Don't let the public poke its nose into my picture" (quoted in Morris, *Confessions in Art* [New York, 1930], 63). By this Homer must have meant that he wished the public neither to get too close physically to the painting nor to get too "nosey" about its meaning.

46. Letter of 8 November 1904 (quoted in Hendricks 1979, 263).

47. Letter to M. Knoedler & Co., 19 November 1907 (M. Knoedler & Co.); see Goodrich and Gerdts 1986, 84–85.

48. Letter to M. Knoedler & Co., 3 October 1900 (typescript, NGA).

49. Introduction to Downes 1911, xxvii.

50. See note 45, above.

51. Downes 1911, 234.

52. The most extended analysis of Homer and his art using Freudian terms is found in Adams 1983, 113–126. Reed 1989, 68–79, has explored the theme of the "Other"—"that against which the self is defined"—in Homer's art. Both articles offer provocative insights about the meaning the sea held for him.

53. Introduction to Downes 1911, xxvi–xxvii.

54. Letter of 13 October 1883 to Henry C. Valentine (Hirschl & Adler Galleries, New York); Homer also observed, rather tellingly in light of his own growing tendency to be gruff: "You are extremely polite & how you can find time to be so & yet attend to your business & family is a mystery to me."

55. Downes 1911, 239.

56. Adams (1983, 122) has also stressed the importance of *Driftwood* as a "symbolic statement," seeing in it "an expression of the immensity of death and the courage and ingenuity of man."

57. This image, like others, necessarily raises questions about Homer's relationships with the opposite sex and what they might tell us about his emotional and mental state. Many writers (see, e.g., Adams 1983 and Reed 1989) have stressed that Homer's sexual persona (such as we can claim to know about it) offers a key to understanding his images of the sea, and have argued that the sea was for him essentially an embodiment of the feminine. This is a reasonable association, and would suggest a point of congruence with Courbet's and Monet's seascapes. But it is also reasonable to assume that many other powerful subconscious forces would have influenced his attitudes toward the sea.

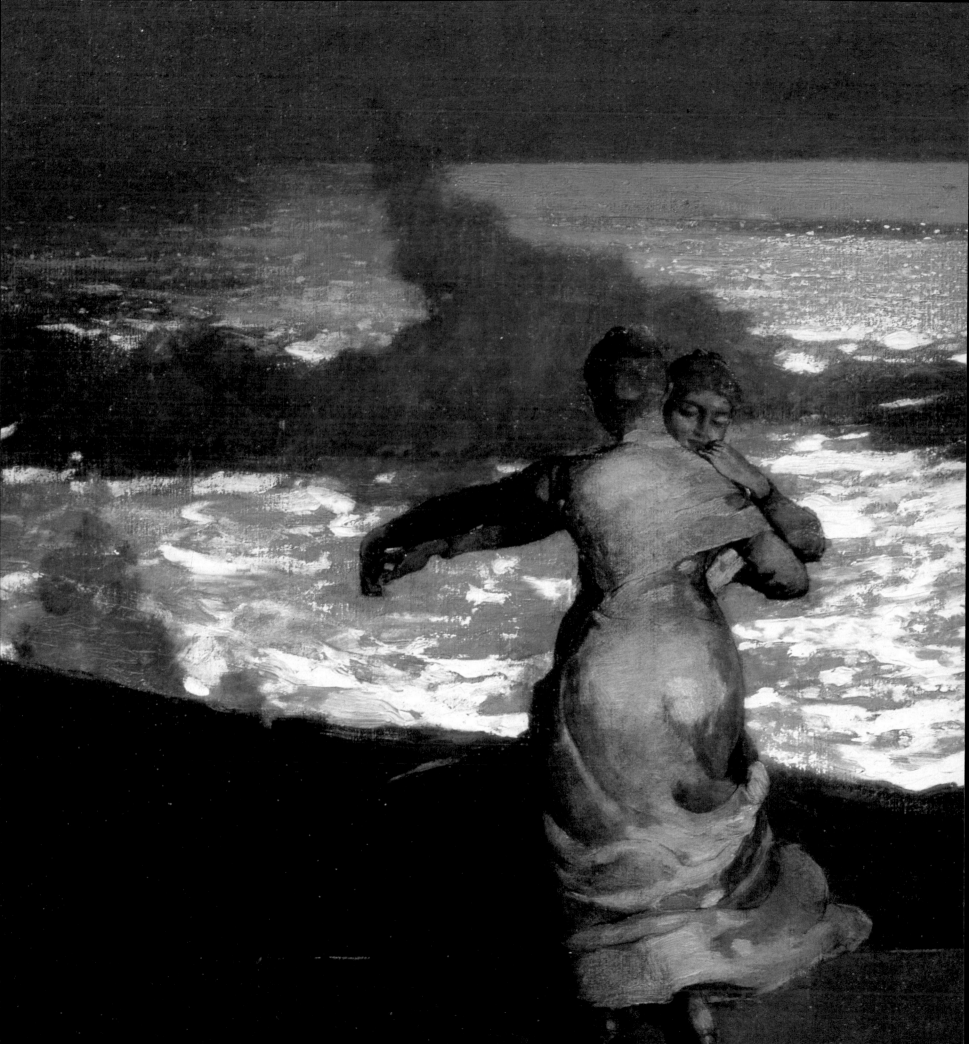

186–187

In 1890, having painted nothing in oil since finishing *Eight Bells* (cat. 144) late in 1886, Homer completed five paintings: *Cloud Shadows* (Spencer Museum of Art, University of Kansas, Lawrence), *Sunlight on the Coast* (see fig. 205), *The Signal of Distress* (cat. 155), and these two. In two of these works—*Cloud Shadows*, where the figures of a fisherman and a woman conversing on a beach recall Cullercoats subjects, and *The Signal of Distress*, which reprises the theme of marine peril found in *The Life Line* and other pictures of the mid-1880s—Homer looked to earlier prototypes. *Sunlight on the Coast*, on the other hand, introduced the sea as the main protagonist for the first time in an oil, and thus initiated his great sequence of seascapes. In these two paintings Homer investigated Prout's Neck scenery under special conditions of weather (the frozen landscape of *Winter Coast*) and lighting (the

moonlight of *Summer Evening*). These were not Homer's first attempts at portraying either snow or moonlight (there are several winter scenes among his early wood engravings and some moonlit watercolors such as *Eastern Point Light* [cat. 104]), nor would they be his last (see *Fox Hunt*, cat. 230, and *Moonlight, Wood Island Light*, cat. 190).

According to Downes, *A Summer Night* was:

a virtually literal transcript of a scene which Homer saw in front of his own studio at Prout's Neck. The platform is the only part of the composition which did not exist in the real scene. The girls were dancing on the lawn. As usual, the artist painted exactly what he saw. The group silhouetted at the right, on the rocks, was composed of a number of young people belonging to the summer colony, and included several of the Homers.[1]

In spite of Downes' assertion that Homer "painted exactly what he saw," what struck him

186. *A Summer Night,* 1890
oil on canvas, 74.9 x 101 (29½ x 39¼)
Musée d'Orsay, Paris
Provenance: Musée du Luxembourg, 1900; Jeu du Paume, 1922–1946; Louvre, 1971–1977; Musée d'Orsay, 1977.

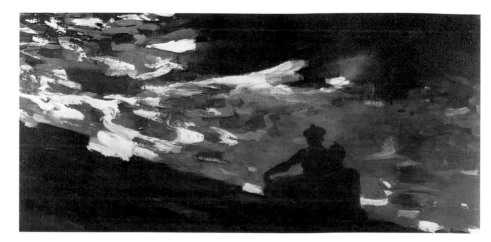

LEFT: fig. 219. *A Summer Night (A Moonlit Sea)*, 1890. Watercolor. Wadsworth Atheneum, Hartford, Gift of James Junius Goodwin

RIGHT: fig. 220. *Moonlight on the Water*, c. 1890. Oil on canvas. Los Angeles County Museum of Art, Paul Rodman Mabury Collection

and others about the picture was its mysteriously evocative mood. As he had already observed in 1900:

The ocean, at night, seen from the brow of a high cliff; a broad and glittering field of moonlight reflected on the tossing waters; the shadowed curve of a mighty wave about to fall and break on the rocks; on the brink of the cliff, the sombre silhouette of a group of people watching the surf; and in the foreground two stalwart girls waltzing in the moonlight. The blue, purple, slate, and silver-gray hues of the night for a bold, rich, and novel harmony in a minor key, an effect of splendid and moving majesty.... Under the phantasmal light of the moon, the titanic lift of the dark billow which comes impending to its crashing fall, the fantastic shape of its crest uplifted against the lighted expanse of glimmering blue and molten silver behind it, and the swirling hollow weltering in its front, are full of the expression of power, grandeur, and mystery.[2]

Beam has given further details about the origins of *A Summer Night*.[3] According to Charles Lowell Homer's recollection, the family had watched a particularly lovely display of moonlight over the ocean in the summer of 1890, and Homer had recorded the event in a sketch. A watercolor now in Hartford (fig. 219), which may be the sketch in question, shows several figures gathered on the rocks with a brightly lit sea beyond. The breaking waves form a distinctive pattern quite similar to that seen in the final picture. Homer seems to have begun an oil painting based on this watercolor, but with different figures (fig. 220); instead of the compact group looking out to sea, the oil has two figures, one wearing a tam-o'-shanter and with her arm raised as if dancing, or holding up her dress. Although this painting has traditionally been called a "sketch" for the final picture, that designation seems improper. For one thing, Homer rarely made oil sketches for his paintings and, in any event, the relatively large size of this picture resembles his easel paintings. In fact, the painting

was originally slightly larger; sometime around 1906 Homer folded part of the top and both sides over the stretcher.[4] If this picture was, in fact, begun in 1890, Homer apparently grew dissatisfied with it, put it aside, and began a new canvas on which he had room to add the platform, "the only part of the composition which did not exist in the real scene." Having thus reconfigured the image, Homer posed two Prout's Neck girls, Maude Sanborn Googins Libby and Cora Googins Sanborn, as the dancing couple and made detailed sketches of them.[5]

When *A Summer Night* debuted at Reichard's Gallery in New York in 1891, along with *Sunlight on the Coast*, *Winter Coast*, and *The Signal of Distress*, it was generally well received, but did evoke some mixed responses. The critic for the *New York Sun*, although judging it "not quite successful as a whole," felt it had "a more marvelous bit of painting than either [sic] of the others."[6] He concluded that in the water and the reflected moonlight, "we see the best that Mr. Homer can do. His figures do not interest us, and we almost wish them out of the way that we might more wholly enjoy the sea." *The Art Amateur* also felt the picture "would be much more impressive if the figures in the foreground were left out."[7] The *New York Times*, however, praised the "unexpected contrast" the dancing women made with "the grandeur and mystery of ocean and moonlight."[8] And for one writer, the dancing women were "most suggestive of youthful witches of Endor, and their phantom-like appearance might mean the impersonation of death or folly or what not."[9] Downes, writing in the *Boston Daily Evening Transcript*, concluded *A Summer Night* was a "masterpiece of moonlight, and a truly inspired poem of the sea."[10]

A Summer Night did not, however, immediately find a buyer. In December 1891 Homer offered it to Potter Palmer, Chicago's collector of French impressionist pictures, calling it *Buffalo Girls*.[11] This was apparently in reference to the popular song

187. **Winter Coast,** 1890
oil on canvas, 91.4 x 80.3 (36 x 31 ⅝)
Philadelphia Museum of Art, The John G. Johnson
Collection
Provenance: John G. Johnson

"Buffalo Gal," which included the line "Buffalo Gal won't you come out tonight and dance by the light of the moon?"[12] Potter declined the offer and Homer lent the picture to the Cumberland Club in Portland, where it remained for the rest of the decade.[13] In 1900 Homer sent *A Summer Night* with *Maine Coast* (cat. 195), *Fox Hunt*, and *The Lookout—"All's Well"* (see fig. 178) to the Exposition Universelle in Paris, where it received a gold medal. The French government purchased the picture for the Luxembourg Palace museum, one of the earliest acquisitions of a work by Homer by any museum

(*Fox Hunt* was purchased by the Pennsylvania Academy of the Fine Arts in 1894, and the Carnegie Institute acquired *The Wreck*, cat. 196, in 1896). Among those who reportedly saw and admired *A Summer Night* at the Luxembourg was the impressionist Claude Monet.[14]

Winter Coast (which Homer first called *Winter by the Seashore*) is in its details virtually the polar opposite of *A Summer Night*, substituting day for night, winter for summer, huge waves breaking against the rocks for a less turbulent sea, and a solitary hunter for the dancing couple. The critic for the *New York Times* termed it a "magnificent

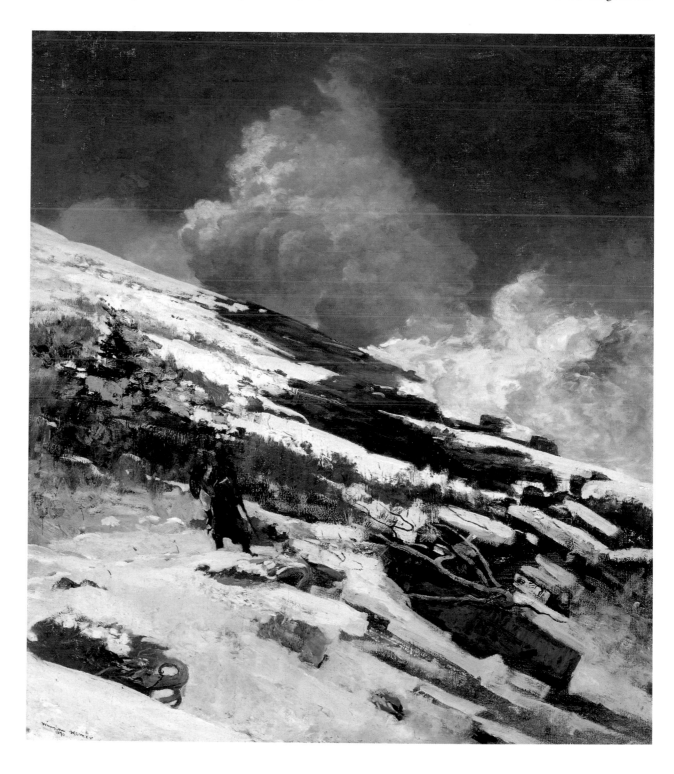

study of surf beating on a brown slope of rocks," and admired the "gunner muffled in an old blue army coat, expressing very clearly the cold of the air...."[5] The *New York Sun* pronounced it "painted with the most admirable veracity and vigor."[16] On the whole, *Winter Coast* was somewhat overshadowed by the three other works shown with it, for critics' attention was more easily won by the heroic narrative of *The Signal of Distress*, the concentrated grandeur of *Sunlight on the Coast*, and the enigmatic qualities of *A Summer Night*. Nevertheless, it stands today as one of Homer's most assured performances as a painter. Long, bold strokes of white paint convincingly define areas of snow, but also float on the surface of the canvas as pure paint. The figure of the hunter, poised confidently in the midst of a powerful and stern environment in a way that anticipates the Adirondack oils of the following year, is painted with great economy. He has been called, with some reason, "one of Homer's most remarkable figures."[17] In the end, however, it is a palpable sense of nature's elemental force, evident in the massive rock cliffs, the harsh climate, and thundering sea, that most powerfully animates the painting. "It is a most bleak, cold, 'shivery' place," observed one critic; a "rigorous condition of affairs."[18]

NOTES

1. Downes 1911, 160–161.

2. *Twelve Great Artists* (Boston, 1900), 118–120; quoted in Downes 1911, 160. Downes' use of the phrase "harmony in a minor key" brings to mind the art of Whistler as, of course, does the nocturnal subject.

3. See his entry on the picture in Beam et al. 1990, 104–108.

4. See Ilene Susan Fort and Michael Quick, *American Art: A Catalogue of the Los Angeles County Museum of Art Collection* (Los Angeles, 1991), 176. On this painting see also Robertson 1990, 33. In 1907 Homer made a similar alteration to the painting known as *Early Evening* (fig. 147), although in that case he actually cut the canvas down rather than simply folding it over.

5. Beam et al. 1990, 106.

6. "Some Questions of Art," *New York Sun*, 25 January 1891.

7. "The Winslow Homer Pictures," *The Art Amateur* 24 (February 1891), 55.

8. "Four Paintings by Homer," *New York Times*, 16 January 1891.

9. Unidentified clipping (Bowdoin).

10. "A Great Picture by Winslow Homer" (undated clipping, Bowdoin).

11. Letter 18 December 1890 (Bowdoin) cited in Beam et al. 1990, 106; Palmer's reply of 23 December 1890 to Homer (Bowdoin) calls the picture *Buffalo Girls*.

12. Hendricks 1979, 202, calls the picture *Buffalo Gals*, but with no source cited.

13. Beam et al. 1990, 106.

14. Beam et al. 1990, 108, citing the recollection of Walter Pach.

15. *New York Times*, 16 January 1891.

16. *New York Sun*, 25 January 1891.

17. David Tatham, "Winslow Homer and the Sea," in Beam et al. 1990, 78. Hendricks 1979, 202, somewhat more hyperbolically, said of the hunter: "For me, one of the finest figures in American art."

18. "The Winslow Homer Pictures" (unidentified clipping, Bowdoin).

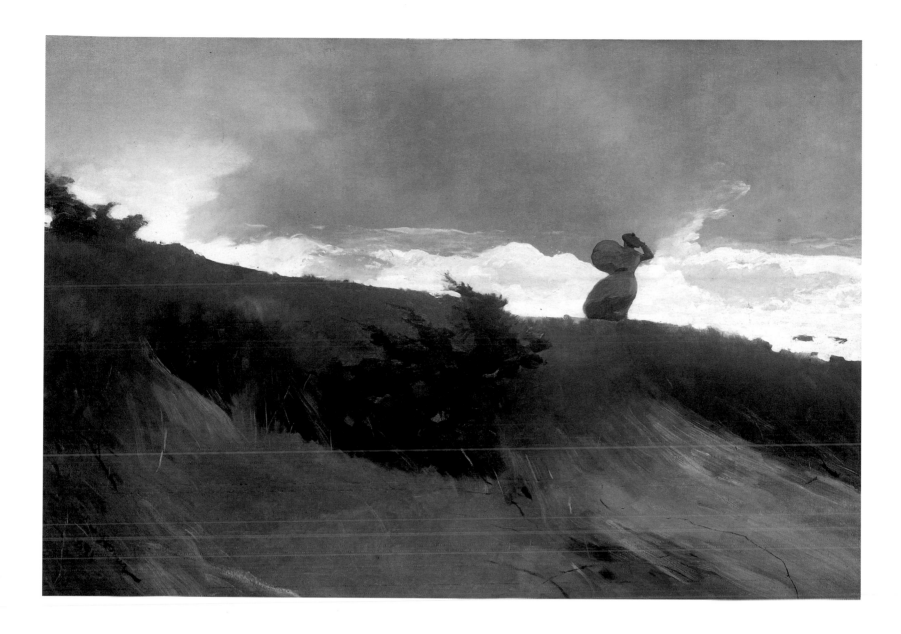

188

During 1891 Homer painted two major Adiron-
dack oils, *Hound and Hunter* and *Huntsman and
Dogs* (cats. 179, 176); a scene of Prout's Neck in
summer, *Watching the Breakers* (Thomas Gil-
crease Institute of History and Art, Tulsa); and
this canvas, which was originally called *March
Wind*.[1] By 1893, when it was shown at the World's
Columbian Exposition (lent by Thomas B.
Clarke), it had acquired the present title. Whe-
ther or not Homer sanctioned the change is not
known, but the revised title may have been an
allusion to Percy Bysshe Shelley's well-known
poem "Ode to the West Wind." Clearly the
most salient feature of the painting is simply
the wind itself, regardless of its direction or sea-
son. Virtually everything Homer depicted —
dried grasses, juniper bushes, the clothing and
hat of the woman, the spray of the waves —
appears, quite literally, windblown.

According to Goodrich, the painting origi-
nated in the spectacle of an autumnal gale:

A friend of the Homers, Mrs. Landreth O. King, wrote:
"It was a very familiar sight to see Winslow out on the
rocks painting, and particularly after a big storm. I
remember one day in the early fall of 1891 when a
strong wind was blowing, seeing him painting as I
stood and watched the magnificent surf. Later, Mrs.
Arthur Homer invited me to go to the studio (by spe-
cial permission of Mr. Homer, who never allowed
anyone inside the doors), saying she had a surprise for
me. Mr. Homer received me most graciously and the
'surprise' was indeed a big one for I recognized at
once that the figure standing on the cliff in the well-
known coat and tam-o'-shanter was myself!"[2]

Beam has noted that the location of the scene
must be the top of High Cliff (see cat. 191), and
that the waves must have been running thirty to
forty feet in height to be seen from this angle.[3]
He also recorded an anecdote told by Charles

Lowell Homer concerning the painting.[4] Supposedly Homer had been dining with his friend the artist John La Farge in New York shortly before painting *The West Wind*, and the two had discussed the use of color. La Farge is said to have asserted that Homer's paintings tended to be dull and that he used too much brown; Homer's reply was to wager one hundred dollars that he could paint a picture in browns that would be praised by both critics and public alike. After the picture had been shown in New York, Homer reportedly wrote to La Farge: "*The West Wind* is brown. It is damned good. Send me your check for $100."

When *The West Wind* was shown at Reichard's Gallery along with *Watching the Breakers*, it did indeed receive praise:

In the finer of the two there is a rather high foreground of dark sand and withered grass, beyond which the tossed gray clouds and the tossing gray sea sweep away to mingle on an horizon which the thickness of the air brings very close, while where the water meets the shore are swirls and upheavals of snowy foam. Never have such air and water and such effects of light been more faithfully painted, and we are made to feel the coldness of the scene as well as the quality of its color and the passion of its mood. Nature has as many tempers as man. Her idyllic movements have been more often and more successfully painted than her dramatic, but there is an almost tragic vigor and intensity in this canvas of Mr. Homer's. The single figure which, in the middle distance, turns its back on us and its face to the water, is well subordinated to the picture's main motive but greatly assists the expression of this motive, showing the force of the wintry blast and accenting the savage loneliness of the coast.[5]

For Downes *The West Wind* was most notable for its overall tonal unity, broad passages of subdued color, and bold composition. "Everything is condensed into the most succinct and significant form," he wrote, "every stroke tells."[6] Goodrich felt it showed "nature in one of her most melancholy moods, with a feeling of the death of the year but also the keen invigorating life of the gale."[7] And in 1908, when *The West Wind* was shown at the National Academy of Design, one reviewer cited its "force and freshness driven home in an unexpectedly exhilarating fashion" as a yardstick for appreciating "the rugged and almost startling reality" of *North River*, by the rising young painter George Bellows (1908, Pennsylvania Academy of the Fine Arts).[8]

NOTES

1. It was shown with that title in January 1892; see *Paintings by American Artists Exhibited at the Union League Club, New York* (New York, 1892), no. 30.

2. Goodrich 1944a, 126.

3. Beam 1966, 96-97; Beam et al. 1990, 112-113.

4. Beam 1966, 97-98; Beam et al. 1990, 113.

5. Unidentified clipping (Bowdoin).

6. Downes 1911, 156.

7. Goodrich 1944a, 125.

8. Unidentified review quoted in Charles H. Morgan, *George Bellows: Painter of America* (New York, 1965), 82-83.

189. *The Gale*, 1883–1893
oil on canvas, 76.8 x 122.7 (30 ¼ x 48 ⁵/₁₆)
Worcester Art Museum, Worcester, Massachusetts
Provenance: Thomas B. Clarke, by March 1893 until
February 1899; (American Art Association, New
York, 16 February 1899, no. 277); T. Harsden
Rhoades; his daughter, Mrs. B. Ogden Chisolm;
(Snedecor & Co., New York).

189

In 1883 Homer exhibited *The Coming Away of the Gale* (see fig. 149), his major depiction of Cullercoats subject matter, at the National Academy of Design. The painting showed the Life Brigade House in the left background, with several men in foul-weather gear gathered just outside, and a large boat pulled up on shore. In the foreground, a Cullercoats woman carrying a child on her back walked from right to left into a strong wind that blew her hair and garments out behind her. Only a few critics offered favorable comments. A writer in *The Art Interchange* praised the "strong action of the figure [of the woman], the novel character of the subject, the curious contrast of color masses, the truthfulness of the storm-charged atmosphere, and vigorous handling of the whole," and concluded that the painting was "far in advance of most of its companions at the exhibition."[1] Most critics, however, condemned Homer's picture, which had been "heralded as one of his greatest achievements," but did not "keep its promise."[2] As one observed: "We regret

to find Mr. Homer so far below his mark: "the design in this case is awkward. The principal figure is conspicuously out of proportion and ill-drawn; the lines of drapery are neither graceful nor natural; the color is monotonous in the extreme—everything being suffused in that purplish hue which is peculiar to Mr. Homer, but which we have not before seen him carry to the same painful extent."[3]

This same reviewer did, however, conclude with some modest praise: "Nevertheless, the picture has a breezy effect, and the expression of the nearly-spent fury of the storm on the white foaming sea is in a measure fine and impressive."

The Coming Away of the Gale did not sell in 1883, so Homer presumably had it in his Prout's Neck studio after the close of the Academy exhibition. Although we do not know when, at some point before the next public appearance of the picture in 1893 Homer radically repainted it, as Goodrich first pointed out.[4] In its revised state only the figure of the woman is present; the boat, the men, and the Life Brigade House are gone. One can still easily make out the roof and pillars

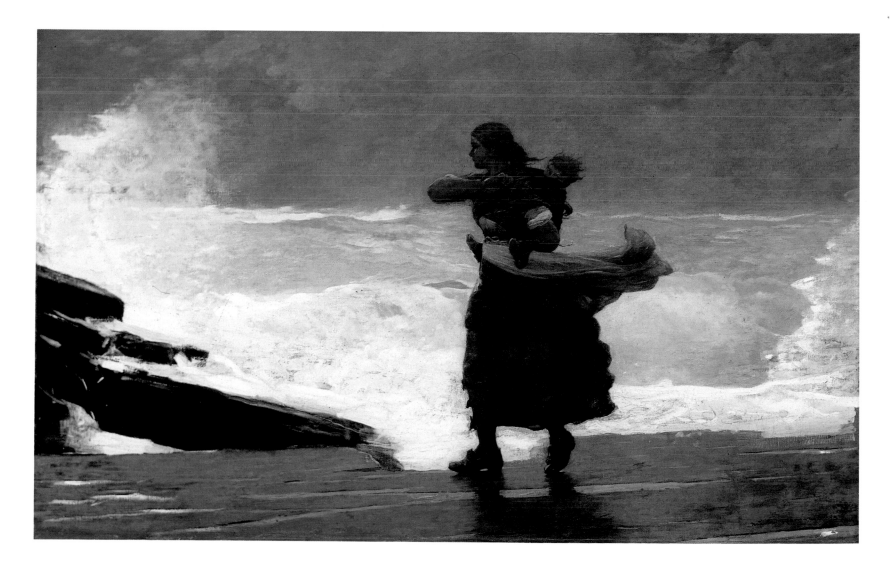

of the Life Brigade House beneath the white spray at the left, but Homer's other alterations left only subtle evidence of the previous surface. As Goodrich wrote:

Closer examination reveals some interesting facts. The sea has been completely repainted in a light bluish green tonality that contrasts with the gray-brown, slightly purplish tone of the rest of the picture. Beneath the present surface of the sea can be seen an older one, whose prevailing color is much like that of the other parts. Where the edges of figure and sea meet, the repainting is especially noticeable, overlapping the figure in places, and elsewhere leaving gaps where one can see the old edges, more meticulously painted, in the gray-brown tone that seems to have been the original key of the whole picture. The repainting differs not only in color but in its bold, slashing brushwork, which contrasts with the tighter handling of the figure and of the earlier sea. Both the warm, grayed color and the careful technique are characteristic of Homer's style of the early '80s, while the cooler tonality and freer brushwork are qualities which began to appear in the late '80s and early '90s.[5]

Homer's revisions to the canvas seem to have been targeted specifically to the areas that had troubled critics in 1883. By removing the background building and figures he eliminated the "awkward" design and solved the problem of the woman being "conspicuously out of proportion" and not properly related to the distant figures. By changing the sea to a lighter color he helped overcome the "monotonous" character of the earlier picture, which was too "suffused in that purplish hue." These various changes also, however, completely changed the essential nature of the subject from a narrative English scene to one more in keeping with Homer's most recent work at Prout's Neck. The result was a remarkable hybrid in which a sturdy Cullercoats fisherwoman was transported to the ledges of Prout's Neck, her forceful demeanor placed in opposition to the ocean's power.

The Gale (or, *The Great Gale*, as it was called in 1893) fared considerably better when it was seen at the World's Columbian Exposition in Chicago than had *The Coming Away of the Gale* in New York ten years earlier. By 1893 Homer was widely reckoned one of America's premier painters, and the fifteen works by him on view in Chicago represented him particularly well. *The Gale* was honored with a medal, one of the first such public honors Homer received. At the sale of the Clarke collection in 1899 the painting brought $1,625, a strong price (Clarke had paid $750 in 1893). In 1916, when *The Gale* was acquired by the Worcester Art Museum for $27,500, it established a record price for a work by an American painter.[6]

NOTES

1. "Fifty-Eighth Academy," *The Art Interchange* 10 (12 April 1883), 94.

2. "Fine Arts. Fifty-Eighth Annual Exhibition of the National Academy of Design," *New York Evening Mail and Express*, 17 April 1883. This critic concluded: "The composition is too angular, and there is not sufficient...distance between the solitary and rather weary figure of a woman in the foreground and the men who are launching the boat."

3. "Fine Arts. Fifty-Eighth Annual Exhibition of the National Academy of Design," *The Nation* 36 (19 April 1883), 348; this review also appeared in the *New York Evening Post* of the same date.

4. "A 'Lost' Winslow Homer," *Worcester Art Museum Annual* 3 (1937–1938), 69–73.

5. "A 'Lost' Homer," 71.

6. See Goodrich 1944a, 82, 156. Goodrich and other sources give the price for the Worcester Art Museum transaction as "around $30,000"; the figure given here ($25,000 to the owner and a 10 percent commission to the dealer) is from the original bill of sale still in the museum's possession (copy kindly provided by Susan E. Strickler).

190. *Moonlight, Wood Island Light*, 1894
oil on canvas, 78.1 x 102.2 (30¼ x 40¼)
The Metropolitan Museum of Art, Gift of George A.
Hearn, in memory of Arthur Hoppock Hearn, 1914
Provenance: (Gustav Reichard & Co., New York, until
February 1895); Thomas B. Clarke, February 1895–
February 1899; (American Art Association, New
York, 17 February 1899, no. 350); (Boussod, Valadon
& Co., New York, February 1899); George A. Hearn,
by 1907 until 1914.

190–192

During 1894 Homer was unusually productive, creating not only these three oils, but also another major Prout's Neck seascape, *Weatherbeaten* (fig. 215); a stark winter landscape, *Below Zero* (Yale University Art Gallery); and the figure painting *The Fisher Girl* (Mead Art Museum, Amherst College). *Moonlight, Wood Island Light* reprises the nocturnal theme and the setting of *A Summer Night* (cat. 186) of four years earlier, although without figures present. The view is from the rocks below Homer's studio out across the sea; the moon is obscured by clouds and haze, but its light is brightly reflected in the water below. A flash of red on the horizon represents the beam from Wood Island Light, lying to the south of Prout's Neck. According to Downes,

the origin of the painting was very much like that of *A Summer Night:*

No one who has lived by the seashore can have failed to treasure the memories of those perfect summer nights when the moon sends its beams athwart the wide field of the moving waters in a path of molten silver; and the fascination of watching this glorious spectacle never lost its power over our artist. One night in the summer of 1894, he was sitting on a bench, smoking, with his nephew, in front of the studio. It was a beautiful evening, with quite a sea running, but not much wind. Of a sudden, Winslow Homer rose from his seat, and said: "I've got an idea! Good night, Arthur!" He almost ran into the studio, seized his painting outfit, emerged from the house, and clambered down over the rocks towards the shore. He worked there uninterruptedly until one o'clock in the

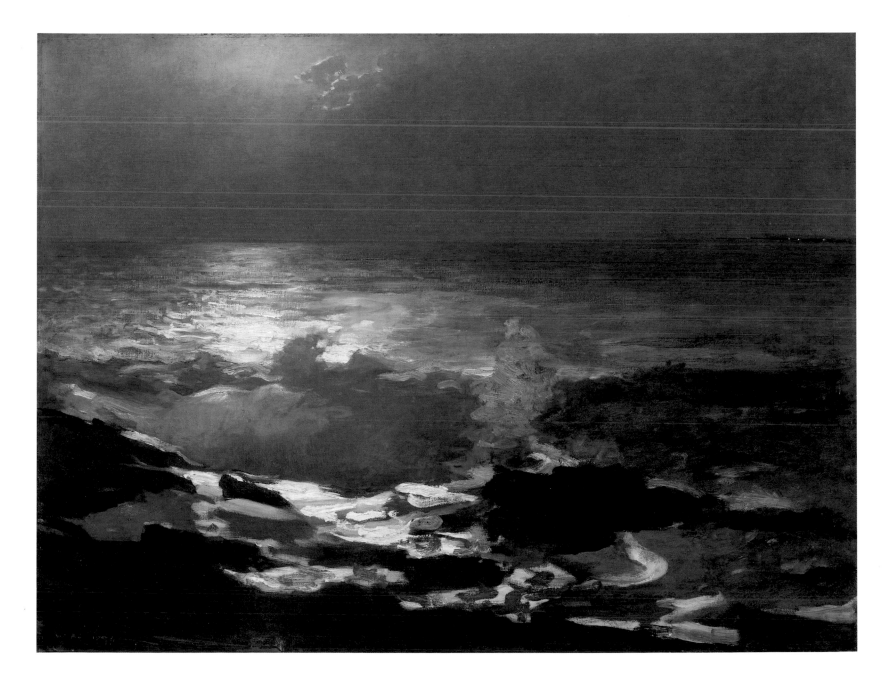

morning. The picture called "Moonlight, Wood Island Light," was the result of that impulse and four or five hours' work. Like his other moonlight pictures, it was painted wholly in and by the light of the moon, and never again retouched. The very essence of moonlight is in it.[1]

Although Goodrich thought Downes' account of the genesis of *Moonlight, Wood Island Light* "may have been true…[because the painting] has all the marks of having been done direct from nature," he concluded, "as to the others, one still wonders."[2] Beam, however, was openly skeptical that anyone could bring a large oil painting to completion working solely by moonlight.[3] In one sense, the story recounted by Downes was simply another manifestation of his emphasis on Homer's realism. But he may also have been deliberately contrasting Homer's moonlights with ones by Albert Pinkham Ryder (1847–1917) and Ralph Albert Blakelock (1847–1919), which were well known for being purely products of the artists' imagination (figs. 221–222). A typical Blakelock night scene was said to have "nothing to do with fact. It is a dream of the night," words that could equally apply to Ryder's marines.[4] Homer, though he would return to the subject of moonlight in late works that were increasingly visionary (see especially cat. 234), at this moment seems to have been more concerned with expressing visual reality.

High Cliff, Coast of Maine, depicting what Beam has called "the crowning feature of Prout's Neck" seen from the east (*The West Wind* showed it from the west), proved a source of some frustration for Homer, because it did not sell until 1903.[5] In the years since, its standing has fluctu-

ated. Downes believed there was nothing "more perfect in all his *oeuvre*, so far as the complete avoidance of commonplace is concerned," and Goodrich placed it "among his greatest works…."[6] Hendricks judged it "not on the level of the earlier pictures," but Beam called attention to its "magnificence."[7] Homer himself thought highly of it, as is revealed in his correspondence with Knoedler's about the picture in 1901–1903. The painting was first shown in 1894 at the Carnegie Institute, but was returned unsold to Homer; in September 1901 he wrote to Knoedler: "I wish to know if you are still overloaded with pictures— I am waiting until some of them get settled for good before *I paint anymore*—I have not painted *anything this summer* but I have a picture that you

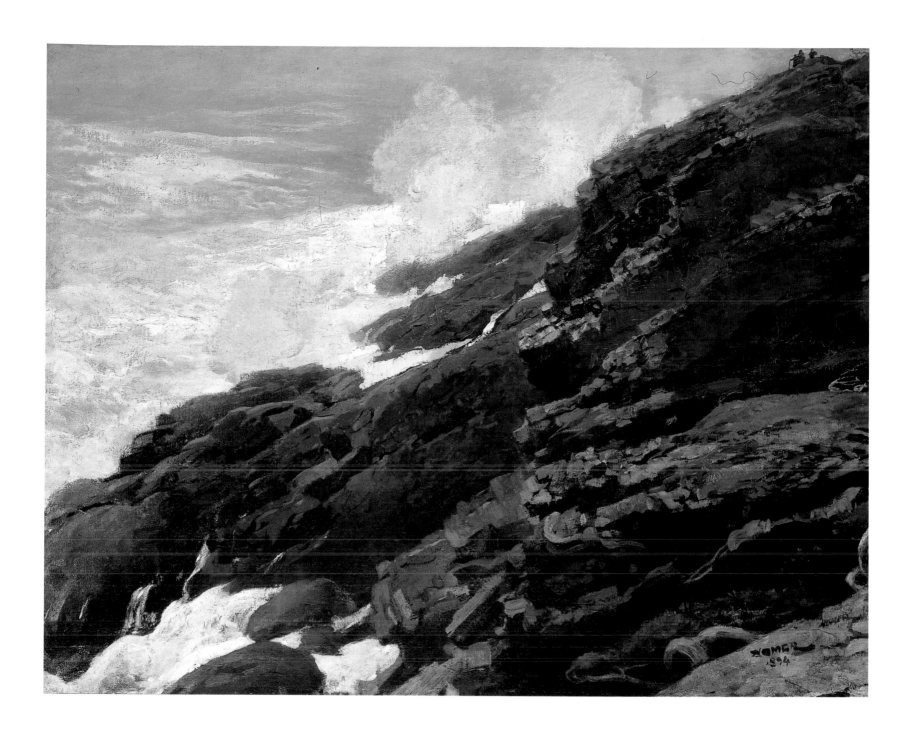

191. *High Cliff, Coast of Maine*, 1894
oil on canvas, 76.5 x 97.2 (30⅛ x 38¼)
National Museum of American Art, Smithsonian
Institution, Gift of William T. Evans
Provenance: (M. Knoedler & Co., New York, September 1894 and January 1902); (O'Brien & Son, Chicago, mid-March 1902–February 1903); (M. Knoedler & Co., 14 February 1903); William T. Evans, March 1903.

have never seen in the shape that it is now in—& it is very beautiful in my opinion."[8]

In January 1902, clearly frustrated that the picture had not found a buyer, Homer wrote to Knoedler: "I think if it will not sell there is little use in my putting out any more things."[9] The New York collector George Hearn thought of buying it early in 1902, but changed his mind in favor of *Maine Coast* (cat. 195).[10] Homer sent the picture to Chicago for display at O'Brien's gallery, but soon complained "Why do you not sell that 'High Cliff' picture? I cannot do better than that. Why should I paint?"[11] By the end of the year, with *High Cliff* "still unsold," he reminded Knoedler that it was "a fine picture.... Do you

wish it again?"[12] In January 1903 he admitted "the fact that good picture High Cliff is unsold has been most discouraging to me...."[13] At last, in March 1903, Knoedler informed Homer that the picture had been sold to William T. Evans.[14]

Although it was exhibited at least once in public during Homer's lifetime—at O'Brien's gallery in Chicago—*The Artist's Studio in an Afternoon Fog* seems to have eluded his early critics and biographers. Neither Downes nor Goodrich mentions it, and the one extended early account of it, from a Chicago newspaper, was premised on a misunderstanding of the time of day represented:

...a "Moonlight Fog" discloses in the distance a num-

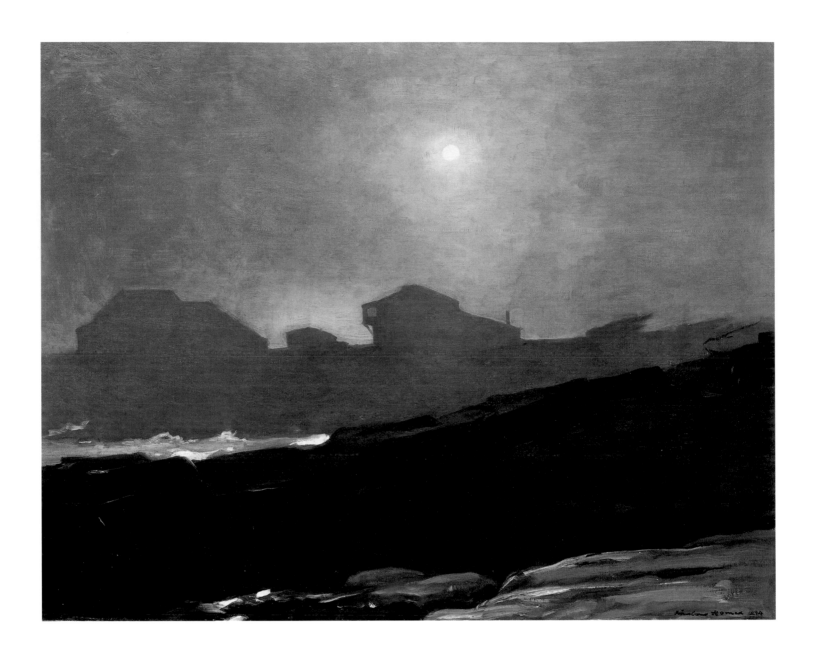

192. ***The Artist's Studio in an Afternoon Fog,*** 1894
oil on canvas, 61 x 76.8 (24 x 30¼)
Memorial Art Gallery of the University of Rochester,
R. T. Miller Fund
Provenance: John Calvin Stevens, until 1941.

ber of houses on a cliff, silhouetted against a bank of dull brown clouds. The silvery moon has burst through the cloud mass and shines forth from a disk of pale blue. The middle distance reveals a charming bit of sea, its crested waves are touched by the moon's rays. In the foreground are shelving rocks. It is a delightful essay, and certain of its features suggest the palette of Cazin.[15]

Upon learning of this mistake, Homer is said to have responded (in a letter to a friend): "That oil is not a moonlight. No one but a first-class fool would take it for one. It is painted in the middle of the afternoon and the sun is shining through a fog. It is a great work."[16]

In spite of Homer's characterization of the painting as a "great work," one wonders precisely what place to assign it in his oeuvre, because it is in many ways singular. As Beam has observed, it is "unique among Homer's marines and, indeed,

is different from any of the hundreds of other pictures he created. Nowhere else does he depict the two buildings, the Ark and his studio...."[17] The painting is also unusual for its relatively small size, its tonal handling, and the reductive geometric ordering of its composition.[18] Those qualities are, however, also found (albeit to rather different ends) in a painting of the same size shown with *The Artist's Studio in an Afternoon Fog* in Chicago, *Coast of Maine* (fig. 223). That work also, as Beam has noted, "almost stands alone," for it takes the familiar terrain of Prout's Neck and transforms it into something one contemporary writer called "weird but fascinating."[19] If Homer was in these two works exploring new stylistic directions, they do not seem to have led to any substantial reevaluation of his art. Although he called *The Artist's Studio in an Afternoon Fog* "great," he also referred to it as a "sketch" when he gave it to his friend, the architect John

fig. 223. *Coast of Maine*, 1893. Oil on canvas. Art Institute of Chicago, The Arthur Jerome Eddy Memorial Collection, 1931.505

Calvin Stevens.[20] He clearly felt it was suitable for public display, or he would not have sent it to Chicago, but "sketch" was, nevertheless, not a term he customarily used for other oils of the period (see also cat. 196).

Perhaps the most revealing aspect of the painting is its essentially personal nature, for it documents, after all, the symbolic center of Homer's world—his home and studio—and places it in close proximity to the world of his family. Prout's Neck was for him a place of refuge from the wider world, and the studio was his *sanctum sanctorum*, a place where he could keep completely alone, even from his family. Homer used a sketch of the studio as the frontispiece to his "Memorandum and Sketchbook" (c. 1898, Bowdoin) and wrote above it: "Where the women cease from troubling & the wicked are at rest—Prout's Neck."[21] He guarded this private space zealously and constantly discouraged visitors. In a very real sense, the interior of the house and studio was a safe haven for Homer's physical, intellectual, emotional, and artistic being, and its exterior was a concrete manifestation of its containing and protective role. Standing alone, but not completely isolated from other buildings, and surrounded by rocks, sea, and sky, the studio as seen in *The Artist's Studio in an Afternoon Fog* appears as a dark, abstracted silhouette pierced by light only in one place: the balcony where Homer spent so much time looking out upon the world. In these terms, *The Artist's Studio in an Afternoon Fog* is, like *Fox Hunt* of the previous year (cat. 230), perhaps as close to self-portraiture as Winslow Homer ever came in his art.

NOTES

1. Downes 1911, 173.

2. Goodrich 1944a, 142.

3. Beam 1966, 88–89. Patricia Junker's entry on the painting in Beam et al. 1990, 130, citing both Goodrich and Beam, also concludes that Homer may have made studies by moonlight, but that painting the large oil outdoors at night would have been "problematic." Spassky 1985, 2: 468–471, quotes Downes' account, but does not dispute it.

4. Elliott Daingerfield, "Ralph Albert Blakelock," *Art In America* 2 (December 1913), 67–68; quoted in Diana Strazdes, *American Painting and Sculpture to 1945 in the Carnegie Museum of Art* (New York, 1992), 76.

5. Beam et al. 1990, 120.

6. Downes 1911, 172; Goodrich 1944a, 135.

7. Hendricks 1979, 220; Beam et al. 1990, 120.

8. 19 September 1901 (typescript, NGA).

9. 14 January 1902 (typescript, NGA).

10. See Knoedler to Homer, 28 January and 14 February 1902, and Homer's replies of 30 January and 16 February 1902 (M. Knoedler & Co.).

11. 27 September 1902 (quoted in Downes 1911, 216–217).

12. 29 December 1902 (typescript, NGA).

13. Letter to Knoedler, 6 January 1903 (typescript, NGA).

14. 11 March 1903 (typescript, NGA).

15. Undated newspaper clipping, probably 1894 or 1895 (Bowdoin).

16. Homer's remarks are quoted in an undated newspaper clipping (Bowdoin).

17. Beam et al. 1990, 126.

18. The painting is discussed by Patricia Junker, "Expressions of Art and Life in *The Artist's Studio in an Afternoon Fog*," in Beam et al. 1990, 34–65; see also John Wilmerding, "Winslow Homer's Maine," in Beam et. al. 1990, 86–96.

19. Beam et al. 1990, 119; undated clipping, as in note 15, above.

20. Homer to John Calvin Stevens, 26 June 1901, Bowdoin; cited in Beam et al. 1990, 129. Stevens had worked with Homer in 1883–1884 in converting the carriage house into the studio, and he also designed the house that the artist built at Kettle Cove in 1901. For the latter service Stevens requested a work of art as payment and received *The Artist's Studio in an Afternoon Fog*.

21. As Junker has noted (Beam et al. 1990, 65), the inscription is a paraphrase of Job 3:17: "There the wicked cease from troubling; and there the weary be at rest."

193. *Cannon Rock*, 1895
oil on canvas, 101.6 x 101.6 (40 x 40)
The Metropolitan Museum of Art, Gift of George A. Hearn, 1906
Provenance: (M. Knoedler & Co., New York, 1900); Frank W. Gunsaulus, Chicago, from 1900. George A. Hearn, 1901–1906.

193–195

By the mid-1890s, the image of a Winslow Homer who lived and worked in solitude at Prout's Neck and who used his art to square off against the forces of nature had become widespread in the popular imagination. As Downes and Frank Torrey Robinson wrote in 1896 of the man they called "that profound original genius, that guide to all great epics of the untamed sea and the unexplored wilderness":

Like Thoreau, Winslow Homer is a recluse, for the reason that art of the sort he lives for is incompatible with the amenities of society. He lives in a lonesome spot on the coast of Maine. His sole companions are natural and unsophisticated beings, outdoor folk, hunters, fishermen, sailors, farmers. No artificial refinements, no etiquette of the drawing-room, no afternoon tea chatter, no club gossip, for this hermit of the brush.[1]

And of all the subjects to which this "virile, magnificent talent" turned his attention, the sea around this time came to be most indelibly associated with him.[2] These three seascapes, the products of an intense pictorial investigation of the Prout's Neck coast that Homer would not again equal until the year 1900, were reckoned by his contemporaries among his most accomplished works.

Cannon Rock depicts one of Prout's Neck's distinctive rock formations, which was described by Downes:

Looking down from the cliff walk, one sees just the outlines of dark rock against the lighter values of the water that are shown in the picture. Nothing is changed, except that, as a matter of course, the angle of the sunlight on the scene may be different at each hour of the day. At the right of the foreground one notices the odd outlines of a projecting rock or segment of rock which bears a semblance of the breech of a cannon. As I stopped to look, I heard a dull, muffled boom, apparently coming from the unseen base of the cliff. This, it was explained, is the report of the cannon. Perhaps it is a little far-fetched. Such ideas are apt to be so. In the middle distance, I saw a wave break repeatedly, as is shown in the painting. That is caused by a sunken reef some little way from shore.[3]

In spite of Downes' assertion that "nothing is changed," Beam has pointed out that Cannon Rock itself actually "appears to be surprisingly small and distant" in comparison to the image of it in the painting and that Homer "intensified its presence through a variety of judicious alterations."[4] In addition to changing the shape and profile of the rocks and the direction of the "cannon," Homer also combined the water levels of both low and high tides. The waves in the middle distance could only be seen breaking over the bar at low tide, but the area immediately below Cannon Rock is only filled with water at high tide. Such changes were, as Beam rightly pointed out, an essential part of Homer's creative process and sufficient in themselves to demonstrate that he did not simply paint nature exactly as he saw it before him.

Homer did not show *Cannon Rock* until five years after its completion. In 1900 he wrote to Knoedler:

The picture now going forward is called "Breaking on the Bar"—Cannon Rock. It was painted in *1895* & has been hanging in my studio untouched—I did not put it out or change it in any way as the breaking on the bar part of it looked so broken & so like decanters & crockery, & at the same time looked so fine at a proper distance—I now take the liberty of sending it out....[5]

He thought *Cannon Rock* might hang well with two of his newest pictures, *Eastern Point, Prout's Neck* and *West Point, Prout's Neck* (cats. 227–228). As he wrote to Thomas B. Clarke: "I now know what I can send you for your Union League exhibition—I think it will be best to have but three pictures—all Marines—one square now at Knoedler's is not of much account, but the ones I am finishing now will make an impression."[6] He also included a sketch (see fig. 225) of the three paintings as they might be hung, with *West Point* on the left, *Cannon Rock* in the middle, and *Eastern Point* on the right. As it turned out, *Cannon Rock* was sold before the Union League Club's exhibition, so Homer substituted *Northeaster.*

Homer used square canvases on only a few occasions during his career (see also cat. 226), but he clearly understood that the format allowed special aesthetic effects. As William H. Gerdts has discussed, the compositional dynamics possible with the square format tend to work against illusionism and draw the viewer's attention to the flatness of the picture plane.[7] Unlike traditional horizontal-format landscapes, which emphasize lateral expansion of space, or vertical ones, which emphasize up and down, the square format tends to contain visual movement, forcing the viewer's eye over and over again to the center of the picture. Gerdts has called *Cannon Rock* "the most significant of Homer's square paintings" and one of his "most flattened and design-conscious canvases," and has also noted how the thick impasto of the breaking wave in the middle distance "pulls that form to the picture plane."[8] Homer's comments about the appearance of that wave, specifically, and his conclusion that the picture looked "fine at a proper distance," indicate he was fully aware of these issues.

194. *Northeaster,* 1895
oil on canvas, 87.6 x 127 (34½ x 50)
The Metropolitan Museum of Art, Gift of George A. Hearn, 1910
Provenance: (M. Knoedler & Co., New York, 1895); Thomas B. Clarke, 1895–1896; the artist, Prout's Neck, Maine; (M. Knoedler & Co., New York, December 1900); George A. Hearn, 1901–1910.

The sea is relatively calm in *Cannon Rock,* but in *Northeaster* we see the full fury of an autumnal storm. According to Beam, a storm like the one depicted must have been capable of driving waves fifty or sixty feet up the rock cliffs to produce such a tower of spray.[9] Homer was known to go out on the rocks to observe dramatic displays of sea and weather, but it would have been completely impossible for him to paint under such conditions. A story told by Downes and repeated by Goodrich had it that Homer had a portable painting house:

This little building was about eight by ten feet in ground dimensions, with a door on one side and a large plateglass window on the other side. In a northeaster, when it would be impossible to manage a canvas of any size out-of-doors, and when exposure would be disagreeable and uncomfortable, he would have the painting-house moved down on the rocks of Eastern Point, and, installing himself in this snug shelter, with his materials, he could place himself in the position that commanded his subject, and work as long as the light and other conditions were favorable. Shut up in

this convenient shanty, he was secure from intrusion, too, and no inquisitive rambler along the shore could look over his shoulder to see what he was painting.[10]

This is a charming story, and it soon became part of the legend of Homer's "uncompromising" realism, making one think of the floating studios used by the French painters Charles Daubigny and Claude Monet. It also seemed to locate Homer as the inheritor of the tradition of painting in storms which ran from Ludolph Backhuysen in seventeenth-century Holland; to Joseph Vernet in eighteenth-century France; J. M. W. Turner in nineteenth-century England; and, in America, to Homer's slightly older contemporary Frederic Edwin Church.[11] Unfortunately, although there is some truth in the story of Homer's portable studio—his brother Charles did build him one, and the artist did try to use it once or twice— it never actually served the purpose Downes thought it did. As Beam pointed out, it would have been extremely difficult to move such a structure around the rocks at Prout's Neck, and during rough weather blowing spray would sure-

ly have made it impossible to see out of the plate-glass window.[12] According to family members, Homer's usual procedure was to make quick sketches on illustration board outdoors and paint on canvas in his studio.

When Homer first showed *Northeaster* in 1895 at Knoedler's and then at the Pennsylvania Academy of the Fine Arts in Philadelphia, it was not in its present form. Originally the picture included two men in foul-weather gear on the rocks at the lower left, and the large burst of spray above them was shaped differently. In spite of the fact that it won a gold medal at the Pennsylvania Academy of the Fine Arts, Homer decided to repaint it at some point before late 1900. As he wrote to Knoedler: "The large picture you have already had in your show window on the opposite corner of 5th Ave five years ago. I have painted on it since & it is better."[13] In addition to painting out the two men and enlarging the cloud of spray and shifting it to the left, Homer also made a richer, more complex pattern of foam floating on the water at the right, reshaped the breaking portion of the wave in the middle distance, and rounded the top edge of the rocks at the far left. These changes reduced the narra-

tive qualities of the picture to a more distilled, even abstracted image, and made *Northeaster* much more like Homer's current seascapes *On a Lee Shore*, *West Point, Prout's Neck* and *Eastern Point, Prout's Neck*. The critic for the *New York Tribune*, who saw the picture hanging with *West Point* and *Eastern Point* at the Union League Club in January 1901, considered *Northeaster* the best of the three:

…a mass of rock to the left in the foreground is contrasted with water that heaves itself up into a ridge of green translucence under a gray sky. The composition is of the simplest, embracing only what might be called three fundamental facts, the rugged strength of the rocks, the weighty, majestic movement of the sea and the large atmosphere of great natural spaces unmarked by the presence of puny man. But Mr. Homer takes hold of these materials and, with the masterful individuality that is the second source of his triumph, fuses them with bold energy into a work of art.[14]

Northeaster was purchased in April 1901 for $2,500 by George A. Hearn, who lent it to the Pennsylvania Academy's annual exhibition in 1902. Again, the painting was awarded a gold medal.

195. *Maine Coast*, 1896
oil on canvas, 76.2 x 101.6 (30 x 40)
The Metropolitan Museum of Art, Gift of George A. Hearn, in memory of Arthur Hoppock Hearn, 1911
Provenance: Thomas B. Clarke, New York, April 1897–15 February 1899; (American Art Association, New York, 15 February 1899, no. 168); F. A. Bell, New York, 1899–after 1900; George A. Hearn, New York, by 1902 until 1911.

Homer's interest in portraying the Prout's Neck coast did not flag in the months immediately after he completed *Cannon Rock* and *Northeaster*. In 1896 he painted *The Wreck* (cat. 196) and at least three seascapes: *Saco Bay* (Sterling and Francine Clark Art Institute), *Watching the Breakers—A High Sea* (Canajoharie Library and Art Gallery), and *Maine Coast*. The composition of the last-named recalls that of *Northeaster*, although with a different arrangement of the foreground rocks and a vantage point that is slightly lower and closer to the water. It is painted with vigorous, even aggressive, brushwork, especially in the white areas of foaming water, which almost seem to dissolve into purely abstract swirls of pigment. Homer knew perfectly well what he had done, for he warned off at least one potential buyer of *Maine Coast* by saying it was "not finished enough—as finish is understood by most people."[15] On the other hand, "most people" obviously did not include Thomas B. Clarke, for Homer wrote to him: "You will like it much. 'A Coast Scene.' The same old story only much better."[16] Clarke's response was to purchase the picture immediately and add it to his substantial collection of works by the artist.

The painting struck a responsive chord with critics from its first appearance. William A. Coffin, writing in *The Century Magazine*, called it a "masterpiece, with a full sense of what the term implies," and continued:

The composition shows some dark rocks in the foreground, one or two of which are covered with seaweed, and swirling, foaming water rushing through after the receding of a mighty wave that has just pounded over them. Beyond is the sea, with great rolling mountains of water, breaking at their crests into white spray. The rain-beaten expanse of the ocean rises high in the picture, and meets a sky of lowering gray. The impression of a wild, squally day is admirably given, and the handling of the subject, quite apart from the technical requirements, is comprehensive and lofty. As to the painting, it is this, of course, which makes the picture such a triumph of art. It is virile and broad. The drawing is simple and big, and the color, while veracious, is exceedingly distinguished. The truthful aspect of the work—the result of highly trained artistic powers of observation—and the effect of the picture as a whole,

attracting by its pure pictorial quality, are equally remarkable.[17]

Other writers discussed the picture with comparable enthusiasm. As Downes noted in 1911: "In the judgment of many critics it is his masterpiece in the line of marine pieces pure and simple."[18] Perhaps thinking that its lack of "finish" made it less palatable to private collectors, Homer advised Knoedler's in 1901, when they had *Maine Coast* for sale: "I should suggest that it should not be shown publicly at present—but try public institutions."[19]

NOTES

1. "Later American Masters," *The New England Magazine* 14 (April 1896), 138, 140.

2. "The Field of Art," *Scribner's Magazine* 19 (March 1896), 390.

3. Downes 1911, 178–179.

4. Beam et al. 1990, 132. See also the photograph of the site by Beam, 134.

5. 3 December 1900 (typescript, NGA).

6. 11 December 1900 (Archives of American Art).

7. "The Square Format and Proto-Modernism in American Painting," *Arts Magazine* 50 (June 1976), 70–75.

8. "Square Format," 74–75.

9. Beam et al. 1990, 134–135, based on information provided by the artist's nephew Charles Lowell Homer.

10. Downes 1911, 176.

11. George Levitine, "*Vernet Tied to a Mast in A Storm*: The Evolution of Art Historical Romantic Folklore," *Art Bulletin* 49 (June 1967), 92–100; Franklin Kelly, *Frederic Edwin Church and the National Landscape* (Washington, 1988), 36.

12. Beam 1966, 156–157. Homer even mounted the studio on a boat to try and make it more mobile, but soon gave up on it entirely. The fate of the portable studio was recorded in a drawing, which shows it as a home for lobsters (Bowdoin).

13. 29 December 1900 (M. Knoedler & Co., quoted in Spassky 1985, 2: 472, which also reproduces a photograph of the painting before it was repainted).

14. "Art Exhibitions. American Paintings at the Union League Club," *New York Tribune*, 12 January 1901.

15. Letter to Oliver H. Darrell, 23 November 1896 (manuscript collection, Boston Public Library).

16. 2 April 1897 (quoted in Spassky 1985, 2: 479).

17. Coffin 1899, 651, 653. For a summary of the early critical reaction to the picture, see Spassky 1985, 2: 480.

18. Downes 1911, 185.

19. 7 December 1901 (typescript, NGA).

196. *The Wreck,* 1896
oil on canvas, 77.2 x 122.7 (30⅜ x 48⁷⁄₁₆)
The Carnegie Museum of Art, Pittsburgh, Museum
Purchase, 1896
Provenance: The artist.

196–201

"[O]ne day in 1896," Philip C. Beam has written, Homer "saw a wreck along the shoreline of Charles Jordan's farm near Higgins Beach [a treacherous shore that joined Prout's Neck to the east], whose sand dunes are quite unlike the terrain of Prout's Neck. He had no materials with him except a pen and an envelope, but in a few strokes he sketched a crew manning a lifeboat and enclosed it in a letter to his brother Charles. And more important, he conceived the idea and the design for what was to be his concluding statement, his summing up of the rescue theme," *The Wreck.*[1] Beam did not illustrate the sketch Homer sent to his brother, or give its present location, so it is not possible to verify this version of the painting's origin. There is some reason to believe, however, that it was not that simple. Another version, for example, has it that *The Wreck* "was based on a sketch of a disaster which befell a three-masted vessel off the coast of Atlantic City [New Jersey] in 1885 or 1886."[2] And what is most damaging to both versions is that

fig. 224. *To the Rescue,* 1886. Oil on canvas. The Phillips Collection, Washington, D.C.

Homer himself indicated very clearly that the painting's most immediate creative origins were artistic more than anything else. On 5 October 1896, he wrote Thomas B. Clarke, "After all these years I have at last used the subject of that sketch that I promised you, as being the size of and painted at the same time as the 'Eight Bells'

197. *First Sketch for "The Wreck,"* 1881
charcoal on paper, 16.9 x 24.3 (6 ¹¹⁄₁₆ x 9 ⁹⁄₁₆)
Cooper-Hewitt, National Design Museum, Smith-
sonian Institution, Gift of Charles Savage Homer, Jr.
Provenance: Estate of the artist; Charles S. Homer, Jr.;
gift to the Cooper Union Museum for the Arts of
Decoration, 1912.
Washington and New York only

198. *"A Call for Volunteers,"* 1886
charcoal on paper, 30.9 x 46.8 (11 ⁵⁄₁₆ x 18 ⅜)
Cooper-Hewitt, National Design Museum, Smith-
sonian Institution, Gift of Charles Savage Homer, Jr.
Provenance: Estate of the artist; Charles S. Homer, Jr.;
gift to the Cooper Union Museum for the Arts of
Decoration, 1912.
Washington and New York only

[cat. 144]. The picture that I have painted is
called 'The Wreck,' and I send it to the Carne-
gie Art Gallery for exhibition. I did not use this
sketch that I am about to send you, but used
what I have guarded for years, that is, the sub-
ject which your sketch would suggest."[3] The
"sketch" in which the idea of *The Wreck* had been
"guarded for years," but which did not directly

supply its pictorial form, is *To the Rescue* (fig. 224),
painted in 1885 or 1886. (Several days later,
writing to Clarke again, Homer gave an indica-
tion of what, in his mind, differentiated a "pic-
ture" from a "sketch": "I considered on looking
at [*To the Rescue*], that it was much better left as
it is than it would be made into a picture by
figures in the distance, as it has…the look of

199. *"The Lookout" and "Sailor with Raised Arm"*
(Studies for *The Look Out — "All's Well"*), 1895–1896
charcoal and chalk on paper, 34.4 x 26.7 (13¾ x 10¼)
Cooper-Hewitt, National Design Museum, Smith-
sonian Institution, Gift of Charles Savage Homer, Jr.
Provenance: Estate of the artist; Charles S. Homer, Jr.;
gift to the Cooper Union Museum for the Arts of
Decoration, 1912.
Washington and New York only

200. *"Masts of Ship with United States Flag"*
(Drawing of the original idea for *The Wreck*), 1897
pencil on board, 96 x 12.4 (3³⁄₁₆ x 4⅞)
Cooper-Hewitt, National Design Museum, Smith-
sonian Institution, Gift of Charles Savage Homer, Jr.
Provenance: Estate of the artist; Charles S. Homer, Jr.;
gift to the Cooper Union Museum for the Arts of
Decoration, 1912.
Washington and New York only

201. *"Lifeboat with Carriage"*
(Study for *The Wreck*), 1895–1896
pencil on paper, 14.4 x 17.4 (5⅝ x 6¹³⁄₁₆)
Cooper-Hewitt, National Design Museum, Smith-
sonian Institution, Gift of Charles Savage Homer, Jr.
Provenance: Estate of the artist; Charles S. Homer, Jr.;
gift to the Cooper Union Museum for the Arts of
Decoration, 1912.
Washington and New York only

cat. 199

being made at once, and is interesting as a quick
sketch from nature. I hope that you have not
expected any more of a picture than this that you
now receive.")[4] Several drawings datable to the
same period—one inscribed "A Call for Volun-
teers" and dated "Oct. 20th 1885[6]" (cat. 198),
and another more closely related still, inscribed
"First Sketch" but not dated (cat. 197)—do indi-
cate that Homer investigated the idea more wide-
ly, and in a form, what is more, clearly related to

the ultimate pictorial configuration and dramatic
construction of *The Wreck*.

The Wreck is, as Beam said, the "summing up"
of a theme that, as Homer said, he had "guarded"
for years. But it was not, so far at least as one of
its major motival parts was concerned, its "con-
cluding statement." The figure gesturing with
his upraised arm that first appeared as a detail of
an 1881 watercolor (cat. 157), and subsequently
grew into an almost obsessionally recurrent image

cat. 200

cat. 201

in drawings of the 1880s and 1890s (cat. 199),[5] first achieved a prominently visible place in the foreground of *The Wreck* in 1896. But that did not exhaust the usefulness or discharge the evidently powerful meaning of that figure, for it appeared again—this time conclusively—in an oil that Homer painted soon after finishing *The Wreck* in the early autumn of 1896, *The Lookout—"All's Well"* (fig. 178).

There is about Homer's effort (not so much simply to use, as to use up this theme and its chief figuration) the character of a deliberate clearing of his creative inventory, as if to prepare himself for a new stage of imaginative effort. After *The Wreck* and *The Lookout*, in any event, Homer painted no important oil until *The Gulf Stream* of 1899 and the great subject pictures and seascapes that followed it in the first decade of the new century.

Homer thought highly of *The Wreck*. On 21 September 1896, he wrote John W. Beatty, the director of the Carnegie Institute's department of fine arts, "I have decided to send but one painting to your [first annual] exhibition but that is the best one I have painted this year."[6] The Carnegie thought highly of it too; it was awarded the chronological medal and a purchase prize in the very considerable amount of five thousand dollars.

Homer continued to think highly of it later. Of an upcoming visit to Pittsburgh, he wrote Beatty on 1 October 1901, "I wish to have time... particularly to overlook & put in order (as it must need it by this time) the picture of the 'Wreck.' I shall bring the proper varnish & brush & sponge." Revealing how his paintings should be taken care of, and how greatly he cared for them, he went on: "That is all I need but clean water. I hope it has not been varnished by any outsider as varnish is what will damage any picture. I hope also that *no glass* has been put over it, as that to me is a red flag to a bull."[7]

He also wrote Beatty, "If you ever see a three-masted schooner coming through the sky, please let me know and I will fix it."[8] He was referring to the masts of a ship, one of them bearing an inverted American flag as a signal of distress, which originally appeared over the edge of the dunes just to the left of center; now they are covered by the spray of a crashing wave. In 1897, Homer made a quick sketch that showed the painting as he remembered it "Before scraping" (cat. 200). This, with *The Signal of Distress* that he terminated but did not finish in 1896 (cat. 155), were the last cases of this sort of extensive narrative recision in Homer's art. That *The Wreck* originally depicted a ship in distress as its narrative and dramatic focus may suggest that it was the successor to *The Signal of Distress*. If so, that may suggest, in turn, that he set that earlier painting and its accumulated frustrations aside in 1896 to consider in another form, and, as it turned out, finally carry to successful closure a subject that had been an imaginative presence and represented an uncomfortably unfulfilled expressive need (or obligation) for well over a decade.

The Wreck depicts a rescue boat (based on a precisely detailed pencil drawing, cat. 201) being pulled to the beach upon which a ship has gone aground. A cluster of onlookers stands on the crest of the dunes at the right. To their left, a breeches buoy, like that in *The Life Line* (cat. 132), has been rigged—as if *The Wreck*, in another form of closure, depicted the same event from a different point of view.

NOTES

1. Beam 1966, 149. This is the version given in Diana Strazdes, *American Paintings and Sculpture to 1945 in the Carnegie Museum of Art* (New York, 1991), 265–266.

2. O'Connor 1937, 300.

3. Letter to Thomas B. Clarke, 5 October 1896, in Downes 1911, 188.

4. Downes 1911, 189.

5. As in Cooper-Hewitt drawings acc. nos. 1912-12-32, -37, -212.

6. Letter to John W. Beatty, Scarboro, Maine, 21 September 1896 (Archives of American Art).

7. Scarboro, Maine, 1 October 1901 (Archives of American Art).

8. Goodrich 1944a, 140.

Homer first visited the Province of Quebec, Canada, in 1893, when he did not paint, and returned in 1895, 1897, and 1902, when he did. The region of Lake St. John and the Saguenay River where Homer stayed on his visits to Canada had in the 1880s become accessible by rail from New York and Boston to anyone who could put up with train trips of thirty hours or more. (In the nineteenth century, the railroad was one of the chief instruments of popularizing and populating places and bringing visitors, including artists, to them: it brought the English to such seaside places as Ramsgate Sands [fig. 62]; the French to Trouville; the French impressionists to such hallowed sites as Louveciennes, Bougival, Chatou, Asnières, and Argenteuil [where Monet painted the railroad bridge];[1] it brought Americans, Homer among them, to Long Branch, to the White Mountains, and the North Shore of Massachusetts; it took Thomas Moran to Green River, Wyoming;[2] William Merritt Chase to Shinnecock, Long Island; and American impressionists such as John Twachtman, Theodore Robinson and J. Alden Weir to Cos Cob and Greenwich, Connecticut.)

Like other sportsmen, driven from the Adirondacks by logging and tourism—by "The relentless lumberman,…the early clearing of the forest,…the rapid disappearance of the deer and trout,…[the] many preserves [that] have been taken up by clubs for the use of their members"[3]—Homer found in Quebec unspoiled forests, lakes, and streams. He also found the newly discovered ouananiche, "the noblest game fish, after the salmon, in the world…," wrote The Reverend "Adirondack" Murray, who also discovered (though he did not as singlehandedly popularize) Quebec. "In appearance it resembles a landlocked salmon, but it takes a fly with the same eagerness and energy a salmon displays, and, when struck, fights for liberty with such fierce vigor and persistence as to tax an angler's skill and tackle alike. This celebrated and justly admired fish, which, in the estimation of many judicious persons, ranks level with the king of game fish, whether on table or in the water, makes its home, its only home, in and around Lake St. John."[4]

"When the waters of Lake St. John begin to subside after the spring floods, usually from the 8th to the 15th of June, the ouananiche makes his appearance in the seething waters of *la Grande Décharge*—that most ideal and picturesque of fishing-grounds, where the surplus waters…are poured out of Lake St. John over a broad, rocky, rugged, and rapid descent nearly forty miles in length…, into the deep, dark chasm adown which rolls the dismal Saguenay to meet the St. Lawrence on its way to the sea."[5]

"The hundreds of American sportsmen who have fished for the gamy ouananiche, the 'fish that loves the foaming water,' in and around Lake St. John…will be enraptured by and with Mr. Homer's strong, truthful, and appreciative pictorial representations of the scenes and sport they love so well.…Mr. Homer's water colors are permeated with outdoor feeling and with the atmosphere of the region, whose delights he has doubtless himself tasted. One feels the splendid swirl of the icy waters and the swift rush of the canoes down the foaming rapids—one almost hears the hurried staccato cries of the French guides as they steer the frail birch-bark canoes through the seething billows.…"[6]

"[A]t Knoedler's was shown in April a collection of twenty-seven of [Homer's] 'Water Colours of Life and Scenes in the Province of Quebec.' One did not have to cross the threshold of the gallery to recognize the supremacy of this painter's touch. One caught a glimpse of them from the entrance hall that was as refreshing visually as is physically a draught of ocean ozone. The thorough healthfulness, the virile directness of Mr. Homer's great swashes of transparent colour, is well-nigh unique in the annals of aquarelle art."[7]

NOTES

1. Robert L. Herbert, *Impressionism: Art, Leisure, and Parisian Society* (New Haven and London, 1988), chapter 6; Scott Schaefer, "Rivers, Roads, and Trains," *A Day in the Country: Impressionism and the French Landscape* [exh. cat., Los Angeles County Museum of Art] (Los Angeles, 1984), 137–172.

2. Nancy K. Anderson, "The Kiss of Enterprise," in *The West as America: Reinterpreting Images of the Frontier, 1820–1920*, ed. William H. Truettner [exh. cat., National Museum of American Art] (Washington, 1991), 246–248.

3. Eugene McCarthy, *The Leaping Ouananiche* (New York, 1894), 24. Homer owned a copy of this book (see Tatham 1977, 92–98).

4. *The Doom of the Mamelons, a Legend of the Saguenay* (Quebec, 1888), 165. "The word ouananiche is a new one but recently in use amongst anglers, as it represents a new member of the salmon family, found in a new section of the country, and is a fish but little known at present" (McCarthy, *Ouananiche*, 10).

5. E. T. D. Chambers, "Playing the Ouananiche," *Harper's Weekly* 41 (2 October 1897), 978.

6. "The Week in the Art World," *New York Times Saturday Review of Books and Art*, 9 April 1898.

7. "American Studio Talk," *International Studio* 5 (1898), iv.

202. ***Under the Falls, The Grand Discharge,*** 1895
watercolor with pencil underdrawing on paper,
35.4 x 50.5 (13 ⁵/₁₆ x 19 ⅞)
The Brooklyn Museum, Bequest of Helen B. Sanders,
78.151.2
Provenance: Charles S. Homer, Jr.; (M. Knoedler & Co.,
New York); Frank Lust Babbott; Mrs. Ian MacDonald
[Helen B. Sanders].
Boston only

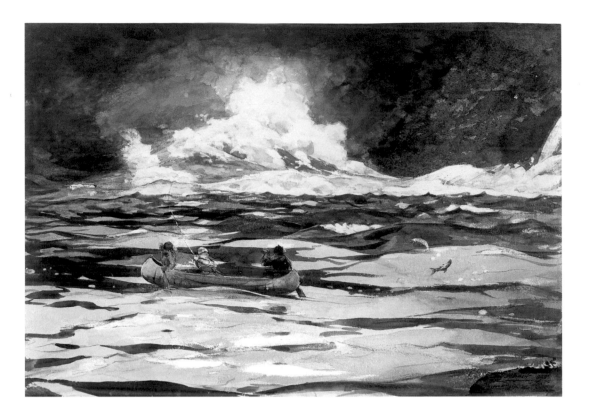

202

"Taking its course through a mountain chasm
filled with rocks, rapids and falls, this great body
of water hurls itself against and over the oppos-
ing barriers with mighty strength, boiling,
surging and leaping with an indescribable roar
and confusion, until…as the dark, mysterious
Saguenay, it quietly seeks the sea."[1]

[I]n "Saguenay River—Grand Discharge," the succes-
sion of rolling crests that ride down the rush of water,
forced up from below by the pressure and speed, is
mainly the [white] paper in reserve; shaded in the hol-
lows with a thin wash of reddish brown. It is in this
way that the artist secures an energy and snap that no
amount of overlaying with white pigment could pro-
duce. There is certainly another reason which makes
this method so stirring to the sense—a psychological
one. It is the result of the picture having been clearly
and completely comprehended in the artist's brain
before brush is put to paper. He sees his picture complet-
ed before he starts to paint, and then marches straight
and swiftly to his conclusion; and the consciousness
of such comprehensive and immediate achievement
acts as a stimulus to our imagination. His masterful
enthusiasm is contagious.

 As a consequence of execution, following so
rapidly and surely upon the conception, there is never
a tired or fumbled passage in the picture and colors
are always pure, sparkling and translucent—gem-like.
How beautiful is Homer's sense of color appears, per-
haps, most markedly in his rendering of water; espe-

cially in the liquid depths of blue and green, tones that
in nature reappear in the crevices of a glacier, but
which in their grandest beauty must be sought for in
the ocean, since then to tone are added the further
charms of movement and transparency. And with what
absoluteness of suggestion he renders these qualities
—in most impressive manner, to be sure, in his oil
paintings, but in the water colors with a closely per-
sonal expression of himself that gives them their partic-
ular value. For it would be impossible to get closer to
the workings and preferences of the artist's mind than
through these watercolors. No interval of time or bar-
rier of technical bewilderments separates us from the
moment of his inspiration. It and himself—his artistic
entity I mean—are intimately revealed.[2]

 This is one of the most felicitous descriptions
and intelligent analyses of the technical methods
and creative mentality, considered very rightly as
an "artistic entity," which were behind the great
watercolors of Homer's later years.

NOTES

1. Eugene McCarthy, *The Leaping Ouananiche* (New York,
1894), 20–21.

2. Review of the 1902 New York Water Color Club exhi-
bition (unidentified clipping, Bowdoin).

203. *A Good Pool, Saguenay River,* 1895
watercolor on paper, 24.8 x 47.9 (9 ¼ x 18 ⅞)
Sterling and Francine Clark Art Institute, Williams-
town, Massachusetts
Provenance: Charles S. Homer, Jr.; P. H. McMahon,
Brooklyn, 1913; (Gustav Reichard & Co., New York);
(American Art Association, New York, 17 April 1917,
no. 87); (M. Knoedler & Co., New York); Robert
Sterling Clark, 1917.
Washington only

204. *Two Men in a Canoe,* 1895
watercolor on paper, 35.4 x 51 (13 ¹⁵/₁₆ x 20 ¹/₁₆)
Portland Museum of Art, Portland, Maine, Bequest
of Charles Shipman Payson, 1988.55.12
Provenance: Probably Charles S. Homer, Jr.; his wife,
Mrs. Charles S. Homer, Jr.; possibly W. H. Arnold,
Nutley, New Jersey; (Macbeth Gallery, New York,
1936); Mrs. Arthur P. Homer, by 1944; (M. Knoedler
& Co., New York, by 1946); Mrs. Charles Shipman
Payson, 1946–1988.
Boston only

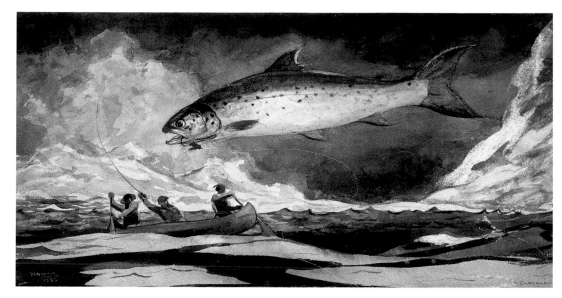

cat. 203

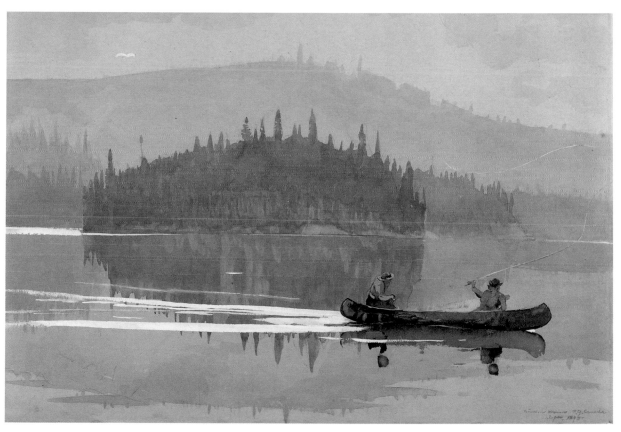

cat. 204

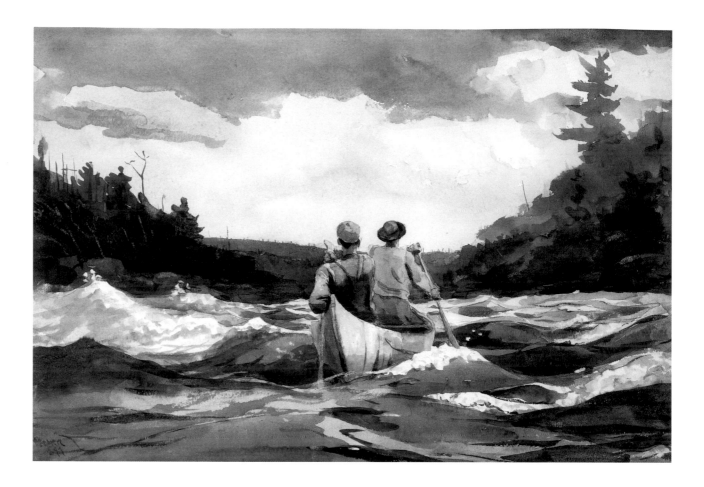

205. **Canoe in the Rapids,** 1897
watercolor on paper, 34.6 x 52.1 (13⅝ x 20½)
Harvard University Art Museums, Fogg Art
Museum, Louise E. Bettens Fund, 1924.30
Provenance: Fogg Art Museum, 1924.
New York only

206. **Shooting the Rapids,** 1902
watercolor with pencil underdrawing on paper,
35.5 x 55.4 (14 x 21¹⁵⁄₁₆)
The Brooklyn Museum, Museum Collection Fund
and Special Subscription 11.537
Provenance: Executor of the artist's estate, Charles S.
Homer, Jr., 1910.
Boston only

207. **Fishing the Rapids, Saguenay,** 1902
watercolor on paper, 34.3 x 50.8 (13½ x 20)
Private Collection
Provenance: Charles S. Homer, Jr., 1910–1911; The
Brooklyn Museum, 1911–1976; (Hirschl & Adler
Galleries, New York, 1976); private collection, 1976–
1982; (Hirschl & Addler Galleries, New York, 1982).

205–206

By such formal means as an internal, outward
pressing of what they contain (cats. 224, 225, 235),
or by pictorial construction that implies the
physical intimacy of the beholder to the paint-
ing's content (cat. 233), Homer's late paintings
often have a sometimes disquieting immediacy
of meaning and expression. It is anticipated by
the sense of shared experience in shared space
that is so strong in these watercolors. If it seems
as though one were in a companion canoe follow-
ing or alongside the depicted one, that is because,
as several quick sketches for them indicate, that
is the way Homer himself observed and recorded
these subjects.

207

The "natural lurking place [of the ouananiche]
is in swift running rapids, or the foam-covered,
whirling, eddying pools below. It seems almost
impossible to find water too rapid for these
fish....The power derived from its large fins
and tail, easily enables it to move through, and
rest in the most rapid water, and by the same
power it can jump fully twelve feet...."[1]

NOTES

1. Eugene McCarthy, *The Leaping Ouananiche* (New York,
1894), 20–21.

cat. 206

cat. 207

208. ***The Turtle Pound,*** 1898
watercolor with pencil underdrawing on paper,
38 x 54.2 (14⁵⁄₁₆ x 21³⁄₈)
The Brooklyn Museum, Sustaining Membership Fund,
A.T. White Memorial Fund, A. Augustus Healy Fund,
23.98
Provenance: Collection of Hamilton Easter Field, 1911.
Boston only

208–215

In December 1898 Homer returned to the Bahamas, which he had not visited since the winter of 1884–1885.[1] He remained in Nassau for more than two months, and it was one of the most productive periods of his later years, resulting in at least twenty-five watercolors. Subjects that had interested him in 1885—architecture, as in *A Wall, Nassau* and *Hurricane, Bahamas* (cats. 209– 210), and especially black men working in the water or on the beach—again received his attention, but his treatment of them tended to be more monumental. The figures in such works as *The Turtle Pound, Rum Cay, The Sponge Diver,*[2] and *West India Divers* are brought closer to the picture plane, giving them greater dominance in the compositions, and they are posed more formally and iconically, with increased emphasis on the definition of their physical forms. Similar characteristics are evident in the figure of the black man in *The Gulf Stream* (cat. 231).

Much attention has been devoted in recent scholarship to considering Homer's attitudes towards blacks as they can be deciphered in his works of art.[3] In his earlier Nassau watercolors such as *A Garden in Nassau* and *Rest* (cats. 145, 149) Homer had seemed to suggest the separateness of blacks from the world of whites by posing them next to (and outside) walls surrounding white dwellings. At first glance, *A Wall, Nassau* appears to be absent of similar content, for there is no black figure present. However, even

the mute walls themselves might, in this instance, be capable of speaking, for many of them were remnants of "the old slave times in Nassau," having been built by forced labor.[4] And the ominous dark forms at the top of the wall, presumably bits of broken glass, suggest that the function of this wall is very much to keep people out. The lovely world of flowers and shining sea that lies beyond the wall thus seems both inviting and forbidden.

Many of the watercolors Homer executed in Nassau in 1898–1899 focused on the work of the island's black men. *The Sponge Diver* and *West India Divers* show the small boats from which men often dived in shallow water for sponges and shells to sell in the markets. Most sponge fishing, however, was done from larger vessels, such as that shown in *Sloop, Nassau. Rum Cay* depicts one of the preferred ways of capturing sea turtles, which was to surprise a female laying eggs on the beach and flip her onto her back.[5] In *The Turtle Pound* two men, having captured a turtle (presumably on the beach), are about to place the animal in a pen, where it could be kept alive and fattened. Homer's signature, in a way that is curiously reminiscent of *Fox Hunt* of 1893 (cat. 230), is half-submerged in the water, suggesting, perhaps, that he in some way identified with the subject.[6] In *Fox Hunt* Homer's sympathies are with the beleaguered animal, but in *The Turtle Pound* the signature most resembles the position of the black man in the water. With that in mind, the signature in *Rum Cay* can be read as echoing the running pose

209. *A Wall, Nassau*, 1898
watercolor and pencil on paper, 37.8 x 54.3 (14 7/8 x 21 3/8)
The Metropolitan Museum of Art, Amelia B. Lazarus
Fund, 1910
Provenance: Executor of the artist's estate, Charles S.
Homer, Jr., 1910.
Washington only

of the figure just above, suggesting that in these works at least, the artist was linking his own identity with that of the black men he portrayed.

In comparison to the Nassau watercolors of 1885, those Homer produced in 1898–1899 are distinguished by brighter light, more intense, saturated colors, broader strokes, and far less use of pencil underdrawing to define forms.[7] In these ways they clearly indicate how successfully Homer translated the skills he had developed in his Adirondack watercolors to the portrayal of a very different environment. Moreover, the 1898–1899 Nassau watercolors represented an important sustained period of artistic activity during a time that Homer was otherwise inactive. As he wrote to John W. Beatty: "I regret to say I have not painted any in oil since I painted that Wild Goose picture [*Wild Geese*, 1897, Portland Museum of Art] a year ago last March. I painted in water colors three months last winter at Nassau, N.P. Bahamas, and have now just commenced arranging a picture from some of the studies."[8] The ultimate origins of the picture Homer mentioned—*The Gulf Stream*—were in his first trip to Nassau in 1885, but his words make it clear that his renewed acquaintance with the island and its inhabitants played a role in the conception of his great masterpiece of 1899.

NOTES

1. On this trip and the resulting watercolors, see Cooper 1986a, 208–217.

2. See Sue Walsh Reed and Carol Troyen, *Awash in Color: Homer, Sargent, and the Great American Watercolor* [exh. cat., Museum of Fine Arts] (Boston, 1993), 125, where it is noted that Homer must have been mistaken when he dated this watercolor "1889," because the paper it is executed on has an 1898 watermark.

3. See, for example, the extended discussion of *The Gulf Stream* in Albert Boime, *The Art of Exclusion: Representing Blacks in the Nineteenth Century* (Washington, 1990), 36–46; see also Stein 1990a, 74–92.

4. William Drysdale, "In Sunny Lands: Out-Door Life in Nassau and Cuba," *Harper's Franklin Square Library*, 18 September 1885, 7, 11.

5. The other way to catch turtles was by "pegging" (i.e., spearing) them in shallow water from a boat; see "In Sunny Lands," 35–36. Pegged turtles were generally sold in local markets for their meat and fat; those captured alive were commonly shipped live to New York for sale in the markets there.

6. Cooper 1986a, 215, notes the signature, but does not attempt to explain the nature of Homer's "identification with the scene being enacted."

7. Cooper 1986a, 208.

8. Letter of 13 September 1899 (Archives of American Art).

210. *Hurricane, Bahamas,* 1898/1899
watercolor and pencil on paper, 36.7 x 53.5 (14⁷⁄₁₆ x 21¹⁄₁₆)
The Metropolitan Museum of Art, Amelia B. Lazarus
Fund, 1910
Provenance: Executor of the artist's estate, Charles S.
Homer, Jr., 1910.
Boston only

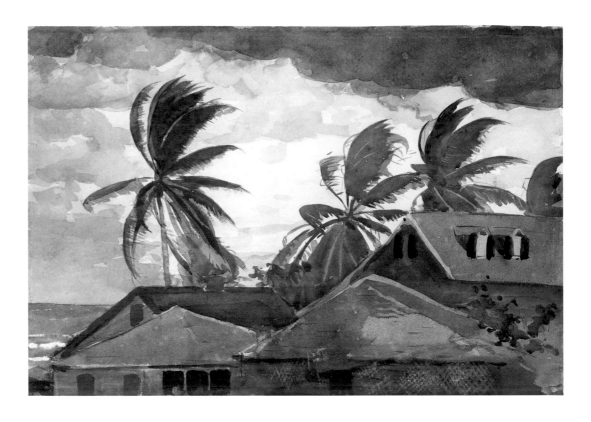

211. *Coconut Palms,* c. 1898/1899
watercolor over pencil on paper, 35.5 x 55.4 (14 x 21¹³⁄₁₆)
The Baltimore Museum of Art, Fanny B. Thalheimer
Memorial Fund, BMA 1958.19
Provenance: Charles S. Homer, Jr., 1910; Martha
French Homer, 1917; Charles L. Homer and Arthur P.
Homer, 1937; (Babcock Galleries, New York, 1954);
(Milch Gallery, New York, 1957); (Hirschl & Adler
Galleries, New York).
Washington and Boston only

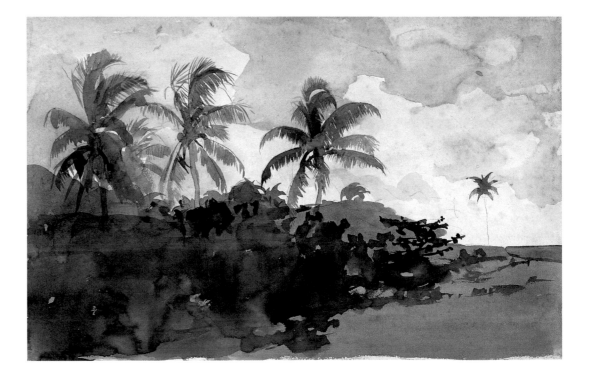

212. *Rum Cay,* 1898–1899
watercolor on paper, 37.9 x 54.3 (14⅚₆ x 21⅜)
Worcester Art Museum, Worcester, Massachusetts
Provenance: Estate of the artist; (M. Knoedler & Co.,
New York).
Washington only

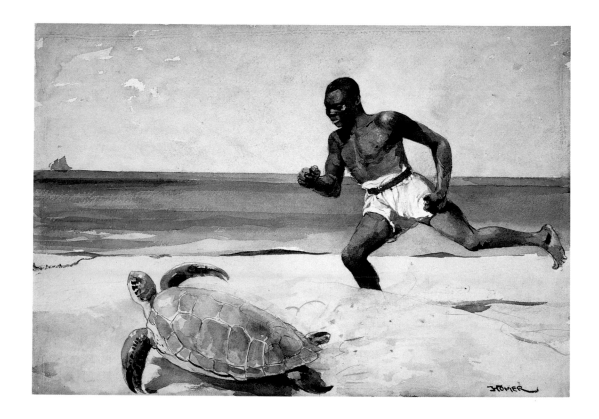

213. *The Sponge Diver,* 1898–1899
watercolor on paper, 38.1 x 54.6 (15 x 21½)
Museum of Fine Arts, Boston, Gift of Mrs. Robert B.
Osgood, 1939.621
Provenance: William Allen Bartlett, 1906; (Macbeth
Gallery, New York); (F. W. Bayley); Horace D. Chapin,
1924; Mrs. Robert B. Osgood, 1939.
not in exhibition

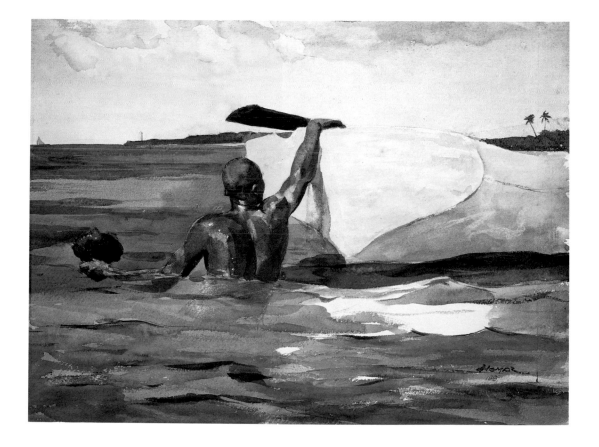

214. ***Sloop, Nassau,*** 1899
watercolor and pencil on paper, 37.8 x 54.3 (14⅞ x 21⅜)
The Metropolitan Museum of Art, Amelia B. Lazarus
Fund, 1910
Provenance: Executor of the artist's estate, Charles S.
Homer, Jr., 1910.
Washington only

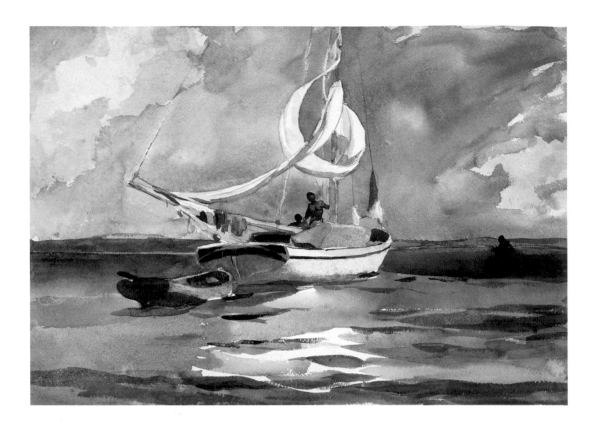

215. ***West India Divers,*** 1899
watercolor on paper, 37.8 x 54.3 (14⅞ x 21⅜)
Spencer Museum of Art, University of Kansas, The
William Bridges Thayer Memorial
Provenance: (J. W. Young, Chicago); Mrs. William B.
Thayer, Kansas City, Missouri, 1910.
Washington only

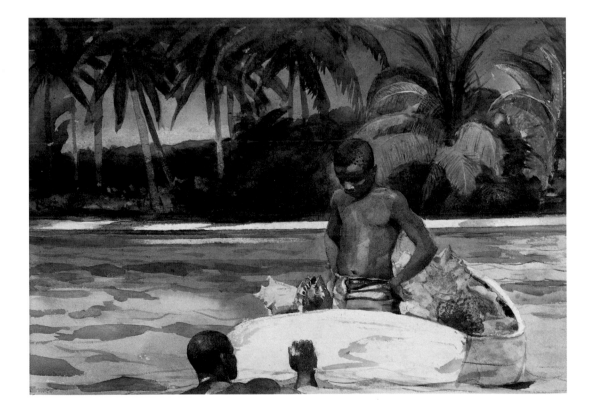

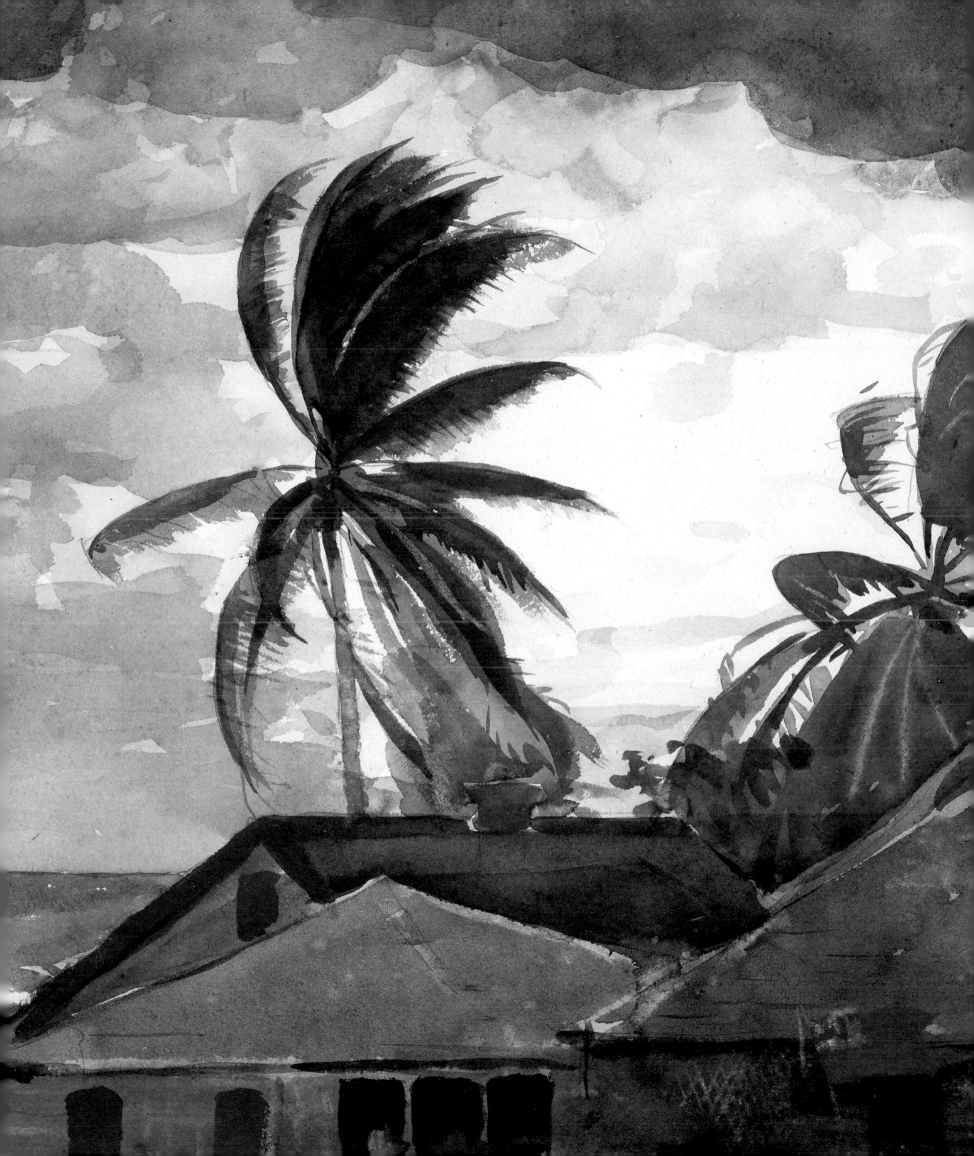

216. *Flower Garden and Bungalow, Bermuda,* 1899
watercolor on paper, 35.6 x 53.3 (14 x 21)
The Metropolitan Museum of Art, Amelia B. Lazarus
Fund, 1910
Provenance: Executor of the artist's estate, Charles S.
Homer, Jr., 1910.
New York only

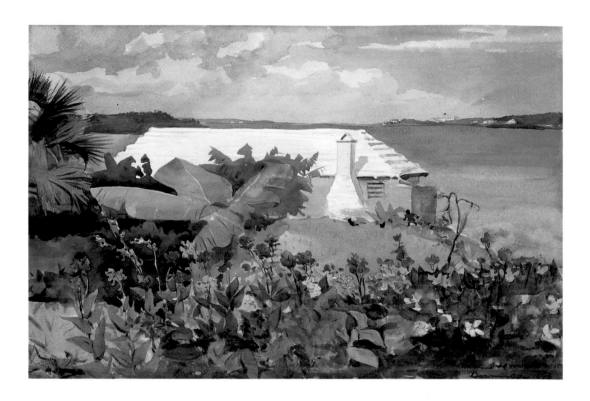

216–218

Having previously visited the Bahamas and Florida during his winter trips, Homer selected a new destination for vacations in 1899–1900 and 1901: the coral island of Bermuda, where he painted at least nineteen watercolors, among which are some of his most beautiful.[1] Like the Bahamas, Bermuda was easily accessible by steamship from New York, and offered a pleasant climate and respite from "the disturbances of modern life."[2] The island was notable for its lovely scenery, combining vegetation characteristic of both northern and southern climates, sparkling beaches, and distinctive buildings constructed of white coral sandstone. Homer was apparently much taken with the natural and manmade landscape of the island, for virtually all of his Bermuda watercolors concentrate on larger vistas; humans are rarely included and when they are (for example, the little girl in *Flower Garden and Bungalow, Bermuda*), their presence is minimized.[3] And only occasionally, as in the striking *Coming Storm*, did Homer portray ominous weather, generally preferring the blue skies and white clouds typical of the island's climate.

Homer was proud of his Bermuda watercolors, believing them to be "as good work…as I ever did."[4] Certainly they reveal—especially in their remarkably fluid washes and large areas of reserved white paper—the consummate mastery of the medium Homer had achieved by this point. There were several Bermuda subjects included in the group of twenty-one watercolors he sent to the 1901 Pan-American Exposition in Buffalo, pricing the group at $4,000. The watercolors received a gold medal, but the group did not sell, and Homer considered not offering them for sale again.[5] Although he did again show several of them at Knoedler's in 1902, in the end Homer kept many of the best along with some of his finest Nassau watercolors as a group, apparently hoping they might all be acquired by a public institution.[6]

NOTES

1. On the Bermuda trips and the resulting watercolors, see Cooper 1986a, 218–227.

2. William Dean Howells, "Editor's Study," *Harper's New Monthly Magazine* 89 (June 1894), 150 (quoted in Cooper 1986a, 218).

3. Cooper 1986a, 218, 223–225.

4. Letter to O'Brien & Son, Chicago, 1902 (quoted in Cooper 1986a, 226).

5. "I shall leave them boxed as they are until such a time as I see fit to put them out. The price will be $400 *each*!! for choice if I ever put them out again." Letter to M. Knoedler and Co. (quoted in Cooper 1986a, 226).

6. Although that did not happen during Homer's lifetime, his brother Charles did arrange for three institutions— the Metropolitan Museum of Art, the Worcester Museum of Art, and the Brooklyn Museum—to purchase the works after the artist's death.

217. *Salt Kettle, Bermuda,* 1899
watercolor over pencil on paper 35.5 x 53.3
(13⅝₆ x 21)
National Gallery of Art, Washington, Gift of Ruth K.
Henschel in memory of her husband, Charles R.
Henschel, 1975.92.15
Provenance: Mrs. Charles S. Homer, Jr., New York,
1936; (Macbeth Gallery, New York); Charles R. Hen-
schel, 11 February 1938; his wife, Ruth K. Henschel.
Washington and Boston only

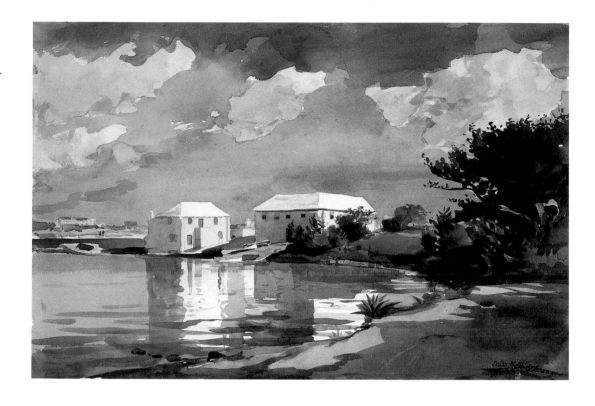

218. *The Coming Storm,* 1901
watercolor over pencil on paper, 36.9 x 53.5
(14½ x 21⅟₁₆)
National Gallery of Art, Washington, Gift of Ruth K.
Henschel in memory of her husband, Charles R.
Henschel, 1975.92.3
Provenance: George Easter Field. Brooklyn Museum,
by 1936. Charles R. Henschel; his wife, Ruth K.
Henschel.
Washington and New York only

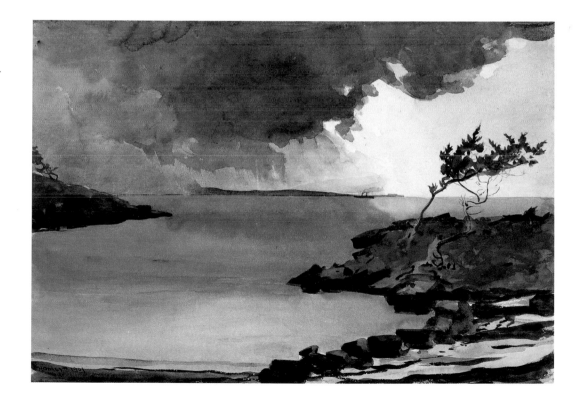

219–224

During the last decade of his life Homer made four visits to Florida, but he only painted watercolors during his trip in the winter of 1903–1904. He first visited Key West, in December 1903, and while there executed at least nine watercolors; after the first of the new year he was in Homosassa, where he painted eleven watercolors.[1] These Florida pictures of 1903–1904 would be Homer's last series of watercolors.

In the Key West watercolors Homer focused on the graceful white sailing vessels that filled the harbor and plied the local waters. As Cooper has discussed, such watercolors as *Fishing Boats, Key West* and *Key West, Hauling Anchor* are among his most "luminous and vibrant" works, and mark a culminating highpoint in his use of the medium.[2] In them he exploited a variety of techniques, but what is most noticeable is the remarkable confidence and freedom of his handling, with details convincingly suggested, but not literally described. The works form a compatible group, suggesting that Homer was inspired to take up his brushes once more because he wished to investigate a specific set of formal problems. As he wrote to his brother, "I have an idea at present of doing some work [Homer had apparently done no work the previous year] but do not know how long that will last."[3]

In early January Homer relocated to Homosassa, one of Florida's finest fishing spots. Homer was an avid angler, and the fishing in Homosassa obviously suited him; he returned there on three subsequent winter visits. In a letter to his brother Arthur, Homer declared the "fishing the best in America as far as I can find" and sketched several varieties of fish, including a "black bass," that were found in the local waters.[4] As he continued: "I shall fish until the 20th then my guide has another engagement & I shall take my own boat & work half the time & fish on my own hook. I have not done any business this Fall so far & shall only paint to see if I am in up [sic] it— & with a chance of paying expenses." Most of Homer's Homosassa watercolors show the waters where he and others fished, sometimes concentrating on broad landscape vistas, as in *The Turkey Buzzard, Red Shirt, Homosassa*, and *The Shell Heap*, and at other times closely focusing on the fish themselves, as in the dramatic *Black Bass, Florida*.[5]

As a group Homer's Homosassa watercolors are perhaps less freighted with emotional intensity than are his Adirondack watercolors, or late oils such as *The Search Light* (cat. 232) or *Kissing the Moon* (cat. 233). But issues of mortality and natural drama do form an undercurrent of meaning in several of them. Ominous gliding buzzards (see cats. 222–223) inevitably remind us of the presence of death, and the fish that Homer's anglers hook are struggling for their lives. As in *A Good Shot, Adirondacks* (cat. 161), the view of the doomed animal in *Black Bass, Florida* is from its perspective and at very close range.[6] And in comparison to the Key West watercolors that immediately preceded them, works such as *Red Shirt, Homosassa* and *Black Bass, Florida* are both literally and emotionally darker. Whereas *Key West, Hauling Anchor* is filled with light, and has large areas of pure white paper, many of the Homosassa watercolors have deep shadows in the jungles and on the waters that are made by saturated areas of color.[7] In that way they recall the dark forests and ponds seen in the Adirondack watercolors. In those works Homer had interpreted the natural world as one filled with strife and struggle; these last watercolors from Florida seem equally to affirm his belief in the workings of Darwinian process.

NOTES

1. Cooper 1986a, 228, 234.

2. Cooper 1986a, 228.

3. Letter to Arthur Homer, 5 December 1903 (Bowdoin).

4. January 1904 (Bowdoin).

5. Black (or large-mouth) bass were especially admired by anglers for their vigorous fighting after being hooked; see James A. Henshall, "Black Bass Fishing," *The Century Magazine* 26 (July 1883), 376–383.

6. Cooper 1986a, 236.

7. These qualities have also been noticed by Cooper 1986a, 234–236.

219. *Fishing Boats, Key West,* 1903
watercolor and pencil on paper, 35.4 x 55.3 (13 15/16 x 21 3/4)
The Metropolitan Museum of Art, Amelia B. Lazarus
Fund, 1910
Provenance: Executor of the artist's estate, Charles S.
Homer, Jr., 1910.
Boston only

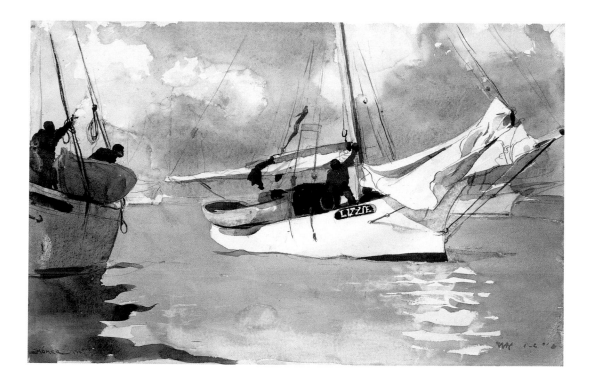

220. *Key West, Hauling Anchor,* 1903
watercolor over pencil on paper, 35.5 x 55.5 (14 x 21 7/8)
National Gallery of Art, Washington, Gift of Ruth
K. Henschel in memory of her husband, Charles R.
Henschel, 1975.92.9
Provenance: (M. Knoedler & Co., New York); George
Calvert, Indianapolis, 7 May 1904; (Milch Galleries,
New York); Charles R. Henschel, 23 January 1926; his
wife, Ruth K. Henschel.
Washington and New York only

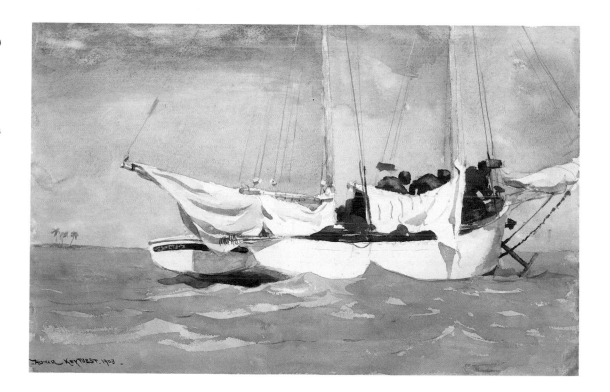

221. *The Shell Heap*, 1904
watercolor on paper, 49.9 x 35.2 (19⅝ x 13⅞)
Private Collection
Provenance: Brooklyn Museum, until 1976; (Hirschl
& Adler Galleries, New York, until 1978).

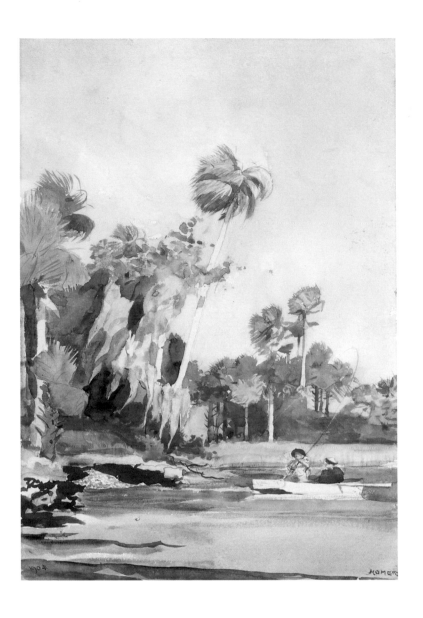

222. *The Turkey Buzzard*, 1904
watercolor on paper, 35.2 x 50.2 (13⅞ x 19¼)
Worcester Art Museum, Worcester, Massachusetts
Provenance: Alexander C. Humphreys, 1906–1917;
(American Art Association, New York, 15 February
1917, no. 129); (R. C. & N. M. Vose, Boston, 1917).
Washington only

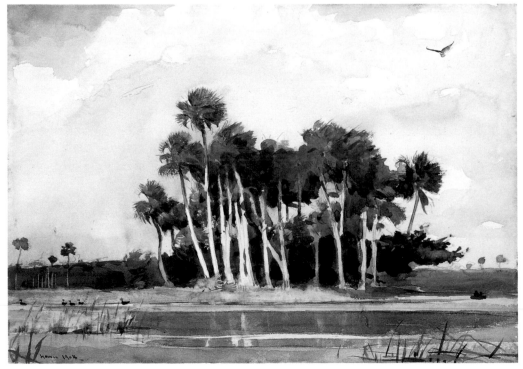

223. *Red Shirt, Homosassa, Florida,* 1904
watercolor over pencil on paper, 35.7 x 50.1 (13⅞ x 19¼)
National Gallery of Art, Washington, Gift of Ruth
K. Henschel in memory of her husband, Charles R.
Henschel, 1975.92.13
Provenance: (M. Knoedler & Co., New York); F. H.
Davis, October 1905; (M. Knoedler & Co., 1926);
Charles R. Henschel; his wife, Ruth K. Henschel.
Washington and Boston only

224. *Black Bass, Florida,* 1904
watercolor on paper, 27.6 x 49.2 (10⅞ x 19⅛)
Mr. and Mrs. Samuel H. Vickers, The Florida
Collection
Provenance: Charles S. Homer, Jr.; his wife, Mrs. Charles
S. Homer; her son, Charles L. Homer; (Wildenstein &
Co., New York, 1947–1971); (Meredith Long & Co.,
Houston, 1971–1974); private collection, 1974–1990;
(Hirschl & Adler Galleries, New York).
Washington and New York only

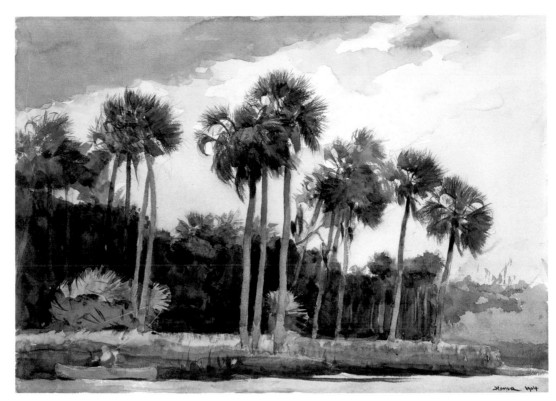

cat. 223

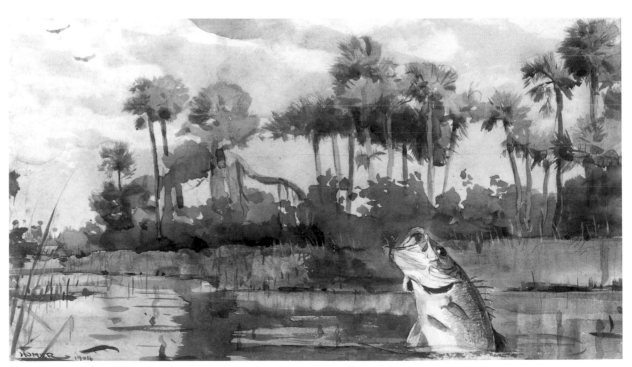

cat. 224

355

225

Diamond Shoal was the last watercolor that Homer signed and dated, and might even be the last one he actually painted.[1] Whatever the case, it is a strong and stirring performance, indicating that Homer's skills in the medium had diminished not at all. As Goodrich observed: "In dramatic force of threatening sky and livid sea, in depth of color, in power of draftsmanship, this was one of his greatest watercolors."[2]

Diamond Shoals, a vast area of treacherous and shifting shallows, extends more than twenty miles out from Cape Hatteras, North Carolina, squarely in the waters known as "the graveyard of the Atlantic." In Homer's day, as now, the area was indelibly associated with marine peril: "Everybody," observed a writer in 1885, "who knows it by reputation, is afraid of Hatteras, because it has a bad name."[3] Since 1897, the shoals had been marked by the Diamond Shoals lightship, moored thirteen miles off the tip of Hatteras.[4] Although steamers making the run from New York or Norfolk to the Bahamas tended to give the area wide berth, those bound for Florida would often pass near the lightship. Homer may have seen it on several occasions, but perhaps it was on his return in late January 1905 from a winter visit to Florida that he formed the idea for this watercolor.[5] Its vigorous handling, broad washes of blue and green color, and large areas of reserved white paper, recall the Key West watercolors of 1903 (see cats. 219–220), but its mood is far more dramatic. Beam has noted the accuracy of nautical details in Homer's portrayal: "The bobbing lightship and urgent activity of the sailors tell us that a gale has suddenly aroused the seas. In quick response the seamen have dropped the flying jib to the bowsprit, have hoisted the mizzen sail to point the bow into the wind, and are frantically trimming the staysail. The mainsail has been hurriedly lowered but left unfurled."[6] One need not necessarily be aware of these details to sense the urgency of the moment, for Homer's composition forcibly collapses pictorial space outward towards the space of the viewer. Our vantage point is from below, as if we were actually in the water, and the sailboat surges towards us; if its course does not change in a moment, it will literally be upon us. In a way that both recalls a work such as *A Good Shot, Adirondacks* of 1892 (cat. 161) and looks ahead to *Right and Left* of 1909 (cat. 235), Homer exploited these compositional elements to create an image in which dramatic content stands as a powerful counterpoint to aesthetic beauty.

NOTES

1. *The Wrecked Schooner*, in the collection of the Saint Louis Museum of Art, is not dated, but was inspired by an event in the summer of 1903. Members of Homer's family believed it was the last watercolor he completed; according to Beam 1983, 42, it was probably painted around 1908. Cooper 1986a, 237, considers *Diamond Shoal* "Homer's last known watercolor."

2. Goodrich 1944a, 183. He concluded: "One wonders how, after reaching this mastery, he could stop." Hendricks 1979, 263, rather peevishly disagreed with Goodrich, declaring "the technique masterful, but the effect contrived."

3. William Drysdale, "In Sunny Lands: Out-Door Life in Nassau and Cuba," *Harper's Franklin Square Library*, 18 September 1885, 3. Drysdale continued by boasting: "I have passed it a great many times in steamers, and never had the slightest trouble with it."

4. *North Carolina: A Guide to the Old North State* (Chapel Hill, 1939), 302.

5. Cooper 1986a, 236–237.

6. Beam 1983, 42.

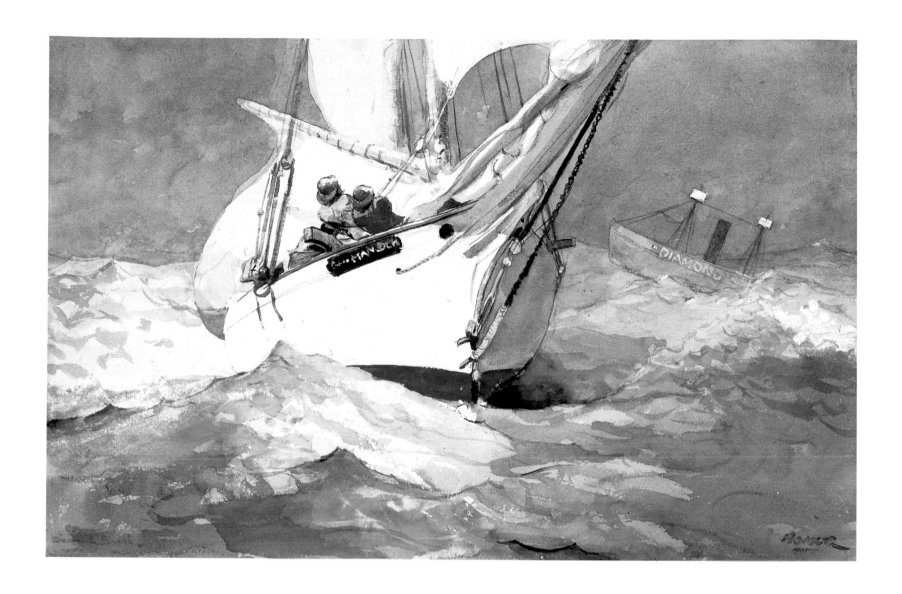

225. ***Diamond Shoal,*** 1905
watercolor on paper, 35.2 x 55.3 (13⅞ x 21¼)
Private Collection, Courtesy of The Caldwell
Gallery, Manlius, New York
Provenance: (M. Knoedler & Co., New York); Mr. and
Mrs. William Harris Arnold, Nutley, New Jersey,
1908; Mr. Weld Arnold, by 1944; (M. Knoedler &
Co., New York); (Grand Central Art Galleries, New
York, 1945); IBM Corporation, Armonk, New York,
1945; (Sotheby's, New York, 25 May 1995, no. 18).
Washington and Boston only

226–228

When Homer felt he had painted a good picture he did not hesitate to say so, especially during the last two decades of his career. That was true with these three paintings, all created during the fall of 1900, and his only oils of that year. *On a Lee Shore* was, according to Homer, "a *very excellent painting*," and he called *Eastern Point, Prout's Neck* and *West Point, Prout's Neck* "wonderful" and "remarkable."[1] For the first time since 1895–1896 (see cats. 193–195) he had again taken up the subject of the Prout's Neck coast.[2] Although he would paint a few more seascapes before his death (see cat. 229), these three great oils in a very real sense stand as his culminating thoughts on the theme.

By 1900 Homer was only painting oils sporadically and, in spite of the pleas he regularly heard from Knoedler's in New York for new pictures to sell, only when he felt like it. "Every condition must be favorable," he wrote to a friend in August 1900, "or I do not work and will not. For the last two months I have not painted—too many people about this place. They all leave here by the middle of September, then I shall work for the balance of the winter."[3] Once the summer residents were gone from Prout's Neck Homer would have the peace and quiet he needed to paint, but he also would need to think of new subjects for pictures. He apparently had plenty of ideas. As he wrote to O'Brien in Chicago in September, after being asked to suggest a subject he might paint for a potential client: "I do not care to put out any ideas for pictures. They are too valuable, and can be appropriated by any art student, defrauding me out of a possible picture. I will risk this one, and I assure you that I have some fine subjects to paint."[4] With his letter Homer included a sketch of a sailing vessel turning sharply to avoid an ocean liner looming out of the fog.[5] Homer had several possible titles for this composition: "On the Grand Banks," "Hard-a-Port," and, simply "Fog." As far as we know, he never worked up this idea as a finished painting, but something of its spirit may have played a role in inspiring *On a Lee Shore*.

On a Lee Shore shows a schooner sailing in rough weather past a rocky shore very much like that seen in *Northeaster* and *Maine Coast* (cats. 194–195). The title indicates that this is a "lee shore," or one toward which the wind is blowing. A "lee" is a safe place sheltered from the wind, but a "lee shore" presents serious danger. The drama Homer set in motion is, on its face, simple and straightforward: the schooner must tack across the wind both to make its way forward and to stay clear of the waves and rocks of the shore, where it would be pounded to bits. Downes recognized the potency of the painting, which he considered perhaps the greatest of all the seascapes:

There are no figures. No words are capable of doing justice to the majestic sense of elemental power, the irresistible onrush, the splendor of untamable forces, that make this marine piece one of the most unforgettable and impressive visions of the sea ever placed upon canvas. It is a page of transcendent beauty and overwhelming might. In it abides the high and solemn poetry of the vasty deep. The composition is singularly strong and novel. The commotion and turmoil of the surf in the foreground is a shade beyond anything in the history of marine painting, and a touch of human interest is added by the little schooner in the offing which is making a brave fight to keep away from the dangerous coast. The passion for truth which had been the main guiding principle of the artist's whole life found here its greatest culmination and its most perfect form of expression.[6]

Goodrich, too, was struck by the painting: "With less obvious violence than earlier marines, the enshrouding fog and the long rhythm of breakers give a penetrating sense of peril and vast loneliness of the ocean."[7] He also noted the sheer aesthetic appeal of the canvas, with its "austere harmony of cool grays," its "sensuous power governed by severe selectivity," and concluded that "its decorative values, linear rhythm and balance of masses make it one of his most satisfying compositions." As in *Cannon Rock* of five years before (cat. 193), Homer had fully exploited the possibilities of a square format combined with the use of bold and vigorous brushwork, creating a convincing image of physical reality that hovers on the brink of dissolving before the viewer's eyes into pure abstraction.

The companion pictures *Eastern Point* and *West Point* depict spots at the opposite ends of the rocks at Prout's Neck, and thus literally bracket this small portion of the world that Homer had come to know so well. They also suggest an opposition of nature's moods, with the stormy weather and cooler colors of *Eastern Point* played off against the calmer water but hotter colors of *West Point*. Homer knew that the two worked well together and felt, as he said to Thomas B. Clarke, they would "make an impression."[8] However, he also felt they would hang well with another work between them, and proposed that they be shown with *Cannon Rock* at the Union League Club in January 1901 (see fig. 225). "A most unexpected & unusual occurrence"—the sale of *Cannon Rock* to a Chicago collector late in 1900 prevented this arrangement, but Homer proposed substituting *Northeaster*, which, he told Clarke, he had "made much finer."[9] His alterations to the latter picture (about which, see the entry for cat. 194)

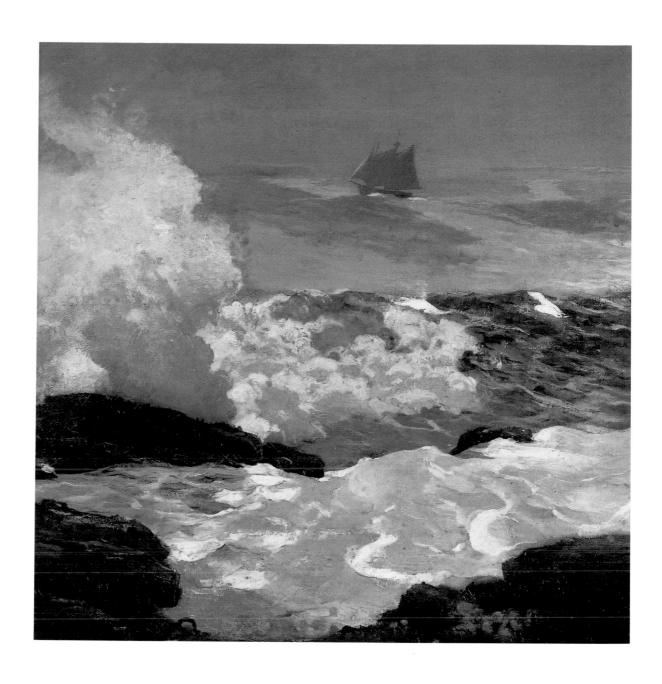

226. **On a Lee Shore,** 1900
oil on canvas, 99.1 x 99.1 (39 x 39)
Museum of Art, Rhode Island School of Design, Jesse
Metcalf Fund
Provenance: (O'Brien & Son, Chicago, October–
November 1900); Frank W. Gunsaulus, by 1900; (M.
Knoedler & Co., New York, May–December 1901).

actually made it more like *On a Lee Shore* both
compositionally and stylistically, and thus served
to update it and make it more compatible with
the two new pictures. The three seascapes, two
new and the other newly reworked, went on view
at the Union League Club in January 1901. At
least one critic saw the three paintings as a nar-
rative series:

At one end of the gallery, hung side by side, are three
large marines by Winslow Homer that are quite the
next thing to a brisk tramp along the shore on a
stormy day. First the storm is at its height, dashing
with increasing fury upon the rock foreground, then
it abates somewhat and the eye penetrates the mist
and spume only to discover other incoming waves,
and finally, in the third canvas, the storm has passed
off and the day is ending in a glow of clouded sunset
reflected by the not yet quieted sea.[10]

The critic for the *Tribune* noted that Homer's
paintings stood out dramatically among the
other pictures at the Union League Club:

Grouped at one end of the gallery, they somehow throw
into shade those twenty-one other pictures by Ameri-
can artists which go to make up the collection. If they
do this it is not because they are necessarily and in
every respect superior to their fellows. Indeed, these
would be better pictures if they possessed some of the
sensuous beauty which Mr. Charles Melville Dewey
has put into his "Sunset," a landscape poorly modelled
as to its foreground, but rejoicing in a splendid sky. We
would not be sorry, either, if Mr. Homer's impressions
of the sea were tinged by the haunting tenderness
which may be discerned in the beautiful "Marine" by
Alexander Harrison, in which the artist seems for the
nonce to have abandoned his later rather crude tones,
and to have returned to the delicate harmonies which

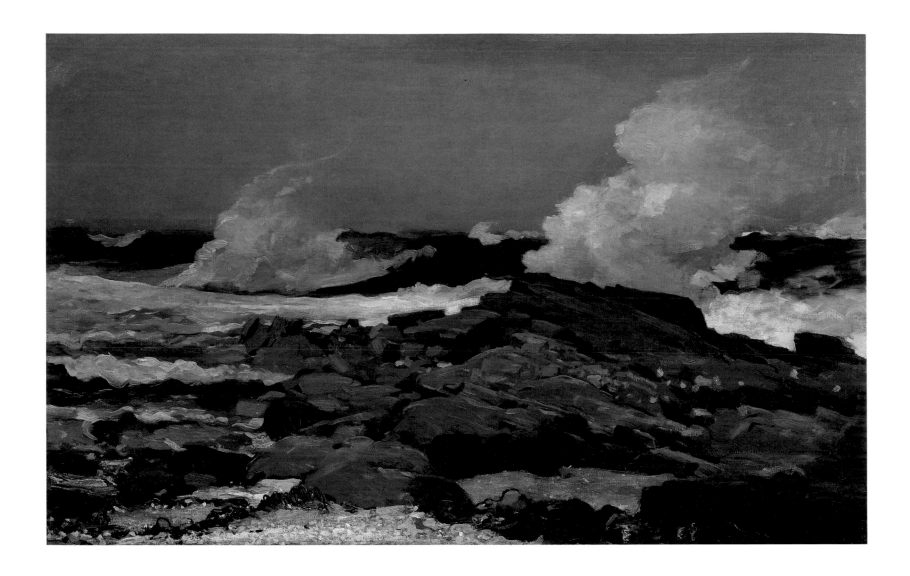

227. *Eastern Point, Prout's Neck,* 1900
oil on canvas, 77.5 x 123.2 (30½ x 48½)
Sterling and Francine Clark Art Institute, Williams-
town, Massachusetts
Provenance: (M. Knoedler & Co., New York, 9 January
1903); Lyman G. Bloomingdale, New York, March
1903; (M. Knoedler & Co., New York, December 1923);
Robert Sterling Clark, December 1923; (Macbeth
Gallery, New York); Thomas Cochrane; Addison
Gallery of American Art, Phillips Academy, Andover,
Massachusetts, 1929; (M. Knoedler & Co., New York,
August 1954); Robert Sterling Clark, 6 November
1954.

fig. 225. Drawing in a letter to Thomas B. Clarke from
Winslow Homer, 11 December 1900. Archives of American
Art

first brought him celebrity. But what Mr. Homer lacks
has been sufficiently indicated.

The source of his pre-eminence is, in the first
place, the directness of his vision. He shows us the
elemental beauty of the sea, and shows it with undiluted
realistic force."

After an extended complimentary discussion of
Northeaster, which this critic considered the best
of the three paintings, he continued:

His style is straightforward and powerful, perhaps
slightly audacious. The clear air of his theme enters
into his workmanship. It is sometimes too potent. As
has been suggested above, it blows out of his composi-
tion some of the finer qualities which we wish might
remain. But even though the blood red horizon in
"West Point, Prout's Neck, Maine," strikes an aggres-
sively raw note; even though all three pictures have a
turbulence and unmeasured vigor in the brushwork
which could be modified without doing any violence
to the spirit of the painter's theme, there is left a strong
original quality, which keeps the work where we first
find it, in the van[guard].

Interestingly, this critic noted, although in a
somewhat negative way, some of the characteris-
tics that modern eyes find so appealing in these
seascapes. Homer certainly meant to "blow out
of his compositions some of the finer qualities"
that typified other seascapes, and he also meant
for the "unmeasured vigor" of his brushwork,

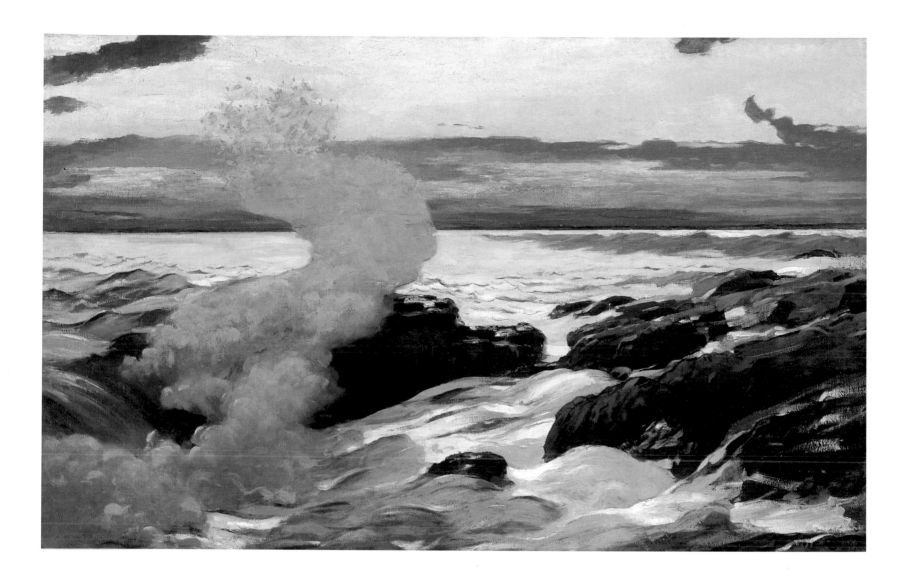

228. *West Point, Prout's Neck*, 1900
oil on canvas, 76.4 x 122.2 (30 1/16 x 48 1/8)
Sterling and Francine Clark Art Institute, Williams-
town, Massachusetts
Provenance: (M. Knoedler & Co., New York, 10–31
January 1901); Hugh H. Harrison, New York, 31 Jan-
uary 1901; George W. Young, New Rochelle, New
York; (I. A. Rose, New York); George G. Heye, c. 1902;
(Mr. Gatterdam); (Babcock Galleries, New York,
1941); (M. Knoedler & Co., New York, 7 November
1941); Robert Sterling Clark, 1 December 1941.

fig. 226. *Sunset, Saco Bay*, 1896. Oil on board. Collection of IBM Corporation, Armonk, New York

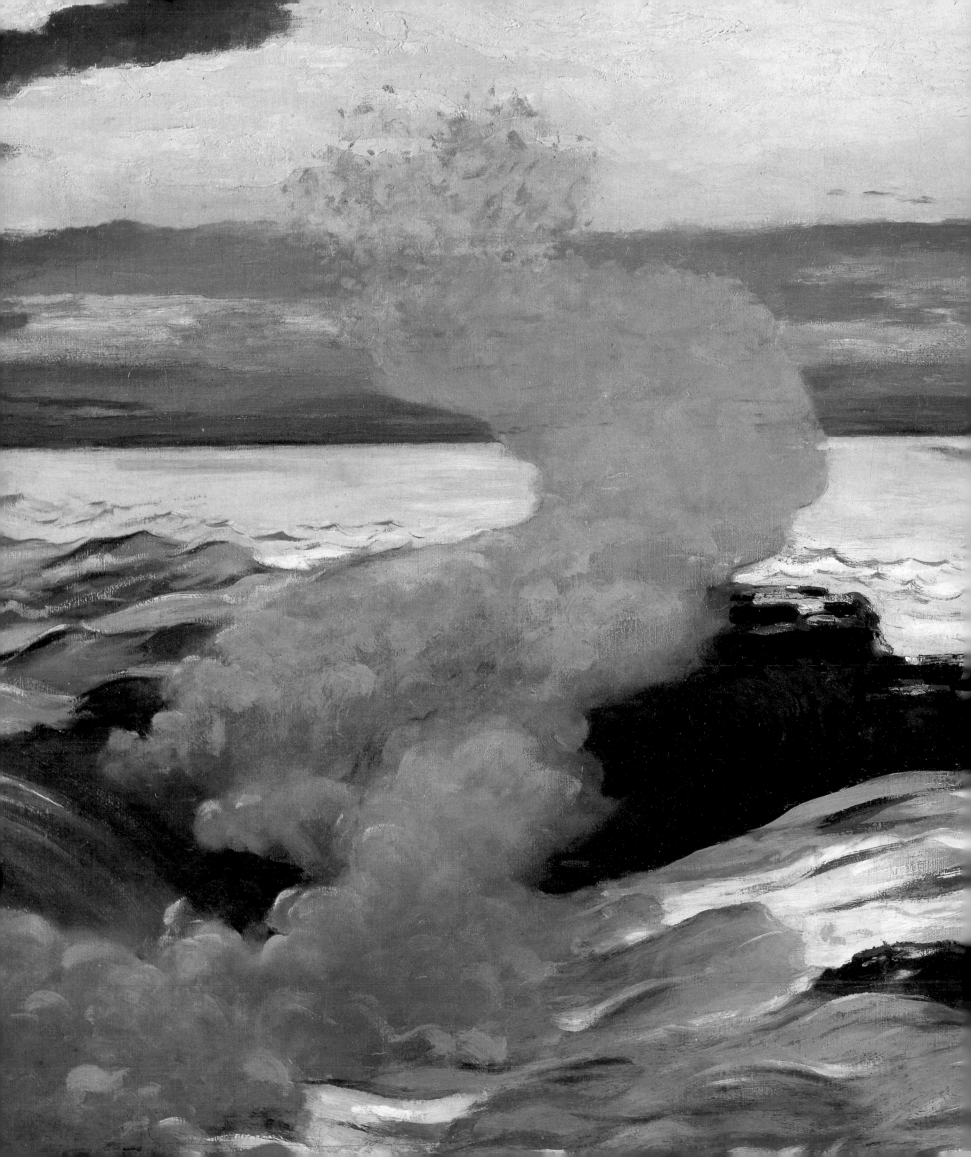

which, in fact, could *not* "be modified without doing any violence to the spirit of the painter's themes," to assist in that expulsion.

West Point and *Eastern Point* were shown at the Society of American Artists exhibition in New York in the spring of 1901, although this time with *On a Lee Shore*. Many painters, some no doubt directly inspired by Homer's example, showed marines:

If last year's exhibition shone in portraits, that of 1901 leads in marines and landscapes with marine attachments. Every tenth picture is more or less a marine.... Leading in this branch is Mr. Winslow Homer, whose "Eastern Point" and "West Point, Prout's Neck," come from his happy hunting grounds on the rocky coast of Maine. The former is a strong, uncompromising piece of realism describing the effect of pounding waves on a day of dull skies; the latter has more incident by reason of the blood-red glow in the sky beyond the racing tide...."On a Lee Shore" concedes the presence of a wrecked [sic] brig as an additional note in carrying out the action of the elements.[12]

The critic for the *New York Sun*, although generally admiring of the three pictures, was troubled by the sky of *West Point*, finding it "spectacular, a deviation from the fundamental enduring truth to an occasional phenomenon."[13] In fact, *West Point* was singled out by more than a few observers for criticism. The most damning notice appeared in *The Brooklyn Daily Eagle*:

By a more general consent, that distinction [i.e., the worst picture in the exhibition] has been earned by Winslow Homer—of all men. He has one good marine with stormy waves dashing against rocks, but its companion, a buff colored sea with an inch of scarlet sunset between it and a buff sky, and some rocks pounded by spray that throws itself at one point into a stiff column, is hard in its lines, without air, disagreeable and cheap in color and altogether mournful.[14]

This assessment runs completely counter to the high place the picture holds in Homer's *oeuvre* today, and the artist himself must have been none too pleased with such criticism. In fact, we know that Homer was especially proud of *West Point, Prout's Neck*. As he wrote to Knoedler in early January 1901: "I send you today a picture that is no ordinary affair. You will kindly notice that I am very particular about it."[15] He also wrote to Clarke: "I consider it the best I have painted... The western light I get from the point of Prout's Neck overlooking the bay and Old Orchard. You will see Old Orchard on the right hand of the picture."[16] Homer set a higher price for *West Point* ($2,400) than he did for *Eastern Point* ($2,000), and told Knoedler: "There is only one picture of the lot that I am particular about—that is the sunset one."[17] And, even though he customarily

bridled at being asked to provide descriptions of his pictures to potential buyers, he actually responded to Knoedler's request for "a few descriptive lines from you concerning the picture."[18] Homer wrote:

I suppose that this wish is prompted by the peculiarity of the light. The picture is painted *fifteen minutes* after sunset—not one minute before—as up to that minute the clouds over the sun would have their edges lighted with a brilliant glow of color—but now (in this picture) the sun has got beyond their immediate range & *they are in shadow*. The light is from the sky in this picture. You can see that it took many days of careful observation to get this, (with a high sea & tide just right).[19]

Homer kept an old shack near Ferry Beach, in the vicinity of West Point, and painted there occasionally. According to one of his Prout's Neck acquaintances, he would often walk home from there backwards, so that he could watch the setting sun over Saco Bay.[20] At times he would make studies in pencil and he was also reported to make quick oil sketches on board, such as *Sunset, Saco Bay* (fig. 226), which has traditionally been associated with the finished oil *Saco Bay* (1896, Sterling and Francine Clark Art Institute). This sketch, however, is similar enough to *West Point, Prout's Neck*, especially in its pattern of dark clouds silhouetted against the bright reds of the sky, to suggest that it was a preliminary study. On the other hand, a drawing on shirt-box cardboard showing small figures watching large waves breaking on the shore (fig. 227), which has been considered a study for *West Point*, seems perhaps too removed in location (the ocean coast of Prout's Neck rather than the Saco Bay side) and in spirit (towering waves and column of spray rather than the human-sized plume) to suit that designation.

In many respects, *West Point, Prout's Neck* remains unique among Homer's seascapes. Scaled to a more personal level, with relatively small rocks and spray that seems only to rise a few feet rather than tower high above the viewer, it has been seen as an abstracted vision, "a metaphor for mortality set against the spectacular rhythms of nature."[21] Its wave has been read as an anthropomorphic stand-in for humanity, a literal reworking of the figure of a statuesque woman seen in *A Light on the Sea*, creating what Jules Prown has called "a complex conflation of women, water, sexuality, and salvation...."[22] That *West Point, Prout's Neck* can easily bear the weight of such associations is testimony not only to its status as summation, but also of its forward-looking qualities. In it we see not just "the same old story" (as Homer said of *Maine Coast*, cat. 195), but also the first clear signs of a new language of form and abstract design that Homer would use

in his late masterpieces such as *Kissing the Moon*, *Cape Trinity*, and *Right and Left* (cats. 233–235).

NOTES

1. Letter to M. O'Brien & Son, Chicago, 19 October 1900; letter to Knoedler, 12 November 1900; letter to Knoedler, 3 December 1900 (M. Knoedler & Co., and typescripts, NGA).

2. In *A Light on the Sea* of 1897 (Corcoran Gallery of Art, Washington), the sea serves primarily as a backdrop for the large figure of a woman.

3. Letter to George G. Briggs (quoted in Goodrich 1944a, 163).

4. Quoted in Goodrich 1944a, 163.

5. The sketch was probably like the one called *Hard-a-Port*, c. 1890–1900, Cooper-Hewitt Museum, New York; see Cikovsky 1990c, 115–116.

6. Downes 1911, 209–210.

7. Goodrich 1944a, 164.

8. Letter of 11 December 1900 (Archives of American Art).

9. Both quotations are from Homer's letter to Clarke of 31 December 1900 (Archives of American Art).

10. "Pictures at the Union League Club," *New York Evening Post*, 11 January 1901.

11. "Art Exhibitions. American Paintings at the Union League Club," *New York Tribune*, 12 January 1901.

12. "The Society of Artists," *New York Times*, 31 March 1901.

13. "Society of American Artists," *New York Sun*, 3 April 1901.

14. "Fine Arts: Society of American Artists," 31 March 1901; Lynn Russell kindly provided the text of this review.

15. 4 January 1901 (M. Knoedler & Co.).

16. 4 January 1901 (Archives of American Art). Homer included in this letter a small sketch of the picture with him standing before it, palette and brushes in his left hand and right hand raised; a line drawn from his right hand to the horizon of the picture apparently was meant to identify location of Old Orchard Beach, one of the longest sand beaches on the Atlantic coast and a popular resort.

17. The prices are given in his letter to Knoedler of 8 January 1901; the second quote is from 14 January 1901 (M. Knoedler & Co.).

18. Knoedler to Homer, 13 April 1901 (M. Knoedler & Co.).

19. 16 April 1901 (quoted in Goodrich 1944a, 165).

20. Beam 1966, 121; Beam et al. 1990, 136.

21. Carol Troyen, entry on *West Point, Prout's Neck*, in *A New World: Masterpieces of American Painting, 1760–1910* [exh. cat., Museum of Fine Arts] (Boston, 1983), 339.

22. Prown 1987, 44.

229

During the fall of 1900, when Homer was working on *On a Lee Shore*, *Eastern Point, Prout's Neck*, and *West Point, Prout's Neck* (cats. 226–228), he also began another, larger seascape. On the stretcher of that painting, *Early Morning After a Storm at Sea*, which he would not complete until 1902, Homer wrote: "First Painting September 26 1900. From a Study of 1883 shown at Doll & Richards."[1] The study was a watercolor now called *Prout's Neck, Breakers* (fig. 228), which was painted during the first year of Homer's residence in Maine.[2] Although he apparently did little work on the canvas during the fall, in late December he wrote to his Chicago dealer O'Brien that he would send it to them once it was finished. "I will look upon it in future as your particular picture," he wrote, adding: "I do not think I can finish it before I have a crack at it out of doors in the spring. I do not like to rely on my study that I have used up to date."[3]

Over the course of the next two years Homer would regularly write to O'Brien with news of his progress—or, more often, the lack thereof—

on the painting, which he took to calling the "O'B." Little seems to have happened during 1901, but in March 1902 he wrote:

…the O'B. is not finished. It will please you to know that, after waiting a full year, looking out every day for it (when I have been here), on the 24 of Feb'y, my birthday, I got the light and the sea that I wanted; but as it was very cold I had to paint out of my window, and I was a little too far away,—and although making a beautiful thing—[Homer here made a drawing of a trumpet with the words "own trumpet"]—it is not good enough yet, and I must have another painting from nature on it.[4]

On the 30th of March he announced: "I will say that I think it is quite possible that the O'B. will be the last thing of importance that I shall paint."[5] Frustrated by O'Brien's failure to sell *High Cliff, Coast of Maine* (cat. 191), Homer asked in the fall of 1902, "Why do you not sell that…I cannot do better than that. Why should I paint?"[6] Then, at the end of October, he wrote:

…make room for "the O'Brien picture." This one will be quite enough to show, and the people who are in the clean-up of October corn may be able to buy

229. ***Early Morning After a Storm at Sea***, 1902
oil on canvas, 76.8 x 127 (30¼ x 50)
The Cleveland Museum of Art, Gift of J. H. Wade
Provenance: (M. Knoedler & Co., New York); W. H. Fox. W. K. Bixby, St. Louis, 1917; Cornelius Vanderbilt Barton, New York; (Frank Rehn, New York, 1924); J. H. Wade.

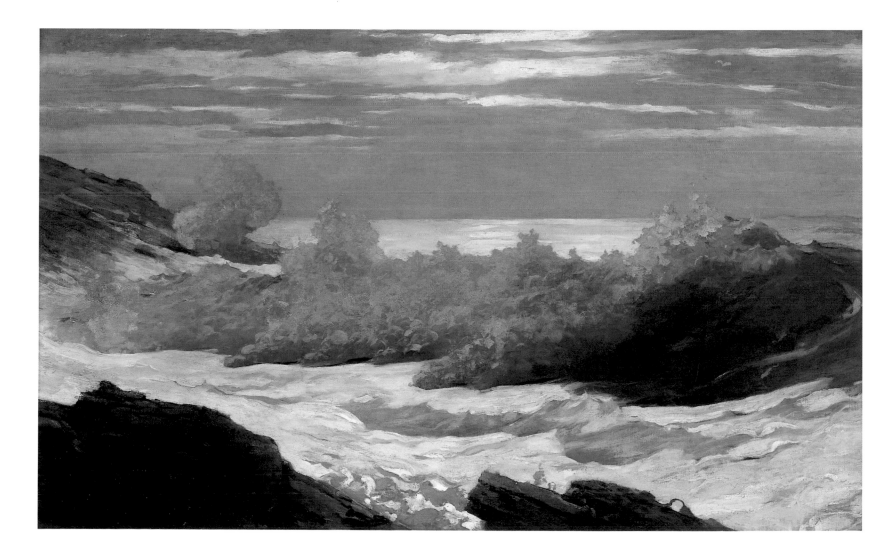

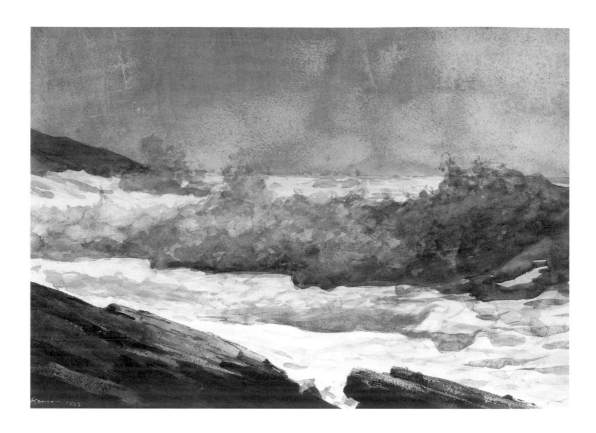

it, but no others, as the price will be too high. This is the only picture that I have been interested in for the past year, and as I have kept you informed about it, and promised to you to manage, I will now say that the long-looked-for day arrived, and from 6 to 8 o'clock A.M. I painted from nature on this "O'B.," finishing it,—making the fourth painting on this canvas of two hours each.

This is the best picture of the sea that I have painted.

The price you will charge is five thousand dollars—$5000. The price net to me will be $4000.

This may be the last as well as the best picture.

I have rents enough to keep me out of the poor-house.[7]

Finally, in November, Homer made arrangements to ship the picture to Chicago, admitting that he was "glad to get it out of my sight before I finish it too highly and spoil it. I hope the original member of your firm is still alive, after all these tedious years of waiting, and that he will be on hand to greet the O'B."[8]

Homer also told Knoedler's in New York about the painting: "I desire to inform you that I have painted a very beautiful picture—it will go to Chicago next week to M. O'Brien & Sons—I shall try & get an invitation to the Union League Am Ex in January & I will have it sent there without fail."[9] The painting was well received in Chicago, but Homer was eager to have it seen in New York. As he wrote to Knoedler:

I did not care to take it out of his [O'Brien's] hands so soon—as he had waited a year & a half for it—& I am willing to pay two commissions as the price that I have fixed is ample for all hands all I care for is to have it shown to the public before it is stolen by Art Students.[10]

Homer also decided the picture needed more work and asked that it be sent to him at Prout's Neck. "I wish to paint on it *about two hours*," he told Knoedler; "M. O'B. was in a great hurry for this & I sent it off *too soon*."[11] The picture was back in New York in late January and Knoedler showed it to the trustees of the Corcoran Gallery of Art, "who seem to want a picture of yours, but for some reason it did not strike their fancy."[12] A "New York collector" offered $3,000 for *Early Morning After a Storm at Sea*, but Homer refused, stating bluntly: "If there is only one man interested in that work I think I will wait until the U.S. of America can produce *two men* each of which will know a good thing when he sees it."[13]

Unfortunately, Homer's hope that someone "would know a good thing when he sees it" was not realized when the painting was shown at the Society of American Artists in New York in the spring of 1903. Although *Cannon Rock*, which was also on view, was extravagantly praised by the reviewer for the *New York Times*, the newer picture did not fare so well:

In the Central Gallery—the most unfortunate place to hang it, by the way—is another marine by Homer,

called "Early Morning," which grievously lacks the virtues of "Cannon Rock." The foam is not foam, but vegetation of some strange, uncanny shape and color. Here was a picture to humor by hanging it high in the Vanderbilt Gallery, in order to give it the benefit of distance, or at one end of the South—more's the pity! It would have been kinder to reject it than to place it where it looks so ill.[14]

A Brooklyn writer criticized the picture even more cruelly: "His 'Early Morning' represents a heaving sea of chalk and pink, with waves topped by bunches of wool, and the distant stretches of his ocean are illuminated with milk."[15]

Homer was apparently deeply hurt by this criticism. As he wrote to John Beatty at the Carnegie in Pittsburgh: "the last picture I painted only met with abuse & no one understood it...."[16] *Early Morning* is, in fact, greatly different in composition and style than earlier marines such as *Northeaster, Maine Coast,* and *Cannon Rock,* works that had become so well known by 1902 that they were virtually synonymous with Homer's name. Its more laterally expansive composition, mottled color effects, and frothy foam seem closest to Homer's contemporaneous watercolors such as *Fishing the Rapids, Saguenay River* (cat. 207), although its strongly decorative qualities also recall *West Point, Prout's Neck* (cat. 228), which was also criticized.

Beatty went to visit Homer in Maine in September 1903 and the two discussed *Early Morning After a Sunrise at Sea.* According to notes kept by Beatty, and quoted by Goodrich, Homer observed:

You go in to Knoedler's and look at that picture. Why, I could in an hour bring that picture within the comprehension of the people. By making it a little lighter. Simple white would do it. By rubbing in white and then rubbing it off. Why, I hang my pictures on the upper balcony of the studio, and go down by the sea seventy-five feet away, and look at them. I can see the least little thing that is out. I can then correct it. They hung it in a little room at the Academy. Why, of course it would look brutal there. Besides that, the people never see that early morning effect. They don't get up early enough.[17]

Homer, however, decided to repaint the picture, for he wrote to Knoedler in early September 1903 requesting that it be sent to him so that he could "overlook" it.[18] He explained what he had done when he returned it to them a week later: "I have lightened the scale of color to bring it within range of the public. Its the same thing. Easy to be understood."[19] He then sent it to Beatty at the Carnegie for exhibition, telling him that he had "been *at work* [on it] for two days. I have lightened the scale of color. I know that it will now be understood & if it can be hung in the long gallery on the second line at the distance across the gallery it will be admired."[20]

Early Morning apparently was better received in Pittsburgh than it had been in New York, but it did not sell. Finally, in the fall of 1904, when the picture was on view at the Louisiana Purchase Exposition in St. Louis, it sold to a collector for $2,700.[21]

NOTES

1. Quoted in Goodrich 1944a, 174.

2. No work of that title was listed in the catalogue of the Doll & Richards exhibition; the most likely candidate was no. 32, *Sunrise.*

3. 20 December 1900 (quoted in Downes 1911, 210).

4. 15 March 1902 (quoted in Downes 1911, 215).

5. Letter to O'Brien, 30 March 1902 (quoted in Downes 1911, 215).

6. 27 September 1902 (quoted in Downes 1911, 217).

7. 29 October 1902 (quoted in Downes 1911, 217).

8. 14 November 1902 (quoted in Downes 1911, 219).

9. Letter to Knoedler, 9 November 1902 (M. Knoedler & Co.).

10. 4 January 1903 (M. Knoedler & Co.).

11. 13 January 1903 (M. Knoedler & Co.).

12. Knoedler to Homer, 26 January 1903 (M. Knoedler & Co.).

13. Homer to Knoedler, 2 February 1903 (typescript, NGA).

14. "The American Artists," *New York Times,* 29 March 1903.

15. From a review in *The Brooklyn Daily Eagle;* quoted in Goodrich 1944a, 177.

16. Undated, but received by Beatty 15 June 1903 (typescript, NGA). Also quoted in Goodrich 1944a, 177.

17. Goodrich 1944a, 177.

18. 5 September 1903 (M. Knoedler & Co.).

19. 14 September 1903 (M. Knoedler & Co.).

20. Quoted in Goodrich 1944a, 178.

21. Knoedler's letter to Homer of 9 November 1904 reports the offer of $2,700; Homer's letter to Knoedler of 23 March 1905 notes that he is due $2,300, the amount he was owed after their commission was deducted (M. Knoedler & Co.).

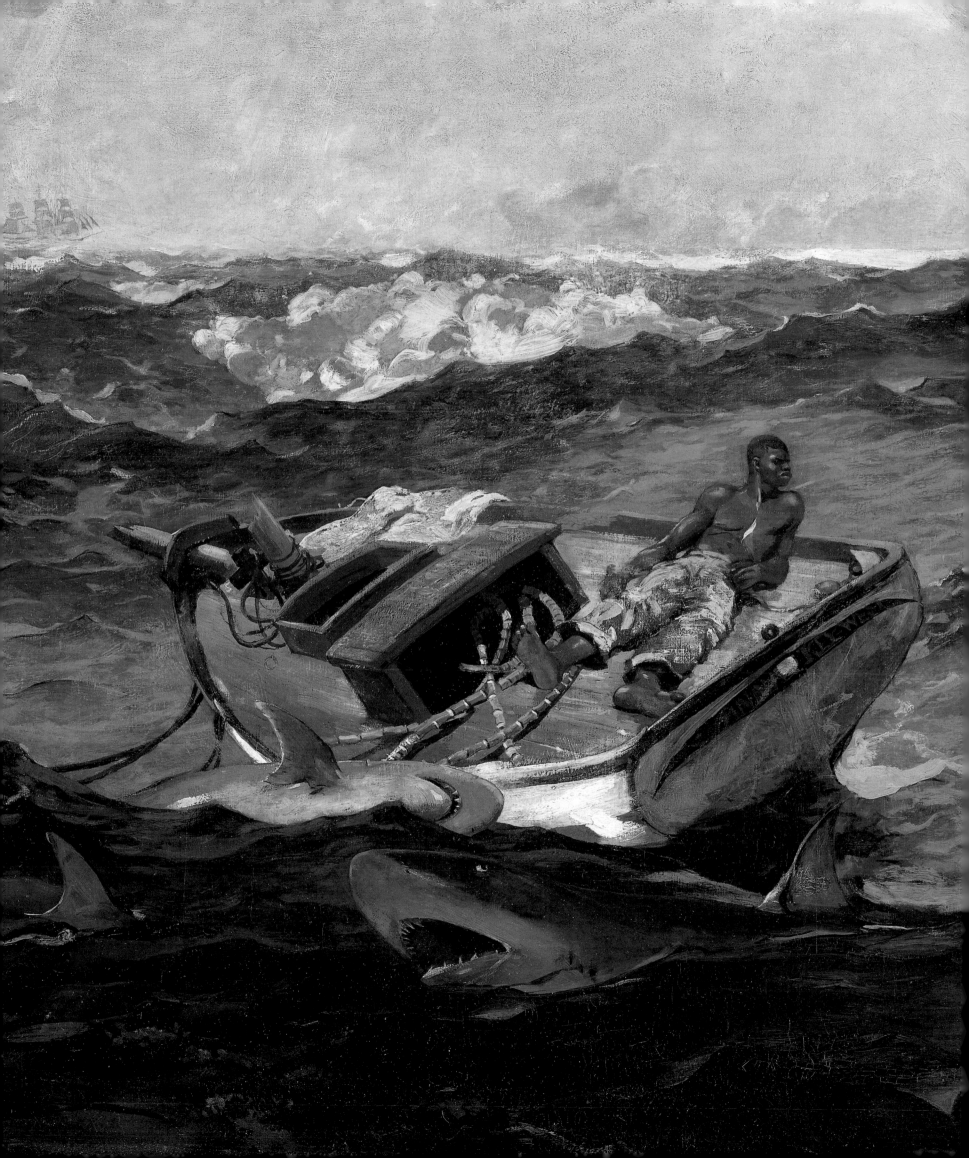

Good Pictures

Nicolai Cikovsky, Jr.

After about 1900 inspiration came less frequently to Homer. That he reworked older paintings almost as much as he painted new ones, and that the new ones were often revisitations of earlier subjects rather than new and direct experiences of life or nature, suggests diminished powers of invention and the less frequent occurrence of fruitful pictorial ideas. But as he wrote his patron and dealer Thomas B. Clarke in 1901, "Do not think that *I have stopped painting*," for, he added, "At any moment I am liable to paint a good picture—."[1] He was absolutely right. The chief subject pictures of the last decade of his life—*The Gulf Stream, Searchlight, Kissing the Moon, Cape Trinity*, and *Right and Left*—include some of the greatest, most complex, most stirring, most moving, and most ambitious paintings he ever made. They were, however, singular events, unconnected by the shared experiences and thematic seriality that had united many of his earlier paintings. Instead, they were created, as he implied to Clarke, in moments of unanticipated inspiration to which he was—almost epiphanically—"liable" in his later years.

His late subject pictures, beginning with *The Gulf Stream* of 1899 (cat. 231), tended also to be summary and synoptic. For as great artists often do in their last works—as did Titian, Rembrandt, Cézanne—Homer's works take up again, not out of wistfulness or nostalgia, but with an understanding of a lifetime's experiences, deepened by adversity and intimations of mortality, laced with memories and (re)arranged by reflection, and in a language of form grown intolerant of pictorial waste and expressive digression, those subjects that were closest and meant most to him—*his* Entombments, Suppers at Emmaus, and Mont Saint-Victoires.

Homer painted *The Gulf Stream* when he was sixty-three years old, in the year following the death of his father, his one surviving parent, and in the last year of the century—a confluence of circumstances, despite Homer's advanced age, that might all too easily have caused him to feel, as never before, alone, abandoned, and mortally vulnerable.

Homer visited Nassau and Florida from December 1898 to February 1899. That visit, with the passage through the Gulf Stream that it required, probably triggered the painting. But it was not its source—only its stimulus. Emotionally and artistically, *The Gulf Stream* was rooted far more deeply within Homer himself and in his past.

fig. 229. *The Derelict*, 1885. Watercolor over pencil. The Brooklyn Museum, 78.151.4, Bequest of Helen B. Sanders

Its most salient thematic part, the dismasted derelict boat, made its first dated appearance in an 1885 watercolor, painted on Homer's first visit to the Caribbean (fig. 229, though an undated pencil sketch, fig. 230, is probably the first notation of what Homer actually observed).[2] But *The Gulf Stream* reached still further into Homer's past, possibly as deep as one of his first Gloucester watercolors of 1873 and earliest conjugations of life and death. In *A Basket of Clams* (cat. 60), death suddenly intrudes into youthful innocence as two boys, reacting with a mixture of revulsion and fascination, come upon a dead shark washed up on the beach. That the shark (in virtually the same "pose") and a listing boat recur a quarter of a century later, recombined as principal parts of *The Gulf Stream*, suggests that a strong and more than merely thematic or motival thread connects them.

fig. 230. *Study for "Gulf Stream."* Pencil. Collection of Lois Homer Graham

It is impossible not to notice *The Gulf Stream*'s close resemblance to a succession of figures in beleaguered boats in still earlier nineteenth-century paintings—to Delacroix's *Barque of Dante* of 1822 (fig. 231), for instance, or Turner's *Slave Ship* of 1840 (fig. 232), or Thomas Cole's *Voyage of Life*, the first version of which was also painted in 1840 (fig. 233). Others, such as Copley's *Watson and the Shark* and Géricault's *Raft of the Medusa*, can be added to this list.[3] But the association of *The Gulf Stream* to the first three is the soundest, visually, and because each of them can with considerable confidence be located within Homer's experience. For Turner's *Slave Ship*, Cole's *Voyage*

fig. 231. Eugène Delacroix. *Barque of Dante*, 1822. Oil on canvas. Musée du Louvre, Paris

fig. 232. Joseph Mallord William Turner. *Slave Ship*, 1840. Oil on canvas. Henry Lillie Pierce Fund, Courtesy Museum of Fine Arts, Boston

of Life, and one of Delacroix's studies for *The Barque of Dante* (titled *Dante and Virgil Crossing the Styx*) were all, at one time, in the collection of John Taylor Johnston in New York. One of the largest and finest American collections at the middle of the nineteenth century, it was regularly open to the public, and its sale in 1876 occasioned much attention. If Homer knew of the Johnston collection for these reasons, he knew of it also for a far more compelling one: his most famous painting, *Prisoners from the Front*, was in it.[4]

The Johnston sale, it is safe to say, was a memorable event in Homer's early artistic life. Whether it was memorable twenty years later, when he painted *The Gulf Stream*, is another matter. He did boast of his "excellent memory" in 1900, the year after painting *The Gulf Stream*.[5] But *The Gulf Stream* itself is the best evidence of the retentive clarity of his memory, and, too, of his return by its agency, whether as a willed act or unforced recollection, to distant but still potently influential experiences of art. For it is plain that *The Gulf Stream* derives every distinctive aspect of its pictorial configuration and the tone and pitch of its visual and particularly its expressive effect far more from remembered experiences of art than from actual experiences of reality. And there is no artistic cognate, none at least that one can be sure Homer knew of, that corresponds as closely and accounts as fully, in form and meaning, for the desperately writhing sharks in *The Gulf Stream* than do the figures of the damned souls in Delacroix's *Barque of Dante*, contorted in moral and physical agony; none that accounts as completely for the howling sea and shrieking sky of *The Gulf Stream* as Turner's lurid and tumultuous *Slave Ship*;[6] and none that accounts as well for—indeed, virtually names and describes—the subject of *The Gulf Stream* and its mode of pictorial utterance as Cole's allegorical *Voyage of Life*.

One of the reasons Homer's late subject pictures seem on the whole more problematic than his earlier ones had been, and so stubbornly to defy easy or conventional interpretation, is because it is never quite clear what *types* of pictures they are, and how, consequently, they should be understood. Are they narrative (as some of Homer's contemporaries believed, or wanted, *The Gulf Stream* to be) or allegorical? Public or private? Real or imaginary? Visual or visionary? The critic who said *Searchlight* (cat. 232) was "A curious sort of still life" expressed that uncertainty.[7] And what, exactly, is *Right and Left* (cat. 235)? Also a sort of still life? A sporting picture? Or, as it has recently been taken to be, a visionary one? The presence of Cole's *Voyage of Life* in the lineage of *The Gulf Stream*, therefore, is of particular interest because it may suggest at least one type of picture Homer intended it to be—an allegory, like Cole's series, of human life, in which (as particularly in its third part, *Manhood*, fig. 233) a rudderless derelict boat with its helpless passenger is borne to its fate by the turbulent flow of that "river in the ocean," as Lieutenant Matthew Maury called the Gulf Stream in his well-known book on oceanography.[8] *The Gulf Stream* in its way is the counterpart to Cole's river of life. Just as *Manhood*, painted when Cole himself was in exactly that time of life, is the most self-expressive part of *The Voyage of Life*—he was projecting his own deepest thoughts and feelings when he described its allegorical meaning by saying "trouble is characteristic of manhood," that

fig. 233. Thomas Cole. *Voyage of Life: Manhood*, 1842. Oil on canvas. National Gallery of Art, Washington, Ailsa Mellon Bruce Fund

fig. 234. *The Fountains at Night, World's Columbian Exposition*, 1893. Oil on canvas. Bowdoin College Museum of Art, Brunswick, Maine, Bequest of Mrs. Charles Savage Homer, Jr.

the ocean which the Voyager approaches "figures the end of life," that the "demon forms [of] Suicide, Intemperance and Murder" in the clouds above him are "the temptations that beset men in their direst trouble,"[9] and that only faith saves him from the destruction that seems inevitable— *The Gulf Stream*, too, is intensely self-expressive. Though couched necessarily in a more congenial (and more modern) language of allusiveness and ambiguity, Homer's painting addresses the same pressing feelings of trouble and temptation, the approaching inevitability of life's end, and the necessity of faith that Cole expressed in the language of allegory.

Searchlight (or, in its full but more cumbersome form, *Searchlight on Harbor Entrance, Santiago de Cuba*) was, like *The Gulf Stream*, based upon a sketch Homer made on his first Caribbean trip in 1885 (fig. 250). And, like *The Gulf Stream*, *Searchlight* is about something else and something more. It depicts the recent American naval blockade of the Spanish fleet in Santiago harbor during the Spanish-American War of 1898, "stern facts," Homer said, "worth recording as a matter of history...."[10] But its reference to historical events and persons is entirely too allusive and elliptical, too almost symbolist—it "strikes once more the ambiguous note with which, upon occasion, this brilliant artist seems to be content," a critic said[11]—for it to be, Homer's claim notwithstanding, a record of fact. Its true subject—not what it depicted but what it was about—lay more wholly in the present than in the historical past. Painted, as many people reckoned it, in its first year, *Searchlight* was about an event of greater moment and more current meaning: the advent of the new century.

The searchlights piercing the night sky were, to be sure, a "stern fact" of the war, used (for the first time in the history of naval warfare) by the blockading American naval squadron to prevent the Spanish fleet from escaping by night. But their function in Homer's painting is more symbolic than factual. The searchlight represents modern enlightenment illuminating and dispelling the darkness of the past. (Morro Castle, in the painting's foreground, in which Cuban political prisoners had been held by the Spanish, was described as "a cesspool of iniquity [and] the last stronghold of medievalism on American soil.")[12] And the modern brilliance of the searchlight, outshining the moon, famously the symbol of romantic sentimentality, outstrips and discredits nature by a technological artifice of culture ("the force of [the searchlight's] actuality [is] contrasted with the tender mystery of the moonlit sky," as one critic put it).[13]

Electricity itself was the clearest signifier of the new century. In the international expositions of the turn of the century by which the modern civilization boasted of its accomplishments, electricity was the most celebrated of them. The World's Columbian Exposition in Chicago in 1893 was "all an electrical exhibit" at which "magnificent search-lights...sweep the horizon with shafts of flame," and it was electrical illumination that converted Frederick MacMonnies' fountain into "leaping rainbows"[14] depicted in Homer's *Fountains at Night, World's Columbian Exposition* (fig. 234). Having had no direct experience of the war, that was the experience, surely, upon which he drew eight

fig. 235. Giacomo Balla. *Street Light*, 1909. Oil on canvas. The Museum of Modern Art, New York, Hillman Periodicals Fund

years later to paint *Searchlight*. A *fête électricité* was a major feature at the 1900 Paris exposition—at the end of which Henry Adams wrote John Hay, "It's a new century, and…electricity is its God." [5]

In *Searchlight* Homer painted one of the most perceptive and compelling, and one of the earliest, images of the new century. It was by a number of years the forerunner in American and even in European art of an iconography of modernism that took as its symbols such technological achievements as electricity, automobiles, airplanes, ocean liners, and factories; Homer's modernist lampoon of moonlight, for example, preceded Giacomo Balla's futurist *Street Light* (fig. 235) by eight years.[16] When *Searchlight* was shown in 1902, critics sensed its originality: "A departure from all recognized manner, both of theme and handling," said one.[17] But they acknowledged it most by their bafflement—the frustrated understanding that resounded as a litany in the critical response to advanced modernism—at the painting's stubbornly hermetic refusal to be customarily legible or familiar. "Some visitors may not *like* the picture," one critic said, while another, explaining why, noted its ambiguity of meaning, its lack of "pictorial charm," and the "baldness" of its design; altogether, "there is something which repels.…We cannot say that it is beautiful."[18] To this misreading of his purpose, Homer responded with terse impatience, "That Santiago de Cuba picture *is not intended to be 'Beautiful*,'" and, suggesting a criterion of value tougher and less purely aesthetic than his critics, expecting only charm and beauty, were able or equipped to grasp, he added simply, "*I find it interesting.*"[19]

In 1904 Homer painted two pictures as utterly different from each other as *Searchlight* had been from *The Gulf Stream*, and very different from both of them as well. When one of them, *Kissing the Moon* (cat. 233), was shown at the Pennsylvania Academy of the Fine Arts early in 1905, the critic Charles H. Caffin said Homer was "scarcely recognizable" in it.[20] But it should not have been quite so unrecognizably his. It shared with *Searchlight* an uningratiating austerity and refusal to concede "to the softer sensibilities,"[21] and it was, in the pattern of other of his major late paintings, a reprise or revisitation of an earlier subject, namely, the great fishing pictures of the 1880s such as *Fog Warning*, *Lost on the Grand Banks*, *The Herring Net*, and, the one that had become the most famous of them and which in certain ways it most resembles, *Eight Bells*. In *Kissing the Moon*, too, Homer struck once again the "ambiguous note" his late paintings were known for and that made it, despite what critics regarded as its distinct oddity of form, hauntingly unforgettable.[22]

Of all of Homer's late paintings, *Kissing the Moon* is without question the one in which pictorial form plays the largest part, and of all of them it is formally the most difficult. Caffin, complaining that "illusion has not been consummated," space "is not explained," and the figures "seem to be plastered" to the first wave, nevertheless put his finger precisely on those extreme compressions and elisions of space that made the painting so inexplicable and troubling but challengingly problematic. The spatial flattening Caffin described is made all the more pronounced by the radically unconventional framing and cropping of the image that recalls Homer's French contemporary Edgar Degas. But despite many congruences in practice and personality between Homer and Degas, Homer's use of this device stems more plausibly and immediately from a pictorial practice of his own, found, for instance, in the eccentric cropping and framing of *Eight Bells* of 1886 (cat. 144), and—what made it, as Homer himself said, so "unexpected and strange"—most conspicuously in *The Lookout—"All's Well"* of 1896 (fig. 178).[23]

Flattening, by forcing the painting's parts forward to lie upon or sometimes seemingly in front of its surface, has clear expressive consequences. Flattening forms to mere shapes drained of material substance reinforces the sense of a transcendent experience and metaphysical presence established by the magically hushed and pregnant stillness of the painting's mood. It is, perhaps, the expression of the mystical presence, the "strange power" that, as Homer wrote to his brother Charles in 1908, "has some overlook on me & [is] directing my life."[24]

Flattening and cropping also have the effect of causing one to feel, as Caffin noticed, "the sensation of being ourselves in the boat," not distantly observing but sharing with intimate intensity and immediacy the experience Homer depicted. Homer first considered this sensation and its effect about twenty years earlier in a large watercolor of 1883 called *The Ship's Boat* (fig. 153), in which four men, only their heads and hands visible along the crest of a large wave, cling to an overturned boat being swept by the stormy sea toward a rocky shore. That the beholder is meant to be a participant in that event is clear from its pictorial construction. But beneath a small sketch for the subject Homer inscribed, "From the retina of a drowned man," and that bizarre

and inescapably unsettling point of sight still adheres, less literally and more intuitively, maybe,
but with no less deeply troubling effect, to *Kissing the Moon.*

Cape Trinity, Saguenay River (cat. 234) was begun in 1904 but not finished until 1909. It origi-
nated on the first of Homer's fishing trips to Canada in 1895, and is, therefore, like his other late
paintings, characteristically retrospective.[25] He was attracted to Canada by the fishing, and to the
Saguenay particularly, by the landlocked salmon, the ouananiche, that was much prized by sport
fishermen (like Homer) for its fight and cleverness (cats. 202–207). But the Saguenay River was,
as it had been for at least half a century, an attraction in itself. There were tourist trips up it by
steamer from the St. Lawrence (of which it is a major tributary)—William Dean Howells' novel,
A Chance Acquaintance (1874), opened with such a trip. The Saguenay was by no means conven-
tionally scenic. Baedeker's handbook for travelers described it as a "gloomy fjord....grand but
sombre";[26] for a writer in *Harper's Weekly* it was "the dismal Saguenay";[27] for William H. H. Mur-
ray it was "the Stygian river."[28] Images of death proliferate in an 1862 description of it: "Anything
which recalls the life and smile of nature is not in unison with the huge, naked cliffs, raw, cold, and
silent as tombs.... [I]t is with a sense of relief that the tourist emerges from its sullen gloom, and
looks back upon it as a kind of vault.—Nature's sarcophagus."[29]

The "culmination," Baedeker's put it, "of the sublime scenery of the Saguenay," were Cape
Eternity and Cape Trinity (fig. 236). Cape Trinity "rises perfectly sheer from the black water, a
naked wall of granite," Baedeker's said, and explained that its name derived "from the three steps
[at the right of Homer's painting] in which it climbs from the river."[30] This was the subject of the
most unusual of Homer's late paintings. He described it in his typically laconic way as "a most
truthful rendering of this most beautiful & impressive cape." But it is, of course, much more (as
Homer may have intended to suggest by adding to his description that it was painted "from a
point of view impossible to take by photograph,"[31] that is, one that was imaginatively and physi-
cally inaccessible to the usual—the most ordinary and merely mechanical—method, by the turn
of the century, of recording scenery).[32] Virtually monochromatic, charged with the somber
images of death and eternity that the gloomy bleakness and dismal blackness of the landscape
itself seemed to inspire in all who experienced it, *Cape Trinity, Saguenay River* is not a scenic but
more truly a symbolic landscape—indeed, almost a symbolist one, for its brooding mood and
chief characteristics of form are strikingly similar to those of one of the most compelling paint-
ings of the turn of the century, Arnold Böcklin's *Isle of the Dead* (fig. 237), which the Swiss artist
painted in six versions, beginning in 1880 (and of which Max Klinger published numerous edi-
tions of prints, the first in 1890). Homer did not finish *Cape Trinity* until June 1909 (certified by
an inscription on its stretcher),[33] fifteen months before his death, but which onsets of serious ill-
ness (the most serious a stroke he suffered in May 1908) already had surely given him cause to
dwell upon. Böcklin's subject, in that condition of physical failure and mortal preparation, and
because of the sepulchral associations of the Saguenay and Cape Trinity, would easily, even irre-
sistibly, assume particular pertinence for Homer.

Homer was reported at work on *Cape Trinity* in the autumn of 1904. Earlier that year, the Copley Society in Boston organized a large, comprehensive memorial exhibition of the work of Homer's slightly older contemporary, James McNeill Whistler, who died the year before. John Beatty recalled Homer's surprise that Whistler "did not leave more works," which suggests that he (Homer) had a recent experience of some number of them, and which, if so, can only have been at the Copley Society exhibition. Beatty also reported Homer's opinion, one of the very few that he delivered (verbally anyway) on other artists, that Whistler's portraits of his mother and Thomas Carlyle (neither of which was in the memorial exhibition though both had been frequently discussed and reproduced) were "important pictures," but, in a reference to the famous Whistler-Ruskin trial of 1878, he said he did not think "those symphonies and queer things Ruskin objected to will live any great while. A few other things are knocking about," he added, "but his mother and Carlyle are the important ones."[34] There are nevertheless few paintings, excepting Böcklin's, that *Cape Trinity* resembles quite as much as Whistler's famous nocturnes. In every way—by its nocturnal, riverine subject; its extreme simplification of form; and its radically restricted and largely tonal coloration— there can be little doubt of its responsiveness to Whistler's most notorious paintings, a good number of which were included in the 1904 memorial exhibition (fig. 238).[35] Perhaps, in the light of his apparent response to Böcklin and other traces of a symbolist inclination on his part, Homer recognized, as did many by the turn of the century, the utility of Whistler's almost infinitely suggestive and, as Max Beerbohm put it at the time Homer was beginning to work on *Saguenay River*, "evasive" style.[36] Or it may be that in later life Homer had the same keen interest in modernity that, in the sense of what was current and fashionable, played so much a part in his early art; for in about 1904 nothing proclaimed modernity—radical, secessionist modernity—at least in America, as much as Whistlerism.

Right and Left (cat. 235) was completed in January 1909, a year and nine months before Homer's death. It was not his last painting, but, made when his artistic powers were still fully intact, it was his last great one. Whether it was made with his own mortality actuarially (as it had been about a decade earlier when he predicted the year of his death) or presciently in view no one can say. But he cannot have made a painting in which mortality was as stark a presence, or a painting as imbued, so deeply that it seems almost deliberated, with summary and (in its legal meaning) almost testamentary finality. It is a reprise, as all of his major late paintings are, of an earlier episode in his art, in this case his sporting subjects. It represents, like them, an engagement with popular imagery (which by this date can be understood to include some version of Audubon's *Birds of America*, which accounts for its resemblance to Audubon's plate of the "Golden-Eye Duck," fig. 239). It may recall in both its motif and design the Japanese art that was at an earlier time of such importance to Homer (cat. 87). Its assignment of human feelings to animals is a characteristic expressive posture of Homer. Its ellipticality and obliqueness, of which that strategy is a part, is in turn a part of the irony—the possibility, simply put, that everything may mean something more or be something other than it seems—that was Homer's central and almost innate artistic instinct.

fig. 240. "L'aeroplane Wright, en plein vol, au dessus de l'hippodrome des Hanaudières (8 aout 1908)." Photograph. From *Les Premiers Hommes-Oiseaux, Wilbur et Orville Wright*, page 51 (LEFT); "Farman's Aeroplane in Flight at Brighton Beach." Photograph. In *Harper's Weekly*, 8 August 1908 (RIGHT)

If *Right and Left* is, as among all his late paintings it seems most to be, a sort of final *résumé* of the cardinal traits of his artistic personality as his life was drawing to its end, it is only fitting that such a memorialization include, as an ultimate expression of his deepest and most abiding artistic instincts, a final act of deviousness, ironic misrepresentation, and modernity.

For years scholars were contentedly tracing the stylistic configuration of *Right and Left* to prints by Hiroshige, Hokusai, and Murayama, and to Audubon. But perhaps Homer was stimulated by an image of an altogether different kind. For precisely at the time *Right and Left* was taking form in 1908 (it must have been the "surprising picture" that he mentioned to his brother Charles in December 1908),[37] a completely new object, with the potential for transforming space and time more profoundly than any other instrument of modern civilization, suddenly entered the consciousness of the twentieth century: the airplane.

The Wright brothers first flew successfully at Kitty Hawk in 1903, but it was not until 1908 that the practicality of heavier-than-air flight was established by such (despite their names) French fliers as Farman and Latham, and most dramatically by Wilbur Wright's flying demonstrations at Hanaudières in August that made him one of the century's great heroes. Images of airplanes (mostly photographic) filled the illustrated press (fig. 240) so ubiquitously that even Homer, in the remoteness of Prout's Neck, could not have escaped them (it would have been far easier for him to see images of airplanes than Japanese prints or Audubon). As *Searchlight* had been earlier, *Right and Left* may also have been incited by one of the great transformative achievements of modernity—but one still so new to modern experience and as yet so completely without any appropriately modern form of representation (in the way that electricity was at first represented by allegorical figures, as in Louis Ernest Barrias' *Allegory of Electricity* of 1898 [Ny Carlsberg glyptotek, Copenhagen], the futurist Umberto Boccioni expressed the dynamism of the modern city by winged horses in *The City Rises* of 1910, painted a year after *Right and Left*, and as Wilbur Wright, in 1908, was called by the French "L'homme-oiseau")[38] that in the vocabulary of high visual and poetic art only conventional images of flight, like the flight of birds, were available to depict it.[39] Nevertheless, just as *Searchlight* anticipated modernist iconography, so *Right and Left* preceded by a year the airplanes photographed by Alfred Stieglitz in 1910, and by four years Robert Delaunay's painted *Homage to Blériot* of 1913.

Without being too literal about a resemblance that, given both Homer's own disinclination to literalness and the symbolic conventions that the novelty of flight made mandatory in the earliest stages of its representation, must be deeply disguised, it cannot at the same time go unnoticed that one of the birds in *Right and Left* falls from the sky. Crashing, all too inevitably in the early years, was part of flying. Indeed, in September 1908, when Orville Wright crashed one of the Wright Flyers during a demonstration at Fort Meyers, Virginia, killing his passenger, powered heavier-than-air flight claimed its first victim.[40]

It should not be surprising that *Right and Left* might bear such meanings or make such references as these. Given Homer's high and spacious intelligence, unflagging visual and mental alertness to everything in the world about him (including the realm of surrogate representation), and acute sensitivity to what things mean and how they have meaning, it would be far more surprising if he did not.

NOTES

1. Letter to Thomas B. Clarke, Scarboro, Maine, 20 December 1901 (Archives of American Art).

2. Homer said he crossed the Gulf Stream ten times in his life. Letter to M. Knoedler & Co., Scarboro, Maine, 19 February 1902 (M. Knoedler & Co.). There were more derelicts in the Gulf Stream than in any other place in the North Atlantic. See Theodore Waters, "Guarding the Highways of the Sea. The Work, Records, and Romances of the Hydrographic Office," *McClure's Magazine* 13 (September 1899), 442. See also the illustration "Dangerous Derelicts in the Track of Ocean Commerce," *Frank Leslie's Illustrated Newspaper* 77 (27 July 1893), 54, for an image suggestively close to *The Gulf Stream*.

3. See Spassky 1985, 2: 486. "It contains more shudders than the 'Raft of the Medusa'" (*New York Sun*, 27 December 1906).

4. See, for example, "The Johnston Collection," *New York Tribune*, 5 November 1876.

5. Letter to M. Knoedler & Co., 31 March 1900 (M. Knoedler & Co.).

6. Spassky 1985, 2: 486, noted that *The Slave Ship* was acquired by the Museum of Fine Arts, Boston, in 1899, the year Homer painted *The Gulf Stream*. "[*The Gulf Stream*] should, so artistic opinion runs, eventually bear the same relation to marine subjects painted by this American that Turner's famous 'Slave Ship' does to that artist's work. Oddly enough, there is a certain resemblance in the theme of the two paintings…" ("Museum Buys a Winslow Homer," *New York Herald*, 21 December 1906).

7. "Union League Pictures," *New York Evening Post*, 11 January 1902.

8. Matthew Fontaine Maury, *The Physical Geography of the Sea* (Cambridge, Mass., 1963 [first ed. 1855]), 38. Homer wrote Knoedler, "I will refer these inquisitive schoolma'ams [who wanted to know what *The Gulf Stream* was about] to Lieut. Maury" (19 February 1902, M. Knoedler & Co.). Maury's portrait was pasted in Homer's copy of G. Chapman Child's *Benedicite. The Great Architect* (New York, 1871).

9. Quoted in Louis Legrand Noble, *The Life and Work of Thomas Cole*, ed. Elliot S. Vesell (Cambridge, Mass., 1964 [first ed. 1853]), 216.

10. Letter to M. Knoedler & Co., Scarboro, Maine, 14 January 1902 (M. Knoedler & Co.).

11. "Art Exhibitions. American Pictures at the Union League Club," *New York Tribune*, 11 January 1902.

12. Stephen Bonsal, "With the Blockading Fleet Off Cuba," *McClure's Magazine* 11 (July 1898), 124.

13. "Among the Galleries. American Pictures at the Union League Club," *New York Sun*, 10 January 1902. Another spoke of "the conflicting rays of a cold moon and a colder electric light" (*New York Tribune*, 11 January 1902).

14. Murat Halstead, "Electricity at the Fair," *The Cosmopolitan* 15 (September 1893), 578, 577.

15. 7 November 1900, in *Letters of Henry Adams (1892–1918)*, ed. Chauncey Worthington Ford (Boston and New York, 1938), 2: 301.

16. Among the most aggressive modernists of the early twentieth century, the Italian futurists, the moon was a favorite object of derision; in "Let's Murder the Moonshine" (1909), F. T. Marinetti wrote: "…turbines transformed the rushing waters into magnetic pulses that rushed up wires, up high poles, up to shining, humming globes. So it was that three hundred electric moons canceled with their rays of blinding mineral whiteness the ancient green queen of loves" (*Marinetti: Selected Writings*, ed. W. R. Flint [New York, 1972], 51).

17. *New York Tribune*, 11 January 1902.

18. *New York Sun*, 10 January 1902; *New York Tribune*, 11 January 1902.

19. Letter to M. Knoedler & Co., Scarboro, Maine, 14 January 1902 (M. Knoedler & Co.).

20. "Pennsylvania Academy Exhibition. By Charles H. Caffin," *International Studio* 25 (March 1905), ii.

21. "The Pennsylvania Academy," *New York Evening Post*, 25 January 1905.

22. From this point of view, its resemblance to Japanese art, particularly to Hokusai's *The Great Wave of Kanagawa*, becomes less persuasive. See Wilmerding 1972, 177.

23. Its most drastic applications, however, are *Low Tide*, which Homer cut into a least two pieces (fig. 67), and the painting now known as *Early Evening* (fig. 96) which, in 1907, Homer cut down to its present size of 33 x 38 inches from its original measurements of about 33 x 50 inches. See Mead 1993, 104–107.

24. Letter to Charles S. Homer, Jr., 25 November [1908 ?] (Bowdoin).

25. Beam 1966, 250.

26. Karl Baedeker, *The Dominion of Canada* (Leipzig, 1900), 63.

27. Chambers, "Ouananiche," 978.

28. "The waters of the Saguenay," Murray wrote in a note, "are unlike those of any other river known. They are purple-brown, and, looked at en masse, are to the eye, almost black. This peculiar color gives it a most gloomy and grewsome [sic] look, and serves to vastly deepen the profound impression its other peculiar characteristics make upon the mind" (William H. H. Murray, *The Doom of the Mamelons, a Legend of the Saguenay* [Quebec, 1888], 108).

29. *The Lower St. Lawrence, or Quebec to Halifax, Via Gaspé and Pictou* (Quebec, 1862), 44–45.

30. Baedeker, *Canada*, 64.

31. Letter to M. Knoedler & Co., 17 November 1904 (M. Knoedler & Co.).

32. One which he himself used at precisely this time in snapshots taken on a fishing trip to Florida, with perfectly ordinary results (and which do not, as many would like to have it, demonstrate the influence of photography upon him—see Chronology 1904). Just at this time, Homer made his views about photographers who thought themselves artists (and, by extension, on confusing photography with art) bluntly clear: "I say that all photographers who pose as artists are damn fools (as they think they do it all, forgetting 'that glorious lamp of Heaven, the Sun')…" (Letter to M. Knoedler & Co., Scarboro, Maine, 5 April 1905 [M. Knoedler & Co.]).

33. Downes 1911, 230.

34. Goodrich 1944a, 213. In 1877, Whistler exhibited *Nocturne in Black and Gold: The Falling Rocket* at the Grosvenor Gallery in London. Ruskin wrote that "I have seen, and heard, much of Cockney impudence before now, but never expected to hear a coxcomb ask two hundred guineas for flinging a pot of paint in the public's face," and Whistler sued him for libel in a much publicized trial. Homer's remarks cannot have been made before Beatty's first visit to Prout's Neck in September 1903.

35. "His incomparable nocturnes are well represented in a few of his highest achievements, travelling way beyond

common ranges of values into infinite complexities, rendering with hazy exactness nature's elusive suggestion of rock and beach and distant village, shipping rising dimly in the soft darkness, the glimmer of a lantern lashed to mast, a first flush of yellow moonlight" ("Whistler Gems from Two Continents Shown in Boston," *Boston Daily Advertiser*, 24 February 1904).

36. Max Beerbohm, "Whistler's Writing," *The Metropolitan Magazine* 20 (September 1904), 731.

37. Letter to Charles S. Homer, Jr., Scarboro, Maine, 8 December 1908 (Bowdoin).

38. When asked how he flew, Wright himself said, "Like a Bird!" ("Comme un Oiseau," *L'Illustration* 188 [19 September 1908], 188). On the relationship between aviation and the arts in the early twentieth century, see now Robert Wohl, *A Passion for Wings: Aviation and the Western Imagination 1908–1918* (New Haven and London, 1994).

39. In the early twentieth century, too, "authors [began] to think of it as natural (at least unexceptional) to move back and forth from the organic to the technical, from the 'trees and animals' to the 'engines.' This enmeshment of images really signals a new worldview in the twentieth century. For the mix of American flora and fauna with pistons, gears, and engines indicates that the perceptual boundary between what is considered to be natural, and what technological, is disappearing" (Cecilia Tichi, *Shifting Gears: Technology, Literature, Culture in Modernist America* [Chapel Hill and London, 1987], 34). Tichi quotes William Carlos Williams, *Notes in Diary Form* (1927): "There are no sagas—only trees now, animals, engines: There's that."

40. "The Fatal Fall of the Wright Aeroplane," *Harper's Weekly* 52 (26 September 1908), 7.

230–235

Psychosexual interpretations of Homer's art and the issue of his sexuality for years had no place at all in Homer scholarship.[1] In 1973, Thomas B. Hess boldly, though only very briefly in a review of an exhibition, raised the question of Homer's sexuality in connection with *Fox Hunt*. In Hess' Freudian analysis, the fox, "dapper, small, inquisitive, shrewd," was Homer's (unconscious) self-portrait; the black crows, as a representation of "the nightmare of the flying penis," were the symbolic manifestation of Homer's repressed sexuality and autoerotic fantasies.[2] But the consideration of this question has only fitfully and peripherally found a place in Homer scholarship. That may be because it is still a suspect subject, or because art-historical scholarship is not equipped to deal confidently or comfortably with it. Homer, to be sure, was almost pathologically guarded and silent about all parts of his private life, including his sexual life and longings. Far from being an impediment to a consideration of his sexuality, however, it is the clearest evidence of its repression (if not of the content that was being repressed). And if Homer himself, or anyone who knew him (and no one knew him closely, except his family, who strictly respected his privacy), never spoke of the nature of his sexuality, as no one would really expect them to, Homer's art, and most especially his late art, the promptings of which were so largely internal, is a virtual catalogue of sexually symbolic meanings.

The sharks in *The Gulf Stream*, for example, circling the helpless boat with sinuous seductiveness, can be read as castrating temptresses, their mouths particularly resembling the *vagina dentata*, the toothed sexual organ that so forcefully expressed the male fear of female aggression (and which appeared so openly and often in the Freudian imagery of surrealism).[3] That Homer's fear of women in these terms was so strong—so strong that he could not fully repress it—is indicated by the language (and imagery) of his response to a letter from Leila Mechlin that his dealer had forwarded to him, requesting photographs for an article she was preparing on Homer: "[O]f course these women who work for the press expect & want everything they can get —& they look forward to what that is—before proposing the article—& then they beat you up —for material," he wrote Knoedler. "I will say (as perhaps *Col Chin of Kentuckey* [sic] may be calling you at this time—) [drawing of a pistol, fig. 241] *That the ladies deserve all they ask for*—."[4] The erotic meaning of *The Gulf Stream* is all the clearer if the painting was, as it seems very much to be, Homer's version of George W. Maynard's *In Strange Seas* (fig. 248), which was in itself a classic type of the late nineteenth-century "fantasy of feminine evil."[5]

In its form and its function, the cannon in *Searchlight* is, like the pistol, a self-evident phallic symbol (which makes Homer's enlargement of it in the drawing upon which the painting is based, fig. 250, as much an erotic as an aesthetic act). When joined to the constellation of the breast-like and vulvular forms of the architecture of the guard house, it verges on becoming one of Picasso's erotic surrealist constructions (fig. 242).

Diana, chaste temptress, cruel hunter, goddess of the moon, was one of the late nineteenth-century male's almost obsessionally favorite symbolic impersonations of Woman. They range from such plastic and painted versions as Augustus Saint-Gauden's *Diana*, a tutelary erotic deity placed on the tower of Sanford White's Madison Square Garden in New York (fig. 243), to the lunette of Diana that John Singer Sargent's modern temptress, Mme. Gautreau, wears in her hair (fig. 244); to such literary ones as George

Meredith's *Diana of the Crossways* and Henry James' Isabel Archer in *Portrait of a Lady. Kissing the Moon* is, therefore, not only the most erotically titled of Homer's paintings, as Bruce Robertson has pointed out,[6] but the one in which the fatal erotic attraction that holds Man in the power of its irresistible enchantment is as explicit as symbolism can make it.

The forms of *Cape Trinity, Saguenay River* are like those of the breasts or buttocks of a recumbent nude, sensually enticing but deathly cold. And if *Cape Trinity* was influenced by or referred to Arnold Böcklin's still more, in these terms, symbolically explicit *Isle of the Dead*—if, indeed, its symbolic content was not the basis for its influence—its sexual symbolism becomes that much clearer.[7]

And the outwardly pressing breasts of the two ducks in *Right and Left* are also, as Robertson has seen, erotically suggestive.[8] They are like the protuberant breasts of myriad fatally tempting and rapacious females—sphinxes, Circes and Venuses, Judiths, Salomes and Delilahs—that populate the art of the late nineteenth century with such obsessive frequency that it is scarcely possible to mistake their meaning.[9]

NOTES

1. As Downes 1911, Goodrich 1944a (and after), and Wilmerding 1972.

2. Hess 1973, 75. Ten years later, Henry Adams' "psycho-biographical" article published a more expanded investigation of Homer's art in Freudian terms (Adams 1983).

3. Hess 1973, 75.

4. Letter to M. Knoedler & Co., Scarboro, Maine, 10 April 1908 (M. Knoedler & Co., New York).

5. Bram Dijkstra, *Idols of Perversity: Fantasies of Feminine Evil in Fin-de-Siècle Culture* (New York and Oxford), 1986, chapter 8 (for mermaids).

6. Robertson 1990, 38.

7. This symbolic meaning is absolutely explicit in Alfred Kubin's *Saut de la Mort* of 1901–1902; see Michael Gibson, *Le Symbolisme* (Cologne, 1994), 141.

8. Robertson 1990, 38.

9. See Dijkstra 1986.

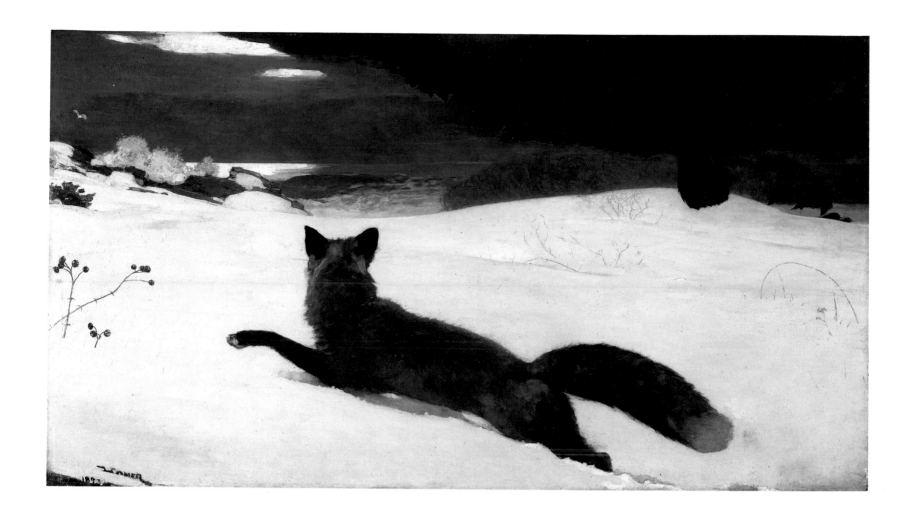

230. *Fox Hunt*, 1893
oil on canvas, 96.5 x 174 (38 x 68½)
Museum of American Art of the Pennsylvania Academy of the Fine Arts, Philadelphia, Joseph E. Temple fund, 1894.4
Provenance: The artist.
Washington and New York only

230

"It is mid-winter on the New England coast. The ground is deep with snow. A wretched fox, driven from his lair by frost and famine, struggles through the heavy drifts in quest of food; and over him, circling nearer and nearer, as he grows weaker and weaker, come the ravens who are soon to pluck his bones."[1]

"The subject is very novel, and requires a word of explanation as to the fact in natural history of which it is a dramatic illustration. In the depths of winter, when the ground is for long intervals covered with snow along the coast of Maine, it is observed that a flock of half-starved crows will have the temerity to attack a fox, relying on their advantage of numbers, the weakened condition of the fox and the deep snow, which makes it the more difficult for the victim to defend himself."[2]

"A fox makes his way through the snow, looking sharply at his enemies—two huge crows which are swooping down to devour him, in which their hunger, made savage by the snowstorm which has covered their usual hunting-ground. Other crows hover restlessly in the distance. A twig or two of last summer's wild-rose bush is the grace note of the picture, redeeming sufficiently the sombre character of the scene."[3]

NOTES

1. Alfred Trumble, "Facts, Ideas, and Opinions," *The Collector* 4 (1 April 1893), 166.

2. "Winslow Homer's Latest Picture, 'The Fox Hunt,' at Doll & Richards'," *Boston Evening Transcript*, 30 June 1893.

3. Helen M. Knowlton, "Winslow Homer's Latest Picture [letter to the editor]," *Boston Evening Transcript*, 5 July 1893.

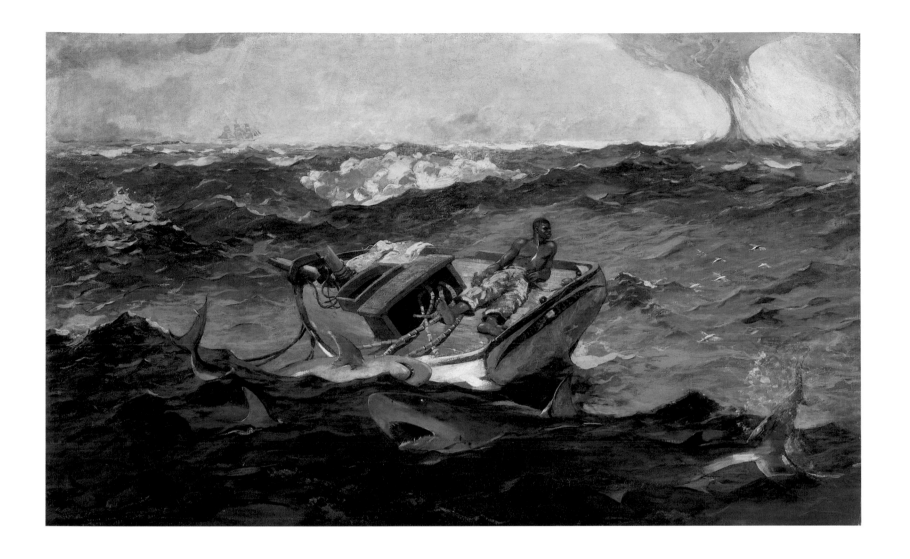

231. ***The Gulf Stream***, 1899
oil on canvas, 71.4 x 124.8 (28⅛ x 49⅛)
The Metropolitan Museum of Art, Wolfe Fund,
Catherine Lorillard Wolfe Collection
Provenance: (O'Brien & Son, Chicago, 1902);
(M. Knoedler & Co., New York, 1906).

231

After completing one of the earliest surveys of the
Gulf Stream, the U.S. brig *Washington* was struck
by a hurricane off Cape Hatteras in September
1846. The pilot's description gives an idea of the
fury of the storm that must have struck Homer's

"Annie" out of Key West: "...sea making breach
over vessel; white foam in every direction....Sea
curled over and tumbled upon vessel. Tremendous
sea—crushing deck cabin and sweeping deck of
everything....Tore up berth deck, beams and
all, all but those lashed were washed over...."[1]

If Homer himself experienced such a storm
on one of his many crossings of the Gulf Stream,
the pictorial germination of *The Gulf Stream* can
be traced to a pencil sketch Homer made of a
dismasted boat that he observed, probably in
1885, on his first trip (through the Gulf Stream)
to the Caribbean (fig. 230). He subsequently
refined and embellished it in two large watercol-
ors, *The Derelict (Sharks)* of 1885 and *The Gulf
Stream* of 1899, to one adding a group of thrash-
ing sharks in the foreground (fig. 229), and to
the other the figure of a black sailor (fig. 245).
And in an even larger watercolor, closest in size
and detail to the painting and therefore probably
closest and even penultimate to it in date, Homer
studied the forward part of the boat (fig. 246).[2]

One detail present in this watercolor, which
appeared in none of the others that preceded it
but does appear in the finished painting, indi-

fig. 245. *The Gulfstream*,
1889. Watercolor.
Photograph © 1994,
The Art Institute of
Chicago, Mr. and Mrs.
Martin A. Ryerson
Collection, 1933.1241

fig. 246. *Study for "The Gulfstream,"* 1885. Watercolor and black chalk. Cooper-Hewitt, National Design Museum, Smithsonian Institution, Gift of Charles Savage Homer, Jr. (1912–12–36). Art Resource, New York

cates a clarifying escalation of an aspect at least of its symbolic purpose. The black cross now added in the boat's bow is in its actual function a cleat; but its symbolic function, in itself inescapably funerary, is to illuminate by that symbolic light the other funerary objects and emblems, which are, like it, disguised as other things, in its vicinity: the open tomb (the hatch, referred to as a tomb in *Moby Dick*, and become pronouncedly more rectangularly tomb-like in the painting); the ropes for lowering the body into the tomb; the common nineteenth-century funerary monument of the broken column (mast); and the shroud (sail) draped over the gunwale that Homer added later, reinforcing this symbolical array.[3] That *Breezing Up* (cat. 76)—the one painting among all of Homer's earlier works positioned most squarely in the lineage of *The Gulf Stream* —contains in its bow the anchor (of hope)[4] added late in its pictorial development to give it its symbolic direction and dimension, is, of course, more than merely curious or coincidental. That the black sailor averts his eyes from the fictitious eschatalogical scheme of death and, as it is figured by the sailing ship on the horizon, salvation, to gaze fixedly instead on the irrefutably horrible actuality of sharks, waterspouts, and a turbid sea, expresses by its pessimism an almost Schopenhauerian philosophical preference (as this quite exactly fin-de-siècle painting does also by turning in reverse the optimistic thrust of its toweringly great predecessor in the beginning of the century, Théodore Géricault's *Raft of the Medusa* of 1818–1819, fig. 247).

One of the most popular American paintings in the late nineteenth century was George W. Maynard's *In Strange Seas* (fig. 248), exhibited to much acclaim at the National Academy of Design in 1890, and later, in February 1899 when *The Gulf Stream* was being conceived, in the sale of the William F. Havemeyer collection (another version of it, *Sport*—for it was far and away

fig. 248. George Willoughby Maynard, *In Strange Seas*, 1889. Oil on canvas. The Metropolitan Museum of Art, Gift of William F. Havemeyer, 1901. (01.22)

Maynard's most famous subject—received the Shaw Fund prize at the Society of American Artists' exhibition in 1897). If it were not absurd to describe a painting so deeply serious as *The Gulf Stream* as a parody of one as frivolous as Maynard's, that would be exactly what it is. And if it takes exalted parodic aim on an undeservingly trivial target, it was because Homer (who despite the recognition and praise lavished upon him in his later years never felt sufficiently regarded and properly understood) could only have been professionally offended and personally embittered by the attention paid to so silly and shallow a painting as this, and made to feel all the more keenly, as he did at those times when he threatened to give up painting altogether, the pointlessness of the enterprise to which he had devoted himself with such deep seriousness and high purpose.

NOTES

1. Quoted in Susan Schlee, *The Edge of an Unfamiliar World: A History of Oceanography* (New York, 1873), 23.

2. Because it has clearly been cut down, this watercolor must originally have depicted the entire boat, as had the early ones.

3. See Spassky 1985, 2:484.

4. Anchors figure also, with symbolic resonance, in *Boy with Anchor* (cat. 68) and *Breezing Up* (cat. 76), and appear as remarques in several of Homer's etchings of the 1880s (cat. 122, fig. 160).

fig. 247. Théodore Géricault. *Raft of the Medusa*, 1818–1819. Oil on canvas. Musée du Louvre, Paris

232. *Searchlight on Harbor Entrance, Santiago de Cuba,* 1901
oil on canvas, 77.5 x 128.3 (30½ x 50½)
The Metropolitan Museum of Art, Gift of George A. Hearn, 1906
Provenance: (M. Knoedler & Co., New York, January 1902); George A. Hearn, 31 January 1902–1906.

232

In the fall of 1901, in what was described as "the most remarkable judicial procedure of the new century"[1] and one widely reported and heatedly discussed—"Never before in the history of the navy has an issue been presented of such supreme and universal interest, not only to the navy, but to the general public...."[2]— a court of inquiry was convened to determine which of the two commanders at the battle of Santiago, Cuba, during the Spanish War of 1898, Admiral Sampson, who commanded the Atlantic Squadron but who was miles away at the time, or Admiral Schley, who commanded the *Brooklyn* when the Spanish fleet tried to escape and was destroyed, deserved credit for the victory.[3] Homer was at work on *Searchlight* by early December 1901, as his daybook shows,[4] and by the end of the month he was urging his New York dealer, Knoedler, to show it "as the subject is now before the people"[5]—how much so, and how clearly, can be gauged by the precisely detailed reconstruction of "The Santiago Fight" that appeared in a *Life* cartoon in November 1901 (fig. 249).

In his letter to Knoedler Homer included a bird's-eye view drawing of the battle site from a point within Santiago harbor looking out through the harbor entrance to the sea beyond, with the searchlight picket boats upon it and the "Point of view of Picture" clearly marked (he described it as "a small part of Morro Castle & immediately over the harbor entrance....from this point were seen all the stirring events of June and July 1898").[6] Homer did not, as this might suggest, actually witness the blockade or the battle of Santiago. He had visited Santiago some twenty years before, when he made the detailed drawing of the ramparts of Morro Castle that became the basis of his painting (fig. 250). He knew of the war, though, as most Americans knew of it, through press accounts. A large and detailed bird's-eye drawing of Santiago by Charles Graham, from a position similar to that of Homer's drawing, appeared in *Harper's Weekly* on 9 July 1898, for example. He could only have known of the presence of the moon, so crucial to the meaning and mood of his painting (and clearly indicated in Homer's drawing), by a description such as that of Admiral Sampson (who was respon-

fig. 249. "The Santiago Fight." In *Life*, 21 November 1901

fig. 250. *Canon—Study for "Searchlight."* Pencil and white chalk. Cooper-Hewitt, National Design Museum, Smithsonian Institution, Gift of Charles Savage Homer, Jr. (1912–12–1). Art Resource, New York

fig. 251. James McNeill Whistler. *Nocturne in Black and Gold: The Falling Rocket*, 1875. Oil on canvas. The Detroit Institute of Arts, Gift of Dexter M. Ferry, Jr.

sible for the innovative use of searchlights): "After we arrived we had the friendly aid of a brilliant, and as the moon waned we became very anxious; but after we had the searchlight we reviled the moon, because we could not see as well with the moon as without it."[7] Perhaps the striking effects of light were also based on descriptions. Sampson wrote that "The scene on a moderately dark night was a very impressive one, the path of the search-light having a certain massiveness, and the slopes and crown of the Morro cliff being lighted up with the brilliancy of silver."[8] And writing of the Spanish point of view—which is, of course, the viewer's—someone said that their soldiers and sailors "were so blinded [by the searchlights] that neither from the castle top nor from the harbor below could they see even the huge shadows of the ships."[9]

Nocturnal scenes, often artificially illuminated, were James McNeill Whistler's most notorious subjects. One of them, the *Nocturne in Black and Gold* of about 1875 (fig. 251), was the centerpiece in the famous libel suit that Whistler brought against the critic John Ruskin (Homer knew about the trial, and the painting had been exhibited in New York in 1883 and was acquired by an American, Samuel Untermeyer, in 1892). But Homer had a more direct experience of nocturnal electric illumination that served him in painting *Searchlight*. Eight years earlier he had witnessed the "magnificent searchlights that sweep the horizon with shafts of flame" at the World's Columbian Exposition in Chicago, and, in *The Fountains at Night* (fig. 234), he painted

"the lofty jets…converted to leaping rainbows, glowing, fantastical, mystical [by the] splendors of electricity."[10]

NOTES

1. "The Schley Court of Inquiry," *Leslie's Weekly* 93 (7 September 1901), 211.

2. "Schley Court Opens," *Boston Evening Transcript*, 12 September 1901.

3. "The Schley-Sampson controversy has raged in the press and on the platform for three years. It has found its way into politics. There are Sampson men and there are Schley men. There are even some men who have gone so far as to suggest that, if the findings of the court favor Admiral Schley, a 'presidential issue' will thereby be afforded. To such men Sampson is a 'pet' and Schley is a 'martyr'" (Editorial, *Boston Evening Transcript*, 12 September 1901).

4. Entries for 4, 5, and 15 December 1901 (Bowdoin).

5. To M. Knoedler & Co., Scarboro, Maine, 30 December 1901 (M. Knoedler & Co.).

6. Letter to M. Knoedler & Co., Scarboro, Maine, 14 January 1902 (M. Knoedler & Co.).

7. Rear Admiral William T. Sampson, U.S.N., "The Atlantic Fleet in the Spanish War," *The Century* 55 (April 1898), 902.

8. Sampson, "The Atlantic Fleet," 901.

9. W. A. M. Goode, "The Inner History of Admiral Sampson's Campaign," *McClure's Magazine* 12 (November 1898), 95.

10. Murat Halstead, "Electricity at the Fair," *The Cosmopolitan* 15 (September 1893), 577–578.

233. *Kissing the Moon,* 1904
oil on canvas, 76.8 x 102.6 (30¼ x 40⅜)
Addison Gallery of American Art, Phillips Academy,
Andover, Massachusetts, Bequest of Candace C.
Stimson
Provenance: (M. Knoedler & Co., New York, from 19
November 1904); Lewis A. Stimson; Candace C.
Stimson.
Washington only

234. *Cape Trinity, Saguenay River,* 1904–1909
oil on canvas, 73 x 123.8 (28¾ x 48¾)
The Regis Collection, Minneapolis, Minnesota
Provenance: (M. Knoedler & Co., New York,
17 November 1904 until 1907 and June 1909); Bur-
ton Mansfield, New Haven, Connecticut, December
1909–September 1927; (M. Knoedler & Co., New
York, September 1927); Phillips Memorial Gallery,
Washington, D.C., September 1927–1928;
(M. Knoedler & Co., New York, 1928–1956); Guen-
nol Collection, Glen Head and Katonah, New York,
1956–1984; (Wildenstein & Co., New York, 1984);
Spring Creek Art Foundation, Inc., New York City
and Dedham, Massachusetts, 1984–1986.

234

Homer made a drawing in which he precisely
and emphatically defined the shapes of Capes
Trinity and Eternity that, following a conven
tional preparatory procedure (though not one
he followed in any other surviving drawing), he
squared for transfer to a larger format (fig. 252).
Not surprisingly, the painting closely resembles
the drawing in its composition. The shape of
the painting is, however, more rectangular, its
forms (particularly that of Cape Trinity in the
right foreground) more highly modeled, and its
striking effects of moonlight belong to it alone.
The drawing and painting both make the form
of Cape Trinity more massive and more omi-
nously looming than it appears in a photograph
(fig. 236), which is what Homer may have meant
when he said his image of it was "from a point
of view impossible to take by photograph."[1]

NOTES

1. See 376, n. 31.

fig. 252. *Study for "Cape Trinity, Saguenay River,"* 1904. Pencil.
Cooper-Hewitt, National Design Museum, Smithsonian
Institution, Gift of Charles Savage Homer, Jr. (1912-12-196).
Art Resource, New York

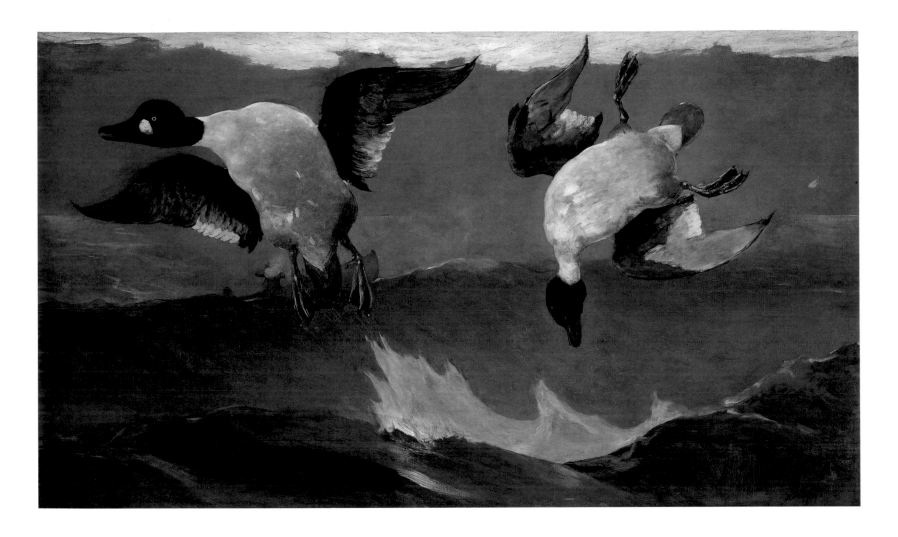

235. *Right and Left*, 1909
oil on canvas, 71.8 x 122.9 (28 ¼ x 48 ⅜)
National Gallery of Art, Washington, Gift of the
Avalon Foundation, 1951.8.1
Provenance: (M. Knoedler & Co., New York, 1909).
Randal Morgan, Chestnut Hill, Pennsylvania, 1909;
his wife, Mrs. Randal Morgan, Chestnut Hill, Penn-
sylvania, 1926; (M. Knoedler & Co., New York, 1950).

235

There are two accounts of the painting's origin.
One was told by Downes, Homer's first biogra-
pher: "The artist bought a fine pair of plump
wild ducks for his Thanksgiving dinner. He did
not intend to make a painting of them, but their
plumage was so handsome, he was tempted; and
before he got through with them his Thanksgiving
dinner was spoiled."[1] Beam heard another ver-
sion from Homer's nephew, Charles L. Homer:
"Winslow's good friend Phineas W. Sprague
from Boston summered at the Neck [Prout's
Neck, Maine], and often stayed on for the fall
duck-hunting. In October or November of 1908
he bagged several ducks, and hung a brace of
them on Homer's studio door. When Winslow
saw them his imagination was set at work and he
soon conceived the design for *Right and Left*."[2]
To the degree these stories imply that the ducks
were to be eaten, they are not fully plausible. The
Golden-eye duck, which these are, while edible is
far from desirable; John James Audubon said the
Golden-eye duck, which he depicted in *The Birds
of America* in a print that Homer's painting close-
ly resembles (fig. 238),[3] was "fishy, and in my
opinion unfit for being eaten."[4] It is not likely

that Homer would buy them to eat at any time,
much less for Thanksgiving.

There are also two versions of how Homer
developed his subject. "He employed his usual
careful methods of observation in this case,"
Downes wrote. "He went out, day after day, in a
boat, with a man who was armed with a double-
barreled shotgun, and studied the positions and
movements of the birds when they were shot."[5]
If so, he witnessed quite a slaughter. According
to Beam: "To see what a shotgun blast looked
like to someone under fire, Homer hired Will
Googins [a neighbor at Prout's Neck] to row off-
shore in a boat and fire blank charges up toward
the cliff where he stood watching."[6] But Homer
knew what it was like to be under fire: In both
Defiance (cat. 5) and *A Good Shot, Adirondacks*
(cat. 161) that is precisely what he depicted.

Downes said that Homer "had no title for the
picture" and that it received the one by which it
is now known when it was exhibited at Knoedler's:
"[A] sportsman came in, caught a glimpse of the
picture, and at once cried out: 'Right and left!'—
admiring not so much the picture *per se*, as the
skill of the hunter who could bring down a bird
with each barrel of his double-barreled shotgun
in quick succession. So the work was christened."[7]

When Knoedler acknowledged receipt of the painting on 30 January 1909, they called it (in quotation marks, as though it were Homer's title, not a description of the subject) "The Golden Eye or Whistler Duck."[8] By 19 April, however, they were referring to it as "Right & Left."[9]

Before deciding to buy it, the painting's first owner, Randal Morgan, wanted to know something about it. His questions were relayed to Homer by Daniel H. Farr of Knoedler's: "First of all he wants to know what direction the big wave is travelling in[.] He thinks it is coming toward the spectator. He would also like to know what causes the choppiness in that part of the picture nearest the spectator. He feels it is the result of the preceding wave after it has broken[,] possibly on the rocks. Mr. Morgan also feels that this choppiness caused the ducks to get off from their feeding. Are these surmises correct? He is deeply interested in the painting & I think will keep it, so I know you won't mind sending us a line which we may forward to him in order that he can understand the details better."[10] Several years earlier Homer had responded with considerable sarcasm to questions from Knoedler about *The Gulf Stream*. In this case, his response is not known, but it cannot have been too scornful because on 3 August 1909 Knoedler's informed Homer that the painting had been sold to Morgan for $5,000 (of which Homer received $4,000).[11]

The questions Morgan asked are utterly different from those that have been asked of the painting since. The depiction of the moment of the ducks' death,[12] added to the fact that the painting was completed about a year and a half before Homer's death, have encouraged interpretations of a distinctly more metaphysical sort (such as that of John Wilmerding, who wrote that it embodied "a sense of the momentary and of the universal, mortality illuminated by showing these creatures at the juncture of life and death").[13]

Recent interpretations have also been more attentive to the painting's affinitive or derivative resemblances to other art, particularly Japanese art. Albert Ten Eyck Gardner said it was "so Japanese in style that one hesitates to emphasize the point."[14] Others were not so hesitant: Beam said it was "reminiscent of Okyo Maruyama's *Flying Wild Geese*,"[15] and Wilmerding, citing the same resemblance, added one to Hiroshige as well.[16] Its Japanism was virtually sanctified by its inclusion in the large *Japonisme* exhibition of 1988 (in the catalogue of which it was compared to the depictions of birds in Hokusai's Santei-Gafu).[17]

Japanese influence was commonplace to the point of ubiquity everywhere in the West in the early twentieth century, so that it is not remarkable that Homer (who had experienced it already in the 1870s) might almost unconsciously avail himself of it. But *Right and Left*, as the very title it was given shows, was conceived more consciously in a very much less sophisticated mode of style. For *Right and Left* is, of course, a sporting picture. The "sportsman" who supplied its title, and its first owner, both of whom were both far more interested in it from that point of view than for its formal refinement (or metaphysical implications), understood that perfectly. And before it underwent its formal and metaphysical elevation it was included in exhibitions of sporting art.[18]

Sporting art was popular art, and *Right and Left* was a popular picture. Not in the opportunistic sense of the appeal it would have, as it clearly did, for someone like Morgan, but as the final (as it turned out) instance in Homer's almost lifelong engagement with the imagery and style of popular art, which is, in turn, one of modernism's principal resources of meaning.[19]

NOTES

1. Downes 1911, 244–245.

2. Beam 1966, 249.

3. Audubon was cited in connection with another of Homer's paintings, the wild geese both alive and dead (as the two ducks may be in *Right and Left*), originally titled *At the Foot of the Lighthouse* (Portland Museum of Art): "The drawing of the birds, which are almost life size, is worthy of Audubon…" ("The Week in the Art World," *The New York Times Saturday Review of Books and Art*, 9 April 1898).

4. Quoted in *John James Audubon: The Watercolors for the Birds of America* (New York 1993), 250. An article describing a hunt for golden-eye ducks makes it clear that they were killed only for sport, not to be eaten (L. J. Flower, "A Day with the Golden-eyes," *Forest and Stream* 26 [11 February 1886], 48).

5. Downes 1911, 245.

6. Beam 1966, 249.

7. Downes 1911, 245.

8. Letter of 30 January 1909 (M. Knoedler & Co.).

9. Farr to Homer, 19 April 1909 (M. Knoedler & Co.).

10. Farr to Homer, 19 April 1909 (M. Knoedler & Co.).

11. Letter of 3 August 1909 (M. Knoedler & Co.).

12. The question of their states of mortality has teased several commentators on the painting; Wilmerding 1980, 83–84, gives his own view of the matter and helpfully summarizes others.

13. *American Art* (Harmondsworth 1976), 136.

14. Gardner 1961, 206.

15. Beam 1966, 248.

16. Wilmerding 1980, 77, and figs. 16, 17.

17. *Le Japonisme* (Paris, 1988), 214, no. 305.

18. *Sport in Art*, Museum of Fine Arts, Boston, 1944, and *Shooting and Fishing in Art*, Baltimore Museum of Art, 1958.

19. For which see Kirk Varnedoe and Adam Gopnik, *High and Low: Modern Art and Popular Culture* (New York, 1990). The essential conception of *Right and Left* is seen in the crudely drawn illustration of "The Pied Duck" being shot by a hunter in a distant boat, in *Field and Stream* 29 (18 August 1887), 64.

Chronology

The following sources were used in compiling this chronology: Archives of American Art (AAA), including the J. Eastman Chase Papers (AAA, Chase) and the William T. Evans Papers (AAA, Evans); Adirondack Museum (AM); Colby College Library (CCL); Frick Art Reference Library (FARL); Massachusetts Historical Society (MHS); Mount Vernon Ladies' Association (MVLA); and the Union League Club Library (ULCL). The M. Knoedler & Co. Archives (MKA) and Bowdoin College Museum of Art Archives (BCMA) are cited most often and were critical in outlining the latter part of Homer's life. Materials in the National Gallery of Art's (NGA) vertical files and its collection of transcripts of Homer's letters were also used.

The chronology also has drawn extensively on the publications of Homer scholars, including the seminal works of William Howe Downes and Lloyd Goodrich. Philip Beam's work on Homer's magazine engravings and David Tatham's publication on Homer's book illustrations were also important sources. Some of the private correspondence cited in Gordon Hendrick's 1979 book on Homer is also incorporated.

Other works were consulted for specific periods of Homer's career. For the Civil War and Reconstruction years, Sally Mills' chronology in *Winslow Homer's Paintings of the Civil War*, the chronology in Peter H. Wood and Karen C. C. Dalton's *Winslow Homer's Images of Blacks*, and Mary Ann Calo's work on Reconstruction were used. Linda Ayres' essay in *Winslow Homer in the 1870s* details Homer's visits to Houghton Farm. D. Scott Atkinson's exhibition catalogue discusses Homer's visits to Gloucester. The respective studies of William Gerdts and John Wilmerding on Homer's Cullercoats works, as well as the research in Helen Cooper's *Winslow Homer Watercolors* were used to outline the English period. Tatham's work is the main source for the dating of Homer's Adirondack trips. Cooper's book also contains information on Homer's Adirondack visits, in addition to accounts of his trips to the Tropics. Homer's time at Prout's Neck is detailed in Beam's *Winslow Homer at Prout's Neck* and the exhibition catalogue *Winslow Homer in the 1890s: Prout's Neck Observed*. Finally, much of the chronology is based upon articles and documents from Nicolai Cikovsky's extensive files on Homer.

Henrietta Maria Benson Homer. Bowdoin College Museum of Art, Brunswick, Maine, Gift of the Homer Family, 1964.69.174

1836

24 February Winslow Homer is born at 25 Friend Street, Boston, Massachusetts, to Charles Savage Homer, Sr. (1809–1898), a hardware merchant, and Henrietta Benson Homer (1809–1884). His two brothers are Charles Savage, Jr. (1834–1917) and Arthur Benson (1841–1916).

Family moves to 7 Bulfinch Street, near Bowdoin Square.

1842

Family moves to semirural Cambridge, Main Street (now Massachusetts Avenue), later moving to Garden Street.

1849

Charles Savage Homer, Sr., gives up his business and travels to California by way of Panama, probably for the Frémont Mining Company, as part of the California Gold Rush. Upon arriving finds that the company's claim has been usurped; he returns to Boston in 1851.

Charles Savage Homer, Sr. Bowdoin College Museum of Art, Brunswick, Maine, Gift of the Homer Family, 1964.69.181.4

1854/1855

Begins an apprenticeship at the lithography shop of John H. Bufford, in Boston, at the corner of Washington and Avon streets. He designs sheet-music covers and similar commercial work.

In 1855, Charles S. Homer, Jr., graduates from Harvard's Lawrence Scientific School; he later becomes a successful chemist and prosperous businessman.

1857

24 February After completing his two-year apprenticeship, leaves Bufford's on his twenty-first birthday. Rents a studio in the Ballou Publishing House building on Winter Street and begins a career as a freelance illustrator.

13 June First illustration, "Corner of Winter, Washington, and Summer Streets, Boston," is published in *Ballou's Pictorial*. *Ballou's* describes Homer as "a promising young artist of this city."

"Ballou's Publishing House, Winter Street, Boston, 1856." Wood engraving. In *Ballou's Pictorial*, 6 December 1856

1 August Publishes first illustration for *Harper's Weekly*, "The Match between the Sophs and Freshmen [at Harvard]."

1858

Family moves to Belmont, Massachusetts, probably early in the year.

4–8 August Attends a Methodist camp meeting at Eastham, Cape Cod, Massachusetts, for *Ballou's Pictorial*.

1859

Fall Leaves Boston for New York, where he lodges at Mrs. Alexander Cushman's boarding house, 52 East 16th Street, with the Boston artist Alfred C. Howland, Alfred's brother Henry, and Charles Vorhees. Also rents a studio in Nassau Street. *Harper's* offers Homer a fulltime position, but he prefers to freelance, later recalling that his apprenticeship was "too fresh in my recollection to let me care to bind myself again."

"Harpers Publishing House, The Franklin Square Front, New York," built 1855. Wood engraving. In *Visitors' Guide to Harper & Brothers' Establishment*

The University Building, New York. Lithograph. Collection of the New-York Historical Society

3 October Registers on or shortly after this date in the Life School of the National Academy of Design. Receives special permission to bypass the required period of drawing from plaster casts.

1860

12 April–16 June *Skating on the Central Park,* probably a work on paper, is his first picture shown at the National Academy of Design. Address is listed as 52 East 16th Street.

10 July Homer's brother Charles presents him with a copy of M. E. Chevreul's *The Principles of Harmony and Contrast of Colors.* (Charles inscribed this date on the book, now in the Strong Museum, Rochester, New York. Copy also indicates that Homer's studio was now "No. 8 University Building, New York City.")

October Enrolls again in the National Academy of Design's Life School.

November 1860–January 1861 Makes drawings of Lincoln and others after Mathew Brady's photos for *Harper's Weekly.*

1861

Takes instruction from Professor Thomas Seir Cummings as a night student at the National Academy of Design. Also studies painting with the French artist Frédéric Rondel.

2 March Sketch of Abraham Lincoln on the balcony of the Astor House is published in *Harper's Weekly.*

March Covers Abraham Lincoln's inauguration in Washington for *Harper's Weekly.*

Summer Probably at family home in Belmont. (Homer drew the nearby Watertown arsenal for *Harper's Weekly,* 20 July.)

July Visits Lake George, New York, with the artist Benjamin Bellows Grant Stone.

October Probably Homer's first visit to the front covering General McClellan's Army of the Potomac for *Harper's.* May have written the following to his father: "I am instructed to go with the skirmisher's

in the next battle. Bonner [managing editor of *Harper's Weekly*] thinks Homer is smart and will do well if he meets no pretty girls down there, which he thinks I have a weakness for. I get $30. per week RR fair paid but no other expenses" (Hendricks 1979, 46).

8 October Fletcher Harper, publisher and editor of *Harper's Weekly,* writes the military to request cooperation and ask that Homer be given "such facilities as the interests of the service will permit for the discharge of his duties as our artist-correspondent" (MVLA).

15 October Issued a pass by an adjutant to General McClellan, which allows him to be "within the line of main guards one week" (Strong Museum).

21 October In Belmont for Thanksgiving dinner with family before leaving for Washington.

28 October Mother writes Arthur: "We hear often from Win he is in Washington 331 F Street Mrs Foster's. He scaled a parapet while out sketching.... the only wonder was that he was not shot his head popping up in such high places..." (Hendricks 1979, 45).

Fall Visits Mount Vernon.

17 December Mother writes Arthur: "Win is well and Happy and back again at Mrs. Cushman's 52 E. 16th Street N. York.... Perhaps you, even you, will be able to contribute towards a loan I hope to get up for him this winter to go abroad in the Spring..." (Hendricks 1979, 45).

1862

1 January Father writes Arthur: "Win must go to Europe and you and Charles must help" (Hendricks 1979, 46).

18 February Letter from Homer's cousin, Lieutenant Colonel Francis Channing Barlow, to Barlow's mother: "I should be glad to see Homer here [Virginia] & if we are farther out he must come out there" (MHS). Barlow is depicted in *Prisoners from the Front* (cat. 10).

1 April At the front to record McClellan's Peninsular Campaign.

Another pass issued to Homer by the provost marshal's office, allowing him "to pass to and from Virginia for the purpose of Business" (BCMA).

2 April Homer, still at Alexandria, inscribes drawing: "The 6th Penn Cavalry/Embarking at Alexandria/for Old Point Comfort/This is a full Regt. All the Men have/Lances which they use with great skill...."

5 April Dated drawing inscribed: "The Ocean Queen with Irish Bregade [sic] on board going down the Potomac."

16 April Dated drawing inscribed: "Assault on Rebel Battery at Lee's Mill April 16th/Motts Battery supporting Hancock's Brigade."

18 April Barlow described a visit by Homer in a letter to his brother Edward: "I have enjoyed his & Homer's visit exceedingly. It seemed quite like home to have them here & I have not laughed so much since I left home..." (MHS).

23 April Barlow, preparing for the siege of Yorktown, writes Edward again: "[Homer] now does not dare go to the front having been the object of suspicion even before. He says he will go home after the battle" (MHS).

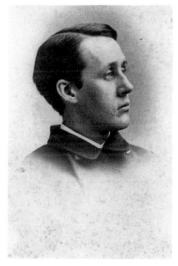

Major General Barlow, c. 1862. Bowdoin College Museum of Art, Brunswick, Maine, Gift of the Homer Family, 1964.69.174.26

31 May–1 June The text, not the image, accompanying Homer's wood engraving "The War for the Union, 1862—A Bayonet Charge," published in *Harper's Weekly* on 12 July, can be linked to the Battle of Seven Pines (or Fair Oaks), Virginia, of 31 May–1 June.

7 June Mother writes Arthur: "Winslow went to the war front of Yorktown and camped out about two months. He suffered much, was without food 3 days at a time & all in camp either died or were carried away with typhoid fever—plug tobacco & coffee was [sic] the Staples.... He came home so changed that his best friends did not know him, but is well & all right now..." (Hendricks 1979, 50).

15 November "The Army of the Potomac—A Sharpshooter on Picket-Duty" is published in *Harper's Weekly* with the inscription "From a painting by W. Homer." Russell Shurtleff, a landscape painter, recalled "his very first picture in oils [cat. 1] was painted in his studio in the old University Building in Washington Square. It represented a 'Sharpshooter' seated in a brig top, aiming at a distant 'Reb.'"

Campaign Sketches, title page. Lithograph. Gift of Charles G. Loring, Courtesy Museum of Fine Arts, Boston

1863

Summer Homer in Belmont, Massachusetts, where he probably collaborates with the lithographer Louis Prang on the series *Campaign Sketches*.

October Enrolls again in the National Academy of Design's life class.

December Agrees to work on a second series of twenty-four lithographs with Prang, *Life in Camp*, later published in 1864.

1864

Elected a member of the Artists' Fund Society.

30 April *New York Leader:* "Mr. Homer studies his figures from reality, in the sunshine. If you wish to see him work you must go out upon the roof and find him painting what he sees."

5–7 May Probably witnesses the Battle of the Wilderness in Virginia. Homer told Charles B. Curtis that the painting *Skirmish in the Wilderness* (cat. 4) had used works made on the spot (ULCL).

May Elected an associate of the National Academy of Design. Instead of the required self-portrait, submits a portrait of himself by Oliver Lay.

15–18 June Ulysses Grant's attack on Petersburg fails and the city is placed under siege. *Defiance: Inviting a Shot before Petersburg* (cat. 5) is most likely based on sketches made at this time.

1865

16 February Reported by the *New York Evening Post* to be working on *The Bright Side* (cat. 6) and *Pitching Quoits* (cat. 7).

May Elected a full academician of the National Academy of Design.

Summer According to *The Round Table*, 9 September 1865, spent his summer in Newport and Saratoga "whence he has sent many excellent contributions to the illustrated journals of the city."

30 November Nominated by William Oliver Stone and Eastman Johnson, is elected a member of the Century Club, New York.

1866

21 February The *Evening Post* reports that he is at work on *Prisoners from the Front* (cat. 10).

9 May Date of Homer's National Academy of Design diploma making him a full academician and noting acceptance of his diploma picture, *Croquet Player*. Homer inscribed the back of the diploma: "Winslow Homer would like to have the privilege of painting a better picture" (BCMA).

19 May Reported by *The Round Table* to be spending most of his summer at Belmont, Massachusetts.

30 June The *New York World* reports: "Winslow Homer…works during the 'heated term' at Belmont, Mass."

July An important early article on Homer by Thomas B. Aldrich appears in *Our Young Folks*. Aldrich reports that Eastman Johnson, A. Fredericks, W. J. Hennessy, Eugene Benson, Edwin White, Marcus Waterman, C. G. Thompson, A. J. Davis, and J. A. Howe all have studios with Homer at the New York University Building.

17 November With Eugene Benson organizes a sale at Leeds and Miner, New York, "The Entire Collection of the Works of Messrs. Winslow Homer and Eugene Benson, who are leaving for Europe," including nineteen works by Homer. The critic for *The Nation* writes: "…these gentlemen are about to sail for Europe, where they propose making a long stay. So far as Mr. Homer is concerned, we are sorry to hear it. His work is delightful and

Eugene Benson. *Self-Portrait*. Oil on canvas. National Academy of Design

strengthening, and promises much; and although it may well be improved in many respects by his residence and study abroad, it is much more likely to be injured.…"

27 November Homer's passport application filed at the State Department. He is listed as five feet, seven inches tall with brown eyes and dark brown hair.

Bautain. *Winslow Homer*, 1867. Bowdoin College Museum of Art, Brunswick, Maine, Gift of the Homer Family, 1964.69.179.1

5 December Sails from Boston on the *Africa* to Europe. Spends a year in Paris, part of the time sharing a studio in Montmartre with his friend from Belmont, Albert Warren Kelsey. During the year produces nineteen small paintings and sends three illustrations to *Harper's Magazine*.

1867

26 August Writes from France to his friend Charles Vorhees in New York asking if he would like to buy the painting *Waverly Oaks* for a hundred dollars: "I am working hard and have improved much, and when I come home can make money, but I wish if possible to stay here a little longer" (Goodrich 1944a, 40).

Late Summer Probably travels to Cernay-la-Ville in Picardy, forty miles outside of Paris.

Fall Arrives in New York. Homer's return fare was apparently paid by Kelsey. Downes reported that "Soon after his return to New York Homer met J. Foxcroft Cole and Joseph E. Baker in Astor Place.…"

Tenth Street Studio Building, 43–55 W. Tenth Street, New York.
T. J. Burton Collection, Collection of the New-York Historical
Society

8 November *New York Evening Mail:* "Winslow Homer has re-established himself in a studio in the University Building."

6 December *New York Evening Mail:* "Winslow Homer is painting a small picture from one of the numerous sketches made by him during his recent visit to Paris."

21 December *Frank Leslie's Illustrated Newspaper:* "Winslow Homer, who has just established himself in one of the towers of the University Building, brings evidence with him of assiduous work during his residence of less than a year in France. Among his studies in oil are several vigorous ones drawn from French peasant-life in the harvest fields, and also some studies of landscapes…."

1868

18 February *New York Evening Post:* "Alfred Howland and Winslow Homer have taken a new studio together in the Mercantile Library Building, between Astor Place and Eighth Street."

4 April *Frank Leslie's Illustrated Newspaper:* "Messrs. Winslow Homer and A. C. Howland have lately established themselves in Clinton Hall, where they occupy one of the pleasantest and best arranged studios in the city."

24 August Probably in the White Mountains of New Hampshire.

1870

September First trip to the Adirondacks, with the artists Eliphalet Terry and John Lee Fitch; stays at the Baker family farm west of Minerva, New York. Also visits Keene Valley, about thirty miles away. The farm was later incorporated in 1887 as The Adirondack Preserve Association for the Encouragement of Social Pastimes and the Preservation of Game and Forests; in 1895 it was renamed the North Woods Club. Over the next forty years Homer would return about nineteen times, producing drawings, wood engravings, watercolors, and paintings.

1871

7 June *New York Evening Post:* "Winslow Homer will spend the summer among the Catskills."

Summer Perhaps begins regular visits to a house in Walden, New York, which Lawson Valentine (an important patron; varnish manufacturer; and the employer of Homer's brother Arthur, a chemist) started renting the previous year, as well as to Hurley, New York.

1872

Moves his studio to the Tenth Street Studio Building, 51 West Tenth Street, New York.

8 June *New York Evening Telegram* reports that Homer is working on the subject of Snapping the Whip and that he has finished *The Dinner Horn* (Detroit Institute of Arts).

8 July *New York Evening Post* reports that "Winslow Homer and F. Wood Perry are at Hurley, Ulster County, N.Y., sketching the quaint old Dutch interiors which abound in that neighborhood."

18 December Attends funeral for the Hudson River School artist J. F. Kensett. Also present are H. B. Brown, Jasper Cropsey, R. S. Gifford, S. R. Gifford, Eastman Johnson, John La Farge, Le Clear, Page, Worthington Whittredge, and J. F. Weir.

1873

By 1873 Homer is a member of the Palette Club, New York.

1 February Attends the monthly meeting of the Century Association.

April No works exhibited at the National Academy of Design. Attends the opening reception and, with Worthington Whittredge and William Oliver Stone, is on the Hanging Committee.

14 May Elected to the council of the National Academy of Design.

Late June Visits Gloucester, Massachusetts, taking rooms at the Atlantic Hotel. Produces his first series of watercolors in Gloucester.

20 August *Gloucester Telegraph:* "Winslow Homer, the artist, has been spending the summer at the Atlantic House, and the pages of 'Harper's Weekly' have been heightened by his seaside sketches." A similar notice appears in *The Cape Ann Advertiser* on 22 August.

Fall *The Courtin'*, a book by James Russell Lowell, is published with illustrations by Homer. The silhouettes used in the book had been made by Homer in the spring of 1871.

3 November The *New York Evening Post* reports that "Messrs. T. W. Wood and Winslow Homer are yet sketching in the country."

1874

Spring Visits Valentine at Walden, New York.

15 May–10 June Second visit to the Adirondacks, where he stays for a month at the Thomas Baker farm near Minerva in Essex County, New York.

21 July Working in East Hampton, Long Island, a summer resort.

Late Summer or Early Fall Visits Keene Valley in the Adirondacks.

By Early October Stays at Widow Beede's Cottage at Keene Valley, possibly traveling to Baker farm with the guides Orson Phelps and Monroe Holt.

1875

8 February The *New York World* reports that Homer is working on *Letting Down the Bars* (*Milking Time*, cat. 49) and *The Course of True Love*.

6 March Attends monthly meeting of the Century Association.

"Gloucester and Scenes along Cape Ann." Wood engraving.
In *Every Saturday*, 18 February 1871

3 April Attends monthly meeting of the Century Association.

22 June The *Daily Evening Transcript*, Boston, reports that "Winslow Homer is to visit the coast of Massachusetts, whence, after spending a season, he will go to the Catskill Mountains." A similar report appears in the 29 June edition.

Homer's brother Arthur marries Alice Patch in Lowell, Massachusetts.

July First visit to Prout's Neck, Maine, to see Arthur and his new bride during their honeymoon at the Willows Hotel.

Henry James reviews Homer's work in the *Galaxy:* "He is a genuine painter; that is, to see, and to reproduce what he sees, is his only care; to think, to imagine, to select, to refine, to compose, to drop into any of the intellectual tricks with which other people sometimes try to eke out the dull pictorial vision—all this Mr. Homer triumphantly avoids."

25 July *New York Evening Post:* "E. Wood Perry and Winslow Homer are passing the summer at East Hampton, Long Island."

30 July *Daily Evening Transcript,* Boston: "E. Wood Perry and Paul P. Ryder are making studies of the old houses at Leeds, Ulster County. Mr. Winslow Homer will join them at the same place during the present week."

7 August A letter from Winslow Homer to Philip Henry Brown indicates that his parents are with him in Prout's Neck.

28 August Last wood engraving for *Harper's,* "The Family Record," is published.

September Arthur Homer and his wife move to Galveston, Texas, where he runs a lumberyard. (There is speculation that Homer may have at one time visited his brother on one of his later trips to Key West, Florida. The Mallory line Key West steamer also went to Galveston.)

1 October *New York Evening Post:* "E. Wood Perry and Winslow Homer are at Hurley, Ulster County."

6 November An article appears in *Appleton's Journal* describing a visit to the artist's studio: "A Visit to Mr. Winslow Homer's studio a few days ago showed us about twenty important studies as the result of his summer vacation.... Looking over the pictures, the visitor finds that Mr. Homer has made great use of some half-dozen models which he has arranged and grouped in a variety of ways."

1876

8 January Attends Century Association meeting.

26 February Elected a member of the American Society of Painters in Water Colors at the close of their annual exhibition.

3 April In a letter to Valentine, Homer discourages him from purchasing *A Fair Wind* (cat. 76), saying "I am about to paint much better pictures" (CCL).

30 August *Daily Evening Transcript,* Boston: "E. Wood Perry and Winslow Homer of New York are sketching in the neighborhood of Hurley, Ulster County."

24 September First documented visit to Valentine's Houghton Farm.

1877

9 June *New York Tribune:* "The fruits of one trip away from New York are already visible at the studio of Mr. Winslow Homer who has been spending a few weeks in the South, and is just home." Although Homer is thought to have visited the South several times in the mid-1870s, specifically Petersburg, Virginia, this is the only direct reference to a trip.

19 June The *Evening Post:* "Mr. Winslow Homer, the artist, has taken the studio formerly occupied by the late Mr. J. Beaufrain Irving in the Tenth Street building."

Fall Member of the Tile Club with William Merritt Chase, Edward Austin Abbey, J. Alden Weir, F. Hopkinson Smith, William R. O'Donovan, C. S. Reinhart, and Arthur Quarterly. The members execute 8 x 8 inch decorative tiles.

13 October *New York Tribune* reports: "Winslow Homer is back from the Adirondacks, finishing two pictures of life in that region, one of a camp-fire at night in the woods, and the other of a tramp to Mt. Marcy."

1878

16 January The *New York Daily Graphic* reports that Homer is at work on *Autumn* (cat. 88) and *Butterfly Girl* (New Britain Museum of Art).

26 January *New York Post* reports that Homer is working on *Sunday Morning in Virginia* (cat. 81) and *A Visit from the Old Mistress* (cat. 80) for the Paris Universal Exhibition.

3 February The *New York Herald* reports that Homer is at work on *Sunday Morning in Virginia.*

7 May *New York Evening Mail:* "Mr. Winslow Homer, feeling a little under the weather, will soon go into the country on a fishing excursion of a week or two."

28 May The *Daily Evening Transcript,* Boston, reports that an exhibition of drawings and sketches by Homer is at Mr. C. F. Libbie's auction room: "There are eighty-four in pencil crayon, charcoal and watercolor, embracing bits of army life, and life (especially child-life) at the seashore and in the country; all as American, as Yankee in character as the 'stars and stripes,' but without a particle of vulgar forcing of that idea."

August An important biographical sketch of Homer by George Sheldon, "American Painters—Winslow Homer and F. A. Bridgman," appears in the New York edition of *The Art Journal.*

Summer and Fall At Houghton Farm in Mountainville, New York, where he produces about fifty watercolors and numerous drawings and oil studies.

11 November *New York Post:* "Mr. Winslow Homer has returned from the country with a large collection of sketches and studies in water-colors, some of which were recently on exhibition at the Century Club."

Napoleon Sarony. *Portrait of Winslow Homer,* 1880. Bowdoin College Museum of Art, Brunswick, Maine, Gift of the Homer Family, 1964.69.179.3

1879

Summer No precisely documented record of Homer's visits to Houghton Farm exists, although it is generally agreed that, in addition to spending time in West Townsend, Massachusetts, he was there sometime during the summer of 1879.

August *The Art Amateur:* "Mr. Winslow Homer's movements in summer-time no person however intimate is ever supposed to have the secret, and the present season is not made an exception."

1880

24 January Attends a Tile Club dinner in honor of the publishers of the *Atlantic* at the Tenth Street studio of William Merritt Chase.

17 February Writes Valentine: "As a great favor to me I ask you to defer the painting of your picture until the 5th of March.... March is my best month for work" (CCL).

20 March *Andrews' American Queen:* "Winslow Homer designs relinquishing his studio at a date not far distant, and continuing his work in private."

April In one of his few recorded comments about his methods, Homer is quoted in the *Art Journal,* New York: "I tell you it is impossible to paint an out-door figure in the studio-light with any degree of certainty. Out-doors you have the sky overhead giving one light; then the reflected light from whatever reflects; then the direct light of the sun:

so that, in the blending and suffusing of these several luminations, there is no such thing as a line to be seen anywhere."

Summer Returns to Gloucester, living in solitude on Ten Pound Island, a tiny spot in the middle of Gloucester Harbor, where he produces more than one hundred watercolors and drawings. J. Eastman Chase recalled: "Here he lived for one summer rowing across to the town only when in need of materials. The freedom from intrusion which he found in this little spot was precisely to his liking...." Joseph E. Baker recalled: "He knew plenty of nice people, but he associated with two fishermen, and preferred their company."

14 September *Daily Evening Transcript*, Boston: "Winslow Homer, the eminent New York figure painter, who has been passing the summer down this way studying his favorite New England types of seaside urchins and country maidens, was in town yesterday, on his way home, with a portfolio bursting with sketches."

December Exhibits more than one hundred watercolors and drawings of Gloucester at Doll & Richards, Boston, a gallery with which he would be associated for the rest of his life.

22 December *Art Interchange*. "To visit him in his studio, is literally bearding a lion in his den; for Mr. Homer's strength as an artist is only equalled by his roughness when he does not happen to be just in the humor of being approached."

1881

15 March Sails to England on the Cunard liner *S. S. Parthia*, landing at Liverpool and then moving on to London. After leaving London, settles in the small fishing village and artist's colony of Cullercoats near Tynemouth. Rents a cottage in addition to a studio at 12 Bank Top overlooking the North Sea. (No exact chronology for Homer's stay in Cullercoats has been established.)

21 July *Art Interchange* reports that the "latest bulletin from Winslow Homer described him as in Parthia," referring to the ship on which Homer had sailed to England.

S. S. Parthia, built 1870, Cunard Line. Courtesy Peabody & Essex Museum, Salem, Massachusetts

31 August A reviewer in the *Tyneside Daily Echo* comments on a Homer watercolor at the Newcastle Art Association Exhibition: "There is an attempt to catch the noble forms and attitudes so frequently to be found in the toilers of the earth and sea, who are unfettered by modern unconventionalities of costume. The aim is an admirable one, for on our English coasts and fields are to be found types of simple and noble beauty equal to those which inspired the old Greek masters, when they gave to the world treasures of hewn marble that stand out clear and unrivalled in all the succeeding ages."

1 September A report in *Art Interchange* indicates that Homer may have been planning to return to New York at the end of the summer.

Mid-September Writes to his Boston dealer J. Eastman Chase offering to pay for advertising and telling him he is sending thirty watercolors to be exhibited "in any way that you think best" (AAA, Chase).

7 October Writes Chase again: "By Dec. 1st I will send you some water colors—large size and price. What is the value of a beautiful picture by Corot 9 x 12 inches painted about thirty years ago— not signed. Can you place such a picture?" (AAA, Chase)

21 October Witnesses the wreck of the *Iron Crown*.

1882

February Chase organizes show of Cullercoats work in Boston. On 9 February the critic for the *Transcript* observed: "But what makes these sketches peculiarly valuable in our eyes is a certain unstrained poetic treatment of the various subjects, which, without any mawkish attempt at conventional sentimentalism, is delightfully suggestive."

Informs Chase that he has forwarded the watercolor *Wreck of the Iron Crown* (cat. 112) "which I saw at Tynemouth Oct. 28th." (The shipwreck occurred on 21 October 1881.) Discussing the sale of his works promises "if you can raise the devil at your end I will try to do it at this" (AAA, Chase).

5 March Writes Chase: "I propose making a 'corner' in my work by giving everything away where it will never come on the market again....I shall send you from time to time a watercolor" (AAA, Chase).

Summer Winslow's brother Arthur builds a cottage for his family on Prout's Neck, dubbing it "El Rancho." (A reference to his Texas home.)

4 November Writes his friend William B. Long in New York City that he will sail for New York on the Cunard liner *Catalonia* in a week.

11 November Departs from Liverpool.

24 November Arrives in New York. He eventually takes up residence at 80 Washington Square East and continues to work on about twenty English subjects based on his stay in Cullercoats.

1883

Starting in early 1883, Charles Homer, Sr., financed by Charles Homer, Jr., buys almost all of Prout's Neck. By the summer the family house, called the Ark, is finished. Over the next twenty years a cottage community is developed by the Homer family, with Winslow taking an active interest in the management of Prout's Neck.

The Ark, Prout's Neck, Maine, c. 1883. Bowdoin College Museum of Art, Brunswick, Maine, Gift of the Homer Family, 1964.69.153.10

12 January Attends the opening of an exhibition of Boston artists at the Kurtz Gallery, New York.

18 May The *Daily Evening Transcript*, Boston: "Winslow Homer is to settle permanently at Scarborough, Me."

1 July The *Boston Globe* writes: "It is said that Mr. Winslow Homer...has had so little financial encouragement in New York that he proposes to leave the city. He will have a studio-dwelling not far from Portland, where he will paint to please himself, expecting to give exhibitions of his works occasionally in Boston, his native city."

Summer Stays at the Ark at Prout's Neck producing watercolor studies of rocks and surf. He uses a room on the top floor as a studio.

Visits Atlantic City. Observes a life-saving crew using a breeches buoy, which he later incorporates into *The Life Line* (cat. 132).

November Mariana Griswold Van Rensselaer publishes "An American Artist in England," an important article on the Cullercoats works, in *The Century Magazine*.

1–15 December A large exhibition of Homer's watercolors is held at Doll & Richards, Boston.

1 December *Boston Advertiser:* "Mr. Homer, as was stated last spring, has left New York and retired to a secluded country house on the coast of Maine, a locality excellently adapted to the practice of his art. He is the painter par excellence of the life of those who go down to the sea in ships."

Late 1883 or Early 1884 Proposes to convert the carriage house at Prout's Neck into a studio and hires the architect John Calvin Stevens to design it.

1884

Spring Makes his first etching, *Saved*, after the painting *The Life Line* (cat. 132). Receives some instruction in etching from his printer, George W. H. Ritchie, but is largely self-taught. Ritchie also initially handled the sale of Homer's prints.

27 April Death of his mother, in Brooklyn.

6 May Writes his sister-in-law, Mrs. Charles Homer, Jr., known as Mattie: "I went into the house at Prout's today—Found it in good order—Thought of Mother with a certain amount of pleasure, Thank the Lord I knew that if possible she was with me. I feel quite well for the first time in two weeks" (BCMA).

14 May Selected to serve on the exhibition committee of the National Academy of Design at their annual meeting.

24 June Writes Mattie: "The Studio will be quite wonderful. Will have it finished in about a week. It's very strong. The piazza is braced so as to hold a complete Sunday school picknick. Charlie will be very much pleased with it" (BCMA). Prout's Neck is now Homer's permanent address.

Winslow Homer on the gallery of his Prout's Neck studio, c. 1884. Bowdoin College Museum of Art, Brunswick, Maine, Gift of the Homer Family, 1964.69.153.11

1 September Writes Charles from Prout's Neck: "We are all well at the Old Ladies Home....I shall stay until December first if not longer. I like my home more than ever as people thin out" (BCMA).

The Royal Victoria Hotel, Nassau, 1885. In William Drysdale, *In Sunny Lands: Out-door Life in Nassau and Cuba*

Late 1884 Commissioned by *Century Magazine* to illustrate an article on the Bahamas. The article, "A Midwinter Resort," written by William C. Church, appears more than two years later in the February 1887 issue, with nine illustrations by Homer.

29 November–6 December An exhibition of Homer's work entitled *Studies in Black and White* is held at Doll & Richards, Boston, with eighty works. A critic for the *Evening Transcript* comments: "...he reads below the external manifestation of Nature, finds the soul of the scene, and leaves the men who see his work to feel in themselves all the superhuman exultation that comes in a mighty tempest...."

December *Boston Herald*, "The Strange Hermitage of Winslow Homer on the Maine Coast": "Here, since his quarters have been fitted to bear the strain, the artist passes summer and winter, in profound and guarded solitude, seeing no company, speaking to any of the natives only on business or necessity, and absolutely tabooing all curious visitors and sightseers."

4 December Sails for the Bahamas with his father on Ward Line steamship *Cienfuegos*, stopping first in Nassau and staying at the Royal Victoria Hotel. During his two-month visit produces more than thirty watercolors.

1885

17 February Takes the Ward Line steamer *S. S. Santiago* to Santiago de Cuba, leaving his father in Nassau. Spends about five weeks in Cuba.

February Writes Charles from Santiago de Cuba: "Here I am fixed for a month—having taken tickets for N.Y. on 8th, leaving 27th of March—this is a redhot place full of soldiers....I expect some fine things, it is certainly the richest field for an artist that I have seen" (BCMA).

27 March Probably leaves Cuba on a steamer from Santiago to the city of Cienfuegos.

8 April Arrives in New York with his father and returns to Maine.

19 April *New York Times:* "Mr. Winslow Homer has been a diligent student this winter of the affects of color on the Bahamas and at St. Iago di Cuba. He brings back a big portfolio of water color sketches, in which his well-known boldness in painting things as they are appears to great advantage."

Summer and Fall Works on *The Herring Net* (cat. 133), *Lost on the Grand Banks* (cat. 135), and *The Fog Warning* (cat. 134).

December On his first trip to Florida, probably arrives in Jacksonville before traveling to Tampa by train.

William Henry Jackson. *St. James Hotel, Jacksonville, Florida,* c. 1900. Library of Congress, Prints and Photographs Division, Detroit Publishing Company Photograph Collection

1886

January Probably sails to Key West from Tampa and remains until late February before returning to Jacksonville.

24 February Celebrates his fiftieth birthday at the St. James Hotel in Jacksonville with his father and Valentine.

Late February or Early March Returns to New York with his father.

5 April Opening of the National Academy of Design exhibition. Homer, through a rotation system, was on the hanging committee with Alfred Howland and R. W. Hubbard, D. Huntington, George Inness, Oliver Lay, and Walter Saterlee.

May "Rush's Lancers, Franklin's Advance Scouts," an illustration, appears in the Century magazine series on *Battles and Leaders of the Civil War*. It is one of fifteen drawings, all based on Homer's Civil War and Reconstruction sketches of the 1860s and 1870s, which were finally published either as part of the magazine series (November 1884–November 1887) or in the four octavo volumes issued by the Century Company between November 1887 and January 1889.

5 December Writes his father about life at Prout's Neck: "I have just put coal on the fire which accounts for this smudge. I made a mistake in not getting a larger stove. It is very comfortable within ten feet of it. It heats the room within two feet of the floor and water freezes anywhere within that space....I thank the Lord for this opportunity for reflection..." (BCMA).

21 December Writes Mattie: "I thank you very much for your wish to have me join your Christmas party but it will not be possible. I hope to cut short my business here...and be in N.Y. New Years Day" (BCMA).

24 December Writes his cousin Grenville H. Norcross: "Thank you for your politeness in sending me the club ticket and I appreciate the compliment from the club. But it must not surprise I should not use it, as I am taking a rest, after a summer of unusual excitement" (MHS).

1887

February In an article on Homer's career for *The Art Review*, Augustus Stonehouse writes: "The singular part of Mr. Homer's development was its slowness. He seems to have inherited along with his baptismal name the characteristic expressed by the punning legend of the Winslow family....He is the author of the complaint attributed to many others, 'For fifteen years the press has called me "a promising young artist," and I am tired of it.'"

"A Midwinter Resort: with Engravings of Winslow Homer's Water-Color Studies in Nassau" is published in *The Century Magazine*.

25 September Writes Charles from Prout's Neck: "I have secured a proof for you—The best in one hundred which I have signed of *The Fog Warning*. Its one of the few printed on parchment. I am very busy painting in water color which means something that I can sell for what people will give" (BCMA).

1888

28 January Elected to the North Woods Club, an outdoor sportsman's club in the Adirondacks.

2 April–12 May *Eight Bells* (cat. 144) is exhibited at the National Academy of Design. After 1888, Homer no longer shows regularly at the Watercolor Society or Academy exhibitions, instead relying mainly on his dealers to show and sell his work.

16 April In Prout's Neck, where he spends the rest of the year. Writes Charles: "You can see I can afford to live better than you can—as I cut off Servants that mean all these good things—each extra one means about three legs of mutton—which you go without and eat corned beef and cabbage" (BCMA).

14 May Writes Chase: "I have an idea for next winter if what I am now engaged on is a success and Mr. Klackner is agreeable. That is to exhibit an oil painting in a robbery box with an etching from it, in the end of your gallery with a pretty girl at the desk to sell and possibly some other etchings

enough to make that end of your place attractive enough for your approval" (AAA, Chase).

1 August Signs an agreement with Christian Klackner, New York, giving him exclusive publishing rights for his etchings (BCMA).

1889

6 May–13 July Returns to the Adirondacks for the first time in fifteen years, registering at the North Woods Club.

1 October–24 November Registered at the North Woods Club. Homer completes nearly three dozen watercolors on these two visits.

1890

After producing no dated paintings between 1887 and 1889, Homer paints five works in 1890: *Cloud Shadows* (Spencer Museum of Art), *A Summer Night* (cat. 186), *Sunlight on the Coast* (fig. 205), *Winter Coast* (cat. 187), and *The Signal of Distress* (cat. 155). *Sunlight on the Coast* is Homer's first pure seascape.

Winslow Homer; his dog Sam; his sister-in-law Mattie Homer; and his father, Charles Savage Homer, sitting on the front porch of the family house. Bowdoin College Museum of Art, Brunswick, Maine, Gift of the Homer Family, 1964.69.153.4

19 January Writes Reichard & Co. from Prout's Neck: "I shall be in New York by February....If you approve of the following notice for publication in the Sporting papers we will have it in: To Fly-fisherman and Sportsman—On exhibition February 5th to 12th a small collection of water colors taken in the North Woods by Winslow Homer N.A. and treating exclusively of fish and fishing" (AAA, Evans).

Early February Leaves Maine for Enterprise, Florida, a fishing resort on the St. Johns River, where he produces at least eleven watercolors.

16 February Writes the collector Thomas B. Clarke from the Brock House Hotel, describing Enterprise as "the most beautiful place in Florida" (AAA).

February Reichard exhibits thirty-two Adirondack watercolors; twenty-seven sell. Exhibits primarily at Reichard's or New York private clubs, such as the Century, Union League, the Manhattan, the New York Athletic Club, and the Lotos Club, in the 1890s.

23 February Writes Reichard & Co. from Enterprise, Florida: "I leave here next Friday. I am quite encouraged at the success of my exhibition and have to thank you for the good management that has produced it. I shall return to New York by the first week in March. I have had good luck here. If you ever wish the best place in Florida to stay a week or two this is it" (AAA, Evans).

10 December Writes Charles: "I sent my Moon Light to C. Klackner to-day....I have got a fine picture called 'The Distress Signal' [cat. 155] a scene in mid ocean" (BCMA).

1891

21 January *Signal of Distress* (cat. 155), *A Summer Night* (cat. 186), *Sunlight on the Coast* (fig. 205), and *Winter Coast* (cat. 187) are exhibited at Reichard's. Alfred Trumble in *The Collector* commented: "To say that Mr Winslow Homer exhibits at Reichard & Company's galleries the four most complete and powerful pictures he has painted, is to do them but half justice. They are, in their way, the four most powerful pictures that any man of our generation and people has painted." *Winter Coast* and *Sunlight on the Coast* were purchased from the exhibition by John G. Johnson of Philadelphia.

5 May Valentine, Homer's friend and patron, dies at Houghton Farm.

9 June–31 July Registered at the North Woods Club.

1 October Registered at the North Woods Club. Completes fewer than ten watercolors during the two visits.

15 October Writes Charles about *Huntsman and Dogs* (cat. 176) and *Hound and Hunter* (cat. 179): "I am working very hard & will without doubt finish the two oil paintings that I commenced Oct. 2nd & great works they are. Your eye being fresh from European pictures, great care is required to make you proud of your brother" (BCMA).

5 November Writes his cousin Marie Blanchard from Prout's Neck: "I am glad to get home again after my long trip to the Adirondacks. Everything is quiet here, but father, and he is like Wall Street on a 'black Friday' with his business" (AAA).

Winslow Homer; his father, Charles Savage Homer; and his dog Sam, at Prout's Neck, c. 1890–1895. Bowdoin College Museum of Art, Brunswick, Maine, Gift of the Homer Family, 1964.69.153.3

29 December Writes Mattie from Prout's Neck: "I have proof that there is something fine in that wine, as I had taken a glass and was peeling vegetables for my dinner and thinking of the painting that I had just finished, and singing with a very loud voice See! the Conquering Hero Come [from Handel's oratorio *Judas Maccabaeus*]. And I sung it, 'Sound the Parsnip, Beat the Drum!'" (BCMA).

1892

28 March In response to Clarke's letter about his plans to create a Homer gallery in his house, Homer answers: "I never for a moment have forgotten you in connection with what success I have had in art. I am under the greatest obligations to you, and will never lose an opportunity of showing it. I shall always value any suggestion that you may make.... Now that you have space in 'your Homer Gallery' I can from time to time as you fancy any work let you have it" (AAA).

1 April Memorandum from C. Klackner to Homer indicating that he has sold twenty-one of Homer's etchings (BCMA).

16 April Writes Mattie from Prout's Neck: "You will be glad to know that I also have had great luck this past year and as Father tells me, I am rich" (BCMA).

18 June–28 July Registered at the North Woods Club.

17 September–10 October Registered at the North Woods Club. Completes more than thirty watercolors during his two visits to the club.

25 October Writes Clarke: "You certainly keep my pictures before the people, and I must acknowledge that you have done more for my reputation than I have. But I think that your idea of an exhibition of my things is wrong just now. It will be better

to wait a year or two and see what I am good for.... I have painted very few things this summer for the reason that good things are scarce and I cannot put out anything in my opinion bad....My plan is to copyright it [*Hound and Hunter*; cat. 179], have Harper publish it in the 'Weekly' to make it known, have Klackner publish it as a print, and then exhibit it for sale, first in Boston (at $2,000), with my watercolors" (AAA).

5 November Clarke writes Homer: "I enclose my cheque for $1000 in payment for the unframed canvases *Carnival* [cat. 82], *Visit to the Missie* [cat. 80]. Your kind letter of Oct. 25 was duly received. I had no idea of exhibiting your picture except in one room in my residence on 44 St. The display at the NAD was for a week and made a happy hit. I thank you for letting me know about your new picture..." (BCMA).

3 December Five sketches shown at the Century Association.

11 December Writes Clarke: "The sketches sent to the Century I shall finish into pictures some day" (AAA).

29 December Writes to Alice Homer from Prout's Neck: "The days are so short and I have so much to do that I now only write one letter that will do for both you and Arthur—I wish to express my thanks for your Christmas Greeting and the book you sent to me and any other kind things you may have done or said…" (BCMA).

1893

14 January An exhibition of the paintings to be shown at the Chicago World's Fair is held at the Mechanics Building in Boston. The *Daily Evening Transcript* reports: "Winslow Homer said to John J. Enneking that it was the best-hung collection of paintings he had ever seen in this country...."

14 February Theodore Robinson diary: "A lot of Homers at Reichard's that are going to Chicago" (FARL).

Spring With Charles, visits Quebec for the first time. They become members of the Tourilli Fish and Game Club on Lake Tourilli near the village of St. Raymond. Makes no watercolors on his first visit, but will subsequently depict the area in forty-eight watercolors.

Spring/Summer Shows fifteen paintings at the Chicago World's Fair, where he is awarded a gold medal and paints *The Fountains at Night* (fig. 234).

9 April Writes Prang in Boston: "Just now I have arranged to leave for some time. I have been here all winter....Only think of our outliving all these other people" (AAA).

11 October Memorandum from C. Klackner to Homer recording the sale of four etchings (BCMA).

23 October In response to the offer for a show from his Chicago dealers, O'Brien & Son, writes: "I would say that I am extremely obliged to you for your offer, and if I have anything in the picture line again I will remember you. At present and for some time past I see no reason why I should paint any pictures. P.S. I will paint for money at any time. Any subject, any size" (Downes 1911, 167).

Homer's cabin, Tourilli Club, Province of Quebec. Bowdoin College Museum of Art, Brunswick, Maine, Gift of the Homer Family

18 December Writes Charles from Prout's Neck: "It has been too cold to go to Boston and leave my water and provisions, in fact it has been the very devil of weather, but I have been most comfortable and happy in having painted a picture 'Below Zero' [Yale University Art Gallery] which is fine" (BCMA).

27 December Writes Charles from Prout's Neck: "I was in luck in having warm weather on my visit to Boston. I find my water all right and now that I am home and Father is well I shall stay here, where I can have a good bed and board and interesting work" (BCMA).

30 December Writes Prang: "I deny that I am a recluse as is generally understood by that term. Neither am I an unsociable hog. I wrote you its true that it was not convenient to receive a visitor, that was to save you as well as myself. Since you must know it I have never yet had a bed in my house. I do my own work. No other man or woman within half a mile & four miles from railroad & P.O. This is the only life in which I am permitted to mind my own business. I suppose I am today the only man in New England who can do it. I am perfectly happy & contented. Happy New Year" (AAA).

1894

19 February Homer writes Harrison Morris, director of the Pennsylvania Academy of the Fine Arts: "…it will give me great pleasure to have my picture [*Fox Hunt*, cat. 230] in the permanent collection of your Academy" (AAA).

April The Pennsylvania Academy of the Fine Arts purchases *Fox Hunt*. It is the first important work by Homer to enter a public institution.

3 June–8 July Registered at the North Woods Club.

1895

22 January Robinson records in his diary: "A Winslow Homer at Macbeth's 1871. A panel, interior of a country store with three or four men—interesting, as he always is" (probably *The Country Store*, cat. 40; FARL).

21 February Writes Charles from Prout's Neck: "I am very well with a birthday to-morrow. I suppose I may have 14 more (that was Mother's age 73 years) and what is 14 years when you look back. The Life that I have chosen gives me my full hours of enjoyment for the balance of my life. The sun will not rise, or set, without my notice, and thanks" (BCMA).

20 April Sends Mattie a sketch of Benjamin Johnson Lang, a renowned musician and organist for King's Chapel Boston (BCMA).

June Writes Charles from Maine: "I shall be through with my work by July and shall loaf in different places, Canada preferred" (Goodrich 1944a, 147).

Probably Late Summer Writes Charles from Quebec: "I shall stay here tomorrow and Tuesday go to Roberval….I thank you for my visit to W. Townsend…" (BCMA).

August/September In Quebec, where he produces twenty-six watercolors including eleven monochromes. Most of them are painted near Lake St. John, far north of Quebec City.

18 September–December *Upland Cotton* (fig. 81) is awarded a gold medal at the Cotton States and International Exposition, Atlanta.

23 December–22 February Awarded a gold medal of honor at the annual exhibition of the Pennsylvania Academy of the Fine Arts.

25 December Writes Mattie: "Father and self have had a very pleasant Christmas. I shall go home to-morrow. I find that living with Father for three days, I grow to be so much like him that I am frightened. We get as much alike as two peas in age and manners. He is very well only he will starve himself. I shall go to Boston once in two weeks this next month to give him a dinner" (BCMA).

1896

19 January Writes Clarke from Maine: "…I can assure you that my best work is yet to come….I am engaged now in depressing things and making a 'corner.' I shall no longer put out anything unless it is carefully considered and made the most of" (AAA).

20 January Robinson records in his diary: "A rum Homer at Ortgies. 'Autumn' [cat. 88], a neat study of a model in walking dress and gloves, about 1870 with conventional brown background. A watercolor, fisherman walking along the shore, holding a little girl's hand, is better" (FARL).

17 March Writes Clarke from Maine: "I have never taken a commission since the days of Mr. Sherwood and I never will and a man who gives one cannot have a very sound idea of what he is about or will get" (AAA).

21 March Writes Charles: "I am in receipt of your invitation to visit New York. It is too soon. I have things to do here that interest me more. I have just returned from burning brush over on the eastern Point" (BCMA).

Winslow Homer. *Canoeist, Lake St. John, Province of Quebec*, c. 1895. Bowdoin College Museum of Art, Brunswick, Maine, Gift of the Homer Family

15 May–15 June Registered at the North Woods Club.

5 December Receives the chronological medal and $5,000 purchase award for *The Wreck* (cat. 196) at the Carnegie Institute's First International Exhibition. In his letter of acceptance to John Beatty, director of the department of fine arts, on 10 December, writes: "I shall prove if possible by my future work, that your opinion and this award has not been misplaced" (Goodrich 1944a, 141).

10 December Writes Charles and Mattie from Prout's Neck: "I thank you for your kind letters. I have been most deeply moved by the many expressions of friendship that I have received, as well as the great distinction conferred on me at Pittsburgh" (BCMA).

Serves on the jury for the Pennsylvania Academy. Director Morris recalled: "He was polite, modest, simple, without side….He might have been mistaken for a successful stock broker" (Goodrich 1944a, 150).

21 December–22 February Awarded the academy medal of honor at the annual exhibition of the Pennsylvania Academy of the Fine Arts.

1897

14 January Writes Charles: "My rooms are very sunny this time of year the sun being low shines under my top piazza into my house and with my new stove makes this place perfect—all but the bobolink—as for robbers I have no fear of them, sleeping or waking. I am a dead shot and should shoot, without asking any questions if anyone was in my house after 12 at night.—I can do this (living alone) without any chance of a mistake….I shall not go to Florida. I have been to Boston three times since you were here and in my trips one in October and two in December…" (BCMA).

21 January Writes Clarke: "I thank you for sending the 'Bright Side' [cat. 6] to the Century…also a great satisfaction to me that my new picture [*The Wreck*, cat. 196] was seen to so great an advantage as you say. I did not think it would ever leave the Carnegie Gallery" (AAA).

25 January Writes Charles from Prout's Neck: "I am just home from a walk this 10AM—very cold—vapor in high strings all over the sea…" (BCMA).

11 March Writes his father: "When I got home about one oclock I opened my fish and cooked two shad roes and cut up a cucumber in cold water then, with a quart of South Side Scarboro Cider—I knew that I was again in my own house" (BCMA).

17 March Writes Charles: "I am glad that I returned here as soon as I did as I was in time to answer a request for pictures for the Society of American Artists—and as I found in Boston that they like that 'Lookout' the 'Man with the Bell' [fig. 178] I have sent them that and Saco Bay [Clark Art Institute]" (Bowdoin).

Winslow Homer at his easel with "The Gulf Stream" in his painting room at Prout's Neck, Maine, c. 1899. Bowdoin College Museum of Art, Brunswick, Maine, Gift of the Homer Family, 1964.69.179.9

22 May Writes Clarke: "I have not been very well lately. The fact is I have had a most disagreeable winter as the unusual prominence given me by my taking that prize has kept me very busy in matters quite outside of my painting.…I expected to have gone to New York by this time on the way to the Adirondacks but my father has been upset in a stage coach and as long as he is black and blue I must study his color here" (AAA).

Summer Returns to Quebec, focusing on images of fishermen and the rapids.

29 September Writes Clarke about the loan of *A Light on the Sea* (Corcoran Gallery of Art) to the Union League Club in January: "It is the picture that must represent me this year as I have been working in watercolors" (AAA).

14–18 October Serves on the Carnegie Institute jury in Pittsburgh for four days with Frank Duveneck, William Merritt Chase, Will Low, Cecilia Beaux, Frank Benson, and Edmund Tarbell. In subsequent years will decline to serve on the jury.

15 December Writes Clarke about Canadian watercolors: "They are for a collection of water colors of Canadian subjects. They are very interesting.…I shall show them in New York in March when I may or may not offer them for sale. My idea is to keep them in one collection for some institution to buy the lot" (AAA).

1898

20 January Formally invited to join the American impressionist movement, later called "The Ten," by J. Alden Weir, but declines: "On receiving your letter I am reminded of the time lost in my life in not having an opportunity like this that you offer. The chance that each member will have of showing their work in a group, the larger the better, and under their own direction will be a great spur in tempting them to great effort and enterprise. I know on my own part that I have been kept from the Academy exhibition by the fear of the corridor and the impropriety of my trying to make terms as to placing my work. You do not realize it, but I am too old for this work and I have already decided to retire from business at the end of the season" (Goodrich 1944a, 154).

February–April Shows twenty-seven Quebec watercolors at Carnegie Institute, writing Beatty on 12 January: "As you have plenty of room I think if it is convenient for you, that the best place in your Galleries for a small show is on the Wall that was behind us when the Committee met and passed on pictures. That is the best light that I remember and would be just about large enough for two deep of my water colors. You know you can always get light by taking the soot off the glass on your roof. P.S. You will find that the men of Pittsburgh will like these things and the women will be curious to know what the men are liking and first thing you

know you will have an audience" (Goodrich 1944a, 149).

28 February Writes Charles from Prout's Neck: "I am going to Boston to have my hair cut. I shall be there from Wednesday to Saturday morning. My home here is very pleasant. I do not wish a better place…" (BCMA).

22 August Death of Charles Homer, Sr.

29 August Writes Beatty: "As I am about to leave here for two or three weeks I thought best to write to you that I may not have anything new for your exhibition. My time has been so taken by overlooking my father that I have not painted anything" (AAA).

30 October Writes Clarke: "I am notifying certain people who I may expect to hear from in the next [?] months that I shall not be in Scarboro Maine.…nothing will be ready until next spring.… My mail is not worth one dollar per year to me in cash. I shall not leave here before December and then I may go through New York and see you.… My father who has prevented any travel on my part of recent years died on August 22nd (89 years five months) in his 90th year" (AAA).

12 December Leaves New York on the *Seneca* to visit the Bahamas for first time since the 1884–1885 winter. He produces about twenty-five watercolors on this excursion.

1899

After 6 February Leaves Nassau for Enterprise, Florida, staying at the Brock House Hotel.

14–17 February The Thomas B. Clarke Collection, including thirty-one Homers, is sold by the American Art Association in New York.

25 February Writes Clarke from Florida: "I owe it to you to express to you my sincere thanks for the great benefit that I have received from your encouragement of my work and to congratulate you.… Only think of my being alive with a reputation (that you have made for me)" (Goodrich 1944a, 157).

7 April In Prout's Neck.

17–22 July Registered at the North Woods Club.

13 September Writes Beatty: "I regret to say I have not painted any in oil since I painted that Wild Goose picture a year ago last March [*Wild Geese in Flight*, 1897, Portland Museum of Art]. I painted in water colors three months last winter at Nassau, N.P. Bahamas, and have now just commenced arranging a picture from some of the studies. Mr. John B. Cauldwell, Director of Fine Arts for Paris, will demand of my list of pictures one of which will be selected for his show" (NGA).

25 November Writes Charles: "I am so very thankful for all 'His mercies,' that I now write you. There is certainly some strange power that has some overlook on me and directing my life. That I am in the right place at present there is no doubt about, as I

Winslow Homer and Lewis Wright talking outside the studio, Prout's Neck, Maine. Bowdoin College Museum of Art, Brunswick, Maine, Gift of the Homer Family, 1964.69.153.5

have found something interesting to work at, in my own field, and time and place and material in which to do it" (BCMA).

8 December Sails on the *Trinidad* for Hamilton, Bermuda. It is his first trip to the British colony.

1900

22 January Leaves Bermuda.

March Sends Knoedler's *Lost on the Grand Banks* (cat. 135) and *Hound and Hunter* (cat. 179).

Exhibits *A Summer Night* (cat. 186), *Fox Hunt* (cat. 230), *The Maine Coast* (cat. 195), and *The Lookout—"All's Well"* at the International Universal Exposition in Paris. Homer is awarded a gold medal and *A Summer Night* is purchased by the French Government for the Luxembourg Museum.

7–28 June Registered at the North Woods Club. Completes his last Adirondack work, the watercolor *The Pioneer* (Metropolitan Museum of Art).

21 June Writes Mattie from the North Woods Club acknowledging her congratulations for his award at the Paris Universal Exposition and noting that "The fishing is over here & I am sketching in water colors." He also notes to tell Charles: "I have a fine sketch of a black bass taken in the boat five minutes after he was caught. I present it to him for his fish room at W. T. [West Townsend]" (BCMA).

August Writes a Civil War friend, George G. Briggs: "Every condition must be favorable or I do not work and will not. For the last two months I have not painted—too many people about this place. They all leave by the middle of September, then I shall work for the balance of the winter…" (Goodrich 1944a, 163).

September Writes his Chicago dealer O'Brien: "I do not care to put out any ideas for pictures. They are too valuable, and can be appropriated by any art Student" (Goodrich 1944a, 163).

8 September A devastating hurricane hits Galveston, Texas, where Homer's brother Arthur and his family reside.

19 October Writes O'Brien: "I have a very excellent painting, *On a Lee Shore* [cat. 226]….I will send it to you if you desire to see it. Good things are scarce" (Goodrich 1944a, 163).

24 October Writes Clarke: "It will give me great pleasure to show something at the Union League next January….I have a very fine collection of West-India subjects never out of my portfolio or put in order for exhibition—thirty or forty….I am very well. I paint very little and my work is improving" (AAA).

12 November Writes Knoedler's informing them about "two wonderful paintings," *Eastern Point* (cat. 227) and *West Point, Prout's Neck* (cat. 228).

Early December Sends Knoedler's *Fog* (i.e., *The Fisher Girl*, 1894, Amherst), commenting: "if you want more sentiment put into this picture I can with one or two touches, in five minutes time, give it the stomach ache that will suit any customer…" (Goodrich 1944a, 171).

December Writes Beatty at the Carnegie Institute from Prout's Neck: "…I may not be at home although I expect to be here until the first week in January—after that my mail will be kept as usual until Spring when I return home" (NGA).

23 December Completes *West Point, Prout's Neck* (cat. 228).

1901

Sends twenty-one watercolors of the Bahamas and first Bermuda trip to the Pan American Exposition in Buffalo, New York, and is awarded a gold medal.

28 January Writes Knoedler's: "I do not like your customer….If this was going into any gentlemens house or club or public gallery, I should say go ahead! But I think this man a speculator….I have met these people before…" (MKA).

21 March Writes Knoedler's: "I will send you some Adirondack things that I made last spring" (MKA).

15 April Writes Knoedler's: "I send you…six watercolors of fishing subjects. They may be of interest to the fishermen now turned loose for spring fishing…" (MKA).

4–22 May Registered at the North Woods Club.

June A second house for Homer is completed at Kettle Cove near Eastern Point on Prout's Neck. It is designed, in collaboration with Homer, by the architect John Calvin Stevens. Homer comments: "Other men build houses to live in, I build this one to die in."

19 September Writes Knoedler's: "I wish to know if you are still overloaded with my pictures. I am waiting until some of them get settled for good, before I paint any more. I have not painted anything this summer…" (NGA).

22 September Writes Morris, Pennsylvania Academy of the Fine Arts: "…I have not the slightest interest in the exhibition that you and others propose….I desire to be free and I do not admit that any man has a right to trade on my liberty or my work" (AAA).

1 October In a letter to Beatty, states: "I will be in Pittsburgh some time on the 15th—the day before the committee meets….I do not regret to say, and I will say, that I have been more interested in other matters than Art for the past year" (NGA). Serves on Carnegie jury for the last time, along with Thomas Eakins.

7 December Writes Knoedler's in reference to *Searchlight on Harbor Entrance, Santiago de Cuba*

Winslow Homer standing in front of the wall near his cottage at Kettle Cove, 1902. Bowdoin College Museum of Art, Brunswick, Maine, Gift of the Homer Family, 1964.69.179.12

(cat. 232): "At present I am in a most happy state of mind as I am hard at work on a fine subject that I can paint without any trouble in my studio. I have been free here for four days, the last tenderfoot having been frozen out, and now out of gun shot of any soul and surrounded by snow drifts, I again take up my brush after nine months of loafing" (NGA).

20 December Writes Clarke: "Do not think that I have stopped painting. At any moment I am liable to paint a good picture" (AAA).

Late December It is thought that at some time during 1901, probably late December, Homer returned to Bermuda.

Receives a gold medal at the Inter-State and West Indian Exposition in Charleston, South Carolina, 1901–1902.

1902

6 March Writes Morris to accept the Temple Gold Medal awarded him by the Pennsylvania Academy of the Fine Arts at their annual exhibition (AAA).

21 May–10 June Registered at the North Woods Club.

12 June Writes Charles from Prout's Neck: "Lewis [the Homer family servant] arrived yesterday and I was very glad to move down to my own house and have things as I like them....I go to Montreal early next week—stop at Windsor two days then to Saratoga…" (BCMA).

June and July Sends Knoedler's fourteen watercolors, including *Rum Cay* (cat. 212), *The Turtle Pound* (cat. 208), and *After the Tornado* (Art Institute of Chicago).

23 July Writes Knoedler's from Prout's Neck: "I wish to notify you that I leave here on Monday next—and that I shall not have any address until I notify you again. Work! now is in order with me" (MKA).

August Visits Canada and paints a group of watercolors at Lake St. John and on the Saguenay. This is his last trip to Quebec.

27 August Writes Knoedler's from Prout's Neck: "I beg to state that I have returned to Scarboro and that I have some watercolors taken on the Saguenay River" (MKA).

14 September Writes Morris at the Pennsylvania Academy of the Fine Arts: "I shall pass the winter south or in Europe. I cannot have the honor of serving on your jury" (AAA).

11 December Writes Knoedler's: "I wish an invitation to send a picture to the Union League Club for their annual exhibition of American pictures. Can you get me one and forward it to me?" (MKA)

Winslow Homer with Charles Homer, Jr., c. 1900. Bowdoin College Museum of Art, Brunswick, Maine, Gift of the Homer Family, 1964.69.179.13

1903

22 and 26 February Writes Knoedler's "I am not well now" and "I have been quite sick for two weeks" (MKA).

26 March Writes Knoedler's from Prout's Neck: "I left here on March 5th. I have just returned and find many letters. In reply to your two letters of March 11th and 18th I wish to thank you sincerely for the fine showing that you have given me while I have been away sick" (MKA).

30 March Letter to Knoedler's: "As I shall go up for the spring fishing I will take my sketch block and will give you a fine line of goods next season [Adirondack subjects]....The trouble was I thought that I would give up drinking—and it was a great mistake and although I reduced the size of my nose and improved my beauty my stomach suffered" (NGA).

23 May–8 June Registered at the North Woods Club.

Early September Beatty visits Homer in Prout's Neck, who writes: "I enjoyed your visit here very much and I have to give you my sincere thanks for the lectures on Art that you unloaded and practised on me. The result has been wonderful. Here is a picture [*Early Morning After a Storm at Sea*, cat. 229] that was laughed at at the Society of American Artists and now in two days work changed into this work that I am now sending to your exhibition and I am proud of it" (NGA).

1 December Writes his cousin John Preston in New Ipswich, New Hampshire: "I think of taking the Mallory line of Steamers for Key West....I hear from my brother that you are about to go South and I thought I would write to you hoping you could meet me some time…" (Hendricks 1979, 257).

5 December Writes Charles: "I decide to go direct to Key West. I have statroom 20 upper deck 'Sabine'—go on board tonight—leave early Sunday morning. I know the place quite well and its near the points in Florida that I wish to visit. I

have an idea at present of doing some work but do not know how long that will last. At any rate I will once more have a good feed of goat flesh and smoke some good cigars and catch some red Snappers I shall return through Florida and by May be at Scarboro" (BCMA).

6 December Takes the steamer *Sabine* from New York to Key West. Executes his last series of watercolors on this trip.

1904

Awarded a gold medal at the Louisiana Purchase Exposition, St. Louis.

January Travels from Key West to Homosassa, Florida.

7 January Registers at the Homosassa Inn, writing to Arthur: "Fishing the best in America as far as I can find." Eleven known watercolors result from his stay.

24 February At the Windsor Hotel in Jacksonville, Florida, for his birthday.

18 March Writes Mrs. Lawson Valentine: "I was in Jacksonville on my birthday February 24th and I remembered with pleasure meeting Mr. Lawson Valentine at that same place and date eighteen years ago....I was on my way home from Key West with my father" (CCL).

Late March Back in Prout's Neck, Maine, working on *A Summer Squall* (Clark Art Institute).

5 May Writes Knoedler's: "It has been so cold and wet here that Paint would not dry—and I had all I could do to keep alive" (MKA).

31 May–27 June Registered at the North Woods Club.

Early July After returning to Prout's Neck from the Adirondacks, writes Beatty: "I shall have a very nice garden this year and the Flounders will bite as usual....If you are anywhere in this neighborhood I shall hope to see you" (NGA).

9 August Writes Beatty: "…there is an automobile with a honk and smell....This machine was brought here by my brother Charles....I am not working and no chance of my doing so as I shall ask my brother to take you to ride in that thing and it will completely close your 'oration box'" (NGA).

7 October Writes Charles from Prout's Neck: "The weather is beautiful. Arthur has not yet expressed my picture 'Cape Trinity' [cat. 234]" (BCMA).

2 November Writes Knoedler's: "My things are too common and cheap and what I am now painting is of quite another order…" (MKA).

8 November Writes Knoedler's: "I will not take your valuable time with any particulars, will simply say that I wish you to run your own store and not let Art Directors and Collectors for Public Exhibitions do it. I shall send you within three weeks two

Palm Trees, Homosassa River, Florida, c. 1904. Bowdoin College Museum of Art, Brunswick, Maine, Gift of the Homer Family

paintings and will ask you to show them one at a time in your show window. That will prevent their being shown at any of the New York Exhibitions, keep them away from critics—and insure their being well hung—Your window is the only place where a Picture can be seen in a proper manner—That is at a point from which an artist paints his Picture—To look at and not smell of" (NGA).

15 November Finishes *Kissing the Moon* (cat. 233) and is also working on *Cape Trinity, Saguenay River* (cat. 234).

6 December At the Windsor Hotel in Jacksonville, Florida. He went directly to Homosassa to fish, not paint.

7 December Writes Knoedler's from Windsor Hotel in Jacksonville, Florida: "My address will be Homosassa, Florida until notice" (MKA).

25 December Writes Mattie: "I have the red paper and green ribbon hanging in my room. I am not working yet—expect to after Jan. 1st" (BCMA).

1905

23 January Writes Knoedler's from Homosassa, Florida: "I notify you that I leave Homosassa, Florida on January 30th....I am very well but have not worked any it being too cold here" (MKA).

Late January May have worked on *Diamond Shoal* (cat. 225), his last dated and last known watercolor, on his return from Florida.

31 March Sends twenty Quebec, Adirondack, and Florida watercolors to M. Knoedler & Co. (MKA).

24 May Writes Knoedler's: "I receive with pleasure this unexpected sum of money. It's not a bad idea this looking at a little money now and then. Who knows but I may paint something more some day" (NGA).

27 June Registered at the North Woods Club.

18 October Writes Prang: "...I retire from business every now and then and then take it up againI have passed the past two winters in Florida, the year before that in Bermuda and before that in Nassau N.P. Bahamas. I think Bahamas the best place I have ever found. I do not know yet where I will go this next winter.... You will be glad to know that I am comfortably fixed for life in regard to cash as I only desire enough for my support and a reasonable help to others—and I am having a happy life, free from care" (AAA).

22 October Writes Prang: "You do not appear to understand my position here at this time of year.... In the first place I will answer your questions. There are no hotels or houses open to receive visitors within ten miles of my house (Portland). They are all closed and shutters up as the Season is over and nothing doing until next summer when teams are at the R.R. station (four miles from my house) but now you would have to hunt for some farmer to take you over—I do not keep any servants. There is a large boat in one of my two rooms.... The other room is 33 x 17—my living room—I have no studio. My water is turned off from the stand pipe—and I regret sincerely to say that I cannot receive a visit from you at this time of year even for a day. My own brothers know better than to come down here..." (AAA).

Winslow Homer and guides on the Homosassa River, Florida. Bowdoin College Museum of Art, Brunswick, Maine, Gift of the Homer Family

23 December Registers at the Hotel Rudolf in Atlantic City, New Jersey, and writes Arthur: "I consider it the best place for an old man that I have seen—You should see those being wheeled about in their bath chairs with their pink cheeks and white hair—and gathered up in sheltered lines reading the papers—It would be very slow for a man who cares to be doing anything but loaf, and be waited on. You have until you are 70 years old before you would think of this kind of thing" (BCMA).

Hotel Rudolf, Atlantic City, c. 1903. Library of Congress, Prints and Photographs Division, Detroit Publishing Company Photograph Collection

Writes his nephew Charlie from Atlantic City: "After seeing a tramp steamer burn up this morning out at sea, I had a quiet half hour to think of my relations knowing they were not on board and I made a draft of my impressions of things in the way of a Christmas greeting to them" (BCMA).

1906

George A. Hearn gives *Cannon Rock* (cat. 193) and *Searchlight on Harbor Entrance, Santiago de Cuba* (cat. 232) to the Metropolitan Museum of Art.

18 February Writes Charles from the Monticello Hotel in Norfolk, Virginia: "I leave here tomorrow morning....I have also received...a birthday suit in which to appear on the walk at Atlantic City.... If you are not about to start south on your own business and should not wish to go to Atlantic City for next Sunday I would go for a day (returning to Atlantic City) for a quiet dinner with you—but a family affair—I do not consider this 70th much of a subject for congratulation" (BCMA).

28 June Registered at the North Woods Club.

Summer For the first time in his life, Homer has a prolonged illness.

14 September Writes Knoedler's: "I leave here immediately for certain points North and I have arranged to be in New York City on next Thursday morning" (NGA).

Early October Writes Beatty: "I have not been well all summer but now think I am all right with no work for the past year" (Goodrich 1944a, 186).

18 October Writes Charles: "I have entirely recovered my health—I am now an ordinary old man. No doubt about either of the above facts" (BCMA).

30 November Writes Knoedler's: "Before leaving here I wish to receive the balance of my water colors....I realize that this small business of mine is of little value to you and from no fault of yours and no fault of mine. You are willing to sell and I am ready to paint but I no longer paint for nothing" (MKA).

22 December–19 January *The Gulf Stream* (cat. 231) and *A Light on the Sea* (Corcoran Gallery of Art) are exhibited at the National Academy of Design's winter exhibition, Homer's first showing at the Academy since 1888. *The Gulf Stream* is purchased by the Metropolitan Museum of Art before the exhibition opens.

1907

Early 1907 Sends *Cloud Shadows* (Spencer Museum of Art) and *Below Zero* (Yale University Art Gallery) to Knoedler's.

21 January Writes Arthur from Prout's Neck: "I am too busy at present to leave here and when I do leave I shall not go south of Norfolk—that is the best Hotel and more sea trips, daily, to go and return same day. I have been south now for five or six years and know it well.…I have no time to write, the days are short and there is now a tide in my affairs that I am taking at the flood" (BCMA).

February The Corcoran Gallery acquires *A Light on the Sea*.

July Writes Leila Mechlin concerning an article she was writing for *International Studio:* "I thank you sincerely for your interest in proposing an article on my work. Perhaps you think that I am still painting and interested in art. That is a mistake. I care nothing for art. I no longer paint. I do not wish to see my name in print again" (Goodrich 1944a, 188).

28 August Writes Beatty asking him to visit: "There will be no painting as I am very well and the smell of paint would not agree with me at my age" (NGA).

M. Knoedler & Co., at the northeast corner of 34th Street and Fifth Avenue, New York, late 1890s. Photo courtesy of Knoedler Gallery, New York

11 October Writes Norcross, a Boston Banker, that he intended to put aside money for his burial "to be handy in case I want to be buried, but I have postponed it now for the present" (MHS).

Early November Writes Beatty: "You will be glad to hear that I am painting again. I work very hard every afternoon from 4.30 to 4.40—that being the limit of the light that I represent, the title of my picture being 'Early Evening'" (fig. 147; Goodrich 1944a, 189).

19 November Writes Knoedler's: "I prefer your show window for two days to any exhibition in America (with another man's hanging) of two months" (MKA).

30 November Writes Charles about *Early Evening:* "I have just finished that picture by 'letting well enough alone.' Which is the rule for grown artists only. This painting will not be new to you as it is the two girls and old pilot that have been hanging in my studio for so long" (BCMA).

7 December Writes Charles from Prout's Neck: "I am enjoying every minute of my life here—busy outdoors and in" (BCMA).

17 December Writes Charles from Prout's Neck that he is planning to depart for Florida shortly.

1908

January and February In Homosassa, Florida.

22 January Knoedler's writes Homer in Homosassa, Florida: "…we have sold your 'Early Evening' to one of the most eminent collectors of this country Mr. C. L. Freer, who may ultimately give your work, with his collection of Whistlers and others to a National Institution" (MKA).

10 February At the Rendezvous Hotel in Homosassa.

7 March Writes Arthur from the Windsor Hotel in Jacksonville, Florida: "I sail from here soon for New York" (BCMA).

By March 29 In Prout's Neck.

4 April Writes Arthur authorizing him to make an offer for land at Prout's Neck: "…this is as high a price as yet paid for land on the Neck—offered by this aged recluse" (BCMA).

11 April Writes Knoedler's concerning a request from Leila Mechlin for photos for an article she proposed: "I never received this letter from the lady.…of course these women who work for the press expect and want everything they can get and they look forward to what that is before proposing the article and they beat you up for material" (MKA).

19 April Writes Beatty from Prout's Neck: "I arrived here on March 20th and ever since I have been bothered by a wind at 60 miles an hour and the fact that my cottage was entered during my absence in Florida and my greatest treasure—a watch given to my mother on the day I was born

Windsor Hotel, Jacksonville, Florida, c. 1903. Library of Congress, Prints and Photographs Division, Detroit Publishing Company Photograph Collection

was stolen.…I am going fishing at Adirondacks middle of May" (NGA).

25 April Writes Mattie: "I shall leave here as soon after the [?] as possible waiting here until Charlie makes his visit and then going to the Adirondacks to my club. The month of August I shall be at home here" (BCMA).

Mid–May Suffers a mild stroke that temporarily impairs his speech and muscle control.

2 June Writes Charles: "This is the first time I have tried to write and I am quite satisfied with it" (BCMA).

4 June Writes Charles: "I can tie my neck tie very well now and shall be able to shave very soon.…I can paint as well as ever. I think my pictures better for having one eye in the pot and one eye up a chimney—a new departure in the art world" (BCMA).

23 June Writes Arthur from The Worden, Saratoga Springs, New York: "I am about to go to the North Woods Club. I have had a very pleasant trip so far" (BCMA).

24 June to c. mid-July Registered at the North Woods Club.

3 July Writes Charles from the North Woods Club: "I appear to be very well—there is only one thing I do not understand about my recent illness that is that I cannot tie my neck tie in the way that I have done for the past twenty years. It is impossible for me to make the sailors knot" (BCMA).

17 July Writes Charles from the North Woods Club: "…enjoying my life here with very good company.…I shall go to Canada on my way home" (BCMA).

August Writes Downes from Prout's Neck: "I returned here last Thursday and I will now answer your letter of June 13—It may seem ungrateful to you that after your twenty-five years of hard work in booming my pictures that I should not agree with you in regard to that proposed sketch of my

life—But I think it would probably kill me…"
(Goodrich 1944a, 197).

5 October Writes Charles that he is "very well"
(BCMA).

8 December Writes Charles from Prout's Neck:
"I do not think I shall leave here before January
then I shall go directly south to Homosassa after
about three days in New York. I am painting when
it is light enough on a most surprising picture…
[*Right and Left*, cat. 235]" (BCMA).

21 December Writes Mattie from Prout's Neck:
"All is lovely outside my house and inside of my
house and myself" (BCMA).

1909

January Sends *Right and Left* (cat. 235) to Knoedler's.

20 February Registers at a hotel in Homosassa,
Florida.

Probably 21 March Writes Arthur from
Homosassa, Florida: "I leave here for home will
arrive on the first week in April and then home
early to Prout's Neck" (BCMA).

6 November Writes Arthur: "I accept your invita-
tion to dinner on Thanksgiving day. As you have
not mentioned any time I suppose it is when din-
ner is ready. So I will go to Quincy at about 10 AM
and leave a reasonable time after dinner. A nice
long day. My nice long nights are my own affair
and I return to my hotel for them" (BCMA).

19 November Writes Arthur: "…I cannot accept
your invitation to Thanksgiving.…I have little
time for anything—many letters unanswered and
work unfinished. I am painting. I am last through
work at 3:30 Cannot give you any more time"
(BCMA). The painting was *Driftwood* (fig. 217).

End of November Sends *Driftwood*, his last paint-
ing, to Knoedler's.

1910

18 January Writes Arthur: "I have not written as
there has been no particular change in my case.
But now that I know all about it I will tell you I
find that much to my surprise there is nothing
unusual the matter with me that after all it is only
an acid stomach…" (BCMA).

19 January Writes Norcross: "You will be glad to
see that I have been very fortunate in the past four
years. I have now given up business—The money I
sent—$6000—was for one picture" (MHS).

23 June–4 July Registered at the North Woods
Club.

13 August In reply to Downes' inquiries, writes:
"No doubt, as you say, a man is known by his works.
That I have heard at many a funeral. And no doubt
in your thoughts it occurred to you in thinking of
me. Others are thinking the same thing. One is the
Mutual Life Insurance Co., in which I have an annu-

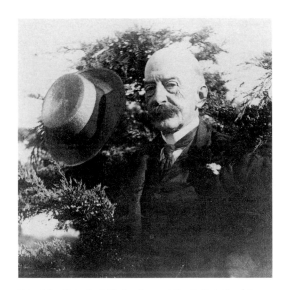

Peter Juley. *Portrait of Winslow Homer at Prout's Neck*. Bowdoin
College Museum of Art, Brunswick, Maine, Gift of the Homer
Family, 1964.69.179.16

ity. But I will beat you both. I have all your letters,
and will answer all your questions in time, if you
live long enough" (Goodrich 1944a, 200).

Late August William Macbeth, a New York Dealer,
visits, later recalling: "What proved to be his last
illness had already laid its grip upon him but in
spite of the pain he insisted on giving himself to
me, and together we roamed over his Prout's Neck
possessions, with their many wonderful views, far
and near.…He knew that his work was over, and,
indeed, he had voluntarily abandoned it years
before" (Goodrich 1944a, 200).

Late Summer Suffers an internal hemorrhage.

29 September Homer dies in the studio, with
both his brothers in attendance.

3 October Homer's funeral is held at Mount
Auburn Cemetery, Cambridge. About twenty-five
people attend. His ashes are buried in the family
plot next to his mother's grave.

Exhibitions in Homer's Lifetime

1860

12 April–16 June, Thirty-fifth Annual Exhibition, National Academy of Design, New York: *Skating on the Central Park*

1863

14 April–24 June, Thirty-eighth Annual Exhibition, National Academy of Design, New York: *Home, Sweet Home* (cat. 2); *The Last Goose at Yorktown*

From 12 November, Fourth Annual Exhibition, Artists' Fund Society, New York: *Playing Old Soldier; The Sutler's Tent*

1864

January, Dodworth's Studio Building, New York: *In Front of the Guard House*

January, Atheneum Club, New York: *Sharpshooter* (cat. 1)

22 February–8 March, Brooklyn and Long Island Fair in Aid of the United States Sanitary Commission, Brooklyn Art Association: *Berdan Sharp-Shooter* (cat. 1)

24 March, Fourth Artists' Reception, Dodworth's Studio Building, New York: *The Brierwood Pipe* (cat. 3); a portrait of a lady

April, Metropolitan Fair in Aid of the United States Sanitary Commission, New York: *Study from Nature*

April, Maryland State Fair in Aid of the United States Sanitary Commission, Baltimore: *Playing Old Soldier*

15 April–25 June, Thirty-ninth Annual Exhibition, National Academy of Design, New York: *In Front of the Guard-House; The Brierwood Pipe* (cat. 3)

June, The Great Central Fair, Philadelphia: *Playing Old Soldier*

November–December, Fifth Annual Exhibition, Artists' Fund Society, New York. [Leeds and Miner, New York, organized a special sale of works in the exhibition on 30 December, which included *Skirmish in the Wilderness* and *Cabbage Garden*]: *Skirmish in the Wilderness* (cat. 4); *The Birch Swing; Cabbage Garden; In the Hay Field; On Guard*

1865

22–25 March, Spring Exhibition, Brooklyn Art Association: *The Bright Side* (cat. 6)

27 April–5 July, Fortieth Annual Exhibition, National Academy of Design, New York: *The Bright Side* (cat. 6); *Pitching Quoits* (cat. 7); *The Initials*

November–December, Annual Exhibition, Artists' Fund Society, New York. [Leeds and Miner, New York, organized an evening sale on 29 December of works in the exhibition, which included *Army Boots* and *The Veteran in a New Field*]: *Army Boots; The Veteran in a New Field* (cat. 8)

1866

16 February, auction, Leeds and Miner, New York: *Playing Old Soldier*

April–4 July, Forty-first Annual Exhibition, National Academy of Design, New York: *The Brush Harrow* (cat. 9); *Prisoners from the Front* (cat. 10)

19 April, auction, Miner and Somerville, New York: *Watching the Shot; Extra Rations (The Sutler's Tent); Pitching Quoits* (cat. 7); *At Rest; On the Picket Line; Near Andersonville*

7 November, Atheneum Club, New York: *Waverly Oaks*

15 November, Samuel Avery Galleries, New York: *Waverly Oaks;* a croquet scene; an oil painting

17 November, auction, The Entire Collection of the Works of Messrs. Winslow Homer and Eugene Benson, who are leaving for Europe, Henry H. Leeds and Miner, New York: nineteen works by Homer, including *The Veteran in a New Field* (cat. 8)

1867

International Exposition, Brussels: *Prisoners from the Front* (cat. 10)

International Exposition, Antwerp: *Prisoners from the Front* (cat. 10)

Utica Art Association: *At Rest*

27–30 March, Spring Exhibition, Brooklyn Art Association: *The Initials*

1 April–31 October, Exposition Universelle, Paris: *Prisoners from the Front* (cat. 10); *The Bright Side* (cat. 6)

14 November–11 March 1868, First Winter Exhibition, National Academy of Design, New York (included a selection of works drawn from the American Art Department of the Paris Universal Exhibition): *Study; Confederate Prisoners at the Front* (cat. 10); *The Bright Side* (cat. 6)

1868

Utica Art Association: *The Violinelist* [sic]

18–21 March, Spring Exhibition, Brooklyn Art Association: *French Pastoral; Spring Violets*

Spring, Forty-third Annual Exhibition, National Academy of Design, New York: *Picardie, France; The Studio*

11 June, Cincinnati Academy of Fine Arts: "a broadly painted picture of a French peasant woman going through the fields to her labor" (*New York Evening Post,* 16 June)

1869

February, Union League Club, New York: *In the Wilderness*

15–20 March, Spring Exhibition, Brooklyn Art Association, New York: *The Bridle Path, White Mountains* (cat. 22)

Spring, Forty-fourth Annual Exhibition, National Academy of Design, New York: *Manchester Coast*

6 November, Century Association, New York: *Mount Washington* (cat. 23); *Green Meadow with Apple Trees; A Black Donkey; Near a Tree*

November/December, Third Winter Exhibition, National Academy of Design, New York: *Long Branch* (probably cat. 27); *Low Tide* (fig. 67)

4 December, Century Association, New York: *Long Branch, Ladies Bathing*

6 December, Nineteenth Reception at the Academy of Music, Brooklyn Art Association: *Long Branch* (probably cat. 27)

1870

Fourth Annual Exhibition, American Society of Painters in Water Colors, New York (part of the Fourth Winter Exhibition of the National Academy of Design): *Study from Nature*

10 January, Century Association, New York: *Girls Playing Croquet; Trout Fishing; Bathing Scene Near Manhattan Island*

5 February, Century Association, New York: *Reaper; Male Figure, Wheat Field*

5 March, Century Association, New York: *The Bathers at Long Branch; Wood Scene*

15 April–early June, Forty-fifth Annual Exhibition, National Academy of Design, New York: *White Mountain Wagon; Sketch from Nature; Mount Adams; Sail Boat; Salem Harbor; Lobster Coast; As You Like It; Sawkill River, Pa.; Eagle Head, Manchester, Mass.* (cat. 31); *The White Mountains* (cat. 22); *Manners and Customs at the Seaside*

16–17 May, auction, Somerville Gallery, New York: *Cabbage Garden; Skirmish in the Wilderness* (cat. 4)

5 November, Century Association, New York: *Haying*

1871

January, Century Association, New York: *Blowing the Horn at the Sea Side*

January, Macbeth Gallery, New York: *The Country Store* (cat. 40)

4 February, Century Association, New York: *Camp Near York Town* (cat. 17); *Girl in the Surf*

20 February, auction, Somerville Gallery, New York: *The Dinner Horn* (cat. 41)

1 April, Century Association, New York: *River Scene with a Man on a Decayed Trunk Guiding a Boat*

14 April–17 June, Forty-sixth Annual Exhibition, National Academy of Design, New York: *Answering the Horn; Landscape*

26–28 April, Union League Club, Philadelphia: *The Musicians*

6 May, Century Association, New York: *River Scene, Boats, 2 Fishermen*

7 October, Century Association, New York: *Sounding Reveille—3 Soldiers with Drums, Tent in Background*

4 November, Century Association, New York: *A Country School-House; Old Mill* (cat. 39)

1872

13 January, Century Association, New York: *Two Boys Going Fishing* (cat. 42)

3 February, Century Association, New York: *Children's School*

12 April–6 July, Forty-seventh Annual Exhibition, National Academy of Design, New York: *The Mill* (probably cat. 39); *The Country School* (Saint Louis Art Museum); *Crossing the Pasture* (cat. 42); *Rainy Day in Camp* (cat. 17); *The Country Store* (cat. 40)

December, Union League Club, New York: *Snapping the Whip* (cat. 38)

1873

Cincinnati Industrial Exposition: *End of the Bridle Path, Mount Washington*

1 February, Century Association, New York: *Female Figure in Black Near a Window*

14 February, Union League, New York: a figure painting

1 March, Century Association, New York: *Girl Reading; Study*

28 March, Tenth Street Studio Building, New York: *Snap the Whip* (cat. 37 or 38); other works

5 April, Century Association, New York: *Study, Girl in Hammock*

29–30 April, auction, Sherwood Collection, New York: *Snapping the Whip* (cat. 37 or 38); *A Country School; Army Teamsters*

May, Century Association, New York: *Study of a Hedge Hog*

13–14 May, Avery sale, Somerville Gallery, New York: *Rainy Day in the Country* (cat. 40)

1 November, Century Association, New York: *Study—Water color,* "a garden scene, with figure" (*New York Evening Post*, 3 November)

1874

Fifth Annual Exhibition, Yale School of Fine Arts, New Haven: *The Last Goose at Yorktown*

Chicago Interstate Industrial Exhibition: *Coming from the Spring*

Cincinnati Industrial Exposition: *Snapping the Whip* (cat. 37 or 38); *Summer-time*

10 January, Century Association, New York: *The Dove Cote* (*Uncle Ned at Home* from description in *New York Evening Post*, 12 January); *A Study*

29 January, Seventh Annual Exhibition, American Society of Painters in Water Colors, New York: five *Leaves from a Sketchbook*

7 February, Century Association, New York: *Gloucester Harbor; Ship-Building* (*The Boat Builders,* cat. 72, from description in *New York Evening Post*, 9 February)

13 February, sale, Leonard's, Boston: *Long Branch*

9 March, Palette Club, New York: *A Temperance Meeting* (cat. 47)

4 April, Century Association, New York: *Blue Fishing; Girls with Wild Flowers*

9 April–6 June, Forty-ninth Annual Exhibition, National Academy of Design, New York: *School Time; Girl; Sunday Morning; Dad's Coming*

2 May, Century Association, New York: two works entitled *A Study*

7 November, Century Association, New York: *A Flirtation; A Study;* six untitled watercolors

1875

Sixth Annual Exhibition, Yale School of Fine Arts, New Haven: *Last Goose at Yorktown*

9 January, Century Association, New York: *Husking Corn;* six watercolors, including *The Sick Chicken* (cat. 65); three pencil drawings

February, Eighth Annual Exhibition, American Society of Painters in Watercolors, New York: seven drawings; *A Pot Fisherman; A Fisherman's Daughter; On the Fence; Fly Fishing; A Clam Bake; Why Don't The Suckers Bite?; Pull Him In!; Cow Boys; The Bazaar Book of Decorum; Good Morning; A Farm Team; Green Apples; On the Sands; Riding at Anchor; What is it?; The Changing Basket; Another Girl; The "Thaddeus of Warsaw"; Skirting the Wheat; A Lazy Day; The City of Gloucester; An Oil Prince; Adirondack Guides; In Charge of Baby* (cat. 70); *A Basket of Clams* (cat. 60); *How Many Eggs?* (cat. 63); *A Sick Chicken* (cat. 65)

6 February, Century Association, New York: *A Study; Frame of Pencil Drawings;* two watercolors

6 March, Century Association, New York: *Chestnutting,* watercolor; *School,* watercolor; *Picket Guard,* watercolor

8 March, First Exhibition, American Society of Painters in Water Colors, Brooklyn Art Association: Three sketches; *The Bazaar Book of Decorum; How Many Eggs?* (cat. 63); *The "Thaddeus of Warsaw"; Green Apples; East Hampton Beach; A Farm Team; An Oil Prince; Why don't the Suckers Bite?; A Fisherman's Daughter; Pull Him In!*

4 April, Century Association, New York: ("a beautiful view of a pasture field with two idle boys seated in the grass," *New York Evening Post*, 5 April); *Two Boys in a Field (Boys in a Pasture);* five watercolor sketches

8 April–29 May, Fiftieth Annual Exhibition, National Academy of Design, New York: *Landscape; Milking Time* (cat. 49); *The Course of True Love; Uncle Ned at Home*

5 June, Century Association, New York: *Milking Time* (cat. 49); *Picking Beans*

September, Chicago Interstate Industrial Exposition: *The Bull Pasture* (cat. 42); *The Course of True Love; Girl and Butterfly; Girl in the Hammock; Gloucester Harbor; Milking Time* (cat. 49)

September, Louisville Industrial Exposition: *Noon Time* (cat. 47); *Get Out of the Grass; Harvest; In Charge of Baby,* watercolor (cat. 70); *The City of Gloucester,* watercolor; *East Hampton Beach,* watercolor; *Thaddeus of Warsaw,* watercolor; *A Fly Fisherman,* watercolor; *Skirting the Wheat,* watercolor; *A Pot Fisherman,* watercolor; *Girl Reading,* watercolor; *Why Don't They Bite?,* watercolor; *Sketch,* watercolor

6 November, Century Association, New York: *Foraging,* "a gay looking Zouave in the foreground holding a calf by the tail" (*New York Evening Post*, 9 November); three watercolors

4 December, Century Association, New York: *Boy and Boat; The Trysting Place;* three drawings

1876

National Academy of Design and the Metropolitan Museum of Art, New York, Centennial Loan Exhibition: *Prisoners from the Front* (cat. 10)

8 January, Century Association, New York: *Taking Away the Calf* (cat. 48); two drawings

25 January, auction, Daniel A. Mathews, New York: *Deer Hunting in the Adirondacks*

5 February, Century Association, New York: *Girl with Lunch Basket*

February, Ninth Annual Exhibition, American Society of Painters in Water Colors, New York: *After the Bath; A Chimney Corner; The Busy Bee; "A Penny for Your Thoughts"; The Gardener's Daughter; A Flower for*

the Teacher; Contraband; Poor Luck; A Fish Story; Fiction; Furling the Jib; Study; Too Thoughtful for Her Years; A Glimpse from a Railroad Train

Spring, Chicago Industrial Exposition: *Gathering Chestnuts; Get out of That Grass!; On the Beach, East Hampton, L. I.; Picket Line, Front of Yorktown; Shoo!; Waiting for a Bite* (cat. 58)

28 March, Fifty-first Annual Exhibition, National Academy of Design, New York: *The Old Boat; Cattle Piece; Over the Hills; A Fair Wind* (cat. 76); *Foraging*

1 April, Century Association, New York: *Rooster*

2 April, Centennial Loan Exhibition, Philadelphia: *The Busy Bee,* watercolor; *A Flower for the Teacher,* watercolor; *The Trysting Place,* watercolor; *In the Garden,* watercolor (cat. 50); *The American Type; Snap the Whip* (cat. 37); *Prisoners from the Front* (cat. 10)

24 April–6 May, Spring Exhibition, Brooklyn Art Association: *Sunny Morning*

6 May, Century Association, New York: *Girl Reading Letter*

31 May, sale, Henry D. Miner, New York: *Uncle Ned at Home*

July, Chicago Academy of Design: *Sunshine and Shadow; Uncle Ned at Home*

4 November, Century Association, New York: *The Dinner Horn* (cat. 41)

December, Century Association, New York: *The American Type*

2 December, Morris, Schwab and Co., San Francisco: *In the Morning; You Jess Come on, Dah!*

4–16 December, Fall Exhibition, Brooklyn Art Association: *The Farmer's Seed Melon*

19 December, Lotos Club, New York: *Country Store on a Rainy Day* (cat. 40)

1877

11 January, Union League Club, New York: *Farm Yard on Long Island*

13 January, Century Association, New York: *Fortune Telling*

23 January, Schenck Art Gallery, New York: *Salem*

30–31 January, Leavitt Art Rooms, New York: *Arrival of the French Ambassador*

February, Century Association, New York: *The Song of the Lark; Ship Yard at Gloucester*

February–4 March, Tenth Annual Exhibition, American Society of Painters in Water Colors, New York: *Blackboard* (cat. 85); *Backgammon* (cat. 87); *Lemon* (cat. 83); *Book* (cat. 84); *Rattlesnake*

26 February, Kurtz Gallery, New York: *A Fair Wind* (cat. 76)

10 March, Century Association, New York: *Cotton Pickers* (cat. 79)

3 April–2 June, Fifty-second Annual Exhibition, National Academy of Design, New York: *Landscape; Answering the Horn*

2–26 May, Second exhibition for 1877, Boston Art Club: *An Afternoon Sun*

2 June, Century Association, New York: *Sketch—4th of July in Virginia* (cat. 82); *Sunday Morning in Virginia* (cat. 81); *The Old Mistress* (cat. 80); *Backgammon,* watercolor (cat. 87); *Girl Reading,* watercolor

5 **October,** Century Association, New York: *A Night in Camp*

3 **November,** Century Association, New York: *The Trapper*

1 **December,** Century Association, New York: *Reception of the French Ambassador; Autumn Leaves?; Single Figure*

3–15 **December,** Fall Exhibition, Brooklyn Art Association: *Otters Signs*

1878

Boston: *Preparing for the Carnival* (cat. 82)

January, Annual Sale of American Pictures, Leavitt Art Rooms, New York: *Autumn* (cat. 88)

25 **January,** sale, Leavitt Art Rooms, New York: *Summer; Winter*

29 **January,** Kurtz Gallery, New York: *In Front of Yorktown*

2 **March,** Century Association, New York: *Portrait Group*

1 **April–end of May,** Fifty-third Annual Exhibition, National Academy of Design, New York: *Morning; Shall I Tell Your Fortune?; A Fresh Morning; The Two Guides* (cat. 59); *The Watermelon Boys; In the Field*

6 **April,** Century Association, New York: *Autumn Study (girl); Autumn Study (boy)*

May–August, Annual Exhibition, Royal Academy of Arts, London: *Cotton Pickers—North Carolina* (cat. 79)

2 **May–August,** Exposition Universelle, Paris: five works; *A Visit from the Old Mistress* (cat. 80); *Sunday Morning in Virginia* (cat. 81); *Snapping the Whip* (cat. 37); *A Country School Room; On the Bright Side* (cat. 6)

28 **May,** C. F. Libbie's auction room, Boston: drawings and sketches

1 **June,** Century Association, New York: "Pastoral," tile fireplace

11 **June,** Barker Art Gallery, New York: *Picking Wild Flowers*

2 **November,** Century Association, New York: *On the Seashore*; ten watercolors; six pencil sketches

12 **November,** Century Association, New York: *On the Seashore*

December, Union League Club, New York: *Waiting for a Bite* (cat. 58)

13 **December,** Union League Club, New York: one watercolor

1879

11 **January,** Century Association, New York: *Old Oaks; Chestnutting; On a Dairy Farm; In a Cornfield; The Shepherdess; A Cornfield*

1 **February–1 March,** Twelfth Annual Exhibition, American Water Color Society, New York: *Husking; Fresh Air; Oak Trees with Girl; Chestnut Tree; Sketch; Girl in a Wind; Watching Sheep; Sketch from Nature; Girl on a Garden Seat; The Strawberry Field; Girl and Boy; Old House; A Rainy Day; October; Oak Trees; Corn; Girl, Sheep, and Basket; Girl and Boat; Willows; Girl, Boat, and Boy; Black and White; Black and White; The School Girl; Sketch; Girl on a Bank; Girl with Half a Rake* (cat. 96); *In the Orchard* (cat. 95); *On the Fence* (cat. 98); *On the Hill* (cat. 93)

April, Fifty-fourth Annual Exhibition, National Academy of Design, New York: *Sundown; Upland Cotton; The Shepherdess of Houghton Farm*

1–7 **April,** American Collection of Paintings, Kurtz Gallery, New York: *Dressing for the Carnival* (cat. 82)

22 **April–24 May,** Exhibition of Contemporary Art, Boston Art Club: paintings and drawings, including *A Visit from the Old Mistress* (cat. 80)

4 **October,** Century Association, New York: *The Shepherdess*

1 **November,** Century Association, New York: *Sundown; Wedding Cards,* watercolor; twenty-eight "Sketches in Black and White"

1880

9 **January,** Union League Club, New York: *Sunday Morning* (cat. 81); *A Visit from the Old Mistress* (cat. 80)

10 **January,** Century Association, New York: *The Shepherdess*

14 **January,** Mathews Art Gallery, New York: *On the Beach*

February, Gill's New Art Galleries, Springfield, Massachusetts: *By the Sea Side* (cat. 103)

2 **February,** Mathews Art Gallery, New York: *Peach Blossoms* (cat. 100)

7 **February,** Century Association, New York: two watercolors

25 **February,** Mathews auction rooms, New York: two oils, "The largest of the two is a landscape, brightened by an American farmer's daughter, who reads a letter while seated on the grass and leaning against a tree; the smaller is a wheat field, through which another specimen of the same interesting type is coming toward you" (*New York Post*)

4 **March,** sale organized by Homer, Mathews auction rooms, New York: seventy-two watercolors and drawings

11 **March,** Union League Club, New York: *Upland Cotton*

12 **March,** sale of the paintings of Mr. J. Abner Harper, Chickering Hall, New York: *Apple Blossoms*

April–October, Loan Collection, Metropolitan Museum of Art, New York: *Prisoners at the Front* (cat. 10)

Spring, Fifty-fifth Annual Exhibition, National Academy of Design, New York: *Summer; Visit from the Old Mistress* (cat. 80); *Camp Fire; Sunday Morning* (cat. 81)

3 **April,** Century Association, New York: three works listed as "Facsimile"

6 **November,** Century Association, New York: *Cabinet Portrait*; forty-two watercolors

7–10 **December,** auction, Chicago gallery on Wabash Avenue near Monroe Street: watercolors and drawings

December, Doll & Richards, Boston, December: more than a hundred watercolors and drawings of Gloucester

7 **December–1 January 1881,** Brooklyn Art Association: *Upland Cotton*

1881

Gill's New Art Galleries, Springfield, Massachusetts: *Peach Blossoms* (cat. 100)

8 **January,** Century Association, New York: *A Study*

23 **January–23 February,** Fourteenth Annual Exhibition, American Water Color Society, New York: *Eastern Point Light* (cat. 104); *Gloucester, Mass.; Winding the Clock; Something Good About This!; Girl Reading; Watercolor; Clover; Girl; Sunset; Coasters at Anchor; July Morning; Gloucester Boys; Water Color; A Lively Time; On the Housatonic River; Early Morning; Sunset; Schooners at Anchor; Ozone; Field Point, Greenwich, Conn.; Three Boys; The Yacht Hope; Fishing Boats at Anchor*

5 **March,** Century Association, New York: *Portrait Group*

8–19 **March,** Spring Exhibition, Brooklyn Art Association: *Startled,* watercolor

26 **August–29 October,** Newcastle Art Association Exhibition, England: *Cullercoats,* watercolor

1882

28 **January–25 February,** Fifteenth Annual Exhibition, American Watercolor Society, New York: *Fishing Fleet Coming In, Newcastle, England* (cat. 123); *Far Away from Billingsgate* (cat. 124)

February 1882, J. Eastman Chase, Boston: Cullercoats watercolors, including *Fisherman's Family (The Lookout)* (cat. 111); *Summer Cloud* (cat. 108); *The Houses of Parliment* (cat. 107)

14–25 **March,** Spring Exhibition, Brooklyn Art Association: *Fisherman's Daughters,* watercolor; *Fishing Fleet, Newcastle, England,* watercolor (cat. 123)

28 **April–27 May,** Twenty-sixth Exhibition, Boston Art Club: *A Young Driver,* drawing; *Fishing Fleet Coming In,* watercolor (cat. 123)

12 **June,** Royal Academy of Arts, London: *Hark, the Lark*

1883

13 **January,** First Annual Exhibition, Art Institute of Chicago: *Study,* watercolor

Late January–25 February, Sixteenth Annual Exhibition, American Watercolor Society, New York: *Tynemouth* (cat. 125); *A Voice from the Cliffs; Inside the Bar* (cat. 128); *The Incoming Tide*

3 **February,** Century Association, New York: *The Foghorn; Looking for the Boats,* watercolor

3 **March,** Century Association, New York: *After a Storm,* watercolor; *In a Storm,* watercolor

April, Fifty-eighth Annual Exhibition, National Academy of Design, New York: *The Coming Away of the Gale*

7 **April,** Century Association, New York: *Sparrow Hall; Scotch Mist,* watercolor; *Sketch*

26–27 **April,** auction, Leavitt and Co., New York: Homer painting in the William Libbey Collection

5 **May,** Century Association, New York: twenty-seven drawings

10 **October,** American Institute Gallery, Boston: one watercolor

1–15 **December,** Water Colors by Winslow Homer, Doll & Richards, Boston (partial list): *Down the Cliff; Fisher Girls; Where are the Boats; A Fresh Breeze; Sun and Cloud; Thick Weather; Here They Come; Waiting for the Boats; A Great Gale—1881; Off Tynemouth; A Swell of the Ocean; High Sea; On the Way Home; Rough Work;*

Landscape; Sunset—Coast of Maine; Low Tide; Along the Shore; Young Hearts of Oak; A High Wave; An Afterglow (cat. 126); *Crab Fishing off Yarmouth; Tynemouth Sands; Wind and Sea; On the Sands at Blyth* (probably cat. 129); *Looking for the Boys; Salmon Net; Daughters of the Sea; Breakwater; Faggot Gatherer; Breakers; Sunrise; Far Away from Billingsgate* (cat. 124); *A Little More Yarn* (cat. 130)

1884

January–1 March, Seventeenth Annual Exhibition, American Water Color Society, New York: *The Ship's Boat; Scotch Mist*

January, Doll & Richards, Boston: *Sparrow Hall*

12 January, Second Annual Exhibition, Art Institute of Chicago: *Watching the Tide Go Out*

12 January, Century Association, New York: *Marine*

1 March, Century Association, New York: *The Life Line* (cat. 132)

5 April–17 May, Fifty-ninth Annual Exhibition, National Academy of Design, New York: *The Life Line* (cat. 132)

5 April, Century Association, New York: *Etching*

29 November–6 December, Studies in Black and White, Doll & Richards, Boston: *A Rough Place; High Sea; A Little More Yarn* (cat. 130); *A Haul of Herring; Taking Out the Net; A Good Haul; Fishing Pinky; Study; Passing the Wreck; Mid-ocean; Waiting for the Fleet; Path Around the Cliff; On the Mussel Bed; Posing as a Shepherdess; Butterflies; Fisher-girl with Net; Fisher-girls Waiting; Rough Weather at the Life Station; Ashore; Gathering Shrimps; Star Fish; Storm Coming; The Salmon Net; The Smuggler of Prout's Neck; Stormy Sky; Inside the Bar; A Brown Study; Returning from the Mussel Bed; The Crab Pot; North Shields; On the Breakwater; A Wreck!; Fisher-girls; Safely Launched; Great Chums; Young Fry; A Dark Hour* (cat. 120); *Quiet Moment; Return of the Fish-wives; Children on the Quay; Low Tide; Wreckers; Wreck of the Iron Crown* (cat. 115); *A Wet Beach; Wet Sands; Hauling Up; Rough Water Ahead; A Great Gale; Under the Forts; A Great Storm; Mussel Gatherers; Work Over; Salt Water; The Life Boat* (cat. 116); *Mother and Daughter; Station of Life Brigade; The Last Boat In* (cat. 118); *The Lookout* (cat. 199); *Sketch from Nature; A Free Wind; Catching Mackerel; Enjoying the Breeze; The Incoming Tide; In the Twilight; Baiting a Trawl; Blyth Sands* (cat. 129); *A Walk Along the Cliff; Hauling Nets; Packing Ground; A Rolling Sea; Herring Fleet; Cannon Rock, Scarborough; Study of Rocks; Pond Lilies; Under the Cliff; The Cliffs of Old Tynemouth; Foreground Study; Herring Boat at Anchor; Black Point, Scarborough; Study of Clouds; Thunder Storm Coming On*

20 December, Century Association, New York: nine charcoal drawings

1885

3–14 January, Twenty-fifth Exhibition, Artists' Fund Society, New York: *Fishing Pinky*, drawing; *Herring Boat at Anchor*, drawing; *The Smuggler of Prout's Neck*, drawing; *Thunder Storm Coming On*, drawing; *Taking Out the Net*, drawing; *The Salmon Net*, drawing; *Catching Mackerel*, drawing; *The Cliffs of Old Tynemouth*, drawing

7 February, Century Association, New York: *A Walk on the Cliff*

7 November, Century Association, New York: *The Herring Net* (cat. 133)

December, National Academy of Design, New York: *The Herring Net* (cat. 133)

5 December, Century Association, New York: thirty-six Nassau and Cuba watercolors, including *Rest* (cat. 149); *The Fog Warning* (cat. 134)

9 December–January 1886, Water-Color Views by Winslow Homer, Reichard & Co., New York: *The Fog Warning* (oil, cat. 134); *Native Cabin* (cat. 147); *Conch Divers—Spanish Wells; Glass Windows—Eleuthera* (cat. 148); *Black Beard; Shark Fishing—Nassau Bar; Bananas for the Attorney General; Over the Garden Wall—Grantstown; Orange Tree; Song Birds—Nassau; Port of Nassau; Dunmore Town Harbor Island; Near the Queen's Staircase; Cocoa-Nut; Fox Hill; Banana Tree; Fresh Flowers; Noon; The Milk in the Cocoa-Nut; Sea Gardens; Cocoa-Nut Tree; Rest* (cat. 149); *Hemp; Sponge; Sea Fans; Market Boat; Hurricane; Morro Castle; Santiago de Cuba; Custom-House; Spanish Club; Street Scene; Street Scene; Volante; Limestone Walls; View Near Town; Street; Cockpit; Cockpit; Cathedral; Royal Palm Trees; Street Architecture; Sharks*

1886

19 February–3 March, Exhibition of Paintings by Walter Gay and Water Color Drawings by Winslow Homer, N.A., Doll & Richards, Boston: *The Herring Net* (oil, cat. 133); *Halibut Fishing* (*Fog Warning*, oil, cat. 134); *Native Cabin* (cat. 147); *Black Beard; Song Birds—Nassau; Port of Nassau; Dunmore Town—Harbor Island; Near the Queen's Staircase; Fox Hill; Banana Tree; Fresh Flowers; Noon; Coconut Tree; Rest* (cat. 149); *Sponge; Sea Fans; Market Boat; Morro Castle; Santiago de Cuba; Custom House; Spanish Club; Street Scene; Street Scene; Volante; Limestone Walls; View near Town; Street; Cockpit; Cathedral; Street Architecture; Sharks*

3 April, Century Association, New York: *Lost on the Grand Banks* (cat. 135); *St. Johns River, Florida*, watercolor (cat. 154); *Sketch at Tampa, Florida*, watercolor

7 April, Doll & Richards, Boston: *The Fog Warning* (cat. 134)

10 April–8 May, Thirty-fourth Exhibition, Boston Art Club: *Down the Cliff*, watercolor

15 April–1 May, Spring Exhibition, St. Botolph Club, Boston: *Lost on the Grand Banks* (cat. 135)

22 November–18 December, National Academy of Design, New York: *Lost on the Grand Banks* (cat. 135)

1887

5 January, Century Association, New York: *Undertow* (cat. 136)

January–February, Doll & Richards, Boston: *Undertow* (cat. 136)

Until 26 February, Twentieth Annual Exhibition, American Water Color Society, National Academy of Design, New York: *Sketch in Key West; Sketch in Florida*

10–12 March, Union League Club, New York: *Breezing Up* (cat. 76)

1 April to mid-May 1887, Sixty-second Annual Exhibition, National Academy of Design, New York: *Undertow* (cat. 136)

2 April, Century Association, New York: *Eight Bells*, etching

November, Art Institute of Chicago: *A Happy Family*

1888

29 January–25 February, Twenty-first Annual Exhibition, American Water-Color Exhibition, New York: *Tampa, Florida; For to be a Farmer's Boy; Florida; A "Norther," Key West; Sand and Sky; Eels*

16 February–29 March, Fifty-eighth Annual Exhibition, Pennsylvania Academy of the Fine Arts, Philadelphia: *Undertow* (cat. 136)

3 March, Century Association, New York: *Peril of the Sea*

2 April–12 May, Sixty-third Annual Exhibition, National Academy of Design, New York: *Eight Bells* (cat. 144)

10–12 May, Union League Club, New York: *Market Day, Nassau*, watercolor; *A Shepherdess*, watercolor

28 May–30 June, First Annual Exhibition of American Oil Paintings, Art Institute of Chicago: *Eight Bells* (cat. 144)

1889

New York Etching Club, National Academy of Design Galleries: *Improve the Present Hour*, etching

9 November, Maritime Exhibition, Boston: *Rocks and Sea Swell*, watercolor; *Baiting the Lobster Pot*, watercolor

1890

13–15 February, American Pictures by American Figure Painters, Union League Club, New York: *The Guides* (*The Two Guides*, cat. 59); *Night in the Woods; Hark the Lark*

February, Thirty-Two Watercolors Conceived in the Adirondacks, Reichard & Co., New York: watercolors, including *Leaping Trout* (cat. 164); *The Campfire; On the Trail* (cat. 168); *Solitude* (cat. 173); *Dog on a Log* (cat. 169); *An October Day* (cat. 170); *Dogs in a Boat* (cat. 172)

March, Reichard & Co., New York: *Two Guides* (cat. 59)

17–29 March, St. Botolph Club, Boston, eight watercolors lent by Edward Hooper: *English Fishwife; Negro Woman in the Bahamas; Children at Gloucester; Custom House in Cuba; Boats off the English Coast; Children at Gloucester; Woman Reading a Letter; A "Northern" at Key West*

10–12 April, Annual Loan Exhibition of Paintings in Water-Color, Union League Club, New York: *Sea View from the Cliffs; Bringing in the Nets; A Disappointing Catch*

1891

21 January, Reichard & Co., New York: *Signal of Distress* (cat. 155); *A Summer Night* (cat. 186); *Sunlight on the Coast; Winter Coast* (cat. 187)

2–28 February, Twenty-fourth Annual Exhibition, American Water Color Society, New York: *Mending Nets* (cat. 124)

7 February, Century Association, New York: untitled work

9–11 April, Annual Loan Collection of Paintings in Water Color, Union League Club, New York: *Returning Home; Gathering Corn Shucks; Leaping Trout* (cat. 164)

2 May, Century Association, New York: *Signal of Distress* (cat. 155)

15 October–28 November, Thomas B. Clarke Collection of American Pictures, Pennsylvania Academy of the Fine Arts, Philadelphia: *The Two Guides—Adirondacks* (cat. 59); *The Campfire; A New England Country School* (cat. 35); *Extra Rations; The Brightside* (cat. 6); *Eight Bells* (cat. 144). Six watercolors: *Peril of the Sea* (cat. 117); *A Disappointing Catch; Danger; Fodder; Forebodings; Watching the Tempest*

December, Reichard & Co., New York: *Huntsman and Dogs* (cat. 176)

December, Loan Collection of Watercolors, St. Botolph Club, Boston: *Hot Day in the Adirondacks; Sponge Fisherman, Jamaica; Rocks and Sea Swell; Clamming; Negress with Basket of Fruit* (cat. 149)

1892

14–16 January, Paintings by American Artists, Union League Club, New York: *March Wind* (cat. 188)

February, Fifteenth Annual Exhibition of American Paintings, Gill's Art Galleries, Springfield, Massachusetts: *The Signal of Distress* (cat. 155)

February, Reichard & Co., New York: *The West Wind* (cat. 188); *Watching the Breakers;* Adirondack watercolors

6 February, Century Association, New York: *The Hunter's Return*

14–16 April, Annual Loan Exhibition of Water Color Paintings, Union League Club, New York: *Returning Home; On the Coast*

7 May, Century Association, New York: untitled work

October, Loan Exhibition: New York Columbian Celebration of the Four Hundredth Anniversary of the Discovery of America, National Academy of Design, New York: *Dressing for the Carnival* (cat. 82); *The Two Guides* (cat. 59); *The Campfire; A Visit from the Old Mistress* (cat. 80)

3 December, Century Association, New York: five sketches

December, In the Adirondack Mountains, Doll & Richards, Boston: twelve watercolors; *The End of the Hunt* (cat. 171)

8–10 December, Exhibition of Old Masters, Union League Club, New York: *In the Adirondacks* (cat. 179)

1893

14 January, Exhibition of the Paintings to be Shown at the Chicago World's Fair, Mechanics Building, Boston

9–11 March, A Group of Paintings by American Artists Accepted for the Columbian Exposition 1893, Union League Club, New York: *Eight Bells* (cat. 144); *The Great Gale* (cat. 189); *Midwinter on the Coast; The March Wind* (cat. 188); *The Carnival* (cat. 82); *The Two Guides* (cat. 59); *Camp Fire*

Late March/April, Reichard & Co., New York: *Fox Hunt* (cat. 230)

Late March/April, Century Association, New York: *Fox Hunt* (cat. 230)

13–15 April, Annual Loan Exhibition of Paintings in Water Colors, Union League Club, New York: *On the English Coast; English Harbor at Sunset*

1 May–31 October, World's Columbian Exhibition, Chicago, awarded gold medal: *Coast in Winter* (cat. 187); *Hound and Hunter* (cat. 179); *Dressing for the Car-*

nival (cat. 82); *A Great Gale* (cat. 189); *The Fog Warning* (cat. 134); *The Two Guides* (cat. 59); *Herring Fishing* (cat. 133); *Lost on the Grand Banks* (cat. 135); *Eight Bells* (cat. 144); *Camp Fire; March Wind* (cat. 188); *Coast in Winter; Sailors Take Warning (Sunset); Sunlight on the Coast; Return from the Hunt* (cat. 176)

Late June/July, Doll & Richards, Boston: *Fox Hunt* (cat. 230)

18 December–24 February 1894, Sixty-third Annual Exhibition, Pennsylvania Academy of the Fine Arts, Philadelphia: *Fox Hunt* (cat. 230); *On the Lake,* watercolor; *Just Caught,* watercolor; *Afternoon,* watercolor

1894

Portraits of Women: Loan Exhibition for the Benefit of St. John's Guild and the Orthopaedic Hospital, National Academy of Design, New York: *Portrait of Helena de Kay* (cat. 54)

Gill's New Art Galleries, Springfield, Massachusetts: *The Return from the Hunt* (cat. 176)

3 March, Century Association, New York: *Below Zero*

April, Exhibition of Water Colors, Union League Club, New York: *Forebodings*

December, Doll & Richards, Boston: fourteen Adirondack watercolors

1895

M. Knoedler & Co., New York: *Northeaster* (cat. 194)

Dedication of the Carnegie Library, Carnegie Institute, Pittsburgh: *Wood Island Light, Moonlight* (cat. 190)

2 February, Century Association, New York: *Storm beaten; Wood Island Light* (cat. 190)

2 March, Century Association, New York: *High Cliff* (cat. 191)

18 September–December, Cotton States and International Exposition, Atlanta, awarded gold medal: *Upland Cotton*

28 October–16 November, St. Botolph Club, Boston: watercolors, including *Montagnais Indians; Montagnais Indians; Lake Tourilli; The Club Canoe; Lake St. John; Approach to the Rapids; Cape Diamond; The Guide; In the Province of Quebec; St. John's Gate*

23 December–22 February 1896, Sixty-fifth Annual Exhibition, Pennsylvania Academy of the Fine Arts, Philadelphia, awarded academy gold medal of honor: *Northeaster* (cat. 194); *Storm-beaten; Wood's Island Light, Moonlight* (cat. 190)

1896

Annual Exhibition of American Art, Cincinnati Art Museum: *Hauling in the Anchor,* watercolor

9–11 January, Loan Collection of Paintings by American Artists, Union League Club, New York: *Coast of Maine* (cat. 195)

5 November–1 January 1897, First Exhibition, Carnegie Institute, Pittsburgh, awarded chronological medal: *The Wreck*

7 November, Century Association, New York: *Saco Bay*

5 December–9 January 1897, Fifty-fifth Exhibition, Boston Art Club: *Storm Beaten*

21 December–22 February 1897, Sixty-sixth Annual Exhibition, Pennsylvania Academy of the Fine Arts, Philadelphia, awarded academy gold medal of honor: *Saco Bay*

1897

14–16 January, Union League Club, New York: *The Wreck* (cat. 196)

11 March, Opening of the New Galleries, Rhode Island School of Design, Providence: *Maine Coast* (cat. 195); *Dogs in a Boat* (cat. 172); *A Halt in the Furrow,* watercolor

28 March–1 May, Nineteenth Annual Exhibition, Society of American Artists, New York: *Marine—Coast* (cat. 195); *The Lookout—"All's Well, Lights All Up"; Saco Bay*

4 November–1 January 1898, Second Annual Exhibition, Carnegie Institute, Pittsburgh: *A Light on the Sea; The Lookout; Maine Coast* (cat. 195)

1898

13–15 January, Union League Club, New York: *The Light on the Sea*

February–April, Water Colors by Winslow Homer of Life and Scenes in the Province of Quebec, Carnegie Institute, Pittsburgh: *Ouananiche Fishing; Entering the First Rapid; Ile Malin; Fishing—Upper Saguenay; The Return Up the River; Under the Falls, The Grand Discharge* (cat. 202); *Young Ducks; Sunset—Lake St. John; End of the Portage; Wicked Island; Trip to Chicoutimi; Ouaniche—Lake St. John; Guides Shooting Rapids; Lake Shore; The Fishing Ground; Rapids Below Grand Discharge; Indian Camp; Canoes in the Rapid; The Head Guide; The Rapids are Near; Cape Diamond; Indian Boy; Indian Girls; St. John's Gate; Wolfe's Cove; Canadian Camp; Trout Fishing*

10–12 March, The Paintings of Two Americans, George Inness and Winslow Homer, The Thomas B. Clarke Collection, Union League Club, New York: *The Life Line* (cat. 132); *Eight Bells* (cat. 144); *The Bright Side* (cat. 6); *The Two Guides* (cat. 59); *Moonlight—Wood's Island Light* (cat. 190); *Visit to the Mistress* (cat. 80); *The Carnival* (cat. 82); *The Gale* (cat. 189); *The Camp Fire; Maine Coast* (cat. 195); *To the Rescue; Rations; Coast in Winter; The Lookout—All's Well; The West Wind* (cat. 188). Watercolors: *Perils of the Sea* (cat. 117); *Leaping Trout* (cat. 164); *Fodder; On the Cliff; Danger; The Breakwater; Foreboding; Watching the Tempest; Unexpected Catch; Market Scene*

April, Water Colors by Winslow Homer of Life and Scenes in the Province of Quebec (Canada), M. Knoedler & Co., New York: twenty-seven Quebec watercolors shown at the Carnegie Institute in February–April 1898; *Wild Geese*

3 November–1 January 1899, Third Annual Exhibition, Carnegie Institute, Pittsburgh: *Wild Geese*

1899

Union League of Philadelphia: *The Life Line* (cat. 132)

14–18 February, sale, Private Art Collection of Thomas B. Clarke, American Art Association, New York: *Coast in Winter; The Lookout—All's Well; The Carnival* (cat. 82); *West Wind* (cat. 188); *The Bright Side* (cat. 6); *Rations; Maine Coast* (cat. 195); *The Life Line* (cat. 132); *To the Rescue; Visit to the Mistress* (cat. 80); *Camp Fire; The Gale* (cat. 189); *Moonlight, Wood's Island Light* (cat. 190); *Two Guides* (cat. 59); *Eight Bells* (cat. 144). Watercolors: *In the Garden; Canoeing in the*

Adirondacks; Watching the Tempest; The Market Scene; An Unexpected Catch; On the Cliffs; Fodder; The Buccaneers; Rise to a Fly; Rowing Homeward; Perils of the Sea (cat. 122); *Danger; Under a Palm Tree* (cat. 153); *Sea on the Bar; Leaping Trout* (cat. 164); *The Breakwater*

17–29 March, Watercolors by Winslow Homer of Life and Scenes in the Province of Quebec (Canada), Doll & Richards, Boston: twenty-seven Quebec watercolors shown at the Carnegie Institute in February–April 1898

2 November–1 January 1900, Fourth Annual Exhibition, Carnegie Institute, Pittsburgh: *High Seas; A Summer Night* (cat. 186)

1900

Exposition Universelle, Paris, awarded gold medal: *A Summer Night* (cat. 186); *The Fox Hunt* (cat. 230); *The Maine Coast* (cat. 195); *The Lookout (All's Well)*

Reichard & Co., New York: *A Summer Night* (cat. 186); *The Fox Hunt* (cat. 230); *The Maine Coast* (cat. 195); *The Lookout (All's Well)*

15 January–24 February, Sixty-ninth Annual Exhibition, Pennsylvania Academy of the Fine Arts, Philadelphia: *The Gulf Stream* (cat. 231); *High Seas*

31 January–2 February, sale, American Paintings Belonging to William T. Evans, Chickering Hall, New York: *Sunday Morning in Virginia* (cat. 81); *Weather Beaten*

24 March–28 April, Twenty-second Annual Exhibition, Society of American Artists, New York: *High Seas*

1 November–1 January 1901, Fifth Annual Exhibition, Carnegie Institute, Pittsburgh: *Hound and Hunter* (cat. 179); *The Gulf Stream* (cat. 231)

3 November, Century Association, New York: one watercolor, no title recorded (according to Knoedler correspondence two Bermuda watercolors were lent to the Century, *Boat Landing* and *North Road*)

1901

Rhode Island School of Design, Providence: *On a Lee Shore* (cat. 226)

M. Knoedler & Co., New York: *The Gulf Stream* (cat. 231)

5 January–2 February, Sixty-third Exhibition, Boston Art Club: *Fog*

10–12 January, Loan Exhibition of American Paintings, Union League Club, New York: *Northeaster* (cat. 194); *West Point, Prout's Neck* (cat. 228); *Eastern Point, Prout's Neck* (cat. 228)

14 January–23 February, Seventieth Annual Exhibition, Pennsylvania Academy of the Fine Arts, Philadelphia: *The Signal of Distress* (cat. 155)

30 March–4 May, Twenty-third Annual Exhibition, Society of American Artists, New York: *West Point, Prout's Neck, Maine* (cat. 228); *Eastern Point* (cat. 227)

1 May–1 November, Exhibition of Fine Arts, Pan American Exposition, Buffalo, awarded gold medal: twenty-one watercolors of the Bahamas and first Bermuda trip

Summer, Esposizione Internationale d'Arte, Venice: *The Gulf Stream* (cat. 231)

13 June–13 August, Second Annual Exhibition, Minneapolis Society: *Marine*

7 November–1 January 1902, Sixth Annual Exhibition, Carnegie Institute, Pittsburgh: *The High Cliffs* (cat. 191)

1901–1902, Inter-State and West Indian Exposition, Charleston, South Carolina: *Cannon Rock* (cat. 193)

1902

4 January–1 February, Sixty-fifth Exhibition, Boston Art Club: *Hunter with Dog—Northwoods* (cat. 179)

6 January, A Group of Pictures by Living American Artists, Union League Club, New York: *Searchlight: Entrance to Harbor, Santiago, Cuba* (cat. 232)

9 January, Edward Runge Collection, American Art Association, New York: *A New England School; Autumn* (cat. 88)

20 January–1 March, Seventy-first Annual Exhibition, Pennsylvania Academy of the Fine Arts, Philadelphia, awarded Temple Gold Medal: *Wild Geese; Northeaster* (cat. 194)

28 March–4 May, Twenty-fourth Annual Exhibition, Society of American Artists, New York: *Northeaster* (cat. 194)

5–26 April, Sixty-sixth Exhibition, Boston Art Club: *The Pioneer,* watercolor

June–July, M. Knoedler & Co., New York: fourteen watercolors; *Rum Cay* (cat. 212); *The Turtle Pound* (cat. 208)

22 November–14 December, Thirteenth Annual Exhibition, New York Watercolor Club: *A Land Mark* (Bermuda); *Coming Storm* (cat. 218); *The Pioneer; Saguenay River, Grand Discharge; Rum Cay, Bermuda; Hogs and Cedars; Street Corner, Santiago; Turtle Pound* (cat. 208); *After the Tornado; Grand Discharge, Lake St. John, Quebec; Approach of Tornado; Cockfight; Banana Carrier; In a Cornfield; Wreck off the English Coast* (cat. 112); *Shark Fishing, Bermuda; Orange Tree, Bermuda; Palm Trees, Bermuda*

11–13 December, Paintings from the Collection of George A. Hearn, Union League Club, New York: *Cannon Rock* (cat. 193); *Maine Coast* (cat. 195)

1903

3–31 January, Sixty-seventh Exhibition, Boston Art Club: *A High Sea*

8–10 January, Paintings by Contemporary Americans, Union League Club, New York: *Early Morning* (cat. 229)

19 January–28 February, Seventy-second Annual Exhibition, Pennsylvania Academy of the Fine Arts, Philadelphia: *Eastern Point* (cat. 227); *The Unruly Calf; Hogs and Cedar: About to Turn Turtle,* watercolor; *Saguenay River,* watercolor; *Coming Storm,* watercolor (cat. 218); *Street Corner: Santiago,* watercolor; *Inland Water: Bermuda,* watercolor; *After the Tornado,* watercolor; *The Pioneer,* watercolor; *Turtle Pound,* watercolor (cat. 208); *Rum Cay,* watercolor (cat. 212); *Grand Discharge,* watercolor (cat. 202)

28 March–3 May, Twenty-fifth Annual Exhibition, Society of American Artists, New York: *Cannon Rock* (cat. 193); *Early Morning* (cat. 229)

4–25 April, Sixty-eighth Exhibition, Boston Art Club: *Inland Water: Bermuda,* watercolor

20 October–25 December, Sixteenth Annual Exhibition of Oil Paintings and Sculpture by American Artists, Art Institute of Chicago: *Below Zero*

5 November–1 January 1904, Eighth Annual Exhibition, Carnegie Institute, Pittsburgh: *Early Morning After Storm at Sea* (cat. 229)

1904

Comparative Exhibition of Native and Foreign Art, American Fine Arts Society, New York: *Maine Coast* (cat. 195)

Doll & Richards, Boston: *Shooting the Rapids,* watercolor (cat. 207)

1–30 January, Sixty-ninth Exhibition, Boston Art Club: *Below Zero*

25 January–5 March, Seventy-third Annual Exhibition, Pennsylvania Academy of the Fine Arts, Philadelphia: *Eight Bells* (cat. 144); *Early Morning; Coast of Maine* (cat. 229)

2 April, Century Association, New York: *A Norther; On the Homosassa River*

May–December, Louisiana Purchase Exposition, St. Louis, awarded gold medal: *Early Morning* (cat. 229); *Weather-beaten; Snake in the Grass,* watercolor

July, American Paintings, Collection of William T. Evans, Wentworth Manor, Montclair, New Jersey: *High Cliff, Coast of Maine* (cat. 191); *A Visit from the Old Mistress* (cat. 80)

November, Recent Watercolors by Winslow Homer, M. Knoedler & Co., New York

3 November–1 January 1905, Ninth Annual Exhibition, Carnegie Institute, Pittsburgh: *A Summer Squall*

3 December, Century Association, New York: *Kissing the Moon* (cat. 233)

1905

23 January–4 March, Hundredth Anniversary Exhibition, Pennsylvania Academy of the Fine Arts, Philadelphia: *Kissing the Moon* (cat. 233)

4 March, Century Association, New York: *A Light on the Sea*

10–27 March, Thirty-eighth Annual Exhibition, American Water Color Society, New York: *Pulling in the Anchor*

20 March–16 April, Fourteenth Annual Exhibition of Water Colors and Pastels, The Art Club of Philadelphia: *Boys in a Dory,* watercolor

April, M. Knoedler & Co., New York: Quebec and Adirondack watercolors; *A Good Pool, Saguenay River* (cat. 203); *Black Bass, Florida* (cat. 224)

3–29 April, Second Annual Exhibition, Philadelphia Water Color Club: *Hell Gate, Florida; Taking on Provisions; Hauling in Anchor; Shell Heap* (cat. 221); *Red Coat; A Norther; In Florida Jungle; Pulling in the Anchor*

May, Albright Art Center, Buffalo: *Kissing the Moon* (cat. 233)

11 May–11 June, Annual Exhibition of Water-Colors, Pastels, and Miniatures by American Artists, Art Institute of Chicago: *Hell Gate, Florida; Hauling in Anchor; Shell Heap* (cat. 221)

1906

22 January–3 March, 101st Annual Exhibition, Pennsylvania Academy of the Fine Arts, Philadelphia: *Long Branch* (cat. 27)

26 March–21 April, Philadelphia Watercolor Club: *A Good Pool* (cat. 203); *Black Bass, Florida* (cat. 224); *Channel Bass; Hudson River at the Blue Ledge; Building a Smudge; Pike; Trout and Float; View from Prospect Hill, Bermuda; Herring Fishing*

3–26 May, Thirty-ninth Annual Exhibition, American Water Color Society, New York: *The Turkey Buzzard* (cat. 222); *Black Bass, Florida* (cat. 224); *Taking on Provisions*

8–18 November, American Paintings from the Collection of William T. Evans, National Arts Club, New York: *High Cliff, Coast of Maine* (cat. 191)

Winter, International Society of Sculptors, Painters, and Gravers, London: *The Signal of Distress* (cat. 155)

22 December–19 January 1907, Winter Exhibition, National Academy of Design, New York: *The Gulf Stream* (cat. 231); *A Light on the Sea*

1907

Exhibition of Landscapes by American Artists, Lotos Club, New York: *Northeaster* (cat. 194)

21 January–24 February, 102d Annual Exhibition, Pennsylvania Academy of the Fine Arts, Philadelphia: *High Cliff: Coast of Maine* (cat. 191)

2 February, Century Association, New York: *Cloud Shadow; Zero Weather*

7 February–9 March, First Exhibition, Oil Paintings by Contemporary American Artists, Corcoran Gallery of Art, Washington: *Long Branch, New Jersey* (cat. 27); *Moonlight, Wood's Island Light* (cat. 190)

30 March, Lotos Club, New York: *A Voice from the Cliffs,* watercolor

11 April–13 June, Eleventh Annual Exhibition, Carnegie Institute, Pittsburgh: *Sparrow Hall; Cloud Shadows; High Cliff, Coast of Maine* (cat. 191)

22 April–4 May, M. Knoedler & Co., New York: watercolors

26 April, Cincinnati Museum of Fine Arts: *Spring*

18 May–17 July, Fourteenth Annual Exhibition of American Art, Cincinnati Museum: *Cape Trinity, Saguenay River* (cat. 234)

22 October–1 December, Annual Exhibition of Oil Paintings and Sculpture by American Artists, Art Institute of Chicago: *The Wreck* (cat. 196); *Spring*

1908

11 January, Works in Water Color by Winslow Homer, Young's Art Galleries, Chicago: ten watercolors

20 January–29 February, 103d Annual Exhibition, Pennsylvania Academy of the Fine Arts, Philadelphia: *The Search Light: Harbor Entrance* (cat. 232)

14 March–18 April, Eighty-third Annual Exhibition, National Academy of Design, New York: *The West Wind* (cat. 188); *Hound and Hunter* (cat. 179)

30 April–30 June, Loan Exhibition of Oil Paintings by Winslow Homer, part of the Twelfth Annual Exhibition, Carnegie Institute, Pittsburgh: twenty-two paintings organized by Beatty; *The Gulf Stream* (cat. 231); *Lost on the Grand Banks* (cat. 135); *Undertow* (cat. 136); *The Gale* (cat. 189); *Banks Fisherman (The Herring Net)* (cat. 133); *Hound and Hunter* (cat. 179); *Two Guides* (cat. 59); *The Fog Warning* (cat. 134); *High Cliffs, Coast of Maine* (cat. 191); *Fox Hunt* (cat. 230); *Huntsman and Dog* (cat. 176); *Cannon Rock* (cat. 193); *The Wreck* (cat. 196); *Searchlight, Harbor Entrance Santiago de Cuba* (cat. 232); *On a Lee Shore* (cat. 226); *Hark, The Lark; The Fisher Girl; A Light on the Sea; Early Evening; Sunset, Saco Bay, Coming Storm; Flight of Wild Geese; The Lookout—All's Well; Maine Coast*

Summer Loan Exhibition, Carnegie Institute, Pittsburgh: *Hound and Hunter* (cat. 179); *Cannon Rock* (cat. 193)

23 November–20 December, Sixth Annual Philadelphia Water Color Exhibition, Philadelphia Water Color Club: *Prout's Neck: Maine; The Spanish Flag; Prout's Neck: Maine; Volante*

1909

Century Association, New York: *Right and Left* (cat. 235)

31 January–14 March, 104th Annual Exhibition, Pennsylvania Academy of the Fine Arts, Philadelphia: *Early Evening*

2–27 February, Seventy-ninth Exhibition, Boston Art Club: *Flight of "Wild Geese"*

29 April–23 May, Forty-second Annual Exhibition, American Water Color Society, New York: four drawings; *By the North Sea*

10 May–30 August, Fourth Annual Exhibition, Selected Paintings by American Artists, Buffalo Fine Arts Academy: *Early Evening; Spring*

1910

23 January–20 March, 105th Annual Exhibition, Pennsylvania Academy of the Fine Arts, Philadelphia: *Right and Left* (cat. 235)

12 March–17 April, Eighty-fifth Annual Exhibition, National Academy of Design, New York: *Below Zero*

17 March, Opening of the National Gallery of Art in the New Building of the United States National Museum: *High Cliff, Coast of Maine* (cat. 191); *A Visit from the Old Mistress* (cat. 80)

Spring, Ausstellung Amerikanischer Kunst, Art Society, Munich, and Berlin Royal Academy of Art: *The Gulf Stream* (cat. 231); *Undertow* (cat. 136)

28 April–22 May, Forty-third Annual Exhibition, American Water Color Society, New York: two drawings

11 May–1 September, Fifth Annual Exhibition, Selected Paintings by American Artists, Buffalo Fine Arts Academy: *Early Morning* (cat. 229)

26 July–28 August, A Collection of Paintings in Water Color by American Artists, Art Institute of Chicago: *After the Hunt* (cat. 162)

Select Bibliography

Archival Sources

J. Eastman Chase Papers, Archives of American Art, Smithsonian Institution

William T. Evans Papers, Archives of American Art, Smithsonian Institution

Winslow Homer Papers, Bowdoin College Museum of Art, Brunswick, Maine, and Archives of American Art, Smithsonian Institution

M. Knoedler & Co. Archives

Miscellaneous Homer Documents, Archives of American Art, Smithsonian Institution

Books, Articles, Exhibitions, Dissertations

Adams, Henry. "Mortal Themes: Winslow Homer." *Art in America* 71 (February 1983), 112–126.

Adams, Henry. "Winslow Homer's Mystery Woman." *Art & Antiques* (November 1984), 38–45.

Adams, Henry. "The Identity of Winslow Homer's 'Mystery Woman.'" *The Burlington Magazine* 132 (April 1990), 244–252. [Adams 1990a]

Adams, Henry. "Winslow Homer's 'Impressionism' and Its Relation to His Trip to France." In *Winslow Homer, A Symposium* [Studies in the History of Art 26], ed. Nicolai Cikovsky, Jr. Washington, 1990, 61–89. [Adams 1990b]

Aldrich, Thomas Bailey. "Among the Studios." *Our Young Folks* 2 (July 1866), 393–398.

Artists of the Nineteenth Century and Their Works, 1: 362–363. Ed. Clara Erskine Clement and Laurence Hutton. Boston, 1884.

Atkinson, D. Scott. *Winslow Homer in Gloucester* [exh. cat., Terra Museum of American Art] (Chicago, 1990).

Ayres, Linda, and John Wilmerding. *Winslow Homer in the 1870s: Selections from the Valentine-Pulsifer Collection* [exh. cat., The Art Museum, Princeton University] (Princeton, 1990).

Beam, Philip Conway. "Winslow Homer." Ph.D. diss., Harvard University, 1944.

Beam, Philip Conway. "Winslow Homer's Father." *The New England Quarterly* 20 (March 1947), 51–74.

Beam, Philip Conway. *Winslow Homer at Prout's Neck*. Boston, 1966.

Beam, Philip Conway. *Winslow Homer's Magazine Engravings*. New York and London, 1979.

Beam, Philip Conway. *Winslow Homer: Watercolors* [exh. cat., Bowdoin College Museum of Art] (Brunswick, Maine, 1983).

Beam, Phillip Conway, et al. *Winslow Homer in the 1890s: Prout's Neck Observed* [exh. cat., Memorial Art Gallery] (Rochester, 1990).

Benjamin, Samuel Green Walter. *Art in America: A Critical and Historical Sketch*, 117. New York, 1880.

Berman, Avis. "Historic Houses: Winslow Homer at Prout's Neck." *Architectural Digest* 41 (July 1984), 136–144.

Boime, Albert. "Blacks in Shark-Infested Waters: Visual Encodings of Racism in Copley and Homer." *Smithsonian Studies in American Art* 3 (Winter 1989), 19–47.

Bolton, Theodore H. "The Art of Winslow Homer: An Estimate in 1932." *The Fine Arts* 18 (February 1932), 23–28, 52–55. [Bolton 1932a]

Bolton, Theodore H. "Water Colors by Homer: Critique and Catalogue." *The Fine Arts* 18 (April 1932), 16–21, 52, 54. [Bolton 1932b]

Brinton, Christian. "Winslow Homer." *Scribner's Magazine* 49 (January 1911), 9–23.

Burroughs, Louise. *Winslow Homer: A Picture Book*. New York, 1939.

Caffin, Charles Henry. *American Masters of Painting*, 71–80. New York, 1902.

Caffin, Charles Henry. *The Story of American Painting*, 233–237. New York, 1907.

Calo, Mary Ann. "Winslow Homer's Visits to Virginia During Reconstruction." *The American Art Journal* 12 (Winter 1980), 4–27.

Carren, Rachel A. "From Reality to Symbol: Images of Children in the Art of Winslow Homer." Ph.D. diss., University of Maryland, 1990.

Carson, Lowell. "New York Letter: Water Colors by Winslow Homer." *Brush and Pencil* 3 (June 1898), 131–143.

Catalogue of a Loan Exhibition of Paintings by Winslow Homer [exh. cat., Metropolitan Museum of Art] (New York, 1911).

Centenary Exhibition of Work of Winslow Homer [exh. cat., Carnegie Institute] (Pittsburgh, 1937).

Century Loan Exhibition as a Memorial to Winslow Homer [exh. cat., Prouts Neck Association] (Prouts Neck, Maine, 1936).

Chase, J. Eastman. "Some Recollections of Winslow Homer." *Harper's Weekly* 54 (22 October 1910), 13.

Church, William C. "A Midwinter Resort, with Engravings of Winslow Homer's Watercolor Studies in Nassau." *The Century Magazine* 33 (February 1887), 499–506.

Cikovsky, Nicolai, Jr. "Winslow Homer's *Prisoners from the Front*." *Metropolitan Museum Journal* 12 (1977), 155–172.

Cikovsky, Nicolai, Jr. "Winslow Homer's *School Time*: A Picture Thoroughly National." In *Essays in Honor of Paul Mellon, Collector and Benefactor*, ed. John Wilmerding. Washington, 1986, 46–69.

Cikovsky, Nicolai, Jr. "Forum: A Homer Drawing of the English Period." *Drawing* 10 (January–February 1989), 108.

Cikovsky, Nicolai, Jr. *Winslow Homer*. New York, 1990. [Cikovsky 1990a]

Cikovsky, Nicolai, Jr. "Homer Around 1900." In *Winslow Homer, A Symposium* [Studies in the History of Art 26], ed. Nicolai Cikovsky, Jr. Washington, 1990, 133–154. [Cikovsky 1990b]

Cikovsky, Nicolai, Jr. "Winslow Homer's Unfinished Business." In *American Art Around 1900: Lectures in Memory of Daniel Fraad* [Studies in the History of Art 37], ed. Doreen Bolger and Nicolai Cikovsky, Jr. Washington, 1990, 93–117. [Cikovsky 1990c]

Cikovsky, Nicolai, Jr. *Winslow Homer Watercolors*. New York, 1991.

Cikovsky, Nicolai, Jr. *Winslow Homer*. New York, 1992. [Cikovsky 1992a]

Cikovsky, Nicolai, Jr. "Winslow Homer's National Style." In *American Icons: Transatlantic Perspectives on Eighteenth- and Nineteenth-Century American Art*, ed. Thomas W. Gaehtgens and Heinz Ickstadt. Santa Monica, 1992, 247–265. [Cikovsky 1992b]

Coburn, F. W. "Winslow Homer's *Fog Warning*." *New England Magazine*, n.s. 38 (July 1908), 616–617.

Coffin, William A. "A Painter of the Sea: Two Pictures by Winslow Homer." *Century Magazine* 58 (September 1899), 651–655.

Cole, Walter W. "Some Crayon Studies, by Winslow Homer." *Brush and Pencil* 11 (January 1903), 271–276.

Conrads, Margaret C. *American Paintings and Sculpture at the Sterling and Francine Clark Art Institute*, 63–100. New York, 1990.

Cook, Clarence. *Art and Artists of Our Time*, 5: 256–258. New York, 1888.

Cooke, Hereward Lester. "The Development of Winslow Homer's Water-color Technique." *Art Quarterly* 24 (Summer 1961), 169–194.

Cooper, Helen A. *Winslow Homer Watercolors* [exh. cat., National Gallery of Art] (New Haven and London, 1986). [Cooper 1986a]

Cooper, Helen A. "Winslow Homer's Watercolors." *Antiques* 129 (April 1986), 824–833. [Cooper 1986b]

Cooper, Helen A. "Winslow Homer's Watercolors: A Study in Theme and Style." Ph.D. diss., Yale University, 1986. [Cooper 1986c]

Cortissoz, Royal. *Catalogue of an Exhibition of Water Colors by Winslow Homer* [exh. cat., Carnegie Institute] (Pittsburgh, 1923). [Cortissoz 1923a]

Cortissoz, Royal. *American Artists*, 119–125. New York, 1923. [Cortissoz 1923b]

Cox, Kenyon. "Three Pictures by Winslow Homer in the Metropolitan Museum." *The Burlington Magazine* 12 (November 1907), 123–124.

Cox, Kenyon. *Winslow Homer*. New York, 1914. [Cox 1914a]

Cox, Kenyon. "The Art of Winslow Homer." *Scribner's Magazine* 56 (September 1914), 377–388. [Cox 1914b]

Cox, Kenyon. "The Watercolors of Winslow Homer." *Art In America* 6 (October 1914), 404–415. [Cox 1914c]

Curry, David Park. "Winslow Homer and Croquet." *Antiques* 126 (July 1984), 154–162. [Curry 1984a]

Curry, David Park. *Winslow Homer: The Croquet Game* [exh. cat., Yale University Art Gallery] (New Haven, 1984). [Curry 1984b]

Curry, David Park. "Homer's *Dressing for the Carnival*." In *Winslow Homer, A Symposium* [Studies in the History of Art 26], ed. Nicolai Cikovsky, Jr. Washington, 1990, 91–113.

Cyclopedia of Painters and Paintings, 2: 285. Ed. John Denison Champlin and Charles C. Perkins. New York, 1886.

Davis, Melinda Dempster. *Winslow Homer: An Annotated Bibliography of Periodical Literature*. Metuchen, N.J., 1975.

de Weck, Ziba. *Winslow Homer and the New England Coast* [exh. cat., Whitney Museum of American Art] (Stamford, Connecticut, 1984–1985).

Docherty, Linda J. *Winslow Homer: Master of the Wood Engraving* [exh. cat., The Ackland Art Museum] (Chapel Hill, 1979).

Docherty, Linda J. "A Problem of Perspective: Winslow Homer, John H. Sherwood, and *Weaning the Calf*." *North Carolina Museum of Art Bulletin* 16 (1993), 32–48.

Downes, William Howe. *Twelve Great Artists*, 103–125. Boston, 1900.

Downes, William Howe. *The Life and Works of Winslow Homer*. Boston and New York, 1911.

Downes, William Howe, and F. T. Robinson. "Some Living American Painters, Winslow Homer, N.A." *Art Interchange* (May 1894), 136–138.

Eager, Gerald. "*Corn Husking* by Winslow Homer." *Phoebus* 3 (1981), 73–79.

Early Winslow Homer [exh. cat., Maynard Walker Gallery] (New York, 1953).

Engel, Charlene. "'For Those in Peril on the Sea': The Intaglio Prints of Winslow Homer." *Print Review* 20 (1985), 22–40.

Exhibit Sixteen: Winslow Homer [exh. cat., Sterling and Francine Clark Art Institute] (Williamstown, Massachusetts, 1961).

Fairburn, Gordon. "Winslow Homer at Prout's Neck." *Horizon* 22 (April 1979), 56–63.

Faxon, Susan, and Paul Metcalf. *Winslow Homer at the Addison* [exh. cat., Addison Gallery of American Art] (Andover, Massachusetts, 1990).

Flexner, James Thomas. *That Wilder Image: The Painting of America's Native School From Thomas Cole to Winslow Homer*. Boston, 1962.

Flexner, James Thomas. "The Homer Show. Few Painters Have So Powerfully Expressed the Vastness of the World." *Art News* 72 (May 1973), 65–67.

Flexner, James Thomas, et al. *The World of Winslow Homer, 1836–1910*. New York, 1966.

Fosburgh, Pieter W. "Winslow Homer, Painter of Fishes and Fishermen." *The Conservationist* (April–May 1972), 4–7.

Foster, Allen Evarts. "Check List of Illustrations by Winslow Homer in Harper's Weekly and Other Periodicals." *Bulletin of the New York Public Library* 40 (October 1936), 842–852.

Foster, Allen Evarts. "A Checklist of Illustrations by Winslow Homer Appearing in Various Periodicals: A Supplement to the Check List Published in the Bulletin of the New York Public Library, October, 1936." *Bulletin of The New York Public Library* 44 (July 1940), 537.

"From Our Permanent Collection: *The Wreck*, by Winslow Homer." *Carnegie Magazine* 24 (January 1950), 201–202, 205.

Gardner, Albert Ten Eyck. *Winslow Homer: A Retrospective Exhibition* [exh. cat., National Gallery of Art, and the Metropolitan Museum of Art] (Washington and New York, 1958).

Gardner, Albert Ten Eyck. "Metropolitan Homers." *Bulletin of the Metropolitan Museum of Art* 7 (January 1959), 132–143. [Gardner 1959a]

Gardner, Albert Ten Eyck. *Winslow Homer: A Retrospective Exhibition* [exh. cat., Museum of Fine Arts, Boston] (Boston, 1959). [Gardner 1959b]

Gardner, Albert Ten Eyck. *Winslow Homer, American Artist: His World and His Work*. New York, 1961.

Gerdts, William H. "Winslow Homer in Cullercoats." *Yale University Art Gallery Bulletin* 36 (Spring 1977), 18–35.

Giese, Lucretia H. "Winslow Homer: Painter of the Civil War." Ph.D. diss., Harvard University [Ann Arbor, University Microforms, 1986]. [Giese 1986a]

Giese, Lucretia H., "Winslow Homer's Civil War Painting *The Initials*: A Little-Known Drawing and Related Works." *The American Art Journal* 18 (1986), 4–19. [Giese 1986b]

Giese, Lucretia H. "Winslow Homer: 'Best Chronicler of the War.'" In *Winslow Homer, A Symposium* [Studies in the History of Art 26], ed. Nicolai Cikovsky, Jr. Washington, 1990, 15–31.

Goodrich, Lloyd. "Winslow Homer." *The Arts* 6 (October 1924), 187–209.

Goodrich, Lloyd. *Winslow Homer Centenary Exhibition* [exh. cat., Whitney Museum of American Art] (New York, 1936).

Goodrich, Lloyd. "A 'Lost' Winslow Homer." *Worcester Art Museum Annual* 3 (1937–1938), 69–73.

Goodrich, Lloyd. *Winslow Homer*. New York, 1944. [Goodrich 1944a]

Goodrich, Lloyd. "Young Winslow Homer." *Magazine of Art* 37 (February 1944), 58–63. [Goodrich 1944b]

Goodrich, Lloyd. *American Watercolor and Winslow Homer* [exh. cat., Walker Art Center] (Minneapolis, 1945).

Goodrich, Lloyd. *A Loan Exhibition of Winslow Homer for the Benefit of the New York Botanical Garden* [exh. cat., Wildenstein & Co.] (New York, 1947).

Goodrich, Lloyd. "Realism and Romanticism in Homer, Eakins and Ryder." *Art Quarterly* 12 (Winter 1949), 17–29.

Goodrich, Lloyd. *The Metropolitan Museum of Art Miniatures: Winslow Homer, 1836–1910*. New York, 1956. [Goodrich 1956a]

Goodrich, Lloyd. "Winslow Homer." *Perspectives U.S.A.* 14 (Winter 1956), 44–54. [Goodrich 1956b]

Goodrich, Lloyd. *Winslow Homer*. New York, 1959.

Goodrich, Lloyd. *Winslow Homer in New York State* [exh. cat., Storm King Art Center] (Mountainville, New York, 1963).

Goodrich, Lloyd. *Homer and the Sea* [exh. cat., Mariner's Museum and the Virginia Museum of Fine Arts] (Richmond, 1964). [Goodrich 1964a]

Goodrich, Lloyd. "Winslow Homer in New York State." *Art in America* 52 (April 1964), 78–87. [Goodrich 1964b]

Goodrich, Lloyd. *The Graphic Art of Winslow Homer* [exh. cat., Museum of Graphic Art] (New York, 1968).

Goodrich, Lloyd. *Winslow Homer's America*. New York, 1969.

Goodrich, Lloyd. *Winslow Homer* [exh. cat., Whitney Museum of American Art] (New York, 1973).

Goodrich, Lloyd, and Abigail Gerdts. *Winslow Homer in Monochrome* [exh. cat., M. Knoedler & Co.] (New York, 1986).

Goodyear, William H. "Water Colors by Winslow Homer in the Museum of the Brooklyn Institute of Arts and Sciences." *The Bulletin of the Brooklyn Institute of Arts and Sciences* 8 (4 May 1912), 387–395.

Goodyear, William H. "The Watercolors of Winslow Homer, 1836–1910." *Brooklyn Museum Quarterly* 3 (October 1915), 367–384.

Gould, Jean. "The Love Affair of Winslow Homer." *Bulletin of The New York Public Library* 62 (September 1962), 444–448. [Gould 1962a]

Gould, Jean. *Winslow Homer, a Portrait*. New York, 1962. [Gould 1962b]

Graham, Lois Homer. "An Intimate Glimpse of Winslow Homer's Art." *Vassar Journal of Undergraduate Studies* 10 (May 1936), 1–16.

Grossman, Julian. *Echo of a Distant Drum: Winslow Homer and the Civil War*. New York, 1974.

H., W. E. "Winslow Homer: Early Criticisms." *Bulletin of the Metropolitan Museum of Art* 5 (December 1910), 268–269.

Hannaway, Patti. *Winslow Homer in the Tropics*. Richmond, 1973.

Hartman, Sadakichi. *A History of American Art*, 1: 189–200. Boston, 1902.

Hathaway, Calvin S. "Drawings by Winslow Homer in the Museum's Collections." *Chronicle of the Museum for the Arts of Decoration of Cooper Union* 1 (April 1936), 52–63.

Heller, Nancy, and Julia Williams. "Winslow Homer: The Great American Coast." *American Artist* 40 (January 1976), 34–39, 94.

Hendricks, Gordon. "The Flood Tide in the Winslow Homer Market." *Art News* 72 (May 1973), 69–71.

Hendricks, Gordon. *The Life and Work of Winslow Homer*. New York, 1979.

Hess, Thomas B. "Come Back to the Raft Ag'in, Winslow Homer Honey." *New York Magazine* (11 June 1973), 75–76.

Hoopes, Donelson F. *Winslow Homer Watercolors*. New York, 1969.

Hoopes, Donelson F. *Winslow Homer Watercolors* [exh. cat., Art Museum of South Texas] (Corpus Christi, Texas, 1978).

Howard, W. Stanton. "*A Northeaster* by Winslow Homer." *Harper's Magazine* 120 (March 1910), 574–575.

Howat, John K., and Natalie Spassky. "Works by Sargent and Homer." *Metropolitan Museum of Art Bulletin* 30 (February–March 1972), 185–186.

Hurley, Patricia M. "Forum: Winslow Homer's *Children Playing on a Fence*." *Drawing* 8 (September–October 1986), 58.

Hyman, Linda. *Winslow Homer: America's Old Master*. New York, 1973.

Ingalls, Hunter. "Elements in the Development of Winslow Homer." *Art Journal* 24 (Fall 1964), 18–22.

An Introduction to Homer [exh. cat., Macbeth Gallery] (New York, 1936).

Isham, Samuel. *The History of American Painting*, 350–358. New York, 1905.

Jackson, Barbara Gelman. *The Wood Engravings of Winslow Homer*. New York, 1969.

James, Henry, Jr. "On Some Pictures Lately Exhibited." *The Galaxy* 20 (July 1875), 89–97.

Jennings, Kate F. *Winslow Homer*. New York, 1990.

Johnston, Sona. *Winslow Homer: Works on Paper* [exh. cat., Baltimore Museum of Art] (Baltimore, 1978).

Johnston, P. C. "Winslow Homer." *Sporting Classics* 5 (1986), 42–51.

Jones, Eleanor Lewis. "*Deer Drinking*: Reflections on a Watercolor by Winslow Homer." *Smithsonian Studies in American Art* 2/3 (Fall 1988), 54–65.

Judge, Mary A. *Winslow Homer*. New York, 1986.

Kaplan, Sidney. "The Negro in the Art of Homer and Eakins." *The Massachusetts Review* 7 (Winter 1966), 105–120.

Katz, Leslie. "The Modernity of Winslow Homer." *Arts* 33 (February 1959), 24–27.

Kelsey, Mavis Parrott. *Winslow Homer Graphics: From the Mavis P. and Mary Wilson Kelsey Collection of Winslow Homer Graphics* [exh. cat., The Museum of Fine Arts, Houston] (Houston, 1977).

Knauff, Christopher W. "Certain Exemplars of Art in America, IV. Elliot Daingerfield—Winslow Homer." *The Churchman*, 23 July 1898, 123–125, 128.

Knipe, Tony, and John Boon et. al. *All the Cullercoats Pictures* [exh. cat., Northern Centre for Contemporary Art] (Sunderland, 1988).

Kobbé, Gustave. "John La Farge and Winslow Homer." *New York Herald* (magazine section), 4 December 1910.

Koehler, Sylvester R. *American Art*, 49–51. New York, 1886.

Kramer, Hilton. "Winslow Homer: The Artifice of Sincerity." *New York Times* (14 May 1972).

Lasher, Pat. "Winslow Homer, 1836–1910." *Southwest Art* 6 (March 1977), 66–71.

Mather, Frank Jewett, Jr. *Sixth Loan Exhibition: Winslow Homer, Albert P. Ryder, Thomas Eakins* [exh. cat., Museum of Modern Art] (New York, 1930).

Mather, Frank Jewett, Jr. "Winslow Homer as a Book Illustrator, with a Descriptive Checklist." *Princeton University Library Chronicle* 1 (November 1939), 15–32.

May, Stephen. "Hymns to the Heroic: The Seascapes of Winslow Homer." *Carnegie Magazine* 61 (March–April 1992), 12–18.

McCaughey, Patrick. "Native and Nomad: Winslow Homer and John Singer Sargent." *Daedalus* 116 (Winter 1987), 133–153.

McSpadden, J. Walker. *Famous Painters of America*, 167–189. New York, 1907.

Mead, Michelle. "Giving Up his Ghost: The Finding of Homer's *Sailors Take Warning (Sunset)*." *American Art* 7 (Spring 1993), 104–107.

Mechlin, Leila. "Winslow Homer." *The International Studio* 34 (June 1908), CXXVII–CXXXVI.

Meyer, Laure. "Les aquarelles de Winslow Homer." *Oeil* 346 (May 1984), 36–43.

Mooz, R. Peter, and Philip C. Beam. *Winslow Homer's Work in Black and White: Selected Works from the Bowdoin College Museum of Art* [exh. cat., Bowdoin College Museum of Art] (Brunswick, Maine, 1975).

Morton, Frederick W. "The Art of Winslow Homer." *Brush and Pencil* 10 (April 1902), 40–54.

Munhall, Edgar. "Winslow Homer (1836–1910)," *Du* 475 (September 1980), 74–80.

Murphy, Alexandra R., Rafael Fernandez, and Jennifer Gordon. *Winslow Homer in the Clark Collection* [exh. cat., The Sterling and Francine Clark Art Institute] (Williamstown, Massachusetts, 1986).

Muther, Richard. *History of Modern Painting*, 4: 313. New York, 1897.

"A New Winslow Homer." *Civil War Times Illustrated* 12 (April 1973), 30–31.

Novak, Barbara. "Winslow Homer: Concept and Precept." In *American Painting of the Nineteenth Century: Realism, Idealism and the American Experience*. New York, 1979, 165–190.

Novak, Barbara. "Self, Time, and Object in American Art: Copley, Lane, and Homer." In *American Icons: Transatlantic Perspectives on Eighteenth- and Nineteenth-Century American Art*, ed. Thomas W. Gaehtgens and Heinz Ickstadt. Santa Monica, 1992, 61–92.

O'Connor, John, Jr. "A Footnote to *The Wreck*." *Carnegie Magazine* 10 (March 1937), 300–301.

Pach, Walter. "Winslow Homer et la signification de son oeuvre." *L'Art et les Artistes* 16 (November 1912), 73–79.

The Paintings of Winslow Homer From the Cooper Union Museum [exh. cat., Ira Spanierman] (New York, 1966).

Pope, Arthur. "Water-colours by Winslow Homer." *Fogg Art Museum Notes* 2 (June 1926), 42–48.

Porter, Fairfield. "Homer. American vs. Artist: A Problem in Identities." *Art News* 57 (December 1958), 24–27, 54, 56.

Pousette-Dart, Nathaniel. *Winslow Homer*. New York, 1923.

Provost, Paul. "Winslow Homer's *The Fog Warning*: The Fisherman as Heroic Character." *The American Art Journal* 22 (1990), 20–27.

Provost, Paul. "Drawn Toward Europe: Winslow Homer's Work in Black-and-White." *Master Drawings* 31 (1993), 35–46.

Prown, Jules David. "Winslow Homer in His Art." *Smithsonian Studies in American Art* 1 (Spring 1987), 31–45.

Quick, Michael. "Homer in Virginia." *Los Angeles County Museum of Art Bulletin* 24 (1978), 60–81.

Reed, Christopher. "The Artist and the Other: The Work of Winslow Homer." *Yale University Art Gallery Bulletin* 40 (Spring 1989), 68–79.

Richardson, Edgar P. "Winslow Homer's Drawings in Harper's Weekly." *Art in America* 19 (December 1930), 38–47.

Richardson, Edgar P. "*The Dinner Horn* by Winslow Homer." *The Art Quarterly* (Detroit Institute of Arts) 11 (Spring 1948), 153–157.

Richardson, Edgar P. "Three Early Works by Winslow Homer." *Bulletin of the Detroit Institute of Arts* 31 (1951–1952), 6–9.

Richardson, Edgar P. "Winslow Homer in Harper's Weekly." *Art in America* 19 (December 1963), 38–47.

Robertson, Bruce. *Reckoning with Winslow Homer: His Late Paintings and Their Influence* [exh. cat., The Cleveland Museum of Art] (Cleveland, 1990).

Rudd, Eric. "Winslow Homer and *Mr. Hardy Lee, His Yacht*." *Antiques* 106 (November 1974), 844–851.

Rudd, Eric. "Winslow Homer and *The Christmas Stocking*." *Antiques* 128 (December 1985), 1206–1209.

Russell, John. "Art: Homer's Small Masterpieces." *New York Times*, 19 September 1976, 34.

Saint-Gaudens, Homer. "Winslow Homer." *The Critic* 46 (April 1905), 322–323.

Saint-Gaudens, Homer. "Winslow Homer." *Carnegie Magazine* 10 (February 1937), 259–268.

Schlageter, Robert W. *Winslow Homer's Florida, 1886–1909* [exh. cat., Cummer Gallery of Art] (Jacksonville, 1977).

Shapiro, David. "Barbaric Simplicity: The Paintings and Prints of Winslow Homer." *Art News* 71 (May 1972), 29–31.

[Sheldon, George William]. "American Painters—Winslow Homer and F. A. Bridgman." *Art Journal* (New York) 4 (August 1878), 225–229.

Sheldon, George William. *American Painters: With Eighty-Three Examples of Their Work Engraved on Wood*, 25–29. New York, 1879.

[Sheldon, George William]. "Sketches and Studies II, From the Portfolios of A. H. Thayer, William M. Chase, Winslow Homer, and Peter Moran." *Art Journal* (New York) 6 (April 1880), 105–109.

Sheldon, George William. *Hours with Art and Artists*, 136–138. New York, 1882.

Sherman, Frederic Fairchild. "The Early Oil Paintings of Winslow Homer." *Art in America* 4 (June 1918), 201–208.

Sherman, Frederic Fairchild. "Note and Comment. A Winslow Homer Miscellany." *Art in America* 24 (April 1936), 84–86.

Sherman, Frederic Fairchild. "Winslow Homer's Book Illustrations." *Art In America* 25 (October 1937), 173–175.

Shurtleff, Roswell. "Correspondence. Shurtleff Recalls Homer." *American Art News* 9 (29 October 1910), 4.

Simpson, Marc, et al. *Winslow Homer's Paintings of the Civil War* [exh. cat., Fine Arts Museums of San Francisco] (San Francisco, 1988).

Spassky, Natalie. "Winslow Homer at the Metropolitan Museum of Art." *Metropolitan Museum of Art Bulletin* 34 (Spring 1982), 1–48.

Spassky, Natalie. *American Paintings in the Metropolitan Museum of Art*, 2: 430–499. New York, 1985.

Stein, Roger B. "Winslow Homer in Context." *American Quarterly* 42 (March 1990), 74–92. [Stein 1990a]

Stein, Roger B. "Picture and Text: The Literary World of Winslow Homer." In *Winslow Homer, A Symposium* [Studies in the History of Art 26], ed. Nicolai Cikovsky, Jr. Washington, 1990, 33–59. [Stein 1990b]

Stepanek, Stephanie. *Winslow Homer* [exh. cat., Museum of Fine Arts, Boston] (Boston, 1977).

Stokes, Charlotte. "*An Adirondack Lake* by Winslow Homer." *Quarto* 4 (October 1977).

Stonehouse, Augustus. "Winslow Homer." *Art Review* 1 (February 1887), 84–86.

Tatham, David. "Winslow Homer in the Mountains." *Appalachia* 36 (15 June 1966), 73–90.

Tatham, David. "Winslow Homer and the Ratcatcher's Daughter." *The Courier*, no. 28 (Winter 1967), 4.

Tatham, David. "Some Apprentice Lithographs of Winslow Homer—Ten Pictorial Title Pages for Sheet Music." *Old Time New England* 59 (April–June 1969), 86–104.

Tatham, David. "Winslow Homer in Boston: 1854–1859." Ph.D. diss., Syracuse University, 1970.

Tatham, David. "Winslow Homer's Arguments of the Chivalry." *American Art Journal* 5 (May 1973), 86.

Tatham, David. "Winslow Homer's Lithographic Portraits for Abner Morse's Genealogies." *Antiques* 106 (November 1974), 871–875.

Tatham, David. "Some Newly Discovered Book Illustrations by Winslow Homer." *Antiques* 110 (December 1976), 1262–1266.

Tatham, David. "Winslow Homer's Library." *American Art Journal* 9 (May 1977), 92–98.

Tatham, David. *Winslow Homer Drawings, 1875–1885: Houghton Farm to Prout's Neck.* [exh. cat., Joe and Emily Lowe Art Gallery, Syracuse University] (Syracuse, 1979). [Tatham 1979a]

Tatham, David. "New Discoveries in American Art: Winslow Homer at the Front in 1862." *American Art Journal* 11 (July 1979), 86–87. [Tatham 1979b]

Tatham, David. "Winslow Homer and the New England Poets." *Proceedings of the American Antiquarian Society* 89 (1980), 241–260.

Tatham, David. *Winslow Homer in the 1880s: Watercolors, Drawings, and Etchings* [exh. cat., Everson Museum of Art] (Syracuse, 1983).

Tatham, David. "A Drawing by Winslow Homer: *Corner of Winter, Washington and Summer Streets.*" *American Art Journal* 18 (1986), 40–50. [Tatham 1986a]

Tatham, David. "*Paddling at Dusk:* Winslow Homer and Ernest Yalden." *Porticus* 9 (1986), 16–19. [Tatham 1986b]

Tatham, David. "An Unrecorded Winslow Homer Lithograph." *American Art Journal* 19 (1987), 75–76.

Tatham, David. "*The Two Guides:* Winslow Homer at Keene Valley, Adirondacks," *American Art Journal* 20 (1988), 20–34.

Tatham, David. "Winslow Homer at the North Woods Club." In *Winslow Homer, A Symposium* [Studies in the History of Art 26], ed. Nicolai Cikovsky, Jr. Washington, 1990, 115–130. [Tatham 1990a]

Tatham, David. "Trapper, Hunter, and Woodsman: Winslow Homer's Adirondack Figures." *American Art Journal* 22 (1990), 41–67. [Tatham 1990b]

Tatham, David. *Winslow Homer and the Illustrated Book.* Syracuse, 1992.

Teitelbaum, Gene. *Winslow Homer: An Annual.* New Albany, Indiana, 1986–1992.

Van Dyke, John C. *American Painting and Its Tradition.* New York, 1919.

Van Rensselaer, Mariana Griswold. "An American Artist in England." *The Century Magazine* 27 (November 1883), 13–21.

Van Rensselaer, Mrs. Schuyler. *Six Portraits.* Boston, 1889.

Walsh, Judith. "Observations on the Watercolor Techniques of Homer and Sargent." In *American Traditions in Watercolor: The Worcester Art Museum Collection*, ed. Susan E. Strickler. New York, 1987, 44–65.

Walsh, Judith. "*A Summer's Pleasure: Incoming Tide, Scarboro, Maine* by Winslow Homer." *American Art Journal* 25 (1993), 63–73.

Watercolors by Winslow Homer [exh. cat., The Brooklyn Museum] (Brooklyn, 1915).

Watercolors by Winslow Homer from the Collection of Mrs. Charles R. Henschel [exh. cat., National Gallery of Art] (Washington, 1962).

Watson, Forbes. "Winslow Homer." *American Magazine of Art* 29 (October 1936), 624–637, 681–683.

Watson, Forbes. *Winslow Homer.* New York, 1942.

Wehle, H. B. "Early Paintings by Homer." *Bulletin of the Metropolitan Museum of Art* 18 (February 1923), 38–41. [Wehle 1923a]

Wehle, H. B. "Two More Early Paintings by Homer." *Bulletin of the Metropolitan Museum of Art* 18 (April 1923), 85–87. [Wehle 1923b]

Weitenkampf, Frank. "Winslow Homer and the Wood Block." *Bulletin of the New York Public Library* 36 (November 1932), 731–736.

Weitenkampf, Frank. "The Intimate Homer: Winslow Homer's Sketches." *Art Quarterly* 6 (Autumn 1943), 306–321.

Weller, Allen. "A Note on Winslow Homer's Drawings in Harper's Weekly." *Art in America* 22 (March 1934), 76–78.

Weller, Allen. "Winslow Homer's Early Illustrations." *The American Magazine of Art* 28 (July 1935), 412–417, 448.

White, Edmund. "Go West, Winslow Homer." *Saturday Review: The Arts*, 7 April 1973, 76.

Wilkins, David G. "Winslow Homer at Carnegie Institute." *Carnegie Magazine* 55 (January 1981), 5–20.

Wilmerding, John. "Interpretations of Place: Views of Gloucester, Massachusetts, by American Artists." *Essex Institute Historical Collections* 103 (January 1967), 53–65.

Wilmerding, John. *Winslow Homer.* New York and London, 1972.

Wilmerding, John. "Winslow Homer's Creative Process." *Antiques* 108 (November 1975), 965–971. [Wilmerding 1975a]

Wilmerding, John. "Winslow Homer's English Period." *The American Art Journal* 7 (November 1975), 60–69. [Wilmerding 1975b]

Wilmerding, John. "Winslow Homer's *Right and Left.*" *Studies in the History of Art* 9 (1980), 59–85.

Wilmerding, John. *Winslow Homer: The Charles Shipman Payson Gift to the Portland Museum of Art, Portland, Maine* [exh. cat., Coe Kerr Gallery] (New York, 1981).

Wilmerding, John. "Winslow Homer's *Dad's Coming.*" In *Essays in Honor of Paul Mellon, Collector and Benefactor*, ed. John Wilmerding. Washington, 1986, 388–401.

Wilmerding, John, and Elaine Evans Dee. *Winslow Homer, 1836–1910: A Selection from the Cooper-Hewitt Collection, Smithsonian Institution* [exh. cat., Cooper-Hewitt Museum of Decorative Arts and Design, Smithsonian Institution] (New York, 1972).

Wilson, Christopher Kent. "A Contemporary Source for Winslow Homer's *Prisoners from the Front.*" *Source* 4 (Summer 1985), 37–40. [Wilson 1985a]

Wilson, Christopher Kent. "Winslow Homer's *The Veteran in a New Field:* A Study of the Harvest Metaphor and Popular Culture." *American Art Journal* 17 (Autumn 1985), 2–27. [Wilson 1985b]

Wilson, Christopher Kent. "Winslow Homer's *Thanksgiving Day—Hanging up the Musket.*" *American Art Journal* 18 (1986), 76–83.

"Winslow Homer." *Art Amateur* 39 (November 1898), 112–113.

"Winslow Homer and His Work. Part I." *Bulletin of the Worcester Art Museum* 2 (October 1911), 4–14.

"Winslow Homer and His Work. Part II. Homer as a Draughtsman." *Bulletin of the Worcester Art Museum* 2 (January 1912), 7–11.

Winslow Homer: 1836–1910 [exh. cat., Pennsylvania Museum of Art] (Philadelphia, 1936).

Winslow Homer: Watercolors, Prints, Drawings [exh. cat., New England Museums Association] (Boston, 1936).

Winslow Homer, 1836–1910 [exh. cat., Worcester Museum of Art] (Worcester, Massachusetts, 1944).

Winslow Homer in the Adirondacks [exh. cat., Adirondack Museum] (Blue Mountain Lake, New York, 1959).

Winslow Homer at Prout's Neck [exh. cat., Bowdoin College Museum of Art] (Brunswick, Maine, 1966).

Winslow Homer 1836–1910 [exh. cat., William A. Farnsworth Library and Art Museum] (Rockland, Maine, 1970).

Winslow Homer [exh. cat., Portland Museum of Art] (Portland, Maine, 1974).

"Winslow Homer in Texas." *Antiques* 112 (November 1977), 892.

"Winslow Homer at the Seashore." *American History Illustrated* 15 (1980), 23–28.

Wolf, Bryan. "The Labor of Seeing: Pragmatism, Ideology, and Gender in Winslow Homer's *The Morning Bell*." *Prospects: An Annual of American Cultural Studies* (1992), 273–318.

Wood, Peter H. "Waiting in Limbo: A Reconsideration of Winslow Homer's *The Gulf Stream*." In *The Southern Enigma: Essays in Race, Class, and Folk Culture*, ed. Walter J. Fraser and Winfred B. Moore, Jr. Westport, Connecticut, 1983, 76–95.

Wood, Peter H., and Karen C. C. Dalton. *Winslow Homer's Images of Blacks: The Civil War and Reconstruction Years* [exh. cat., The Menil Collection] (Houston, 1988).

Wright, Willard Huntington. "Modern American Painters—and Winslow Homer." *The Forum* 54 (December 1915), 661–672.

Yankee Painter: A Retrospective Exhibition of Oils, Water Colors and Graphics by Winslow Homer [exh. cat., University of Arizona Art Gallery] (Tucson, 1963).

Young, J. W. "The Art of Winslow Homer." *Fine Arts Journal* 19 (February 1908), 57–63.

Zalesch, Saul E. "Winslow Homer, Against the Current." *American Art Review* 5 (Fall 1993), 120–125.

Zbornik, Matthew. *Winslow Homer: Water and Light, Selected Watercolors, 1874–1897* [exh. cat., Center for the Fine Arts] (Miami, 1991).

Index of Titles